Northern Haida
Master Carvers

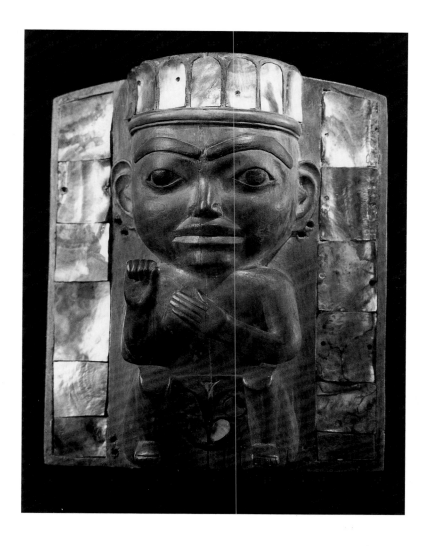

ROBIN K. WRIGHT

UNIVERSITY OF WASHINGTON PRESS *Seattle & London*

DOUGLAS & MCINTYRE *Vancouver & Toronto*

This book was published with the assistance of the Getty Grant Program.

Published simultaneously in the United States and Canada

University of Washington Press
P.O. Box 50096
Seattle, Washington 98145-5096

Douglas & McIntyre
2323 Quebec Street, Suite 201
Vancouver, British Columbia V5T 4S7

LIBRARY OF CONGRESS CATALOGING-IN-PUBLICATION DATA
Wright, Robin Kathleen.
 Northern Haida master carvers / Robin K. Wright.
 p. cm.
 Includes bibliographical references and index.
 ISBN 0-295-98084-2 (alk. paper)
 1. Haida artists. 2. Haida sculpture. I. Title.

E99.H2 W75 2001
 704.03'972 — dc21 00-050311

CANADIAN CATALOGUING IN PUBLICATION DATA
Wright, Robin K. (Robin Kathleen)
Northern Haida master carvers.
Includes bibliographical references and index.
ISBN 1-55054-842-5
1. Haida artists. 2. Haida sculpture. 3. Totem poles — Northwest Coast of North America. I. Title
E99.H2W75 2001 730',92'27111 C00-911524-2

xàadasran
tl'a kuniisii stlanlaayan

For the Haida people
Their ancestors were good with their hands

Contents

Charts

Maps

Foreword

Thanks to the Great Spirits

Thanks to HAIDA GWAII, the seas, the lands,

Thanks to the salmon, to the cedar tree.

Thanks to the weather, the rain, the winds,

 the mists, the sun.

Thanks for culture, the different ways we think, we live.

Thanks to our oral stories, told & passed on with great care.

Thanks to the safely kept writings of the past,

 of things observed, of things interpreted.

Thanks to the well-made objects, the monumental art,

 the story, the history.

Thanks to the legacy,

 the honor to carry on . . . the fine lines,

 the reason we are today,

 How-aa

Thanks to Robin Wright who researched her growing idea,

 who pulled this book together,

 who sees the need.

 Thanks.

Jim Hart, Chief *7idansuu*

February 2001

Acknowledgments

This book could not have been completed without the help and support of many generous people. The initial research was funded by a grant from the University of Washington Royalty Research Fund in 1994–95, which allowed me to travel to museums and archives in England and Europe, including the Museums of Ethnography in Berlin and Bremen, Germany; the Museum of Mankind, British Museum, in London; the Church Missionary Society Archives in Birmingham, England; the British Columbia Archives and the Royal British Columbia Museum in Victoria, B.C.; the University of British Columbia Museum of Anthropology in Vancouver; the Field Museum of Natural History in Chicago; the American Museum of Natural History in New York; the National Museum of Natural History, Smithsonian Institution, in Washington, D.C.; the National Museum of Civilization in Hull, Quebec; and the Oakland Museum in Oakland, California. In addition, I received a Canadian Studies Research Grant, International Council for Canadian Studies, from the Canadian Embassy that funded a portion of my research during a sabbatical year in 1997. It allowed me to spend time talking with people in Massett and Skidegate in Haida Gwaii and to conduct research at the Haida Gwaii Museum in Skidegate, as well as to make return trips to several museums and archives.

how7aa to the many Haida people who generously shared their knowledge with me. Robert Davidson, Reg Davidson, and Captain Gold (Wanagan) generously shared their genealogy research with me at an early stage in my work. Thanks also to Robert Davidson, Jim Hart, and John Bennett for their advice on the book manuscript. Many other Haida people helped with their family genealogies, including Primrose Adams, Joyce Alexander, Joyce Bennett, Evelyn Brillon, John Campbell, Dolores Churchill, April Churchill, Bruce Cook, Nathalie Crosby-Fournier, Freda Diesing, Aimee Edenshaw, Phyllis Edenshaw, Dorothy Grant, Joan Hart, Virginia Hunter, James (Bussy) McGuire, Elsie Mooney, Terry Peele, Chrystal Robinson, Isabel Rorick, Evelyn Vanderhoop, Lee Wallace, Lavina White, Willis White, and Sonny and Molly York. Thanks also to Oliver Bell for the memorable trip to *k'yuust'aa, daa.adans, qang,* and *yaan* and to Lucille Bell and Vince Collison of Old Massett Heritage Economic Development and Heritage Resources, Old Massett, B.C. Thanks also to Violet Edgars for sharing with me her photograph of Isabella Edenshaw.

Many museum curators, registrars, and archivists provided valuable assistance, including Steve Henrikson, curator of collections, Alaska State Museum,

Juneau; Belinda Kaye, Anibal Rodriguez, Barbara Mathe, Kristen Mable, and Laila Williams, Anthropology Department, American Museum of Natural History, New York; Paula Willey and Mark Katzman, Special Collections, Department of Library Services, American Museum of Natural History, New York; Walter Van Horn, curator, Anchorage Museum of History and Art, Anchorage, Alaska; Diana Fane, curator, Brooklyn Museum, Brooklyn, New York; Peter Bolz, curator, Museum für Völkerkunde, Berlin, Germany; George MacDonald, director, Andrea Laforet, head of ethnography, and Margot Reid, collection manager, Canadian Museum of Civilization, Hull, Quebec; Roanne Moctar, Imaging and Photo Services, Public Archives of Canada; Nancy J. Blomberg, curator of native arts, Denver Art Museum; Gib Vincent and Sherry Brydon, New York State Historical Association, Fenimore House Museum; Janice Klein, Christine Gross, Steve Nash, and Nina Cummings, Anthropology Division, Field Museum of Natural History, Chicago; Howard B. Reed, Jr., senior curator, Fairbanks Museum and Planetarium, St. Johnsbury, Vermont; Beth Carter, ethnology curator, Glenbow Museum, Calgary, Alberta; Nathalie Macfarlane, director, Haida Gwaii Museum, Skidegate, B.C.; Niki Clerk, director of the Jefferson County Historical Museum, Port Townsend, Washington; Brenda Abney and Richard Van Cleave, Tongass Historical Museum, Ketchikan, Alaska; Paz Cabello, curator, Museo de América, Madrid, Spain; Mireille Simoni-Abbat, Chargée du Département d'Amérique, Musée de l'Homme, Paris; Jean Matheson, National Archives of Canada; Mary Jane Lenz, senior curator, National Museum of the American Indian, Smithsonian Institution, Washington, D.C.; Carey Caldwell, curator, Oakland Museum, Oakland, California; Thomas Vaughan, Oregon Historical Society; Bill Mercer, curator, Portland Art Museum, Portland, Oregon; Julia Nicholson, assistant curator, Pitt Rivers Museum, Oxford, UK; Dan Savard and Alan Hoover, Anthropological Collections, Royal British Columbia Museum; Ken Lister and Arni Brownstone, Royal Ontario Museum; Candace Greene and Felicia Pickering, National Museum of Natural History, Department of Anthropology, Smithsonian Institution, Washington, D.C.; Bill McLennan, University of British Columbia Museum of Anthropology, Vancouver; Carla Rickerson, Special Collections, University of Washington Libraries, Seattle; Viola König, Übersee Museum, Bremen, Germany; Lynn Maranda, Vancouver Museum, Vancouver, B.C.; and Lynette Miller, curator of Native American collections, Washington State Historical Society, Tacoma. Thanks to Jonathan C. H. King, assistant keeper, Department of Ethnography, Museum of Mankind, British Museum, London, for finding the photograph of John Gwaytihl; to Joyce Herold and Peggy Whitehead at the Denver Museum of Natural History for bringing the museum's cane to my attention; and to Scott Wilcox, curator of prints and drawings, Yale Center for British Art, for his help with the Mellon Collection. And not least, thanks to staff members of the Anglican Diocese of Caledonia, Prince Rupert, B.C.; the United Church of Canada Archives at the University of British Columbia, Vancouver; the British Columbia Archives, Victoria, B.C.; the Church Missionary Society Archives, Birmingham, England; and the University of British Columbia Library, Special Collections, Vancouver. Thanks to Janet Berlo for finding the Simeon *sdiihldaa* pole in Vermont. I also owe a debt of gratitude to Allen Wardwell, who generously shared his research notes on Simeon *sdiihldaa* with me before his death. I am also indebted to Jack

Henry and to his wife Jean, who donated his research notes and photo files to the Burke Museum after his death.

I am deeply indebted to John Enrico for his extensive help with the Haida language and for allowing me to reprint his Haida orthography. Thanks also to Katie Bunn-Marcuse for her help with research on silver bracelets at the National Museum of Natural History and to Silvia Koros for accompanying me on our trip to *k'yuust'aa*. Thanks as well to Steve Brown for his advice on silver bracelets and pole carvers, and to Nancy Harris for sharing her silver jewelry photographs.

Of course, I would not have started down this research path without a strong foundation built on the research and advice of Bill Holm, curator emeritus of Northwest Coast art at the Burke Museum and professor emeritus of art history at the University of Washington. Thanks go to Bill for his expert advice on the manuscript and for painting the perfect cover illustration. Another very special thanks goes to Margaret B. Blackman for generously sharing her Haida research with me, including transcripts of her interviews with Florence Edenshaw Davidson and field notes from her 1977 trip to Klinkwan, Alaska. Thanks go to my mother, Lorraine M. Wright, who carefully read my manuscript and funded the cover illustration. Thanks as well to Carol S. Ivory for her advice and support over the many years of our partnership.

Northern Haida Master Carvers

The First *gyaa.aang*

The research for this book began simply as an attempt to identify the art-work of Albert Edward Edenshaw, who had long been recognized as an important person in nineteenth-century Haida history but whose art histori-cal significance had not yet been explored.[1] The project soon expanded to include many of the other artists whose lives and work are important threads in the fabric of this complicated story. The outcome is a chronological examination of the work of several northern Haida artists from the late eighteenth century through the early twentieth century.

In this chapter, I examine the evidence in Haida oral history for the impor-tance of carved monumental sculpture, and I review twentieth-century scholar-ship on the subject. Then, in chapter 2, I present evidence from the journals of late-eighteenth- and early-nineteenth-century explorers, focusing on the identities and lives of the Haida leaders they met — *gannyaa, gu.uu, yaahl dàa-jee* — and on evidence of the arts from this early contact period. Chapter 3 examines the first evidence of the chiefly name *7idansuu* (later Anglicized as Edenshaw or Edensaw) and begins to trace the history of the holders of this name in the early nineteenth century, from "old *7idansuu*" (and even "old old *7idansuu*") to the early career of Albert Edward Edenshaw. Chapter 4 contin-ues this story into the mid- to late nineteenth century, during the peak of Albert Edward Edenshaw's artistic career and his association with his nephew, *da.a xiigang* (Charles Edenshaw). Their relationship with Duncan *ginaawaan*, a relative from *hlanqwáan* (Klinkwan), Alaska, and the evidence of his artis-tic influence are also examined, along with information on the carved poles attributed to Dwight Wallace, a close relative, also from *hlanqwáan*.

Chapter 5 explores Charles Edenshaw's work during the height of his art-istic career, including his relationship with his relative John Robson of Skidegate. It also covers several Massett artists whose work has been confused with Charles Edenshaw's, including Isaac Chapman (*skilee*), John Gwaytihl (*gwaay t'iihld*), and Simeon Stilthda (*sdiihldaa*). Finally, in chapter 6, I briefly discuss the heirs of this artistic legacy — the twentieth-century relatives of these artists — including Jim Hart, the current holder of the name *7idansuu;* Robert Davidson, Charles Edenshaw's great-grandson; and Freda Diesing and Donald Yeomans, both descendants of Simeon Stilthda.

Much information about these nineteenth-century artists remains obscured by the passage of time and the inadequacy of the historical records. We can

never hope to have a complete understanding of the events that affected their lives and their art. I hope, however, that this book will begin to provide a fuller picture of the human story surrounding the great nineteenth-century works of northern Haida art. That picture reveals not only the identities of some of the artists and the historical contexts within which they worked but also a glimpse of their personalities and personal carving styles and their changing roles within Haida history.

Much of the evidence that remains is anecdotal, and so by necessity this history has become a series of pieced-together stories with many gaps and holes. My research was based on a variety of sources, including explorers' journals, the archival records of collectors such as C. F. Newcombe and James G. Swan and ethnologists John Swanton and Franz Boas, and the field notes of Margaret Blackman and her transcriptions of interviews with Florence Edenshaw Davidson. Invaluable genealogical information was provided by Robert and Reg Davidson and by discussions with many other Haida people, including Jim Hart and Freda Diesing. Other sources were the genealogical records at the Haida Gwaii Museum in Skidegate, government records including the Canadian census reports for 1881 and 1891, and church records preserved at the Anglican Diocese of Caledonia in Prince Rupert and the United Church of Canada Archives at the University of British Columbia in Vancouver. Museum collections and associated accession documentation and photographic archives were also crucial to the research, as was the advice of many consultants.

The Edenshaw family was a logical place to start, since much attention has been paid to them over time both by people who met them in the nineteenth century and by later scholars. Albert Edward Edenshaw (*gwaaygu 7anhlan*, meaning "one who rests his head on an island") was well known to visitors to Haida Gwaii (the Queen Charlotte Islands) in the last half of the nineteenth century, and he often served as a guide to them.[2] He himself claimed to be "the greatest chief of all the Haidas" (Gough 1993: 289). His position in Haida society has been analyzed by several twentieth-century anthropologists and historians (Boelscher 1988; Gough 1982, 1993; MacDonald 1996; Sterns 1981, 1984). Though it was known that he was a carver and a coppersmith, only Wilson Duff and George MacDonald had previously attempted to attribute works of art to him (Anderson 1996; MacDonald 1996).

On the other hand, the artistry of *gwaaygu 7anhlan*'s nephew, *da.a xiigang*, has received considerable attention. Charles Edenshaw was heralded during his own time as the best Haida artist, and his fame was spread by Franz Boas, John Swanton, and Charles F. Newcombe, among others who commissioned his work (Boas 1927: 212; Cole 1985: 195; Swanton 1901). The fame of Charles Edenshaw, though well deserved, has tended to overshadow that of many other Northwest Coast artists, including his uncle. In some cases, perhaps because they both had the name Edenshaw, the identities of Albert Edward and Charles were confused, and poles carved by Albert Edward Edenshaw were attributed to Charles Edenshaw (MacDonald 1983: 146, 198). At the time I began my research on Albert Edward Edenshaw, I knew of only two objects that could be firmly attributed to him — a memorial pole in honor of chief *sdiihldaa* of Massett, collected by Johan Adrian Jacobsen and taken to Berlin, and a headdress frontlet that had been passed down in his family (see figs. 3.12 and 4.42). Many more can now be added to this list.

The names of relatively few nineteenth-century Haida artists have been known to outsiders, and nineteenth-century works of art from Haida Gwaii are largely unattributed to their individual makers. The attempt by twentieth-century scholars to identify these artists really began with the writings of C. Marius Barbeau (1953, 1957, 1958). Unfortunately, many of Barbeau's attributions, particularly those for Charles Edenshaw, have proved to be incorrect. More recently, much work has been done to clarify the record, starting with the 1967 exhibit "Arts of the Raven," curated by Wilson Duff, Bill Holm, and Bill Reid at the Vancouver Art Gallery. It featured an entire gallery (sixty-six objects) called "Charles Edenshaw: Master Artist," devoted to the work of Charles Edenshaw (Duff, Holm, and Reid 1967: objects numbered 341–406). I now believe that at least twenty of the objects attributed to Charles Edenshaw in the "Arts of the Raven" exhibit were made by other artists. Since 1967, even more attention has been focused on the work of Charles Edenshaw, and other authors, such as Susan Thomas [Davidson] (Thomas 1967), Peter Macnair (Macnair and Hoover 1984; Macnair, Hoover, and Neary 1980), Alan Hoover (1981, 1983, 1995), Carol Sheehan (1981), and Leslie Drew and Douglas Wilson (1980), have written about his work.

The most detailed analysis of Charles Edenshaw's art to date was published by Bill Holm (1981). This was the first attempt to analyze a progression in Charles Edenshaw's style through time and also to differentiate it from the styles of several other Haida artists whose work had been confused with his, including John Robson, *gwaay t'iihld,* Simeon Stilthda, Tom Price, John Cross, and the so-called Master of the Chicago Settee.[3] These artists were all contemporaries of Charles Edenshaw, working in Massett or Skidegate.

Gradually, during the last quarter of the twentieth century, a sharper picture of the bodies of work of several late-nineteenth-century Haida artists has emerged, providing a better understanding of both the individual artists and their complex and overlapping stories. This book brings this recent scholarship together in a comprehensive study and at the same time provides a basis for further research. Knowing that attributions can be highly speculative, I undertake this effort with the clear understanding and fervent hope that future researchers will revise and correct what is inaccurate in it. I have made every effort to identify my sources of information, which I hope will help in that undertaking.

Haida Artists and Art

During the nineteenth century, Haida artists occupied an important place in Haida society. They were leaders of their communities and carriers of culture who were not only trained in the highly technical skills of making canoes, monumental sculpture, and ceremonial regalia but were also high-ranking members of the noble class — chiefs who inherited their rank along with the privilege of being trained as artists. Haida artists have continued to occupy an honored place and to play essential roles in twentieth-century Haida life, leading the efforts to maintain and strengthen Haida culture.

The Haida artist Robert Davidson has spoken eloquently about the important link between art, language, and culture:

It is said that language is the key to a culture. In the Haida language, as in those of many First Nations here in the Americas, we do not have a word

for art. So for lack of a better word, I will borrow the English word "art." We Haida were once surrounded by art. Art was one with our culture. We had art that was sacred, brought out only for certain ceremonies. We also had art that was on permanent display, validating our place in the world. Art is our only written language. It documented the histories of our families; it documented our progress as a people. Throughout our history, art has kept our spirit alive. Now, art is helping us to reconnect with our cultural past. It is also helping to bridge the gap of misunderstanding between our culture and yours. (Steltzer and Davidson 1994: vii)

The next thing we need to reclaim is our language. Language holds insights and philosophies of our culture. It will add to the foundation we are rebuilding, as a nation, from the frustrations that came through my parents' generation, from the experiences they lived through as children. It can come only from us as Haida People. (Seattle Art Museum 1995: 99)

The Haida language does have words for the many kinds of carved, painted, and woven objects that were so pervasive and central to the culture during the time before Europeans arrived on the Pacific Northwest Coast, and words for the people who made them.[4] The word *gyaa.aang* is the Haida term for the carved poles that fronted the people's large cedar-plank houses, displaying the heraldic crests that proclaimed the identity, status, and history of those who lived within. These heraldic columns have come to be called totem poles. John Wallace, a Haida pole carver, told Viola Garfield that the translation of the word *gyaa.aang* (*g.an*) is "man stands up straight," a descriptive rather than a literal translation (Garfield 1941: 5). The term "totem pole" is not a native Northwest Coast phrase. Indeed, the use of the term "totem" to refer to the Northwest Coast images of family crests or emblems is not strictly accurate. The word "totem" itself derives from an Ojibwa word, *ototeman,* and "totemism" in anthropological terms refers to the belief that a kin group is descended from a certain animal and treats it with special care, refraining from eating or hunting it. The figures carved on Northwest Coast poles generally represent ancestors and supernatural beings that were once encountered by the ancestors of the lineage, who thereby acquired the right to represent them as crests, symbols of their identity, and records of their history (Jonaitis 1999: 116; Miller 2000: 3).[5]

The Haida word *stlanlaas* is the closest to the English word "artist," though it is translated "good with their hands." The phrase *gyaa.aangray ga hlranggu-lagan.gee* means "those who worked on totem poles," *tl'a gyaa q'iid raayaa* means "good carvers," and *qyaa q'iid 'lee.ilang* means "masters of carving." Other Haida words describe the different types of carved poles, such as memorial poles (*q'aa.l*), which were placed near the house to honor deceased family members; mortuary poles (*xaad*), which housed their coffins and remains; interior house posts (*gáats'aay*), which displayed the family crests inside the house; and *la.al,* house screens.[6]

Only the best artists were commissioned to carve the monumental heraldic poles that were placed in front of and inside houses proclaiming the identity, status, and history of the noble people who owned them. Because many of these poles were photographed in place during the nineteenth century, it is possible to reconstruct the changing appearance of some nineteenth-century Haida vil-

lages over time.[7] Photographs can often be blurred or taken from too great a distance or at odd angles, and they are sometimes inadequate records of the nuances of carving styles. But many of the poles have survived, some in place and others in museum collections where they can be studied more closely. By analyzing the styles of the poles along with their locations and other documentation, both the histories of the families who owned them and their carvers' identities can sometimes be revealed. Poles were often more carefully documented than were smaller, more portable objects such as spoons, boxes, chests, bowls, masks, and rattles, simply because of their size and the difficulty collectors had in acquiring them. By comparing the carving styles on full-sized poles with those on smaller Haida objects, it is sometimes possible to determine something about the origin and makers of the smaller objects as well. For all of these reasons, totem poles are central to the focus of this book.

gyaa.aang

By the end of the nineteenth century, after more than a hundred years of contact with people of European descent — explorers, fur traders, missionaries, government agents, colonists, and anthropologists — most of the totem poles were gone from Haida Gwaii. They had been allowed to decay, they had been cut down and chopped up, or they had been taken or sold to museums, galleries, and dealers around the world. The major purpose for doing the art was also taken away by the Canadian government, which in 1884 passed legislation outlawing the potlatch (*7waahlal*), the essential celebration that must accompany the raising of a new house and pole and the validation of an inherited name and other important privileges. During the 1880s, Christian missionaries converted and baptized the Haida people, in many cases taking away their Haida names and undermining the matrilineal system of reckoning descent, which is an important part of Haida heritage. After this Haida artists made carvings primarily for consumption by outsiders, who relegated them to their category "tourist art." Not until 1951 was the anti-potlatch law dropped in Canada, and it took until the last three decades of the twentieth century for the Haida people to begin to relocate what was lost, recapture what was taken, and once again carve, raise, and potlatch *gyaa.aang* on Haida Gwaii.

During the early twentieth century, scholars wrote about the Haida art housed in museum collections around the world, starting with the early ethnographers Franz Boas and John Swanton and continuing with Marius Barbeau in the 1930s and 1940s. Throughout the twentieth century, scholars debated the antiquity of the tradition of totem pole carving on the Northwest Coast, starting with the controversial ideas published by Barbeau. He was the first author to recognize the identities of Haida artists, to record something of their biographies, and to attempt to attribute carvings to the artists who made them. He performed an invaluable service at a time when few outsiders were interested in the identities or lives of Haida carvers (Barbeau 1953, 1957). His publications brought images of Haida art back to Haida Gwaii to become dog-eared references for a new generation of Haida carvers.

While offering images and information on the Haida carvers of the past, however, Barbeau's publications also contained much that was inaccurate and misleading about the art of the Haida people. Barbeau believed that very recent

migrations of people from Siberia through the Aleutian Islands, most recently the Tsimshian, had brought to the Northwest Coast the concepts of phratric exogamy (marrying outside one's clan), secret societies, and the totemic crest system. He believed, largely on the basis of these migration theories, that the use of crests had in turn been recently borrowed from the Russian and English fur-trading companies, in the form of the Russian imperial crest, the double-headed eagle, and the Hudson's Bay Company's beaver. Barbeau's theories erroneously denied the long history and gradual development that these traditions have had in place on the Northwest Coast (Barbeau 1930, 1939, 1940, 1942, 1944, 1950).

Because he believed that the crest system and the carving of totem poles had developed side by side and that the crest system was recently introduced, it followed that totem pole carving was also recent. Yet as Wilson Duff pointed out, many scholars have misinterpreted what Barbeau actually said. Duff's critical assessment of Barbeau's theories (Duff 1964) points out that in fact Barbeau recognized that house frontal poles and mortuary art existed on the Northwest Coast at and before the time of first European contact.[8] Barbeau, however, defined the term "totem pole" narrowly to refer exclusively to the freestanding memorial pole, which he proposed developed only after 1850 as a standard feature of Haida, Tsimshian, and Tlingit villages (Barbeau 1942: 507). His narrow definition of the term "totem pole" (which he himself strayed from in his two-volume publication on totem poles [Barbeau 1950]) was overlooked by many readers, leading them to misinterpret what he said.

Nevertheless, Barbeau did misunderstand much of the evidence he found in explorers' journals about the early appearance of Haida villages. William Newcombe and Philip Drucker both criticized his interpretation of these journals, pointing out that explorers' failure to observe large numbers of poles was the result of their not being in the right place to see them (Drucker 1948; Newcombe 1931). Duff's assessment of the same evidence led him to conclude that frontal poles, mortuary poles, and free-standing memorial poles were present in Haida villages in the late eighteenth century and that totem poles were a well-established feature of the precontact culture of the Northwest Coast (Duff 1964: 91).

This conclusion is widely accepted by scholars today, though until recently, little new research has been focused on the history of the totem pole on the Northwest Coast. Several publications have served as guidebooks to new and old totem poles still standing on the Northwest Coast (Garfield and Forrest 1949; Halpin 1981; Keithahn 1963; Malin 1986; Stewart 1993; Wherry 1974). George MacDonald's *Haida Monumental Art* (1983) added considerably to the literature on Haida poles, combining photographic, ethnographic, and archaeological data documenting the houses and poles in the major nineteenth-century Haida villages.[9] More recent research on totem poles by Aldona Jonaitis echoes what Barbeau originally said about the flourishing of pole carving during the nineteenth century. She points out that whereas "the pole itself originated in pre-contact times, its abundance during the nineteenth century in certain Northwest Coast villages, especially those of the Haida and Tsimshian, had a great deal to do with the interchanges between Natives and non-Natives" (Jonaitis 1999: 107). Her current research focuses on the proliferation of the model totem pole through tourism and the appropriation of the totem pole as

a symbol in popular culture. Kate Duncan's work on one of the curio shops that acted as an agent in this proliferation has added to our understanding of the process of appropriation (Duncan 2000). Thus, current scholarship is focusing on recent developments in totem pole history. This book focuses on earlier periods in an attempt to compile more evidence about the development of pole carving and the other arts of the northern Haida since the late eighteenth century.

The First *gyáa.aang*

The scholarly debate during the twentieth century on the origins of pole carving has largely ignored the oral histories of the Haida people, which provide another viewpoint on the antiquity of pole carving. The primary sources for this information are the publications of John R. Swanton, who came to Haida Gwaii under the sponsorship of Franz Boas's Jesup North Pacific Expedition in September 1900 and stayed until August 1901 (Enrico 1995; Swanton 1905a, 1905b, 1908b; Swanton and Boas 1912). By transcribing his interviews with Haida consultants in Skidegate and Massett during this time, a pivotal moment in Haida history, Swanton recorded a portion of the oral traditions that tell how the Haida people trace their histories back to their distant ancestors and to a time even before Raven first discovered humankind.

Raven, the trickster-creator, is the principal character responsible for changing the world into its present form, according to the indigenous cosmologies of the Haida, Tlingit, and Tsimshian peoples of the northern Pacific Northwest Coast. Raven goes by many names in the Haida language: *yaahl* (after the Tlingit *yehl*) or *xuyaa* (the Skidegate Haida word for Raven), and *nang kilsdlaas* (nʌñki'l-sʟas), "he whose voice is obeyed," or "the person-who-accomplished-things-by-his-word," that is, the Creator Raven.[10] Although *nang kilsdlaas* is considered to be responsible for changing the world into its present form through various acts of trickery or pure foolishness, Raven is also the crest symbol that identifies half of Haida society, which is divided into two exogamous matrilineal moieties identified as Eagles and Ravens (Ravens should marry Eagles and vice versa, and descent is reckoned through the female line).

The Raven story, told in many variations, basically traces the travels of Raven and the changes that occurred in the world as the result of his actions. Much of the story takes place during a time before human beings were created, when the world was occupied only by supernatural beings. In the earliest times there was only a boundless expanse of sea and sky, with a single exposed reef upon which all of the supernatural beings were heaped. The word in the Haida language for supernatural being or power, *sraa.n*, also means orca or killer whale, and these beings were thought to be the most powerful of the supernatural Ocean People, who had towns scattered along the shores beneath the water at every prominent cape, hill, or reef. When traveling about, these Ocean People appear as killer whales, but in their underwater towns they are like human beings (Swanton 1905a: 13, 17). In the time before land, the single reef where all the supernatural beings were heaped was at *k'il* (Flatrock Island), opposite the island of *sran gwaay* (*nan sdins*, or Ninstints village), the "red cod island" (map 1).

Raven flew about, unable to find a foothold, and at last, looking up into the sky, he stuck his beak through and climbed up. In the sky country he found a

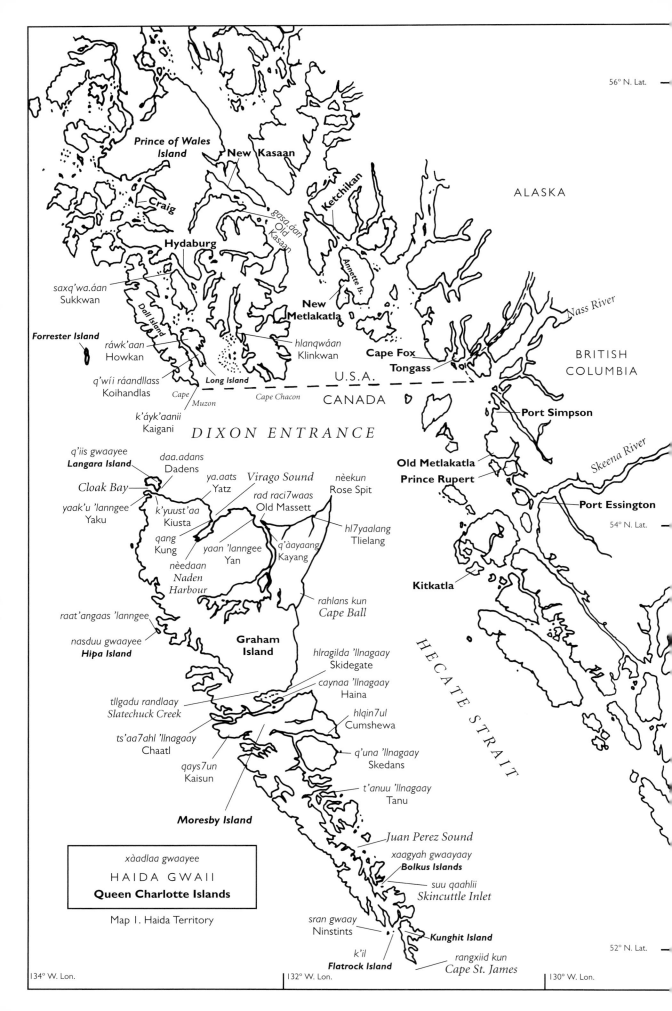

56° N. Lat.

Prince of Wales Island

New Kasaan

ALASKA

Craig

gasa.áan Old Kasaan

Ketchikan

Hydaburg

Annette Is.

saxq'wa.áan Sukkwan

New Metlakatla

Forrester Island

Dall Island

ráwk'aan Howkan

hlanqwáan Klinkwan

Nass River

q'wíi ráandllass Koihandlas

Long Island

Cape Muzon

Cape Chacon

Cape Fox

Tongass

U.S.A.

CANADA

BRITISH COLUMBIA

Port Simpson

k'áyk'aanii Kaigani

DIXON ENTRANCE

Skeena River

q'iis gwaayee **Langara Island**

daa.adans Dadens

ya.aats Yatz

Virago Sound

nèekun Rose Spit

rad raci7waas Old Massett

Old Metlakatla

Prince Rupert

Cloak Bay

yaak'u 'lanngee Yaku

k'yuust'aa Kiusta

qang Kung

yaan 'lanngee Yan

q'àayaang Kayang

hl7yaalang Tlielang

Port Essington

54° N. Lat.

nèedaan Naden Harbour

raat'angaas 'lanngee

rahlans kun Cape Ball

Kitkatla

nasduu gwaayee **Hipa Island**

Graham Island

hlragilda 'llnagaay Skidegate

tllgadu randlaay Slatechuck Creek

caynaa 'llnagaay Haina

hlqin7ul Cumshewa

HECATE STRAIT

ts'aa7ahl 'llnagaay Chaatl

qays7un Kaisun

q'una 'llnagaay Skedans

t'anuu 'llnagaay Tanu

Moresby Island

Juan Perez Sound

xaagyah gwaayaay **Bolkus Islands**

suu qaahlii *Skincuttle Inlet*

xàadlaa gwaayee

HAIDA GWAII
Queen Charlotte Islands

Map 1. Haida Territory

sran gwaay Ninstints

Kunghit Island

k'il **Flatrock Island**

rangxiid kun *Cape St. James*

52° N. Lat.

134° W. Lon.

132° W. Lon.

130° W. Lon.

town with five rows of houses, where the town chief's daughter had just given birth. Raven entered the chief's house, scooped the baby out of its skin, and took its place. Soon Raven became hungry, because the baby was too young to take solid food. He slipped out one night and stole and ate an eyeball from everyone living in the first row of houses. He did this for four nights in a row, but he was observed by a woman who was made of stone from her hips down. She never slept and sat in the corner of the house. She told the people what had happened. The town chief called the people together, and they sang a song for the child, but in the middle of the song Raven slipped out of the arms of the one holding him and fell to the sea below. His cradle drifted about in the sea, and the child-Raven cried for a long time. John Enrico's translation of Swanton's original transcript of this story provides the following episode as told by John Sky (*sgaay*) of the *q'una qiirawaay* Eagle lineage of the village of *t'anuu* (Tanu).

> When he had slept for a while he heard something say to him "Your powerful grandfather tells you to come in!" He glanced quickly at it out of his blanket but there was nothing there. And after he had floated around some more something said the same thing to him. He looked at it quickly but there was nothing there. Then he looked out through an eyehole in the marten skin and a grebe came up. "Your powerful grandfather tells you to come in," it said as it dived.
>
> Then he got up. He had been bumping against a two-headed bull kelp. He walked on it into the water. What do you know, he walked on a two-headed housefront pole of stone! Down he went. Things below were just like things above for him. (Enrico 1995: 17–19)

Beneath the sea Raven found a house, which he entered. He found a man who looked like a seagull sitting at the back of the house. This old man sent him for a box that hung in the corner. There were four boxes inside this one, and inside the last box were two long objects, one covered with shining points and the other one black. The old man instructed Raven how to place these objects in the water. After doing it wrong once, Raven did the right thing, and the black object stretched out, becoming the Haida country. All of the supernatural beings swam over to it. The other object became the mainland (Swanton 1905a: 72–74).

Sometime after the land was created, there was a great flood caused by one of the supernatural Ocean People. The origin of the Raven moiety is traced back to a time just after this. When the first piece of land appeared as the floodwaters receded, Foam Woman, the ancestor of the Raven moiety, was sitting upon it. This was where the village of *xaagyah* (Xa'gi) was built, on the present Bolkus Islands. Foam Woman had many breasts — some say as many as ten on a side — so she could nurse the grandmother of each of the various Raven families among the Haida (Enrico 1995: 15–21; Swanton 1905a: 72–75, 1905b: 110–112).

Continuing with Raven's travels, other references to house frontal poles are found. Raven eventually came to live with his uncle (the spirit inhabiting Cape Ball) at *rahlans kun*. He had sex with his uncle's wife while his uncle was out hunting, and the next day his uncle wore a hat with a column of *sgil* (meaning "wealth spirit," the word used for cylindrical basketry hat rings that symbolize great status) with a large puff of foam spinning on top. This spinning foam

became a flood, and Raven grabbed his mother under his arm and floated up on the water, eventually rising out of the smoke hole and flying into the sky. When he looked down he saw smoke coming out of his uncle's house, and he became angry and flew down and ran his beak into the house frontal pole (Enrico 1995: 47–49). Raven's uncle was living in a house with a frontal pole.

Edward Curtis recorded a version of the same Raven story that included the following account of the episode after the flood caused by Raven's uncle: "He began to think about his uncle and mother and wondered what they were doing. He looked down and saw the house, and the foam was settling down, all white over it, and smoke was rising from the house. This made him angry. He put on his raven skin, flew straight down, and landed on the pole in front of the house, splitting it in two" (Curtis 1916: 148–155; also see Enrico 1995: 102).

Charles Edenshaw gave a different version of the Raven story to Franz Boas. In this version, Raven left his home at Rose Spit, where he was born: "Finally they reached the house of *nang kilsdlaas* [the uncle of Raven's mother], which was located in *hlrayxaa* [Halibut Bight south of Cape Ball]. A large pole was standing in front of his house. *nang kilsdlaas*'s slaves were outside the house when *gayhlra jadd* [Raven's mother] was approaching, carrying her child" (Enrico 1995: 89).

Also in Charles Edenshaw's version of the Raven story is this account of what happened when Raven ate the eyeballs of the people and his deed was discovered:

> The floor of the house was made of stone. The chief then broke it, took the boy [Raven], and threw him down to our earth. At that time the water was still high, and only the top of his totem pole was seen above the surface of the water. The boy dropped upon the top of the totem pole, crying "Qa!" and assumed the shape of a raven. The pole split in two when he dropped down on it. Then the waters began to subside, and he began his migrations. (Enrico 1995: 94)

This corresponds with Swanton's other version, in which Raven climbs down a double-headed pole to a house below the sea. All of these references to poles in front of houses that Raven stepped on, stuck his beak into, climbed down, or split place the carved house frontal pole firmly within mythic times, before the arrival of human beings, according to Haida oral history.

There are also Haida stories about the supernatural being who first taught humans to carve poles. In an unpublished notebook, Viola Garfield recorded the following story from John Wallace in Hydaburg, Alaska, in 1941. This account was given to her in conjunction with a pole that Wallace had carved for the Mud Bight Totem Park.[11]

The Story of North Island

Many years ago the Haidas used to live at North Island. It stormed for many days and the people ran out of food. They couldn't go out and hunt or go fishing on account of the storm.

One day it cleared up and all the people moved to the West Side to fish for halibut. All the people left excepting the chief's sister. The chief's sister was very old. The chief said she wouldn't have any more children, so he

wanted to leave her behind in the village alone so that she would starve and not eat up needed food. He gave orders to the people to put out their fires before they left so his sister would have no fire. This her grandchild heard, so she got a clam shell and put coals in it and buried it for her grandmother. This she told her while no one was around. After everyone left the woman went after the clam shell and started her fire with the coals.

After she started her fire she looked up in the sky and asked for help. While she still stood on the beach she saw an eagle coming toward her with something in his beak. He dropped it down to the old lady. It was a red cod. The second day the eagle brought a halibut, the third day a seal and the fourth day a porpoise. Before the old lady could get the porpoise a bear came down and took it. The eagle brought her many things and the bear would get it before she could. She got tired of it and asked for a child to protect her. Long time ago they used to be afraid to say anything carelessly about the air. It was just like believing in God now.

That night the old woman felt her left leg itch all night. Toward morning she felt a head, then she realized that she was having a baby. She was afraid it would run away so she grabbed its legs.

The child learned to talk in a month and in six months he was a big boy. One night the boy dreamed of a man. This man was showing the boy how to make a bow and arrow in his dream. He told the boy to make one so he could kill the bear that was taking the old woman's food. When he woke up the next morning he started to make the bow and arrow. When the bear came out again he killed it.

The next night he had another dream. The man came again and this time his finger and toe nails were painted with human faces and his chest and whole body were tattooed. He told the boy that when they went to bed the next night neither he nor the old lady should open their eyes until they were sure the sun was up, no matter how much noise they heard. The next night as soon as they went to bed they heard loud noises which lasted all night. When they thought the sun was up they opened their eyes. They were in a large house. It was carved inside and when they went outside there were three totems on the front and the front of the house was carved. There was one totem on each corner of the house and one in the center by the door. Those were the first totems ever seen. They couldn't believe their eyes when they looked at the house.

The next day they found a large whale on the beach. They cooked every bit of it and put it in square boxes, the old fashioned oil or grease boxes.

In the meantime the chief began to think of his sister and sent a slave back to bury her body, for he thought she had starved by this time. When the woman slave landed on the beach she was surprised to see a big house in the old deserted village. She was also surprised to find the little boy living with the old woman.

The chief's sister took her in and fed her, but told her not to save any of the food that she gave her. The slave disobeyed and hid a piece of seal meat in her blanket. When she got home in the evening all were in bed, but there was a little fire left. She fed the piece of seal meat to the baby. After the child was through she threw the left over meat in the fire and it burned brightly.

The chief asked her what it was and she then told them about the carved house full of food. The next day all the people went over to North Island to see the old woman.

The chief dressed his nieces and they painted their faces for he wanted the boy to marry one of them. Only the girl who had left the coals was not painted. She was considered too poor to marry the wealthy chief's nephew.

They came into shore and the young man wanted only to marry the girl who had saved his mother. That is the end. (Garfield 1941: Notebook 1, 20)

Garfield's published version of this story eliminated the reference to its origin at North Island (Langara Island, British Columbia) and used the term "Master Carpenter" or "Master Carver" for the being who taught carving to the Haida.[12] Garfield's handwritten notes, taken during her interview with Wallace, reveal the name *o'át kung,* which means "bright salmon jumping and flashing," for this being (not a literal translation). Wallace's carving of him included a necklace with ten faces that were used to represent his "experiences," which in the original story were painted on his toenails and fingernails. Since the pole was too small, Wallace put the figures on the necklace instead. Wallace also reported to Garfield that long before iron was brought by traders, the Haida found driftwood with iron nails that they traded for one slave each. Totem poles were made only after this driftwood iron was found and used for cutting tools. He explained that his father's father was the first generation to know this (Garfield 1941).

Swanton recorded two Massett stories about the origin of carved posts and carving:

Some people living in Masset Inlet went to Rose Spit to pick berries. On the way a woman looked into the sea and saw a carved post there. The people looked at it long enough to remember how it was made, and, when they got home, carved two posts just like it. At this, however, the supernatural beings became angry and raised a flood, compelling the people to take to their canoes. They threw one of the posts into the sea, and put the other on top of a low mountain. Then they began to sing, and the flood fell; but they were changed into birds, called Giu'gadaga. The post which they left on the mountain is sometimes seen by those who are going to become rich. (Swanton 1905a: 218)

A child in the town of Da'ñʌngun (Alaska) made fun of the other children, and was told to leave the town. So he and his grandmother went off and camped by themselves. By and by, when the town people were short of food, he killed a bird and invited them to eat it. Then they made him town chief. He had also found the first spear-head, and now began to go out hunting for hair-seal. But one day there was a menstruant woman in the house, whereupon the spear went off and never returned. A woman found another spear in the sea, however, which he continued to use. At a later time he looked at a menstruant woman, and was unable to kill any seals until one of the supernatural beings cleansed his eyes and his spear. Again he went out hunting and speared what he supposed to be a seal; but his spear broke upon it, and he found that it was a carving belonging to the supernatural beings. From this they learned how to carve. One of the

figures was a killer-whale; so the Ravens have owned the killer-whale crest ever since. (Swanton 1905a: 219)

The only reference to "Master Carpenter" in Swanton's accounts is in the story "How Master-carpenter began making a canoe to war with Southeast." Southeast Wind was causing too much bad weather, and Master Carpenter made several canoes before he finally succeeded in making one that would not split. He then set off to wage war on Southeast Wind. He captured Southeast Wind and learned that the reason he had given the people bad weather was because they had used the name *darahl* (*da'gał*, "tomorrow"), which was his sister's name. So after that they used another name (Swanton 1905a: 190–191, 1905b: 32–35). Thus, canoe carving, too, is a skill that was acquired in ancient times.

Another account of the first person to carve large poles was given by Edward Russ in 1948 to Marius Barbeau at Massett. In this account, a man named Oti wans (*ruud ʒiwʒwaans*) is credited with being the first to carve large poles. This man and his family came from Nesto (Hippah) Island (*nasduu gwaayee*) and later moved to *yaan*.[13] Oti wans was a canoe carver and a pole carver, and he told his nephew about the use of medicines for his hands, to make him a good carver. Russ gave a long account of the carving of one of the first house frontal poles at *yaan*. The house was named *na k'udangqins,* and Swanton listed it as House 14 at *yaan*: "Na k!ō'dAñ qens ('house looking at its beak'). The carved block of wood — which in very old times took the place of the house-pole — on this house bore the beak of a bird standing out in front" (Swanton 1905a: 292).

MacDonald suggested that this ancient style of house frontal pole was located on the predecessor of this house in a different village (MacDonald 1983: 167, plate 227). Swanton (1905a: 292) listed the owner of this house as Stī'łta (*sdiihldaa,* meaning "returned"), of the *tuuhlk'aa git'anee* (T!ōłk!a gītAnā'i, E16) (see fig. 5.49).[14] Judging from Russ's account of the history of this family, the older house was probably located at *raat'angaas 'lanngee* (Hatanas), a village on Hippah Island (*nasduu gwaayee*) (Barbeau 1916–1954: B-F-256.9, B-F-256.13).[15]

All of these bits of evidence drawn from interviews with Haida people confirm that house frontal poles predate the arrival of Europeans on the Northwest Coast and were important elements of Haida history, both during ancient times and in more recent family histories. Certainly, during the nineteenth century the number and sizes of Haida poles increased dramatically, owing to a variety of factors, including the increased wealth brought by the fur trade, the improved availability of iron tools, and the dynamic social and political environment characterized by new wealth, population loss, family relocations, and chiefly rivalries. This book examines the history surrounding these changes during the nineteenth century, with reference to some of the northern Haida artists who were active during this time.

The Early Contact Period, 1774 to 1799

gannyaa, gu.uu, yaahl dàajee, and the Maritime Fur Traders

Haida oral histories that recount events going back to ancient times contain many references to carved poles, woven hats, and other works of art. A very different chapter in the history of the Haida people begins with the first arrival of Spanish explorers off the village of *k'yuust'aa* (Kiusta) on July 19 and 20, 1774. There starts the written history of the interaction between Haida people and foreign explorers and entrepreneurs. This history is recorded in the journals of the visitors and so presents the story only from their point of view. Nevertheless, contained in these journals are bits of information that can add to the oral histories kept by the Haida people themselves, telling us something about the community of people who lived in this area, their leaders, their villages, their art, and their lives. In the following pages I review this literature in an effort to draw together those bits of information to clarify what was recorded about the northern Haida people and their arts during this initial period of contact. I give the fullest possible excerpts from these journals in order not to edit out any anecdotal evidence that might be relevant to this history.

It is likely that isolated, though possibly numerous, contacts between Haidas and Asian people had taken place along the Pacific Northwest Coast of North America over hundreds of years, owing to the prevailing easterly currents that tend to bring wrecked and disabled vessels to the shores of this coast from the region of Japan (Quimby 1985).[1] European intrusion into the northeastern Pacific from the south began in the sixteenth century with both the British (Sir Francis Drake, 1579) and the Spanish (Sebastián Vizcaíno, 1602), who had sailed at least as far north as the Oregon coast by the beginning of the seventeenth century. After that time, Spanish ships might have been lost and wrecked on the Northwest Coast, but they ceased their explorations there for over one hundred years (Beals 1989: 4–10).

The Russians were the next European explorers to approach the Northwest Coast, and, like the crews of wrecked Japanese vessels, they came from the northwest. During the 1741 expedition of Vitus Bering and Aleksei Chirikov, their two ships became separated. Chirikov, who sailed farther south than Bering, sighted land on July 15 off the islands west of Prince of Wales Island (55° 21' N) and then turned and sailed north. He had come within seventy-five miles of the northwest corner of Haida Gwaii (the Queen Charlotte Islands). Three days later, near Lisianski Strait (Cross Sound), fifteen men with the party's only two small boats were lost and presumed captured or killed by Tlingit residents when

they went ashore. Shortly thereafter Chirikov sighted two canoes filled with Tlingit people who gestured at the ship, but no contact was made. This incident is the first documented encounter between Northwest Coast and European peoples (Beals 1989: 11–14).

Partially in response to Russian exploration of the Northwest Coast, Spain occupied southern California (San Diego and Monterey) in 1769 and a few years later resumed exploration of the more northern coast. Juan Pérez, who commanded one of the Spanish ships that arrived at San Diego in 1769, was sent on the first expedition north of Monterey in 1774. He had been ordered by Viceroy Bucareli to sail north to 60° N latitude and wherever possible to land, mark the site with a wooden cross, and formally take possession of the territory. He was specifically forbidden to "antagonize the Indians or forcibly take possession of land," but rather was to treat any inhabitants affectionately and give them "articles which he carried for this purpose." He was to record their customs, characteristics, religion, and political organization and take note of whether they had paid tribute or taxes to any other — that is, Russian — ships (Beals 1989: 24–27).

Pérez accomplished few of these goals. He sailed only to south of 54° 40' N latitude, was never able to land or take possession of territory, and made contact with the inhabitants only by sea in two locations — off Langara Island and in Nootka Sound (plate 1). Pérez and his men did, however, sail farther north than any previous Spanish expedition, and they avoided antagonizing the residents (unlike the Chirikov expedition, apparently) while they conducted "affectionate" exchanges of material with Haida people at Langara Island and with the Nuu-chah-nulth at Nootka Sound. They also provided several accounts of the appearance, behavior, and material culture of the Haida and Nuu-chah-nulth people, which may be the most valuable legacy of the voyage (Beals 1989: 41).

Four separate firsthand accounts of this voyage have survived: the diaries of the captain, Juan Pérez, his second officer, Esteban José Martínez (Beals 1989: 58–98, 100–102), and the two Franciscan chaplains, Fray Juan Crespi and Fray Tomás de la Pena y Saravia (Cutter and Griffin 1969: 135–278). Following are excerpts from these four accounts as they relate to the encounter with the Haida at Langara Island.

Juan Pérez's *Diario*

19th to Wednesday 20 July 1774

We proceeded on with the four principal sails, the jibsail, and the main top staysail with one reefing, turning to a course ENE, the wind SE fresh, heading for a point surrounded by the sea. It jutted out from an extended hill and was about 3 leagues long, appearing separated from the coast and looking like an island from a distance. I named it Santa Margarita [Langara Island]. A great deal of smoke came from the said hill, and at 3 in the afternoon we descried 3 canoes, which came toward us. At 4:30 they arrived alongside, and in the meanwhile we took the occasion to examine the character of these people and their things. In the first place, the men were of good stature, well formed, a smiling face, beautiful eyes and good looking. Their hair was tied up and arranged in the manner of a wig with a tail. Some wore it tied in the back and had beards and mustaches in the manner

of the Chinese people. The first thing they did when they approached within about a musket shot of the ship was to begin singing in unison their motet and to cast their feathers on the water, as the Indians do at the Santa Barbara Channel. But these [Indians] use a particular signal that is not used by the others of the Channel, nor those under our rule. They open their arms, forming themselves in a cross, and place their arms on the chest in the same fashion, an appropriate sign of their peacefulness.

From what has been experienced with them, they are very adept at trading and commerce, judging by the briskness with which they dealt with us, and because before they would give any trifles they had to hold those things they wanted in their hands, examining them and satisfying their fancy with a look. If pleased with them they ask for more, making it clear that without giving more they will not pay. Noticing this, one may readily believe that there is frequent commerce between them. Their canoes are very well made and of one piece, except for a farca on the gunwale. They are very swift. The Indians row with neatly-made oars or paddles that are one and one-half varas [about 49.5 inches] long. All their commerce amounts to giving animal pelts such as seals, sea otters, and bears. They also have a kind of white wool, which they extract from an unknown species of animal that produces it. They weave beautiful blankets, of which I acquired four. They are not large, but woven and wrought nicely. Of the three canoes referred to, the largest carried 9 men, and would measure about 24 codos long [33 feet; the *codo* is the same as the English cubit, about 16.5 inches], and 4 wide [5.5 feet]. The others carried 7 men. It was not noted that they had any weapons. They invited us by signs to come ashore, and we signalled that on the next day we would go there. With this they withdrew to the land at 5 in the afternoon . . . (Beals 1989: 75–77)

20th to Thursday 21 July 1774

Considering that we were unable to accomplish anything against the swiftness of the current, we endeavored to withdraw ourselves somewhat, and being at a moderate distance [from shore], the wind slackened. Several canoes of Indians came into view, and seeing that we were not making any headway, they approached us and began trading with our crew. But first, they sang and danced, and cast feathers in the air. All the rest of the afternoon 21 canoes of different sizes swarmed around. The largest of them, in which an old man came representing [himself] to be a king or captain [this was probably the chief named *gannyaa* — RKW], was from 25 to 30 codos long and about 10 wide.[2] It carried 24 to 30 Indians, and in the others some had 9, others 15 and others 7. All the people are stocky and good-looking, white in color as well as in their features. Most of them have blue eyes. They tie their hair like the Spanish, and some wear a shoulder strap like soldiers. Those who wear mustaches also have beards. The king or captain referred to above carried his tambourine, jingling it. Before arriving they danced and sang; later they began to trade their pelts of sea otter, wolves and bears, of which the crew gathered in plenty in exchange for old clothes. They also collected some blankets beautifully woven and made, according to what I saw, on a loom. I also obtained some. I noticed among them some things

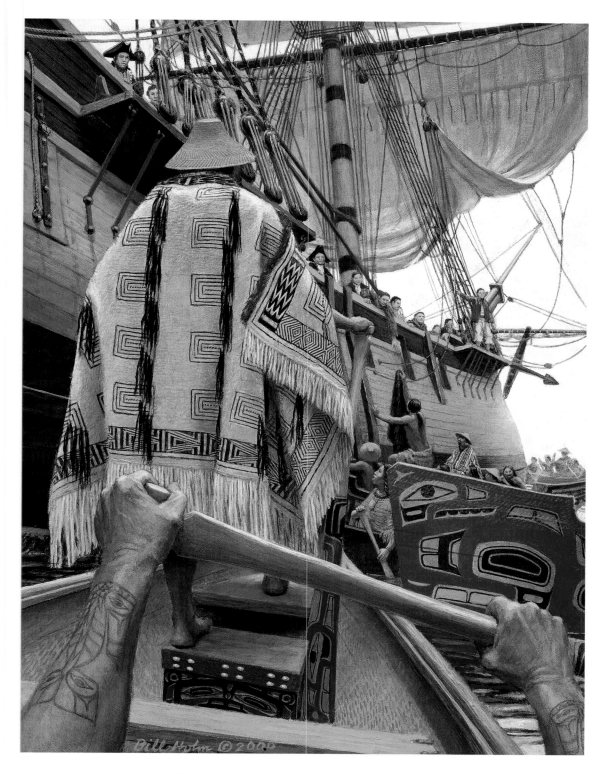

Plate 1. GANNYAA AND JUAN PÉREZ, by Bill Holm, 2000
Acrylic on canvas, 24" X 18". Collection of Robin K. Wright

[Statement by the artist: On the afternoon of July 20, 1774, twenty-one canoes bearing 150
Haida people clustered around the becalmed Spanish frigate *Santiago* to trade with the strange
foreigners who had suddenly sailed into their home waters. The ship's captain, Juan Pérez; his

(*continued on next page*)

(Plate 1 continued)

second officer, Esteban José Martinez; and the two chaplains aboard, Fr. Tomás de la Peña and Fr. Juan Crespi, all kept journals describing the events of those two days. This was the first recorded contact between Europeans and Northwest Coast Natives and the journals contain descriptions of the people and their actions. The meeting took place at the north side of Langara Island, the northwesternmost of the Queen Charlotte Islands, in present-day British Columbia. Although Pérez wanted to anchor and go ashore, adverse currents, weather, and an uncertain shore prevented him from doing so, and in the evening, as the wind freshened, he sailed to the northwest across Dixon Entrance. He sighted Cape Muzon, the southern tip of southeastern Alaska, before turning south again toward his base at Monterey.

The accounts of Pérez, Martinez, and the two chaplains record the appearance, dress, canoes, and paraphernalia of the Haida who crowded around the ship. The ceremonial dancing and singing before and after the trading session were described by them, as well as the trading itself. A good many objects, including hats, robes of fur or woven of mountain goat wool, carved chests, and weapons, were among the souvenirs traded for old clothes, knives, and beads. Only two of these artifacts are known to have survived—a hat woven of spruce root and a small, exquisitely carved ivory bird, traded from a woman who carried it in a basketry pouch. Both are now in the Muséo de America in Madrid. The journals are the first to describe the use of labrets by Northwest Coast women, and their bracelets of iron and copper. One older man among the Haidas was clearly the "chief" or "captain." Though his name was not recorded, this may have been *gannyaa,* the most powerful leader of the Northern Haida, according to late eighteenth-century accounts. I have shown him in the bow of his great canoe, overseeing the commerce between his people and the occupants of the huge and strange vessel.

I am indebted to Mark Myers, PRSMA, F/ASMA, an outstanding marine artist and authority on eighteenth-century ships and sailing, for his generous advice on those aspects of the painting.]

Plate 2. Information with a photograph at the Tongass Historical Society (neg. no. 76.8.7.8) identifies this house screen as "Raven Sitting on Rock" from Chief Jim's house in Howkan (*ráwk'aan*), Alaska. Lord Alfred C. Bossom Collection, purchased from Walter C. Waters' Curio Store in Wrangell, Alaska, circa 1900; 380 cm wide. Photograph courtesy of the Canadian Museum of Civilization, cat. no. VII-B-1527, neg. no. 586-20.

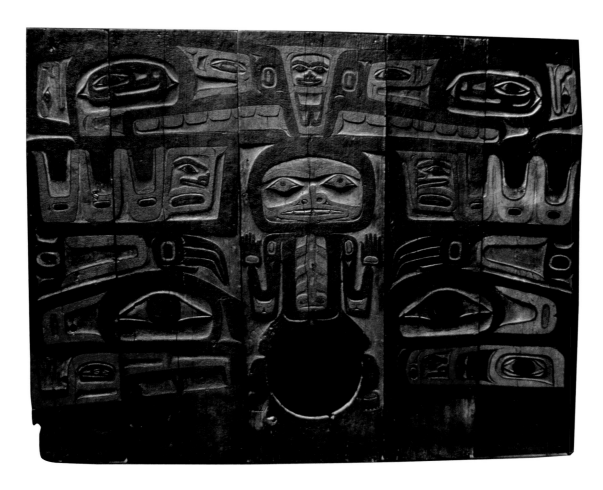

Plate 3. Watercolor by Sigismund Bacstrom, 1793, "Cunnyha an Indian Chief on the North-Side of Queen Charlotte's Island, NW Coast of America," 31.4 by 22.6 cm. Courtesy of the Paul Mellon Collection, Yale Collection of Western Americana, Beinecke Rare Book and Manuscript Library.

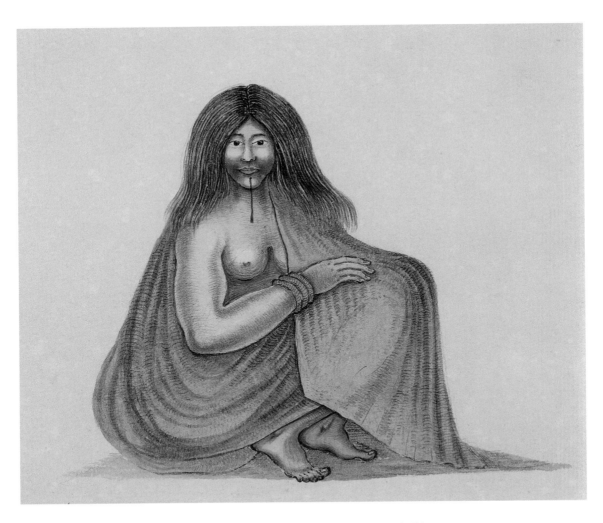

Plate 4. Watercolor by Sigismund Bacstrom, "Cunnyha's Eldest Daughter named Koota-Hilslinga, a young woman at Hain's Cove Tattesko belonging to Cunniha's Family who was along Side the Vessel on Mond: 18 March 1793 drawn on [Friday] 22 March 1793," 20.4 by 31.3 cm. Courtesy of the Paul Mellon Collection, Yale Collection of Western Americana, Beinecke Rare Book and Manuscript Library.

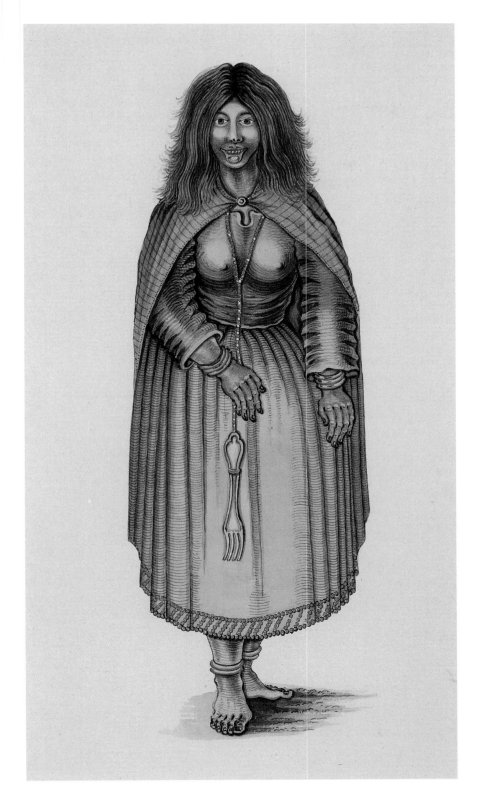

Plate 5. Watercolor by Sigismund Bacstrom, 1793, "Hangi a Chief's Daughter at Tattesko near Bocarelli Sound, N.W. Coast of America," 27 by 21.4 cm. Courtesy of the Paul Mellon Collection, Yale Collection of Western Americana, Beinecke Rare Book and Manuscript Library.

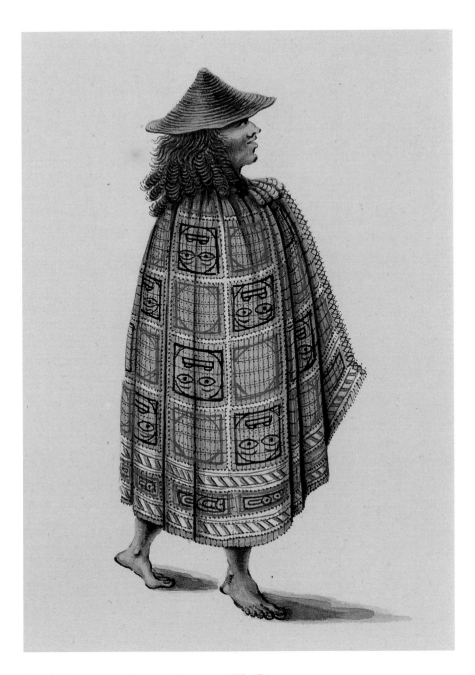

Plate 6. Watercolor by Sigismund Bacstrom, 1793, "Tchua a Chief of Queen Charlotte's Island in Lat. 52, 12N," 27.1 by 18.8 cm. Courtesy of the Paul Mellon Collection, Yale Collection of Western Americana, Beinecke Rare Book and Manuscript Library.

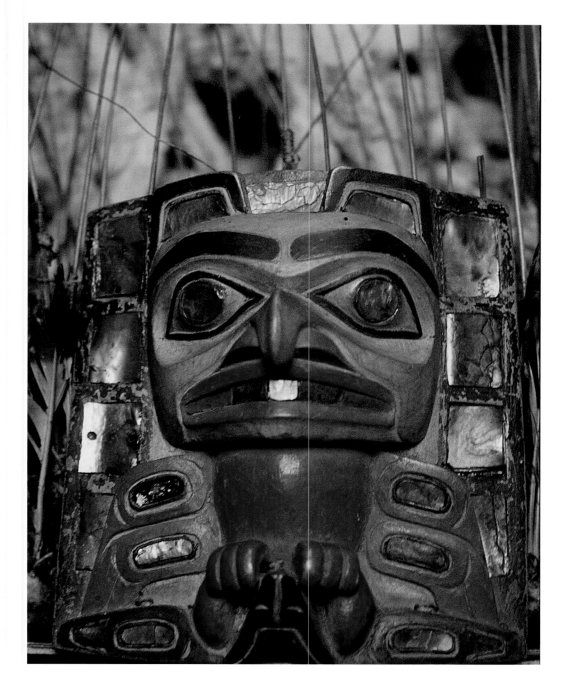

Plate 7. Eagle headdress frontlet, 16 by 15 by 6.5 cm. This
frontlet belonged to Albert Edward Edenshaw and is attributed
to him. Collected by the Reverend Charles Harrison. Pitt Rivers
Museum, Oxford, England, cat. no. 1891.49.12. Photograph by
Bill Holm.

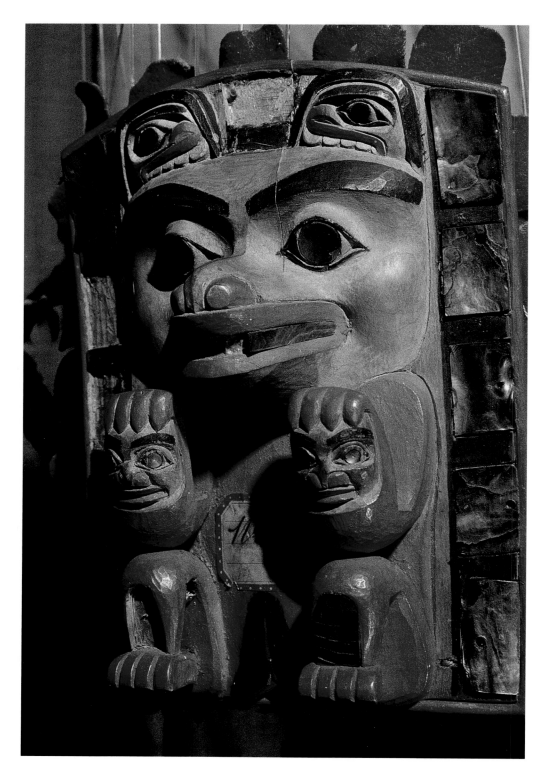

Plate 8. Bear headdress frontlet attributed to Charles Edenshaw,
19 by 14.5 cm. Collected by George T. Emmons from the Gitksan,
upper Skeena River, B.C. American Museum of Natural History,
cat. no. 16.1/604. Photograph by the author.

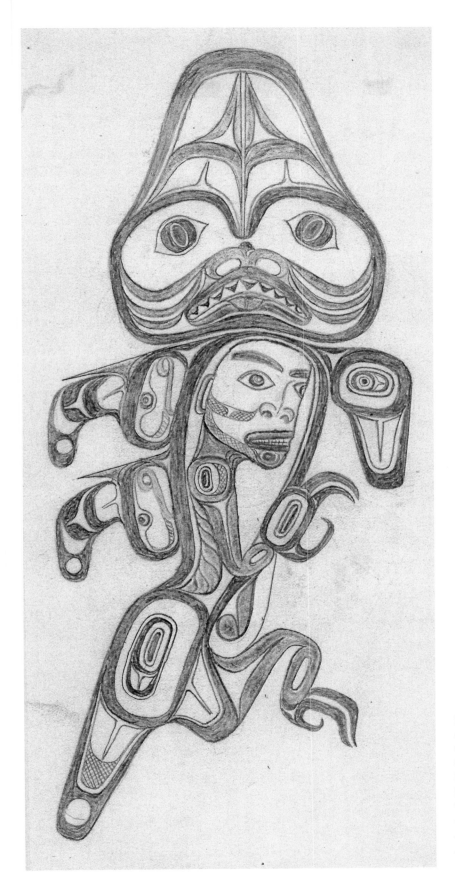

Plate 9. Isabella Edenshaw's dogfish tattoo design, drawn with colored pencils by Charles Edenshaw at Port Essington in 1897, 23.3 by 27.5 cm. Courtesy of the American Museum of Natural History, Anthropology Department Archives, Boas Collection. Photograph by the author.

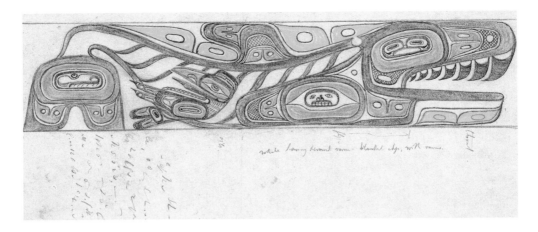

Plate 10. Blanket border design by Charles Edenshaw depicting a whale with a raven. Colored pencil, 1897, 20.3 by 25.2 cm. Courtesy of the American Museum of Natural History, Anthropology Department Archives, Boas Collection. Photograph by the author.

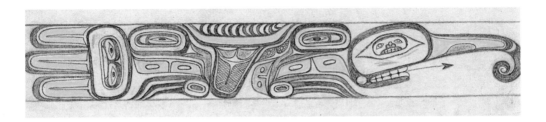

Plate 11. Blanket border design by Charles Edenshaw depicting a mosquito with a scrolled snout. Colored pencil, 1897, 20.3 by 25.2 cm. Courtesy of the American Museum of Natural History, Anthropology Department Archives, Boas Collection. Photograph by the author.

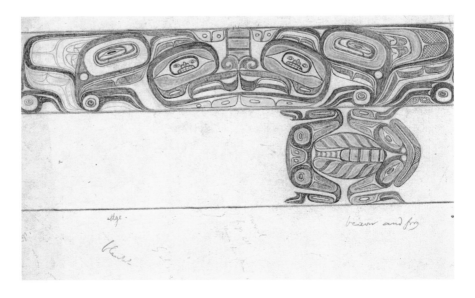

Plate 12. Blanket border design by Charles Edenshaw depicting a beaver and a frog. Colored pencil, 1897, 20.3 by 25.2 cm. Courtesy of the American Museum of Natural History, Anthropology Department Archives, Boas Collection. Photograph by the author.

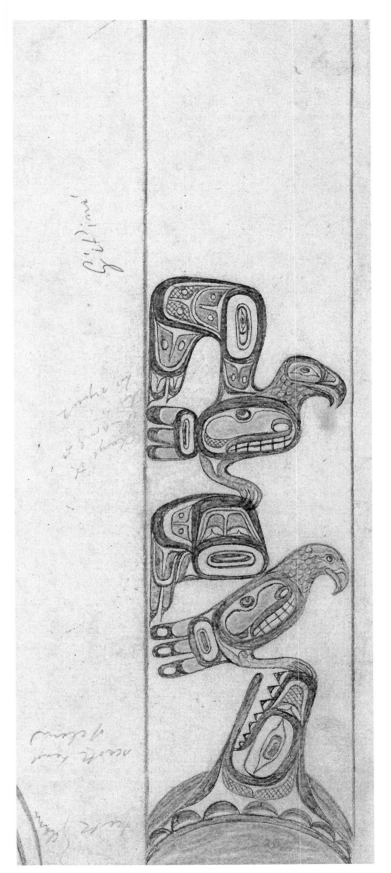

Plate 13. Blanket border design by Charles Edenshaw depicting the story of the eagle and the clam. Colored pencil, 1897, 20.3 by 25.2 cm. Courtesy of the American Museum of Natural History, Anthropology Department Archives, Boas Collection. Photograph by the author.

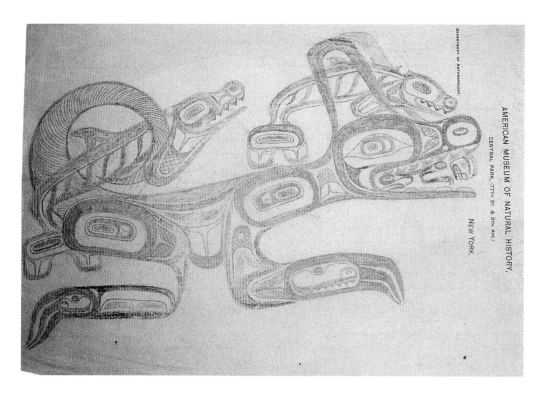

Plate 14. Colored pencil drawing of a *7waasru* (Wasgo) with whales by Charles Edenshaw, 20.5 by 27 cm. American Museum of Natural History, Anthropology Department Archives, Boas Collection. Photograph by the author.

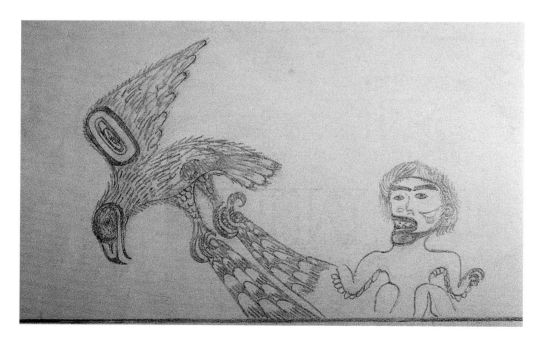

Plate 15. Colored pencil drawing of a woman being carried away by an eagle, by Charles Edenshaw, 1897, 20.3 by 25.2 cm. Courtesy of the American Museum of Natural History, Anthropology Department Archives, Boas Collection. Photograph by the author.

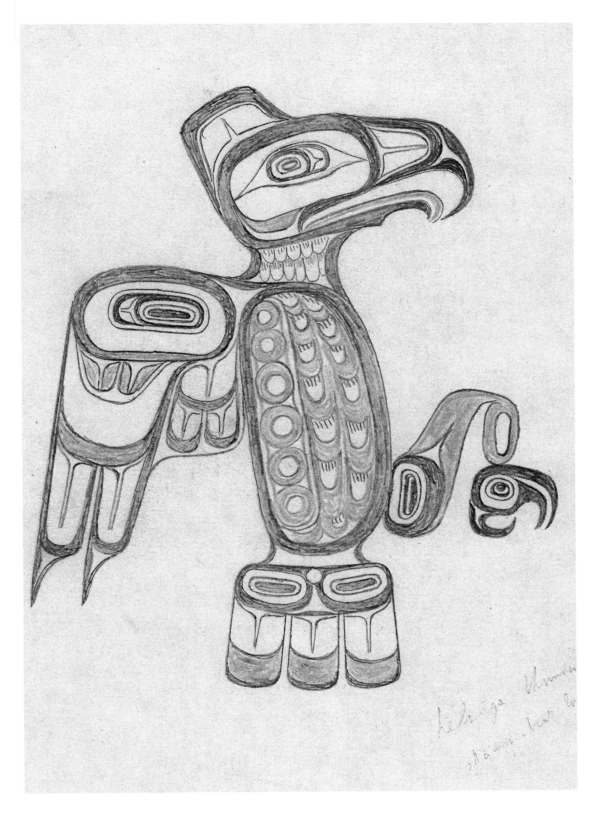

Plate 16. Colored pencil drawing of a thunderbird by Charles Edenshaw, 1897, 20.3 by 25.2 cm. Courtesy of the American Museum of Natural History, Anthropology Department Archives, Boas Collection. Photograph by the author.

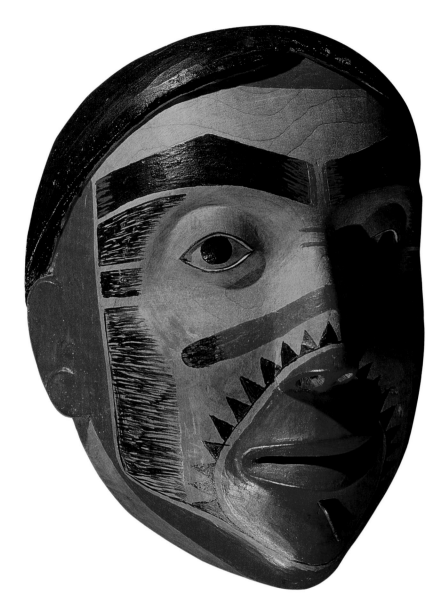

Plate 17. Young woman mask made by John *gwaay t'iihld*. An inscription on the back reads: "Carved by Quaa-telth Masset Qn. Char. Is. 1882." American Museum of Natural History cat. no. 16/364, neg. no. 318694. Photograph by the author. See alternate view in fig. 5.57.

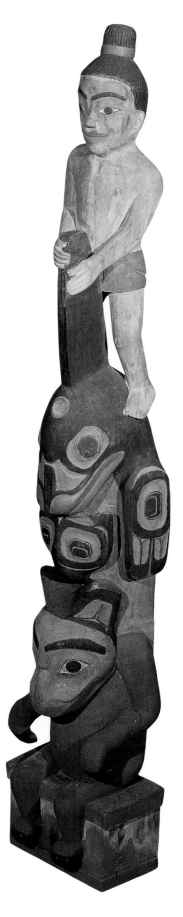

Plate 18. Model pole attributed to Simeon *sdiihldaa (skil kingaans)*. Fairbanks Museum and Planetarium, St. Johnsbury, Vermont, cat. no. NA304. Photograph by the author. See alternate view in fig. 5.68.

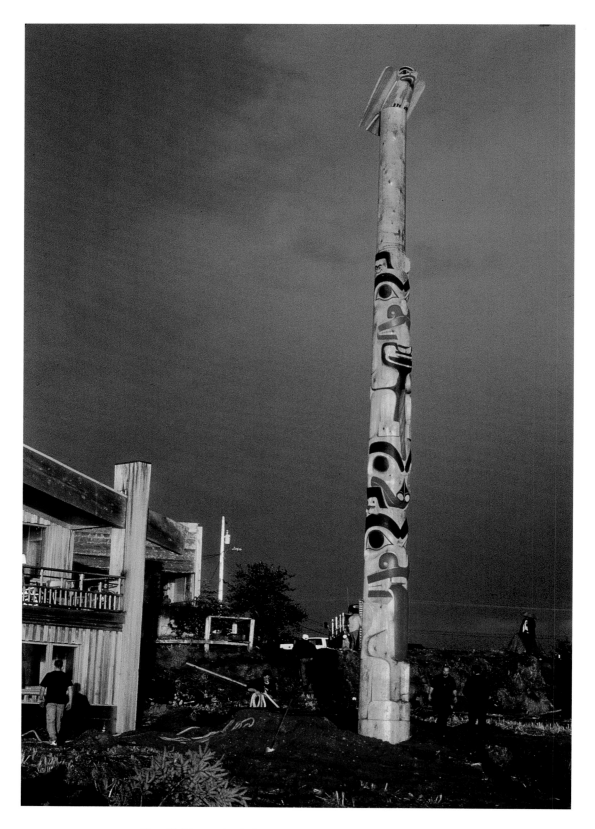

Plate 19. Memorial pole for Morris White raised by Jim Hart on the occasion of Hart's taking the name *7idansuu*, Old Massett, August 28, 1999. Photograph by the author.

made of iron in the canoes, such as instruments for cutting, like half of a bayonet and a piece of a sword. Knives do not please them, and by signs they asked for long swords or machetes; but finally they settled for some knives that the sailors gave in exchange for pelts. They carried some small wooden boxes in which to store their things. I put a thousand questions to them, but they did not understand me, even by signs. Some of our crew jumped into their canoes, and two of them came aboard [the ship] to whom gifts of bread and cheese were given, as well as some glass beads to satisfy them. Meanwhile I held out hope that the weather would permit me to go ashore in their land. They embraced and kissed those who went in their canoes as a sign of friendship; and they invited them to go ashore to eat and sleep, telling them they had much to eat and drink.

Among the 21 canoes two were filled with women and babies at the breast and older children. They were all good looking, white and fair. Many of them wear bracelets of iron and copper, and some small rings of the same. They wear their clothes of pelts fitted to the body. They have a perforation in the middle of the lower lip, and in it they put a piece of painted shell, which strikes their noses when they speak, although they have normal movement. Those who wear it apparently are married, because some of the young girls were not wearing it. They are of good build, like the men. Finally, they show evidence of docility and a good nature, because it was manifest in their actions. It was afternoon and everyone was cheerful; but less so I, who wanted to anchor but was unable to get help from the wind. It made me ill-tempered, and even more so seeing that without a wind the furious flow of the current was separating me from the coast. I had thought about anchoring in an inlet formed by the coast, sheltered from all the winds; but since the wind and current prevented me from it, I had to submit to the will of God. The referred-to inlet is sheltered from the winds of the South, SW, W and NW, because its entrance and outlet are NE, SW.

The canoes retired at the close of evening with a great clamor. They were content having traded with us; while we were unhappy seeing that the current failed us. Though I was unable to go ashore, however, I had the pleasure of viewing the land up close and examining it. (Beals 1989: 78–79)

José Martínez's *Diario*

20th to 21 July 1774

As we remained becalmed, the Indians took the opportunity to satisfy their desire to trade with us, and we with them. For the rest of the afternoon they gathered about us in 21 canoes, which according to my count had in total some 150 Indians, all stocky, robust, and past the age of majority. Two canoes arrived full of women and some babies that were nursing at the breast, and some that were older. The women are good looking; they wore a tablet in the mouth that looked like the lip of a painted shell. They had the lower lip pierced where they attached the tablet, a very ugly thing. They wore bracelets of iron or lead, and also of copper, and many small rings. In one large canoe there came someone representing [himself] to be the king or captain, with 22 Indians, accompanied by the jingling of tambourines, all dancing and shouting. This king, or whatever he was, took a fancy to

my red cap. I gave it to him and he presented me with the cloak that he was wearing, which is a blanket that I will forward to Your Excellency on my arrival. It is beautiful for being handmade by people without culture. Various other things were obtained by my companions. I also noticed in their canoes some small plates of iron and some other stone implements. But what surprised me was to see among them half of a bayonet and another [Indian] with a piece of a sword made into a knife. They were not much inclined to this [last-mentioned] instrument, and indeed they asked by signs for swords and large knives. All trade was reduced to the sailors' giving them some old clothes for blankets of coarsely woven wool and pelts of wolf as well as otter, which is the clothing they wear wrapped about the body. The women were dressed the same way, and they wore their hair like the Spaniards. As for the men, they wear theirs in a shoulder knot like the soldiers, tied with wool strips and very thin rawhide.

I asked them a thousand questions, all having to do with whether we could cast anchor, but they did not understand me, and their replies were to say that they had plenty to eat and drink if we would come ashore. Some of our men got into their canoes; they gave them presents and two of them came aboard, to whom were given presents of bread and cheese. It was a very pleasant afternoon, but we had wanted to cast anchor. However, there was nowhere in this place it could be done because of the heavy breakers along the coastline. The Indians also use hats, but they are of straw like [those of] the workmen at the Santa Barbara Channel. I also saw a wooden spoon, and I picked up two first rate arrows, unlike those used by other Indians in New Spain. We always hoped to plant the cross of Christ in this place, but the weather deprived us of this wish, as was said before.

The afternoon ended with the canoes withdrawing, and us becalmed, with only a little wind. We parted, and as night came on the sky was covered with fog so that the land was not visible (Beals 1989: 100–101).

Fray Tomás de la Peña's *Diario*

After dawn, on the 20th [July], the wind came from east-southeast, and the ship's head was put on a course north 1/4 northeast, the fog continuing very dense and wet. About nine o'clock the course was altered to east-northeast, that we might examine the low land that showed at the end of the point. At ten o'clock it was noted from the masthead that it consisted of three small islands which were near to the mainland. These the Captain named the Islands of Santa Margarita, this being the day of that glorious lady. It was impossible to get an observation today on account of the heavy fog and drizzle. About three in the afternoon we were near the land which had appeared to consist of islands, although this could not be verified because the fog so limited the view when we were about three leagues away, and we went about and stood off shore with the intention of continuing tacking along the land, so that when the weather cleared we might find anchorage ground and take in a supply of water. At that hour we saw bonfires on the land, and presently there came to us a canoe with nine men in it. This canoe drew near to the vessel, the pagans in it singing; but they would not come near enough for us to communicate by means of signs. Having followed us for some time, they returned to the land. About five o'clock this canoe,

and another in which there were six pagans, caught up with us, both drawing up to our stern. The Captain made them a present of some strings of beads and they gave us some dried fish. But they would not come on board the ship. These persons are well-built, white, with long hair; and they were clothed in pelts and skins, some of them were bearded. They had some iron implements in their canoes, but we were unable to inquire where they obtained them, for presently they went back to land, inviting us thither, and offering to give us water on the following day. About six o'clock there arrived another canoe with seven pagans, who drew near, singing the same air the others had sung. These followed us for about an hour without being willing to come aboard the ship. When at length they went back to land we were about eight leagues from it, and there was a high sea on. These canoes resemble those used in Santa Barbara Channel, but are of greater burden. This afternoon the wind was in the southeast, and at ten o'clock it died away entirely.

Shortly after midnight, it being the 21st, it began to blow very fresh from the southeast, and the ship stood off shore with her head to the southwest 1/4 south. At eight in the morning we went about toward the land on a course east 1/4 northeast. This morning there was a dense fog. The navigating officers could not take an observation, for the sky was overcast. About noon we made the point of land to the northward of Santa Margarita, a quarter of a league away, and we coasted along it to the eastward for about half a league with intent to discover whether there were an anchorage behind a point to the eastward where there seemed to be an indentation in the coast line. But we could not double this point, for the current carried us to the southward. For this reason we went about, and, after we had sailed about a league to the southwestward, the wind, which all the morning had blown with much force and had raised a heavy sea, died away. About half past two, canoes, some larger than others, all full of pagans, began to arrive. The larger canoes were twelve or thirteen yards in length, and appeared to be of a single piece, excepting that there was planking along the sides and at the bow. In these canoes were some two hundred persons; in one there were counted twenty-one, in another nineteen, while in the others were five, seven, twelve and fifteen. One canoe contained twelve or thirteen women and no men. In others, also, there were women but the majority consisted of men. At the time the women's canoe arrived at the ship it happened that its prow struck that of another canoe whose occupants were men and broke it; at this the men became very angry, and one of them, seizing the prow of the women's canoe, broke it to pieces in order to repay their carelessness. All the afternoon these canoes, twenty-one in all, were about the ship, their occupants trading with the ship's people, for which purpose they had brought a great quantity of mats, skins of various kinds of animals and fish, hats made of rushes and caps made of skins, bunches of feathers arranged in various shapes, and, above all, many coverlets, or pieces of woven woolen stuffs very elaborately embroidered and about a yard and a half square, with a fringe of the same wool about the edges and various figures embroidered in different colors. Our people bought several of all these articles, in return for clothing, knives and beads. It was apparent that what they liked most were things made of iron; but they wanted large pieces with a cutting edge,

such as swords, wood-knives and the like — for, on being shown ribands they intimated that these were of trifling value, and, when offered barrel hoops, they signified that these had no edge. Two of the pagans came aboard the ship, and were much pleased with the vessel and things on board of it. The women have the lower lip pierced, and pendent therefrom a flat round disk; we were unable to learn the significance of this, nor of what material the disk was made. Their dress consists of a cape with a fringe about the edge and a cloth reaching to the feet, made of their woven woolen stuff, or of skins, and covering the whole body. Their hair is long and falls in braids to the shoulder. They are as fair and rosy as any Spanish woman, but are rendered ugly by the disk they have in the lip, which hangs to the chin. The men also are covered, with the skins or with the woven cloths of wool, and many have capes like those of the women; but they do not hesitate about remaining naked when occasion for selling their clothing offers. At six o'clock, taking leave of us, they made for the land, and they made evident their desire that we should go thither. Some sailors went down into the canoes and the pagans painted their faces with delight and shouts of joy. These pagans gave us to understand that we should not pass on to the northward because the people there were bad and shot arrows and killed.[3] How common it is for pagans to say that all are bad except themselves! The calm lasted all the afternoon and the current took us about two leagues farther from the land. (Cutter and Griffin 1969: 157–161)

Fray Juan Crespi's *Diario*

At daybreak on Wednesday, the 20th, there was a very thick fog, so that at a short distance nothing could be seen. There was a drizzling rain and an east wind so strong that the ship was tossed about continually. The sails were loosed and the ship's head put to northeast 1/4 east. Before nine o'clock the weather lightened, so that we made out the land very well. We went about and stood northeast, in order to make a point of the land. At ten we were about four leagues from this point, which to all seemed to consist of three islands. At midday no observation could be obtained, for it was cloudy and the sun was hidden. About three in the afternoon we were some two leagues from the land, and what had appeared to us to be three islands now seemed to be one, not very distant from the land. We saw many bonfires of its inhabitants, and that it was a land densely covered with trees, apparently pines, and that behind said point was a good bight or bay.

And we noticed that a canoe came out from a break in the land like the mouth of a river and was paddled toward the ship. While it was still distant from the vessel we heard the people in it singing, and by the intonation we knew that they were pagans, for it was the same sung at the dances of pagans from San Diego to Monterey. Presently they drew near to the ship and we saw that they were eight men and a boy. Seven of them were paddling; the other, who was advanced in years, was upright and making dancing movements. Throwing several feathers into the sea, they made a turn about the ship. From the gallery of the cabin we called out to them that they should draw near; and, although at first they did not venture to do this because of some fear they entertained, after showing them handkerchiefs, beads and biscuit, they came near to the stern of the ship and took all

that was thrown to them. A rope was thrown to them, that they might come on board; although they took hold of it they did not venture to ascend it, but, keeping hold of it, they went on with us to a considerable distance.

When this canoe reached the ship it was about four in the afternoon, and a dense fog had come on, while the wind was not favorable. For these reasons it was ordered that the ship be put about, farther approach to the coast and a landing being put off till tomorrow. The pagans, seeing that we were going away from their country, invited us thither, and we knew, or understood from their signs, that they told us there were provisions and abundant water there and a place where the ship might anchor; and, we replying by signs that on the following day we would go thither, they went away.

These pagans are corpulent and fat, having good features with a red and white complexion and long hair. They were clothed in skins of the otter and the seawolf, as it seemed to us, and all, or most of them, wore well woven hats of rushes, the crown running up to a point. They are not noisy brawlers, all appearing to us to be of a mild and gentle disposition.

About half an hour after the departure of the canoe we heard singing again and we saw another canoe, smaller than the first, which joined the other, and the two came together to the ship. In the second canoe came six pagans. Both canoes drew near to the stern of the ship and we gave these people various trifles, telling them that on the day following we would visit their country. After having followed us for some time they went away, all very content.

These canoes seemed to us to be of a single piece of wood except the gunwale. They are well made, their keels being fashioned almost like those used by the natives of the Channel of Santa Barbara, except that these have a poop and the prow is not open like those of the channel, and their paddles are well made. In these canoes we saw two very large harpoons for fishing and two axes. One of these seemed, on account of the shining appearance of the edge, to be of iron; but I could not verify this. We saw that the head of one of the harpoons was of iron, and it looked like that of a boarding-pike.

After the canoes had gone away and night had fallen, and we were all reciting the rosary of Our Lady of the Immaculate Conception, we again heard singing. This proceeded from another canoe, which drew near with the same ceremonies observed by the others. Seeing that no attention was paid to them, because we were at prayers, the people in the canoe began to cry out, and they continued shouting until such time as the daily recital of the rosary and special prayers to some saints were concluded and the hymn of praise, which caused great admiration on their part, was sung. As it was now dark the Captain ordered lights to the side of the frigate, and we saw that another canoe, containing seven pagans, had arrived. They were asked to come aboard the ship, but either they did not wish to do so or they did not understand the signs made to them. They were given some little things of trifling value, and gave us in return some dried fish which seemed to be cod, although it was whiter.

A sailor obtained in exchange for a large knife he gave them, a hat of rushes, well woven of several colors. The crown was conical and about a third of a vara in height, while the brim was not more than a sixth of a vara

in its breadth. For a large knife, also, another sailor obtained a piece of stuff about a square vara in size; it was very showy, apparently woven of fine palm leaves. The colors were black and white, and woven in little checks; it was a very good and showy piece of work. This canoe remained alongside about an hour, when, on our telling them by signs that they should go away, for it was very late, and that on the following day we would go to their land, they went away content. They had to go six leagues, for we were already at a distance from land. (Cutter and Griffin 1969: 225–229).

[Thursday, July 21, 1774]

After the calm had lasted twelve hours and the ship was about a league from land, off the southwest point or hill of Santa Margarita, canoes began to put out, both from this southwest point and that running to the east-southeast; and, in short time twenty-one canoes had come near to us. Some were very large; others of medium size; others small. Among them were two, neither of which would measure less than twelve varas along the keel; in one of these were twenty men and in the other nineteen. In the canoes of medium size there were ten or twelve persons, and in the smallest not less that six or seven. In a short time we saw ourselves surrounded by these twenty-one canoes, which contained more than two hundred persons, between men, women, boys and girls — for in the greater number of the canoes there were some women. Among the canoes was one containing only women, some twelve in number, and they alone paddled and managed the canoe as well as the most expert sailors could.

These canoes came alongside without their occupants manifesting the least distrust, they singing and playing instruments of wood fashioned like drums or timbrels, and some making movements like dancing. They drew close to the ship, surrounding her on all sides, and presently there began between them and our people a traffic, and we soon knew that they had come for the purpose of bartering their effects for ours. The sailors gave them knives, old clothing and beads, and they in return gave skins of the otter and other animals unknown, very well tanned and dressed; coverlets of otter skins sewn together so well that the best tailor could not sew them better; other coverlets, or blankets of fine wool, or the hair of animals that seemed like wool, finely woven and ornamented with the same hair of various colors, principally white, black and yellow, the weaving being so close that it appeared as though done on a loom.

All these coverlets have around the edge a fringe of some thread twisted, so that they are very fit for tablecloths, or covers, as if they had been made for that purpose. They gave us, also, some little mats, seemingly made of fine palm leaves, wrought in different colors; some hats made of reeds, some coarse and others of better quality, most of them painted, their shape being, as I have said, conical with a narrow brim, and having a string which passing under the chin keeps the hat from being carried away by the wind. There were obtained from them, also, some small wooden platters, well made and ornamented, the figures of men, animals and birds being executed, in relief or by incising, in the wood; also some wooden spoons, carved on the outside and smooth within the bowl, and one rather large spoon made of a horn, though we could not tell from what animal it came.

There were obtained from them two boxes made of pine, each about a vara square, of boards well wrought and instead of being fastened together by nails, they were sewed with thread at all the corners. They have neither hinges nor locks, but the cover comes down like that of a trunk with a fastening like that of a powder chest; and they are rather roughly fashioned within, but outside are well made and smooth, the front being carved with various figures and branches, and inlaid with marine shells in a manner so admirable that we could not discover how the inlay was made. Some of these figures are painted in various colors, chiefly red and yellow. In all the canoes we saw these boxes and some of them were nearly a yard and a half long and of a proportionate width. They use them for guarding their little possessions and as seats when paddling. They gave us, also, some belts very closely woven of threads of wool or hair, and some dried fish of the kind I mentioned yesterday. It is apparent that they have a great liking for articles made of iron for cutting, if they be not small. For beads they did not show a great liking. They accepted biscuit and ate it without the least examination of it.

As I have said, these Indians are well built; their faces are good and rather fair and rosy; their hair is long, and some of them were bearded. All appeared with the body completely covered, some with skins of otter and other animals, others with cloaks woven of wool, or hair which looked like fine wool, and a garment like a cape and covering them to the waist, the rest of the person being clothed in dressed skins or the woven woolen cloths of different colors in handsome patterns. Some of these garments have sleeves; others have not. Most of them wore hats of reeds, such as I have described. The women are clothed in the same manner. They wear pendent from the lower lip, which is pierced, a disk painted in colors, which appeared to be of wood, slight and curved, which makes them seem very ugly, and, at a little distance they appear as if the tongue were hanging out of the mouth. Easily, and with only a movement of the lip, they raise it so that it covers the mouth and part of the nose. Those of our people who saw them from a short distance said that a hole was pierced in the lower lip and the disk hung therefrom. We do not know the object of this; whether it be done to make themselves ugly, as some think, or for the purpose of ornament. I incline to the latter opinion; for, among the heathen found from San Diego to Monterey, we have noted that, when they go to visit a neighboring village, they paint themselves in such a manner as to make themselves most ugly. We saw that some of the men were painted with red ochre of a fine tint.

Although we invited these Indians to come aboard ship they did not venture to do so, except two of them, who were shown everything and who were astonished at all they saw in the vessel. They entered the cabin and we showed them the image of Our Lady. After looking at it with astonishment, they touched it with the hand and we understood that they were examining it in order to learn whether it were alive. We made presents to them, and told them by signs that we were going to their land in order to obtain water. While these two were on board the frigate two of our sailors went down into the canoes, whereat the Indians rejoiced greatly, and made a great to-do. They painted them and danced with them with such expressions of content that they could not have done more had they been well known to them,

giving it to be understood by the sign of placing the hand on the breast that they loved them dearly.

From this we all inferred that this is a peaceable and very docile people. Those in the canoes invited the two sailors to their land, telling them that, if they wished, they would take them thither in their canoes; but they did not wish to go, telling them that they would go in the vessel with the rest of the people. But this was not possible, on account of the calm which lasted all the afternoon and the currents which bore us away from the land. So the canoes went away, the Indians inviting us to visit their country, and we understood them to say by signs that we should not go further up the coast because the people there were warlike and slayers of men, this being the customary warning of almost all pagans, in order to make it understood that they are good men and the rest bad. Our attention was drawn to the pleasant faces of both men and women and their long hair well combed and braided, the women particularly keeping the head in good condition, to their using clothing almost like woven stuffs, the fabric being as good and as well made, and to the manufactured articles of wood, palm, reeds and ivory which our people got from them.

It astonished us, also, to find that the women wore rings on their fingers and bracelets, of iron and of copper. These things I saw on several women, and the sailors who saw them nearer assured me that there was a woman who had five or six rings of iron and of copper on the fingers of her hands. We saw these metals, though not to any great amount, in their possession, and we noted their appreciation of these metals, especially for large articles and those meant for cutting. The Captain, who spent a great deal of time in China and the Philippines, says that they greatly resemble the Sangleyes of the Philippines. It is certain that the weaving of the fine little mats resemble[s] those that come from China. Although the night is very short, for the sun rises before four o'clock, yet this night was long for us, on account of the desire we had to go ashore. Some of the sailors who bought cloaks passed a bad night, for, having put them on, they found themselves obliged to take to scratching, on account of the bites they suffered from the little animals these pagans breed in their clothing. (Cutter and Griffin 1969: 233–241)

Though no drawings were made on this voyage, these four written accounts provide a rich verbal picture of the scenes that occurred during the two-day encounter. The appearance and ceremonial approach of the canoes with the scattering of feathers (probably eagle down, a universal symbol of peace on the northern Northwest Coast), the welcoming arm gestures of the chief, and the songs and the playing of instruments described as tambourines (probably puffin-beak rattles) suggest a formal and peaceful first contact. The descriptions of the appearance of the Haida people — their hairstyles, hats, clothing, and jewelry, including labrets (Haida noble women pierced their lower lips and wore increasingly larger lip plugs throughout life as a sign of beauty and high rank) and iron and copper rings and bracelets — confirm the precontact development of the art of weaving elaborate robes from mountain goat wool, cedar bark, and sea-otter fur, as well as the precontact use of precious metals for ornaments and tools.

We know from these journals that in exchange for iron knives, old clothes, strings of beads, and biscuits, the Spaniards obtained dried codlike fish (probably halibut), several woven mats, belts (possibly tumplines — burden straps for carrying baskets and other loads), painted hats, a number of woven woolen robes, some carved, painted, and inlaid wooden boxes, and some wooden and horn spoons (probably made of mountain sheep and/or mountain goat horn) and carved wooden platters ornamented with figures of men, animals, and birds executed in relief. They also described, but apparently did not acquire, large wooden chests that the Haida filled with their gear and used for seats aboard the canoes.

The extensive list of objects mentioned in the journals as having been obtained from the Haida people is not reflected in the inventory of the objects officially reported from the voyage:[4]

A cloak that appears to be of coconut burlap.

Another of the same made with greater ability and bordered on one side with white and black, with little pieces of sea-otter skin in the form of little squares on both sides like a checker board.

A belt or sash that looks like wool and [is] well-woven with the edges bordered with black.

A skin cap that looks like a he-goat with a sort of vizor of black seal skin adorned with two rows of teeth alongside, which appear to be those of a fish.

A hat woven with a great deal of ability which appears to be of fine basketry [fig. 2.1].

Another of the same, of Chinese style and much more beautiful because of its weaving and because it has depicted thereon the canoes which they use, and made of basketry material dyed black.

A quadrangular pouch also of basketry and without any stitching, with 24 little sticks of wood, well-carved and delicate, which they use for playing music during their dances.

A pouch or bag of very delicate basketry, very beautifully made, and on it, a species of bird made of bone with its upper beak broken, acquired from an Indian woman who wore it around her neck along with a number of little teeth, which looked like those of small alligators [fig. 2.2]. (Cutter and Griffin 1969: 278)

It is probable that all but two of the items on this list were obtained from the Haida off Langara Island. The two exceptions are the hat with the images of canoes, which is no doubt a Nuu-chah-nulth whaler's hat, and the first woven robe, which was probably a plain yellow cedar-bark robe of a type known from the Nootka Sound area. The encounter with the Nuu-chah-nulth near Nootka Sound was much briefer than that with the Haida. Crespi's journal mentions that on August 9 the Spaniards obtained sea-otter furs, hats with conical crowns ending in a ball like a little pear, and some cloths woven of a material like hemp (Cutter and Griffin 1969: 259).

The second robe on the list is no doubt one of the five mountain-goat wool

Fig. 2.1. Spruce-root hat collected by Juan Pérez near *k'yuust'aa* (Kiusta), July 1774, 14 cm high. Museo de América, Madrid, Spain, cat. no. 13.571. Photograph by the author.

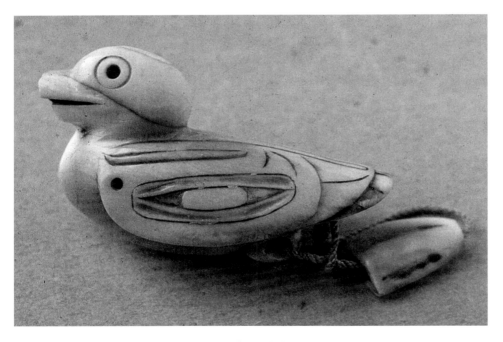

Fig. 2.2. Ivory bird, a woman's neck ornament, collected by Juan Pérez near *k'yuust'aa,* July 1774, 6.9 by 4.3 cm. Museo de América, Madrid, Spain, cat. no. 13.042. Photograph by the author.

robes mentioned in the diaries as having been collected by Pérez and Martínez from the Haida (see plate 6 for a similar robe). The intriguing "skin cap that looks like a he-goat" with a seal-skin visor and rows of fishlike teeth was possibly a carved crest headdress or helmet of some sort. The pouch with "24 little sticks of wood" probably denotes a set of gambling sticks rather than musical instruments; the sticks fit the description of the gambling pieces that were most commonly used on the northern Northwest Coast.

The other numerous items listed in the diaries might have been kept as personal souvenirs by the crew and therefore not listed in the inventory. It is possible that some of these items still exist in museum or private collections, but if so, they have, unfortunately, been separated from their documentation. We do know that two of the items from this list survived and are housed in the Museo de América in Madrid: the fine basketry hat (fig. 2.1) made of spruce root and the ivory amulet in the form of a bird with two teeth that was once attached to a basketry pouch and worn around the neck of a woman (fig. 2.2). The carving on this exquisite little pendant displays the classic early style of northern Northwest Coast art and tells us that this "formline" design system was fully developed well before the first European contact (Brown 1998: 12–13; Holm 1965, 1989: 105–106).[5]

In the year following the Pérez expedition, 1775, Spain sent a second expedition north in the same ship, the *Santiago*, under the command of Bruno Heceta, with Pérez second in command. Heceta's party was accompanied by Juan Francisco de la Bodega y Quadra in the schooner *Sonora*. After landing near Point Grenville in what is now Washington State — followed by an unfortunate encounter with the Quinault that resulted in the death of seven Quinault and seven Spaniards (see Wright 1991: 29–30) — the two ships separated. Heceta proceeded south while Bodega y Quadra in the *Sonora* sailed north, bypassing Haida Gwaii and going on to Tlingit country north of Sitka Sound, near Shelikof Bay of Kruzof Island. Bodega y Quadra's men sighted two canoes that quickly fled. The Spaniards then sailed farther north, to 57° 20' N, and went ashore to plant a cross near a deserted hut and a stockaded enclosure. Though the house had appeared deserted during this "possession-taking" ceremony, the residents, who had no doubt been observing from a safely removed position, were later seen from the ship to move the cross to the front of their huts. Bodega y Quadra also landed and "took possession" farther north at Sea Lion Bay, near Salisbury Sound, and farther south at Bucareli Bay on Prince of Wales Island, thus completing an assignment given to Pérez the year before (Barrington 1781; Gormly 1977: 10; Wagner 1937: 460–490).

In 1779 Spain mounted the Ignacio Arteaga expedition with two vessels, the *Princessa* and the *Favorita*, which sailed from San Blas to Prince of Wales Island and on to Prince William Sound. We have both the Spanish accounts of this voyage and a Haida oral history of the encounter, which are remarkably consistent in their recording of the facts. The Spaniards' accounts record that they planted another cross at Bucareli Bay and explored extensively around the bay. This time the residents took the cross down, and an altercation followed, with cannon fired at a canoe, though no one was harmed. A chief was seized as a hostage for two sailors who, it was later learned, had voluntarily deserted. According to Mary Gormly's reading of the journals, Arteaga purchased five children for the purpose of "gaining a better knowledge of the people and their

customs" before leaving Bucareli Bay and sailing north as far as the Kenai Peninsula (Gormly 1977: 13–14). It is possible, considering that they were readily sold to strangers, that these children were slaves, though apparently only the four younger children were exchanged for trade goods; an older boy was invited on board as an interpreter (Pethick 1976: 50–52). The area around Bucareli Bay is usually considered to be Tlingit country, with the village of Klawock nearby, but there is some evidence from Haida oral history that the people whom Arteaga encountered there were in fact Haida. Erma Lawrence recorded the following account from Robert Cogo, the husband of Nora, one of Charles Edenshaw's daughters.

> The next expedition (of the Spanish) made a complete survey of Bucareli Bay. This expedition sailed into Port Santa Cruz from St. John's Island. There were two large ships. They stayed over one month, they surveyed the whole bay, they looked around. They (the Spanish) named places and two boats were put overboard and left, and long after the harbor (was named) the interior was marked and surveyed (by the men in the smaller boats). While this was going on, the Haida surrounded the Spanish ships in numbers. There were eighty canoes surrounding them. The people (Haida) were numerous. The captain was afraid when he thought of being surrounded, and not knowing what to do, he fired cannons from the two large ships. He thought that the Haida would flee after he fired the cannons, but they surrounded him all the more. The Spanish fired another round from the cannons, hitting a canoe and killing two Haida. Then the Spanish and the Haida talked and made peace, exchanging gifts. The Haida gave the Spanish four children, two boys and two girls; since there were two ships they put the boys on one ship and the girls on the other. They all exchanged many gifts, then they buried the two dead bodies. As they buried the dead, the Spanish placed a pistol in each grave as a token of peace. After two months they sailed away and the Haida never saw them again. These Spanish people never reported what they did with the four Haida children. No report ever came back. This is all of my story. (Lawrence 1975:26, as quoted in Vaughan 1985: 29–30)

Whatever happened to these children is indeed unknown. The older boy might have been released after serving his purpose, but apparently the four younger children were taken away to Mexico, where the ships returned after the expedition.[6]

Britain made its first explorations of the Northwest Coast starting in 1778 with Captain Cook's third voyage to the Pacific, in which he sailed past Haida Gwaii without noticing it on the way from Nootka Sound to Prince William Sound. Following the reports of sea-otter pelts available at Nootka Sound published in the accounts of Cook's voyage, the first British fur-trading vessel, the *Sea Otter,* captained by James Hanna, arrived on the Northwest Coast in 1785. Unfortunately for historians, only part of his journal survives, and it ends just as he arrives on the Northwest Coast (Hanna 1785). In 1786, Captain James Strange and Alexander Walker on the *Captain Cook* sailed from India to Nootka Sound and on toward Prince William Sound, but like Cook, they sailed right past Haida Gwaii without stopping (Walker 1982).

All of these intervening expeditions were focused either north or south of Haida Gwaii, and the next documented meeting with Haida people did not take place until thirteen years after the Pérez expedition. This encounter was with the British fur trader George Dixon on the *Queen Charlotte;* he arrived at and named North Island (Santa Margarita or Langara Island) in July 1787. A Captain Portlock, on the ship *King George,* was in charge of the expedition, but the two vessels had separated at Prince William Sound, and Dixon visited Haida Gwaii alone while Portlock remained in more northern waters. Both Portlock and Dixon had been officers on Captain Cook's third voyage (Walbran 1971: 13–14). Dixon conducted extensive trade for nearly a month down the west coast of Haida Gwaii, around Cape St. James, and as far north on the east side as Skidegate Inlet, determining that this was a group of islands. He never set foot on land but was responsible for giving several features names that have remained in use. Dixon Entrance was named in his honor, and because of the extensive trade in sea-otter cloaks conducted there, Dixon named a small bay on the west side of North Island Cloak Bay. He also named Haida Gwaii after his ship, the *Queen Charlotte,* which was in turn named for King George III's wife. The account of Dixon's voyage was recorded by William Beresford, the expedition's supercargo (the person in charge of commercial concerns), as a series of letters, from which I have excerpted the following passages.

George Dixon's Expedition

[July 2, 1787]

During the night we had light variable airs in every direction, together with a heavy swell from the South West; so that in the morning of the 2d, we found our every effort to reach the bay ineffectual; however, a moderate breeze springing up at North East, we stood in for the land close by the wind with our starboard tacks on board. At seven o'clock, to our very great joy, we saw several canoes full of Indians, who appeared to have been out at sea, making towards us. On their coming up with the vessel, we found them to be a fishing party; but some of them wore excellent beaver cloaks, the sight of which — but at present I must lay down my pen, with a promise to resume it soon . . .

The Indians we fell in with in the morning of the 2d of July, did not seem inclined to dispose of their cloaks, though we endeavored to tempt them by exhibiting various articles of trade, such as toes [iron spikes or chisels], hatchets, adzes, howels, tin kettles, pans, &c. their attention seemed entirely taken up with viewing the vessel, which they apparently did with marks of wonder and surprize. This we looked on as a good omen, and the event shewed, that for once we were not mistaken.

After their curiosity, in some measure, subsided, they began to trade, and we presently bought what cloaks and skins they had got in exchange for toes, which they seemed to like very much.

They made signs for us to go in towards the shore, and gave us to understand, that we should find more inhabitants, and plenty of furs.

By ten o'clock we were within a mile of the shore, and saw the village where these Indians dwelt right a-breast of us: it consisted of about six huts, which appeared to be built in a more regular form than any we had yet seen,

and the situation very pleasant, but the shore was rocky, and afforded no place for us to anchor in. A bay now opened to the Eastward, on which we hauled by the wind, which blew pretty fresh from the Northward and Eastward, and steered directly for it. During this time, several of the people whom we traded with in the morning, had been on shore, probably to shew their newly acquired bargains; but on seeing us steer for the bay, they presently pushed after us, joined by several other canoes.

As we advanced up the bay, there appeared to be an excellent harbour, well land locked, about a league a-head; we had soundings from ten to twenty-five fathom water, over a rocky bottom, but unluckily, the harbour trended right in the wind, and at one o'clock the tide set so strongly against us, that we found it impossible to make the harbour, as we lost ground every board, on which we hove the main top-sail to the mast, in order to trade with the Indians.

A scene now commenced, which absolutely beggars all description, and with which we were so overjoyed, that we could scarcely believe the evidence of our senses. There were ten canoes about the ship, which contained, as nearly as I could estimate, 120 people; many of these brought most beautiful beaver cloaks; others excellent skins, and, in short, none came empty handed, and the rapidity with which they sold them, was a circumstance additionally pleasing; they fairly quarrelled with each other about which should sell his cloak first; and some actually threw their furs on board, if nobody was at hand to receive them; but we took particular care to let none go from the vessel unpaid. Toes were almost the only article we bartered with on this occasion, and indeed they were taken so very eagerly, that there was not the least occasion to offer any thing else. In less than half an hour we purchased near 300 beaver skins, of an excellent quality; a circumstance which greatly raised our spirits, and the more, as both the plenty of fine furs, and the avidity of the natives in parting with them, were convincing proofs, that no traffic whatever had recently been carried on near this place, and consequently we might expect a continuation of this plentiful commerce. That thou mayest form some idea of the cloaks we purchased here, I shall just observe, that they generally contain three good sea otter skins, one of which is cut in two pieces, afterwards they are neatly sewed together, so as to form a square, and are loosely tied about the shoulders with small leather strings fastened on each side.

At three o'clock, our trade being intirely over, and the wind still against us, we made sail, and stood out of the bay, intending to try again for the harbour in the morning. At eight o'clock the points of the bay we had lately left, bore from North 19 deg. East to East, about three leagues distant. During the night we stretched to the Southward and Westward, plying as occasion required.

In the morning of the 3d, we had a fresh Easterly breeze, and squally weather, with rain; but as we approached the land, it grew calm; and at 10 o'clock, being not more than a mile distant from shore, the tide set us strongly on a rocky point to the Northward of the bay, on which the whale-boat and yawl were hoisted out and sent a-head, to tow the vessel of the rocks.

Several canoes came along-side, but we knew them to be our friends

whom we had traded with the day before, and found that they were stripped of every thing worth purchasing, which made us less anxious of getting into our proposed harbour, as there was a greater probability of our meeting with fresh supplies of furs to the Eastward. At three o'clock a fresh breeze springing up, we hoisted in the boats, and the weather turning hazy, we stretched to the South West, tacking occasionally during the night . . .

[On July 4, Dixon named Cloak Bay and then sailed south along the west coast of Graham Island for the next four days. On the fifth he traded with people in canoes alongside: brass pans, pewter basins, and tin kettles for good sea-otter cloaks. At 53°16' N he named Hippah Island, where the party encountered 34–36 people living in a very large hut on a small island, built like the New Zealand fortresses known as "hippahs."[7]]

In the forenoon of the 9th, we had five canoes along-side, containing about thirty-eight or forty people, from whom we purchased some very good cloaks, and a few good skins; they too were fond of variety, and did not fix on any particular article; but tin kettles and pewter basons seemed to have the preference to any thing we could shew them.

In one of the canoes was an old man, who appeared to have some authority over the rest, though he had nothing to dispose of: he gave us to understand, that in another part of these islands, (pointing to the Eastward) he could procure plenty of furs for us, on which Captain Dixon gave him a light horseman's cap: this present added greatly to his consequence, and procured him the envy of his companions in the other canoes, who beheld the cap with a longing eye, and seemed to wish it in their possession.

There were likewise a few women amongst them, who all seemed pretty well advanced in years; their under lips were distorted in the same manner as those of the women at Port Mulgrave, and Norfolk Sound, and the pieces of wood were particularly large. One of these lip-pieces appearing to be peculiarly ornamented, Captain Dixon wished to purchase it, and offered the old woman to whom it belonged a hatchet; but this she refused with contempt; toes, basons, and several other articles were afterwards shewn to her, and as constantly rejected. Our Captain began now to despair of making his wished-for purchase, and had nearly given it up, when one of our people happening to shew the old lady a few buttons, which looked remarkably bright, she eagerly embraced the offer, and was now altogether as ready to part with her wooden ornament, as before she was desirous of keeping it. This curious lip-piece measured three and seven-eighth inches long, and two and five-eighth inches in the widest part: it was inlaid with a small pearly shell, round which was a rim of copper.

These people were evidently a different tribe from that inhabiting Hippah Island, but appeared equally savage and fierce in their dispositions, and were well provided with offensive weapons; however, they traded very quietly, and did not give us the least disturbance. When the furs which they brought for barter were disposed of, they left us, and paddled in for the shore. Our observation at noon gave 52 deg. 54 min. North latitude; and the longitude by lunar observation was 132 deg. East, to North 42 deg. West; and our distance from shore about six miles.

In the afternoon, four canoes, containing about 32 people, came along-side, but they belonged to our morning visitants, and what cloaks they brought us were indifferent, being pretty much wore. By four o'clock the Indians, (having disposed of all their trade) left us, and made for the land.

During the night we had a strong breeze from the Westward, with constant rain, which continued till the forenoon of the 10th, when the wind grew light and variable, with thick hazy weather. Our observation at noon gave 52 deg. 48 min. North latitude. At six o'clock the extremes of the land bore from North East by North to North 75 deg. West; a small island North 22 deg. East, distant four leagues. In the night the wind again settled at North West, blowing a fresh breeze, the weather cloudy; we stood to the South West as usual . . .

Off Queen Charlotte's Islands, 12 July. (Beresford 1789: 198–209)

[After sailing around Cape St. James and trading with the people in that area, Dixon proceeded up the east side of the islands to near the opening of Skidegate Inlet.] The morning of the 29th [of July 1787] was moderate and cloudy; the wind being light and variable, we tacked occasionally, in order to stand well in with the shore, that no opportunity of trading might be lost. Towards noon the weather cleared up; our meridian observation gave 52 deg. 59 min. North latitude; so that we were near the middle of the island towards the Northward and Eastward. In this situation we saw high land to the NorthWest, near thirty leagues distant, and which evidently was the same we had seen on the 1st of July. This circumstance clearly proved, the land we had been coasting along for near a month, to be a group of islands.

Early in the afternoon we saw several canoes coming from shore, and by three o'clock we had no less than eighteen along-side, containing more than 200 people, chiefly men: this was not only the greatest concourse of traders we had seen, but what rendered the circumstance additionally pleasing, was the quantity of excellent furs they brought us, our trade now being equal, if not superior to that we met with in Cloak Bay, both in number of skins, and the facility with which the natives traded, so that all of us were busily employed, and our articles of traffic exhibited in the greatest variety; toes, hatchets, howels, tin kettles, pewter basons, brass pans, buckles, knives, rings, &c. being preferred by turns, according to the fancy of our numerous visitants.

Amongst these traders was the old Chief, whom we had seen on the other side these islands, and who now appearing to be a person of the first consequence, Captain Dixon permitted him to come on board. The moment he got on the quarter deck he began to tell a long story, the purport of which was, that he had lost in battle the cap which we had given him; and to convince us how true this story was, he shewed us several wounds he had received in defending his property; notwithstanding this, he begged for another cap, intimating at the same time, that he would never lose it but with his life. Our Captain, willing to gratify his ambition, made him a present of another cap, and we presently found it was not bestowed in vain, for he became extremely useful to us in our traffic; whenever any dispute or mistake arose in the unavoidable hurry occasioned by so great a number

of traders, they always referred the matter to him, and were constantly satisfied with his determination.

On our pointing to the Eastward, and asking the old man whether we should meet with any furs there, he gave us to understand, that it was a different nation from his, and that he did not even understand their language, but was always at war with them; that he had killed great numbers, and had many of their heads in his possession.

The old fellow seemed to take particular pleasure in relating these circumstances, and took uncommon pains to make us comprehend his meaning; he closed his relation with advising us not to come near that part of the coast, for that the inhabitants would certainly destroy us. I endeavoured to learn how they disposed of the bodies of their enemies who were slain in battle; and though I could not understand the Chief clearly enough positively to assert, that they are feasted on by the victors; yet there is too much reason to fear, that this horrid custom is practised on this part of the coast; the heads are always preserved, as standing trophies of victory.[8]

Of all the Indians we had seen, this Chief had the most savage aspect, and his whole appearance sufficiently marked him as a proper person to lead a tribe of cannibals. His stature was above the common size; his body spare and thin and though at first sight he appeared lank and emaciated, yet his step was bold and firm, and his limbs apparently strong and muscular; his eyes were large and gogling, and seemed ready to start out of their sockets; his forehead deeply wrinkled, not merely by age, but from a continual frown; all this, joined to a long visage, hollow cheeks, high elevated cheek bones, and a natural ferocity of temper, formed a countenance not easily beheld without some degree of emotion: however, he proved very useful in conducting our traffic with his people, and the intelligence he gave us, and the methods he took to make himself understood, shewed him to possess a strong natural capacity.

Besides the large quantity of furs we got from this party, (at least 350 skins) they brought several racoon cloaks, each cloak consisting of seven racoon skins, neatly sewed together; they had also a good quantity of oil in bladders of various sizes, from a pint to near a gallon, which we purchased for rings and buttons: this oil appeared to be of a most excellent kind for the lamp, was perfectly sweet, and chiefly collected from the fat of animals.

By seven o'clock we had entirely stripped our numerous traders of every saleable article, on which they left us, and paddled for the shore. The wind during the night being variable, we tacked occasionally, in order to keep as near the coast as was consistent with prudence.

Every person on board is greatly elated with our present charming prospects, but no one more so than thy assured friend. W.B.

Off Queen Charlotte's Islands, July 30th. (Beresford 1789: 216–219)

In the morning of the 30th July, we had a moderate breeze at South, the weather tolerably fine. Our latitude at noon was 52 deg. 30 min. North; the shore about four miles distant. In the afternoon we had eight canoes alongside, but they brought very few skins, and those of an inferior quality; at the same time giving us to understand, that their stock was nearly exhausted: they were part of the traders who had been with us the day before; some

of them had been on a fishing party, and caught a number of halibut, which proved a very seasonable supply, our fish having been expended some time.

Hitherto all the people we had met with at those islands, though evidently of a savage disposition, had behaved in a quiet orderly manner, but this evening they gave us a convincing proof of their mischievous disposition, and that in a manner which shewed a considerable degree of cunning.

The people who had got the halibut to sell, artfully prolonged their traffic more than was customary, and endeavoured by various methods, to engage our attention; in the mean time, several canoes paddled slily a-stern, and seeing some skins piled against one of the cabin windows, one of the Indians thrust his spear through it, in order to steal the furs, but perceiving the noise alarmed us, they paddled away with precipitation; however, to make them sensible that we were able to punish attempts of this sort, even at a distance, we fired several musquets after them, but did not perceive that they were attended with any fatal effects. (Beresford 1789: 220–221)

[August 1]

Towards the close of the day, a canoe with fourteen people came alongside, but they had scarcely any thing to sell; they gave us to understand, that one of their companions was dead of the wounds he received from our musquets; and at the same time endeavoured to make us sensible, that they were not at variance with us on that account: indeed they came alongside the vessel without the least fear, and it is probable that the design of their visit was to inform us of the above circumstance. (Beresford 1789: 222)

Dixon observed six houses while he was at Cloak Bay, but there is no mention in Beresford's letters of carved poles. It is uncertain exactly where these houses were, since the villages of *daa.adans* on North Island and *k'yuust'aa* and *yaak'u 'lanngee* (Yaku) on Graham Island would not have been visible from Cloak Bay unless Dixon sailed into Parry Passage. On a chart made in 1791 during the Marchand expedition, Captain Prosper Chanal marked four houses on the north shore of Graham Island that would have been visible from Cloak Bay (see map 2); it might have been these houses that Dixon noticed.

Though Beresford recorded no Haida names, he gave an interesting account of the old chief to whom they gave the light horseman's caps (fig. 2.3). They met him first on the west coast of Graham Island, somewhere near the villages of *ts'aa7ahl* and *qays7un* at the western opening of Skidegate Channel. He traveled easily by canoe through Skidegate Channel while the *Queen Charlotte* sailed south and around Cape St. James. When first encountered on the west side of the islands, he had no furs with him but indicated he could get them to the eastward. This suggests that perhaps his home was at Skidegate. Since he is described as a chief of the first consequence, he may indeed have been Chief Skidegate (*sriida giids*). Certain types of hats, such as crest hats and headdresses, are important signifiers of status on the Northwest Coast. The Pérez expedition had acquired several Haida hats, and José Martinez had given his own red hat to the "king" (probably *gannyaa*) in 1774 in exchange for his mountain-goat wool robe. Whether the Haida chief encountered by Dixon knew of *gannyaa*'s red Spanish hat is unknown, but it is clear that the English light horseman's caps were treasured as exotic status symbols.

Fig. 2.3. A Philadelphia Cavalry light horseman's cap, 1775. (Reproduced from Wilcox 1948: 171.)

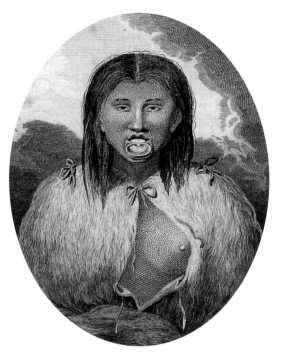

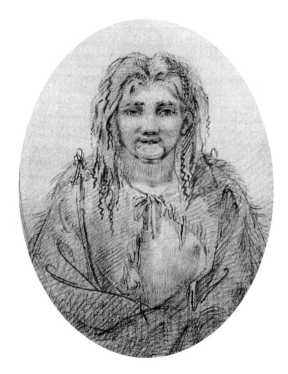

Fig. 2.4. Drawing by E. F. Burney of George Dixon's sketch of a Haida woman wearing a labret. Courtesy of the British Museum. (Reproduced from King 1981: plate 38.)

Fig. 2.5. Engraving made after Burney's drawing of Dixon's sketch of a Haida woman. Special Collections Division, University of Washington Libraries, neg. no. 3938. (Reproduced from Beresford 1789: opposite p. 226.)

The only Haida object Beresford mentioned as having been collected by Dixon was a large inlaid labret that he acquired from an old woman who accompanied the chief who received the light horseman's hat. Dixon sketched this woman wearing the labret; this is the earliest known portrait of a Haida woman. Sadly, Dixon's original sketch has not survived, but E. F. Burney made a drawing based on it (fig. 2.4), which was in turn copied for an engraving by A. Birell that was printed in the published version of Beresford's letters (Beresford 1789: facing p. 226) (fig. 2.5). It is interesting that in both the final engraving and the drawing by Burney the woman's fur robe is pulled aside rather unnaturally and her left breast is exposed. John F. Henry pointed out in his analysis of the engraving that "the bared breast was a device often used by engravers to differentiate the sexes" (1984: 81). He concluded that the woman probably would not have appeared to Dixon this way, judging from a later entry in Beresford's letters that describes the garments of a woman who came aboard the ship off the point

at Cape St. James: "She was neatly dressed after their fashion; her under garment, which was made of fine tanned leather, sat close to her body, and reached from her neck to the calf of her leg: her cloak or upper garment was rather coarser, and sat loose like a petticoat, and tied with leather strings" (Beresford 1789: 226).

Several other journal accounts confirm this style of dress for Haida women, with a tanned leather undergarment that completely covered the body. It is unfortunate that Dixon's original drawing did not survive, but it appears in Burney's drawing that there is a faint indication of this leather undergarment, with a narrow slit opening at the neck, that was eliminated in the final engraving.

The labret collected by Dixon, which was given to Sir Joseph Banks, was in the British Museum at least through the mid-nineteenth century but is now missing (King 1981: 61, plate 37). Another plate published with Beresford's letters shows a close-up of the labret as well as a sheep-horn ladle with the head of a raven carved on the handle (Beresford 1789: facing p. 208). Though not mentioned in the account, this ladle (fig. 2.6) was probably acquired during this sequence of exchanges along with a carved wooden grease dish in the form of a human figure (fig. 2.7). Both the ladle and the bowl have survived in the British Museum. Also sometime during this voyage, Dixon collected a specimen of the now extinct native tobacco plant, the only plant cultivated on the Northwest Coast before white contact. It is now one of only two samples of this plant that have survived. The other was acquired by Archibald Menzies, probably in the Queen Charlottes in August 1887.[9]

The first Americans to circumnavigate the globe, Captain Robert Gray on the *Columbia* and Captain John Kendrick on the *Lady Washington*, sailed from Boston in 1787. Gray did not make contact with the Haida until May 1789. The account of this visit, recorded by Robert Haswell, is significant in that it provides the first mention of the name Cuneah (*gannyaa*) and of his village, Custa (*k'yuust'aa*, or Kiusta).[10] The two captains switched ships after they arrived at Nootka Sound; Kendrick stayed there on the *Columbia* while Gray on the *Lady Washington* had his first encounter with Haidas on May 21, 1789, off the north coast of Graham Island. There he met an elderly man and two boys in a canoe, and he traded for several skins. He named the islands Washington's Islands after the American general, and it was by this name that most Americans thereafter referred to Haida Gwaii. He proceeded north to Bucareli Bay, where his ship went aground, and he later returned south.

Captain Gray's First Voyage, 1789

May 28th [off Cloak Bay]

[A]t 6 p.m. a vast number of Natives men Women and Children came off and brought with them several sea otter skins we understood of them that their was a large tribe not far off the weather was very thick hazey

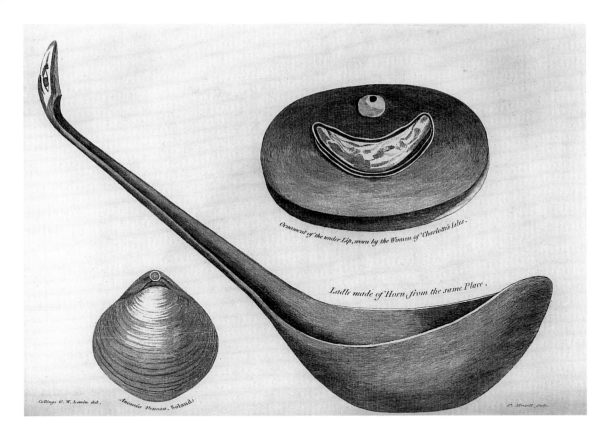

Ornament of the under Lip, worn by the Women of Charlotte's Isles.

Ladle made of Horn from the same Place.

Collings & W. Lewin del.

Anomia Venosa. Soland.

P. Mazell sculp.

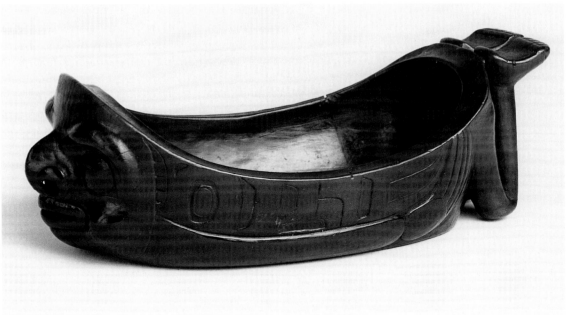

Fig. 2.7. Grease bowl collected by George Dixon, 1787, 25.4 cm long. Photograph courtesy of the British Museum, cat. no. NWC-25, neg. no. PS092065.

and we were but little distance from the land We soon saw their village from which they lanched twenty or thurty very large canoes and came off in great perade padleing off swiftly and singing a very agreable air. 1789. June. of those people were purchaced to the amount of two hundred skins in a very fue moments for one chizle each we bought all the skins they appeared to have by 10 in the evening when they returned to their Village for the night no doubt intending to bring off more in the morning but we did not stop but stood on to the southward the natives called their villag Custa it is situated in a sandy bay on the NW end of the Island their Chiefs name is Cuneah and appears to be a very good old Fellow his wife was off and had vast authority over every person alongside I was greved to leve them so soon, as it appeared to be the best place for skins that we had seen. (Howay 1990: 95–96)

Gray then sailed south to the village of *sran gwaay* (Ninstints), where on June 11 he traded with a man named Coya. Clothing was in more demand than iron. He learned from a written note shown to him that James Colnett of the *Prince of Wales* and Charles Duncan of the *Princess Royal* had been there May 24 (Howay 1990: 97–98).

Though *gannyaa*'s wife's name is not recorded, Haswell's description of her command of the fur-trading scene is the first of many similar accounts that were to follow. Only a few days after Gray's visit, Captain William Douglas on the *Iphigenia* came to North Island after having traded for several days at Haines Cove near Kaigani (*k'áyk'aanii*). According to John Meares's account of this visit (Meares 1967 [1790]), Douglas had been there on a previous voyage. Again *gannyaa* is described by name, though curiously, Meares added the prefix "Blakow" before Coneehaw. No other account uses the name Blakow for *gannyaa,* and its origin is unknown. It is significant that although contact with Europeans had been made fifteen years earlier, this encounter with Captain Douglas was the one recalled by both *gannyaa* himself and later by Albert Edward Edenshaw as the Haida's first contact with Europeans (see Burling's journal of the *Eliza,* below). Perhaps this occasion was remembered as the most important because it was marked by the exchange of names between Captain Douglas and *gannyaa,* after which *gannyaa* frequently referred to himself as Douglas *gannyaa.* It may also qualify as the first actual visit, in that it may have been the first occasion on which sailors actually set foot on Haida land. In any case, Meares's is the first recorded account of such a landing. Also for the first time in this account we are given the name Tartanee or Tatanee for the village of *daa.adans* (Dadens), as well as the first written description of totem poles.

Captain Douglas's Naming

Saturday, June 20, 1789

At five o'clock they dropped the bower anchor in twenty-five fathoms water, about four miles from the shore, and two from a small barren, rocky island, which happened to prove the residence of a chief, named Blakow-Coneehaw, whom Captain Douglas had seen on the coast in his last voyage. He came immediately on board, and welcomed the arrival of the ship with a song, to which two hundred of his people formed a chorus of the most

pleasing melody. When the voices ceased, he paid Captain Douglas the compliment of exchanging names with him, after the manner of the chiefs of the Sandwich Islands.

Sunday, June 21, 1789

At seven in the morning they stood up the inlet, and at nine came to in eighteen fathoms water, when they moored the ship with the stream-anchor. Through this channel, which is formed by Charlotte's Islands, and an island that lies off the West end of it, the tide was found to run very rapid. The passage takes its course East and West, about ten or twelve miles, and forms a communication with the open sea. It was now named Cox's Channel. Very soon after the ship was moored, the long-boat was sent to sound in the mid-channel, but no soundings could be obtained with eighty fathoms of line; but near the rocks, on the starboard shore, they had twenty and thirty fathoms water.

Having been visited the preceding night by two canoes, which lay on their paddles, and dropped down with the tide, as was supposed, in expectation of finding us all asleep, they were desired to keep off, and finding themselves discovered they made hastily for the shore. As no orders had been given to fire at any boat, however suspicious its appearance might be, these people were suffered to retreat without being interrupted. This night, however, there happened to be several women on board, and they gave Captain Douglas to understand, that if he or his crew should fall asleep, all their heads would be cut off, as a plan had been formed by a considerable number of the natives, as soon as the lights were out, to make an attempt upon the ship. The gunner therefore received his instructions, in consequence of this information, and soon after the lights were extinguished, on seeing a canoe coming out from among the rocks, he gave the alarm, and fired a gun over her, which was accompanied by the discharge of several muskets, which drove her back again with the utmost precipation [sic].

Monday, June 22

In the morning the old chief, Blakow Coneehaw, made a long speech from the beach; and the long-boat going on shore for wood, there were upwards of forty men issued from behind a rock, and held up a thimble and some other trifling things, which they had stolen from the ship; but when they found that the party did not intend to molest them, they gave a very ready and active assistance in cutting wood, and bringing the water-casks down to the boat. Some time after the chief came on board, arrayed, as may be supposed, in a fashion of extraordinary ceremony, having four skins of the ermine hanging from each ear, and one from his nose; when, after Captain Douglas had explained to him the reason of their firing the preceding night, he first made a long speech to his own people, and then assured him that the attempt which had been made, was by some of the tribe who inhabited the opposite shore [probably *daa.adans*]; and entreated, if they should repeat their nocturnal visit, that they might be killed as they deserved. He added, that he had left his house, in order to live along-side the ship, for the purpose of its protection, and that he himself had commanded the women

to give that information which they had communicated. This old man exercised the most friendly services in his power to Captain Douglas, and possessed a degree of authority over his tribe, very superior to that of any other chief whom they had seen on the Coast of America.

In the afternoon Captain Douglas took the long-boat and ran across the channel, to an island which lay between the ship and the village of Tatanee [*daa.adans*], and invited the chief to be of the party; who, having seen him pull up the wild parsley and eat it, he was so attentive as to order a large quantity of it, with some salmon, to be sent on board every morning.

Tuesday, June 23, 1789

At six o'clock in the morning of the 23rd, finding the ground to be bad, they ran across the channel to a small harbour, which is named Beal's Harbour, on the Tartanee side; and at ten dropped anchor in nineteen fathoms water, about half a cable's length from the shore; the land locked all round, and the great wooden images of Tartanee bore East, one quarter North; the village on the opposite shore bearing South half West. This harbour is in the latitude of 54° 18' North, and longitude 277° 6' east. It was high water there at the change, twenty minutes past midnight; and the tide flows from the Westward, sixteen feet perpendicular. The night tides were higher, by two feet, than those of the day.

The three following days were employed in purchasing skins, and preparing to depart; but as all the stock of iron was expended they were under the necessity of cutting up the hatch-bars and chain plates.

Saturday, June 27

On the morning of the 27th, as soon as the chief returned, who had gone on shore the preceding evening, to get a fresh supply of provisions, Captain Douglas gave orders to unmoor, and a breeze springing up, at half past nine they got under way, and steered through Cox's channel, with several canoes in tow. At eleven, having got out of the strength of the tide, which run very rappid, they hove to, and a brisk trade commenced with the natives, who bartered their skins for coats, jackets, trowsers, pots, kettles, frying-pans, wash-hand basons, and whatever articles of a similar nature could be procured, either from the officers or the men; but they refused to take any more of the chain-plates, as the iron of which they were made proved so brittle that it broke in their manufacturing of it. The loss of the iron and other articles of trade, which had been taken out of the ship by the Spaniards,[11] was now very severely felt, as the natives carried back no small quantity of furs, which Captain Douglas had not the means of purchasing.

This tribe is very numerous; and the village of Tartanee stands on a very fine spot of ground, round which was some appearance of cultivation; and in one place in particular it was evident that seed had been lately sown. In all probability Captain Gray, in the sloop Washington, had fallen in with this tribe, and employed his considerate friendship in forming this garden; but this is mere matter of conjecture, as the real fact could not be learned from the natives. From the same benevolent spirit Captain Douglas himself planted some beans, and gave the natives a quantity for the same useful

purpose; and there is little doubt but that excellent and wholesome vegetable, at this time, forms an article of luxury in the village of Tatanee. This people, indeed, were so fond of the cookery practised on board the Iphigenia, that they very frequently refused to traffic with their skins, till they had been taken down to the cabin, and regaled with a previous entertainment.

The weather had been so thick and hazy, since they had quitted Nootka sound, that it was impossible to get a sight of the moon or stars for the purpose of making an observation; Captain Douglas, therefore, was under the necessity of reducing the longitude of the different places which he visited, from the observations he had made during his voyage of the preceding year. (Meares 1967 [1790]: 365–369)

Curiously, Meares described *gannyaa* as living on a small, barren, rocky island, which does not fit the description of *k'yuust'aa*. George MacDonald concluded that this was Lucy Island, the only island in Parry Passage large enough for a habitation (MacDonald 1983: 187). Because Meares's journal goes on to indicate that *gannyaa* "had left his house, in order to live along-side the ship" for their protection, it appears that *gannyaa* may have taken up temporary residence at the fortress on the west end of Lucy Island in order to be near the ship, which anchored nearby. Captain Joseph Ingraham and Captain Chanal both later described this fortress in detail (see below). Although Meares speculated that the crops observed might have been beans left by Captain Gray, his visit had occurred only a few days before, and there is no record of his having gone ashore. The cultivated crops Meares saw at *daa.adans* might in fact have been the native tobacco plant, which the Haida people are known to have cultivated before white contact. Newly introduced crops, such as the beans left by Captain Douglas, and also potatoes, became important cash crops for the Haida, who raised them in large numbers for sale at Fort Simpson on the mainland.[12]

In 1791, John Bartlett on the *Gustavus* visited North Island and provided us with the first sketch of a house and frontal pole, as well as a written description of the house and frontal pole that Meares had earlier described as "great wooden images." Bartlett made two visits to Cloak Bay in 1791 and went ashore on both occasions, once in late April to gather wood and a second time in July to see the house with the frontal pole that he then sketched (fig. 2.8). It is unclear from his journal exactly where this house was located, but it conforms to the description of a house in the village of *daa.adans* recorded by Ingraham in the same year.

John Bartlett's Drawing, 1791

On April 24th, the weather became more moderate and we stood for land and the next day saw land and ran close in and came to anchor in twelve fathoms of water with a hawser run out on each quarter and made fast to the limbs of trees ashore. The place was called Cloak Bay and their chief's name was Connehow. The natives came off with plenty of large halibut and other fish. The carpenter's mate, Charles Treadwell and I went ashore to cut wood and the natives behaved very civil while we were at work. There were thirty to forty there at a time, the most of whom were women who kept up

a continual singing. The ship while here was surrounded by two or three hundred canoes at a time with plenty of furs. The chief trade was iron, buttons and old clothes.

The next day, April the 26th, while trading with the natives on the quarter deck, a large canoe came alongside having on board a great number of spears and bows and arrows. The men began to flock on board in great numbers and at the same time we noticed that they were sending their women ashore which seemed to show a bad design. They also were seen to put on their shields and hand up their targets and pass their knives from one to the other on the quarter deck there being about one hundred and fifty of the natives there at the time. Seeing this we manned our tops and blunderbusses and the remainder of our men with small arms. Charles and I were on shore at the time of the fray with the natives on board. The women surrounded us on shore singing their war song. We both took up our pistols, resolved to sell our lives as dearly as possible if they molested us. Soon the noise on board began to abate and the natives would not trade any more unless we would disarm our men. We did so as all was quiet. Their armed canoes went away and trade went on brisker than ever.

The next day the natives began to come in large numbers from all parts of the islands and the captain began to grow dubious of the appearance of things and at ten o'clock cast off at the stern and hove up the anchor to go out but we were prevented by a variable wind in the passage. Trade went on faster than ever when the natives saw that we intended to go out. There were about six hundred canoes alongside at the time. We bought about four hundred skins in this bay. The next morning we got under way bound southward with a great many canoes following us. (Snow 1925: 299–300)

[From here, Bartlett sailed around the southern tip of Haida Gwaii and up the eastern shore, recording the names of three chiefs with whom his party traded: Clutiver (Clue, the chief of Tanu), Comeeshier (Comshewa), who, with his son, remained on board all night, and Skoitscut (Skidegate). He then sailed north to Tlingit country before returning to Haida Gwaii in late June.]

June 23rd

The next day we got under way and directed our course for Queen Charlotte's Islands, bound for Cloak Bay, and two days later came to in 19 fathoms of water and ran a hawser ashore from each quarter and made fast to the limbs of trees to steady the ship. There were few natives here in comparison with the number here when we left it before. Most of them wore red jackets and we knew by this that Captain Douglass had been here. We did not get a single skin here.

Connehaw, their chief, came on board and informed us that most of his tribe had left their winter quarters and distributed themselves among the islands for the summer. They return to their winter houses about the end of August. The natives at this place use no bread nor do they at any other part of the coast. The most of their living is fish which they cook in baskets by first digging holes in the sand and making the sand hot; then setting the basket in it and feeding it with hot stones until the fish is boiled enough. We went ashore where one of their winter houses stood. The entrance was cut

Fig. 2.8. John Bartlett's drawing of a house on North Island (*daa.adans*), 1791. Courtesy of the Peabody Essex Museum, neg. no. A4956.

out of a large tree and carved all the way up and down. The door was made like a man's head and the passage into the house was between his teeth and was built before they knew the use of iron. Our people were very uneasy and wished to proceed homewards on account of provisions being very short; bread in particular. (Snow 1925: 306)

The year 1791 was a busy one in the fur trade on the Northwest Coast, and Cloak Bay by then had almost become a congested trading center. Joseph Ingraham, who had been second mate on the *Columbia* from 1787 to 1790, became captain of the *Hope* in 1791. His journal at Cloak Bay provides a further description of the village and poles at *daa.adans*. In July 1791, two high-ranking chiefs were in residence there, Cow (*gu.uu*) and Goi, with whom Ingraham became friendly.[13] A third, unnamed chief may have been *yaahl dàajee* (Yeltadzie), since *gannyaa* was said to be away at Kaigani at this time.

Ingraham's Journal

July 10, 1791

Shortly after, another canoe came off in which were seven men, one among them being a chief [*yaahl dàajee?*]. He pointed to the place we had seen in the morning (and of which I made mention as having the appearance of a good harbor) saying there was nuck'y quan — plenty of skins — for which he would trade with us. At the same time he offered to remain on board till we got in. A breeze springing up favorable for the purpose, I accepted this offer. Hence he obtained the name of Pilot from us. The canoe which the women came off in returned to the place they came from taking the canoe the men came off in too. Neither of these canoes had any furs. The women seemed those of the very lowest class; they had nothing for sale but some

stinking fish. The men brought off several fine halibut which we bought as many as we had occasion for, but previous to their coming off we caught several fine red fish. Before we got into the harbor, another canoe came off in which was a chief whose name was Cow [*gu.uu*]. He was usually chief at Meares Bay [Kaigani] and was known to two of the men whom I took from the Sandwich Islands who had been on the coast with Captain Douglas.

At eight o'clock we moored in a fine cove with two small anchors and two fasts to the shore. After that we rewarded Pilot and discharged him. Several canoes came alongside, but we saw only two skins and a few tails among them all. Two of the latter we bought but could not purchase the skins as they asked for them a most exorbitant price. I showed Cow the articles we had for trade which upon the whole he did not seem much enamoured with, saying they had plenty of such things which they had got from Captains Douglas, Barnett, etc. who had been there before us and purchased all the skins. This was unpleasant news and seemed to indicate we were the day after the fair. My only hopes seemed to rest on wintering here and improving the first of the following season to the best advantage; however, this season was terminated more favorably than I expected, as will appear in the sequel. Cow informed me if I would wait ten days he would go and fetch some skins, but this I refused. Then he lowered it to five and finally one, which of course I agreed to as necessity obliged me to stay longer than his last proposal. Many of the natives had on blue jackets and trowsers which from their appearance it was evident they had possessed but a short time; these they informed me they got from Captain Douglas.

After the vessel was fast, I went in the boat accompanied by Cow to view two pillars which were situated in the front of a village about a quarter of a mile distant from our vessel on the north shore. They were about forty feet in height, carved in a very curious manner indeed, representing men, toads, etc., the whole of which I thought did great credit to the natural genius of these people. In one of the houses of this village the door was through the mouth of one of the before mentioned images. In another was a large square pit with seats all round it sufficient to contain a great number of people, built in such a manner as not to obstruct each other's sight. It seemed intended for some exhibition, perhaps dancing or boxing.

There were but few people living at this village at present. Cow informed me it was the usual residence of many more who were absent with Cunneyah at the time. I did not examine everything I saw as particularly as my curiosity prompted me to, as it was near dark and I made a point never to trust boats away from the vessel after sunset among savages, whatever might be the terms we were upon, which were as far as we saw at present those of the firmest friendship with these people. Yet it would be doing wrong to trust to these appearances, as will appear by a circumstance I shall have occasion to mention in some of the following pages, where some of our countrymen fell victims to their credulity on the mask of friendship worn by these people.

11 July

In the afternoon the wind became more moderate and the weather pleasant. Several canoes came alongside from whom we purchased about twenty tolerable skins but at so high a price that I stopped for the present. While

we were trading, one of the natives offended another by some means on which the one who thought himself injured threw a spear at his antagonist who in fending it off with his hand threw it against his friend who sat in a canoe beside him. It struck him in the head and cut him considerably. The wounded man lay with his head between his knees a few moments. Then he started up suddenly and paddled towards the spear which had been thrown at him and which lay floating at a little distance from his canoe. On this a general confusion ensued, and the canoes divided into two parties, both men and women seizing their knives and lashing them fast with a string about their wrists. Some of them were provided with spears. They scolded at times with great vociferation at each other and made use of threatening gestures. It was soon dropped by all except the two who began it. They seemed frequently to challenge each other pointing to the shore, but these challenges not being accepted on either side it finally ended without any further mischief. When it began, I hoisted the boarding nettings on which they all called out waa'com, waa'com — terms of friendship.

Cow, the chief before mentioned, was on board and had continued with us since our arrival. He observed to me it was near dark and desired I would fire a gun so the canoes would depart, which I did, and they soon left to go away. As they were going off, a man in one of the canoes called out to me that I had best go away for Douglas had bought all the skins and that my remaining would be to no purpose. However, Cow contradicted this man and urged me to remain, assuring me I should get skins. This I adhered to for the present and did not after repent.

12 July

In the morning I had the forge set up and set the smith to work to make iron collars of three iron rods twisted together about the size of a man's finger. These I had made from a pattern I saw on a woman's neck alongside. When finished they weighed from five to seven pounds and would purchase three of their best skins in preference to anything we had on board. Likewise heavy iron rings or bracelets for the wrist were preferred before our polished copper ones so much esteemed by the ladies of Nootka Sound.

Hitherto we made but little progress in the purchase of furs, but I yet rested patient on the promises of our friend Cow. In the meantime, our situation was not ineligible, as we were daily supplied with good fresh halibut, cod, and salmon at a very moderate price. Cow continued on board and was very serviceable to us on many occasions.

13 July

Towards night a large war canoe was seen coming into the cove. While they were at a distance, Cow said they were of his tribe and had plenty of skins, but on a nearer approach he said they were pushack — bad.[14] However, as I observed they were well stocked with skins and Cow could assign no reason for their being bad except they were not of his tribe, I invited an old man whom they termed their chief on board and showed him our articles of trade. As it rained and was near dark, he said he would defer trading till the next day which I agreed to, and they hauled their canoe up in the cove and took their station for the night. They were well prepared to defend them-

selves in case Cow's tribe should attack them as every man was provided with a spear and a dagger. The former was fastened to a pole about twenty feet long. Both spears and daggers were perfectly bright and sharp as razors. These people, no doubt like those to the southward on the mainland, live constantly in fear of each other, depending on their arms and warlike agilities [*sic*] for their safety from day to day.

Previous to the coming of the canoe I went with Cow in our boat to examine their fort or place of defense when attacked by any of the neighboring tribes. It resembled the New Zealand hippahs as far as I could judge from the various descriptions I had read of them. This was situated on a rock of considerable height, accessible only on one side which is secured by palisades, and divided into different retreats. If the enemy should get within the first gate of the palisades, they have yet to carry two more — and these worse than the first, as their antagonists will be full thirty feet above their heads where the rock is inaccessible. They have large beams, one end of which rests on the tops of high trees, the other on the summit of the rock, on which they have boards placed transversely so as to form a large stage from which they could attack their besiegers with stones or arrows to great advantage. The top of this was flat and occupied by the frames of a number of houses and some very broad boards painted in a curious manner. No doubt in time of war their whole tribe takes up their residence on this rock, but there is no water in it. How they manage to supply themselves with this necessary article I cannot say, and my slender knowledge of their language prevented many enquiries I wished to make.

Returning on board, we stopped to examine another rock of curious form. At one view it appears exactly like the hull of a vessel, from which our sailors called it the Old Sloop. On the top of this rock, although it is not more than fifty feet in diameter, are a number of trees and bushes which shade the remains of several chiefs or those of their families. At low tide it is inaccessible without a ladder or some such contrivance, but the tide being up, one of our seamen gained the summit by the help of some branches of trees which projected over the edge of the rock. After being up we threw him a rope by which I got on top. I found on it two houses of oblong square form, the top slanting to shed rain. Each of these houses was full of boxes containing the remains of the dead. The boxes were made in the neatest manner, carved and decorated with sea otter teeth. I wished much to examine the inside of one of the boxes but did not as Cow begged we would not and I did not wish to hurt his feelings. Before one of the houses were four images resembling the human form and otherwise curiously carved. Should any more of the royal family die soon, they must find some new repository or dislodge some of this to give place, for it will not admit of any more. However, near the village I saw a box lodged on two pillars about ten feet high which I was told contained one of the chief's family. Having satisfied my curiosity, I returned on board.

14 July

In the morning the war canoe before spoken of came on board. It was some time ere we could agree on a price, but when this was settled it was not long before we had all their skins. As they took off their fur garments,

they dressed themselves in blue jackets and trowsers obtained for them. The old chief seeing one of the iron collars stopped trading and would take nothing else. As we had none made, he waited till one was made for which he gave his last three skins. It was fortunate he saw none of them before as it required much time and trouble to make one. During the time we were trading with these people Cow frequently urged me to take their skins from them by force and drive them away, but this I did not attend to as they traded fair and behaved very well.

17 July

In the morning when enquiring about breakfast we missed our cook, a Negro man whom I took from the Island of St. Jagos to prevent his being starved. After calling for him in all parts of the vessel I was apprehensive he had fallen overboard in the night and been drowned. Yet this I could not reconcile to myself as I knew he was an excellent swimmer and we did not lie about 200 yards from the shore. While we were in this state of suspense, an Indian observed our anxiety and said Nicholas was on shore. I was at first undetermined whether to use rash means to recover him or endeavor to get him by promise of reward. However, the latter finally pre-ponderated for many reasons, the principal of which was I had not bought all their skins and by a quarrel with them, detaining their chief, etc. would no doubt put an end to all traffic for the present, if not the ensuing year as well, which I depended much on. I had every reason to believe Cow was not privy to his elopement as the chief was at his house on the opposite shore when the cook left us. Therefore, I promised Cow if he would bring him on board I would make him and Goi, his friend who was to accompany him, a handsome present.

On that they both set off in a canoe to a village on the south shore, and in about an hour they returned with the deserter. I rewarded them for their trouble, likewise the cook for the trouble he had given me. This fellow was one of the most restless beings I ever knew, for although I took him first on board to prevent his being starved and he had always been well treated, which he acknowledged, yet at every place we had stopped he was fain to leave us. The loss of him would have been of but little consequence to me as with the men I got at the Sandwich Islands I had more than my comple-ment, yet if I had suffered him to remain, although attended with no imme-diate ill consequence to me, I considered he would be a general disservice to all trading vessels. He might instruct these people in the use of arms, telling them the strength of small vessels, etc. which might render them very trouble-some and occasion much mischief, which no doubt the natives would feel the fatal effects of sooner or later. Be this as it may, I pursued the means I thought most eligible to my present and future success as well as to ensure a good reception to those who may visit the port hereafter.

19 July

Having by every appearance bought all the skins this tribe possessed, which Cow assured me was the case, I determined to put to sea on the first fair wind. Accordingly on the morning of the 19th with a moderate breeze at S.W. we weighed anchor, slipped our howser and long warp which we had

fast to the western shore, and made sail, leaving a boat with four hands to bring the howsers and warp after us. We sailed out of the eastern passage, and after being clear of danger we brought to and waited for our boat which joined us at half past eleven o'clock, and we hoisted her in. Cow accompanied us out, which was a proposal of his own several days prior to our sailing, saying he would go with us to Meares Bay, which he called Kieunnee [Kaigani], and that after remaining there a little while we should get plenty of skins. But he now changed his mind and returned in one of the canoes. While we lay waiting for our boat, several canoes came alongside. As some of them had skins, we added a little to our stock.

After Cow changed his mind about accompanying us to Meares Bay, I likewise concluded to alter my original intention of going to the northward and decided to cruise on the eastern part of these islands. The men I took from the Sandwich Islands, who had been here with Captain Douglas, informed me they got a great number of skins there. In the harbor we left we had procured about 300 skins, which was doing much better than I expected when we first anchored. As I intend giving a general description of the harbors we have visited on this coast with directions for sailing in and out of them, I shall reserve my observations relative to the port we have left until that time.

Having taken our leave of Cow, we made sail to the S.E. (It will be no more than justice due to this chief to remember that during our stay in this port he behaved at all times in such a manner as to deserve great commendations, being of infinite service to us both in trading and in preserving peace and good order among his countrymen.) (Kaplanoff 1971: 101–111)

Captain Ingraham's journal offers the first indication that there were in fact two forty-foot-tall carved poles in front of the village of *daa.adans,* not just the one that Bartlett drew and described. Only one of these is specifically described as a house frontal pole with the doorway through the base. It is unclear how the second pole was situated, or whether it was a house frontal pole, too, or a free-standing pole. A second house, however, is described as having an excavated interior with retaining planks (*daa.a*), a type of house known to have had great status. In this account, Ingraham has also given us a detailed description of the fortress on Lucy Island, mentioning several houses with broad painted boards. This was probably where *gannyaa* had stayed during Douglas's visit. These houses were later described more fully in the journals of the Marchand expedition. Ingraham's is also the first description of the burial houses with four free-standing memorial figures on what is probably "Flower Pot" Island, and of a double mortuary near the village of *daa.adans.*

From here Captain Ingraham went to Virago Sound but saw no people in residence. He then sailed east around Rose Spit and to the south, where he saw the *Columbia* with Captain Gray, Haswell, and John Hoskins, supercargo on the *Columbia.* He recorded the names of several Haida men with whom he traded on that trip: Ucah (at *suu qaahlii,* Skincuttle Inlet), Koyah (*xuyaa*) and Kanskeeni (at Juan Pérez Sound), Kliew (*xyuu* at *t'anuu*), and Cummashawaa (*hlqin7ul,* Cumshewa), Skutkiss (*sriida giids,* Skidegate), and Skatzi (*srats'i?*) at Cumshewa's village. He drew charts of both Cumshewa's harbour and Port Ucah

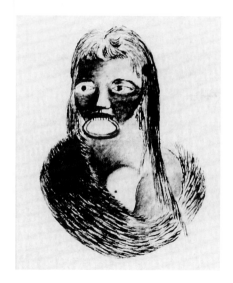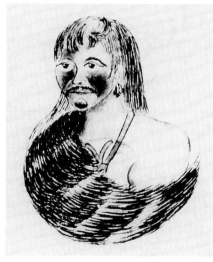

Fig. 2.9. Joseph Ingraham's drawings of a Haida woman and man, 1791. Courtesy of the Special Collections Division, University of Washington Libraries. Photograph in the John F. Henry Collection, Burke Museum. (Reproduced from Kaplanoff 1971: 96.)

(Kaplanoff 1971: 111–124).[15] Ingraham also drew, rather crudely, two portraits of "Natives of Washington's Isles," becoming the second fur trader to record the appearance of the Haida people. He sketched a man wearing a dagger in a sheath around his neck and a woman with a large labret (fig. 2.9). Ingraham reported that Koyah (*xuyaa*) and a chief named Kilkinants had joined forces and gone to attack Skidegate. This is the first mention of the name Kilkinants (*skil kingaans?*), who may have been a relative of Simeon *sdiihldaa* (see chapter 5; Kaplanoff 1971: 145). Further evidence that Kilkinants was an ally of *xuyaa*'s is found later in Ingraham's journal.[16]

A month after Ingraham's visit, on August 23, 1791, Captain Étienne Marchand arrived on the *Solide*, the first French vessel to visit *daa.adans*. Charles Pierre Claret de Fleurieu published an account of the Marchand expedition, combining information from the journals of two of its officers, Captain Chanal and Surgeon Roblet (Fleurieu 1801). As the *Solide* stood off at the opening of the bay, four men — Chanal, Roblet, Lieutenant Murat, and Volunteer Décany — set out in a small boat to explore. Chanal drew a chart of the area and took soundings of Cox's Channel (map 2). The men also explored the fortress on Lucy Island, which by then had become the standard tourist stop for the Haida guides.

Marchand's Visit, August 1791

While the boat was employed in the morning in taking the soundings of Cloak Bay, she had been accosted by three canoes containing about thirty Americans [Haidas], men, women, and children, who had come from the northern coast of the great island, on which were distinguished some habitations. These islanders were without arms, and announced peaceable dispositions; but they offered nothing to barter but some fresh fish and a few old skins. On recollecting the plentiful harvest which Captain Dixon, in the space of half an hour, had made off this very Cloak Bay, our voyagers had hoped, if not for equal success, at least for an indemnification for the

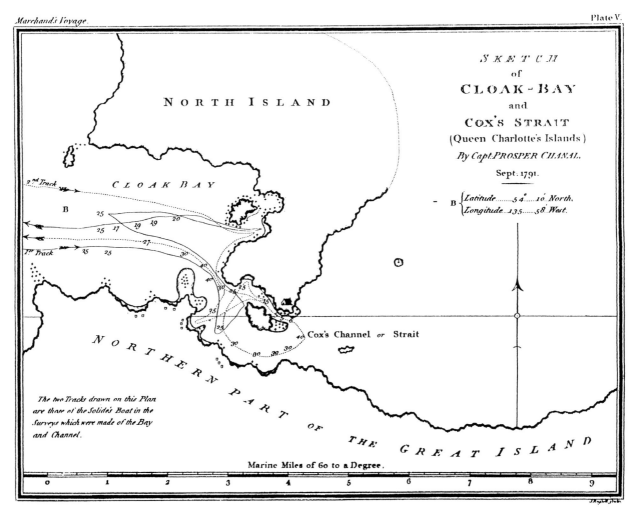

Map 2. Captain Prosper Chanal's 1791 chart
of Cloak Bay, North Island, and Cox's Channel.
(Reproduced from Fleurieu 1801, plate 5.)

time which had been employed in examining it; but every hope vanished, when the natives gave them to understand that a vessel, which had visited their coast very recently, had obtained all the furs that they possessed.

In the afternoon, at the moment when Captain Chanal was setting out from Cox's Channel to re-enter Cloak Bay, the boat was joined by other canoes; their arrival revived the hope that, if a few inhabitants were collected, he might be able to procure some furs from them. He therefore determined to turn back, and land on the west point of that island [Lucy Island], two thirds of a mile long by one third broad, which divides into two arms Cox's Channel or Strait.

On this small island, Captain Chanal perceived some palisades which appeared to be the work of Europeans; and he had the curiosity to examine them closely. He found that they form the enclosure of a platform of moderate elevation, resting on one side against a rock, and supported at certain distances by stakes, rafters, and other pieces of wood forming the frame of a building well put together and well contrived: he ascended it by a staircase made out of the trunk of a tree. On examination, he judged this monument, with every thing that belongs to it, to be the produce of the arts of the West part of North America: the wood bore the impression of time and age; and this evidence against which no objection can be made, did not allow it to be supposed that the construction was modern, or the work of Europeans who might have anchored in the bay. He here remarked several boxes without a lid, the use of which the islanders explained: these perform the office of a drum from which they draw a sound, by striking with the fist against the outer sides. But what particularly attracted the attention of the French, and well deserved to fix it, were two pictures each of which eight or nine feet long, by five high, was composed only of two planks put together. On one of these pictures is seen represented, in colours rather lively, red, black, and green, the different parts of the human body, painted separately; the whole surface is covered with them. The latter picture appears to be a copy of the former, or perhaps it is the original: it is difficult to decide to which of the two belongs the priority, so much are the features of both effaced by age. The natives gave Captain Chanal to understand that these pictures are called Caniak in their language; and this is all that he could get from them. They remind us of those paintings, those large pictures of Mexico the descriptions and drawings of which the Spanish historians have transmitted to us: and the tribes that inhabit the islands which, at this moment, engage our attention, might very probably not have been, at all times, as great strangers to the Mexicans as they may have become since the destruction of the empire.

From the examination which was made of the fort of redoubt where are deposited these two monuments of an ancient date, it was not supposed, although it appeared very susceptible of being defended against an enemy who might wish to attack it, that the object of the islanders has been to secure there for themselves a retreat, a place of refuge in case of attack; Captain Chanal judged, from some information which he was able to obtain from them, and which he thought he understood, that it was rather a place consecrated to religious ceremonies, or public diversions, or perhaps to both uses.

The islanders withdrew about three o'clock in the afternoon, after having exchanged the few furs which they possessed, consisting of five otter skins, some of cub otters, some old otter cloaks, and one only of beaver. The French might also have procured two fine skins; but the proprietor required, in exchange, woollen jackets and blankets, and none of those articles had been put into the boat. The Americans, before they withdrew, had given them to understand, pointing to the eastern part of the north coast of the large island, that, if their visiters would stop a few days, they would go and hunt in that quarter, and thence bring back a great quantity of furs.

In the course of the day, Captain Chanal had had a communication with seven or eight canoes, which might carry in the whole sixty individuals of all ages and of both sexes; but, to judge from the number of huts which he distinguished on the boarders of the channel, he reckoned that he had seen but a small part of its inhabitants. (Fleurieu 1801: 264–267)

Chanal then tried to meet up with the *Solide,* but the ship was too far away, and he was unable to overtake her before it grew too dark to see. The four took shelter on the beach behind a small island in the northeast of Cloak Bay (indicated on map 2). This is the first documented overnight stay by European visitors on Haida land. The next day the *Solide* returned to the bay, and the four were able to board. The longboat was then equipped with enough supplies for three days, and nine men went aboard, including the original four, and they again spent the night on shore behind the small island. On August 25, finding that most of the natives had gone off hunting, they passed the time by exploring the area further in the area of a small cove on the southern coast of North Island (Henslung Cove?).

Waiting for their return, Captain Chanal and his party availed themselves of the good will of a chief of the district, who had offered to accompany them, and they employed the time in visiting two habitations, situated on this part of the coast, and built on a plan nearly uniform. In describing them, I shall blend the separate descriptions given by Captain Chanal and Surgeon Roblet, and form of them but one; they are the same in the main, and differ only by some details which are met with in the one, and are not to be found in the other.

The form of these habitations is that of a regular parallelogram, from forty to fifty feet in front by thirty-five in depth. Six, eight, or ten trees, cut and planted in the ground on each front, form the enclosure of a habitation, and are fastened to each other, by planks ten inches in width by three or four in thickness, which are solidly joined to the stakes, by tenons and mortices. The partitions, six or seven feet high, are surmounted by a roof, a little sloped, the summit of which is raised from ten to twelve feet above the ground. These partitions and the roofing are faced with planks, each of which is about two feet wide. In the middle of the roof, is made a large square opening which affords, at once, both entrance to the light, and issue to the smoke. There are also a few small windows open on the sides. These houses have two stories, although one only be visible. The second is under ground, or rather its upper part, or ceiling, is even with the surface of the spot in which the stakes are driven. It consists of a cellar about five feet

in depth, dug in the inside of the habitation, at the distance of six feet from the walls throughout the whole of the circumference. The descent to it is by three or four steps made in the platform of earth which is reserved between the foundations of the walls and the cellar; and these steps, of earth well beaten, are cased with planks which prevent the soil from falling in. Beams laid across, and covered with thick planks, form the upper floor of this subterraneous story, which preserves from moisture the outer story whose floor is on a level with the ground. The guide of the French explained to them that the cellar is the winter habitation.

The entrance-door of these edifices deserves a particular description.

This door, the threshold of which is raised about a foot and a half above the ground, is of an elliptical figure; the great diameter, which is given by the height of the opening, is not more than three feet, and the small diameter, or the breadth, is not more than two: it may be conceived that it is not very convenient to enter the house by this oval. This opening is made in the thickness of a large trunk of a tree which rises perpendicularly in the middle of one of the fronts of the habitation, and occupies the whole of its height: it imitates the form of a gaping human mouth, or rather that of a beast, and it is surmounted by a hooked nose about two feet in length, proportioned, in point of size, to the monstrous face to which it belongs. Over the door, is seen the figure of a man carved, in the attitude of a child in the womb, and remarkable for the extreme smallness of the parts which characterize his sex; and above this figure, rises a gigantic statue of a man erect, which terminates the sculpture and the decoration of the portal; the head of this statue is dressed with a cap in the form or a sugar-loaf, the height of which is almost equal to that of the figure itself. On the parts of the surface which are not occupied by the capital subjects, are interspersed carved figures of frogs or toads, lizards, and other animals, and arms, legs, thighs, and other parts of the human body: a stranger might imagine that he saw the ex voto suspended to the door-case of the niche of a Madona.

On comparing these pieces of sculpture to those large pictures which had been seen the day before in a place which appears consecrated to a Supreme Being, we should be tempted to believe that these various figures are emblems which are connected with the religion of these people. But how inquire into the matter when the voyager is ignorant of the language of the country? All that Captain Chanal and his party could comprehend from the answers which the chief of the district who accompanied them, was pleased to give to the questions that they had endeavoured to make him understand, is that the erect figure, placed above each portal, and to which every thing that is below appears to serve as a pedistal, is the image of a chief who was held [in] veneration in the country. It is recalling the arts to their real institution, to appropriate them to honour virtue, and to perpetuate the memory of men who have deserved well of their fellow-creatures . . . (Fleurieu 1801: 268–271)

When Captain Chanal had before taken the soundings of the south arm of Cox's Channel, he had an opportunity of examining some of the habitations which are erected on its southern side, the north coast of the great island; they neither are so large nor so handsome as those of the North

Island, and are not decorated with the superb portal in sculpture which distinguishes the habitations of this latter island; but, in other respects, they differ not from them either in form, style of architecture, general disposition, or furniture.

In the vicinity of the habitations which Captain Chanal had just visited, were scattered here and there a few huts which appeared to be only temporary establishments of the natives of some other island, who, attracted by trade, had removed to the North Island: the inhabitants of Queen Charlotte's Islands, like those of Tchinkitanay, always carry in their canoes, stakes, planks, and large strips of bark, which are employed for forming occasionally, and on the first piece of ground that presents itself, a shelter against the snow and rain; these are, as it were, travelling necessaries which, during the summer, they put together in the places where a more easy or more abundant chace [chase] induces them to make some stay. But, during winter, they inhabit for a constancy their palaces, which they render still more impenetrable to the cold by the addition of the planks and strips of bark which compose their temporary habitations.

At some distance from these palaces, were perceived several mausolea or tombs which bear much resemblance to the morais of the islands of the Great Ocean. These monuments are of two sorts; the first and more simple are composed only of a single post about ten feet in height and a foot in diameter, on the summit of which are fixed planks forming a small platform; and in some this platform is supported by two posts. The body, deposited on this platform, is covered with moss and large stones. The chief whom Surgeon Roblet questioned respecting one of these tombs which was seen not far from his habitation, gave him to understand that it was the tomb of one of his children for whom he had long mourned. The mausolia of the second sort are more complex: four posts planted in the ground, and raised two feet only above it, bear a sarcophagus wrought with art and hermetically closed. It might be supposed that the latter contain the bodies of families or tribes. (Fleurieu 1801: 272–274)

Next Chanal and Roblet described what they called some kind of "temple." George MacDonald suggested that this was probably the grave house known later as sran.gu na, or "Skungo's house," the abode of the "hermit of k'yuust'aa," located north of daa.adans (MacDonald 1983: 192, 197; see also Swan 1883a: entries for August 4–9).

It is on an elevated spot, and insulated as much as possible, that the American builds what we call his temple. Some strong posts, six or eight feet high, form an enclosure in which are preserved all the trees that are standing; but all the shrubs are carefully torn up; and the ground is everywhere put in order and well beaten. In the middle of this enclosure, where a cave is sometimes made, is seen a square and uncovered edifice; it is constructed with handsome planks, the workmanship of which is admirable, and a stranger cannot behold without astonishment that these planks are twenty-five feet in length, by four feet in breadth and two inches and a half in thickness. What a time it must have required to prepare and finish them with the sort of tools which are employed in this work . . . I observe too

that a cave is made in the enclosure of the temple: I am ignorant of the use of it; but at least nothing indicates that it can be a catacomb. (Fleurieu 1801: 274–275)

Captain Chanal and his party hoped that trade was going to assume a degree of activity when, in the evening, they saw some large canoes which had come from the eastward, land at a sandy cove situated on the southern coast of the North Island [*daa.adans*], to the northward of the small island of the strait; and they immediately proceeded thither. Two handsome habitations presented themselves on the coast of this part of the island; and they there found assembled a rather considerable number of islanders, who, no doubt, belonged to one same tribe. The chief of the canoes requested to be admitted into the long-boat, and to this Captain Chanal consented with pleasure. He purchased of him four fine otter-skins, of which the chief disposed, although it was very evident that they were not his own property. He at first asked in exchange muskets and powder; but Captain Chanal positively refused to grant him any; and he then lowered their demand to jackets, trowsers, kettles, basins, and daggers. The natives appeared not inclined to make any other exchanges; but as the French had seen several of them convey skins from the canoes to the habitations, and as all of them expressed the greatest eagerness to detain the long-boat, Captain Chanal hoped for a more abundant traffic the next morning, and he promised them that he would repair at day-light to the same cove. But he did not choose to pass the night on so populous a part of the coast, judging it more prudent to resume the anchoring station which he had occupied the two preceding nights.

The French were punctual to their appointment; yet they had been anticipated by the Americans. They were received by the same chief, with whom they had traded the evening before; but they were not a little astonished that he would scarcely deign to cast his eyes on the various articles which they displayed before him in order that he might make his choice: he contented himself, from time to time, with promising a great many furs, and always recurred to the expedient of giving them to understand that they must hope. They perceived that, during this negociation, the plenipotentiary stole a brass bell which he dropped into the sea, very certain of finding it again when the strangers should retire. They pretended not to have noticed the theft; but they watched him so closely, that their vigilance disconcerted his assurance and dexterity: this is the only theft with which they have to reproach the inhabitants of this island.

The chief proposed to the French to visit his habitation; and they consented to this, in hopes of seeing there some furs, and of being able to determine him to conclude some bargain. He was extremely attentive in his behaviour to his guests, and in doing the honours of his house. He seized with singular intelligence all the questions which they endeavoured to make him understand, and most freqently he contrived to answer them. They admired his air of affability, his readiness to oblige, and an ease in his manners, which seemed not to belong to a class of men whom the Europeans still consider as savages. It could not be doubted, from the sight of all the European utensils which this people possess, and the clothes of different

sorts some of which were already worn out, that they had a communication for years past with English navigators, and had received from them frequent visits: the facility with which every individual pronounced the word Englishman, which they often repeated, was sufficient to prove this . . .

Captain Chanal and his party availed themselves of the situation in which they were, and of the good will of the chief to whom they were paying a visit, in order to examine minutely the interior state of a habitation when it is actually occupied by the master of the house.

The fire is placed in the middle of the edifice; there it is that the food is dressed. This same apartment fifty feet long, the frame and the general disposition of which I have described, serves, at once, for kitchen, dining-room, bed-chamber, store-house, and workshop, and also as a shed for the canoe, when she is not employed afloat. While, on one side, some women are giving their attention to the children and to the family concerns, some, elsewhere, are drying and smoking fish for the winter stock; and others are busied in making mats, and joining and sewing furs in order to make them into cloaks. No fixed places were distinguishable for sleeping, and, accord-ing to appearances, all the individuals of a family sleep pell-mell on the boarded floor of the habitation. The disgusting filthiness of the place might, however, induce the supposition that they spread on the ground, for the time of sleep, mats or skins; and this may be supposed without taxing them with sensuality. But if they are so negligent with respect to themselves, they are less so in regard to their children: the youngest are laid in cradles suspended like hammocks. Our voyagers saw a somewhat considerable number of chests piled up on the sides and in the corners of the habitation, and they learnt that these chests hold the winter provisions, and that, in others, are contained bows and arrows. In different places of the walls, were hung darts, lances, nets, fish-hooks, with poles and lines for fishing.

The habitations are, in general, painted and decorated in various ways; but what was particularly remarkable in that which the French visited, was a picture somewhat like those which they had seen in the fort of redoubt erected in the small island of the strait, which occupied the head of the apartment, as is seen suspended in the drawing-rooms in Spain, over the Estrado, the picture of the immaculate conception. Surgeon Roblet has described this production of the fine arts of the North-west coast of America. "Among a great number of figures very much varied, and which at first appeared to me" says he, "to resemble nothing, I distinguished in the middle a human figure which its extraordinary proportions, still more than its size, render monstrous. Its thighs extended horizontally, after the manner of tailors seated, are slim, long, out of all proportion, and form a carpenter's square with the legs which are equally ill-made; the arms extended in the form of a cross, and terminated by fingers, slender and bent. The face is twelve inches, from the extremity of the chin to the top of the forehead, and eighteen inches from one ear to the other; it is surmounted by a sort of cap. Dark red," adds he, "apple green, and black are here blended with the natural colour of the wood, and distributed in

symmetrical spots, with sufficient intelligence to afford at a distance an agreeable object." . . .

I have already made known part of the moveables of the habitation that we are visiting; of these the cooking utensils appear to form a considerable portion: here are seen confounded with wooden vessels and spoons of horn or of whalebone, peculiar to the country, iron pots and kettles, stew-pans, frying pans, boilers, tin basins, and the other household utensils, with which the Europeans have furnished the Americans, and the use of which is become as familiar to them as to ourselves. There were also seen sheets of copper, large pieces of bar iron, hatchets, adzes, joiner's chisels, plane-irons, daggers, and lances, the whole of English manufacture, mingled and con-founded with American lances; bones jagged or barbed for arming the point of lances, fish-hooks of stone or bone, mats and ropes, no doubt of the bark of trees, or other plants whose exterior filaments are easily detached from the ligneous part, lastly hats made of rushes, and other weapons, tools, implements, utensils, and dresses, which may be called indigenous, because they are those which the Americans had invented and fabricated for them-selves, before the Europeans, by introducing into the islands the produce of industry, had brought them to know new conveniences and new wants.

The master of the habitation also possessed for his own particular use four muskets and half a pound of powder; but, fortunately for him, and perhaps for others, he neither had balls or lead. (Fleurieu 1801: 276–282)

Fleurieu goes on to indicate that it appeared that the chief did not know how to operate the musket or that ball and lead were required. The French party concluded its trading and returned to the *Solide* on August 27, after sighting an English ship and its tender in the distance to the east.

Chanal's and Roblet's descriptions of the painted images on the boards at the Lucy Island fortress, the carved house frontal pole (probably the same one drawn by Bartlett in 1791; see fig. 2.8), the various types of mortuary poles at *k'yuust'aa,* and the painted interior house screen at *daa.adans* provide the fullest contemporary account of eighteenth-century Haida art known to have been recorded. Their descriptions of the houses suggest that there was indeed more than one house frontal pole at *daa.adans.* The French visitors' interest in the form and meaning of these carvings and paintings surpassed that of any of the other visitors of this period. They even interviewed their Haida guides to the extent of obtaining the Haida name "Caniak" for the painted panels.[17] Here, for the first time since Crespi's mention of figures painted in various colors, chiefly red and yellow, the colors of the paintings, black, red, and apple green, are recorded, and the abstract human and animal "formline" designs are described in enough detail to confirm that two-dimensional formline design paintings were used on screens inside houses at this time. No Haida painted panels or interior house screens survive from this period, which makes these descriptions all the more valuable. One nineteenth-century interior house panel from the village of *ráwk'aan* (Howkan) does survive (plate 2), and an exami-nation of its features suggests that it may closely resemble the panels described in the Marchand journals.

From the same month and year as Marchand's visit, August 1791, we have the first account of a visit to the body of water now known as Massett Inlet.[18] It was recorded by John Hoskins, who was on the *Columbia* with Captain Gray. While anchored on July 10 near Rose Harbour at the southern tip of Haida Gwaii, the ship's officers learned the native account of a now infamous encounter between Captain Kendrick and *xuyaa*, the chief at *sran gwaay*.[19] They later continued up the east side of Haida Gwaii and on to Kaigani country. There they met with Captain Crowell on the *Hancock*, who told them of his having recently killed four natives. Together with the *Hancock*, the *Columbia* sailed down to Haida Gwaii and entered Massett Inlet, which Gray named Hancock's River, the name by which Americans later knew it. There Hoskins recorded the names of two chiefs, Kow (*gu.uu*) and Cuddah (*k'udee*). Kow was apparently visiting Massett, for he was frequently mentioned by other Europeans as being the principal chief at *daa.adans* and later at Kaigani.

Captains Gray and Crowell Visit Massett (Masheet), August 1791

The next morning [August 18] Mr. Haswell was sent in the pinnace armed on a survey of the River [Masset Inlet] a few natives visited us with skins among others was a Chief named Kow [*gu.uu*] belonging to Clegauhny [Kaigani] a tribe so called who inhabit a bay to the westward of Brown's sound this man was very serviceable to us in trade and very intelligable he informed me this river ran some distance into the country terminating in a lake which was supplied by a number of small rivulets which abound with salmon round this lake are situated their villages as I had an idea this might afford a passage through to the eastern side of the island I questioned him on that head his answers were so very clear that I have no longer a doubt of its being anything more than a river as he described . . . The tribe which inhabits this river I am informed is large though we saw but few natives their Chief is named Cuddah [*k'udee* — this is certainly the ancestor of Dr. *k'udee*, a Haida shaman who lived in Massett in the late nineteenth century]. (Howay 1990: 228–230)

From Massett Inlet the party sailed on to Cumshewa (*hlqin7ul*, called by Hoskins Tooschcondolth) and found that the *Hope* with Captain Ingraham was already there, and that Ingraham had purchased all the available skins. The *Columbia* then sailed south to Clayoquot Sound (Howay 1990: 230–232).

Hoskins concluded his narrative with a general description of the Haida, including an account of a house frontal pole and fortress that closely resembles descriptions of the frontal pole and fortress at *daa.adans*. The *Columbia*, however, did not visit *daa.adans* on this second voyage, and Hoskins might have based his comments on hearsay. Though he complained that Captain Gray did not know where *daa.adans* was, Gray was there in 1789 on his first voyage and could well have given Hoskins a description of its appearance (Howay 1990: 234). We know that other villages had fortresses nearby, and they might also have had frontal poles at this time, though no direct mention of them is made in the eighteenth-century descriptions of the other villages. Thus it is unclear whether Hoskins's general account of the appearance of Haida villages applies to more than just *daa.adans*, though it certainly seems to imply that more than one Haida village looked like this:

[T]heir head villages are neatly and regularly built the houses end on with pitched roofs in front is a large post reaching above the roof neatly carved but with the most distorted figures at the bottom is an oval or round hole which is either the mouth or belly of some deformed object this serves for a door way near to those head villages they have fortified towns or villages which they call "Touts" to which they retreat when invaded by a more powerfull [sic] enemy these are built on the most natural fortifications and much improved by art they endeavour to have only one means of access and this by a wooden pole with notches cut in it to admit the toe by which they ascend when they are all up the pole is hauled after them they then with stones which these places are well supplied with annoy their enemy and are in general able to repel most any attack these places are also well supplied with provissions [sic] and water by which they can hold out a siege of several months if there enemy had the ability or skill to carry it on.

The government of these people appear by no means to be absolute the Chiefs having little or no commands over their subjects Cunniah the Chief of Tahtence is acknowledged to be the greatest on the Islands his wife of course must be the Empress for they are intirely [sic] subject to a petticoat government the women in all cases taking the lead. (Howay 1990: 234–235)

Here for the first time we have an assessment of *gannyaa* as the greatest Haida chief. Hoskins also listed in his account the names of all the Haida chiefs of whom he had learned: "Cunniah [*gannyaa*], Needen [*nèedaan* from Naden Harbour], Cuddah [*k'udee* from Massett Inlet], Skediates [*sriida giids*], Comsuah [Cumshewa], Caswhat [?], Ugah [from Skincuttle Inlet], Coyah [*xuyaa* from *sran gwaay*]" (Howay 1990: 236).

In April 1792, the Sloop *Adventure* arrived at Massett Inlet, and in the log of this journey, Robert Haswell, who had visited the year before on the *Columbia*, recorded a new name, Cattar, whose holder was described as "the chief of this port." This chief of Massett cannot at present be identified. Later the *Adventure* visited *daa.adans,* where its men met "Cunnea" and his wife (who was described as the "superior officer"), met with Captain Magee on the *Margaret* at Barrell's Sound (who went on to visit *daa.adans*), and proceeded around to Cumshewa, across to Tsimshian country, and back across to Kaigani. They returned to Massett on July 7, where they "purchased huckleberries, raspberries, and the finest flavored strawberries I ever tasted." At Naden Harbor they met a native man who had gone to China with Captain Crowell (see below). While at *k'yu-ust'aa* they reported that Captain Thomas Cole on the *Florinda* was also there. They returned to Massett on August 25 (Howay 1990: 325–349).

In July 1792, Joseph Ingraham returned to Haida Gwaii. When he arrived at Cloak Bay on July 2, he was greeted by *gannyaa*, who told Ingraham that his was the sixth vessel to have visited him that season. When Ingraham inquired about his friends Gow and Goi, *gannyaa* told him they were dead, perhaps to discourage Ingraham from seeking them out at Kaigani, where they were in residence. Ingraham learned that they were indeed alive when Goi arrived at *daa.adans* later during this visit.

During the passage from Macau (Macao) on this return trip, Ingraham had instructed his blacksmith to make numerous iron daggers based on patterns

he had taken from native daggers the year before. Now he was dismayed that neither these nor the iron neck rings he had traded in profusion the year before were in demand. Instead, the Haida were desirous of silver spoons, copper, leather for armor, and abalone shells.

While at Cloak Bay, Ingraham was joined by a Captain Crowell in the *Hancock*. He learned that Crowell had taken a man from Cloak Bay with him to Macau the year before and was returning him safely home. Crowell had left one of his crew to live with the Haidas and collect skins. A Haida man was taken to China as a hostage for his safe treatment. This sailor had recently left with a Portuguese ship, not waiting for Crowell's return (Kaplanoff 1971: 191–193).[20]

Captain Ingraham's Second Visit

3 July [1792]

On leaving the coast last voyage Captain Crowell left one of his seamen in this port to collect skins, and he took one of the natives with him to Macao as a hostage. The native was now returned, but it seems the man left the port in the first vessel that came the present season — a Portuguese brigantine belonging to Macao [probably the *Iphigenia*, sometimes known as the *Felice Adventurer*, under Captain Vianna; see Howay 1934: 124]. Captain Crowell was not without his fears that the natives had killed his man; however, it afterwards proved that his suspicions were ill grounded. The man had stayed the time agreed on and was very well treated by the natives. As a mark of their friendship each chief made him a present of skins, so that when he embarked he was possessed of between thirty and forty fine skins. This I learned from Captain Magee, who arrived in the port before the Portuguese bringantine before mentioned. The Indian returned from his peregrination was dressed in a good suit of clothes to meet his friends, but there was nothing extraordinary discovered when they met; indeed I was informed they took less notice of him than anyone else on board. Neither did it appear that this man could influence them to trade, or at least if he could, he did not while we were in company. (Kaplanoff 1971: 193–194)

Because their ships were "very foul," Ingraham and Crowell decided to take turns hauling the ships out on the beach and scraping down their hulls. Each vessel's guns and cables were transferred in turn to the other. While engaged in this work, the crews had occasion to celebrate the Fourth of July by roasting a pig and having a feast on the beach. Among their invited guests was *gannyaa*. It is possible that this incident gave rise to the name "Pig House" at *daa.adans*, a name that is reported to have originated in that village and that later reappeared in *hlanqwáan*:[21]

4 July

Next morning was the anniversary of American Independence. In order to celebrate it in the best manner our situation would admit of, I had — as on my last voyage — a hog of sixty pounds weight roasted whole on the beach and invited Captain Crowell and his officers to dine with me. At twelve o'clock we fired a gun, hoisted our colors, and gave three cheers, which the Hancock returned. As the Hope was on a careen, we dined on shore under a tree near the beach. Old Cunneyah was one of our guests.

However, the day did not end so pleasantly as it began. In the afternoon when Captain Crowell and his officers were returned on board and we were trading with the natives, some of the Hancock's men who were cutting wood on shore lost an axe (perhaps by carelessness). However, they challenged the natives with the theft and seized several skins and two spears, on which I saw the Indians who had taken their temporary abode near us embarking in their canoes. On hearing the cause, I repaired on board the Hancock to inform Captain Crowell, that he might take proper care of his men. Captain Crowell immediately went on shore and brought the men off with him, leaving the skins with my chief officer. Shortly after, two or three natives returned to the beach, and Captain Crowell desired me to give orders that the skins might be given to those people, which I did. After the men were possessed of the skins, they offered them for sale for a jacket and trowsers, which one of the men was trying on. Then a man came alongside the Hancock and said the skins were his. On this Captain Crowell desired I would hail again and give orders that the skins might be given to the man who claimed them last, and this I did. Seeing the right owner coming to receive them, the man who was bargaining for them endeavored to run off with the jacket and trowsers. My chief officer gave orders to pursue him and for the sentinels on the beach to fire, which they did. Two muskets were fired before I was able to stop the men from pursuing him. The jacket was recovered, but the trowsers the man carried off.

I was very sorry it happened, but I was on board the Hancock at the time. The natives informed me the man was wounded in the side, which — had I been on shore — I should have prevented. So might the officer if he had been trading where he ought to have (on board the brigantine), but bringing the articles of trade on the beach was giving the natives an opportunity they could not withstand.

After this circumstance took place, every canoe left us and set up a hue and cry, or rather a howling. The same evening, our bottom being finished, we hauled off and took in the Hancock's guns, balls, etc., after which she hauled on shore.

6 July

The Hancock being graved, she took her guns on board again. I determined to sail in the course of the day. About noon a canoe was seen coming towards us with the chief standing up and the paddlers singing. When she came alongside, I found the chief to be one of my old friends whose name was Goi. This man informed me Cow, a chief of whom I made frequent mention when in this port last season, was not dead as Cunneyah informed me but that he had withdrawn his tribe from Cunneyah's and lived on the main at a place they called Kywannee. Far from being dead, he said, Cow was very stout and had three wives, which many would suppose was enough to kill him in a short time. However, Goi had several good skins which we purchased on as moderate terms as could be expected.

At two in the afternoon we got under weigh. Goi accompanied us out and ended his stock of skins ere we parted. After being clear out, we steered E.N.E. (Kaplanoff 1971: 194–196)

On July 22, 1792, Captain Jacinto Caamaño on the frigate *Aranzazu* erected the first cross on Haida Gwaii itself — on Graham Island at *k'yuust'aa*. The service was attended by a man called "the Tasen" in Wagner's English translation of Caamaño's journal (Wagner and Newcombe 1938: 217). In the original Spanish, the name would have been El Tasen — surely this must have been the name Yeltadzie (*yaahl dàajee*). If so, then Caamaño's is the first mention of this chief's name in any visitor's journal, though this could be the same man whom Ingraham had nicknamed "Pilot" the year before. Caamaño was also the first to mention both *gannyaa*'s son and a daughter in an explorer's account. On the day before his arrival at Cloak Bay, a canoe with four Haidas came alongside and asked for the captain. One, who he later learned was *gannyaa*'s son, slept on board, shook Caamaño's hand, and asked to go down to his cabin. There he asked if the captain was planning to go into the harbor and, upon learning that he was, made a gift of a sea-otter skin to Caamaño, who in turn gave him some shells, knives, and looking glasses (Wagner and Newcombe 1938: 213–215). After asking whether he and his friend might remain on board, *gannyaa*'s son sent their canoe away.

Caamaño's Visit, July 19, 1792

They wandered all over the ship, without showing wonder at anything, nor was there any object of which they did not appear to know the use, until 9 o'clock, when I had them to supper with me. They ate of all that was on the table, showing no sign of dislike of anything, or wishing first to taste it; and were more at home in the management of fork and spoon than any Spanish squireen. They drank wine and spirits at first sight; and, altogether, their behaviour seemed to point to a considerable intercourse with Europeans. After supper they returned to the quarter deck; but very soon came down into my cabin, where they were quick asleep. (Wagner and Newcombe 1938: 215)

[The next day, while they approached Cloak Bay, two canoes came out to them:]

The first to arrive was that of the principal chief in the harbour, by name Taglas Cania [Douglas *gannyaa*], and father of the Indian who had boarded us the night before. He was accompanied by some forty-five people, including women and children. This canoe had eight paddles each side. All, men and women, were seated or kneeling except the Samoguet (a native word meaning "skipper" or "coxswain"),[22] who stood upright intoning one of their songs or chants, in which he was followed by the rest in unison, and to which the paddlers kept time with their strokes.

Two men, in the bows of the canoe, also beat this time with the hilt of their paddles on a small thwart, placed for this purpose and for the support of a large drum, which a lusty native struck with his fists, producing sounds much the same as those of a European bass drum. This sight greatly astonished us, as did also the size of the canoe. I had the latter measured, and found the following dimensions: length fifty-three feet; beam, averaging six feet; depth, including that of two well fitted wash-streaks, four and one half feet. These latter raised the height of the gunwhale, and ran from stem

to stern, which were both fashioned as bluff cutwaters. We were not less struck by the fine features and good figures of almost all in the canoe. These, so soon as they came alongside, dropped their paddles and proceeded to dress themselves, some in their native clothes, much the same as those of Bucarely [Bucareli Bay], but the greater number in long frocks, coats, or jumpers, trousers, or loose short breeches, and pieces of cloth serving as capes of different colours, but blue predominating.

The Samoguet's [gannyaa's] dress consisted of wide breeches made of a light blue-grey serge, and a large cloak formed of marten skins. This latter is the distinguishing mark of a village chief, and was ornamented with a great number of extra tails. His son was the first to speak, pointing me out as captain of the ship to his father who then saluted me, and asked leave to come on board.

This granted, he at once mounted the side, walked aft to me, and gave me his hand. Then, gently touching my face with both his hands, he said, "Bueno, Bueno." This was the first time that I had seen this form of friendly greeting used by the Indians; but, no doubt, they had learnt it from intercourse with Europeans. Shortly afterwards, several more of the natives came on board. Amongst these was one of the chief's own daughters. She wore no wooden toggle [labret] in her lower lip, and was, indeed, a good looking girl.

Her father made me a gift of her, with a view to the girl being for my pleasure, as she herself later hinted to me in the cabin, to which she had quickly betaken herself. Soon afterwards the second canoe arrived alongside. It was rather smaller, and contained about twenty-five Indians of both sexes and all ages, as well as another chief, called the "Tasen." All were singing similarly to the first lot, though with less noise and show. From this, I gathered that he was of inferior quality to Taglas Cania; but he went through the same ceremonies and saluted me in just the same manner.

[After they anchored off the mouth of Parry Passage, they sent the canoes ashore,] the principal chief taking his daughter along with him. She, apparently, was not too well satisfied with the attentions that I had paid her, or the various trifles that I had given her. I had also entertained her father and brother. Both had dinner with me, when it gave me no little pleasure to observe the former's graceful and easy manners. Indeed, in this respect, the bearing, simplicity, and dignity of this fine Indian would bear comparison with the character and qualities of a respectable inhabitant of "Old Castile." [A map was drawn of the harbor.] . . .

July 21st

This day a great number of natives came aboard; for, besides those from the seven good-sized villages in its vicinity, the news of the arrival of the largest ship that had yet been seen there, attracted people from those roundabout. The furs they brought were of very fine quality, and also extremely well cured. The Indians wanted to exchange them for clothing, or shells, but the latter they desired to have of as green a colour as those that some wore in great numbers hanging at their ears. We were surprised to see that several had those of a sort that is found only at Monterey [abalone], and even more

surprised when they told us that we ought to arrange that in Spain the meat be not extracted by heating the shells, as this process damaged the enamel, but that it should be done with a knife. I enquired who had taught them this, or had given them the Monterey shells, but either they did not catch my meaning, or I misunderstood their reply. The Tasen [*yaahl dàajee*] having come aboard in the forenoon, I invited him to dine with me, and I noticed that his manners were equally as good as those of the former chiefs. This fact, together with the quality of his surroundings, led me to judge that he was in no respect inferior to them.

He was of ordinary height, and spare in body. He had a cheerful expression, regular features, was light in colour, and about fifty years of age. He wore the distinguished cloak of a chief, breeches of flesh coloured silk ornamented with small gold stamped flowers, and on his head a high hat. This went very well with all the remainder, so that with his hair tied up in a neat cue by a narrow lace of leather he gave the appearance of being something quite different from what he really was.

Cania [*gannyaa*] came on board at 5 o'clock that evening. He is of very big frame, and stout in proportion, with a handsome face, and is about seventy years old. His clothing, all of sky-blue cloth, consisted of two loose frock coats one over the other, ornamented with Chinese cash, each one strung on a piece of sail-making twine with a large light-blue glass bead the size of a hazel nut, loosely attached to the material, and together forming a button. His breeches, in the form of trousers, were also trimmed with many of these cash, so that he sounded like a carriage mule, as he walked. He had on a frilled shirt, and wore a pair of unlike silver buckles; not, however, in his shoes, but at the feet of his trousers. The trimming of his clothes was formed by the selvage of the cloth; and this made up for the lining, which was altogether lacking. He wore a head-dress similar to that of the Tasen; and, at a little distance, looked very fine in his extravagant costume.

Before leaving the ship, which they generally did at sunset, the natives gave me one of their musical performances; but this consisted of little more than a series of discordant shouts. A blind man in one of the canoes began dancing to this accompaniment. In each hand he held the tail feathers of an eagle, which appeared in jerking fashion from under his cloak, or as imitating the gesture of flying, as he leapt to the cadence of the music, thundering meanwhile at the singers in a terrifying voice, each time more loudly.[23] The concert over, they all took their departure, seemingly well pleased with themselves, and leaving us no less so at their great civility.

At daylight of the 22nd the cutter in charge of a master's mate, was sent to complete the survey and plan of the harbour, with orders to return so soon as possible. They were back by 9 o'clock of the forenoon; and at 10, I landed with the greater part of the seamen and marines in the pinnace and cutter, and Mass was celebrated under an awning formed of the ships' flags. This service was attended by the Tasen and several other Indians, all of whom showed great respect and attention. I then went through the ceremonies of taking possession of the country with all the prescribed formalities and set up a Cross, over twenty feet in height, charging the natives not to over-set it; which they promised to observe [the location of

the cross is shown on Caamaño's map, directly south of Lucy Island on Graham Island].

When all this was finished, I returned on board accompanied by the chief and one of his sons, who is also chief of another village. I kept them to dinner with me, and during the meal explained to them that I must weigh and get under sail directly it was over. As they imagined that this was for the purpose of proceeding into the harbour, they showed great pleasure, but, on learning that it was in order to begin our journey homewards for Spain, they became very sorrowful and with much insistence begged me not to leave so soon, but to bring the frigate inside the harbour, assuring me that the anchorage was both safe and convenient, and that they would supply good store of nutria skins. As, however, our business was not that to which they are accustomed, we got under weigh at 4 that afternoon, parting from the inhabitants with considerable regret on each side. Indeed, along the whole of this coast populated by Indians, I do not believe that one will meet with kinder people, more civilized in essentials or of better disposition.

In general, the women are well made, and not bad looking. Many of them do not wear the labret through the lower lip, but their dress is less modest than those of Bucarely, for their cloak alone serves to cover their breasts, and they seem quite careless whether it does so or not [this is in contradiction to other accounts]. The dialect appears to be the same as at Bucarely. I was not able to learn much about their customs and managed only to gather that they practise monogamy. Their houses, built of boards, are spacious, clean and well kept. They are protected against the attacks of possible raiders by large wooden towers standing on steep rocks, and, for such occcasions are provided with a couple of pretty good brass swivels, some muskets, long bows, darts, and daggers. Ordinarily, however, they carry none of these weapons; except the spears used for killing the nutria, of which they always take a sufficient number with them in their canoes.

An Indian youth, aged about sixteen to eighteen, of pleasant appearance, who had come on the first day with Cania, asked leave to sleep that night on board the ship. This I allowed, and the next day he told me that he wished to go with us. I said that I had no objection, but, fearing that his request was prompted merely by the desire of seeing strange countries, on the understanding that he was to be repatriated, as had been the case already on several occasions with British vessels in this district, which conveyed them to Macao, I explained that if he came with us, it would not be for Macao but for Spain, and for all time, as I should never be returning again to his country or to see Cania.

On hearing this he remained some time in thought and then intimated that he preferred staying at home. Then he seemed to turn the proposition over again in his mind for, a second time, he expressed in most determined manner his wish to come. I told him, repeatedly, that in such case he would never return to his native land, but was unable to shake his resolution. On the eve of sailing, he begged me to give him some clothing, as he intended to leave his nutria cloak behind. I gave him a shirt and trousers, also a piece of serge, whereupon he threw his own garments into one of the canoes last remaining alongside, and that too not belonging to his own village.

Later on, during the time we speant in surveying these coast, several of his compatriots endeavoured to induce him to remain with them. Not only, however, did he disregard all their persuasions, but he also avoided their company, shunned their conversation and would even rail at them. (Wagner and Newcombe 1938: 215–222)

This young man might have been one of *gannyaa*'s sons or nephews, since he is said to have come aboard with *gannyaa* the first day, though he may not have been the first son to greet the ship. What became of this fellow is unknown, though presumably he stayed with the ship until it reached Spain. Caamaño named Dixon's North Island and Pérez's Santa Margarita "Isla de Langara" after a Spanish admiral. Langara Island is the name it retains in today's charts; its Haida name is *q'iis gwaayee.*[24] From Langara Island, Caamaño sailed north and named Cordova Bay (after Luis de Cordova y Cordova) between Long and Prince of Wales Islands, sighting the American brig *Hancock* at anchor near Kaigani Strait (Haines' Cove?) on July 23. He returned and sailed along the north shore of Graham Island, noting the entrances to both Massett Inlet and Virago Sound. The party continued from there to Tsimshian country (Napean Sound), recording the chiefs' names "Jammisit" and "Gitejon" and describing in great detail a painted house front, several masked dances, and a puppet performance (Wagner and Newcombe 1938: 265–293).[25] Caamaño's graphic descriptions of the song led by a blind man on board ship and of the Tsimshian masked dances and puppetry rank with the French descriptions of the visual arts and add immeasurably to our understanding of eighteenth-century ceremonialism on the northern Northwest Coast. It was not until the next year that more colorful visual portraits were recorded.

In the spring of 1793, Sigismund Bacstrom, aboard the *Three Brothers* with Captain William Alder, visited *k'yuust'aa*, Rose Harbour, and Tattesko (Haines Cove, near Kaigani) on Dall Island. At these places he painted eight portraits of Haida people (Vaughan and Holm 1982: 208–209): "Cunnyha an Indian Chief on the North-Side of Queen Charlotte's Island, NW Coast of America" (plate 3), "Cunnyha's Eldest Daughter named Koota-Hilslinga, a young woman at Hain's Cove Tattesko belonging to Cunniha's Family who was along Side the Vessel on Mond: 18 March 1793" (plate 4), "Hangi a chief's daughter at Tattesko near Bocarelli Sound, N.W. Coast of America" (plate 5), "The wife and child of Hatzia, a Chief in Port Rose South End of Queen Charlotte's Island, Lat: 52.20 N.," "The wife of Hatzia Chief in Port Rose Queen Charlotte's Island in Lat. 52,,20 N," "Keets Rist, a well known Indian Woman belonging to Hatzia's family Queen Charlotte's Island N.W. Coast of America," and "Tchua a Chief of Queen Charlotte's Island in Lat. 52,,12 N" (plate 6). No journal survives from this journey, but the drawings are inscribed with names, places, and dates that document the visit (Cole 1980: 82).

This is our first image of *gannyaa,* who had been described so many times in earlier journals. He is shown wearing a sea-otter robe, grey serge sailor's pants, a red shirt, and a spruce-root hat, much as Caamaño described him in his first encounter with him. Although Dixon's and Ingraham's published journals contained engravings of busts of two Haida women (figs. 2.5, 2.9), Bacstrom gave us the first full-length, individualized portraits of Haida people and was the first

to record Haida women's names. Koota-Hilslinga, *gannyaa*'s daughter, is shown seated with a robe of either cedar bark or fur over her shoulders. Her face is painted red from the nose down, and she wears a long cord or wire from her pierced lower lip, indicating that she was a young woman whose lip had been newly pierced. She also wears triple bracelets of some sort, probably of copper. In considering the incident of *gannyaa*'s offering his daughter to Caamaño, Margaret Blackman speculated that since the young woman's lip had not been pierced, it was probably not his daughter but a slave, offered to the Spaniard for sexual services (Blackman 1982: 43; Wright 1986: 41). One would think that if the young girl offered to Caamaño had been the Koota-Hilslinga drawn by Bacstrom, Caamaño might have commented on the long ornament hanging from her lower lip, unless perhaps the piercing ceremony occurred over the winter separating his visit and Bacstrom's.

Hangi must have been an older woman, because she wears a larger labret along with the same red facial paint. From her necklace hangs a large silver fork of the type that was in such demand the year before, when Ingraham visited. She, too, wears copper-colored bracelets as well as anklets, and her skirt and cape appear to be made of woven cedar bark. The cape worn by Tchua is of the type described during the Pérez expedition, with a checkerboard design of faces typical of the proto-Chilkat style of weaving (see Holm 1982).[26]

Captain Roberts on the *Jefferson* visited Cloak Bay shortly after Bacstrom and again the following spring. During his second visit he helped raise a memorial pole using two spare topmasts and tackle. After Roberts arrived at the end of May, he recorded that Cawe (*gu.uu*), Cunneah (*gannyaa*), Eldarge (*yaahl dàa-jee*), and Skilkada (?) returned from Tattisco (*k'áyk'aanii*), their winter village on Dall Island. Since Captain Douglas had described *k'yuust'aa* as being *gannyaa*'s winter village in 1789, this account suggests that sometime between 1789 and 1794 *gannyaa* had moved his winter village from *k'yuust'aa* to *k'áyk'aanii*. The Haidas had many otter skins, but Roberts had little with which to trade. Frederick Howay (1930: 89) speculated that Roberts's offer to assist with the pole raising stemmed from his being desperately short of goods, having previously bartered his last elk hide, his worn-out sails (made into women's clothing), a Japanese flag, seal oil, old clothing, the cabin looking glass, and the officers' trunks, swivels, and muskets, as well as the ship's crockery. Bernard Magee kept the log of the *Jefferson* during its extended stay at *k'yuust'aa* from late April through mid-August 1874:

Captain Roberts Helps Raise a Pole

May 31st, 1794

very pleasent weather & clair..wind from the North[wd]. Still imployd repairing the sails..smiths working up the old iron for the Sandwich Island trade..in the course of the day were visited as usel by the natives. sold the last remaining clamon[27] No. 252 for 6 prime skins purchassd in all 14 skins No. 1146 & 14 tails..in the evening arived Cowe Cunneah Eldarge Skilkadee & other chiefs with a numerous fleet of canoes from Tattasco on the main..the chief pleasuring us with a visite..& after supping on board went on shore in the cove & incampt for the night..Cowe only remaining on

board..all the canoes apeard to be full of skins which the[y] were ready to dispose of for clamons. Clothing & other articles..& I supose not less then 800 skins were brought over in the different canoes.

June 1st, 1794

Exceeding pleasant weather all the 24 hours. With light variable airs were visited by a great number of the Natives through the day purchassd 30 skins No. 1176 & 124 tails among other articles sold the lower Std sails for four & the Japanese flag for one skin. having little or nothing now left of our trading stock except powder took up such articles of clothing as were offerd by individuals for sail & which were bought up by the natives with the greatest avidity..in the evening arrived a number more canoes from the main.

June 2nd, 1794

[A]greable weather all this day. with pleasent breezes from the westrd. . .the carpenters repaird the jolly boat which sold to Cowe with a small sail for 5 skins one barrel of seal oyl for 5 skins...disposed of such articles as could be spaired & the[y] fancied..purchassd in all 27 skins. No. 1203 & 65 tails..for which as yestserday took up in clothing paid in powder etc.

June 3rd, 1794

[F]ind pleasent weather..with fresh breezes from the westrd. painted the head & stern..in the afternoon some natives on board..purchassd 15 skins No. 1218 & 19 tails..sold the cabbin looking glass for one prime skin..the carpenter imploy'd making trunks the[y] being in great demand. with the natives...having sold them all the trunk belong to the different officers for a prime skins each..besides the ingaging those that were amaking . . .

June 17th, 1794

Fine pleasant weather wind from the SWrd..in the afternoon the Capt. with the Carpenters & some hands in the pinnace went to the village at the request of Cunneah to plane and smooth a monumental pillar of wood previous to its erection on the morrow..in the evening returned on board . . . but few natives visite us this day. purchassd 1 skin with 5 fathm Hiquah [dentalium shells]. No. 1313 & 2 tails.

June 18th, 1794

[W]ind & weather as yesterday..in the morning I went in the pinnace with the Carpenters & 2 hands to the village took along with us 2 spars top masts for sheers & sufficient tackling to set up the pillar..which in the afternoon got in its place..after finishing the necessary requisites for its intended purpose of sepulture [sepulcher] of a daughter of Cunneahs..I returned to the ship..but few natives on board the course of the day..purchassd one tail.

June 19th, 1794

[T]he fore part of the day pleasent weather. the latter part rainy wind from the Eastrd..about noon Cunneah with his wife & son came on board to request the Captains atendance at the village with the officers etc & after

Dinner the Capt. purcer & Docter accompained them in the pinnace to the village where whin landed Cunneah adressed his Chiefs & peoples on the occasion of this our visite. & urging the properity of thine making such acknowledgements to Roberts for his service & assistance in setting up the monument as the[y] saw fit..& by which the[y] would shew the[y] considered him as thire [their] frend & by whose frendship the[y] might hope to greater mutel advantages & or in words to that affect..after he had done speaking another cheiff stepd forth & adressd himself to the same affect which ended the[y] were conducted into a house & each of them presented with a skin..to which was afterwards added to the Capt. by different persons of distinction five skins & three tails & expressd a desire that he would cause the pillar to be painted..which signified to them would be done the first fair weather..& after a short tarry took leve of them. & returned on board.. a few natives on board from whome purchassd 3 skins & 5 tails..in the evening a canoe came along side from fishing which informed of there seeing a sail in the offing. but could not distinguish what it might be..purchassd a few hallibut. Skins No. 1324 . . .

June 23, 1794

Pleasant weather all this day wind from the Southrd & Westrd ...many natives viste us today...purchassd from them 9 skins being mostly for the middle stay sail made into women's garments. being the last of the light sails that we could possably spair..having disposed in the same manner of 3 top gallent steering sails one top mast & two lower ditto..the flying jibb & main top mast stay sails. the whole of which precured about 40 prime skins..in short everything that could be spaired on board were purchassd up by the natives with the greatest evidity. & seemed in want of everything the[y] got thire eye on exepting from which was in little or no demand which we could no more then purchass fish with. & then was oblidged to work it up into different trinkets to thire fancy...& I have no doubt if we had a sufficiency of trade. cloth thick copper etc. that there might be precured at this place between 1000 & 1500 skins of the best quality. as we have already procured upwards of 400 skins & that only with the drags of all our trade. which we had no right to supose according to the prices given the last season to Command more then 150 skins we have disposed of articles in this part this year that would not even draw there atention the last season. & at a very advantagious rate and no end to the quantity of skins brought on board & along side every day for sail. of which we purchasd dayly a few with some article or other...Carpenters continualy making chests which sell for a prime skin each . . .

July 8th

Raw Coole weather & Cloudy wind variable. in the afternoon I went to the village with some hands at the desire of Cunneah in the morning. to raise an image on the monument lately set up. which the[y] cut & carved with a great deal of art. being the representation of some wild anemile [animal] unknown to us. some what the Resemblance of a tode [probably a bear]. a few natives on board in the fore noon purchassd nothing.

July 9th

Thick weather with rain all this day..wind from the southrd.& in the evening blew fresh..a few natives on board in the forenoon purchassd 3 skins. Cunneah at the same time came to invite the Capt. & officers to the village to the ceremony of distributing the presents to be made by Enow, the father of the infant to whose memory the monument was erected, a principal chieff & son or son in law to Cunneah to the Cheeffs & people who were also invited upon the occasion as well as to preform the ceremony of incision upon some young females at the same time, after Dinner the Capt. with the Docter & purcer acompanyd Cunneah to the village to the house of Enow which was thronged with guests & spectators & the scene was then opened by the ceremony of introducing the wives of Enow & Cunneah & the candidates for incision or boring (each comming in seperratly & backwards from behind the scenes..being saluted by a regular vocal musical of all present & which had no unpleasing effect... in the same manner the presents were usherd in & displayd to the vew of all present & thrown together in a heap being a prefuse collection of Clamons Racoons & other Cutsacks [sea-otter cloaks] Cunstagas both iron & copper & a verity of ornaments this being done the spectators were dismissd & the guests placed in order round the house...the incision was then preformed on the lips & noses of 2 grown & 2 small girls which ended the distribution was then begun of the above articles. the Capt. receiving 5 otter skins the other articles were distributed among the different cheiffs according to there distinction. After which the Capt. took his leave & returned on board. Skins No. 1392. (Magee 1794)

Initially, Magee says that the pole is to be a sepulcher for the daughter of *gannyaa*, but later he identifies the deceased as the infant daughter of Enow, a principal chief and the son or son-in-law of *gannyaa*. Howay's account of these events is notable in its omission of these important facts (Howay 1930: 91–92). Although Magee's account does not specifically describe the painting of the pole by Roberts's men, they did agreed to do this, and later descriptions confirm that the pole was colorfully painted (see Burling's account, below). It is interesting that the raising of the bear sculpture took place twenty days after the support pole was raised, and both occasions were followed one day later by the giving of gifts and speech making. The final positioning of the bear (possibly accompanied by the interment of the child's body within, though this was not described) was clearly the climax of the event, after which the women's lips and noses were pierced with great ceremony.

All of the sea traffic that converged on Haida Gwaii during the 1790s led, perhaps inevitably, to several violent incidents. Often the fur traders would hold one of the native people on board as a hostage to assure that his fellow villagers would return to trade. John Boit, captain of the *Union,* who had earlier been fifth mate aboard the *Columbia* with Robert Gray, recorded such practices at *k'yuust'aa* in 1795. His log also recorded the trip of two Haida women from *k'yuust'aa* to China aboard a Portuguese ship with a Captain Vianna. Perhaps these women were *gannyaa*'s daughters:

John Boit's Log, 1795

June 7th, 1795

At 9 AM abreast Tadent's village. The cheif came off with a great number of his people & several valuable furs was purchased. These natives inform'd me that a Portugueze Brig had been here & carried away two of the kings daughters to Macoa in China by consent, that he was to return them in 6 moons. We soon came on to blow a gale of wind, the canoes left us & we struck off. At noon picked up a canoe full of indians [among them] 2 chiefs almost found dead.

June 8th, 1795

Heavy gales with rain. A Standing too & fro under ye lee of North Island. At 2 PM A large canoe come of but brought no Skins. At 3 She left us leaving ye Chief on board, ye Natives told us they had plenty of Skins. But they was saving them for Vianna a Portugueze who had carried two of there Woman to Macoa. Lat Obsd 54° 31' N.

June 9th, 1795

Moderate breezes & hazy. A 4 PM A Canoe boarded us, in which was Cunniah's Wife, Who made a present of two Skins for which I made a Suitable return. The Canoe had many skins on board her, but She would not sell them. At 6 The Natives all left us, except one cheif, whom I detained for fear they wou'd not come of again. At 8 AM A large Canoe come of from the Village Neden, & a fine lot of prime skins was purchased out of her, Some Small Canoes from Cunniah's with fish. Iron & cloth most in demand but furs are at least 100 P cent dearer than when the Columbia was to the coast.

June 10th, 1795

Moderate breezes & pleasant, Standing in towards ye Village. At 3 Was close in with it. Fir'd a gun, & hoisted the ensign, down Mainsail. At 4 A large canoe came of & brought a few Skins. Cunniah's wife was in ye Canoe, So I took her on board & let ye Cheif go, & Sent the Canoe to inform them of it at ye Village. At 8 Two Canoes came along side from Cunniah Out of which I purrchased a Capitall lot of prime furs, & paid them well for them. So I made ye Old woman a present & let her go, besides making many presents to all her people. At 9 PM Made Sail for Barrells sound. (Hayes 1981: 45–47)

Although the majority of early encounters were cordial, some less-than-scrupulous fur traders treated the Haida people cruelly, and either they or the next Euro-Americans to happen along reaped their retaliation. In 1799, *gu.uu* complained to Samuel Burling, clerk on the ship *Eliza,* that in 1795 Captain William Wake on the *Prince William Henry* had imprisoned him and two other chiefs and ransomed each of them for two hundred skins (Burling 1799: 39–40). Another such unscrupulous captain was Kendrick, who had detained *xuyaa* and Skulkinants on board the *Lady Washington* in 1791, clamping their legs in the trunion socket of the gun carriage and holding them hostage for the return of some stolen laundry. After their being ransomed for all the furs in the village as well as the stolen laundry, *xuyaa* unsuccessfully attacked the ship. He was

wounded in the back and lost his wife and several other members of his family along with forty to sixty other Haida people. This was such a humiliation to *xuyaa* that he was forced to attack several additional European ships in order to save face (see note 15).[28]

One such ship was the *Union* under John Boit, who, after leaving *k'yuust'aa* in June 1795, had proceeded south to *xuyaa*'s village. There Boit recorded the names of both Skoich Eye, reporting that he seemed to be the head man, and Coyar (*xuyaa*), who was the second. Clearly, *xuyaa* had been the most important chief in this area before the Kendrick incident, and Boit's account suggests that he had indeed lost stature as a result. Boit tells us that Skoich Eye led forty canoes, each with thirty men aboard, in an attack against the *Union* on June 21, 1795, and was killed in the effort by Boit. Several others on board were knocked down and wounded, and forty more were killed trying to escape. The Haidas later ransomed the wounded and captured warriors and reported that seventy of their number had been killed.

Though Boit made no specific mention of "Coyar" in his account of this battle, both Wilson Duff (1976) and Edmund Hayes (1981) concluded that *xuyaa* was among the dead in the battle (mistaking him for Skoitch Eye).[29] Because no further account of him appears in the journals, *xuyaa* may well have perished there. Scatts Eye, however, is mentioned by name in the journal of Captain Charles Bishop of the *Ruby* as being at Cumshewa the very next month after the Boit incident. "Skoitch Eye" also reappears four years later in the journal of the ship *Eliza*. He is described has having been responsible for attacks on several American vessels and in possession of six scalps taken from his victims (see below). This clearly suggests that Boit was mistaken in thinking he had killed Skoitch Eye. Perhaps he survived his wounds, or perhaps it was in fact *xuyaa* whom Boit killed. Another possibility is that the later Skoitch Eye was a nephew or brother who took the name after his predecessor's death. Swanton gave the name Nañ na'gage skilxa'ogas (*nang naara rii skil cawgyaas*), "costly things fall into his house," for the chief of the *qay7ahl 'laanaas* (Qa'-iał la'nas, People of the Sea Lion Town, E9), who lived in Skotsgai Bay (Swanton 1905a: 274). This might have been an heir of the late-eighteenth-century Skoitch Eye. MacDonald identified this man as a late-nineteenth-century village chief at Kaisun, located on the west coast of Moresby Island. He suggested that the name "Skotsgai" and related spellings of it were a corruption of the last part of this name (MacDonald 1983: 117).[30]

Violent attacks during this period were not limited to those between Euro-Americans and Haidas. Captain Bishop of the *Ruby* recorded *gu.uu*'s account of a conflict in which *gannyaa, gu.uu,* and *yaahl dàajee* were allied against Cumshewa. This incident may have been a factor in these chiefs' moving their permanent residences to Kaigani and other more northern villages.

Captain Bishop's Journal, July 1795

Monday 27th, 54°

The ship was tacked and we Stood towards her when very soon after the Cannoe came alongside. She was Paddled by 3 men, and a Forth with a great Coat and round Hatt on sat in the middle: He came on board with Confidance and taking me by the Hand Said "How do you do Sir." "Cluto

(ship [in Chinook jargon]) be England King George Cluto." "He be Boston Cluto." When answer'd it was an English ship He expressed great Satisfaction. He now told us his Name, Illtadza [*yaahl dàajee*], said He was chief, Equal to Kowe "and lived at the same place at a norther villige." He also informed us of Captain Moore's having been there: but had Sailed a good while ago: he also mentioned another Captain. He promised us a Large Quantity of Furs: In the afternoon the breeze Springing up Fresh he ordered the Cannoe away being fearful of having her upset by the voloscity of the Ship through the water! Staying on board himself to accompany us to Port Mears [Kaigani], his place of residence: dureing the Evening and all night it blew Fresh from the S West with Thick Foggy weather: and altho' we keept Plying pretty close in Shore we did not see the Land till Daylight when it Ceas'd up. We found we had gained but little Ground, owing to a South Easterly Current, Port Mears bearing West 4 or 5 Leagues.

Illtadza knows Captain Adamson of Mr. Teast Ship the Jenny, and Counted 12 moons since he was at Port Mears, where he got "Quan Nuckees."

As we where beating accross the Sound to get within Cape Irvin [Cape Muzon] where the Chiefs Kowe and Illtandza has their Summers residence a Cannoe under Sail full of People boarded us. The Chief was the Person mentioned in Mears voyages to the NWest America who Exchanged names with Captain Douglas when he first discovered this Large Tribe. Upon his approaching the ship he called out "Douglas Con nee ha", "whats your name." Upon being answered he said he had no skins to sell but that he was going to Shakes upon a trading Expidaton. Being presented with a trifling Present he took his departure. Illtadza told us Douglas Con nee ha was chief of the whole district, and that himself and Kowe were the next but where all united under the command of the "Huen Smokett" Douglas Con nee ha. At six oclock in the Evening we anchored at Port Mears in 26 fathoms water distant from the shore 1/2 mile Cape Irvin bearing SEbE 3/4 mile. Kowe and his Family came off in a Jolly boat which a Captain "Hubbuts" (Roberts) had given him. The Chief instantly Presented me with 2 Rare Furs of the Sea Otter, and the Jolly Boat. Said Captain "Moore" and Captain "Lukwanny" [Newberry] had been there before us and he had Sold most of his nuckees, but nevertheless, when we had bought all that was at "Cye Ganny" as he called his Town, he would conduct the Ship to where we should get Plenty of Trade. Kowe sleept on board, and the next morning and dureing the whole day we carried on a Brisk Trade for some of the best Furs we had hitherto seen. Kowe staid on board and Enforced the trade to our advantage. He also informed us that Comswa had Cutt off a Brig belonging to Boston the Captian's name Paulin or "Pullen" (Berleig) [Burling, the brother of Samuel Burling, on the *Resolution*] and Killed all the Crew but one man, a Sailor, which he keeps at his house, that as soon as they see a ship apper they Put him in a cave in Irons. Indeed we had Observed when we where there and at the Sound before we came there, that these Indians were uncommonly Bold and Impudent, their large cannoes full of Fire arms and Spears, and where ready no doubt to snatch any advantage over us that might offer. As it was we where on our Guard, but had we known this Event it would of doubled our vigilence and after they had disposed of their Skins should

have availed ourselves of the favourable opportunity of seizing this bloody Chief as he staid on board some time after the rest where gone on shore, and kept him till they brought off the Poor Sailor, whose heart no doubt must have Sunk within him when we fired Guns as signals for trade.

Thursday 30th

This morning Kowe informed me that had sold all their Furs at Cye Ganny and advised that we should get under weigh and Proceed up the N West Branch of the Sound. This we did . . .

Kowe is about 36 years of age, an hansome Robust Figure. His Actions bespeak him an affectionate Husband and Father, and tho' Gentle and Easy with his Friends, not wanting in Spirit to commit the most horrid Acts of revenge upon his Enemies. From his living with me on board and sleeping in the Cabbin, I have learned much of their manners and mode of Life. It appears that when a Chief dies his children do not inherit the fathers office, but his brother and so on till they are all Dead. It then takes its right through the Male Issue of the Eldest sister and on in right through the Family, and in Case of default an Election takes Place in another Family. They mostly have but one wife, however the Chiefs tread out of the Common road and Kowe has his Trio. The women seldom have more than four children, scarcely ever five and Six is a Prodigy. When told that the Queen had borne 16 they would hardly credit the assertion, and being informed that myself was one of eleven they surveyed me with great attention repeating the account to each other for some time. There women as well as those at Charlotte Isles and Shakes Sound have the under lip perforated, some few of them Excepted, and there where Generally Ladies of Easy access, but this Tribe both Men and women possess more native modesty than we have hitherto met and are infinately Superiour to the Southern Tribes both in Manners and Persons. They are very numerous, and where much more so before the small Pox, which raged here a few years since, and by Kowes Account, swept off two thirds of the People, scarcely any that where affected Survived — They understand the use of Fire Arms well and Kowe himself is reckoned the Best Marksman among them. Of this we had a Proof. He shott 2 Large Geese at a single shott: leaving only one Flying. Kowe informed us that as soon as Trade was over and the "Huen Clews" great Ships where all gone and they had Provided their winters Store of Fish, that the whole tribe united where going to attack Comswa in a fleet of Thirty War Cannoes and requested if we should touch there not to Sell them Powder Musketts and Ball. The Cause of this Expidition is Kowe sometime since sent a Cannoe in which was his brother and one of his Wives on a trading Errant to a tribe near Comswas and while they where there, comswa attacked these People and subdued them. He also seized Kowes cannoe and Killed his Wife Brother and the Crew. Kowe has been at some pains even dureing the time he has been on board of us to rouse the Chiefs to Revenge, and Douglas Con nee ha (the great Smokett) is gone to Shakes as well to trade as to win him over to join them, or to stand nuter. These People Kowe ashured me are not Cannibals, but that they Cut the heads of their Enemies and Scalping them. When cleaned the Sculls are deposited in their great houses as trophies of their Prowess and Victory.

We cannot help wishing him success and victory over Comswa and his Bloody Tribe. Kowe seems confidant of it and Promises to take care of the Poor Sailor if they find him alive, and we even made him ashure us that altho' Comswa should oblige him to fight against Kowe, He should not fall in cool Blood. (Roe 1967: 80–84)

Later on this voyage, after encountering the American vessel *Mercury* at Nootka Sound, Bishop learned both of Captain Newberry's accidental death at *yaahl dàajee*'s hand and of the rescue of the sailor held at Cumshewa, who had been captured the year before (in July 1794) when the schooner consort of Captain Roberts's brig was attacked and all but this man were killed:

Captain Lewberry [Newberry] arrived on the coast near Norfolk Sound Latt 57° N. in May last from Boston: and trading the Coast along to Mears anchored there on the Evening 19th July. His Friend the Chief Illtadza was sitting in the Cabin with him and Snapping a Pistol which was not known to be loaded, and which Captain Lewberry had given him, it went off, and shott Poor Lewberry Dead. The confusion which such an Event through the ship in may be concieved. Lewberry had just life to say it was an accident, and Prevented any Bloodshed with the Natives, who to a man, expressed a deep concern for his ill Fate, and assisted at his Funeral with their Death Songs and meloncholy orations. The ship staid and made good trade there afterwards — and then Sailed in Company with the Mercury to Comswas, to try and Catch that Chief, and redeem the Poor Sailor — this was executed with the desired Success, for on the Evening of their arrival they seized Scatts Eye the Chiefs Brother, his Family, and a son of Comswas. In doing this there was several Lives lost, on the side of the Natives and the Women fought with a degree of Desperation unequalled. Having secured their Prisoners, they demanded the Sailor, whose Existence was denied by every one for a long time, but at last on a Promise that their lifes should be sacred and Seeing the Humanity of their conquorers in dressing their wound &c one of the Women confessed that he was chained to a tree in the Woods. — The man who owned this Poor Fellow as his slave, was Brother to the only Native that was killed in the attack of the vessel [the schooner under Captain Roberts], and when a Division took Place of their Booty, He was decreed to him as a Sacrifice to the manes [*sic*] of his Brother. This Native demanded all the accumulated treasures of Sacctseye to redeem him, and which was Paid the next day, when the Sailor was brought on board the Mercury by two Women in a Cannoe. (Roe 1967: 95–97)

From this we learn that Skatts Eye, said to be Cumshewa's brother, and his family were captured and ransomed for the enslaved Boston sailor. Skatts Eye had to pay dearly for his own release and that of the sailor slave. Certainly this must have further enraged him against the Boston men. The freed sailor also told of a battle between Cumshewa's and Skidegate's tribes that he had witnessed during his year of captivity. It took place on the beach at Skidegate, and Skotseye initiated it with spears and daggers. During the fight, eleven of Cumshewa's people were killed, and eight of Skidegate's wounded (Roe 1967: 98–99).

Samuel Burling, clerk for Captain James Rowan on the ship *Eliza*, which sailed from Boston in 1798, picked up this story as it unfolded four years later.[31] By this time the ranking chiefs were careful not to venture aboard ship without having a hostage go ashore. Consequently, more members of the crews had the opportunity to experience life in the villages. After trading at *k'áyk'aanii*, the *Eliza* went south to *k'yuust'aa* and *daa.adans*. Burling, the willing hostage, stayed one night in the house of *yaahl dàajee* at *daa.adans* and the next night at the house of Chilsenjosh, *gannyaa*'s brother, at *k'yuust'aa*.

Burling's Journal of the *Eliza*, 1799

March 17

In the morning having a fair wind from the westward we were obliged to postpone visiting Captain Duffin. We got under way with a light breeze and of course did not run out of the bay fast. We passed Caiganee point at 1/2 past 10 o'clock and taking a Buoy off it; and though we were close hauled all the way, yet anchored at North Island at four o'clock in the afternoon in Cloak Bay, so called, I believe by Captain George Dixon who anchored here in the Queen in the year [1787].

We soon had several canoes round us, among them was the wife of Cunneaw a Chief here who resides at a Village on the opposite shore to the Southward of us. Another was Altatsee well known on account of the unfortunate death of Captain Newberry whom he accidentally shot with a pistol that he was buying of him in his cabin. He, however, would not venture himself on board of us; having been several times made prisoner by different vessels and obliged to ransom himself by giving up the greatest part of his skins. This was the way some people, not worthy of the name of Men (and who I thank Heaven cannot call themselves Americans), took to make their fortunes. Cunneaw, Cow and Altatsee the principal chiefs on the Coast they trepanned on board their ships, and having seized and even laid some of them in irons, forced them contrary to every principle of honour or humanity to deliver up their Skins before they would give them their liberty.

March 18th

In the morning we had ten or twelve canoes along side. Among them was Altatsee and Cunneaw with all his family. Some of them (and among the rest Altatsee) stayed till dark before they left us. We, however, only bought in the course of the day fifty six Sea Otters' Skins, one prime cotsack and twenty two tails. The wind all day has been at South or Southwest, attended at times with a thick fog.

March 19

We had the wind generally at the Southward with a thick fog. We had no canoe alongside till late in the day, and when come they did not trade at all smart; not being satisfied, though we gave them the best things we had in the Ship. Neither Altatsee nor Cunneaw would venture on board the Ship; and on Captain R[owan]'s pressing the old man considerably, he at length consented on condition that I should go into the canoe with his family and

be hostage for his safe return. This was agreed to. I went into the canoe and he came into the Ship without any difficulty. When dinner time came, however, the old woman, was so unjust she would not let me go on board to dinner, and if Mr. Bumstead had not humanely taken my place by her side, I should certainly have lost my dinner through female obstinacy. Altatsee likewise came on board on the same conditions as Cunneaw. He did not, however, stay long and what time he did appeared restive and uneasy. They informed us to day that Captn Dodge in the *Alexander* had a skirmish with Cumshewah's tribe and had three of his men wounded. He had, however, killed two of them, and got two or three scalps of white people as ransom for the lives of several more he had made prisoners. We bought in the course of the day fifty five Sea Otters' skins and forty five tails.

March 20th

We had several canoes alongside, among the rest Cunneaw, Altatsee and Chilsenjosh a brother of Cunneaw and who I understand will be Chief of the tribe on his brother's death. The old man however would not come on board as yesterday and persisted in not leaving his canoe. At noon Altatsee agreed to stay on board the ship as a hostage whilst Mr. Bumstead went to see his Village of Tatance [*daa.adans*], which consists of the large number of two houses. After staying a couple of hours and examining them he returned safe to the Ship. Having a great curiosity to see the Village and the manner in which the natives of the Coast live, I agreed with Altatsee to sleep at his house at night, and he left his oldest son on board as a hostage for my safe appearance in the morning. I set out about fifteen minutes before dark, and at dark was abreast of the Village of Tatance. As soon as the canoe struck the beach, Altatsee set up a loud halloo and five or six women slaves a number of dogs and children came running down to the beach to welcome us. Their astonishment at the sight of a white person in the canoe was extreme and they did not know what to make of it till they found that their brother Skittlekitts was missing. They then concluded that Skittlekitts was going to Boston and I was to stay with them in his room. Altatsee now took me by the hand and led me towards the house. On entering it you may well imagine my astonishment when, instead of six or eight people as I expected, I beheld about forty people, men, women and children seated round an enormous fire which was made in the middle of the house. Some were employed in making fish-hooks for halibut, some wooden bowls. The women were busy broiling and boiling halibut. The children waiting upon the old folks and several of the females who were not slaves making wooden pipes.

At my entrance labour stood suspended, and they looked at me with about as much astonishment as Hamlet when he first saw his father's Ghost. Altatsee led me to the head of the room, and having drawn a large chest before the fire seated me on it by his side, and told me he was glad I was not afraid to trust myself in their power; and that I might be assured that even if I had come and Skittlekitts had not been left in my room on board the vessel they should not have hurt me or even talked bad to me any more than they had done to [?] and several others who had lived among them a long time. They always treated all white people as brothers who treated them well. They were not like Cumshewahs, and so far from it they were his

enemies as much as ourselves, and they would give us three skins apiece for every slave we would bring them from there; and that Cunneaw would give us twenty of the largest in [exchange] for Cumshewahs himself.

Your brother said he; . . . who was in Captn Roberts little vessel he killed and Kendrick's brother too. You will certainly kill him to revenge these deaths if you see him when you go there. I could do no less to support my credit than to answer in the affirmative.[32]

You would do well in doing so, said he, and if you do, will save of us that trouble. He killed my mother at the time he drove us from Keustat to Caiganee, who was sick and could not fly, but was obliged to be left behind and fell a sacrifice to Cumshewahs. He attempted to kill me when I went on a trading party to his village as his friend; but I made my escape and got over land to Skittlekitts country who gave me shelter.

They made me a kind of drink, or rather a kind of broth which was considered as a rich composition by them I suppose appearing to be extremely fond of it. I, however, did not relish it quite so well. It was made of Birch bark, or something that had that taste, and on my showing a piece and asking if it was made of that, they answered in the affirmative, and that it was much trouble to beat it up, and get it so that it could be eaten. Whether they told the truth or not, I cannot say, but must leave it for those who have lived among them to determine.

We spent the rest of the evening in talking about the trade — what was best to bring, what trinkets they liked best, &c. Altatsee then showed me his riches which were contained in the trunk we sat upon. There were some . . . [chenilles] several garments made of the wool of the Mountain Sheep and marked in spots with Sea Otter's fur which were very handsome. An ornament for the waist made of leather, with several hundred of the small hoofs on it that belong to the Deers' feet; this is used in dancing and makes a loud rattling when shook.

He had likewise a number of beautiful Ermine Skins which it seems they consider as a kind of money on the Coast; and a large silver spoon which he told me was a present from Captain Roberts. There were besides a number more of things, which he would not let me see, in the bottom of the chest; and I was informed by Mr. Bumstead that he refused him a sight of them in the same manner as he did myself.

He finally carried me to see his brother who was sick at the next house. He had the Venereal and had been in the same situation I found him in for six months they told me; they being utterly ignorant of the nature of the disease, and what it arose from, and were very thankful when I told them we would send him something from the Ship that would cure him.

We then returned to Altatsee's where they spread me some blue cloth on the floor (for the house was all floored with thick plank) and I laid myself down to sleep for the night, though they did not like my sleeping with my cutlass on, and pistol by my side. The night, however, passed without any interruption, except from the dogs who when they happened to stroll near me would acknowledge their dislike by growling not very agreeably in my ear, which, you may well suppose, was no sweetner [sic] to my repose.

I rose at day light, and having taken a sketch of the two houses to save the length of description, and seen two images that were a short distance from

them which Altatsee told me were intended to represent two Chiefs that were his relations (or rather they were his ancestors for they looked as if they were upwards of a hundred years of age) that had been killed in battle. I then got in to a canoe and was soon paddled along-side the Ship . . . (Burling 1799: 27a–32a)

March 21

On our arrival at the Ship they told us that Sky had arrived at Tatance, and we supposed he was from a trading expedition as he had left Caiganee some time before we did.

March 22nd

In the morning Sky came on board. He informed us that he was direct from Caiganee. That Captain Duffin gave such a poor price that they had not sold him three skins, and he had sailed three days since for Skittlekitts. After selling us a few Skins and getting a present of a bottle of rum, he left us and went over to Keustak.

Rum at present is not so much liked as Molasses by these people; the latter they are extremely fond of, for yesterday Cunneaw's wife sold the best Sea Otter skin we have seen since we have been on the Coast for four bottles of it. The name of it they pronounce not a great ways from brassis and rum they call lambs. This destructive liquor, I have no doubt, will in short time get to be prevalent all over the Coast. The Chiefs at present will always get drunk with it when they can get it given to them; and the Indians though they will not buy it yet, at Caiganee which is pretty much visited, they will take it fast enough as a present.

Old Cunneaw's wife is the best encourager of the consumption of rum here. Regularly before she goes home at nights she always comes on board to get drunk, and when in that situation is an object of astonishment to the whole Village of Keustak on account of the noise she can make with her tongue; and a dreadful plague to the old man who dare as well defy the devil as her, when artificial fluency is added to that tongue which is naturally so eloquent. He, however, has a quiet house of it for the fore noon of the next day, for she is obliged to sleep the whole of that to recruit her exhausted spirits and get ready for a fresh visit to the Ship.

In the afternoon Chilsensask [sic] came on board and, expressing a wish to sleep in the Ship, if I would go and stay with his family at Keustak, I willingly agreed to it; and just before dark set out on my second expedition.

It is pretty nigh two miles from Cloak Bay to the opposite shore where the Village is situated, and through this passage the tide runs the swiftest I ever beheld it. We went over just at low water when the tide was turning and the Indians expected to be able to reach the opposite shore before they were caught by the current, but in this they were mistaken. They had not got more than two thirds of the way over when we heard it coming in making a roar like a cataract, and they were soon obliged to use their paddles with great dexterity to keep the canoe's head one way and her sweep with the tide till she was taken by an eddy current; favored by that we soon reached the Village, or rather the beach before it; there being a long point of rocks extending near half a mile into the bay, inside of which is a large

flat at low water, which you have to go over to get to the Village, that being extended behind the reef on quite a level spot of ground. The force of the sea breaks on the reef and leaves it quite calm and smooth inside of it, so that no damage can happen to their canoes.

Over the flats they carried me on their shoulders and landed me safe on the dry beach before the Village. It was, however, so dark I could not see the houses but faintly, and was obliged to suspend my curiosity till daylight appeared.

The children and dogs, as at Tatance, came running down to meet us and I was obliged to walk rather fast to get rid of them. Chilsensash's [sic] wife walked before to show me the way to the house, and entering, introduced me to the relations of her husband. They then led me to the further side of the house and complimented me with the highest seat which was raised about two feet above the floor and ran entirely across that end of the house.

To my satisfaction I found here old acquaintance in the brother of Altatsee, who appeared to be as much at home as at his brother's house. He was very glad to see me and exerted himself all he could to entertain me by singing their war song and those of other tribes, each one having a song for themselves.

We were interrupted by a message from Sky who was in the next house desiring to see me. On entering the house I found the lazy rascal laying naked flat upon his back before a large fire. He half raised himself at my entrance, and made one of his people draw a large chest before the fire for me to sit on, then addressed me in what he thought excellent English . . . how de does? . . . sit down; and having placed himself in his former elegant posture, with the addition of sticking up his knees, began to enquire what other vessels we expected on the Coast from Boston . . . or country; and told me that the day he left Caiganee, they had seen two ships off. This was thrown out as a bait for me; but I felt determined not to gratify him on that head, and told him they must have been mistaken in seeing two ships; it must have been Duffin going to the Northward that they saw, for I knew of no other Ship except our's that was coming from Boston. He was rather too knowing however to believe that story, and said he knew I spoke twice, that being the name they give to a falsehood.

Captain R. having made him a present of a bottle of New England rum, he thought he could do no less in common courtesy, than to treat me with some; and accordingly mixed about a pint quite weak, which for a wonder he had the politeness to offer me first; and then with the exclamation of "Lambs lux" swallowed all but about two gills, which he was just going to send the same way with the first, without any regard to the rest of the company, when his wife interposed and insisted upon having her share with so much eloquence that Sky, thinking himself the weaker vessel quietly submitted, and surrendered up half, but when she got it in her hands, in violation of treaty, she drank the whole, and Sky, afraid to grumble could only hold on, by what was left in the bottle, determined to defend that as long as he could have the power of speech, and till she proceeded I suppose to arguments of force. The lady, however, satisfied with what she had got, contented herself and retreated quietly from the field of battle.

Upon my asking Sky if he would go with me and see Cunneaw, he replied

in the negative; what should I go to see Cunneaw for, said he: but besides I have dined on board your Ship, look admittedly I have eat a great deal and had rather lay here and sleep than go with you to Cunneaw's; but one of these that have not dined with you at your ship will go and show you the house. I then took leave of him and set out with my guide for Cunneaw's.

Being shown the house, I entered and found the old man, like the patriarch of old sitting (surrounded by his children) naked before a large fire. There were two or three children grown up; twelve to thirteen between four and fourteen years old, besides nieces and grandchildren. Reckoning slaves, slaves' children and all his family amounted to about sixty persons.

The old man and his wife expressed great joy to see me at their house, and drawing a small box between them, seated me upon it and began each to talk upon the subject nearest at heart. The old woman laid violent siege to me about letting her have some more brassis (molasses) for a large skin she had; it was with some difficulty I avoided being forced to take it with me to sleep upon over night.

The old man told me a long story about the first vessels that visited the Islands. Captain Douglas as well as I could learn was the first that visited this part, and laid the foundation for a firm friendship with the tribe, by his kind behaviour towards them, and to this day his memory is much revered among them all. Cunneaw and he made an exchange of names and the old man as often calls himself Douglas as Cunneaw and always if he is asked his name by white people tells them it is Douglas Cunneaw.

Since Eastgut is dead who was an old chief who resided at Chilcait up Menzies Straits in the latitude of 60., Cunneaw is, I believe, the oldest Chief on the Coast; and is likewise the most respected by those of the neighboring tribes to whom he is known; indeed, we never visited a place on the Coast, but what we found they knew him or his tribe by woeful experience, having often made expeditions to the northward when at war as far as Sheetkah, plundered their Villages and brought off numbers of prisoners. Capt. Rowan saw several girls here that he had formerly seen as far to the Northward as 59° that were now in the condition of slaves here.

They pressed me with great earnestness to eat, and set before me all the house afforded that which was roasted halibut and dried Salmon and a wild liquorice that grows here and is very sweet, but finding I was not inclined for these goodys, the old woman proceeded to the last offer of friendship which was a lady for the night out of her numerous seraglio, with which she accommodates all vessels that stop here. I told her I must decline that favor as I had engaged to sleep at Chilsen's house and it must not do to break my word as he slept on board the ship in my room: and I now had somebody to back me in this, for Chilsen wife thinking that perhaps I might take it into my head to quit the village and she should then have nobody to remain as hostage for her husband sent one of her relations, with Altatsee's brother, to request I would return there and not stay to sleep at Cunneaw's.

I was therefore obliged to take leave of the old man and his wife and return to the house of my hostage where they were much pleased to see me and exerted themselves to the utmost to entertain me by singing songs, to the tune of which a poor little fellow not higher than my knee danced. His name they pronounce the same as Consequence. This unfortunate little

wretch (who was not more than five years old) was a slave. His father was formerly a chief of some note in the neighborhood of Sheetkah, and in an expedition which was headed by Altatsee and Chilsenjosh to the Northward, they attacked the Village of his father, whose whole family were the first that they murdered, this boy being then extremely young they kept alive, and he was now a great favorite in the family of Chilsenjosh. This night they had painted his face and powdered his head with feathers and made the poor fellow dance till he was most tired to death, and I was obliged to interpose in his behalf.

I spent so much time in visiting Sky and Cunneaw and going into the other houses of the village that it was nigh 1 o'clock before I laid myself down on my bead of blue cloth with a bundle of skins for my pillow. I however slept without interruption till the morning.

March 23rd

In the morning I was early to examine the Village and take a sketch of it before I went on board. The Village consisted of eight houses of which Cunneaw's was the largest being about fifty feet long, thirty broad and fifteen to the rise of the roof — to the peak of it I suppose it was about twenty two or three feet. At the right hand of the village as you go to it were a number of wooden structures raised I suppose over the bodies of their dead chiefs. Some were exactly like a gallows, some a solid square piece of timber about fifteen feet high on which were carved the figures of men and children. But the only thing that I saw which had any idea of proportion was a pillar by the side of Cunneaw's house on the top of which was a figure intended to represent a bear; the figure and pillar were both painted red with ochre. The teeth, eyes, nostrils, and the inside of the ears (which were stuck forward) of the animal were made of the mother of pearl shell; which gave it a very beautiful appearance in comparison to what Northwest sculpture generally has. Altatsee was on board the ship on my arrival, but as soon as I got in at one side he got out at the other and was soon in his canoe. The rest of the day passed without anything material.

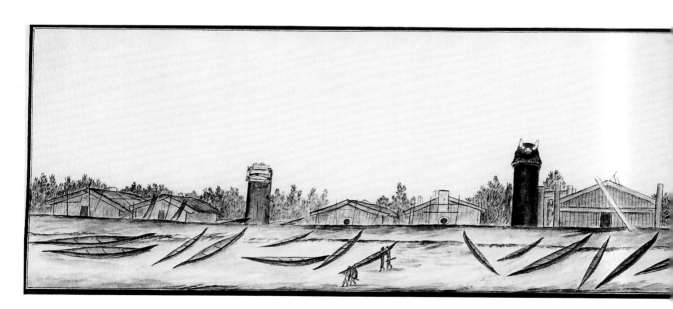

March 24th

 In the morning it being tolerably clear and a fresh breeze we attempted
to get under way, but the wind shifting to our great mortification we were
obliged to give up the attempt and remain in our present station. This day
we were employed in purchasing board to make boxes for our skins. The
whole of the day cloudy with rain.

 Altatsee was alongside several times. We endeavored much to persuade
him to let a son of his called Skittlekitts go with us to Boston. He was a fine
boy about twelve years old and the likeliest we had seen on the Coast. His
father, however, would not consent to his going without our leaving
another person in his room, and the son was not overwilling to go on any
terms. (Burling 1799:32a–39)

 Unfortunately, the sketch that Burling made of the two houses at *daa.adans*
apparently has not survived.[33] He reported that there were only two houses at
daa.adans at this time, belonging to *yaahl dàajee* and his brother. The drawing
Burling made of the village of *k'yuust'aa* did survive (fig. 2.10) and clearly shows
a pole with a bear figure on top to the left of the largest house. This was the
pole raised by Captain Roberts five years earlier and described by Magee as a
mortuary pole for Enow's daughter, *gannyaa*'s granddaughter. Burling's descrip-
tion of the bear with inlaid ears, eyes, teeth, and nostrils, and of red paint on
both the bear and the pole, adds to our knowledge of this memorial sculpture.
The shaft of a similar pole still stands at *k'yuust'aa* today, and a bear, which has
fallen, rests on its back at the base (fig. 2.11). It is possible that this is the same
pole.[34] In addition to all eight houses and eighteen canoes drawn up on the beach,
Burling's sketch shows what is probably a double mortuary in front of the houses
to the left end of the village and a mortuary with four posts and what appears
to be a carved human figure tucked behind *gannyaa*'s house and the new bear
memorial. True to other descriptions of this village, there are no house frontal
poles, though the house to the left of *gannyaa*'s has a wide vertical panel above
the door.

Fig. 2.10. Samuel Burling's drawing of
k'yuust'aa village, 1799. Courtesy of
the Massachusetts Historical Society.
Photograph in the John F. Henry
Collection, Burke Museum.

From *k'yuust'aa*, the *Eliza* proceeded back to Taddiskey Cove, near Kaigani, where Burling and Captain Rowan learned from *gu.uu* (Cow) that he, too, had been subjected to maltreatment, in his case by Captain Wake. They also heard an account of *yaahl dàajee*'s accidental killing of Captain Newberry:

March 25th

In about fifteen minutes our old friend Cow who had known us as we passed by his village came on board, and was much rejoiced to see us returned safe. He, as usual, slept on board. We spent the evening in conversation on several topics particularly respecting the treatment he suffered from Captain Wake which we could not have believed had we not afterwards have been informed by a person who was with Captain Wake that it was all literally true.

Wake it seems in a thick South East gale ran into Meares Bay, before the harbours of Taddy's Cove or Key were known to the vessels that had been on the Coast, or, at least, *he* knew nothing of them. In his distress Cow came off to him and piloted his vessel into Taddy's Cove, when he ungratefully seized him, and not only detained him a prisoner, but laid him in irons and kept him in that situation till he ransomed himself. I told him, cried he, that I was a Chief and not a common man — those irons are disgraceful — take them off — kill me, and I will say you are good. But he was a great thief, said he, and not a good chief.

Neither did we without emotion hear him recount the particulars of Captain Newberry's death (which happened in this place) and to which he was an eyewitness. This unfortunate man, whilst he lay in this harbor was accidentally shot by Altatsee with a pistol which he was buying of him and expired in a few minutes, having only time to declare that Altatsee was innocent, having himself told him that the pistol was not loaded. Altatsee instantly snapped it, and the charge went through Newberry's body who sat the opposite side of the table. He lies buried in the edge of the wood opposite the ship. Before we leave this place I shall go look at his grave. Newberry, said Cow was a good man; he is gone to a good country, and I shall not see him again, but I have his chest at my house in which he kept his clothes, and when I look at it, I think of him. (Burling 1799:39–40)

March 29th [at Kaigani]

In the afternoon Cow having left one of his children on board, I went ashore with him to the village. It is situated about thirty rods from the water at the foot of a rocky mountain. No situation could be better chosen for a village in this Northern region, the houses fronting the sun and the high mountain at the back being an effectual screen from the freezing Northerly gales. It is larger than Keustak, the houses being eleven in number, they were all built in the same style as at Keustak except one which I took a sketch of.

Cow's house, so far from being any way ornamental like Altatsee's at Tatance, was the shabbiest looking one in the Village and hardly tight enough to keep out the weather. It, however, was well furnished with the goods of this world, inside being lined with trunks and chests full of provisions, Skins and trade that he had bought of us. Among other things Cow showed me about one hundred and twenty beautiful white Ermine Skins

which I now found were really considered here in the same light that we do Silver and Gold, except that they never part with them but hoard them up with great care; the chiefs, however, have the best opportunity of amassing them, for as they are not to be got by barter, the common people can have but little chance to collect them, whereas the Chiefs generally get a present of some Northern Chiefs as a mark of friendship, when they are trading among them, and often are bribed, I suppose, with the same as the price of peace with their tribe when they are making a successful war.

Cow told me that next Cunneaw's his was the greatest number possessed by any Southern Chief. Sky, he told me had but twenty and Altatsee I knew had but twenty five of them which he considered as a considerable treasure. The value of them, it was difficult to ascertain, for we were bound to the Northward to Chilcart where they are brought from and had promised them to purchase some to bring here, they of course endeavoured to keep the value a secret from us. Cow, however, told me that he would buy as far as his Skins would go at the rate of a prime Sea Otter's skin for four of these "click" as they call them, and that Sky would do the same. I saw likewise a number of little presents that had been given to him by different Captains who had visited this port; a number of suits of clothes, all packed away with great care for to put on, on great occasions, and at the upper part of the house stood Captain Newberry's chest that he had told us he held in so much esteem.

Cow's wife who is a very pretty woman (setting aside her wooden lip) was employed like a good housewife at her needle, though she left off her work at my entrance to talk to me about the trinkets she wanted me to bring them when I came to the Coast again; and being certain that would never happen, I did not scruple to promise to all they wished me knowing they would not have an opportunity to reproach me with breach of promise. I was extremely glad to hear how well pleased they were with our trade and good treatment of them, their satisfaction of which they expressed in strong terms.

On leaving the Village, Cow pointed out to me the residence of the . . . Chief Shanahkite which was on small island about forty rods from the Village, and separated from it by a swift stream running between. They are not allowed it seems to enter the Village (or perhaps they may be afraid to, for what I know) so great is the jealousy of one tribe towards another, though friends. (Burling 1799: 42–44)

Talking with *yaahl dàajee* (Altatsee), Captain Rowan had learned of the trading network that existed between the Haida and the Tsimshian (Cockathane and Chibbaskah tribes),[35] through which the Haida acquired many furs that they then traded with the Boston men. He determined to go to the source, much against the wishes of Cow, and he engaged a Kaigani man named Cotseye to guide him there. This apparently was a different person from Skotseye, for he was later described as being the son of Hatestey, a Kaigani man. While at Chibbaskah [Kitkatla?] the party met a man named Kilshart (*kilsdlaa*?) who was a brother of Cow. He was later described in lectures by William Sturgis, a former assistant to Captain Rowan on the *Eliza*, as having a pockmarked face, one sunken eye, and one blind walleye (Jackman 1978: 131). Kilshart told them

that Scotseye, a chief of Cumshewah's tribe, and the person by whose means Captain Roberts tender was cut off and several more unfortunate Americans butchered, among whom were Captain Hill, Mr. Elliot and Daggett the Steward of the *Otter*, was at this time up at Chibbaskah, and that he had been up there some days; that Scotseye had stopped to see him as he went up, and shown him the scalps of six white men, and told him their names, but he had forgotten them: four, however, were taken off the heads of those killed in the little vessel he said, and who the other two were he had forgot, but Scotseye had shown him two among them, which he said he was sure he had told him were chiefs. His son was with him and his brother who was the identical person that stabbed Captain Hill and probably took an active part in despatching of the unfortunate Mr. Elliott likewise. If these two villains should happen to fall on our way, which they cannot now well avoid, they will not fail to receive the reward due to their many merits. We shall decoy them by calling ourselves an English ship, they being willing to go on board anything "George [cluto, or ship]" but American vessels they are very careful not even to come in sight of, much less reach. (Jackman 1978: 86–87)

On May 7, 1799, at Chebbaskah, after trading for all the skins that were available, the *Eliza* successfully captured Scotseye, his brother, and his only son, Elswosh (*7iljuwaas*). A Tsimshian chief named Shakes attempted to negotiate their freedom, and Captain Rowan tried to exchange the son, who was considered innocent of the offenses charged to his father and uncle, for the scalps of their victims. Shakes turned three of the scalps over to Rowan but said the other three were in the possession of Scotseye's wife, and she refused to give them up. All three prisoners were therefore taken to Kaigani. Rowan planned, however, to return Scotseye's son to Skidegate at Shakes's request, since *7iljuwaas* was married to Skidegate's sister and was more at home there than at Cumshewa. But when the *Eliza* arrived at Kaigani, Rowan found the ship *Ulysses* in a state of mutiny and was obliged to deal with that situation. He turned both Scotseye and his brother over to *gu.uu*, but he kept *7iljuwaas* on board. Through a complicated turn of events, Captain Lamb of the *Ulysses* was seized by *gu.uu* and held hostage for *7iljuwaas*, who was eventually turned over in exchange for Lamb's release. *7iljuwaas* later told Rowan that he was content to remain at Kaigani and that his mother-in-law, Altatsee's wife, had come over from *daa.adans* to see him (Jackman 1978: 92–99).

William Sturgis, in a lecture years later, gave a colorful account of the execution by stabbing of both Skotseye and his brother, saying that eighteen hundred to two thousand Haidas, as well as the crews of three Boston ships, witnessed the event, which took place on May 12 in a large war canoe off of Kaigani. In the middle of the canoe stood *gu.uu* (Kow) with the executioners, who were identified as Quoltong and Kilchart, *gu.uu*'s nephew and brother. Curiously, Burling's journal of the *Eliza* does not mention this execution, and one wonders whether Sturgis embellished the event for his own purposes at a later date (Jackman 1978: 99–100; see also Malloy 2000). Burling did record that in parting on May 13, *gu.uu* "made me a present of his dagger which was the handsomest I had seen on the Coast" (Jackman 1978: 101; see also Malloy 2000).

About a month after this incident, the *Caroline*, with Captain Richard Jeffry

Cleveland in command, sailed past Kaigani and found the village deserted (MacNair 1938: 190). This fits with a Haida account of the abandonment of Kaigani in which the people moved to *hlanqwáan* after the death of *7iljuwaas:*

> After that, they came to live at K!aiga'ni. The Middle-Town-People, the Tc!ā'aɬ-Town People [E23], and the Sᵉalᴀ'ndas [E22] lived there; but still they did not stay there in winter. Only when spring came they began to live there; and when the salmon began to run, they started off. They lived there a long time. But at length Xā'dᴀsgot came thither and killed a Skidegate man there, named Î'ldjiwas. After that, they ceased living there. After they had entirely given it up, they came to live at Klinkwan, where they staid. They stopped going out. (Swanton 1905a: 89)

This oral history suggests that rather than being returned safely to Skidegate, Skotseye's son, *7iljuwaas,* might also have been executed (with his father and uncle?) at *k'áyk'aanii.*

After going to Skidegate, Captain Cleveland returned north, anchored south of Point Rose (Rose Spit), and met two canoes, including one carrying *gannyaa*'s son-in-law (Enow?), who revealed that relations between his people and Cumshewa's were not good:

Log of the *Caroline,* June 1799

June 24th

[W]e came to anchor in 10 fathoms, about 2 leagues southard of Point Rose; as one of the Warriors was very solicitous to come on board, & our business being nearly compleated on the Coast; I permitted him to; & this was the first Indian that had been on board since our arrival; this warrior is Soninlaw to (Coneyaw) the head chief of the Tytantes tribes, who with a number of warriors, have come over on an expedition against Comma- shawaws tribe; after purchasing what Skins they had, amounting to 59 Skins, 5 Cotsacks and 29 tails, as the Indian on board, had assisted us considerably, we rig'd him out in a Shirt, jacket & trowses, with which he appear'd much pleased; but this pleasure was much damped, by presenting him a handkerchief in an improper manner; it was tossed across the Cabbin to him; which hurt his keen feelings so much, that he threw it from him in disgust, & tears started from his eyes; we however pacified him by assuring him that we did not know the North West fashion & that that was our man- ner of making presents. (MacNair 1938: 192)

It seems unlikely that *gannyaa*'s son-in-law and his warriors would have attacked Cumshewa's village with only two war canoes, but if the missing Kaiganis had been along on this expedition, they must already have been on their way back when Cleveland encountered *gannyaa*'s son-in-law, because three days later he found *gu.uu* (Kow) in residence at Kaigani:

June 27th

[P]ass'd the Southern point of Higanny; previous to which; the celebrated Chief Cow (*gu.uu*) came off; he is generally indulg'd with coming on board every Vessel & particularly this; it would therefore have been folly to have

prevented him; he was much confused on first coming on board, at not finding the former commander, but soon regain'd composeure; I sold him my perspective glass for 2 prime Skins, made him several little presents, and he left us extremely well satisfied. . . .

June 28th

[W]ere abreast the village on North Island, from whence we soon had a number of canoes off; among them was Coneyaw [*gannyaa*] & Eltargee [*yaahl dàajee*] (the head Chiefs) the latter of whom very readily came on board without asking permission; this is the Indian that accidentally shot Capt. Newberry; a sulky illnatur'd fellow, & one I would not admit on board again. (MacNair 1938: 193–194)

After twenty-five years of commerce between Haidas and Europeans and Euro-Americans, starting with the brief and "affectionate" visit of Juan Pérez, relationships had gone from friendly to wary, and the affairs of the visitors had become seriously enmeshed with internal relationships among the Haida people. Although this review of the visitors' journal accounts reveals only an inkling of the events that were unfolding and cannot possibly tell us how the Haida's internal conflicts played out, it does give us a glimpse into the personalities of the players and a fragmented view of their complex family relationships.

We know that *gannyaa* was the principal chief at *k'yuust'aa* and that he and his wife dominated the trade there in the late eighteenth century. They had several children (see chart 1),[36] including a son who was a chief at an unknown neighboring village, probably the home of his mother's brother (Wagner and Newcombe 1938: 222), and a daughter named Koota-Hilslinga (Cole 1980: 82). A brother of *gannyaa*'s named Chilsenjosh lived at *k'yuust'aa* and was to succeed to his position after his death (Burling 1799: 27a–32a). Moreover, *gannyaa* had a son or son-in-law named Enow, who erected a mortuary pole at *k'yuust'aa* for his infant daughter with the help of Captain Roberts (Magee 1794). There were several mortuary figures at *k'yuust'aa*, as well as raised single, double, and quadruple mortuaries, but none of the houses had frontal poles at this time. Only one house had a broad panel above the door.

In neighboring *daa.adans* there were two tall house frontal poles as well as carved memorial figures, and *gu.uu* and *yaahl dàajee* were the principal chiefs. Thanks to Burling's detailed account, we can reconstruct something of the genealogies of these two families (see charts 2 and 3). It is possible that *yaahl dàajee* was married to Chief Skidegate's sister, since their son was named Skittlekitts (Skidegate). This fits with the Haida's matrilineal system, in which either the chief's brother or his sister's son inherits his names and titles after his death. The mother of *yaahl dàajee* had been killed in a raid by Cumshewa when the rest of *yaahl dàajee*'s family escaped to the north. This led to further hostilities between the two families, culminating in the execution of two of Cumshewa's brothers at Kaigani. One of them was Skotseye, and it is possible that *yaahl dàajee*'s wife's son-in-law, *7iljuwaas*, who was Skotseye's son, was also executed there.

These events may have been the final episode in the migration of several *k'yuust'aa* and *daa.adans* families to Kaigani and other villages on Dall and Prince

Chart 1. The family of *gannyaa* at *k'yuust'aa*.

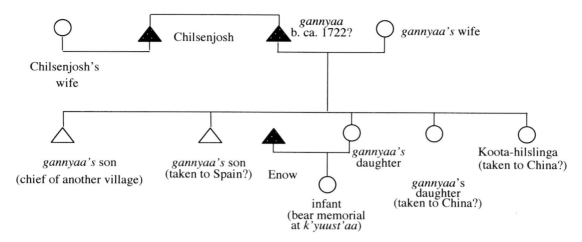

Chart 2. The family of *gu.uu* at *daa.adans*.

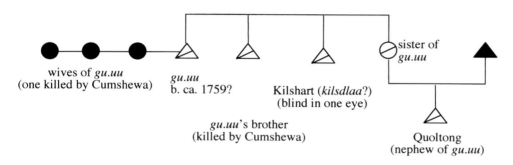

Chart 3. The family of *yaahl dàajee* at *daa.adans*.

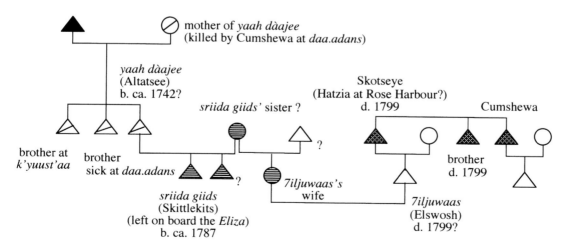

of Wales Islands. This move had apparently been occurring gradually over many years. It is believed that at some time during the late seventeenth or early eighteenth century, Haida people from the northern part of Graham Island began to move north and settled at several villages including Howkan (*ráwk'aan*), Koihandlas (*q'wíi rándllass*), Sukkwan (*saxq'wa.áan*), Kasaan (*gasa.áan*), and Klinkwan (*hlanqwáan*) (see Swanton 1905a: 88–89; Vaughan 1985: 20–27). On the basis of her study of Haida lineages, Margaret Blackman suggested that this migration might have begun in the early eighteenth century rather than late in that century, as Swanton had suggested (Blackman 1981: 75–76).

In the late eighteenth century, the village of Kaigani was occupied primarily as a summer residence, convenient for trade with visiting fur-trading vessels and as a staging area for travel to the permanent Haida winter villages on Dall and Prince of Wales Islands. By 1799, however, Kaigani was larger than either *k'yuust'aa* or *daa.adans,* with eleven houses, one of which belonged to *gu.uu* (Burling 1799: 39–44). By this time, most of the families from *k'yuust'aa* and *daa.adans* were making their permanent winter homes at *ráwk'aan, q'wíi randllass, hlanqwáan, saxq'wa.áan,* and *gasa.áan.*

The nineteenth century ushered in a new era in the fur trade and new residents at *k'yuust'aa.* Moving in to fill the void left by *gannyaa, gu.uu,* and *yaahl dàajee*'s families, residents of the villages of *rad raci7waas* (Old Massett) and *hl7yaalang* (Tlielang) moved west. Although their names do not appear in the written record of the late eighteenth century, they were to become prominent in the accounts of the next one hundred years.

Key to charts 1–3.

△ = male

○ = female

○——△ or ○—△ = spouses

| = descendants

△——○ = siblings

▲ = *juus xàadee* Eagle clan (E18) △ = *yahgu 'laanaas* Raven clan (R19)

▲ = *st'awaas qiirawaay* Eagle clan (E5) △ = unknown Raven clan

▲ = *gid7ins* Eagle clan (E6)

▲ = unknown Eagle clan

The Early Nineteenth Century, 1800 to 1853

Old 7idansuu, Sqiltcange, and gwaaygu 7anhlan

By the end of the eighteenth century, the dominant chiefs of the northern Haida, *gannyaa*, *gu.uu*, and *yaahl dàajee*, had moved to permanent winter villages on Dall and Prince of Wales Islands, leaving *k'yuust'aa* and *daa.adans* to families who migrated there from villages in the surrounding area. It was not until the early nineteenth century that the name *7idansuu*,[1] one of the best-known Haida names of that century, was first mentioned in written documents. The earliest of these was the journal of the voyage of Camille de Roquefeuil, a French trader on the ship *Le Bordelais*.

De Roquefeuil had engaged forty-seven Kodiak hunters with their *bidarkas* to kill sea otters, which by this time had become scarce on the coast because of overhunting. On June 18, 1818, while they were camped on the beach near the ship at the north of Prince of Wales Island, the Kodiak hunters were attacked. Twenty of them were killed and another twelve severely wounded, one of whom later died. De Roquefeuil believed that a man from Kaigani who had come on board to trade had initiated this attack, and this was confirmed by Russians and Americans at Sitka. Sailing south from Sitka, *Le Bordelais* arrived at "Kaigarny" with the intention of seizing the first person to come on board and holding him for a ransom of furs in retaliation for the attack. De Roquefeuil disguised the ship and raised the American flag in order to surprise the Haidas, but they would not come near the ship. De Roquefeuil gave up the attempt and sailed on to Massett.

Camille de Roquefeuil's Journal, 1818

August 26, 1818

Early on the 26th we entered the port, or rather arm of the sea, at Massett, under the guidance of an Indian named Tayaan, who came in a canoe to meet us. He made us steer towards the south-east part. At eight o'clock we passed the south-east point, and soon after, being opposite to a large village, we were surrounded by canoes. At nine o'clock, being within seven or eight miles of the point, we cast anchor. Several canoes came alongside on the 27th, with furs, of which we obtained only two, because the Indians, who desired woollen goods in exchange, found ours of bad quality. . . .

Several canoes came on the 28th, but they had but few otter skins; they attributed this scarcity to the visits they had already received from the

Americans. We obtained a pretty canoe for an indifferent double-barreled gun. . . .

The Indians gave us no cause for alarm. They are the finest men on the north-west coast; they seem better fed, stronger, and much cleaner than the others. In their persons, and in every thing belonging to them, there is an appearance of opulence and comparative cleanliness, superior to all that we had before observed. As far as we could judge, the huts composing the four villages, on the two sides of the entrance, are better built, and in better order, than those of the north. There is something picturesque in the whole appearance of this large village; it is particularly remarkable for the monstrous and colossal figures which dominate the houses of the principal inhabitants, and the wide gaping mouths of which serve as a door. Ascending the arm of the sea, there is, on the north side, above the largest village, a fort, the parapet of which is covered with beautiful turf, and surrounded by a palisade in good condition, which gives it the appearance of the out-works of our fortresses. This district, and the whole north side of Queen Charlotte's Island, is beyond comparison the finest that we saw in this part of America. The Indians were informed not only of the affair at Kowalt, but also of our appearance at Kaigarany, a boat of that tribe, which was their ally, came to inform them of it. This circumstance, and the recent quarrel with the *Brutus* [an American brig under Captain Nye], explained the terror of those who had quitted us to [*sic*] suddenly the day before. They disapproved of the conduct of those at Kaigarny, or at least endeavored to persuade us so.

My intention was to get under weigh the 29th, with the ebb, but the fog prevented me. We hoisted three flags, to dry them; the sight of these obtained us a visit from a dozen canoes, of which only two had come before. Itemtchou [*7idansuu*], the head chief of Masset came in a handsome canoe, accompanied by his three wives. His face is long, a little morose and savage, and has something of a Swiss character. A zig-zag red line on his forehead, was continued to part of his nose. He wore, by way of a mantle, a white blanket, with a blue stripe at the extremities, open before, and fastened by a cord: his hat was in the form of a truncated cone, in the Chinese fashion. He would not come on board, till we had promised that an officer should remain as a hostage in his boat. We received him in the best manner, and made some presents, both to him and to his wives. We conversed by means of an Indian of Skitigats, named Intchortge. Having asked the name of the chief, telling him my own, he thought I wanted to change names with him, which among these people, is the most inviolable pledge of friendship. He eagerly acceded to this proposal, which seemed to flatter him. The exchange was made, notwithstanding the difficulty the chief found in pronouncing his new name, which, to oblige him, I softened to Roki; we made each other some presents, and parted good friends. In endeavoring to quit this place, our movements were so counteracted by contrary currents, that the ship run aground close in shore. We had not less then [*sic*] eleven fathoms water, a cable's length from the shore, not ten minutes before we ran aground. We had then only eight feet before, and twelve under the mizen-chain-wales.

We immediately proceeded to take the best steps in this disagreeable situ-

ation, but it having been necessary to take down the nets, the Indians who accompanied us to trade, gradually got on board in such numbers that they became at least equal to that of our own crew. Though the few arms, and the numbers of women and children in the canoes, did not indicate any thing hostile on their part, any more than their conduct, these pacific appearances might change in a moment. But in the circumstances in which we were placed, it was less dangerous to act with confidence, than to shew a distrust, which, by letting them see our critical situation, might induce them to take advantage of it, to attack us. Besides, I was made easy by the presence of my friend Itemtchou, who had come on board shortly after we had run aground, without requiring a hostage. He endeavored to make me easy respecting the situation of the ship, and especially with regard to his personal sentiments in our favour, on which he said I might entirely depend, in consequence of the friendship which united us. I expressed to him the entire confidence which I placed in his inclinations towards us, as well as in the pacific disposition of his subjects; men which covered the deck, and the quantity of canoes which surrounded the ship, making us uneasy, hindered us greatly in the measures which it was necessary for us to take to get the ship afloat. He made no answer to this indirect solicitation, but, a moment after, when we were going to carry out an anchor, he took leave of us. After he had left the ship, he spoke some words in a loud voice, and, in about five minutes, there did not remain a single canoe alongside, and not a single man on board, except the interpreter. This Indian told me, that he stayed only with the permission of his chief, and also begged mine, which I readily gave him. This man, whose English I understood, was very intelligent, and well acquainted with this country. Continuing our operations during the night, we got the vessel afloat again before noon, on the 30th. My friend Itemtchou came back in the morning, like a man certain of being welcome, and expressed much joy at our success. I gave him, besides several trifles, a double-barrelled gun. This man has a feeling heart, and this, perhaps, prevented all hostile attacks from his subjects. We bargained for some more otter-skins, and weighed anchor soon after. (Roquefeuil 1981: 106–110)

Here we find Itemtchou (*7idansuu*) described as the head chief of Massett, exchanging names with de Roquefeuil (Roki) in much the same manner as that in which Captain Douglas had exchanged names with *gannyaa* twenty-nine years earlier. This account provides the first description of monumental poles in front of houses at Massett, with doors in the mouths of their carved figures, much like the one described at *daa.adans* seventeen years earlier. Whether these poles had been at Massett when the *Columbia* first visited there in 1789 is unknown, though neither Hoskins nor Haswell mentioned seeing them there.

Eleven years after de Roquefeuil's visit, the first Christian missionary to visit this area, the Reverend Jonathan S. Green on the barque *Volunteer* (under Captain Charles Taylor), provided the next mention of the name *7idansuu*, as well as an account of *gu.uu* and the death of *gannyaa* at Kaigani.

Jonathan Green's Journal, 1829

April 23

This afternoon we cast anchor in Cordoo sound, at a place called Kiganee, lat. 54° 41 minutes. The Kaiganee tribe is a small one, consisting, probably of five or six hundred men, women, and children. They formerly belonged to North Island (Langara Island), a small island separated from Queen Charlotte's only by a narrow strait. Their language is the same.

The Masset Indians, who now occupy North Island, are here at present on business. Eadinshu [ʒidansuu], one of their chiefs, with several Kiganee men, was seen on board. After learning my object, he gave me an apparently hearty "kill-sly" (salutation), and entreated me to go to North Island, which he assured me was a much better country than this. (Green 1915: 64–65)

April 24

As I was going from house to house, I saw a bust at the mouth of a cabin, curiously carved and painted. I asked what it was. My Indian guide said it was Douglass, a chief of this tribe, who not long since died in a drunken frolick. He went with me to examine it. He drew back the board which closed the mouth of the tomb. The remains of the chief were deposited in a box, or coffin, curiously wrought, and gaily painted. They usually deposit their dead in similar boxes, though they commonly elevate them several feet from the ground. (Green 1915: 66)

April 28

On my return, I met Kowe [gu.uu], a Kiganee chief, who has been on board the *Volunteer* most of the time since the Sabbath. He is a sober man, appears very friendly, and affords me great assistance in studying the language. I have had much conversation with him, and have given him many interesting items of Bible history.

May 2

Kowe is still with me, and I spend a considerable portion of my time in making and answering inquiries. I learned from him today, that all the young women of the tribe visit ships for the purpose of gain by prostitution, and in most cases destroy their children, the fruit of this infamous intercourse. (Green 1915: 68)

May 4, Monday

In answer to some of my inquiries, Eadinshu, chief of the Masset tribe, acknowledged that he knew nothing of the destiny of the soul, nor whether it were desirable to go to heaven at death; but he said he greatly desired instruction. What would it be to pour the light of heaven on his darkened mind, to lead him to the cross of Christ!

May 11

I have been on shore again today to visit the Indians. The two chiefs, Sankart and Kowe, received me with great cordiality; and I speant some time with them very pleasantly. . . .

Kowe, I find has been very communicative of the statements I have made

him. He told me today, that many of the Indians think I am imposing upon them; but I believe that I have convinced him of the sincerity of my desires to benefit him and his tribe. He proposes to accompany me to the Islands, to take with him a little daughter, and leave her to receive an education. This I have encouraged, and I have also advised this tribe to remove to North Island, and cultivate the soil. The chiefs say they will remove, if I will come and live with them. (Green 1915: 69–71)

During his time at Kaigani, Green mentioned at several points the problem of drunkenness. As the *Volunteer* got ready to leave Kaigani, the Haidas were ordered off the ship, and one gave a blow to Captain Taylor's head. A scuffle ensued, and Green was threatened by someone with a knife. Green ran below to Taylor's stateroom, prayed, and pulled a pistol from under the pillow while muskets were fired on deck. The first officer received a severe wound. In the end, two Haidas were dead, including one woman. Others went overboard, and still others were wounded. Five were kept on board as hostages, including two chiefs, one of them Sankart, who was deemed to be innocent in the matter. The crew set the ship for Norfolk Sound to get medical aid for the first officer (Green 1915: 72–75). They returned to Kaigani on May 21, and Taylor set three of the five hostages free, retaining the two chiefs on board as the ship sailed to the Nass River. On June 4 he returned again to Kaigani and spoke with *gu.uu* (Kowe): "Kowe was soon on board, and a long conversation with the traders ensued. Kowe declared, that the Indians who begun the quarrel were fools, that they had been drinking, and were greatly in fault; but that he and the tribe generally were disposed to live in peace" (Green 1915: 81).

The families of the wounded and deceased came on board amid feathers that they blew; *gu.uu* was mediator, and they agreed to settle for a small present. "Of the shargers [shamans], one made a long speech, in which he descanted on the benefits of peace, and assured them that he had seen Kowe, a chief of great celebrity, long since dead, and that he declared that it would be well for the tribe to be at peace with 'the iron men'" (Green 1915: 82). The shamans had apparently foreseen the future and advised peace. Presents were given to the brothers of the deceased. The *Volunteer* remained at Kaigani until June 14 and then proceeded across to Point Rose at Haida Gwaii.

June 24

Today we ran round "Point Rose," the northeastern part of Queen Charlotte's Island, and sailed down the eastern side of the island to Skidegas. The day was pleasant, and the prospect, for this part of the coast, delightful. Just before we cast anchor, we passed the village of Skidegas. To me the prospect was most enchanting, and, more than any thing I had seen, reminded me of a civilized country. The houses, of which there are thirty or forty, appeared tolerably good, and before the door of many of them stood a large mast carved in the form of the human countenance, of the dog, wolf, etc., neatly painted. The land about the village appeared to be in a good state of cultivation. The indians did not raise much, excepting potatoes, as they have not a variety of seeds; yet, from the appearance of the land, I presume they may greatly vary their vegetable productions. Several of the tribe met us before we cast anchor, and remained till evening.

To these I soon made known my object. They appeared pleased, and most earnestly solicited me to go on shore. They offered four or five of their principal men as hostages, and they repeatedly assured me that all would be well. Though I am anxious to see the country, and visit this village, yet I am not quite clear that I ought to go. I could not effect much by a single visit, and there are too many chiefs here, to ensure safety from the fact of having on board a hostage. (Green 1915: 84–85)

On June 25

Here they manufacture, from grass, hats of an excellent quality, some of which they value as high as two dollars. Their pipes, which they make of a kind of slate-stone, are curiously wrought. They are fierce for trade, bringing for sale fish, fowls, eggs, and berries, and offering them in exchange for tobacco, knives, spoons, carpenter's tools of various kinds, buttons, and clothes. Many of these articles they have pilfrered from other vessels. (Green 1915: 86)

Green's description of the house frontal poles in the village of Skidegate matches those of poles at Massett and *daa.adans* by earlier writers. Here, also, for the first time is an account of the carving of argillite pipes at Skidegate.2 From Green's account we learn that *gannyaa* (Douglas) had recently died and been buried at Kaigani in a mortuary house with a "bust" at the door. Though his death was described as the result of a "drunken frolick," if Camaaño's estimate of his age as seventy in 1792 is correct, then by the late 1820s he would have been over one hundred years old. On the other hand, *gu.uu* was very much alive at this time and apparently the highest-ranking chief at Kaigani. If *gu.uu* was thirty-six in 1795, as reported by Captain Bishop, then he would have been seventy in 1829. Green's account of *7idansuu* suggests that by 1829 he had moved from Massett, where he was during de Roquefeuil's visit, to *k'yuust'aa*, or North Island, along with other families from Massett.

Old 7idansuu

The "Chief Itemtchou" who exchanged names with de Roquefeuil in 1818 and the "Eadinshu" who spoke with Green at Kaigani in 1829 must certainly have been the same man. This person has been called "Old Chief Edenshaw" in order to distinguish him from his heir and successor, *gwaaygu 7anhlan* (Albert Edward Edenshaw), who was the next person to hold that name. It is likely that there was an even older *7idansuu* who preceded this man, though the evidence for this is somewhat confusing. The "old old" *7idansuu* was probably a Tlingit man. There is some evidence to suggest that "old Edenshaw" once made his home at the village of *hl7yaalang* (Tlielang, Łi'elañ, or Hiellan) on the east bank at the mouth of the Hiellan River between Tow Hill and Rose Spit. John Swanton recorded the names of three houses in *hl7yaalang* village from Hai'as of the *hl7yaalang sdast'aay* (Łi'elañ qē'gawa-i, Those Born at Tlielang [E21c]). According to Hai'as, one of houses was "Sk!u'lxa hai'yet (indicates that a crowd could be accommodated in it on account of its size).3 It was owned by EdA'nsa, chief of the StA'stas. Family: Łi'elañ qē'awa-i (E21c) as part of the StA'stas" (Swanton 1905a: 289).4 Whether Hai'as was referring to old *7idansuu* or to Albert

Edward Edenshaw (*gwaaygu 7anhlan*) is unclear. At the time Swanton collected this information, in 1901, both of these men were dead, and it is most likely that Albert Edward Edenshaw inherited the house from his uncle, old *7idansuu*.

The frontal pole of this house has survived (fig. 3.1).[5] Charles Edenshaw carved a model of it at New Kasaan in July 1902; the model was purchased there by Charles F. Newcombe and is now at the Field Museum of Natural History in Chicago (fig. 3.2). Charles Edenshaw gave Newcombe not only the name of this house and its owner but also, most remarkably, the name of the artist who carved the original frontal pole:

> This is a copy of a pole which was erected at Tlielan, a town which until a few years ago stood just to the east of the prominent land mark Tow Hill, near Rose spit, at the north east end of the Queen Charlotte Islands.
>
> The pole in question was made near the beginning of the 19th century by a well known carver named Sqiltcange of Tca-aatl [*ts'aa7ahl 'llnagaay,* or Chaatl], a town at the west end of the channel that separates the two largest islands of the Queen Charlotte group.[6] The pole stood in front of a house called Squlha haiat, meaning "the house for a large crowd of people." The Chief who erected the pole was named Sqilao, who was closely related on the maternal side with Itensa, a great man at the time the whites first made their appearance in Haida country. The village consisted of seven houses but Sqilao's was the largest. It had a deep central excavated basement, carved inside posts, and the roof beams and the large planks supporting the sides of the excavation were also all carved. (Newcombe 1900–1911: vol. 38, folder 3; vol. 55, folder 7)

The name of this house corresponds to the name Swanton recorded in 1901, but Charles Edenshaw said the name of the owner was Sqilao (*skil.aa.u,* "wealth spirit"), who is described as "closely related on the maternal side with Itensa [*7idansuu*], a great man at the time the whites first made their appearance in the Haida country" (Newcombe 1900–1911: vol. 38, folder 3; vol. 55, folder 7). Wilson Duff believed, probably on the basis of Swanton's account, that the old *7idansuu* whom *gwaaygu 7anhlan* succeeded was the owner of the house at *hl7yaalang,* that he lived there before he moved to *k'yuust'aa,* and that he continued to maintain the house after his move (Dalzell 1968: 63n2). It is possible that *skil.aa.u* was simply another name held by old *7idansuu,* since high-ranking people usually had several names. Charles Edenshaw, however, confirmed to Newcombe that the man named *skil.aa.u* and the old chief *7idansuu* were not the same person but were closely related. They may have been brothers, half-brothers, or even maternal cousins. If we believe de Roquefeuil's account, old *7idansuu* was a chief at Massett in 1818, which suggests that he would have had a house in that village. If *skil.aa.u* and old *7idansuu* were two different people, it might be that old *7idansuu* had a house in Massett in the early nineteenth century and inherited *skil.aa.u*'s *hl7yaalang* house after the death of *skil.aa.u.* Newcombe's information from Charles Edenshaw also confirms that *skil.aa.u* was Albert Edward Edenshaw's uncle, and it further suggests that it was *skil.aa.u* who succeeded *gannyaa* — probably at *k'yuust'aa* rather than at *daa.adans* as Newcombe says in the following passage:

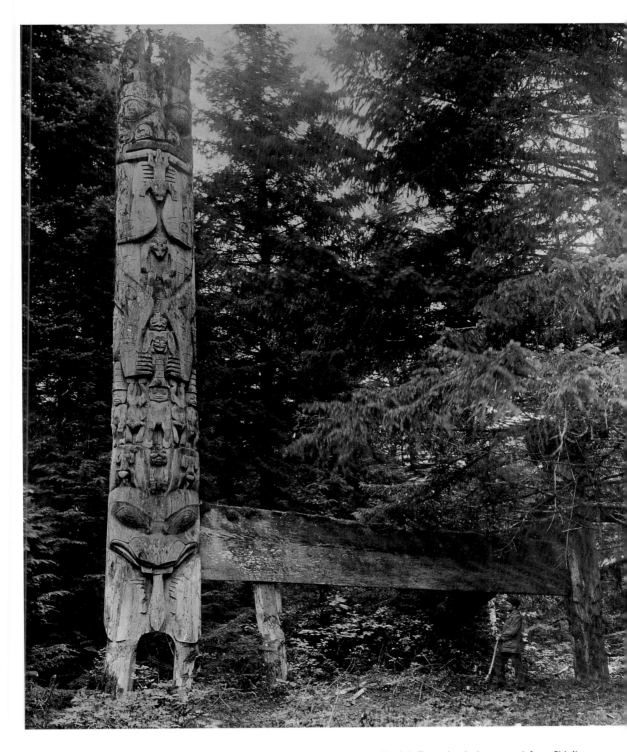

Fig. 3.1. Frontal pole (*gyaa.aang*) from Sk!u'lxa hai'at, "house for a large crowd of people," owned by *skil.aa.u.* Carved by Sqiltcange, early nineteenth century. Photograph courtesy of the Canadian Museum of Civilization, neg. no. 46694.

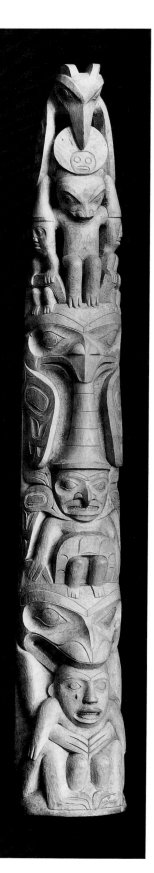

Fig. 3.2. Model of *skil.aa.u*'s house frontal pole in *hl7yaalang* made by Charles Edenshaw, 82 by 12 by 9 cm. Collected by C. F. Newcombe in 1902 at New Kasaan, Alaska. Photograph courtesy of the Field Museum of Natural History, cat. no. 79696, neg. no. CSA 18216.

C.Ed.	no. 1 [Charles Edenshaw, Edenshaw no. 1]
uncle (henry's father)	no. 2 [Charles's uncle, Albert Edward Edenshaw, father of Henry Edenshaw]
his uncle	no. 3 [Albert Edward Edenshaw's uncle, Old Edenshaw]

Story of Totem pole at Tielen near Masset, erected by C. Edensa's uncle's uncle who succeeded Gunia as chief, at *daa.adans*. (Newcombe 1900–1911: vol. 56, folder 1)

If old *7idansuu* survived *skil.aa.u* and inherited his position (and his house at Tlielang), but *skil.aa.u* had previously moved from *hl7yaalang* to *k'yuust'aa* after *gannyaa* moved north, then this would explain why old *7idansuu* moved from Massett to *k'yuust'aa* between 1818 and 1829, between his encounters with de Roquefeuil and Green. It might also place *skil.aa.u*'s death sometime between those dates. Wilson Duff believed that old Edenshaw was born about 1780 and died around 1845 (Anderson 1996: 219). This belief seems to be supported by the historical record, for if there had been a powerful Chief *7idansuu* in Haida Gwaii in the late eighteenth century, then we might expect his name to have appeared in at least one of the journals of those visiting the area, which it does not.[7] If old *7idansuu* was born around 1780, then he was not yet born when Pérez arrived in 1774 and was only nine years old when Douglas visited in 1789. By 1818, when de Roquefeuil visited Massett, he would have been thirty-eight and in the prime of life, and by 1829, when he met Green, he would have been forty-nine, approaching elderhood.

Newcombe's record also provides Charles Edenshaw's explanation of the meaning of the figures on the *hl7yaalang* frontal pole:

Model of Totem Pole, Made by C. Edensaw at Kasaan. July 1902.

Made of native maple found at Kasaan Bay, *Acer glabrum*, Pursh.=sin. A copy of a pole erected by Sqîlao, the uncle of C. Edensa's maternal uncle near the beginning of the last century at Ŧlielen near Massett. It was made by Sqîltcánge of Tcaaŧ. There were seven large houses at Ŧlielan and Sqîlao's was the largest. It had a deep cellar, carved roof beams, and carved inside posts. The planks round the central excavation were also carved. The name of the house was Sqûla haiat meaning "the house of a large crowd of people."

The Story.

The lowest figure represents Qats,[8] a Tlingit chief who lived at or near Tongas. He was a great hunter of grizzly bear. One day he hunted for a long time without success. Next day his dogs put up a she grizzly bear, and Qats chased her, and after a struggle, secured her and sent her to his house in care of his men. She became greatly attached to him, and dug herself a hole in the house where she concealed herself and where she was often visited at night by Qats. The he bear, her husband, looked in vain for her, and at last gave her up as lost to him.

Now Qats had already a Tlingit wife who had born him two children but these he neglected for his new bride. The she bear bore him two children also, and now he began to long to see once more his first wife and children. The she bear begged him not to leave her, but as he persisted she could only succeed in getting him to promise to mention neither herself nor her off-spring. So Qats went home and stayed for some time with his wife quite happily. One day his wife asked him to go back into the forest to get her some water from a cool spring. He told her he was afraid, his secret reason being that his jealous bear wife would claim him and use her claws to punish him for leaving her; for this reason, too, he had never dared lately to hunt far from town.

He thought he would be safer hunting seal and other sea animals, and often went off in his canoe. His two children by the she bear had by this time turned into porpoises and he occasionally met them and recognizing them as his children fed them with scraps of seal or sea-lion meat. At last they found out that he was their father and kept a sharp lookout for him, pricking up their ears for some sound of his canoe returning as they were jealous of the Tlingit wife. At last Qats was caught by them and torn in pieces.

The lowest bear represents the he-grizzly, the bear near the top of the pole is the bear wife, and the two small figures on the sides are the two children of Qats, who killed him.

The remaining figures belong to one of the numerous stories of Nemkilstlas [Raven].

In early days it seems there was no sun, and Nemkilstlas went about everywhere in almost complete darkness. At last he heard that a great chief on the Naas River had possession of light in a portable form, probably the Moon, and Nemkilstlas managed to steal it. At this time the Naas River people were gathering oolachans with fish-rakes (qiqu); dip nets of nettle fibre not having yet been introduced amongst them though now in common use.

Nemkilstlas, who had concealed his feathers and was going about as a man, went up to the fishermen and said, "Please give me some fish." They refused, so Nemkilstlas told them that if they would consent to give him some fish he in return would make them a present of a strong light. They now all treated him liberally so he took the moon from under his coat and broke it up, and then threw the pieces into the air. The largest piece flew up into the sky and became the sun, the next largest became the moon, and the small pieces turned into stars.

The top figure of the model shows Nimkilstlas holding the moon in his beak.

Third Story

The eagle used to be a great friend of the raven and constantly travelled about in company with him. One day they visited the house of a great chief, a friend of theirs. He made a great feast in their honor, and they gorged themselves with berries and grease and fish, until they became so full that they were unable to fly. Soon after leaving the house they had to cross a river so they put a long stick across it as a bridge. As the eagle was over-loaded and timid, the raven crossed first and waited on the other side saying encouraging things to the eagle. At length the latter attempted to cross, but when half-way over the log rolled to one side and the eagle slipped into the water and was carried by the stream to the sea shore, the raven following him along the river bank. A Chief enquired what the eagle was doing in the water; the raven replied that he was having a quiet swim. Finding no symp-toms of life in the eagle who now lay on his back on the sea shore with his stomach still distended after his abundant meal, the raven ripped him up and ate the eagle's share of the feast.

The middle figure represents itlinga, the chief of the river (which was crossed), the hat with many crowns is the log bridge, over which the raven crossed. There is also a carving of the eagle. (Newcombe 1900–1911: vol. 55, file 7)

The identification of the bear story on this pole is particularly interesting in light of what we know about the history of the *7idansuu* name. The right to display this story must have come to *skil.aa.u* through the Tlingit branch of his family, probably through his wife. Swanton tells us that the name *7idansuu* is a Tlingit name that means "melting ice from a glacier," from the Tlingit word for "wasting away — nothing left of it," or "waterfall." He recorded the name EdA'nsa, from the Tlingit *itinacu'*, "nothing left of it," which is applied to a glac-ier where it comes down into the sea and melts away (Gough 1993: 289; Swanton 1905a: 275). According to Henry Edenshaw (Albert Edward's son), "his father, who was chief of the StA'stas, assigned two origins to his family. A small part of them, including the chief, came down from the Stikine, whence was derived the name EdA'nsa ('glacier'), but the majority came from the Nass" (Swanton 1905a: 101). It is probable, then, that the "old old" *7idansuu* lived on the Stikine and not at *k'yuust'aa,* and the first *7idansuu* to move to *k'yuust'aa* was Albert Edward Edenshaw's predecessor, old *7idansuu.*[9]

Sqiltcange

With his description of the *hl7yaalang* house and pole, Charles Edenshaw, through Newcombe's notes, gave us the earliest known name and attributed work of any Haida artist, Sqiltcange. Newcombe provided some further infor-mation about this man: "Squiltcange was the man who made pole which model shows who died before Ed. no. 2 was born. Who also worked at Skidegate. He belonged to a Gold Harbour town either Tcaal or Kaisun. He also worked at Kiuste" (Newcombe 1900–1911: vol. 56, folder 1).

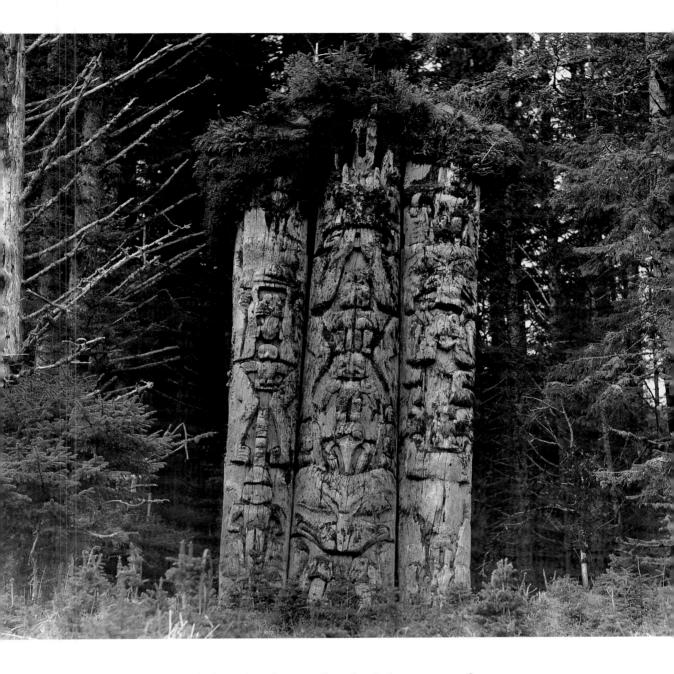

Fig. 3.3. Triple mortuary poles at *k'yuust'aa*, attributed to Sqiltcange, early nineteenth century. Courtesy of the Royal British Columbia Museum, neg. no. PN 7398. Photograph by G. C. Carl, 1952.

Though no poles in Skidegate have been attributed to Sqiltcange, a set of mortuary poles (fig. 3.3) that still stands at *k'yuust'aa* has been attributed to him, owing to the poles' close similarity in style to the house frontal pole at *hl7yaalang* (MacDonald 1983: 174, 1996: 191). This mortuary is a set of four poles, three of which are fully carved. The fourth pole is a plain post at the back that supported the burial chamber.[10]

The figures on the left pole are, first, a small human figure between the ears of a bearlike figure that holds a frog in its mouth and has a small eagle with outstretched wings on its belly and, second, a small human figure with a six-ringed hat positioned between the ears of a large animal figure at the bottom. The middle pole has an unidentifiable figure at the top; a bearlike figure with its hands at its mouth, a small humanoid figure with U-form ears on its chest,

and a small eagle between its legs; and an insectlike figure (butterfly?) between the ears of a bear that has small birds in its ears and holds a birdlike figure with formline wings in its paws. The right pole depicts an unidentifiable figure at the top, then a small human figure between the ears of a beaver with a frog in its mouth, and finally a whale with its tail up and its head down, a raven(?) between the flukes of its tail, and a small human on its head. The bear figure at the top of the central pole has formline ovoids with elaborate inner ovoids positioned within the arms and legs at odd angles. The inner ovoids on the arm have full frontal faces. Also interesting are the ears of the beaver on the right pole, which are decorated with four horizontal hollowed grooves. This method of decorating ears is typical of later-nineteenth-century Kaigani Haida poles and is one of the stylistic features that helps to differentiate Kaigani poles from other Haida poles. The beaver's ears on the *k'yuust'aa* mortuary may be the earliest example of this motif, which suggests that Haida artists might have brought this feature from *k'yuust'aa* to Alaska.

Stylistically, the *k'yuust'aa* mortuary poles are similar to the *hl7yaalang* pole in their shallow carving and massive formlines (an archaic style) and in the stretched-out posture of the large figures. Most nineteenth-century Haida poles have figures that are compact, with the knees drawn up to touch the elbows. Here the legs are extended, with only a slight bend at the knee. The small birds are also shown with wings extended in a style atypical of most nineteenth-century Haida art.

The *hl7yaalang* pole has full frontal stylized faces on the inner ovoids of the eyes of the bears.[11] Several early-nineteenth-century Haida argillite pipes also display this detail. Argillite is a black carbonaceous shale found in a single quarry located near *tllgaduu randlaay* (Slatechuck Creek), which is located between *ts'aa7ahl 'llnagaay* (Chaatl) and *hlragilda 'llnagaay* (Skidegate). The carving of argillite is an art form that was just in its infancy in the early nineteenth century. The Reverend Jonathan Green's 1829 journal provides the first written account of the carving of argillite at Skidegate, and the first argillite documented in a museum collection dates to 1820. It was soon to develop into the first tourist art on the Northwest Coast.[12]

It is possible that Sqiltcange was one of the artists who helped to invent this tradition. The Portland Art Museum has a pipe fragment with two principal figures, a raven and a bear (fig. 3.4). A human figure crouches between them holding a smaller bear figure at the back of the raven. A broken head extends from the back of the principal raven like a dorsal fin. A human head at the mouth of the bear extends its tongue into the mouth of a frog. A quarter of the pipe between the raven and the bear has been broken away, leaving only small feet in the mouth of the raven. The eyes of the bear have been elaborated with full stylized faces, particularly similar to the eyes of the bear on the *hl7yaalang* pole (fig. 3.5).

Another distinctive feature of this pipe is the complex formline design decorating the wing joint, consisting of a "salmon-trout-head" with a solid-U secondary cheek design and another secondary solid U in the snout. Another ovoid complex with U-form feathers joins this joint at a sharp angle. The *hl7yaalang* pole also has complex formline designs carved in low relief on the arms and legs of the bears. These formlines are massive, with slitlike reliefs and solid secondary Us, similar to the secondary complexes in the Portland pipe.

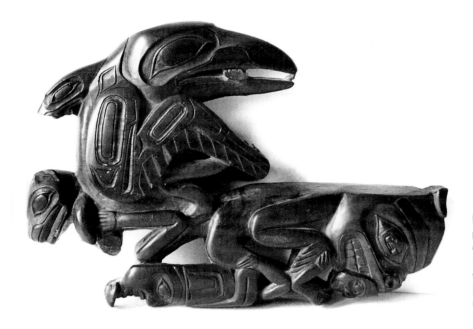

Fig. 3.4. Haida argillite pipe, early nineteenth century, 19.7 by 3.8 by 16.5 cm. Courtesy of the Portland Art Museum, cat. no. 43.18.2.

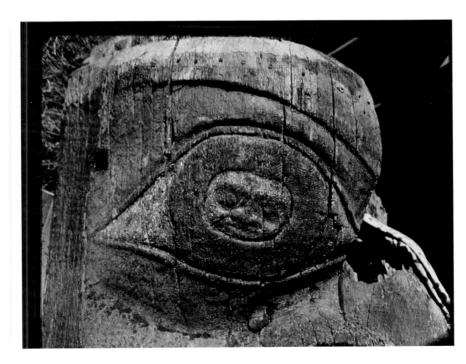

Fig. 3.5. Detail of *hl7yaalang* pole (fig. 3.1). Photograph by Bill Holm, 1980.

A raven pipe in the Museum für Völkerkunde in Berlin is also similar in style (fig. 3.6). This pipe displays two birds. One (with the thick beak) is a raven with its tail turned up as on a raven rattle. The other (with the thin beak) is a kingfisher-like tail bird holding in its beak the broken tongue of a human face between the crest feathers of the raven. The raven has a face with a recurved beak at its breast above its legs. The tail bird has humanoid arms, small wings, and birdlike feet. On its back, a human figure with its knees behind the bird's head feathers connects with a frog, and the space below its tail is decorated with a human face with long U-form feathers on the bottom. Though it lacks the stylized face in the eye ovoids, this pipe has a complex wing joint with "salmon-trout-head" and U-form wing feathers attached at a sharp angle to the joint. Solid secondary Us in the tail and wing complexes are also similar to those on the Portland pipe. The oval profile and the large size of the bowls on these two pipes is characteristic of the earliest style of argillite pipes, dating to the first two decades of the nineteenth century.[13]

Another stylistic link exists between these two pipes and two wooden pipes that are among the earliest known Haida tobacco pipes. The earliest known drawing of a Haida pipe was published by Louis Choris (fig. 3.7), the artist who accompanied the Kotzebue expedition to the Northwest Coast in 1815–1818. The form of this pipe is remarkably similar to that of a wooden pipe inlaid with whale bone and abalone shell that is now in the Museum of Mankind in London (fig. 3.8). This latter pipe takes the form of a whale (the pipe bowl is in the blow hole) with a humanoid raven on its back. A human figure is crouched in the belly of the whale, and the whale's tail is turned up with a human face extending its tongue into the mouth of the raven, which reclines on the back of the whale. The Choris pipe has a human figure extending through the mouth of the whale, and a raven's head that forms the dorsal fin of the whale holds the extended tongue of the human figure at the whale's tail. It may be that the same artist made both of these pipes, though the current location of the Choris pipe (if it still exists) is unknown. The elaborate "salmon-trout-head" design on the pectoral fin of the whale, the shapes of the eye ovoids, and the raven's head on the British Museum pipe resemble those on the argillite pipes discussed above, and there is a possibility that these two wooden pipes, as well as the argillite ones, were carved by Sqiltcange around the beginning of the nineteenth century. The British Museum pipe is well worn, showing the patina of long years of use.

The attribution of these argillite and wooden tobacco pipes to Sqiltcange must remain speculative. The similarity between the *hl7yaalang* pole and the mortuary at *k'yuust'aa,* however, seems compelling. Also intriguing is the similarity between these two monumental sculptures and John Bartlett's drawing of the pole at *daa.adans* (see fig. 2.8). Despite the loose and sketchy nature of this drawing, the relationship between the large principal and smaller secondary figures on the pole seems to fit closely with the style of the surviving Sqiltcange poles, which supports late-eighteenth- or early-nineteenth-century dates for their production.

The *k'yuust'aa* triple mortuary has been identified as the grave of old *7idansuu.* It is believed that *gwaaygu 7anhlan* commissioned the mortuary for his predecessor when he assumed his place (Jim Hart, personal communication, September 1998). In 1983, George MacDonald speculated that "it is most likely

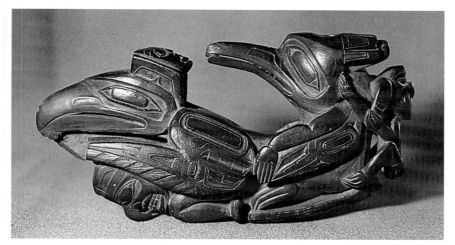

Fig. 3.6. Haida argillite pipe, early nineteenth century, 15 by 8 by 3.6 cm. Museum für Völkerkunde, Berlin, cat. no. IV A 8116. Photograph by the author.

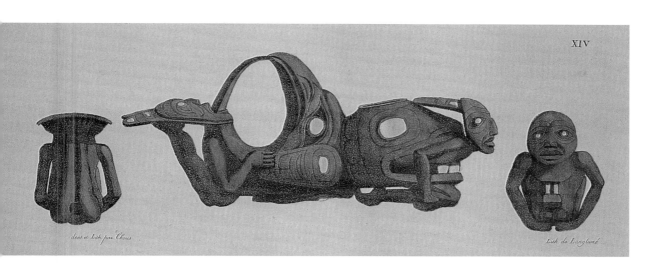

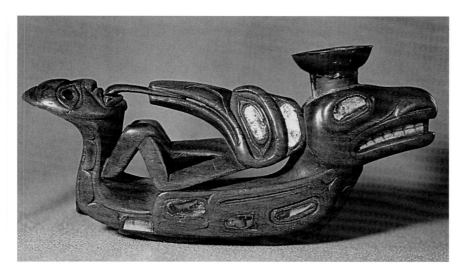

Fig. 3.7. Drawing of a Haida wooden pipe by Louis Choris, 1818. Special Collections Division, University of Washington Libraries, neg. no. 18591. (Reproduced from Choris 1822: plate 14.)

Fig. 3.8. Haida wooden pipe, early nineteenth century, 16.2 by 8 by 3 cm. Museum of Mankind, British Museum, cat. no. 1949.AM22.79. Photograph by the author.

the mortuary of the first Edenshaw who settled at Kiusta, since it is archaic in style and probably dates from around 1850." He identified the figures on the center poles as portraying the same story as that found on the "Myth House" built by *gwaaygu 7anhlan* in the 1840s (see below) (MacDonald 1983: 191). MacDonald's identification of the butterfly-like figure as the "bird of the air" and the bearlike figure at the bottom as a whale, however, seems speculative, and these figures might just as easily be described as similar to those on the *hl7yaalang* pole. MacDonald later adjusted his dating of this pole to around 1820, describing the figures on both poles as large bears (MacDonald 1996: 191). He may have based his dating of this mortuary originally on the death date of *gwaaygu 7anhlan*'s immediate predecessor, since Albert Edward Edenshaw is said to have taken the name *7idansuu* around the year 1840.[14] If the *k'yuust'aa* mortuary actually dates to the very early nineteenth century, as the style suggests, then the predecessor of *gwaaygu 7anhlan* would still have been alive at the time it was erected. Perhaps old *7idansuu* had commissioned this mortuary for *skil.aa.u* or his family and was himself interred there at his death by *gwaaygu 7anhlan*. Some large raised mortuary monuments such as this one are known to have housed multiple burials of lineage members (MacDonald 1973: 3).

There were two different houses at *k'yuust'aa* that have been identified as having belonged to old *7idansuu*: MacDonald's House 4, "house pole reaching the sky," and a house named Property House that stood at the location where *gwaaygu 7anhlan* later built his "Myth House," MacDonald's House 7 (MacDonald 1983: 189). It was not uncommon for a chief to own more than one house in a village.

gwaaygu 7anhlan and His Work

Though we have tantalizingly few firsthand written accounts of old *7idansuu* and none of old old *7idansuu*, and though their identities remain obscure, their successor, *gwaaygu 7anhlan,* was written about in many nineteenth-century accounts. Shown in figure 3.9, *gwaaygu 7anhlan*, meaning "one who rests his head on an island," was one of the most renowned Haida chiefs of the nineteenth century. He himself claimed to be "the greatest chief of all the Haidas" (Gough 1993: 289). It can safely be said that his name, like *gannyaa*'s in the eighteenth century, appears more frequently in the written accounts of nineteenth-century visitors to Haida Gwaii than that of any other Haida person. "Few Haida chiefs have attracted as much attention from explorers, traders, naval officers, ethnologists and historians as Edenshaw" (Gough 1982: 131). The first missionary in Massett (1876–1879), the Reverend William H. Collison, reported: "This chief, Edenshaw, who was thus received, was formerly the most powerful chief on the islands" (Collison 1981: 71). The first published biography of his life was written by the Reverend Charles Harrison, the Anglican missionary in Massett from 1883 to 1890, who knew him in the last four years before Edenshaw's death (Harrison 1911–1913). From Harrison's series of articles come a number of the most repeated stories about *gwaaygu 7anhlan*'s life. Some inaccuracies have also been repeated from this source.[15]

The name of *gwaaygu 7anhlan*'s mother remains unknown,[16] though if Charles Edenshaw's account to Newcombe is correct, then she was the sister of *skil.aa.u*. The name of *gwaaygu 7anhlan*'s father, Cowhoe, was written in the

Fig. 3.9. Albert Edward Edenshaw (*gwaaygu 7anhlan,* left) and *7wii.aa* on the beach at *ya.aats'* (Yatz). National Archives of Canada, neg. no. PA38147. Photograph by George Dawson, August 23, 1878.

church document recorded by Harrison when he married Albert Edward Edenshaw and his wife, Amy, in 1885.[17] This is the same surname that Albert Edward Edenshaw's son, George Cowhoe, had. The name Cowhoe is an alternate spelling of the name *gu.uu,* or Kow, so both *gwaaygu 7anhlan'*s father and his son may have been from the same Raven clan (*yahgu 'laanaas*) as the late-eighteenth- and early-nineteenth-century chief of that name from *daa.adans* and *k'áyk'aanii.*[18]

Around 1812,[19] *gwaaygu 7anhlan* was born in the village of *rahlans kun* (Gatlins-kun or "High Point Town") near Cape Ball, between Tlell and Rose Spit on the northeast shore of Graham Island (Gough 1993: 289).[20] A Raven village, *rahlans kun* had as its town chief *tl'aajaang quuna,*[21] "Great Swashing of Waves" of the *na7i kun qiirawaay* ("Those Born at Rose Spit" [R13]; Swanton 1905a: 270, 280).[22] Sometime after his birth, the sea cut away much of the land at *rahlans kun.* The village was also attacked by the Tongass people sometime before 1840, and this, coupled with the erosion of the land, caused the villagers to move. Most went to Skidegate, but some moved to Massett (Newcombe 1900–1911: vol. 55, file 7). Because of its abandonment, no photographs or descriptive written accounts exist for *rahlans kun.* After the move to Skidegate, however, "House of the Stormy Sea" was built there; it is said to be a copy of the

one built by *tl'aajaang quuna* at Cape Ball around 1820. The Skidegate house was sold by Thomas Stevens in 1892 to the Indian agent James Deans, who transported it to the World's Columbian Exposition in Chicago, where it was exhibited. The house was apparently destroyed after the fair, but the frontal pole was retained and is currently on exhibit in the main hall of the Field Museum of Natural History in Chicago (see fig. 5.34).

According to MacDonald, *tl'aajaang quuna,* the owner of the original house in Cape Ball, was married to the daughter of Albert Edward Edenshaw. It is more likely, however, that this woman was Edenshaw's sister, because there is no record that he had any daughters who survived to adulthood — and this would have been at a time before he was even married. Certainly, this chief would not have married a woman from the Raven moiety, which Edenshaw's daughter would have been, whereas his sister would have been a *sdast'a.aas* Eagle and an appropriate wife for a Raven chief.

We know that *gwaaygu 7anhlan* had several brothers and sisters (see chart 4). Harrison reported that he had two older brothers, who would have been first in line to succeed old *7idansuu.* They are said to have died in raids a few years prior to *gwaaygu 7anhlan*'s being called to prepare for taking his uncle's place (Harrison 1911–1913: vol. 1, no. 52, p. 3; see also Dalzell 1968: 63; Harris 1992: 56). He is also known to have had two younger brothers, *stlaang du.ungaad* (Stłandung7át), who married *gid gudgaang* (Gitgutgang), the sister of *gu.uu 7aww* (meaning the mother of *gu.uu,* old *7idansuu*'s wife), and another brother of unknown name who married *7ilsgidee* (Ílsgide) (1842–1862), the daughter of his brother *stlaang du.ungaad* and *gid gudgaang.* They were the parents of Isabella (1858–1926), Charles Edenshaw's wife. During the 1862 smallpox epidemic, *stlaang du.ungaad, 7ilsgidee,* and her husband all perished.

In addition, Florence Edenshaw Davidson, a daughter of Charles Edenshaw, remembered that Albert Edward Edenshaw had four sisters (Margaret Blackman, personal communication, 1994). One of them was *q'àaw quunaa* (Qawkúna), Charles Edenshaw's mother, and another, according to Newcombe's notes, was named *ga agit,* "branches."[23] The latter woman was married to one of the men named *tl'aajaang quuna* (Kł'ajangkúna) in Skidegate. Charles Edenshaw's mother, *q'àaw quunaa* (Qawkúna) was also said to have married a man by this name. After *ga agit*'s death, *tl'aajaang quuna* erected a memorial pole to her around 1880 carved with a beaver and a stack of hat rings (*sgil*), with a Raven and more hat rings above (visible to the right in Dossetter's 1881 photograph, MacDonald's plate 42). This was the last old pole to stand in the village of Skidegate until the 1990s, when it blew down in a winter storm. Newcombe originally provided this information with the name *ga agit* in a list of Skidegate houses and poles as they appear in a Maynard photograph (fig. 5.20) (Newcombe 1900–1911: vol. 55, folder 10; MacDonald 1983: 46). Though MacDonald associates this pole with a house owned by Daniel Eldjiwus (*7iljuwaas*), saying that he was married to another of Albert Edward Edenshaw's "daughters," *tl'aajaang quuna* lived two houses west, and it is more likely that the beaver memorial was associated with his "House of the Stormy Sea," that was based on the earlier house located at Cape Ball (MacDonald 1983: 47). Two similar poles, also having beavers with tall stacks of *sgil,* appear in the same Maynard photograph in front of Grizzly Bear's Mouth House. One of these was raised by John Robson in honor of his wife, *q'àaw quunaa,* Charles Edenshaw's mother (see chapter

5). Albert Edward Edenshaw's other two sisters were *gid qunee* (Gitkonee, Gitkuné, or Gidkonii), who was Mary Watson's grandmother, and *gulsigut*, who was the mother of Jane Shakespeare and *q'aawiidaa*.

The date of the deaths of Albert Edward Edenshaw's older brothers is unknown, though according to Harrison, they must have perished a few years before the death of old *7idansuu*.[24] Swanton recorded the account of a series of battles between the people who lived at *hl7yaalang* and the Nass River Tsimshian, the Nisga.a, during which many people were killed on both sides. This series of reciprocal battles apparently took place over several years, resulting ultimately in the abandonment of *hl7yaalang* when its residents moved to Massett for safety. The two war leaders of *hl7yaalang,* who led the Haida in battle, were named *skil kingaans* (Skîlqe'xas) and *gyaawhlans* (Gia'oĺins),[25] the same men who owned houses near *skil.aa.u*'s in *hl7yaalang* (Swanton 1905b: 393–400). It is interesting that *skil.aa.u* is not mentioned as having taken part in these battles, and it may be that he was too old to participate or had already died or moved to *k'yuust'aa* at this time. Perhaps it was during one of these battles that his two nephews, *gwaaygu 7anhlan*'s older brothers, were killed. MacDonald (1983: 173) suggested that the abandonment of *hl7yaalang* occurred around 1860, though it may have happened even earlier, in the 1830s before old *7idansuu* died.

After Cape Ball was abandoned during his childhood, *gwaaygu 7anhlan* may have moved with his family to Skidegate. Harrison (1911–1913: vol. 1, no. 52, p. 3) reported that Albert Edward Edenshaw lived in Skidegate before he was appointed chief. He may also have lived part of this time (perhaps with his brothers) in *skil.aa.u*'s house at *hl7yaalang*, since *skil.aa.u* was his maternal uncle. It was the custom for a chief's heir, usually his sister's son, to move into his house when he came of age in order for him to be trained to take his uncle's place. Jonathan Green's account suggests that old *7idansuu* had moved to *k'yuust'aa* from Massett sometime before 1829. If *gwaaygu 7anhlan* was born about 1812, he would have been seventeen at this time. He might have lived with old *7idansuu* for several years before succeeding him, and he certainly would have been brought to live with him after the death of his brothers (in the 1830s?). Harrison (1911–1913: vol. 1, no. 52, p. 3) reported that he was put in charge of his uncle's canoes and sent on many expeditions as his representative, which would explain how he gained his reported skill at seamanship. MacDonald (1996: 171) suggested that Albert Edward Edenshaw moved to *k'yuust'aa* sometime after 1834, when he was involved in an unsuccessful attempt to loot a Hudson's Bay Company ship, the *Vancouver*. John Work, the Hudson's Bay Company's factor, or chief trader, learned of this incident in February 1835 at the newly established Hudson's Bay Company's Fort Simpson:

Feb. 23

Among the other Indians who visited us, was a half-breed named George Whitemore dressed in fashionable velvet caped surtout white shirt flashy waistcoat, beaver hat, fine trousers, white stockings, and pumps. This individual handed us a letter from Capt. Duncan to Capt. McNeill dated at this place 27th Feby. last, when he was going to depart a few days before he lost the vessel [the schooner *Vancouver,* wrecked on March 3, 1834], he complains that he could not trade but a very few skins, notwithstanding the high prices he offered. Whiteworth [*sic*] has also two certificates, one

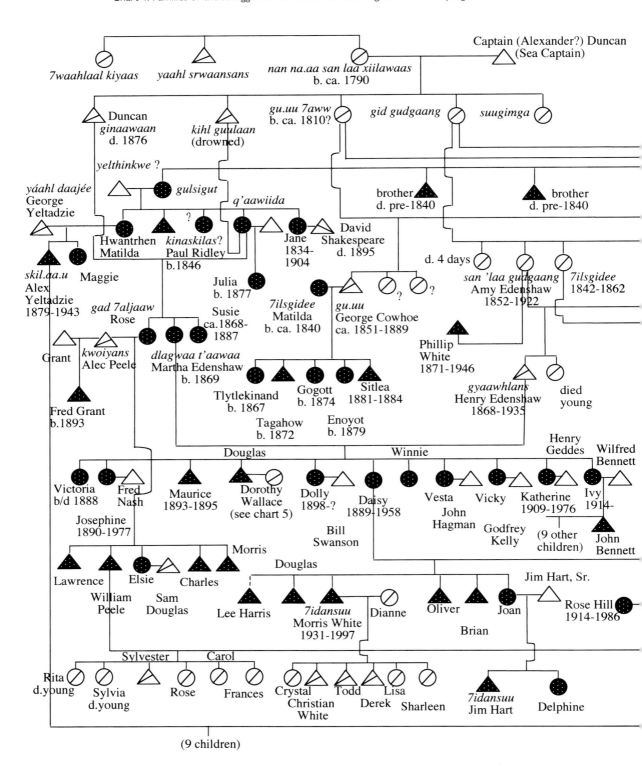

Chart 4. Families of the *saangga.ahl 'laanaas-sdast'a.aas* Eagles, and of the *yahgu 'laanaas* Ravens.

△ = male

○ = female

○——▲ or ○——▲ = spouses

| = descendants ┊ = adoption

┌──┐
△ ○ = siblings

▲ = *saangga.ahl 'laanaas, sdast'a.aas*
Eagle clan (E21)

△ = *yahgu 'laanaas*
Raven clan (R19)

▲ = *ts'aa7ahl 'laanaas*
Eagle clan (E9)

△ = *na7ikun qiirawaay*
Raven clan (R13)

▲ = *git'ans*
Eagle clan (E13)

△ = *q'adasru qiirawaay*
Raven clan (R3)

▲ = unknown Eagle clan

△ = unknown Raven clan

△ = unknown or *yaats xàadee*
(non-Haida)

of his good conduct when on the Otter hunting parties, the other stating that a chief here had stopped one of Picken's [sic] boats [probably Captain Benjamin Pickens, who was a frequent visitor to the coast. He was engaged primarily in the sea-otter trade. He visited the coast in 1831 in the brig *Convoy* and again in 1832 in the brig *Crusader*, but I have found no reference to a visit in 1834] and Crew on shore and that it was only by the interference of the other Indians they were got off. From this man we also learn, that Capt. Pickens on hearing of the loss of the Vancouver from the Indians, very laudably proceeded to the place to render every assistance in his power accompanied by Whitemore & other Indians. But on arrival at the place nobody was to be seen and the vessel was broke up. From what these people learned from the Indians, it was most unfortunate that they abandoned the vessel so soon as they did, for the next tide she floated off to her anchor & might easily have been saved. It also appears that a great deal of the danger they apprehended from the Indians was imaginary for the Natives themselves affirm that only 8 were on the ground, and that in order to intimidate the Crew, they kindled a great number of fires in the night to make it be believed that their numbers were greater than they really were. Since the wreck the Indians who obtained the property have enriched themselves buying slaves &c. It is a pity there were not means of compelling them to give back the property or something in lieu of it and at the same time of punishing them effectually for what they have been guilty of. But were we to go there we would not be able to do any thing by force, and until we [can] do so it is deemed better to say nothing on the subject, further than that it will not be dropped. (Work 1945: 21–22)

Work later reported that the leader of the Haidas who had looted the Vancouver was an old chief named "Kinsly":

Monday, June 8

The Masset Indians went off about noon. Their Old Chief, (the Old scoundrel Kinsly, who was the head and active hand at pillaging the Vancouver) presented himself with a party of his men at the gates in the morning, but knowing he merited punishment he would not trust himself in the fort. When Dr. Kennedy went out to speak to him, he said we are friends now and that when a vessel went to Necoon he would give some beaver skins. His offer of friendship was not accepted or refused, and indeed very little conversation took place, as he did not feel himself safe and shortly went off. It was our object to have got him into the fort & secured, but as his men were armed we could not effect this without bloodshed. We had every wish to punish them and we might have shot several of them without much risk to ourselves, but as several of the Pearl Harbour Indians were mixed among them, some of them would have been unavoidably killed also and that would have embroiled us in a quarrel with them also, and been attended with a heavy expense to make up the matter. We were therefore compelled reluctantly, to let them go off unhurt, but it is to be hoped that some favourable opportunity may offer when they can be chastised effectually. After they were gone we learned that the Chiefs here

were anxious that we would get the old scoundrel into the fort and that a row would be the consequence, when they would avail themselves of the opportunity to join the fracas and pillage them of every thing they had. Even had we been aware of these sentiments, no matter how desireable it would have been to punish the villains, it would not have been advisable to have acceded to this plan, because the want of principle and love of pillage in these Indians would urge them to pillage any other tribes that would come here, and strangers from a distance would thereby be deterred from visiting the fort. We also learned after they were gone, that they had some of the Vancouver's blunderbusses with them which they intended to make us a present of had matters been made up. They also had been trying to draw over the Pearl Harbour Chiefs to their side, but the others say they declined. What little they traded here was done only by slaves or men of little note so that seizing any of them would have been of no avail. (Work 1945: 48–49)

Alfred Adams, a Haida consultant in Massett, recalled to the ethnographer Marius Barbeau that Albert Edward Edenshaw had been involved in the looting of a ship wrecked on Rose Spit; this may have been the same incident:

The first white visitors that came here were wrecked on Rose-Spit; name of the boat heard, by now forgotten. The boat and all the cargo burnt up; Edensaw got some of the guns which were burnt. He took the burnt metal and he made guns of all the stocks he got there, and completed them all. He became a metalsmith. He replaced the wood in those muskets that had burnt. The guns he made could be used. He sold them. He had lots of slaves in those days. He used some of the guns to buy slaves. (Barbeau 1916–1954: B-F-251.13)

This suggests that *gwaaygu 7anhlan* might have been living at *hl7yaalang* in 1834, because there he would have been in position to loot the *Vancouver* on Rose Spit. We know that after the death of old *7idansuu*, perhaps around 1840, *gwaaygu 7anhlan*, then about twenty-eight, inherited the name *7idansuu* as well as the leadership of the *sdast'a.aas saangga.ahl 'laanaas* clan.[26] Along with this position came his uncles' (*skil.aa.u*'s and old *7idansuu*'s) houses in *hl7yaalang* and *k'yuust'aa* and his other property, which included twelve slaves (Dalzell 1968: 64; Harrison 1911–1913, vol. 2, no. 1, p. 4). Alfred Adams told Barbeau that *gwaaygu 7anhlan* had a house at Tow Hill (*hl7yaalang*) and that he gave ten potlatches there (Barbeau 1916–1954: B-F-254.13: 3). This number might refer to the total number of potlatches he gave, including those held at other locations. Wilson Duff reported: "He shared with Ninstints of Anthony Island the distinction of having given ten potlatches" (Duff and Kew 1957: 24), and the Reverend Charles Harrison (1925: 65, 170) said: "Chief Edenshaw during his lifetime made seven great potlatches, and was consequently esteemed a very high and important personage." In his edited version of Harrison's account, Charles Lillard (1984: 142) noted: "Without question Edenshaw was the power at Massett and among the northern Haida, but at the other end of the islands, Ninstints was an equally powerful Eagle chief. . . . Both men were credited with ten large potlatches.

Harrison's 'seven' may be the correct number as 'ten' is a ritual number among the Haida."

At *k'yuust'aa*, the house named *qwii kijgad*, "house pole reaching the sky," is said to have been owned by "Old Edenshaw, predecessor of Albert Edward Edenshaw" (MacDonald 1983: 189). Kathleen Dalzell (1973: 453) stated that after *gannyaa* moved to Kaigani in the late eighteenth century, Edenshaw took over as the head chief of *k'yuust'aa,* and though he maintained two houses, one at *hl7yaalang* and one in *k'yuust'aa,* his main residence was in *k'yuust'aa.* Accounts recorded by Mary Lee Sterns (1984) and by Marianne Boelscher (1988), however, suggest that *gwaaygu 7anhlan* was the first of his lineage to move to *k'yuust'aa* in the early 1840s. After the death of the *k'yuust'aa* town chief, *7ihldii'nii* (head of the *k'aawaas* Eagles, a related *sdast'a.aas* lineage), *gwaaygu 7anhlan* claimed the position of town chief of this village, a position he retained throughout his life. This status was often recorded in Euro-American accounts (Swanton [1905a: 281] listed the town chief of Kiusta as EdA'nsa), but members of the *k'aawaas* lineage have always disputed this claim. Morris Marks, who held the name *7ihldii'nii* in 1962, told Sterns the following during an interview:

> Oral traditions which I collected in Masset in 1962 tell that long ago (probably in the early 1840s) when the K'awas were living alone in Kiusta under their head Iłtine, a large party of canoes appeared offshore and attempted to land. The people rushed down to the beach and threw things at the visitors to keep them from coming ashore, but the chief came out and scolded them, saying that this was no way to greet friends. "Why didn't the people want these others to land?" "Well, they knew this man (Edenshaw) was going to try to take over. But they let him come ashore and right away they built a huge house, called Story House, and their chief gave a big potlatch. And sure enough, when the old chief (Iłtine) died, this man grabbed the name and made himself chief." (Sterns 1984: 205–206)

We know that during the late eighteenth century *gannyaa* was the most prominent leader in this area, before he moved with his family to Alaska. It is likely that both the *k'aawaas sdast'a.aas* (E21a) and the *saangga.ahl sdast'a.aas* (E21) moved to *k'yuust'aa* from *hl7yaalang* and other villages near Rose Spit after *gannyaa*'s departure in the late eighteenth century. It was only then that the chief of the *k'aawaas* would have claimed the role of town chief there. It was said that *7ihldii'nii* went to Alaska, never to return, and Swanton (1905b:15–25) gave a long account of how *7ihldii'nii* had gone out fishing from *k'yuust'aa* and been swept away in a storm, was rescued by Tlingit villagers on the Stikine, and was nursed back to health and continued to live there until his death. When *7ihldii'nii* died (or disappeared), he had no male heir, and his niece assumed the role of head of the lineage. Sterns also quoted an account given to her by Marianne Boelscher from an informant whose mother's father was of the K'aawaas:

> Henry Edenshaw's father is not the chief of Kiusta. Kiusta was full when they (the Sta'stas) tried to get in there. . . . Finally they (the K'awas) had a big meeting called together by Iłsqandas. She was taking care of the village. She must be the niece of the chief. They allowed others to stay there for a

while. When they had the meeting they told Edenshaw to anchor way out while they had it. They just allowed him to stay there — didn't give him any land. (Sterns 1984: 206; see also Boelscher 1988: 40–41)

Although *gwaaygu 7anhlan* claimed descent from *gannyaa*, *gannyaa* was from the *juus xàadee*, a different though related Eagle moiety (Djus xade' or "Djus Island People," a *git'ans* subgroup — E18; MacDonald 1983: 188; Swanton 1905a: 275).[27] It may be that in order for *gwaaygu 7anhlan* to establish a leadership role at *k'yuust'aa* he also had to claim descent from *gannyaa*, who preceeded the *k'aawaas* as the leader of *k'yuust'aa*. It is possible that old *7idansuu* had been given the name "Douglas" either directly by *gannyaa* or by one of his heirs. In any case, *gwaaygu 7anhlan* frequently mentioned to Euro-American visitors his being related to *gannyaa* and having the name "Douglas." Perhaps this was his way of legitimating his position at *k'yuust'aa*.

Artists with a professional status on the northern Northwest Coast were usually members of the noble class who inherited their position and were trained as artists as well as leaders. This hierarchical social system was based on noble birth and marriage as well as on the accumulation of wealth that allowed those of high rank to potlatch, thereby validating and increasing their status. In keeping with this system, *gwaaygu 7anhlan*'s fame was based on his hereditary position as the leader of the *saangga.ahl 'laanaas* Eagles, as well as his noble marriages with the *yahgu 'laanaas* Ravens of *hlanqwáan* and his accumulation of wealth, which allowed him to potlatch extensively over the course of his lifetime.

As was the custom among Haida nobility, *gwaaygu 7anhlan* married old *7idansuu*'s widow when he took his place. Old *7idansuu*'s widow was called *gu.uu 7aww*, which means "*gu.uu*'s mother" in the Haida language. She was born around 1810 and was therefore about the same age as *gwaaygu 7anhlan*. She was the daughter of a white sea captain named Duncan and a woman named *nan na.aa san 'laa xiilawaas* from the *yahgu 'laanaas* Ravens (R19) of *hlanqwáan* (Klinkwan), Alaska.[28] Shortly after *gwaaygu 7anhlan* assumed his uncle's place, *gu.uu 7aww* had a son with him named *gu.uu* (Gau, George Cowhoe), who was born in 1851. As mentioned earlier, this must be the same name as that held by the nineteenth-century Kow (*gu.uu*), who lived at *daa.adans* before moving to *k'áyk'aanii*, which suggests that *nan na.aa san laa xiilawaas* was closely related to the older Kow (*gu.uu*).

t'áa.u (Coppers)

Albert Edward Edenshaw's position in Haida society has been analyzed by several twentieth-century anthropologists and historians (Boelscher 1988; Gough 1982, 1993; Sterns 1981, 1984). None of these scholars focused on his contributions as an artist. As Lillard pointed out, however, "he was well known in Collison's time as a copper and iron smith, and a leading carver of totems" (Lillard 1981: 70). MacDonald pointed out Edenshaw's reputation as a carver, in particular his specialty as a maker of coppers and steel daggers. He illustrated a large copper with a female grizzly bear design (fig. 3.10) that belonged to *gwaaygu 7anhlan* and was said to have been made by him (MacDonald 1996: 214). It was left to Charles Edenshaw and was sold in 1970 by his grand-

daughter, Mary Yaehltetsi (*yáah daajée*), the daughter of Alex Yaelhtetsi (a nephew of Charles Edenshaw's) and Agnes Edenshaw Yaelhtetsi (Charles Edenshaw's daughter). The missing pieces taken out of the lower corners are said to have been used to patch up a boat. Along with this piece in the collection of the Canadian Museum of Civilization are two small coppers that were once attached to *gwaaygu 7anhlan*'s headdress (fig. 3.11). These were collected and described by Alexander MacKenzie, the Hudson's Bay Company's factor at Massett from 1878 to 1887 (Dalzell 1968:77–78). They were purchased from him by Dr. William Fraser Tolmie, a medical officer in the service of the Hudson's Bay Company, in 1884:

> Ancient "Coppers" (Haida Taow). — These are the only two antique coppers known among the people of Masset, and were made before the natives procured sheet copper from the Russians in Alaska. They have been in the possession of the same family through a long line of chiefs who displayed them on festal occasions. A chief named Edensaw, now long deceased, used to wear them bound one to each side of his head-dress (tsilk) on occasions of ceremonial dances, etc. (Mackenzie 1891: 52)

MacKenzie went on to list the names of several coppers, two of which were sold by Edenshaw to the Tsimshian chief Legaic:

> Taow-ked-oos — "The copper that steals all the people"
>
> Yen-an-taous — "The copper that is like a cloud"
>
> Taow-kee-ass — "The copper that stands perpendicular"
>
> Len-ah-taous — "The copper that must needs be fathomed" [referring to its large size]
>
> These names served to perpetuate the identity of the copper when it changed hands, and were used in referring to it in the traditions of the people.
>
> The name of a copper in Haida is Taow, Sitka Tinnah, Tshimsean Hy-y-etsk.
>
> Examples of the prices paid for such coppers may be interesting. Thus Taow-ked-oos was sold by Edensaw to Legaic, a Tshimsean chief, for ten slaves. Yen-an-taous was sold by Edensaw to the same man for ten slaves, two large cedar canoes and one dance headdress. Taw-kee-ass was purchased by a Tshimsean chief named Nees-thlan-on-oos from a Haida chief for eight slaves, one large cedar canoe, one hundred elk skins and eighty boxes of grease. (MacKenzie 1891: 52–53)

Barbeau collected two coppers from Alfred Sqatin of Gitlaxdamks in 1927 that were said to have been made by a Haida artist for Sqatin's uncle (also named Sqatin) (Royal Ontario Museum cat. nos. HN760, HN761). One of these, with a whale design, seems somewhat similar in style to Mary Yaehltetsi's copper, and it is possible that one or both of these were also made by *gwaaygu 7anhlan*. Albert Edward Edenshaw's carving skills and copper vending practices were described to Barbeau by Alfred Adams:

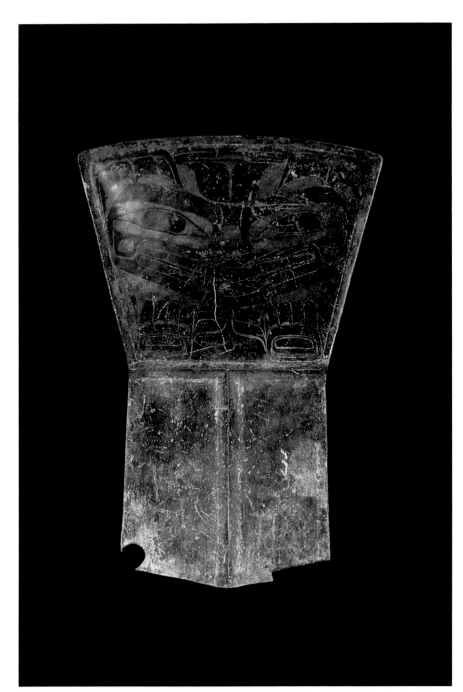

Fig. 3.10. A copper with a
female grizzly bear design
that once belonged to
Albert Edward Edenshaw
and is attributed to him.
Mid-nineteenth century,
116 by 75 cm. Courtesy
of the Canadian Museum
of Civilization, cat. no.
VII-B-1595, neg. no. S92-
4312.

Fig. 3.11. Small coppers from
Albert Edward Edenshaw's
headdress. Canadian Museum of
Civilization, cat. nos. VII-B-963 (14
by 21.7 cm), VII-B-964 (15.2 by 22
cm). Photograph courtesy of the
Canadian Museum of Civilization,
neg. no. S95-29395.

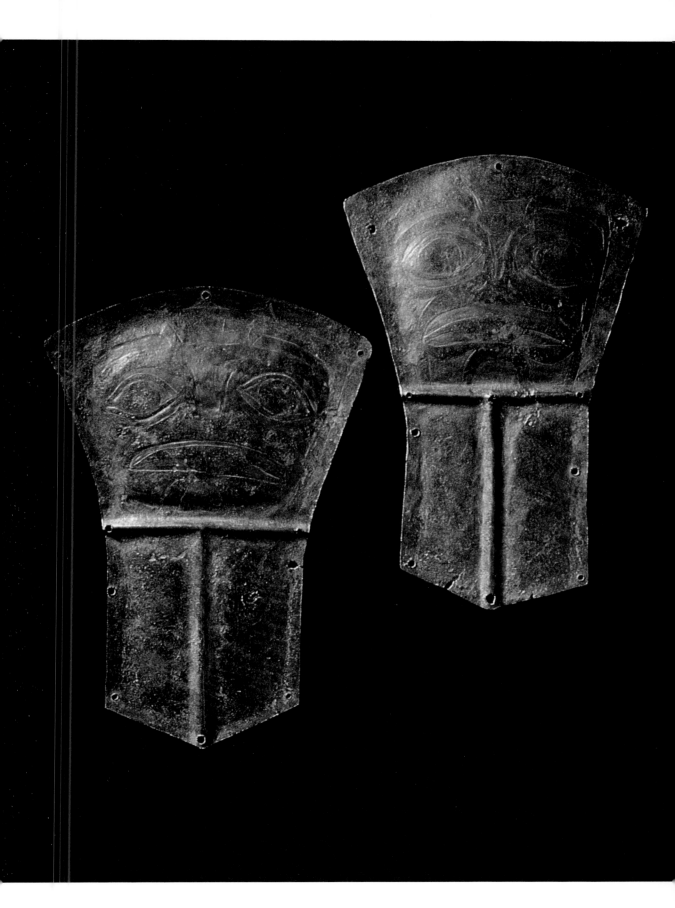

I don't think he made any canoes. He was famous as a totem pole carver. I did not see any small carving by him. He did some big hayetsh or copper shields, he carved some of them. Large ones. He had a special knife and tools and chisels for it. The copper, I think he secured it from Alaska... I don't know where he got his copper, most of it from Alaska. That is why the southern B. C. Indians were crazy about it, it was scarce there. When I was with him one summer, I and one of his nephews, I saw him get a small copper shield, about 30" high and 14" wide; it was real native copper it was already made old, he sold this to a chief of the Fraser river for hundreds of dollars. I was with him. I don't know why they were so crazy about it. I did not see him do any silver work. I did not see him do any argillite work, his nephews did: Charlie in particular. (Barbeau 1916–1954: B-F-253.3)

The Reverend William Collison provided a colorful account of Albert Edward Edenshaw's arrival at Massett in 1876 and of the use of coppers on that occasion:

The following day Edenshew, an influential chief, arrived from Virago Sound, accompanied by a large number of his tribe in several war canoes. His own canoe was manned principally by his slaves. He and his men were received with honours, and a dance of peace was accorded them. There had been a quarrel between the two tribes, and Edenshew with his leading men had been invited for the purpose of making peace. As their large canoes approached the shore the occupants chanted the brave deeds of the past, and were answered in a similar strain by the concourse of the shore. The chanting was accompanied by regular and graceful motions of the head and body and waving of the hands. The time was kept by a large drum formed like a chest, and made of red cedar wood, painted with grotesque figures, and covered with skin. This was beaten by a drummer seated in the bow of the leading canoe. Naked slaves with their bodies blackened, each bearing a large copper shield, now rushed into the water and cast the shields into the deep, in front of the canoes of the visitors. As these shields are made of native copper, and inscribed with their crestal signs, they are very highly valued amongst the Indians, consequently this was one of the highest marks of welcome and honour. Not that the copper shields were lost to the owners, as they were recovered afterwards on the ebb of the tide. (Collison 1915: 109–110)

This passage suggests that it was the welcoming host, presumably Chief *7wii.aa*, who had his slaves rush out and cast coppers into the water as *7idansuu*'s canoes arrived, as a sign of respect. One might imagine that on that occasion, Chief *7idansuu* was wearing his headdress with the small coppers attached at the sides. Indeed, Collison's account goes on to mention the elaborate headdresses worn by *7wii.aa*'s party on this occasion:

On landing the visitors were preceded by a number of dancers, male and female, specially arrayed and with faces painted, who led the way to the lodge prepared for their reception. The central seat was given to the chief, and his leading men were seated around. A messenger now entered to

announce the coming of his chief and party to welcome his guests. These at once entered, the chief [ʒwii.aa] preceding and followed by the sub-chiefs, and principal men in their dancing attire. The headdress or shikid bore the crest of the tribe on the front inlaid with mother-of-pearl, and surmounted by a circlet or crown formed of the bristled of the sea lion, standing closely together so as to form a receptacle. This was filled with swan or eagle's down, very fine and specially prepared. As the procession danced around in front of the guests chanting the song of peace, the chief bowed before each of his visitors, and as he did so, a cloud of the swansdown descended in a shower over his guest. Passing on, this was repeated before each, and thus peace was made and sealed. (Collison 1915: 110)

Henry Edenshaw, *gwaaygu ʒanhlan*'s son, also confirmed that his father was a copper maker and that he sold his work for high prices (Barbeau 1916–1954: B-F-251.10). Barbeau acquired a different account of metal smithing in the Edenshaw family from Charles Barton, an older chief of the Nass River. He spoke of "Idensu," a chief of Massett:

The old man Idensu was a great maker and seller of "coppers" and knives. He must have been a good ironsmith. He carved the knife I have in my possession. The Edenshaws were both of Massett and Skidegate (Charles Edenshaw, who died a few years ago, was a good carver of silver). It was his grandfather who made knives. There was also Charlie's uncle, who was called Idensu, different from the maker of knives. The maker of knives preceded him. Talent ran in the family. (Barbeau 1916–1954: B-F-258.3)

It may be that Charles Barton was referring to Charles Edenshaw's great-uncle rather than to his grandfather, because this man is later described as the one who preceded Charles's uncle. This suggests that old *ʒidansuu* was an iron smith, a maker of daggers. He might have trained his nephew (Charles Edenshaw's uncle) *gwaaygu ʒanhlan* in metalworking. The current location of Charles Barton's dagger is unknown, but it might represent the only known work of old *ʒidansuu*.

jahlk'a or *sakii.id* (Headdress Frontlets)

There are several headdress frontlets that can be attributed to the hand of Albert Edward Edenshaw. One, in the Seattle Art Museum (fig. 3.12), was collected at Hydaburg from Fred Grant, Sr., the grandson of *q'aawiidaa* and *Duncan ginaawaan,* who attributed it to Albert Edward Edenshaw. This frontlet represents the story of the *suu sraa.n* (*sū sᵋān*, or Wasgo [*ʒwaasru*]), the sea-wolf, showing the young man who killed this sea monster wearing its skin like a head-dress and holding a whale in his hands. This story was also selected by *gwaaygu ʒanhlan* for display on the house that he built at *k'yuust'aa* (see below). The distinctive open, unconstricted shape of the eyelid lines on this frontlet, as well as the shapes of the ovoids and other formline details on the whale's body, provides a characteristic detail that helps us to identify other works by the same artist. A second headdress frontlet known to have been owned by *gwaaygu*

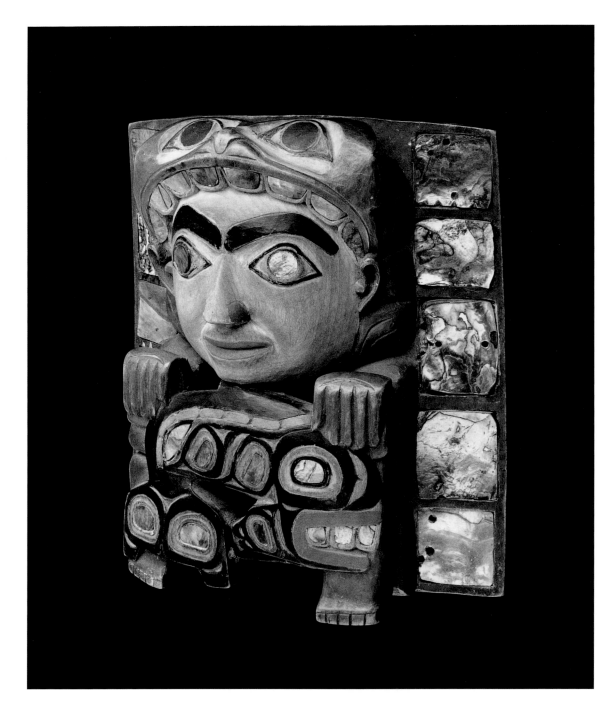

Fig. 3.12. Headdress frontlet attributed to
Albert Edward Edenshaw, 15.9 by 14.9 by
5.7 cm. Gift of John H. Hauberg. Courtesy
of the Seattle Art Museum, cat. no. 91.1.82.
Photograph by Paul Macapia.

7anhlan is now in the Pitt Rivers Museum in Oxford, England (plate 7). It probably represents an eagle, one of *7idansuu*'s crests, and shows an identical open, unconstricted treatment of the eyelid lines, though the eye sockets are sharply carved as opposed to the more portraitlike treatment of the young man's face on the Seattle Art Museum frontlet. Both frontlets appear to have been made by the same artist, perhaps *gwaaygu 7anhlan*.

Another frontlet (fig. 3.13), also in the Pitt Rivers Museum, was owned by *gwaaygu 7anhlan* but was probably made by a different artist. It displays one of *7idansuu*'s wife's crests, the bear with a frog on its chest. Here the eyelid lines are constricted and the eye socket area is treated differently. Certainly, high-ranking families owned many items of regalia, some of which they made for themselves and others that were made for them by other artists. A third headdress frontlet that has been attributed to Albert Edward Edenshaw (fig. 3.14) is in the Anchorage Museum of History and Art. It, too, belonged to Fred Grant, Sr., whose name is inscribed on the back of it. This frontlet represents a hawk-like figure with a recurved beak holding the upstretched wings of a smaller bird (an eagle?) with a hooked beak, both of which grasp double raven's heads with their feet. The open, unconstricted eyelid lines, as well as the association with Fred Grant, Sr., suggest that an Albert Edward Edenshaw attribution is possible, though this piece differs from the others in some respects. The formline eyebrows are broader, and the ovoid eye socket is cut less sharply. Red dashing is painted over the black formlines on the eagle and the raven heads.

In a conversation between Bill Holm and Bill Reid about the DeMenil Collection (Holm and Reid 1975), the two discussed several Haida headdress frontlets. Reid mentioned a possible Charles Edenshaw attribution for a bear frontlet in the DeMenil Collection (fig. 3.15), owing to its similarity to a Charles Edenshaw beaver frontlet in the American Museum of Natural History (see fig. 5.3). Holm, however, pointed out the differences between this frontlet and the one by Charles:

> Personally I'm not strong for an Edenshaw connection here. The unfinished frontlet is different, especially in the structure of the eyes. Its limbs are rounded and modeled, not flat and angular. The only thing here that suggests Edenshaw to me is its similarity in structure to another bear frontlet, belonging to Mr. Morton I. Sosland [fig. 3.16], with little naturalistic faces, in the ears, that look like Edenshaw faces. This frontlet also seems to belong with a dogfish frontlet in the Denver Art Museum [fig. 3.17]. I think all are classic Haida frontlets and the work of one man. They show more real Haida style — while Edenshaw's work skitters around the edges, devolving from it but going off into another thing.
>
> To me, the crispness of it, the definition of eye sockets, the spiral nostrils, the rather geometric or formline limb structure, and the almost self-consciously structural form of the whole thing make it classic Haida — maybe not Edenshaw. (Holm and Reid 1975: discussion with plate 70)

The human faces with the sharply carved ovoid eye sockets in the ears of the DeMenil frontlet (fig. 3.15) are very similar to the face in the tail of the dogfish frontlet (fig. 3.17). Also, the small naturalistic faces in the ears of the Sosland

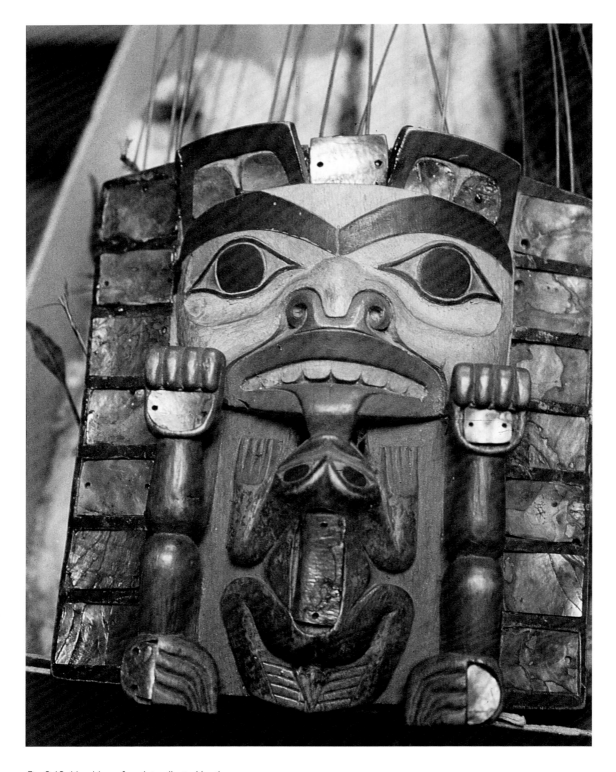

Fig. 3.13. Headdress frontlet collected by the
Reverend Charles Harrison. It belonged to
Albert Edward Edenshaw and is attributed
to an unknown artist. Pitt Rivers Museum,
Oxford, UK, cat. no. 1891.49.11. Photograph
by Bill Holm.

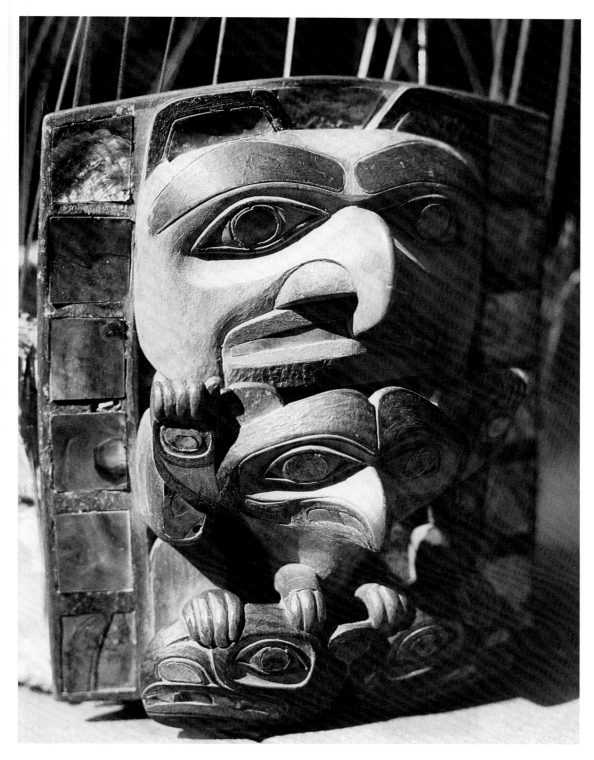

Fig. 3.14. Headdress frontlet attributed to Albert Edward Edenshaw. The name "Fred Grant, Sr." is inscribed on the back. Anchorage Museum of History and Art, cat. no. 78.34. Photograph by Bill Holm.

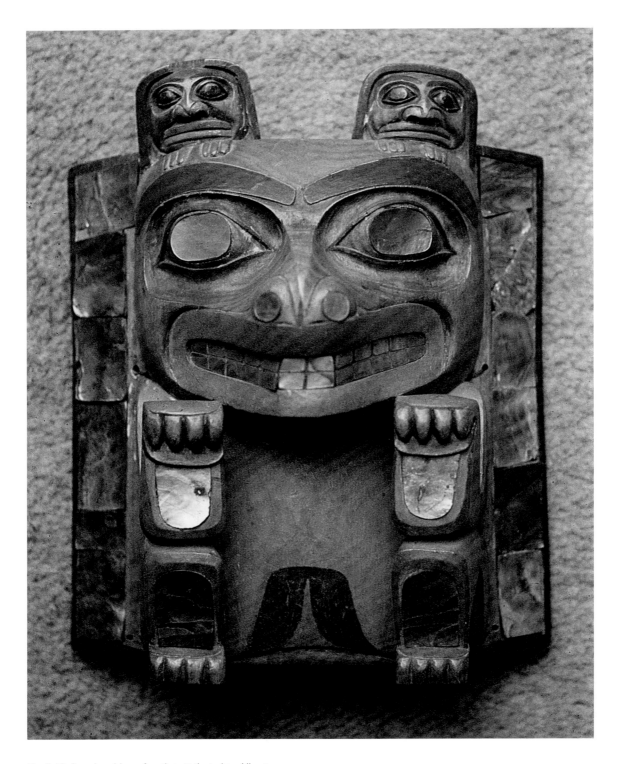

Fig. 3.15. Bear headdress frontlet attributed to Albert
Edward Edenshaw, 17.5 by 14 by 6.7 cm. Private
collection. Photograph by Bill Holm.

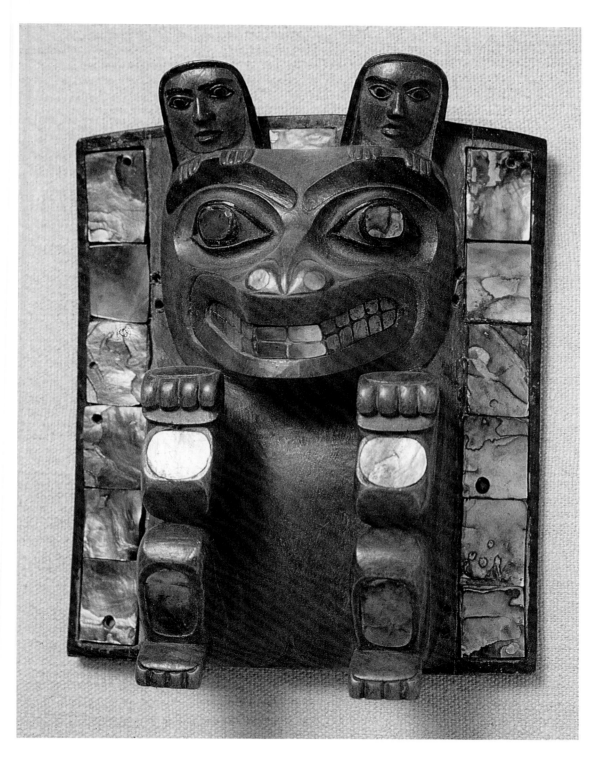

Fig. 3.16. Bear headdress frontlet attributed to Albert Edward Edenshaw. Mr. and Mrs. Morton I. Sosland Collection. Photograph by Bill Holm.

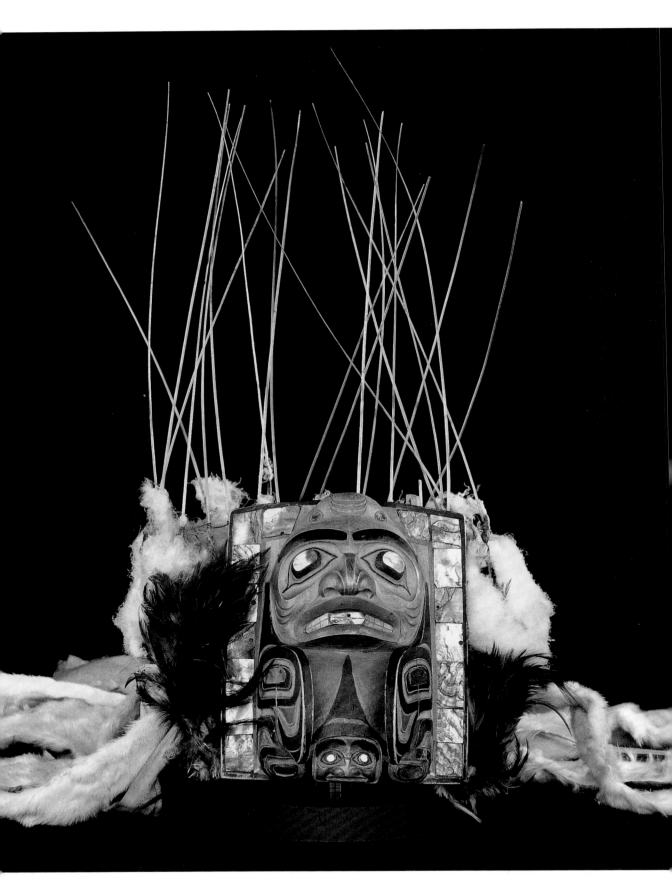

frontlet (fig. 3.16) that Holm described as looking like Charles Edenshaw's faces are quite similar to the naturalistic face on the Seattle Art Museum frontlet (fig. 3.12). It is possible that Albert Edward Edenshaw made all six of these frontlets (plate 7, figs. 3.12, 3.14–3.17). Since he was certainly one of Charles Edenshaw's teachers, this would explain the similarities in the portraitlike faces they both carved.

I would add one more frontlet to the list of those possibly made by Albert Edward Edenshaw. A frontlet in the American Museum of Natural History (fig. 3.18) has a humanoid hawk figure that grasps a salmon with its hands and feet. Here, however, the eyelid lines are constricted on the lower edge, much like those on the Denver Art Museum shark frontlet (fig. 3.17). The rounded shapes of the ovoids match those on the Seattle Art Museum frontlet (fig. 3.12), and there is red dashing on the double Us at the bottom similar to that on the Anchorage frontlet (fig. 3.14). In many ways this American Museum of Natural History frontlet seems to fit with this group of frontlets.

Fig. 3.17. Dogfish headdress frontlet attributed to Albert Edward Edenshaw, 17.7 by 15.5 by 6 cm. Photograph courtesy of the Denver Art Museum, cat. no. 1948.315.

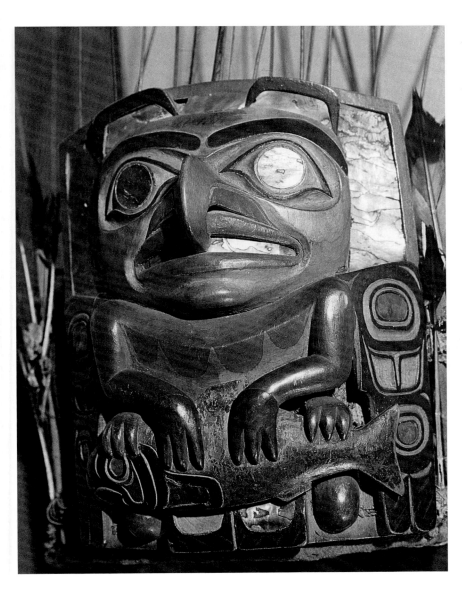

Fig. 3.18. Headdress frontlet depicting a hawk(?) holding a salmon, attributed to Albert Edward Edenshaw, 19.5 by 15 by 5 cm. Collected by Israel W. Powell for Heber R. Bishop, 1882–1885. American Museum of Natural History, cat. no. 16/253. Photograph by the author.

gùulaang.u gyaat'aad (Button Robes), *tluwaa* (Canoes), and *san* (Gambling Sticks)

In addition to coppers and frontlets, a few other objects in museum collections are known to have been owned by *gwaaygu 7anhlan,* passed down to his heirs, and later sold. One of these is an appliquéd robe known from a photograph in the Royal British Columbia Museum's anthropology archives (fig. 3.19). This trade-cloth robe has a button border around the outer edge and a beaver figure, another of the *7idansuu* crests, made entirely of appliquéd dentalium shells and abalone. A set of his gambling sticks was collected by Newcombe and is now at the Field Museum (fig. 3.20), and a model of a head canoe — an archaic style of canoe on the northern Northwest Coast — is in the Canadian Museum of Civilization (fig. 3.21). According to the museum's records, the collector, Israel Powell, the Indian superintendent for British Columbia, noted:

> Model of ancient large Hydah canoe which belonged to a Hydah Chief named "Edenshaw" uncle of the present "Edenshaw" scale 2/3" to the foot. No canoes of this build or dimensions exist at the present day. The supports at the stern were intended to give additional strength to the prow. They were firmly lashed with roots, not nailed or pinned as shown in this model. Canoes of this size were used in their war excursions and sometimes carried fifty or sixty men. This model was made by the present "Edenshaw" at Masset Queen Char. Isn. October 1879. (Canadian Museum of Civilization catalog)

Fig. 3.19. Trade cloth robe with buttons, dentalium shells, and abalone appliqué, collected by Thomas Deasy and sold to George T. Emmons. Notation by Thomas Deasy: "Dentalia blanket. Haida chief's ceremonial blanket, formerly owned and worn by the late Chief Edenshaw, Czar of the Northern Haida, the 'Terrors of the North.'" Courtesy of the Royal British Columbia Museum, neg. no. PN5511.

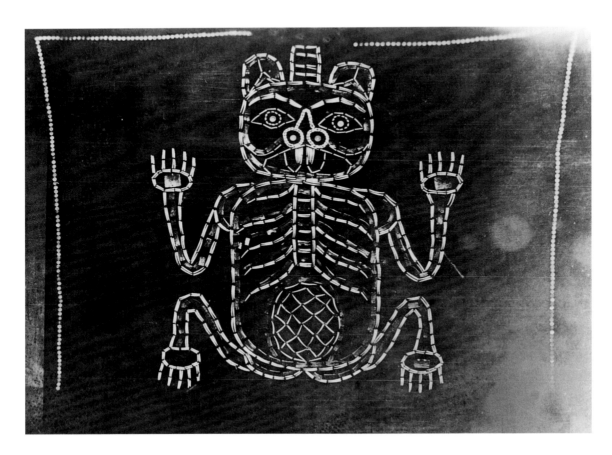

In 1879, then, Albert Edward Edenshaw was still alive and holding the name Chief Edenshaw; Charles had not yet been baptized with that name. If Powell's account is correct, this model was a copy of a canoe that belonged to old *7idansuu*, and it was made by *gwaaygu 7anhlan*. If so, the painting on it gives us a unique view of *gwaaygu 7anhlan*'s late formline style of painting, which has relatively thin formlines and slightly constricted eyelid lines. The ovoid shapes, however, match quite closely the ovoids of the frontlets discussed earlier. If *gwaaygu 7anhlan* made this model canoe, then it conflicts with Alfred Adams's recollection that he was not a canoe maker. Perhaps he painted the model after it was carved by someone else, much as Charles Edenshaw is known to have done.

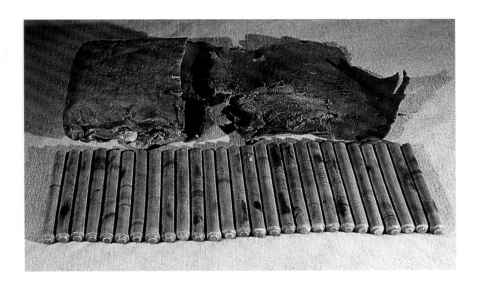

Fig. 3.20. Gambling sticks with leather pouch that belonged to Albert Edward Edenshaw, collected by C. F. Newcombe, 19 by 16 cm (pouch). Field Museum of Natural History, cat. no. 79584. Photograph by the author.

Fig. 3.21. Model of a head canoe collected by Israel Powell at Massett, October 1879; 121 by 23 by 19 cm (canoe), 28 by 4 cm (paddles). Photograph courtesy of the Canadian Museum of Civilization, cat. no. VII-B-125, neg. no. 80-13454.

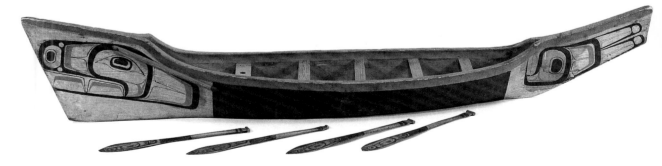

ruda (Boxes and Chests)

Charles F. Newcombe collected a number of chests and boxes in Massett in the early years of the twentieth century. One old-style bentwood box is particularly interesting (fig. 3.22). It was said to have been 150 years old in 1902 and to have belonged to a chief at *qang* (Kung), a village at the narrows leading to Naden Harbour in Virago Sound. This might refer to Albert Edward Edenshaw, since he lived in *qang* from the 1850s through the 1870s and was often identified as a chief of Virago Sound. The estimated date of 1750 for this box is believable, considering the old, massive formline style displayed on it (see Brown 1998).

Another chest (fig. 3.23) collected by Newcombe at Massett was said to have been used by the *sdast'a.aas* family at dances for a dramatic performance involving the sleight-of-hand disappearance of a young boy who was apparently killed by being stabbed with a spear and then concealed within the chest. One side of the chest is hinged to allow quick opening and closing. This chest shows an unusual formline style by an unknown maker who separated the tertiary lines around the inner ovoids by a very wide space. A second chest collected by Newcombe at Massett and purchased by Stewart Culin (fig. 3.24) was apparently used for the same purpose, probably also by the *sdast'a.aas*. Culin reported:

> The carved box, a very fine one, Dr. Newcombe let me have for twenty dollars, much less than it would ordinarily have been worth. This was on account of its having a piece cut out at the back and loosely fitten in. It had been employed, Dr. Newcombe said, in a performance in which a

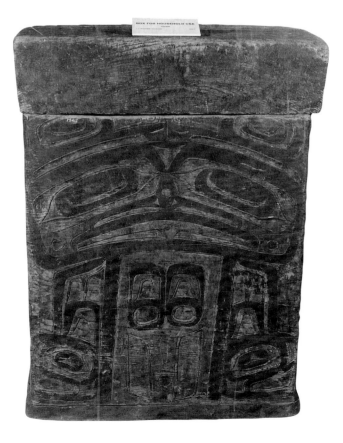

Fig. 3.22. Bentwood box that belonged to a chief at Kung, Virago Sound, said to be 150 years old in 1902. Collected by C. F. Newcombe, 1902. Photograph courtesy of the Field Museum of Natural History, cat. no. 79417, neg. no. A104168_8.

child had been put in a box and knives thrust through, like the well known Hindu basket trick. The Haidas had had it for a long time, and he thought it of native American origin. (Fane, Jacknis, and Breen 1991: 273)

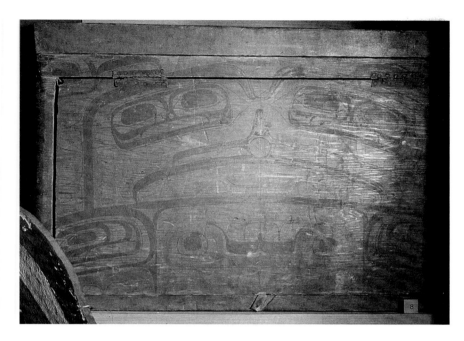

Fig. 3.23. Bentwood chest collected by C. F. Newcombe at Massett, 1901. Newcombe described this as "a chest with back that falls down, allowing the disappearance of a temporary inmate who is supposed to be stabbed with a spear the head of which sinks into the shaft when the point is pressed against anything. With this goes a real spear handed round to prove no deception." Field Museum of Natural History, cat. no. 79590. Photograph by the author.

Fig. 3.24. Bentwood chest collected by C. F. Newcombe and sold to Stewart Culin in 1908; 93 by 56.5 by 60 cm. A piece cut out of the back and loosely fitted in allowed a child to be hidden in the chest as part of a performance. Photograph courtesy of the Brooklyn Museum, cat. no. 08.491.8903.

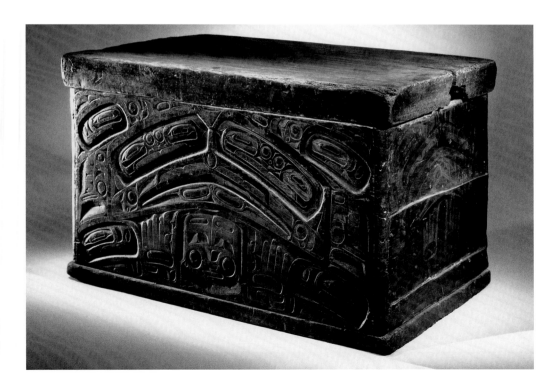

Newcombe collected several chests from Charles Edenshaw, including one in the Royal British Columbia Museum (fig. 3.25) that is similar in style to the Culin chest. There are crosshatched subsecondary elements on both chests. This chest, among others, led Wilson Duff to attribute several bentwood chests to the hand of Albert Edward Edenshaw. At the time of his death, Duff had been planning to write a book about Edenshaw. Portions of his unpublished thoughts were later published by E. N. Anderson (1996); they reveal that Duff had attributed more than thirty bentwood chests, collected throughout the Northwest Coast, to Albert Edward Edenshaw's hand. He also attributed to him the famous bowl (which Duff called a box) at the American Museum of Natural History (cat. no. 19/1233) that George Emmons collected from the Chilkat and that Charles Edenshaw later interpreted for Franz Boas (see chapter 5; Anderson 1996: 142–143, 239–249; Boas 1927: 275–276). Duff's attribution of this bowl to Albert Edward Edenshaw was something that he arrived at late in life. He wrote little about how he reached or justified the attribution of this bowl or the other chests, and all of these attributions can be questioned.

In addition to the chests collected by Newcombe from Charles Edenshaw, Duff apparently based his chest attributions on the documentation for one chest that Marius Barbeau collected in 1929 from Nisyoq (Neesyoq) of the Wolf phratry at Gitlakdamiks on the Nass River (Anderson 1996: 242–243). This chest is now in the Royal Ontario Museum in Toronto (fig. 3.26). Barbeau's description of the chest included an account of how Nisyoq used it:

> It was used as a dancing platform in feasts; the box was filled with moose skins, which were distributed after the chief had danced on it. It was twice used by Nisyoq. . . . This box was carved by Wutensu' (Edenshaw), a Haida, before the present Nisyoq was born (He seems around 75 years old. The carvings are not meant for crests; they are sa.dəbisəst "to butterfly" or "to beautify" (a.dəbis = butterfly); or again "a work of art." (Barbeau's notes at the Royal Ontario Museum Department of Anthropology archives)

If Barbeau's interpretation of the name Wutensu as Edenshaw is correct, and if his estimated age for Nisyoq is accurate, then this chest was carved sometime before 1854 and so could indeed have been carved by Albert Edward Edenshaw. Duff apparently believed that the Tsimshian never made bentwood chests of this type (Anderson 1996: 242–244). Research conducted in more recent years has largely disproved Duff's theories. Bentwood chests and boxes were traded widely up and down the Northwest Coast, and as Duff rightly pointed out, their collection history does not necessarily indicate their place of origin. Many chests were made by northern Wakashan and Tsimshian artists, and it is possible to identify the work of individual artists by a close comparison of their stylistic features. Bill McClennan's work with infrared photography at the University of British Columbia Museum of Anthropology has led to a better understanding of these schools of bentwood box and chest design, particularly of pieces made by Heitsuk and Tsimshian artists (McLennan and Duffek 2000). The chest Newcombe collected from Charles Edenshaw (fig. 3.25) and the one he sold to Culin (fig. 3.24) may fit within the Tsimshian style of chest carving.

Nisyoq's chest, however, does bear a striking resemblance to a chest in the Thaw Collection at the Fenimore House Museum in New York State (fig. 3.27).

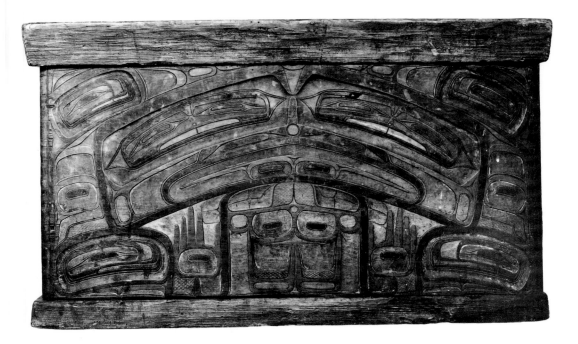

Fig. 3.25. Bentwood chest collected by
C. F. Newcombe from Charles Edenshaw,
circa 1909. Photograph courtesy of the
Royal British Columbia Museum, cat. no.
1295, neg. no. 10966B.

Fig. 3.26. Bentwood chest collected in 1929
by Marius Barbeau from Nisyoq [Neesyoq]
of the Wolf phratry at Gitlakdamiks on the
Nass River. Photograph courtesy of the Royal
Ontario Museum, cat. no. 1929.21.61, neg.
no. 75ETH10.

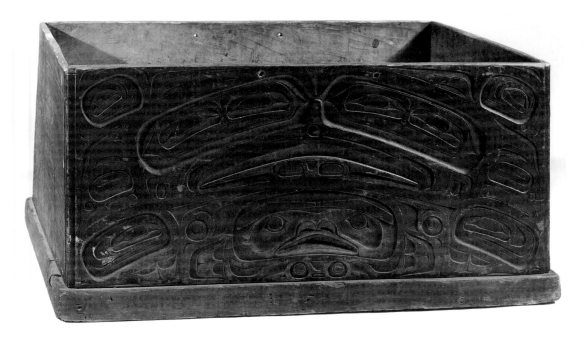

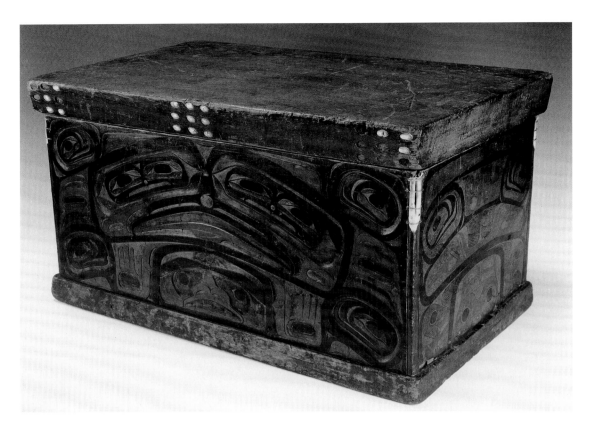

Fig. 3.27. Bentwood chest from the Eugene and Clare Thaw
Collection. Collected by Alton Dickerman in Sitka, Alaska,
circa 1883. Courtesy of the Fenimore House Museum, New
York State Historical Association, cat. nos. T189a, T189b.
Photograph by Richard Walker.

Fig. 3.28. Bentwood chest collected by George
Emmons from Coudahwot of the Gaanax.teidí
clan at Klukwan, Alaska, before 1905. Burke
Museum, cat. no. 2291. Photograph by Bill Holm.

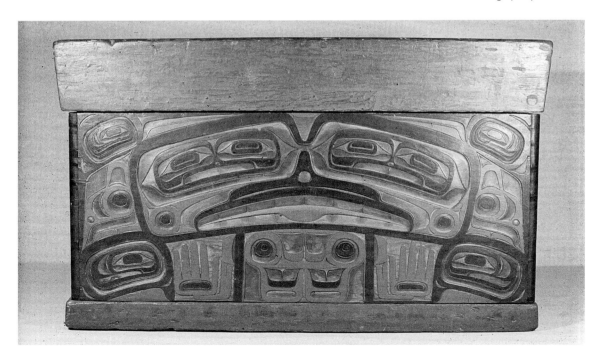

In particular, the stylized faces in the bodies on the two-step structure (double-eye) sides (see Holm 1997) of both chests and in the mouth on the one-step structure (single-eye) side of Nisyoq's chest are alike in the form of the eye sockets, eyebrows, nose, and lips. Also, the rounded shapes of the "salmon-trout-head" inner ovoids in the upper corners are much alike, and the painting on the end panels is similar in the use of cross-hatching.

These two chests are similar in some ways to a Haida chest now at the Burke Museum (fig. 3.28) that Emmons collected from Coudahwot, a chief of the Tlingit Ganakhtedi (Gaanax.teidí) clan at Klukwan, Alaska. Emmons was told that Coudahwot had acquired this chest from Haidas of the Queen Charlotte Islands. The Burke Museum chest, however, shows a more angular structure to the primary formlines that form the body, whereas the Thaw and Nisyoq chests have softer, more curvilinear lines in this area (Holm 1987: 148–149).

At present there are no chests that can be firmly attributed to Albert Edward Edenshaw, though if Barbeau's notes are accurate, it may be that he made Nisyoq's chest and the Thaw chest.[29] It is possible that Nisyoq's chest was simply a gift to him from Albert Edward Edenshaw and was not actually made by Edenshaw, since the name of the giver of the gift would no doubt have been more important for Nisyoq to remember and report to Barbeau than the name of the maker of the chest. Those who knew Albert Edward Edenshaw credited his fame as an artist not to chest making but to his skill as a totem pole carver.

gyaa.aang and na (Poles and Houses)

It is not known exactly when gwaaygu ʒanhlan first started carving poles, but Barbeau recorded an account of the event as given to him by Alfred Adams in Massett in 1947:

> He carved large poles. I understand that he got medicine — drinking medicine and he would fast and got his imagination and his conception of different stories and legends. His nephew (sic) [son] (Henry) told me that his father never was a carver when he was young, not a public carver. But once he was invited in Hawkan (Wales Island) [Howkan, ráwk'aan] and was hired to make a carving there, a big totem pole. He began to fast and deny himself and some medicine. When he got to the big tree, he could see all the figures on the tree he visualized them that he was to put on. That is how he started but he had not done very much of this before. That was the first time he became a public carver. And he was well rewarded for it, there were other chiefs also associated with him for carving. From that day on, Chief Edensaw did a great deal of carving. Totem tree at Hawkan was his, erected by a Raven chief. The opposite side erected it: Ravens for Eagles and vice-versa. One here was picked up at Seven-Mile (Beynon knows which). He carved quite a number of poles in the circle here at Prince Rupert; they come from different Haida villages. (Barbeau 1916–1954: B-F-251.13: 3)

George MacDonald speculated that one of Yeltatdzie's poles at ráwk'aan was the one first carved by Albert Edward Edenshaw (MacDonald 1996: 200). This pole, however, has been attributed to Dwight Wallace, the father of John Wallace (Feldman 1996: 66) (see fig. 4.25).[30]

It is said that after dreaming of it, *gwaaygu 7anhlan* built a large house named *q'iigangng na.aas*, "Myth House" (or Story House) at *k'yuust'aa* on the site of his predecessor's house, *skil na.as*, "Property House" (MacDonald 1983: 189). Swanton collected a model of the house (fig. 3.29) and a description of it from Charles Edenshaw. According to Charles Edenshaw, *gwaaygu 7anhlan* originally intended Myth House for his son *gu.uu* (George Cowhoe) when he grew up, but later he changed his mind (Swanton 1905a: 125). Because *gu.uu* was not born until 1851, a few years before *gwaaygu 7anhlan* moved east to *qang*, Myth House must have been built either before the son was born or while he was still an infant. Charles Edenshaw also told Swanton that at the time of the house's construction there was a great potlatch to which the Massett, "West Coast" (of Graham Island), Skidegate, and Kaigani Haidas were invited. On that occasion a big canoe was broken up and used for firewood — an action that displayed the wealth of *gwaaygu 7anhlan* (Swanton 1905a: 126).

Sterns's accounts suggest that this house was built shortly after *gwaaygu 7anhlan* moved to *k'yuust'aa:* "But they let him come ashore and right away they built a huge house, called Story House, and their chief gave a big potlatch" (Sterns 1984: 205–206). Sterns further suggested that one of the reasons *gwaaygu 7anhlan* built the house for his son was to strengthen his political position in the village. When *gu.uu* came of age, however (well after *gwaaygu 7anhlan* had moved to *qang*), he became lineage head of the *yahgu 'laanaas* (Swanton's Middle Town People, R19) and town chief at *daa.adans*, just across Parry Passage on North Island from *k'yuust'aa,* assuming the position once held by his name-sake, *gu.uu* (Kow) (Sterns 1984: 207).[31]

The figures on the frontal pole of Myth House are from the story of the *suu sraa.n*. This story was presumably given to Swanton by Charles Edenshaw:

All the figures on the main house-pole of this house, except the three watchmen at the top, illustrate the following story:

There was once a youth at Gwais-kun, a town belonging to the Sta'stas, who lay in bed so many days, instead of going to work, that his mother-in-law made a remark which caused him to feel ashamed. Then he got up and went into the woods. In a lake back in the forest lived a lake-monster (sū s²ān) similar to the wa'gso, which used to go after black whales every night and bring them ashore. Assisted by Bird-in-the-Air (Sîns xê'tada-i), the hero split a cedar-tree in halves, fastened the two together at their ends, spread them apart at the centre by means of a cross-piece, and laid them in the water just over where the sū s²ān lived. For bait he fastened two children to a rope attached to the end of a pole, and dropped them between. When the sū s²ān came up, the hero knocked out the cross-piece and caught it. After that he put on the sū s²ān's skin and hunted fish of various sorts, which he left in front of his mother-in-law's house. Finding these things left there every morning, the woman persuaded herself that she was a shaman. When he finally showed himself, she was so overcome by shame that she died.

At the bottom of the pole is a black whale representing those which the sū s²ān next figured used to catch. Above the sū s²ān comes the mother-in-law of the hero; and above her, Bird-in-the-Air. Next is shown where

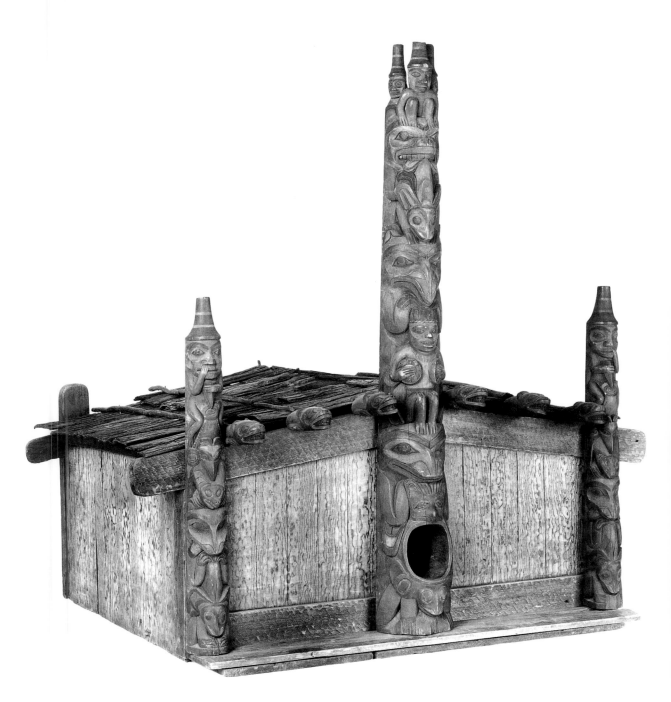

Fig. 3.29. Model of *q'iigangng na.as*, "Myth House,"
Albert Edward Edenshaw's *k'yuust'aa* house, made by
Charles Edenshaw in 1901 for John Swanton, 89 by 68
by 35 cm. Photograph courtesy of the American
Museum of Natural History, cat. no. 16-8771, neg. no.
2A18682.

the sū sᵉān, or the man wearing its skin, caught a whale; and finally come the children that were used as bait.

Only the greatest chiefs are said to have had three watchmen at the top of their house-poles like this.

The figures on the corner posts of this house are the following, from bottom to top. The first two are, in order, a bull-head and a grizzly bear, the second of which is probably intended as a crest. The succeeding figures illustrate a favorite episode in the Raven story. This is where Raven, in the form of a halibut, tried to steal bait from the hooks of halibut-fishermen. Finally he was caught, pulled to the surface, and put over a fire. Then the skin began to shrink, and caused him so much pain that he thought, "I wish that every one would run over to one end of the town!" So all left him except the small boy who was watching him, whereupon Raven came out and flew away. In the design the beak is represented coming out from the halibut's side. In another attempt upon the fishermen's hooks, — which some say was made after the above, some before, — Raven's beak was pulled off, and Raven came back to the town holding his hand over his nose to conceal the deficiency. This has been represented in the final group.

In the left rear corner of this house, as one entered, was a well or water-hole called Property-Water (Skîl ᵉAnʟs). There were usually covers over such wells, but this had none. On the front of the screen in the inside of the house was painted the figure of something called by a Tlingit word, Qo'nʌqʌdʌ. This something was shaped like a house, and appeared out of the water to one who was going to become wealthy. Such objects were called skîl. The projecting ends of the roof-timbers of this house in front are carved into the shapes of grisly-bear heads, and the steps leading down into the house from the doorway were called Grisly-Bear's-Trail (X̱u'ʌdj k!īwa). The grisly bear was used so much because this house was intended, as we have said, for Edensaw's son, who belonged to the Middle-Town-People (R19), and the grisly bear was an important crest of that family. (Swanton 1905a: 126–127)

Charles Edenshaw's model of the interior screen of Myth House (fig. 3.30) displays an image resembling a frog (one of his own *sdast'a.aas* crests), though it was identified by him as *gunaakadeet*, a wealth-giving being from under the sea that is often considered to be the Tlingit equivalent of the Haida *suu sraa.n.* The story about *gwaaygu 7anhlan*'s dream of the house suggests that he was its designer if not its actual carver. According to Haida custom, the carving of a mortuary pole for a mortuary potlatch was always done by members of the moiety opposite that of the deceased and his heir (members of this opposite moiety would also be the recipients of the potlatch payments) (Blackman 1977: 45). Just the reverse arrangement occurred at house-raising potlatches, when members of the owner's lineage selected the house timbers and carved the house pole (Blackman 1977: 42). According to Blackman (1977: 40), "a Haida became eligible for a chiefly title in his matrilineage only if he were *yahɛt* [*yah riid*], the child of a man who had given a *wałał* [*7waahlal*] 'potlatch'." She went on to point out that a *7waahlal* potlatch was given upon the completion of a cedar-plank dwelling and the accession of the new house owner to the position of

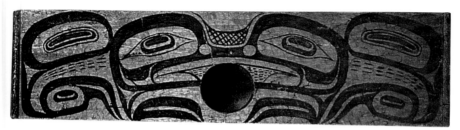

Fig. 3.30. Model of the interior screen of "Myth House" made by Charles Edenshaw in 1901 for John Swanton, 59 by 15.5 by 1 cm. According to Swanton's notes, "the painting on the house screen is of a kind of sk.îl that was called qo'nequde [a Tlingit word, *gunaakadeet*, meaning "wealth giver from under the sea"]. Something shaped like a house appeared out of the water to one who was going to become wealthy." Photograph by Bill Holm.

house chief, as well as upon the raising of a totem pole. On these occasions both husband and wife acted as hosts of the *7waahlal* potlatch, and the potlatch wealth came equally from the two:

> The distribution of potlatch wealth in the *wałał* potlatch differs from that in other Haida potlatches. In the former, it is members of the new house owner's own lineage and moiety who are the recipients of potlatch goods. While this is counter to the dispersal of wealth in the other forms of Haida potlatches, the giving of wealth to members of one's own group is intelligible when it is recalled that a critical element of the *wałał* potlatch is the conferral of *yahɛt* status on the children of the house owner. The recipients of potlatch goods are members of the moiety opposite these children, and they are receiving wealth not only for their part in the construction of the house but, perhaps more importantly, for witnessing the bestowal of names and tattoos on children of the opposite moiety. (Blackman 1977: 45)

This concept, that the father builds and potlatches a house to ensure his children's status, might explain why Charles Edenshaw told Newcombe that *gwaaygu 7anhlan* built Myth House for his son *gu.uu*. Perhaps it was never meant that *gu.uu* would own Myth House, but merely that the building and potlatching of it would assure his status as *yah riid*. Since the owner's own moiety would carve the house frontal pole, it is entirely possible that *gwaaygu 7anhlan* both designed and carved Story House himself. He certainly would have supervised every aspect of its carving. Sadly, little remains of the original house, and we know it only from Charles Edenshaw's model.

The collector James G. Swan identified one house frontal pole that once stood at *k'yuust'aa* as having been carved by Albert Edward Edenshaw. Swan sketched and measured the house and pole while in the village in 1883 (fig. 3.31), guided by Albert Edward Edenshaw himself. Owing to the sketchiness of this drawing, it is unclear which house this is, but judging from Swan's measurements — 48 feet square — it could only have been the largest house in the village, Mac-Donald's House 9, which belonged to *7ihldii'nii*, chief of the *k'aawaas sdast'a.aas*. MacDonald measured this house at 13.5 meters (44.28 feet) wide (1983: 190). He measured Myth House at more than 12 meters square (39 or 40 feet) (MacDonald

Fig. 3.31. Sketch of pole and house at *k'yuust'aa* (Kiusta) from James G. Swan's 1883 notebook. Special Collections Division, University of Washington Libraries. Photograph by the author.

1983: 190), making it smaller than the house that Swan drew. Considering the rivalry that was known to have existed between Albert Edward Edenshaw and *7ihldii'nii*'s family, it might seem unlikely that *7ihldii'nii* commissioned him to carve his pole. Although it is possible that Albert Edward Edenshaw told Swan he had carved this pole when he actually had not, the rivalry with *7ihldii'nii* apparently did not arise until after *7ihldii'nii*'s death or disappearance. It is possible that Albert Edward did carve this pole.

Swan published his finished drawing of the pole in an article in *The West Shore* the year after his trip, 1884 (Swan 1884: 252). It was later used as an illustration

by Lucile McDonald (1972: 170) in her biography *Swan among the Indians* (fig. 3.32). Swan was accompanied on this trip by James Deans, the Indian agent, and Johnny Kit Elswa, his Haida interpreter and assistant. With Kit Elswa's help, Swan hired Albert Edward Edenshaw at Massett to guide them in their canoe trip around Graham Island. Also along on the trip were Amy Edenshaw, Albert's wife, their son Henry, and two of Albert's nephews, including Henry White, who later married Amy after Albert's death (Newcombe 1900–1911: vol. 55, folder 11). While camped at *k'yuust'aa*, Swan described his experience:

> I had noticed in some of the carvings certain strange looking things which I could not make out; one of these at Kioosta had a trunk or proboscis curled up, and, but for the absence of tusks, might have been taken for an elephant. I asked Edinso what it represented. He said it was a butterfly and explained his meaning by pointing to a butterfly which had lit on a bush near us. As he said he had carved the column on which this creature was shown I presumed he knew what he meant to represent. I asked him to tell me the legend about the butterfly. He said that when the Hooyeh or raven was a man, he lived in a country beyond California, that he got angry with his uncle and lit down on his head and split it open. Then fearing his relatives he changed to a bird and flew to Queen Charlotte Islands where he was told good land could be found. The butterfly, a creature as big as a house accompanied him and would fly up in the air and when he saw any good land he would unfold his proboscis and point with it. He went around just as Johnny was going with me showing me places. This idea of comparing Johnny with a butterfly amused him very much and he requested me to make a sketch of the column, which I did, and he promised when we reached Skidegate that he would carve me a similar column out of the argillaceous slate found there, which he subsequently did. (Swan 1883b)

It is possible that the bottom of the pole that Swan sketched was still standing in 1939 when Marius Barbeau photographed a pole at *k'yuust'aa* (fig. 3.35).[32] The upper part of this pole had fallen and decayed, but a comparison of its remaining bear figure with the lowest bear on Swan's drawing shows an interesting similarity. The argillite model pole made by Johnny Kit Elswa on the basis of Swan's sketch (fig. 3.34) has survived and is now in the Field Museum of Natural History in Chicago. For some time it was displayed hanging on the wall of Swan's home in Port Townsend (fig. 3.33). We know that models of poles made by Haida artists often were not exact "copies" but differed from the originals in their proportions and arrangements of figures while remaining true to the identity or essence of the pole (see Charles Edenshaw's copy of *skil.aa.u*'s *hl7yaalang* pole, figs. 3.1 and 3.2). It is likely that neither Charles Edenshaw's copy of Myth House nor Swan's and Kit Elswa's copies of the other *k'yuust'aa* pole carved by *gwaaygu 7anhlan* (possibly *7ihldii'nii*'s house frontal pole) replicate these poles exactly, yet they provide the most accurate record of *gwaaygu 7anhlan*'s *k'yuust'aa* poles, which have survived in no other form. The butterfly held by the bear on the Kit Elswa model, with its head down, seems similar to the small whale held in the mouth of the *suu sraa.n* at the top of the Myth House frontal pole. These figures, as well as the large bear figures, might in turn have

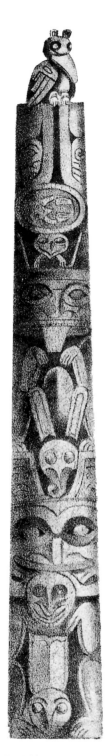

Fig. 3.32. James G. Swan's finished drawing of the *k'yuust'aa* pole, 1884, as reproduced in Lucile McDonald's biography of Swan (McDonald 1972: plate between pp. 170 and 171).

been inspired by Sqiltcange's work on the triple mortuary poles at *k'yuust'aa*, which includes a similar butterfly-like figure with a long proboscis above the head of the bear at the base (see fig. 3.3).

Even with these filtered reflections of *gwaaygu 7anhlan*'s *k'yuust'aa* poles, we are left with the question, What did *gwaaygu 7anhlan*'s early work really look like? Perhaps our best evidence to date about his carving style in the 1840s comes from a carved wooden staff now in the Oakland Museum (fig. 3.36; Wright 1992). This staff provides us with a further Tlingit connection for the *7idansuu* chiefs. According to Swanton, it was given by "Edenshaw's people" to Chief Kadashan, a Tlingit of Wrangell. Wrangell is on the Stikine River, the place of origin of the name *7idansuu*. Chief Kadashan was a leader of the Kasq!a gue'di, a Tlingit Raven clan, and was one of Swanton's principal consultants in Wrangell. Swanton (1908a: 416–417) listed the crests and clan treasures of the Kasq!a gue'di clan as the "green paint hat" that had two tops side by side, the raven at the head of the Nass pole, and "an eagle cane obtained from Edensaw's people at Massett, Queen Charlotte Islands." He identified the smaller of Kadashan's two house poles as having been "copied from a dancing cane which came from the Haida and is very highly valued."

According to the Juneau photographers Lloyd Winter and Percy Pond (1905), Kadashan's ancestors were high-ranking Haidas who intermarried with Tlingits and moved to the Stikine River region. Swanton confirmed this family connection: "At Wrangel . . . we find the Raven Kasq!a gue'di considered as part of Edenshaw's family at Massett, which is Eagle." Swanton brought this up specifically to point out that the Raven and Eagle moieties of the Haida were reversed among the Tlingit. That is, the Haida Eagles were considered to be of the same moiety as the Tlingit Ravens, and the Haida Ravens were equivalent to Tlingit Wolves (or Tlingit Eagles in the north). Therefore, though Edenshaw's family was Eagle and Kadashan's was Raven, they were considered to be "on the same side." Kadashan's Haida ancestry provides a partial explanation for why Edenshaw's people in Massett might have given him this staff. We do not as yet know, however, the exact relationship between Kadashan's Haida ancestors and the Edenshaw family or the exact circumstances surrounding the gift of the staff.

The Kasq!a gue'di clan, according to Ronald Olson (1967), originally came from the Queen Charlotte Islands, where the people called themselves Wŭhtcĭnnĭna'h. From there, one group moved to *gasa.áan*, and another went to the Tlingit town of Tcukwásan at Mill Creek, where members of the Nanyaayih, Siknahaddih, Tihittan, Kiksadi, and Katcadih clans were residing. These people are said to have refused to admit the newcomers because they smelled too strongly of salmon eggs. So they went on and settled at Kask!le'k (in Brown's Cove, near Dry Island). Later they moved to Anstàga'ku, across the channel from Petersberg. It was only after the whites came that they moved to Wrangell (Olson 1967: 31). It may be that the connections between the Kasq!a gue'di and the *7idansuu* family go back to the early origins of this clan in the Queen Charlotte Islands.

The oldest photograph of Kadashan's poles was taken by Eadweard Muybridge in 1868 (fig. 3.37).[33] At this time the house behind the two poles was partially dismantled. Paint is clearly visible on both of the poles, and judging by their condition, they must have been carved several years before this photograph was

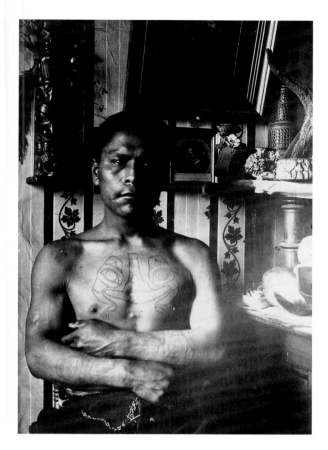

Fig. 3.33. Johnny Kit Elswa in James G. Swan's
Port Townsend office with Kit Elswa's argillite
model pole on the wall. Courtesy of the
Smithsonian Institution, Anthropological
Archives, neg. no. SI4117.

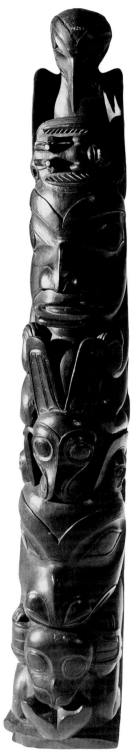

Fig. 3.34. Model argillite pole carved by Johnny
Kit Elswa in 1883 for James G. Swan, based on
Swan's sketch of a *k'yuust'aa* pole. 53.8 cm. high.
Acquired by the Field Museum of Natural
History in October 1893. Photograph by Ron
Testa, courtesy of the Field Museum, cat. no.
14254, neg. no. A106490.

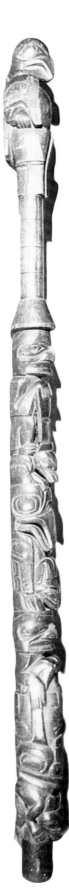

Fig. 3.35. Base of a pole at *k'yuust'aa*
photographed by Marius Barbeau in
1939. Courtesy of the Canadian
Museum of Civilization, neg. no. 87482.

Fig. 3.36. Kadashan's staff, 147 cm high.
Donated by Dorothy K. Haberman in 1959
from the collection of her uncle, F. W. Carlyon,
store owner in Wrangell, Alaska, after 1899.
Oakland Museum, cat. no. 4153-2. Photograph
by the author.

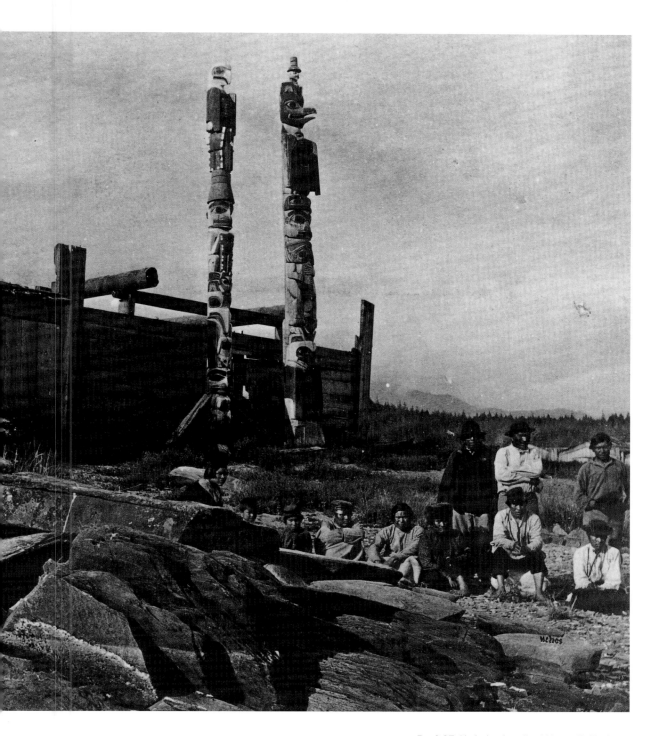

Fig. 3.37. Kadashan's poles, Wrangell, Alaska.
Courtesy of the Bancroft Library, University
of California, Berkeley, neg. no. 1971.055: 484.
Photograph by Eadweard Muybridge, 1868.

Fig. 3.38. Kadashan's staff in doorway of Chief Shakes's house, Wrangell, 1887. Courtesy of the Alaska State Library, neg. no. 87-117. Photograph by Lloyd Winter and Percy Pond.

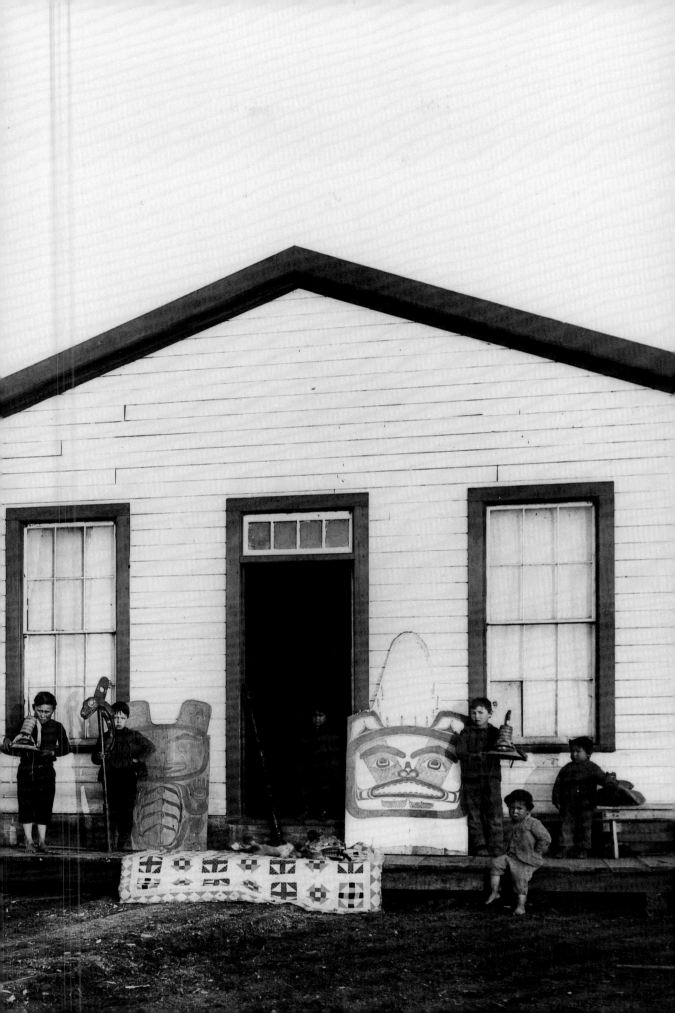

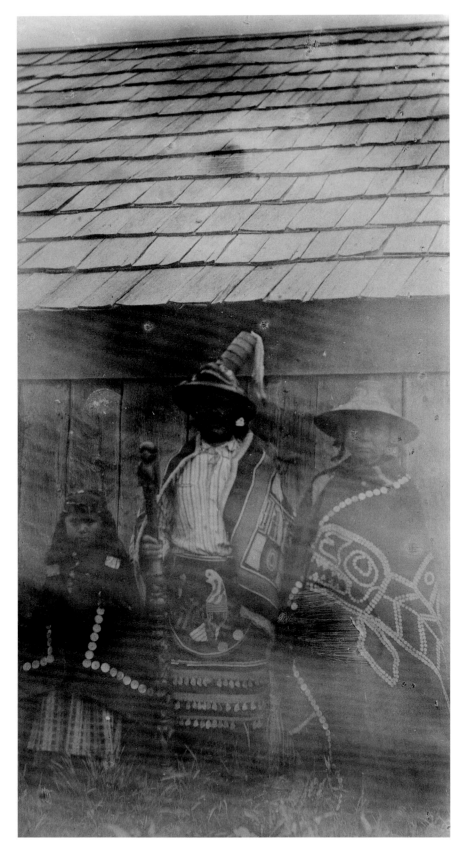

Fig. 3.39. John Kadashan holding the Haida staff, with his wife and child, 1892. Courtesy of Department of Library Services, American Museum of Natural History, neg. no. 338571. Photograph by George T. Emmons.

taken. John Kadashan (c. 1834–1914) was the Chief Kadashan who was helpful to Swanton, but the Kadashan who erected the pole based on the Edenshaw cane, perhaps in the 1850s or, at the latest, the early 1860s, was probably John Kadashan's maternal uncle. Because the gift of the Haida staff by Edenshaw's people would have occurred sometime before it was copied on the pole, this transfer must also have been made to John Kadashan's uncle, perhaps sometime in the 1850s or even earlier

At least three photographs were taken of the staff when it was still in Wrangell. One, made by Winter and Pond in 1887, shows the staff leaning against the door of Chief Shakes's house (fig. 3.38). The other two, probably both taken by George T. Emmons in 1892, show the staff being held by John Kadashan. In one shot he stands alone (Wright 1992: 52, fig. 11), and in the other he is with his wife and daughter (fig. 3.39). A handwritten note with this photo, presumably written by Emmons, identifies it as a "picture of Katashan a chief of a family of the Stackhene qwan and his wife and child, all dressed in ceremonial dress and the chief carries in his hand the ornamentally carved totem dance stick of his family. Taken at Wrangel 1892."[34] These two were probably taken on the same occasion, since Kadashan appears wearing the same beaded eagle apron, Chilkat robe, and hat.

Swanton (1908: 416–417) described the figures on Kadashan's pole from top to bottom. At the top is an eagle holding two coppers; below is *gunaakadeet* holding a copper; and below this is a figure Swanton described as a frog. This particular identification is problematical, because on both the pole and the staff it appears to be a small bearlike figure with U-form ears, not a frog. Next is a sandhill crane with a downturned beak and a broad U form rising above it between the bird's eyes. Another frog, in this case truly froglike, and another *gunaakadeet* are at the bottom of the pole. The figures on the staff and the pole match except at the bottom, where the staff has two figures — a sculpinlike fish and a bear — that were left off of the pole.

There are no known Haida poles with the same arrangement of figures as that found on the staff. It is intriguing to consider the similarity between the bear and the sculpinlike figure at the bottom of Kadashan's staff and the bears with the sculpins on the two corner posts of Myth House at *k'yuust'aa*. The specific occasion for the gift of the staff remains unknown, but the dating of Kadashan's pole, which is based on the staff, to the 1850s or early 1860s allows us to associate the gift of the staff with *gwaaygu 7anhlan*, who was Chief *7idan-suu* at this time. It must have been either during his residence at *k'yuust'aa* or shortly after his move to *qang* that Albert Edward Edenshaw gave the wooden staff to Kadashan. On this occasion, as with the gift of the chest to Nisyoq, it was more important for Kadashan to acknowledge the source of the gift, the Edenshaw family, than to recognize the maker of the staff. However, a stylistic comparison of the staff with three poles known to have been carved by *gwaaygu 7anhlan* several decades later suggests that *gwaaygu 7anhlan* might have made the staff himself as a gift to Kadashan (see chapter 4). It is even possible that *gwaaygu 7anhlan* carved or helped to carve Kadashan's pole in Wrangell, since it is carved in the Haida style.

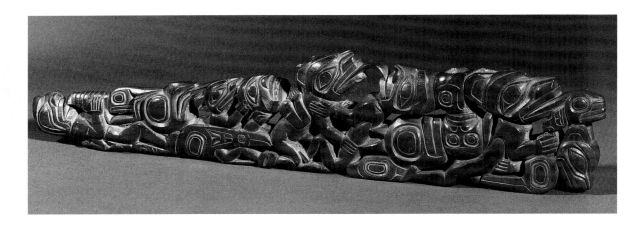

Fig. 3.40. Haida argillite pipe, 35 cm long.
Collected by the Charles Wilkes expedition
at the mouth of the Columbia River, 1841.
Courtesy of the National Museum of Natural
History, Smithsonian Institution, cat. no. 2586,
neg. no. 78-3044.

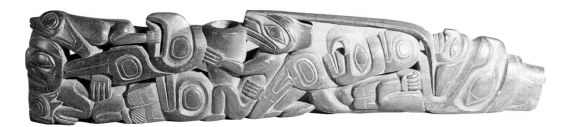

Fig. 3.41. Haida argillite pipe, 28 by 6 by 2.1 cm.
Collected by the Charles Wilkes expedition at
the mouth of the Columbia River, 1841. National
Museum of Natural History, Smithsonian Institution,
cat. no. 2587. Photograph by the author.

qwa.a s7a laa (Soft Rock — Argillite)

The clearest stylistic evidence linking the staff to other, contemporaneous carv-
ings exists in a group of argillite pipes that date to the late 1830s to 1840s. A pipe
that is now in the U.S. National Museum of Natural History (fig. 3.40) was col-
lected at the mouth of the Columbia River in 1841 by the Wilkes expedition from
a Hudson's Bay Company ship that had just returned from a trip to the north.
It likely was newly carved at that time. A comparison of the human face on the
pipe with one on the staff is particularly telling. The broad, open eyelid lines,
the proportions of the eye sockets, and the shapes of the lips, nostrils, and eye-
brows are all similar. The two bird figures with downturned beaks are also com-
pellingly similar. The shape of the eye ovoids, with their broad tertiary lines,
and the concave area above the lips joining the raised ridge on the beaks are
distinctive. Compare also the bear heads with their sharply carved nostrils, also
with a raised ridge along the bridge of the nose. The pipe has a feature that does
not occur on the staff but that links it to several other pipes. The wing feathers

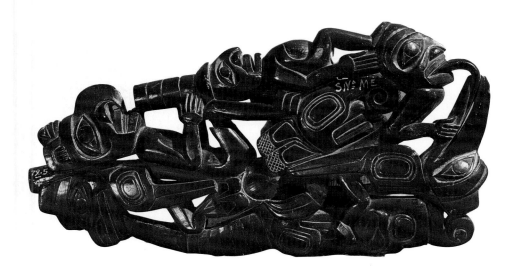

Fig. 3.42. Haida argillite pipe, 21.5 by 11
by 2.5 cm. Sent to Dr. Scouler in Paris by
Dr. William Tolmie in 1839. Musée de
l'Homme, cat. no. 1879.5/4. Photograph
by Bill Holm.

Fig. 3.43. Haida argillite pipe depicting a nursing
mountain goat and Euro-American figures, 26
by 6 by 2.5 cm. Courtesy of the Museum of
Anthropology and Ethnography, St. Petersburg,
Russia, cat. no. 4105-18.

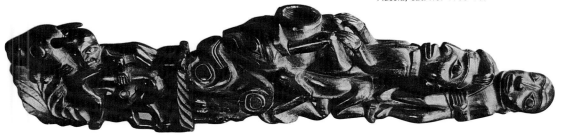

on this bear-headed bird taper to a single point where they are attached to the
joint ovoid. Another pipe collected at the same time by the Wilkes expedition
has this feature (fig. 3.41). Notice also the shapes of the ovoids, the broad ter-
tiary lines, and the similarity of the bird beaks and bear heads. The long, extended
bear's tongue is a feature found on several Haida poles from the northern shore
of Graham Island, including the one at Albert Edward Edenshaw's house at *qang*
(see fig. 4.1).

A pipe that is now in the Musée de l'Homme in Paris (fig. 3.42) was proba-
bly collected by Dr. William Fraser Tolmie in 1839. The oval profile shape of
this pipe, along with the collection data, dates it slightly earlier than the two Wilkes
pipes (Macnair and Hoover 1984: 204; Wright 1985: 151). On this pipe, two bird
wings show the tapering feathers joining at a single point. Compare the similar
winged bear on the Smithsonian pipe (fig. 3.40). Other stylistic details, particu-
larly the wide, open eyelid lines and the shape of the ovoids, are similar.

Three final pipes that are linked stylistically to this group are interesting
because of their inclusion of Euro-American motifs along with Haida motifs
and their depiction of female figures nursing babies. A pipe in the Museum of
Anthropology and Ethnography in St. Petersburg, Russia, has two Euro-

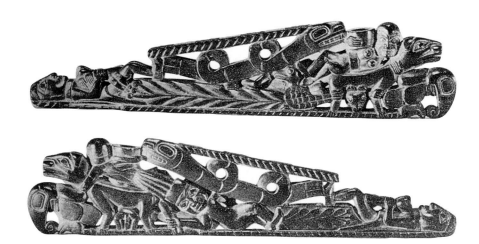

Fig. 3.44. Haida argillite pipe showing a baby animal with its mother, a child held by a Euro-American figure, and a double-coiled serpent; 31.7 cm long. Private collection. Photograph courtesy of Sotheby Parke Bernet, New York (Sotheby Parke Bernet 1982: Lot 191).

Fig. 3.45. Haida argillite pipe showing a nursing woman and a double-coiled serpent; 29.5 by 8 by 2.5 cm. Anne and Sidney Gerber Collection, Burke Museum, cat. no. 25.0/282. Photograph by the author.

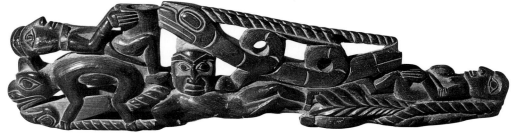

American figures at one end (fig. 3.43). They are identified by their portraitlike faces, which lack the sharply carved formline eye sockets, and by their tailored clothing. An animal with the bowl at its back touches noses with an eagle figure similar to those on the other pipes in this group, especially to the eagle on the Smithsonian pipe (fig. 3.40). Notably, this bird has feathers that taper to join at a single point. At the other end a mountain goat with short stubby horns is clutched by a human figure. A baby mountain goat nurses below its mother.

A related pipe in a private collection (fig. 3.44) has an insectlike figure in front of a doglike animal with downturned ears. A human clutches its neck, and a baby animal clings to its feet like the mountain goat on the Russian pipe. Ropes and leaves are combined with a double-coiled serpent (see Holm 1972: 89). Notice the shape of the serpent's eye ovoid. At the narrow end of the pipe, a human figure wearing a tail coat reclines holding a baby on its chest. A pipe in the Burke Museum (fig. 3.45) is remarkably similar. The same double-coiled serpent with a rope extending from its head rises above another reclining figure. The rope runs through a block at the bottom, as in a ship's rigging. Finally, a reclining

female figure with bared breast holds a suckling child on her chest (see Wright 1986: 42, fig. 8).

Although the attribution remains speculative, the possibility exists that these six pipes and Kadashan's staff were made by *gwaaygu 7anhlan*. Though Alfred Adams did not remember seeing Albert Edward Edenshaw carve argillite, the carving of these pipes would have taken place when *gwaaygu 7anhlan* was still a young man, well before Adams's time (Barbeau 1916–1954: B-F-253.3). This would have been the period immediately before and just after he replaced his uncle and moved to *k'yuust'aa*. It is known that argillite was carved in *k'yuust'aa* during this period. Archaeological excavations conducted by Nicholas Gessler turned up two pipe fragments and three argillite platter fragments with geometric and floral motifs in the corner of the house that was the last to have been occupied at *k'yuust'aa* (Gessler and Gessler 1977: 14–15). Certainly, the carving of argillite was one of the many new sources of wealth developed by Haida artists to supplement their major source of income, the sale of sea-otter skins. Because of the overexploitation of this resource, sea otters were becoming scarce after 1825. The art form of argillite tobacco pipes, which had been invented by artists such as Sqiltcange in the earlier generation, was now taking on greater economic importance. Rather than being made only as functional tobacco pipes used in funeral feasts and house raisings, these objects began to be made for sale to fur traders on their sailing ships and to depict exotic motifs to appeal to this new market.

The Exploits of *gwaaygu 7anhlan*

By the mid-nineteenth century, *gwaaygu 7anhlan* had already established a reputation as a powerful chief and a shrewd trader, though his exploits sometimes courted disaster. According to the Reverend Charles Harrison, shortly after he became chief, *gwaaygu 7anhlan* went with a large party to the Nass to sell a slave and a large copper. The slave was recognized as one of the Nisga.a (Tsimshian) people, and they demanded him back without payment. A dispute between *gwaaygu 7anhlan* and a Tsimshian chief resulted in hand-to-hand combat. A bystander shot at *gwaaygu 7anhlan,* but he managed to swing the Tsimshian chief into the line of fire, and he was killed. In making his escape, *gwaaygu 7anhlan* received two bullet wounds, and he is said to have carried the bullets to the end of his life (Dalzell 1968: 64; Harrison 1911–1913: vol. 2, no. 3).

Near the time of *gu.uu*'s birth, gold was discovered in the Queen Charlotte Islands, and many schooners (often American) began visiting there in search of it. The actual discovery of gold in Haida Gwaii is credited to the wife of Captain Gold (thus his name), whose Haida name meant "he whose voice is obeyed" and who was chief of the Pebble Town People (Swanton's R9). In 1850, he and his wife were the first to report finding gold, while they were living at *qays7un* (Kaisun) on the west coast of Moresby Island (MacDonald 1983: 55).

A story of *gwaaygu 7anhlan*'s involvement in the gold craze was told to Kathleen Dalzell by Mrs. Fred Nash, Albert Edward Edenshaw's granddaughter, and was also reported in Charles Harrison's account of Edenshaw's life. He is said to have shown a sample of gold, which he got from the Hudson's Bay factor at Fort Simpson, to a woman at Skidegate (presumably Captain Gold's wife), who then produced a much better piece and showed him where she got

it. She is said to have taken *gwaaygu 7anhlan,* his wife, and his son *gu.uu* to Mitchell Inlet, where they left young ("four-year-old") *gu.uu* in the canoe and proceeded to quarry a large amount of gold ore, leaving it in the canoe with the boy. While they were away working, *gu.uu* is said to have thrown all the gold into the saltwater, piece by piece (Dalzell 1968: 59–60; Harrison 1911–1913: vol. 2, no. 1).[35] If the date of around 1850 for this incident is accurate, it would indicate that *gu.uu* was born in 1846 — five years earlier than the date on his gravestone, which indicates that he died in 1889 at the age of thirty-eight. In the first census report done in Massett, in 1881, *gu.uu*'s age was estimated at thirty-two, which would make his birth year 1849. His marriage record in 1883 gives his age as thirty-six, which would make his birth year 1847. The date of *gu.uu*'s birth helps to clarify the approximate date of *gwaaygu 7anhlan*'s marriage to his uncle's widow, *gu.uu*'s mother.

In any case, *gwaaygu 7anhlan* was able to bring a sample of the gold to Fort Simpson, and in the spring of 1851 he was hired to guide the Hudson's Bay Company's factor, John Work, by canoe to the source of the gold in Mitchell Inlet. This scouting trip was followed immediately by an expedition led by Captain Mitchell on the *Una.* The party is said to have mined gold ore worth approximately $75,000 before the vein was depleted — but like the first gold obtained by *gwaaygu 7anhlan,* this cargo went to the bottom of the sea when the *Una* was grounded off Neah Bay and sank (Dalzell 1968: 61).

With a reputation as an expert pilot, *gwaaygu 7anhlan* was frequently sought out by Euro-American captains to help them navigate the tricky waters of Haida Gwaii. They also needed protection against raids by the Haida. In November 1851, the sloop *Georgiana* ran aground and twenty-seven passengers were held for a ransom of goods worth $1,839, paid by the Hudson's Bay factor at Fort Simpson (Gough 1982: 133; Henderson 1972: 62).

In 1852 the American schooner *Susan Sturgis,* under the command of Matthew Rooney, was trading in the Queen Charlotte Islands. This vessel had come north the year before from California in response to the reports of gold. In September it was in Skidegate, and Rooney hired *gwaaygu 7anhlan,* accompanied by his wife and son, as pilot for the trip to *qang.* While in Skidegate, Rooney was warned by Chief Nestecanna not to linger but to leave, "as the Indians were talking bad"; he should tell the local Indians that he was going to leave on a certain day but actually leave earlier. After the *Susan Sturgis* sailed, the Skidegates told the Massetts that the schooner could be easily captured (Gough 1982: 134; Prevost 1853).

After the ship rounded Rose Spit it was boarded by Chief *7wii.aa* of Massett. He and *gwaaygu 7anhlan* exchanged words. Edenshaw later claimed that he told *7wii.aa* only to bring items for barter alongside the schooner, but subsequent Indian testimony stated that he told *7wii.aa* of the vessel's defenseless state and that he intended to seize it as soon as she entered his harbour at *qang* (Gough 1982: 134).

The next day, near the village of *yaan,* across the inlet from Massett, twenty-five canoes carrying warriors dressed for battle came alongside, led by *7wii.aa.* Edenshaw apparently offered no warnings. One hundred fifty Massetts boarded the schooner, took the passengers prisoner, stripped them of their clothes, took $1,500 in gold and silver from the strongbox, and wrecked and burned the schooner (Prevost 1853). It is said that *gwaaygu 7anhlan* may have persuaded

7wii.aa to spare the lives of the passengers, pointing out that the Hudson's Bay Company, as it had with the *Georgiana,* would pay a ransom in blankets for the safe delivery of the whites to the fort. Edenshaw later told the Reverend William Henry Collison that when the crew and passengers were about to be shot, he gave them protection. Rooney wrote that he owed his life to Edenshaw. On September 26, 1852, in a letter addressed to "Whatever Christian This May Come," he said: "This is to inform the public that the Captain and crew of the schooner Susan Sturgis are now confined in the after cabin of said vessel, the tribe of Massett Indians having taken the ship this day at 10 a.m., and are now fighting with Edenshaw and a few of his men who are trying to save our lives" (Howay and Scholefield 1914, vol. 2, p. 5).

John Work, at Fort Simpson, obtained the release of all the prisoners by paying $250 each in blankets for Rooney and his mate and $30 for each of the others (Howay and Scholefield 1914, vol. 2, p. 5). A subsequent investigation by the Royal Navy revealed that Indian testimony suggested that *7idansuu* had told *7wii.aa* of the schooner's lack of defenses. Captain Augustus Leopold Kuper of the *Thetis* believed that *gwaaygu 7anhlan* had shared in the plunder, though his complicity was never proved (Lamb 1942). John Work, too, was of the opinion that Edenshaw was a party to the whole affair (Gough 1982: 135).

In May 1853, Commander James C. Prevost, aboard HMS *Virago,* a paddle-wheel warship, was sent to investigate the plunder of the *Susan Sturgis.* He took Edenshaw aboard at Fort Simpson to prevent any treachery by him during the investigation that would follow in the Queen Charlotte Islands (Treven 1852–1854: 299). During the investigation, testimony about *gwaaygu 7anhlan*'s character was recorded from several sources. Treven, the ship's surgeon, described him as "a sharp fellow and known to be a great rogue . . . a great vagabond" (Treven 1852–1854: 300–302). The ship's master, G. H. Inskip, described him as "a very shrewd and intelligent fellow" (Inskip 1853: 625). Captain Augustus L. Kuper of the *Thetis* said he was "a man of great influence in the neighbourhood and one worth treating with every consideration."[36] Commander Prevost of the *Virago,* on which the chief had been detained for questioning, said he was "decidedly the most advanced Indian I have met on the Coast: quick, cunning, ambitious, crafty, and above all, anxious to obtain the good opinion of the white men." William Henry Hills, the *Virago's* paymaster, has given us the longest description of him:

> He is decidedly an interesting character, and an example of what splendid abilities are only waiting culture among these Indians. He would make a Peter the Great, or Napoleon, with their opportunities. He has great good sense and judgment, very quick, and is subtle and cunning as the serpent. Unfortunately like all his countrymen he has no perception of right and wrong, but what self interest dictates: he is ambitious and leaves no stone unturned to increase his power and property. He is now about thirty-five years old; his father dying while he was young — left him poor, at the head of a weak tribe, only safe from the attacks of their neighbour on account of their poverty, which made them not worth attacking: to better this he contrived to marry a woman nearly 50 years of age, who is a high Chief of the Kilgarny tribe, inhabiting the coast opposite the North coast of Queen Charlotte, one of the strongest of the North west tribes of Indians. Backed

by such influence he is able to remove his people to Nadun, close to the powerful Masset tribe, where with the advantage of a good harbour and making his people cultivate the ground he hopes to attract vessels. He also talks of trading with the other tribes for furs in the same way as the Hudson's Bay Company, and then selling them to them, or to the highest bidder; should he carry out this idea he will prove an awkward customer for the Hudson's Bay Company to deal with. He talks very intelligible English; and is a very sharp hand to driving a bargain. As a pilot he is the only Indian we met with that seemed to have made a distinction in his own mind between a passage fit for canoes, and one where a large vessel can pass. . . . Edenshaw seems to have let his foresight carry him under water as well as above: — where he reported "good water" we found it deep; — where he pointed out "small water" it proved shoal; — and at any spot where he said "plenty stone stop," there sure enough it was rocky. In personal appearance, he stands about 5 feet 7 ins., with a shade of yellow in his complexion, hazel eyes rather small, and broad features. Square and high shoulders and a wiry form. Wears his hair in European style, and whenever we saw him was always dressed neatly; quite different from the usual Indian style that rejoices in gaudy colours: his dress consisted of a blue cloth travelling cap, white shirt, and black silk handkerchief, blue cloth monkey jacket, white waistcoat, blue cloth trousers and boots; and every article fitted as if made for him. (Hills 1853: 217–19)

Indeed, *gwaaygu ʒanhlan* might have collaborated with *ʒwii.aa* in raiding the ship, just as he might have aided in the rescue of the crew. But through his own skills and cunning he was able to avoid being charged with any crime and in fact came through the incident looking like a hero to the British and Americans alike (Gough 1982: 131). In the few years since the death of old *ʒidan-suu, gwaaygu ʒanhlan* had built and potlatched a house in *k'yuust'aa,* thereby not only establishing the status of his son *gu.uu* but also securing for himself the position of a leader at *k'yuust'aa.* He had accumulated wealth, along with the respect of the British and Euro-American community, through his success as a trader, pilot, and opportunist. He had cemented his relationship with his Tlingit relatives in Wrangell through the gift of a staff that became one of their treasured heirlooms. To this set of accomplishments must be added the creation of a large body of artwork. Though many of the poles he carved have not survived, we are beginning to identify some of the things he once owned and a few of the things he made that have been preserved in museum collections.

The Mid- to Late Nineteenth Century, 1853 to the 1880s

gwaaygu 7anhlan, da.a xiigang,

ginaawaan, and gid k'wáajuss

By 1853, *gwaaygu 7anhlan* had established himself as both a leader and an artist and had probably carved a number of poles, among them possibly those for his own house and others at *k'yuust'aa* and for members of his wife's Raven clan in *hlanqwáan* and *ráwk'aan*. It is estimated that he moved his family from *k'yuust'aa* to *qang* (Kung) sometime around 1853,[1] and it has been suggested that this occurred shortly after the looting of the *Susan Sturgis* (Cole and Lockner 1989: 504). It is probable, however, that he had established a residence at *qang* before this, because Captain Rooney was said to be returning Edenshaw and his family to their home at *qang* on the *Susan Sturgis* in September 1852, when it was plundered at *yaan* (Yan). He was also in residence at *qang* the next year, 1853, when Captain Wallace Houstoun on HMS *Trincomalee* visited Virago Sound and met with Edenshaw there (Gough 1982: 134, 137). It may be that his share of the plunder from the *Susan Sturgis* provided the wealth for him to build and potlatch a new house at *qang* — the largest one in the village.

gwaaygu 7anhlan at *qang*

The village of *qang* (Kung, Qañ) had been called Nigh-tasis before *gwaaygu 7anhlan* and his family arrived there.[2] It sits on a protected point in Virago Sound at the entrance to Naden Harbour. It was occupied by the *sa'gua laa'naas* (Swanton's "Up-Inlet-Town" people, E19), whose town chief was *gu.laas* ("abalone shell"). The new name *qang* means "dream town" and is said to refer to this village's being *gwaaygu 7anhlan*'s dream village (Dalzell 1973:443). The *sdast'a.aas* Eagles occupied the west end of the village, where they built a row of new houses in front of the older ones (MacDonald 1983: 177). Edenshaw's house was named Sk!ū'lxa hai'at, "house that can hold a great crowd of people," after his uncle *skil.aa.u*'s house in *hl7yaalang* (Swanton 1905a: 292) (see fig. 3.1). It had a frontal pole as well as an interior house post (figs. 4.1, 4.2, and see fig. 4.4).

The frontal pole of this house differed from *skil.aa.u*'s in having four large bear figures. The top bear had four hat rings (*sgil*) on its head and a small bear between its knees (see fig. 4.4). A bear with a long tongue extending downward to another small bear was above the gable. At the bottom was a third and perhaps a fourth large bear, which is obscured in the photograph.[3] Whereas the bear figure on *skil.aa.u*'s frontal pole probably came from his wife's Tlingit crest (telling the story of Qats; see chapter 2), the bears on the *qang* house frontal

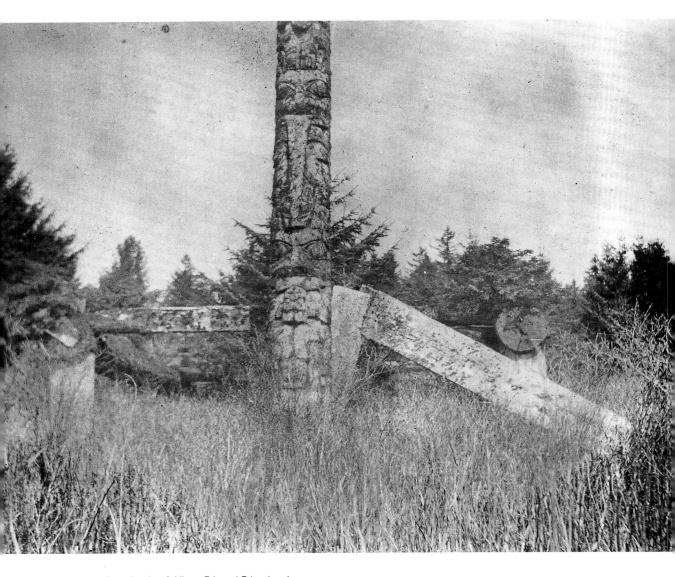

Fig. 4.1. The frontal pole of Albert Edward Edenshaw's
house at Kung (*qang*). Courtesy of the Royal British
Columbia Museum, neg. no. PN 5625. Photograph by
C. F. Newcombe, 1913.

Fig. 4.2. The interior post of Albert Edward
Edenshaw's house at *qang*. Courtesy of the
Royal British Columbia Museum, neg. no. PN26.
Photograph by C. F. Newcombe, 1913.

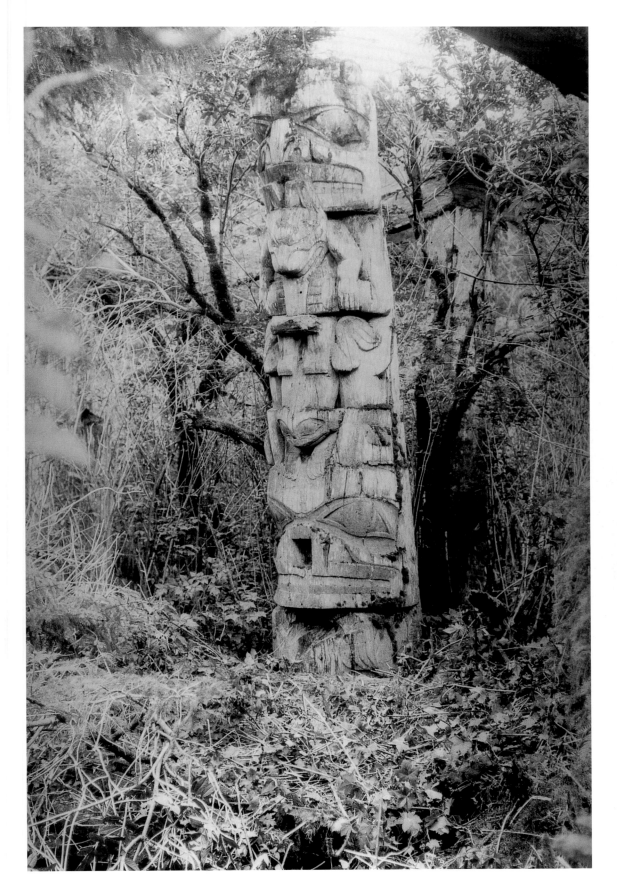

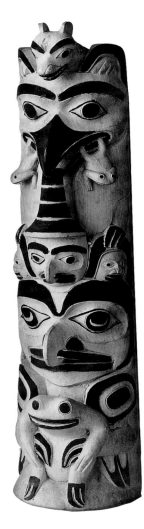

Fig. 4.3. Charles Edenshaw's model of Albert Edward Edenshaw's interior house post at *qang*. The *qang* post was based on the older interior post from *skil.aa.u* 's house at *hl7yaalang*. Courtesy of the American Museum of Natural History, cat. no. 16/8770 (currently missing from the collection), neg. no. 315468.

pole probably represented the grizzly bear, which is a crest of the *yahgu 'laanaas, gwaaygu 7anhlan*'s wife's clan. In addition to the grizzly bear, the crests of the *yahgu 'laanaas* include the raven, killer whale, berry picker (or woman in the moon), and dogfish (or shark). Inside the house, the interior post at the back had a human figure at the top, said to represent *sran.gu* (*sgan'gu* or Skungo), the "hermit of *k'yuust'aa*," holding a bear cub. A frog with its head pointing downward appeared between the ears of a bird whose beak is missing in the extant photograph (MacDonald 1983: 180). Charles Edenshaw carved a model of this interior house post for John Swanton in 1901 (fig. 4.3); it differs from the *qang* interior post. Swanton described the interior post on the basis of Charles Edenshaw's explanation:

> It stood in another house of Chief Edensaw, called One-that-can-hold-Crowds (Sk!ū'lha haiya't), which he occupied after his people moved from K!iū'stᴀ to Kung in Naden Harbor; but it was copied from a still older one in a house belonging to this family at Łī'elᴀñ River.
>
> From the bottom up, the figures are a frog, hawk (surmounted by the figure of a young hawk wearing a dance-hat), raven with two frogs in its mouth, and grizzly bear. All of these except the grizzly bear, the presence of which was not explained, were claimed as crests of the Sta'stas. Although the hawk (skiä'msm) was owned by several Raven families, it is said that when the original pole was put up at Łi'elᴀñ, this family was also possessed of it. (Swanton 1905a: 128)

This passage explains that the model of the interior post (fig. 4.3) was really based on the interior post from *skil.aa.u*'s house at *hl7yaalang* (of which there is no photograph), which may be why it does not closely resemble the *qang* interior post (fig. 4.2). The *qang* interior post was probably no closer in design to the one in the original *hl7yaalang* house than the *qang* frontal pole was. The bird at the bottom of the model is identified as a blue hawk (the Haida thunderbird) and is shown holding a frog, whereas the *qang* post has the frog between the ears of the hawk at the bottom. The small grizzly bear, which was also on the *hl7yaalang* frontal pole, could be explained as the crest of *skil.aa.u*'s wife. The hawk is not usually listed among the crests of Edenshaw's *sdast'a.aas* lineage, which include the beaver, frog, eagle, raven, and *sran'gu*. Perhaps the hawk was also one of the crests of the wife of *skil.aa.u*. The figure of *sran'gu* does not appear on the model post as it does on the *qang* interior post. This *sran'gu* crest must have been acquired during either old *7idansuu*'s or Albert Edward Edenshaw's residence at *k'yuust'aa*, after their move from *hl7yaalang*, because the "hermit of *k'yuust'aa*" is local to that area (see MacDonald 1983: 192, 197). Thus, even though Albert Edward Edenshaw retained the name of his uncle's *hl7yaalang* house, he customized the interior and house frontal poles to reflect his own family's identity.

We know that *gwaaygu 7anhlan* raised a big pole for his new wife, *san 'laa gudgaang* (Amy), and her niece, *qwii.aang* (Isabella), when he brought them to *qang* from *hlanqwáan* some time around 1866 or 1867 (Blackman 1982: 68). It may be that the frontal pole of the *qang* house was raised on this occasion, which would make its date slightly later than previously thought. House frontal poles were usually raised and potlatched before the house was built. The poor quality of the photographs of the frontal pole (figs. 4.1, 4.4) makes a stylistic analy-

sis of its carving style difficult, but the photo of the interior post (fig. 4.2) is clear. This post is similar in style to the Kadashan staff, and it is possible that it was carved by *gwaaygu 7anhlan* himself.

Next door to Edenshaw's house was Thunder House, owned by *qasgyaahl*, also of the *sdast'a.aas* Eagles. In front of it stood two memorial poles (figs. 4.4, 4.5). One of them (the one on the right in the photographs) displays a style similar to what I believe may be Albert Edward Edenshaw's style of carving. The large size of the eye ovoids with open, almost diamond-shaped eyelid lines suggests a possible link with him. Interestingly, at the base of this pole, a butterfly is being held in the hands of a bear. This figure is similar to the butterfly Edenshaw carved on the pole sketched by James Swan at *k'yuust'aa* (see figs. 3.31, 3.32).

According to the Reverend Charles Harrison, the Anglican missionary in Massett from 1883 to 1890, *gwaaygu 7anhlan* erected a freestanding pole in *qang* in honor of Governor James Douglas, the first governor of British Columbia (Harrison 1925: 176).[4] The figure at the top of this plain pole was a portrait of Governor Douglas wearing a top hat and tailored clothing, standing on a bird-like head (fig. 4.6). Unfortunately, the stylistic details of the carving on this figure are difficult to make out in the photograph. Harrison explained that Albert Edward Edenshaw had raised this pole around 1860 in honor of Governor Douglas, who had given him many presents. George MacDonald (1983: 181) concurred, pointing out that Douglas left office in 1864 and agreeing that the pole was probably raised around 1860. This would make the Douglas pole earlier than Albert Edward Edenshaw's house at *qang*. Harrison's account suggests that at the time this pole was raised, Edenshaw was living in a house near it:[5] "On his return to his village at Kung, in Virago Sound, after this memorable trip, he caused his followers to erect another totem in front of his house, and the topmost figure was a splendid likeness of the governor in his frock coat and high silk hat" (Harrison 1925: 176).

Accounts in the *British Colonist*, the Victoria, British Columbia, newspaper published from 1858 to 1866, confirm that 1860 is a likely date for the raising of the pole. Victoria had been established as a Hudson's Bay Company post in 1849, but not until 1858, with the Fraser River gold rush, did its population swell. During the late 1850s, Edenshaw traveled frequently to Victoria, and some of his visits were recorded in the *British Colonist*. On February 5, 1859, a report of a murder was recorded:

> Last Monday an Indian was shot by a man named Johnson, who escaped, and for whose apprehension a reward is offered. The Indians became greatly excited, and demanded Johnson or pay for the Indian killed. His Excellency Gov. Douglas was pleased to accede to their demand for pay, and gave chief Edensaw, of Queen Charlotte's Island, a due bill: "Good to Edensaw for twenty-five 5 pt. Best Blankets, on their departure from the Island."

In the same newspaper a reward was posted: "Fifty Pounds Reward. Whereas an Indian was shot this day near Roch Bay, Victoria, by a white man, a reward of Fifty Pounds will be paid for such information as will lead to the apprehension and conviction of the person who committed the murder. By order of the Governor. August Pemberton, Commissioner of Police."

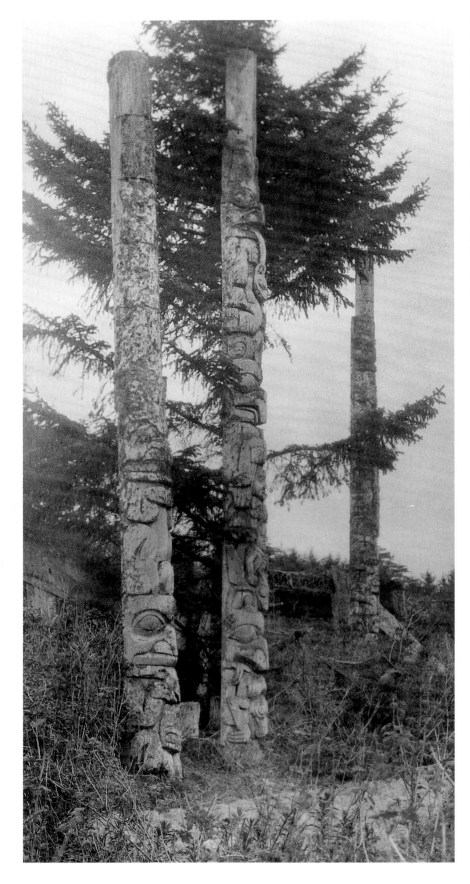

Fig. 4.4. Memorial poles in front of Thunder House at *qang*. The third pole, at far right, is the frontal pole of Albert Edward Edenshaw's house, also shown in figure 4.1. Royal British Columbia Museum, neg. no. PN27. Photograph by C. F. Newcombe, 1913.

(*opposite*) Fig. 4.5. Detail of memorial poles in front of Thunder House at *qang*. Courtesy of the Edmonton Art Gallery, neg. no. 78.12.94. Photograph by Edward S. Curtis, 1914.

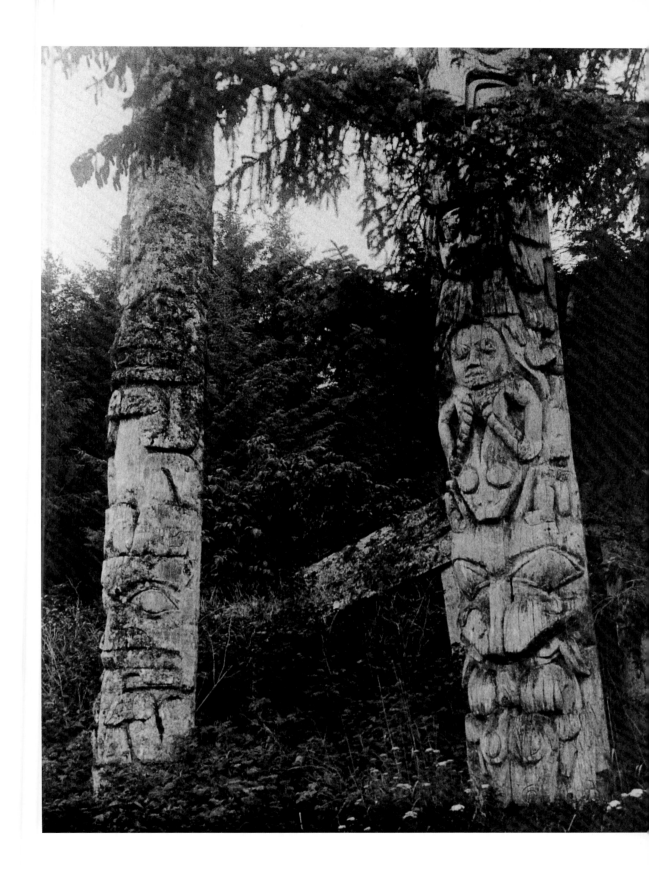

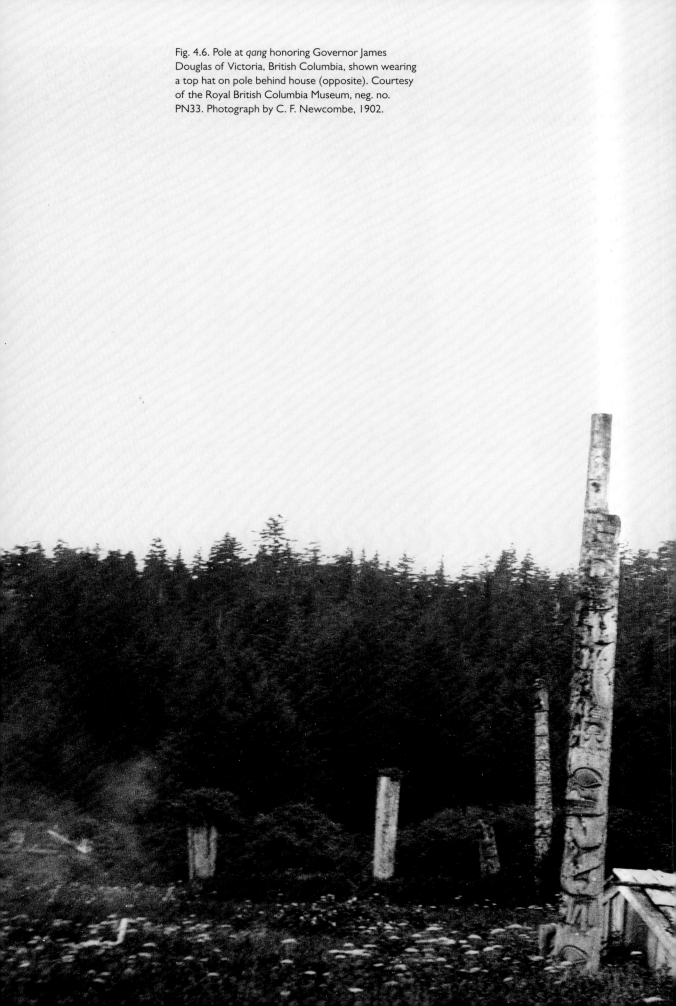

Fig. 4.6. Pole at *qang* honoring Governor James Douglas of Victoria, British Columbia, shown wearing a top hat on pole behind house (opposite). Courtesy of the Royal British Columbia Museum, neg. no. PN33. Photograph by C. F. Newcombe, 1902.

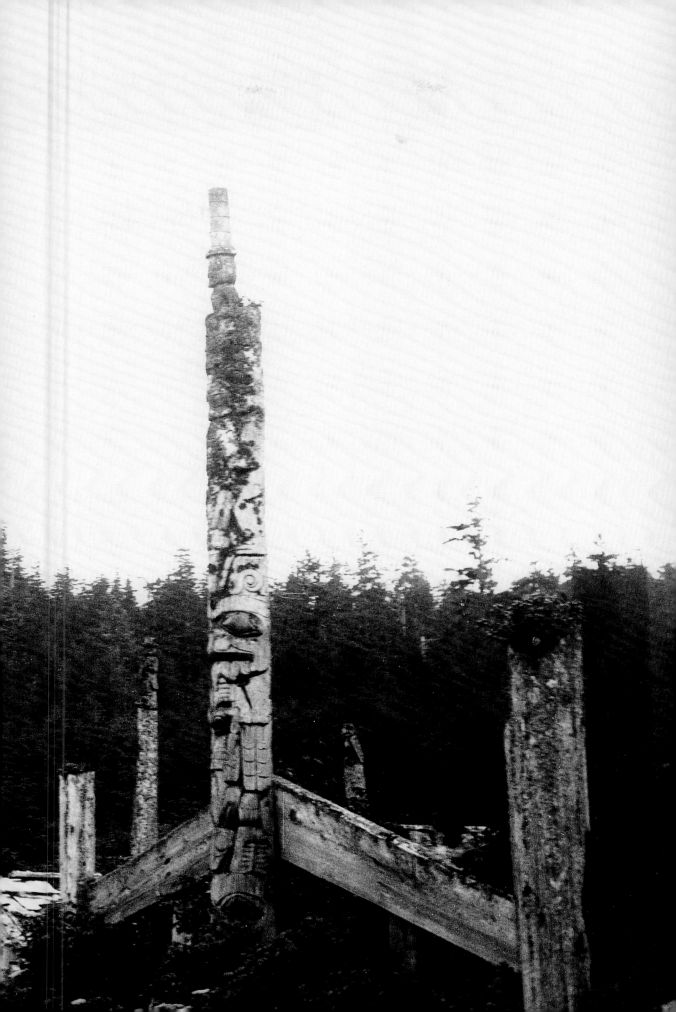

The next year, on July 3, 1860, it was reported that a man named "Captain John," who was said to be a Haida but apparently was a Tlingit married to a Haida woman, was arrested along with his brother for the murder of a Tongass man. In a struggle that ensued, both he and his brother were killed. His biography was printed in the July 5 edition of the *British Colonist*, and on July 10, an article warned about a possible "Indian War" that might follow the death of Captain John. It contained the following passage:

> Formerly, owing to the few men in the forts of the Company, it has been the policy to buy off the Indians by donations of blankets. A case of this kind occurred here about fifteen months ago, when a white man killed an Indian at the north end of town. The Indians were consequently excited, and Gov. Douglas ordered a considerable number of blankets to be given them to appease their anger; and Edensaw, the Queen Charlotte chief, departed satisfied.

The pole in *qang* honoring Governor Douglas was no doubt raised after this payment was made.[6] We know that *gwaaygu 7anhlan* considered himself to be related to Governor Douglas because they shared the name given to *gannyaa* by Captain William Douglas in 1788. This probably enhanced their friendly relationship. *gwaaygu 7anhlan* claimed that his hereditary title descended from Chief "Blakow-Coneehaw," who had exchanged names with Captain William Douglas in 1788, and thus he claimed the name Douglas (Dawson 1880: 160; Fisher 1977: 70–94; Gough 1982: 132; Walbran 1971: 163). Apparently *gwaaygu 7anhlan* embellished this story to the extent of actually claiming that it was he who had met Captain Douglas, not his predecessor (Collison 1981: 180).[7]

By 1860, *gwaaygu 7anhlan* would have been nearly fifty and looking after the training of his nephew. It was probably to his house in *qang* that *da.a xiigang*, Charles Edenshaw, moved when he came of age. *da.a xiigang* was born in the village of Skidegate around 1839.[8] Florence Edenshaw Davidson, his daughter, recalled: "Maybe my dad was about 18 or 19 when he came to Massett. His uncle, Albert Edward Edenshaw, wanted him, so he came here. And when it was time, he married my mother. They were married in the Indian way before the missionaries came" (Blackman 1982: 72). *da.a xiigang* would have been eighteen or nineteen around 1857, several years after Albert Edward moved to *qang* and before he is believed to have moved to Massett.

Like his uncle before him, *da.a xiigang* was famous as an artist during his own lifetime.[9] He was recognized by the Haida people as well as by collectors and anthropologists as one of the most accomplished Haida artists, and one hundred years later he continues to be the most famous Haida artist of the late nineteenth century. He was born at a time when Haida culture was experiencing an economic and artistic florescence spurred by the increased wealth brought by the European and Euro-American fur trade. He survived the devastating smallpox epidemic of 1862 and the later periods of missionary effort and colonizing by Euro-Canadians. By the time he was baptized with the name Edenshaw in 1885, potlatching had been outlawed in Canada, and much of the social and ceremonial role that had accompanied that name in the past had been forbidden and suppressed by missionaries and government agents. Indeed, rather than taking the name Edenshaw after the death of his uncle — at a memorial

potlatch — Charles was given the name by a missionary on the occasion of his baptism, while his uncle was still alive.

Perhaps partly because the political roles of high-ranking chiefs had changed by the late nineteenth century, Charles Edenshaw was able to focus all his efforts on his artwork, carving wood, argillite, silver, and gold. He worked as an artist well into the twentieth century, developing a personal style that is renowned for its originality and innovative narrative forms yet acclaimed for its adherence to the sophisticated formline design principles that characterize Haida art. His fame during his lifetime arose from his own lineage standing, from his talent as an artist, and from his relationships with missionaries, government agents, the anthropologists Franz Boas and John Swanton, and collectors such as C. F. Newcombe, James G. Swan, and George T. Emmons. In a letter to Boas from Massett, Swanton described Charles Edenshaw as "the best carver here."[10] Boas (1927: 212) reported that he was "the best carver and painter among the Haida." In 1902, Newcombe said he was "the best carver in wood and stone now living" (Cole 1985: 195).

da.a xiigang (1839–1870s)

Little is known of *da.a xiigang*'s early childhood or his early artwork. He was the son of *q'àaw quunaa* of the *sdast'a.aas* Eagle lineage, who was the sister of *gwaaygu 7anhlan*. His father is said to have been *tl'aajaang quuna* of the *na7ikun qiirawaay* Raven lineage (Those Born at Rose Spit) (Barbeau 1916–1954: B-F-251.14, 1957: 156, 172–173; Blackman 1982: 69; Swanton 1905a: 270).[11] Though his father died while he was still a boy, it is said that his parents were able to potlatch extensively, as is indicated in one of his names, *nang qwi.igee tlaa.ahls*, "they gave ten potlatches for him," which was conferred at his parents' final potlatch (Blackman 1982: 53). As was the custom, he was tattooed at these potlatches on his back, arms, legs, chest, and hands. His daughter, Florence Edenshaw Davidson, remembered eagle, sea wolf, and frog tattoos (Blackman 1982: 70). According to Davidson:

> My father started carving one winter when he was sick. When he was
> about fourteen he was sick all winter long.[12] He was in bed, but he got
> some argillite and started carving a totem pole. He was so sick he didn't
> want to eat anything, but his mother had an iron pot and she put hot water,
> seaweed, and grease in it, and she made my dad eat it. In May he got better.
> He took a walk and something came out from his chest right up his throat.
> He spit it in the creek. It looked like a devilfish with legs on it. That's what
> made him sick, and as soon as he got rid of it he got better. After that he
> carved his first bracelet, out of five silver-dollar pieces melted together.
> Later, after he married my mother but before my time, he used to go to
> Victoria and carve all winter long. (Blackman 1982: 72)

Charles would have been about fourteen in 1853, when he is said to have started carving argillite. No argillite model poles, however — by Charles or any other carver — have been dated to this early period, though it is possible that they first began to be made then.

Much of what has been written about Charles Edenshaw's childhood derives

from stories recorded by Marius Barbeau in the 1930s and 1940s, which were based on information provided by Charles Thompson:

> His childhood was sad, because he grew ill, and excepting his mother, his relatives all died. She used to gather oolachen grease (candlefish) and sea-weed, which she dried. These foods and her sollicitous care restored her son to health. She worked very hard for they were extremely poor.
>
> When the time came, . . . she desired him to leave Skidegate, and return and marry among her people at Massett. He prepared to follow her advice. She gave him an old-fashioned revolver, with which he began fiddling while lying abed one day. He turned the muzzle towards his face. The third time he pulled the trigger, the revolver fired, and the pellet narrowly missed his face.
>
> To celebrate his narrow escape, Charlie Edensaw gave a potlach. Holding the revolver to his face, he re-enacted his escape before the guests.
>
> Shortly afterwards, he left Skidegate and made his way towards Massett. He took the revolver with him, and when he reached Massett, held another potlach. Putting the muzzle into his mouth, he said:
>
> "Had the revolver not missed its mark, I would not be here today."
>
> Then he broached his real purpose in holding the feast, explaining: "Massett is our ancestral home. All my people died away from here. That is why I returned to Massett. I wish to be one of your people, to marry and live here. I have settled everything in readiness for my future wife, and shall be attached to my brother-in-law as though they were my own brothers. All my people were hunters, but I am a silversmith, (ladzoolá). To be a silversmith is my trade. (Barbeau 1916–1954, Box 314, file 10; see also Barbeau 1957: 158)

Both Florence Davidson's account and those recorded by Barbeau suggest that Charles Edenshaw moved from Skidegate to Massett at this time, but it is probable that although he was frequently in Massett during these years, his principal residence was in *qang* with his uncle until the late 1870s. According to Newcombe's notes, Henry Edenshaw, *gwaaygu 7anhlan*'s son, told him that "he and his father lived with old Weeah for some years when they first came to Massett from Kung, to which place they had previously moved from Kiusta" (Newcombe 1900–1911: vol. 33, folder 6, June 30).

It is unclear from Florence Davidson's quoted statement whether Charles Edenshaw carved his first bracelet in Skidegate in the early 1850s or later, after he moved north. According to the Reverend Charles Harrison, "Chief Edenshaw" was the first Haida carver to attempt manipulating silver and gold (Harrison 1911–1913: May 27, 1912). It is probable, however, that Harrison was referring not to Charles Edenshaw but to his uncle, *gwaaygu 7anhlan*, since other references Harrison made using the term "Chief Edenshaw" refer to the elder Edenshaw. If so, Harrison was probably inaccurate in ascribing the invention of silver engraving to *gwaaygu 7anhlan*; no other sources indicate that this was one of his skills. It may be that his brother-in-law, Duncan *ginaawaan*, should be credited with carving silver at an early date (see below). The earliest silver bracelets that can be attributed to Charles Edenshaw were collected in 1879 (see figs. 5.14, 5.15), and it is possible that Charles Edenshaw learned silver engraving from Duncan *ginaawaan*, his wife's mother's uncle, after moving north in

the 1850s. We know that Charles and his wife, Isabella, named their first son (Robert) *ginaawaan* after this man, two years after his death.

According to Florence Davidson, Charles Edenshaw's father, *tl'aajaang quuna*, was a very good carver and canoe builder (Blackman 1982: 69). It is possible that Charles learned wood carving from his father, but the date of *tl'aajaang quuna*'s death is unknown, and so it is also unknown whether Charles was old enough to have learned from him before he died.

Well after *da.a xiigang*'s move in the late 1850s, arrangements were made for his marriage. His bride, *qwii.aang* (Isabella), was closely related to both of *gwaaygu 7anhlan*'s wives, and she was brought to *qang* in 1865 or 1866, when she was seven or eight years old, together with *gwaaygu 7anhlan*'s second wife, *san 'laa gudgaang* (Amy), who was about fourteen at the time. When *gwaaygu 7anhlan* had taken his uncle's place, he had married his uncle's widow, *gu.uu 7aww*. After the smallpox epidemic in 1862, she is said to have missed her young nieces — Amy and Isabella — who were living in Klinkwan with their uncles. They had both narrowly escaped the smallpox epidemic, having been rescued by their uncles at the Jalun River in 1862 after their parents died. It was agreed by *gwaaygu 7anhlan* and his wife, *gu.uu 7aww*, that he should bring these young girls to *qang*, marry *gu.uu 7aww*'s niece, *san 'laa gudgaang*, and adopt her great-niece, *qwii.aang*, as his daughter. Florence Davidson explained that they had a big wedding ceremony that lasted for many days at *qang*, where *gwaaygu 7anhlan* had a new house (Blackman 1982: 66–68). Davidson said that *gwaaygu 7anhlan* potlatched for the girls because they were orphans, and he had a big pole raising for them. It was at this potlatch that *qwii.aang* was tattooed — a long dogfish on one leg, a grizzly bear on the other, and a quarter moon and lady on each arm (Blackman 1982: 68).

A few years later, in about 1873, when *qwii.aang* came of age, *da.a xiigang* married her. They were probably still living in *qang* at this time, though it is likely that they maintained multiple residences during the 1870s in *qang*, *ya.aats'*, and Massett. According to Florence Davidson, "when it was time, he married my mother. They were married in the Indian way before the missionaries came" (Blackman 1982: 72). We know that Charles Edenshaw frequently visited his wife's home at *hlanqwáan* with his family in later years, and he was probably continuing a pattern that had been started by old *7idaansuu* in the early nineteenth century.

Duncan *ginaawaan*

The close association between the *sdast'a.aas* Eagles and the *yahgu 'laanaas* Ravens dates back to the days before the *yahgu 'laanaas* migrated to Alaska from their homes at *daa.adans* and *yaak'u 'lanngee*. The village of *hlanqwáan* has a long history going back to Tlingit times, before Haida people occupied it. The name *hlanqwáan* (sometimes spelled Klinkwan, Klinquan, Łenkwan, or Łinqoa'n) is a Tlingit word meaning "shellfish town,"[13] and it is believed originally to have been a Tlingit village (Swanton 1905a: 247–249). At some time during the late seventeenth or early eighteenth century, Haida people from Graham Island moved north and settled at several villages, including *ráwk'aan*, *q'wíi rándllass, saxq'wa.áan, gasa.áan*, and *hlanqwáan*.[14] At all of these villages except *q'wíi rándllass*, the Haida newcomers used the village names of the previous

Tlingit residents. Other names that have been used for *hlanqwáan* include "the town-that-has-a-head" (a'nsa-ʌne), from the appearance of the point that projects from the middle of the village, and "Click-ass," after the nearby Klakas Inlet (Swanton 1905a: 247). There is a long narrow point at *hlanqwáan* that separates two small coves. The cove to the left (when looking from the water) was where the older houses were located, and the cove to the right had newer structures, including the house and store of a non-native trader named James Miller, who started a saltery in nearby Hunter Bay in 1886 (Vaughan 1985: 98). On the older side of town, the beach makes a nearly right-angle corner where a small creek enters the cove. The population of the village was estimated to be 417 in 1835 and only 125 by 1880, after smallpox and other diseases introduced by Europeans had swept through the area (Dawson 1880: 173B; Vaughan 1985: 96). In the fall of 1911, at the urging of the Alaskan Bureau of Education, the people who lived in *ráwk'aan* and *hlanqwáan* decided to create the new village, Hydaburg, and to move there in order to receive the benefits of a school and a lumber mill.

Perhaps the most famous early resident of *hlanqwáan* was a man named Duncan *ginaawaan*,[15] of the *yahgu 'laanaas* Ravens (d. 1876).[16] His Haida name was *ginaawaan*, and the name Duncan came from his father, who was said to have been a white sea captain. The Reverend S. Hall Young described *ginaawaan* as "the most famous carver in wood, silver and stone ever known in Alaska, [who] was himself a quarter-breed; that is, he had a quarter of white blood, his father being a half-breed" (Young 1927: 232).

Florence Edenshaw Davidson, whose mother was *ginaawaan*'s great-niece, described *ginaawaan* as having "light curly hair and big blue eyes . . . because they came from a woman who was married, in the Indian way, to a white boat captain" (Blackman 1982: 69). According to Davidson, *ginaawaan*'s mother was named *nan na.aa san 'laa xiilawaas*, and she had five children with this captain. This would make the captain *ginaawaan*'s father rather than his grandfather, as Young suggested.[17] Newcombe recorded the name of *ginaawaan*'s house in *hlanqwáan* as "Pig House,"[18] a house name that came from the village of *daa.adans* on North Island (Langara Island).

Duncan *ginaawaan*'s family in *hlanqwáan* and Albert Edward Edenshaw's were complexly intertwined (see chart 4). Duncan *ginaawaan* was married to *q'aawiidaa*, a *sdast'a.aas* Eagle, Albert Edward Edenshaw's sister's daughter. Duncan *ginaawaan*'s sister, *gu.uu ʒaww*, became the wife of Albert Edward Edenshaw (*gwaaygu ʒanhlan*) and had previously been married to Albert Edward Edenshaw's uncle (old *ʒidansuu*). After old *ʒidansuu*'s death, his heir and nephew, *gwaaygu ʒanhlan*, married his widow, as was the custom for a nephew taking his uncle's place. Albert Edward Edenshaw and *gu.uu ʒaww* had a son, George Cowhoe (*gu.uu*, 1851–1889), who became the first native teacher in Massett. George Cowhoe was *ginaawaan*'s sister's son and therefore his heir. Albert Edward later took a younger wife, *san 'laa gudgaang* (Amy, 1852–1922), who was the niece of *ginaawaan* and *gu.uu ʒaww* (their sister *gid gudgaang*'s daughter by *gwaaygu ʒanhlan*'s brother). Albert Edward and Amy had a son, Henry Edenshaw (1868–1935), who also became a teacher in Massett and is said to have inherited a house in *hlanqwáan* (Newcombe 1900–1911). Later, Charles Edenshaw (*da.a xiigang*) married Isabella (*qwii.aang*), who was Amy's niece (her sister *ʒilsgidee*'s daughter) (Blackman 1982: 60–61). All of the Edenshaws' wives

were from *hlanqwáan* and belonged to the *yahgu 'laanaas* Raven clan. They had the raven, grizzly bear, dogfish, and woman in the moon as crests.

MacDonald identified Duncan *ginaawaan*'s house (fig. 4.7) as the one with two corner posts and a tall frontal pole located at the corner of the cove at *hlanqwáan* (MacDonald 1996: 192–193, plate 141).[19] The frontal pole combined his *yahgu 'laanaas* crests with the *sdast'a.aas* crests of his wife, *q'aawiidaa*. A beaver with frogs in its ears at the bottom is a *sdast'a.aas* Eagle crest. Above the beaver, a grizzly bear, a crest of the *yahgu 'laanaas*, holds an insectlike figure; a humanoid figure and a raven with ten hat rings (*sgil*) are above his head.[20] A small raven sits at the very top. The corner posts both show the *yahgu 'laanaas* bear crests; the left corner post has a bird at the top, with a bear holding an insect above a bear holding a human figure. The right corner post (fig. 4.8) has a figure at the top holding the moon with a human figure inside, possibly the woman in the moon, a *yahgu 'laanaas* crest.[21] Below, a bear with a large extended tongue has a small female figure on its chest, and another grizzly bear sits at the bottom. John Swanton recorded the story of the woman in the moon in 1901:[22]

> A woman used to point her fingers at a certain star as a sign of contempt, for which she was taken up to a house in the sky and hung in the smoke-hole. Her brothers, however, made an image of her, hung it in her place, and took her away. By and by she pointed her fingers at the moon, and was carried thither, together with the bucket of water which she had at the time, and the salal-bushes that she seized hold of to stop herself. (Swanton 1905a: 217–218)

The small female figure with breasts and long hair on the right-hand corner post is unusual in its naturalism. Referring specifically to this figure, MacDonald suggested that these poles might be the work of Albert Edward Edenshaw, but it is more likely that Duncan *ginaawaan* himself was the principal carver of his own house poles. The ears of the lower bear on the right-hand pole, as well as the tall ears of the raven on the frontal pole, display the horizontal parallel grooves that are characteristic of Kaigani-style carving.[23]

Charles Edenshaw carved a model of a pole for John Swanton (fig. 4.11) that is similar to a pole that stood in front of a house named *na gíit'ii* at *hlanqwáan* (figs. 4.9, 4.10) (Swanton 1905a: plate 5, fig. 3). Of this model, Swanton wrote:

> [M]odel of a pole erected for Duncan Gina'wan, whose mother belonged to the Middle-Town-People (R19), and who received his first name from his father, a white man named Duncan. One of the same design formerly stood at Old Kaigani in Alaska. At the bottom is a grizzly bear. The flattened shaft surmounting this, together with the raven standing on top, represent the mythical killer called Raven-Fin (Tc!ilia'lAs). In the original the eyes and feathers were set with abelone-shell. On the front of the fin there were originally two coppers; but one of these, called Standing-Copper (T!ao giā'as), was afterwards removed, and sold for two hundred and seventy-five dollars in cash and twenty-five dollars in blankets. The other, which is tied to the model (but not represented in the cut), was called Mountain-Copper (Ldao t!aos). It was of very little value. (Swanton 1905a: 130)

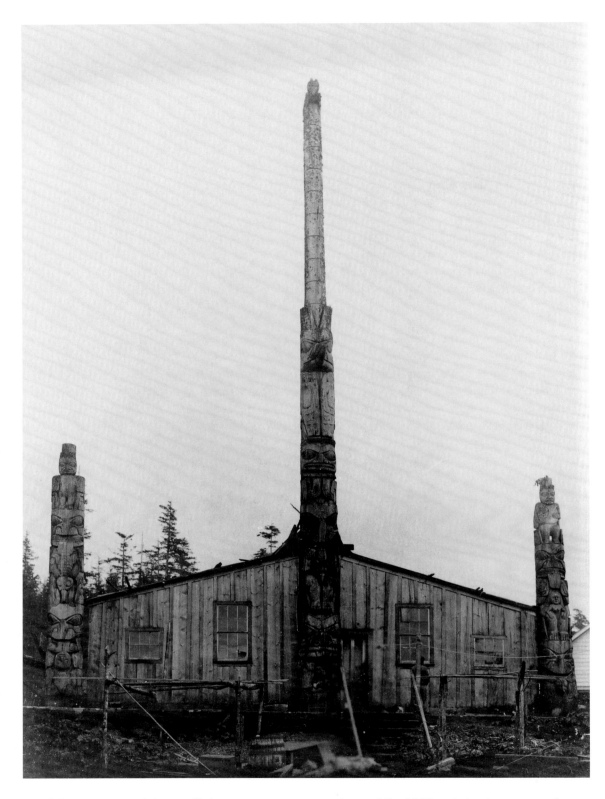

Fig. 4.7. Duncan *ginaawaan*'s house in Klinkwan
(*hlanqwáan*), Alaska. Courtesy of the Smithsonian
Institution, neg. no. 38583-E. U.S. Bureau of
Fisheries photograph, 1888–1889.

(*opposite*) Fig. 4.8. The right-hand corner post of
ginaawaan's house. Below the boardwalk is the head of
the frontal pole (fig. 4.7) after it was cut up to support
the boardwalk. Courtesy of the Smithsonian Institution,
neg. no. SI4318. Photograph by J. E. Thwaites, 1922.

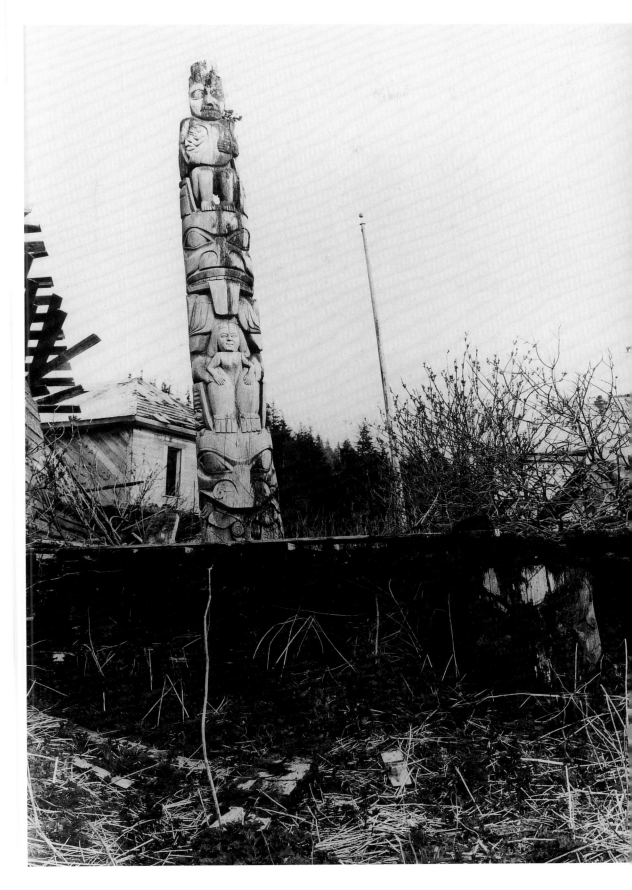

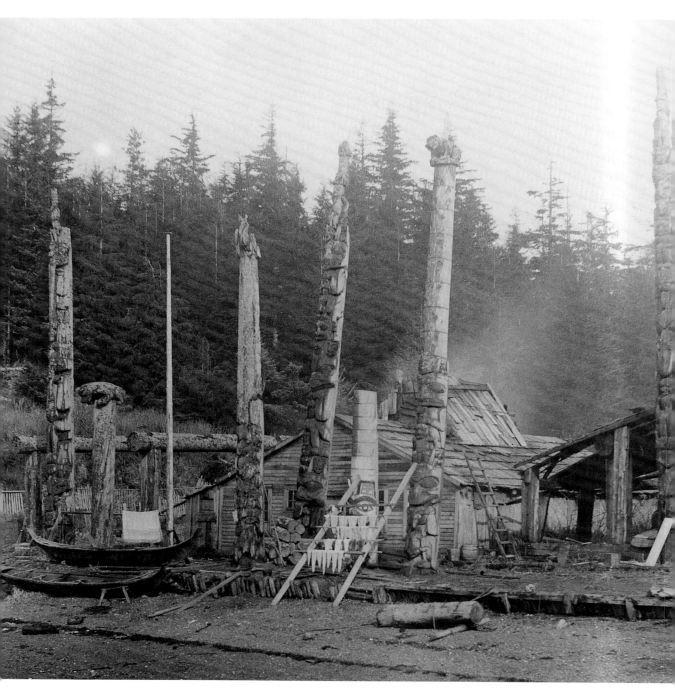

Fig. 4.9. Klinkwan, Alaska. The raven-fin pole said by John Wallace to have belonged to Duncan *ginaawaan* is third from the left, in front of the house known as *na gíit'ii*, House Child. The house known as *na 7íw7waans*, Big House, is to the right, and Duncan *ginaawaan*'s bear-tracks pole is the second pole from the right. Courtesy of the Royal British Columbia Museum, neg. no. PN 977. Photograph by C. F. Newcombe, 1902.

Fig. 4.10. Duncan *ginaawaan*'s raven-fin memorial pole in Klinkwan, Alaska (opposite at left). Courtesy of the Special Collections Division, University of Washington Libraries, neg. no. 3617. Photograph by J. E. Thwaites, 1923, from the Viola Garfield Collection.

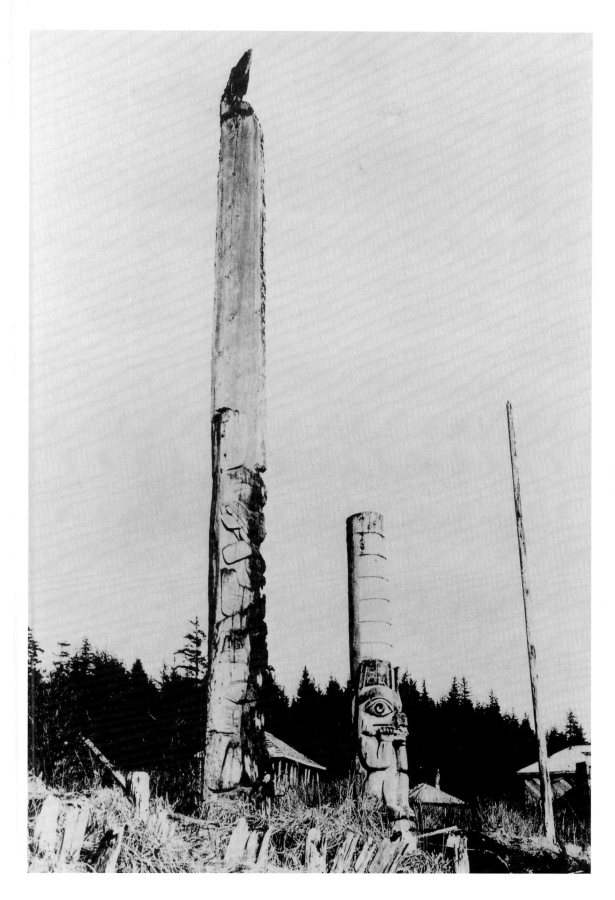

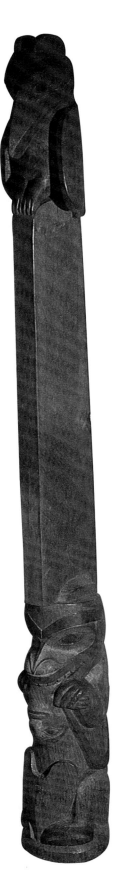

Fig. 4.11. Charles Edenshaw's model of a memorial pole erected for Duncan *ginaawaan,* 67 by 8.5 by 7 cm. Commissioned by John Swanton, 1901. American Museum of Natural History, cat. no. 16/8761. Photograph by the author.

Another, similar pole stood at Massett, in front and just to the right of Albert Edward Edenshaw's house (see fig. 4.47). MacDonald reported that Charles Edenshaw's model was a copy of the Massett pole, quoting Swanton's description. He also quoted Barbeau as saying that this pole (22M2) was the last pole to be raised in Massett and that it was put up during the 1890s by Luke Bennett in front of his house, next door to the Edenshaw house (MacDonald 1983: 148). The photographer Robert Reford, however, recorded this pole in 1890, so it must have been raised before that. It is possible that the memorial raised by Luke Bennett was actually the one that his son, Benjamin Bennett, is standing next to in a Newcombe photograph (see MacDonald 1983: 148, plate 199). This pole was nearby but does not appear in earlier photographs of these houses.

The Massett memorial would certainly have been conveniently located for Charles Edenshaw to copy it — literally right outside his door — and it did have a copper attached above the bear's head, as shown in the photograph (see fig. 4.47). The *hlanqwáan* pole (fig. 4.10) is more complex than the other two (the Massett pole and the model), with two large figures at the base, a bear at the bottom, and a raven-finned whale above it holding a smaller whale in its mouth. The pectoral fins of this whale extend upward along the tall dorsal fin. The bear and the whale were combined into one figure on the Massett pole and on Edenshaw's model. It might seem more likely that the pole raised for *ginaawaan* would have gone up in *hlanqwáan,* where he lived, but he was closely related to both of Albert Edward Edenshaw's wives, and his nephews lived in Massett. Perhaps the *hlanqwáan* pole is the one Swanton (1905a: 130) referred to as the older pole in old Kaigani, or there might have been a third pole at *k'áyk'aanii* village, even older than the *hlanqwáan* pole.

To the right of the *hlanqwáan* pole in figure 4.9 is another pole (the second from the right) with a stack of eight *sgil* (hat rings) with bear tracks leading up them and a bear on top. When Viola Garfield interviewed John Wallace about this pole, Wallace could not remember the story about the bear tracks, but he did recall that this pole belonged to Duncan "Kina'uan," whom he identified as his father's brother (Garfield 1941: 51).[24] John Wallace carved a copy of this pole for Hydaburg Totem Park in 1941 (see fig. 6.5). Both of these poles are free-standing memorial poles that were probably raised in honor of Duncan *ginaawaan*'s *yahgu 'laanaas* relatives. Because the carving of memorial and mortuary poles was usually done by someone from the moiety opposite that of the deceased and the heir commissioning the pole, it is possible that Albert Edward Edenshaw was the carver of these two poles. Their carving style supports this supposition.

The house located just to the right of the bear-tracks pole in figure 4.9 was named Na yū'ᴀɴs (*na ɂíw7waans*), "Big House," according to Swanton, who listed it as having been owned by a man named Gᴀ'sawak (*gasáawaag*) of the

Q!ā'ad na'as Xadā'-i, "Dogfish House" People, his R19b (the *q'a.ad na.as yahgu 'laanaas* Raven clan) (Swanton 1905a: 294).[25] This house had two frontal poles (fig. 4.12) — an older one with a doorway at its base that probably belonged to an earlier house on this spot, and a newer, taller one placed to the left of the door on a new, milled-lumber house with windows. This house also had elaborately carved retaining planks (*dáa7aay* in the Alaskan Haida dialect) and an interior house post (fig. 4.13). Both John Brady, governor of Alaska, and C. F. Newcombe attempted to purchase these planks, without success. Newcombe negotiated with Henry Edenshaw, Albert Edward Edenshaw's second son, who was said to have been the owner of the house in 1905. Henry Edenshaw would have inherited this house through his mother, Amy's, family.[26]

We are fortunate to have a photographic record of the carved *dáa7aay* from *na 7íw7waans* that shows two tiers of retaining planks (fig. 4.13). The two planks at the back of the house were elaborately carved with alternating chest and copper designs; they are the most elaborate such planks known.[27] A single interior house post has a bird at the bottom, which was missing its beak when Newcombe photographed it, and a bear holding an insect figure above. MacDonald (1996: 195) suggested that Albert Edward Edenshaw was the carver of both the interior post and the *dáa7aay*. The crisp carving style of the post, the shapes of the ovoids, and the open eyelid lines are consistent with this attribution. Newcombe's 1902 photograph of the exterior of the house (fig. 4.9), taken at the same time as the interior photographs, shows the house missing its siding but retaining its roof and corner posts. Still later, after a church had been built on the hill in 1907 (Vaughan 1985: 100), only the tall frontal pole and one set of corner posts and beam remained (fig. 4.14).[28] This frontal pole fits with Albert Edward Edenshaw's style and may have been carved by him along with the interior post, although this house belonged to the opposite Raven clan. A bear at the bottom is surmounted by a bird with a downturned beak, a small human figure, an insectlike figure, another human, a bear with small figures in its mouth and between its ears, and three watchmen at the very top. Interestingly, the center watchman figure is completely cut through at the sides of his body, a technique used with success by Robert Davidson in the 1980s and 1990s.

In 1902 Charles F. Newcombe visited *hlanqwáan* and was able to purchase a number of objects that went to the Field Museum in Chicago. Many of these objects had been photographed around 1900 by the Juneau photographers Winter and Pond (figs. 4.15, 4.16). A Haida woman named Mrs. Sanderson told Margaret Blackman that this was the last traditional "doing" held at *hlanqwáan* before evacuation of the village for Hydaburg, Alaska. These photos were probably posed for the photographers (Weber 1985:71). Newcombe unsuccessfully attempted to purchase poles and house parts from *hlanqwáan* during his 1902 visit. The following year, Governor Brady was able to remove one totem pole from *hlanqwáan* and also what were described as "two heavy timbers" and "carved planks" for exhibition at the Louisiana Purchase Exposition in St. Louis in 1904. All of these were acquired from "Edward" (Edwin) Scott, who had the name *gasáawaag* at this time. Brady first met Edwin Scott in *ráwk'aan* on November 9, 1903. Scott told him that his brother, who was at *hlanqwáan*, could act for him, because Scott was planning to stay in *ráwk'aan* for a few days. Brady went aboard the USS *Rush* to *hlanqwáan* on November 11:

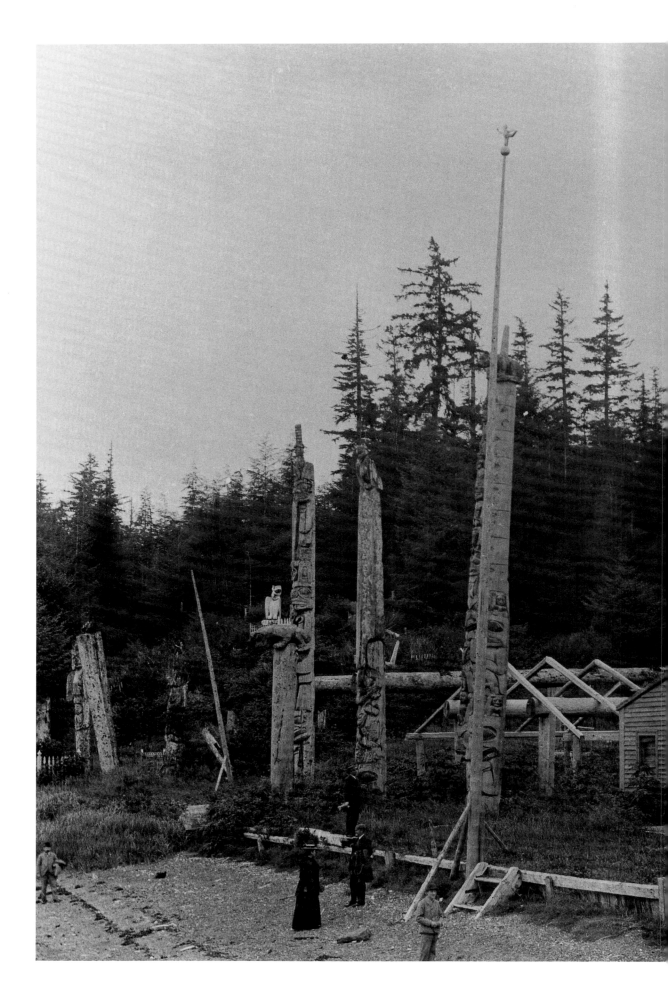

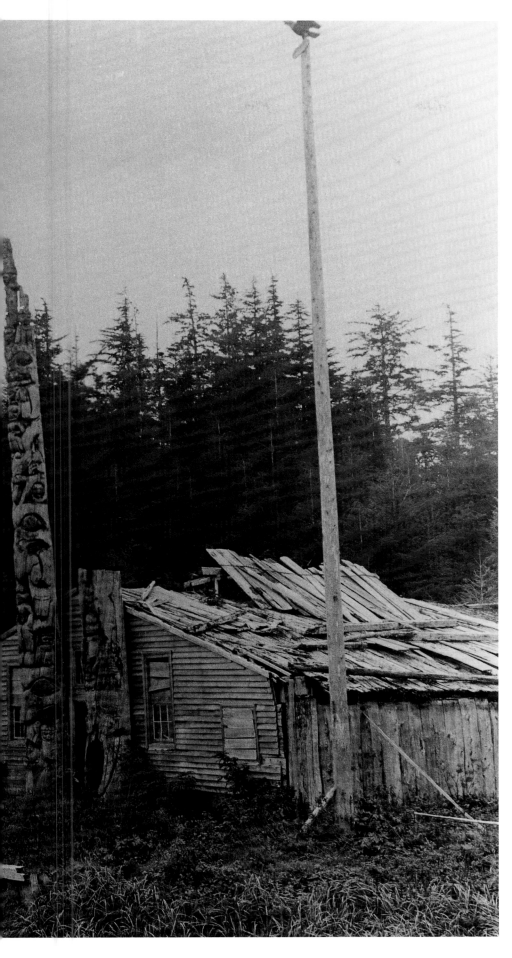

Fig. 4.12. Big House (right), or *na 7íw7waans*, with the bear-tracks pole to the left (behind flagpole), Klinkwan, Alaska. Described by C. F. Newcombe as Henry Edenshaw's house. Courtesy of the American Museum of Natural History, neg. no. 296256.

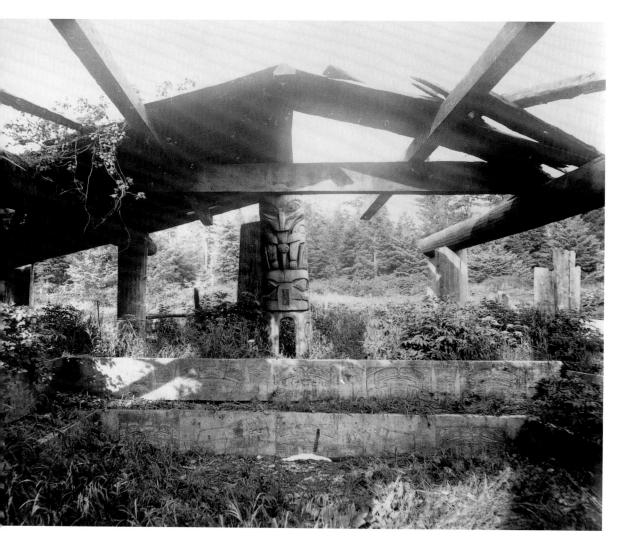

Fig. 4.13. Interior of *na 7íw7waans*, Klinkwan,
Alaska. Courtesy of the Royal British Columbia
Museum, neg. no. PN 160. Photograph by C. F.
Newcombe, 1902.

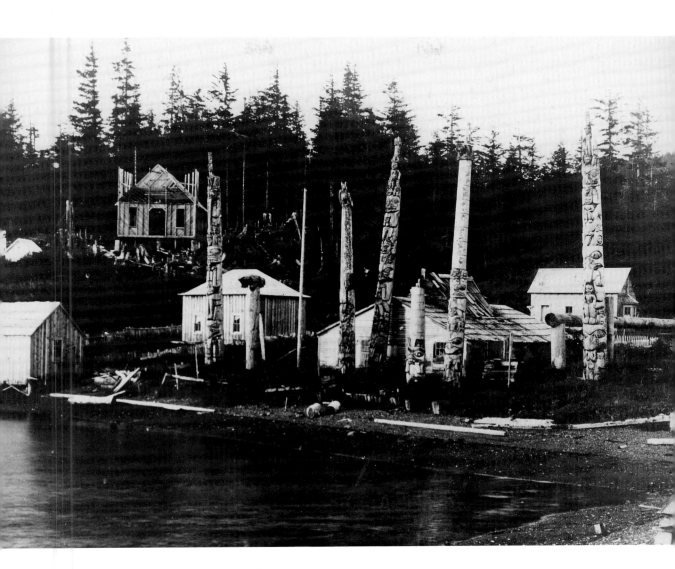

Fig. 4.14. Klinkwan, Alaska. Frontal pole of
na 7íw7waans at right, after 1907. Courtesy
of the Smithsonian Institution, neg. no. 72-505.

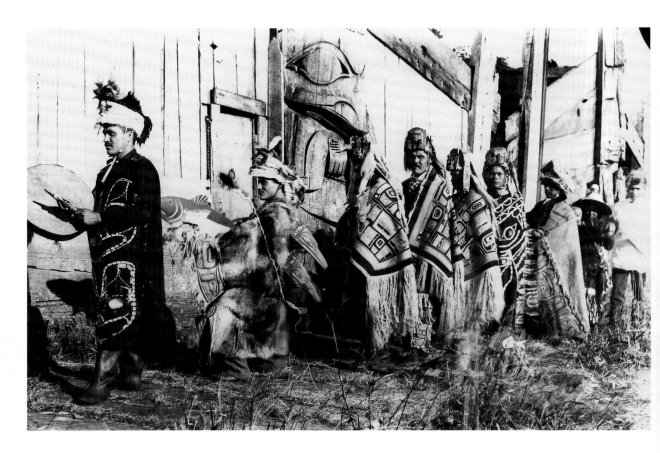

Fig. 4.15. Display of regalia, Klinkwan, Alaska, circa 1900.
The people in the photo have been identified as (left to
right) Donald Mekatla (or Robert Edenshaw), Matthew
Collison, an unidentified man, Edwin Scott (*gasáawaag*),
Eddie Cogo or Hugh Cogo (identified as Eddie Cogo by his
son in 1977), an unidentified man, Mike George (Anklleq),
Ben Duncan (Gennowwu), and Nasauk (Adam Spoon's
son). Courtesy of the Alaska State Library, neg. no. 87-318.
Photograph by Winter and Pond.

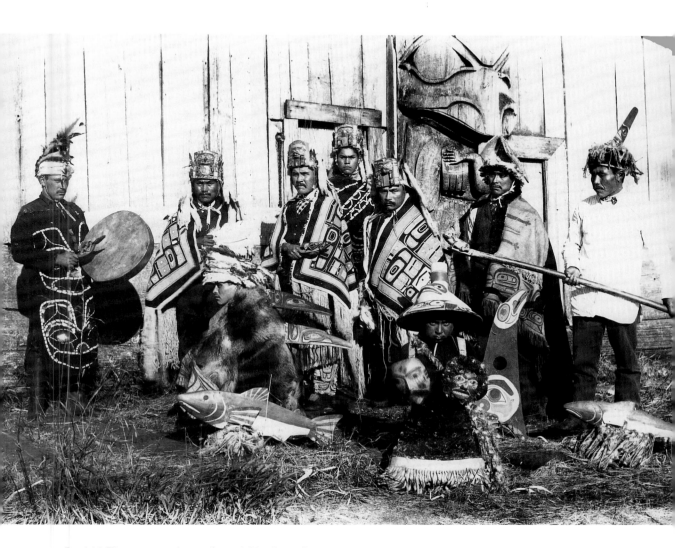

Fig. 4.16. The same people as in figure 4.15 in front of
Edwin Scott's Dogfish House (q'a.ad na.as), Klinkwan,
Alaska. Courtesy of the Alaska State Library, neg. no.
87-316. Photograph by Winter and Pond, circa 1900.

We got Edward [*sic*] Scott's pole in the water and 2 long broad timbers for the inner part of the house. They have old carvings on them. There were not many of the people at home. The launch will [be] sent to tow them along side in the morning. A native by the name of Duncan called me into his house and offered me two inner uprights which are well carved but are too old to take to St. Louis and besides they have been cut off even with the ground.[29] I promised to take them to the museum at Sitka but could not take them now as the ship is about full. (Brady 1903: 10)

The pole Brady acquired from Edwin Scott was the house frontal pole from *q'a.ad na.as*, Dogfish House (fig. 4.17). Isabella Edenshaw is said to have lived in *q'a.ad na.as*, which was located at the extreme end of the point in the center of *hlanqwáan*. Edwin Scott is said to have inherited the house from his uncle, Nekaetla (Blackman 1971), though Swanton (1905a: 294) listed the owners of this house in the mid-nineteenth century as Nañ ᵋā'ʟdjîgias (*nang.áa tl' jagíi.aas*), "one unable to buy" (he once had a copper that his opponent was unable to buy) and then Gusū'udañ (*gusu'udang*), "all mixed together" (as people are at a potlatch). Edwin Scott's Haida names were *gasáawaag* (Gusawak) and *gu.uu* (Gao or Kow, the same name held by Albert Edward Edenshaw's son, George Cowhoe).

Edwin Scott's *q'a.ad na.as* frontal pole appears in photographs taken of the Alaska building at the St. Louis World's Fair. Two houses and two groups of poles were erected on either side of the Alaska building. Scott's pole was the closest to the Alaska building in the right-hand grouping of poles (fig. 4.18). Most of the poles were restored and repainted by a crew of carvers whom Brady brought to St. Louis, among them William Kinninook, Yeltadsi's son, and John Baronovich from *gasa.áan* (Wyatt 1986: 20). It appears that Scott's pole was significantly restored. The beak and figure above the raven's head may have been damaged in transit, because the original beak photographed by Newcombe in 1902 is quite slim, whereas the beak in St. Louis has a distinct bulge. The small bear figure between the ears has been completely removed, and simple split Us have been carved in the ears. The entire pole has been brightly painted, but the formline details on the raven's wings, the bear figure at the bottom, and the small bear climbing at the top of the potlatch rings identify this as the same pole.

Although most of the poles collected by Brady and exhibited in St. Louis were returned to the Sitka National Historic Park, two poles were sold.[30] Edwin Scott's carved planks were either given or sold to Charles Newcombe at the end of the fair. He sold them to the Field Museum of Natural History (cat. no. 887990) and wrote the label copy for them, which identifies them as coming from *na 7íw7waans*, Big House, at *hlanqwáan*:

Fig. 4.17. Edwin's Scott's frontal pole at Dogfish House (*q'a.ad na.as*), Klinkwan, Alaska. Courtesy of the Royal British Columbia Museum, neg. no. PN 117. Photograph by C. F. Newcombe, July 12, 1901.

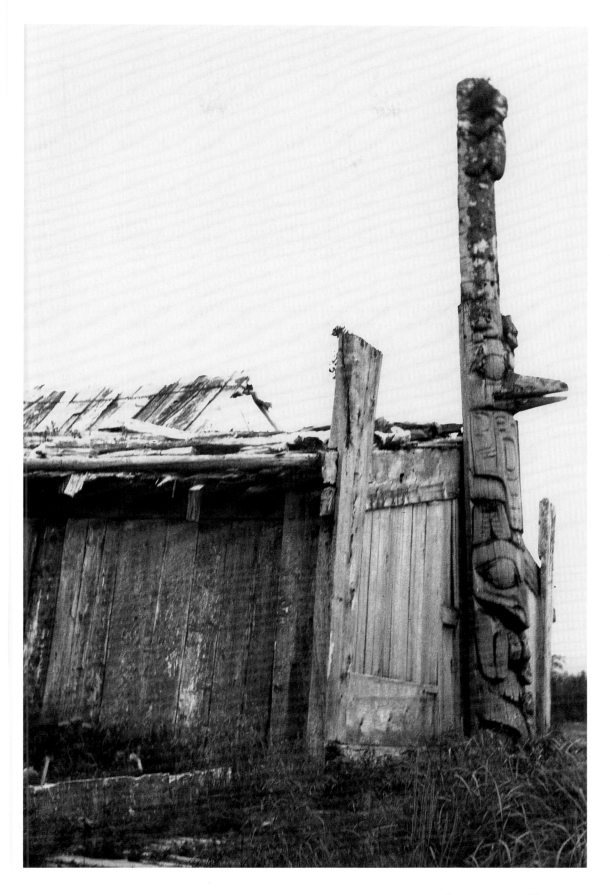

Carved House Boards (Daiikungit).

Of red cedar. Length 32 feet; width 28 inches; thickness 8 inches. The incised carving represents killer-whales and the mythical monster tsilialas or raven-fin.[31] These timbers formed part of the support of the sides of the central pit of the house belonging to Chief Gasawak. He belonged to the Yakulanas family of the Raven Clan. House name NaYuans, the Big House.

Haida
Klinkwan, Alaska
Gov. Brady, collector, 1904
87990 (1 and 2). (Newcombe 1900–1911: vol. 38, folder 3)

There is some confusion, however, over which house these planks actually came from. Edwin Scott's Dogfish House on the point apparently did not have carved retaining planks, and Newcombe's label description of them says they are from *na ʔíw7waans* — but he was still attempting to purchase the *na ʔíw7waans* planks from Henry Edenshaw in 1905, the year after the fair. In a letter from Newcombe to Henry Edenshaw dated November 15, 1905, Newcombe offered to purchase from him the carved planks from his house at *hlanqwáan*, saying: "Although we took from Gov. Brady Edwin Scott's big carved cellar boards (Killer Whale & Tsilialas) we could still do with the two at the top of your house if you are done talking with the New York people." In a later letter dated May 23, 1906, Newcombe repeated the offer, saying: "The Field Museum will take the two carved boards at the end of your house under the carved post if including all your expenses in shipping on board steamer, and the freight on board the steamer you can deliver them at Seattle to the Great Northern Railway for $80 or $90." On April 2, 1906, Henry Edenshaw replied: "Regarding to the carved boards at Klinquan when I said I could sell them to Dr. Swanton for $40.00 I never thought a minute that I have to make a trip to Alaska special for that, when I sized the thing up it will cost me more than it is worth. Therefore I drop the agreement. If you could do me a favor by taking them from me I shall be very thankful to you" (Newcombe 1900–1911: vol. 2, file 51).

Apparently this deal never went through, and the planks most likely remained in *hlanqwáan* and decayed there. Edwin Scott's set of carved house retaining planks from *hlanqwáan* were exchanged by the Field Museum around 1904, and their current location is unknown (Stephen E. Nash, personal communication, October 1999). It is possible that these planks were actually from the house named *na gíit'ii* (see below).

Unlike the missing *dáaʒaay*, the fate of Scott's frontal pole can be traced. It was returned to Sitka after the St. Louis fair and was erected in the totem park there. The record of its identity was lost, and when the Alaska Natural History Association published a guidebook to the poles in the park in 1980, the replica of this pole was described as a Haida crest pole "possibly from Sukkwan. . . . Unfortunately, little information on its origin is available." The original pole apparently disintegrated, for the entry continues: "The original Frog/Raven column was patched, trimmed, and painted, but by 1939, park records state: '[it is] doubtful if it can be repaired, for when it dries out for working, it may fall apart.' This replica was carved during the early 1940s, reportedly by George

Fig. 4.18. Alaskan poles acquired by Governor Brady and displayed around the Alaska Building at the 1904 St. Louis World's Fair. Edwin Scott's *q'a.ad na.as* frontal pole is closest to the building. Photograph courtesy of the Beinecke Rare Book and Manuscript Library, Yale University.

Benson and John Sam" (Edelstein 1980: 5). The replica of this pole has altered its original appearance even further than the St. Louis restoration did, in that the little bear that was climbing upward at the top was replaced with a frog that faces downward (fig. 4.19).

gid k'wáajuss (Dwight Wallace)

The two bear house posts offered to Brady by the man named Duncan apparently were never acquired for Sitka Totem Park but were removed to Hydaburg in the 1930s. John Wallace carved a model of the house from which these posts came for the 1939 San Francisco World's Fair. It is currently in the Tongass Historical Museum in Ketchikan, Alaska (figs. 4.20, 4.21). It shows a seated-bear house post at the rear of the house, paired with a bird post. The retaining planks inside the house are painted with what looks like a whale figure and a raven head, probably *ts'ál yáalaas*. This suggests that the house planks collected by Brady and taken to St. Louis were those from this house. A photograph of a seated-bear post taken by Newcombe in 1902 shows one of the original bear posts (fig. 4.22). John Wallace copied these bear house posts for Hydaburg Totem Park and identified his father as the carver of the originals (Garfield 1941: notebook 1, Hydaburg, Klawock, p. 43). The originals were later destroyed. He said that the house had belonged to his mother's father, Yeltadzie, before he moved to *q'wíi rándllass* and *ráwk'aan* when John Wallace was not more than ten to fifteen years old (see chart 5). John Wallace was eighty-three in 1941, which would

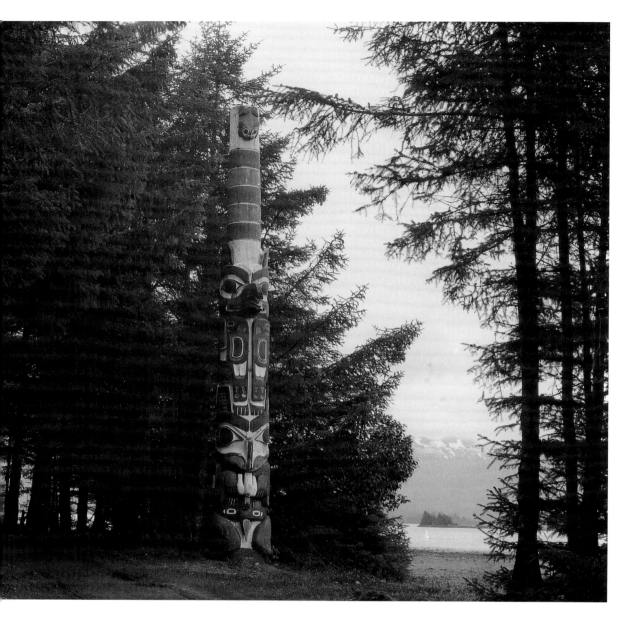

Fig. 4.19. Edwin Scott's Dogfish House (*qa.ad na.as*) frontal pole, Sitka National Monument, circa 1910. The bear climbing up at the top has been changed to a frog facing downward, and the beak has been restored. Courtesy of the American Museum of Natural History, neg. no. 124696.

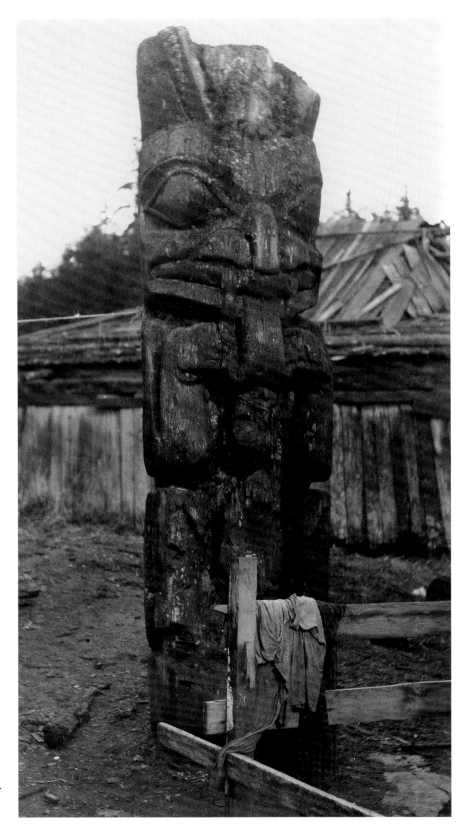

Fig. 4.22 Bear house post, Klinkwan, Alaska. Courtesy of the Royal British Columbia Museum, neg. no. PN218. Photograph by C. F. Newcombe, 1902.

Chart 5. The family of *gid k'wáajuss* (Dwight Wallace).

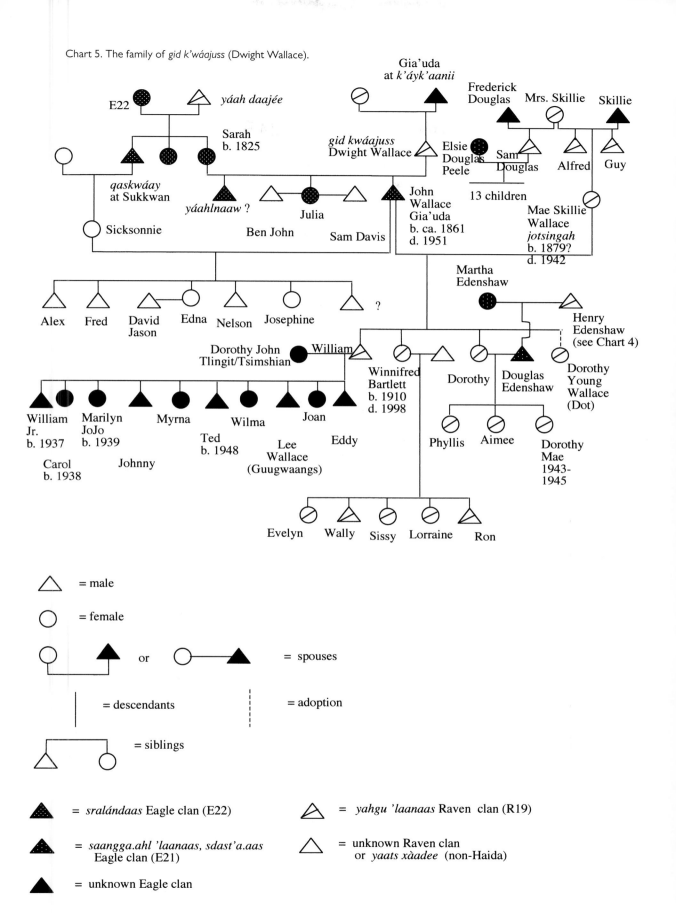

date this house to the late 1860s or early 1870s (Garfield 1941: 26). Swanton listed its name as *na gíit'ii*, "House Child" (his House 10); it was next door to *na 7íw7waans*, Big House. Both of them had excavated interiors faced with retaining planks.[32]

The frontal pole of Wallace's model has a raven at the top and two bear figures holding fish below. This may be a simplified version of the old house frontal pole that stands at a slight angle in front of the house (see the center house in fig. 4.14). According to John Wallace, the leaning frontal pole was cut up and used to support a boardwalk in the early twentieth century (Garfield 1941: notebook 1, Hydaburg, Klawock, p. 45). To the left of the leaning frontal pole is Duncan *ginaawaan*'s memorial pole, which was copied in a model by Charles Edenshaw. Swanton recorded the owner of this house as *wa'jdiye*, "Doubtful," also of the *q'a.ad na.as* Ravens (R19b). None of these poles has survived except through John Wallace's copies, made in 1940 and 1941.[33]

John Wallace's father, Dwight Wallace (fig. 4.23), lived in "Keet naas, Pet House" in *hlanqwáan*, according to Newcombe (1900–1911: vol. 2, file 44).[34] John Wallace gave his father's name as Kit qwaədza'us (*gid k'wáajuss*), "great quiet

Fig. 4.23. Dwight Wallace (seated with Chilkat robe over lap) with other people at Klinkwan, Alaska, circa 1900. The woman with the neck ring standing behind Wallace wears a hat that was probably painted by Charles Edenshaw. Photograph courtesy of the Beinecke Rare Book and Manuscript Library, Yale University.

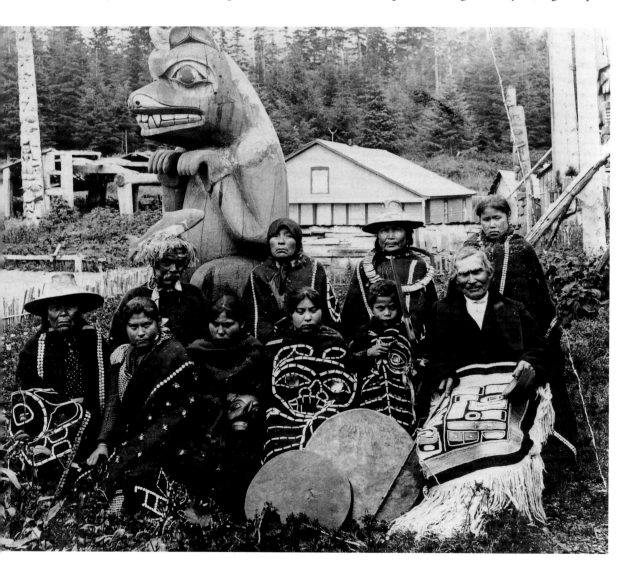

boy" (Garfield 1941: notebook 1, Hydaburg, Klawock, p. 43).[35] Dwight Wallace is said to have carved a pole (fig. 4.24) that once stood in *saxq'wa.áan* and was later removed to Juneau (Keithahn 1963: 26, 146).[36] This pole belonged to John Wallace's uncle's son in *saxq'wa.áan* (Garfield 1941: notebook 1, Hydaburg, Klawock, p. 87). Viola Garfield's notes document several other poles that John Wallace attributed to his father. These include a pole in *ráwk'aan* that belonged to Yeltadzie (*yaahl dàajee*) (Garfield 1941: notebook 1, Hydaburg, Klawock, p. 29) (fig. 4.25). Yeltadzie also owned a close mate to this pole at *q'wíi rándllass*, near *ráwk'aan* (fig. 4.26). It was collected by Governor Brady for the St. Louis World's Fair in 1904 and has also been attributed to Dwight Wallace (Feldman 1996). These three poles all portray the story of the *suu sraa.n* (Wasgo or *gunaakadeet*), showing the monster who could capture whales. On the *q'wíi rándllass* and *ráwk'aan* poles, the jealous mother-in-law figure holds circular puffin-beak rattles similar to those on the house frontal pole at Albert Edward Edenshaw's Myth House at *k'yuust'aa*. On the *saxq'wa.áan* pole, she is absent, but a bearded *gunaakadeet* in human form holds whales in his arms (Garfield 1941: notebook 1, Hydaburg, Klawock, p. 9–15).

Another pole from *saxq'wa.áan* (fig. 4.27), which John Wallace took to the San Francisco fair in 1940, was also carved by Wallace's father. It was sold in 1941 to the University of Pennsylvania Museum in Philadelphia and later went to the Denver Art Museum. It had belonged to John Wallace's uncle (his mother's brother), who willed it to him. John Wallace told Viola Garfield the story of the figures on the pole:

> Ku.ł qe — name of Tlingit man about whom the story is told. One family went to Cape Chommaney camping. One man take his dog and go hunting on point at C[ape] Muzon. A wave smashed his canoe and he and the dog swam for shore. On the beach he saw his smashed canoe. He found a cave in the rock and there were two men with no clothes. Their mouths were large and they put their hands over their mouths and looked at him. When they talked they talked quiet, esp[ecially] when they saw him. Their body all right but ears and head changed.
>
> He got dry cedar bark and got a drill and made a fire. Used ear wax to help start it.
>
> If people drowned the dog is changed quick by land otters. Man killed his dog and dried its skin and put it over his head. Next day his "sister" came and cried and cried and his brothers too. They went ashore and felt good because they thought they had found the brother. They had hunting clubs. Man took his club and jumped at his "sister" and clubbed her. Kuł qe killed many land otters, others came on sticks that they use for canoes. Land otters use logs for canoes.
>
> He saw his "brother" and took his club and hit his "brother" and killed land otters.
>
> Brother-in-law came and talked differently (like with false teeth!) with a sister and talked nicely to him. Then they talked Tlingit to him but he killed them.
>
> Others of his family came and saw smoke. They talked plain Tlingit and said "that's our brother." They were the real relatives. Man put on his dog headdress. He asked the sister for tobacco to prove if this was really she.

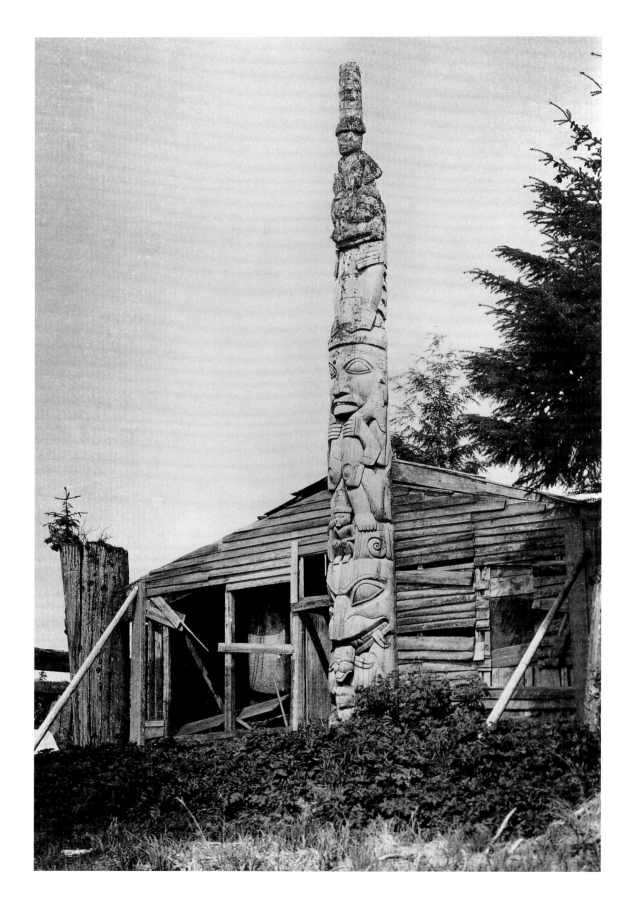

(*opposite*) Fig. 4.24. The pole in *saxq'wa.áan* (Sukkwan) known as the "Old Witch Pole," attributed by John Wallace to his father, Dwight Wallace. This pole stood for many years in front of the Nugget Shop in Juneau, Alaska, and is now on display in the atrium of the State Office Building in Juneau. Alaska State Museum, cat. no. 11-B-1632. Courtesy of the Special Collections Division, University of Washington Libraries, neg. no. 18613. Photograph by Schallerer, circa 1939, from the Viola Garfield Collection.

Fig. 4.25. Yeltadzie's pole (left) at Howkan, circa 1901, attributed to Dwight Wallace. Courtesy of the Special Collections Division, University of Washington Libraries, neg. no. 3607. Photograph by J. E. Thwaites, 1923, from the Viola Garfield Collection.

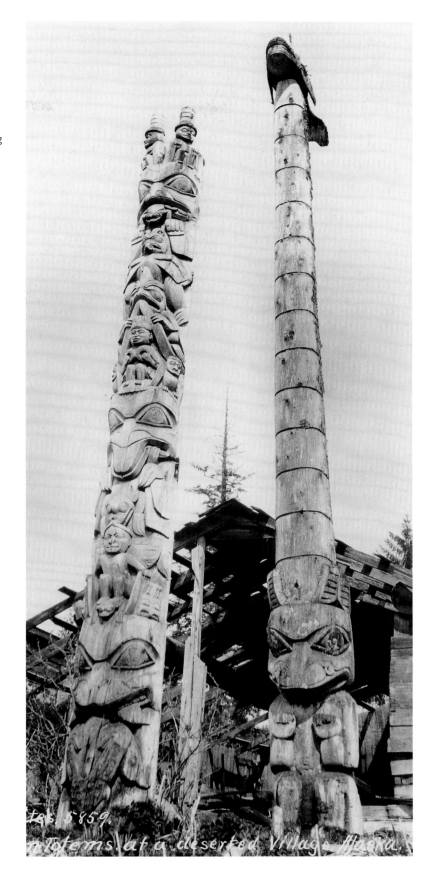

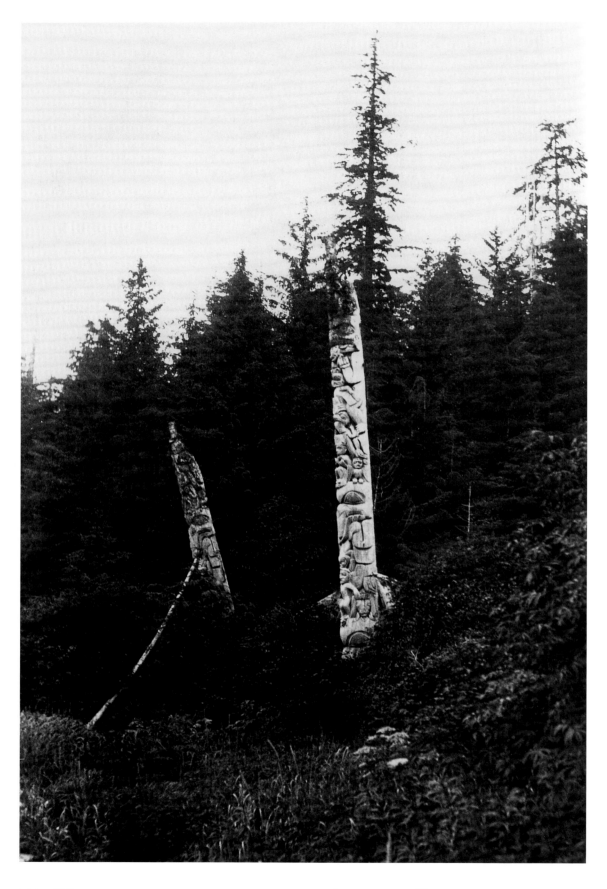

She gave him some and he knew they were really his relatives. He went with them to the camp. He told the story of what he had seen.

Tiny face in man's mouth is mink which the land otter sent to try to get the man when he was asleep. In his hands is a club with carved head. This he used to kill land otters. His dog headdress on his head. In his hands he holds the land otter. Land otter is holding the logs they use for canoes. Under the log is land otter man with spirit changed by the land otter.

Next is the Stone or Rock cave with the mink in its mouth. This is the cave where the two land otter men were living and the mink lived. Under it is one of the men in human form before he was changed.

Lower figure is stone cave again with a sting ray in its hands. This fish has same shaped tail (and ear) as a land otter, or so the people think. Tlingits eat sting rays but Haidas don't. (Garfield 1941: notebook 1, Hydaburg, Klawock: 61–65)

At the time John Wallace told Garfield this story in 1941, he was working on a copy of this pole for Mud Bight Park north of Ketchikan. To suggest the beach scene of the story, he added a devilfish figure at the bottom that was not on the Dwight Wallace pole (Garfield and Forrest 1949: 92–93, fig. 63).

Both Sam Davis and John Wallace told Garfield that Dwight Wallace had also carved the famous pole from old *gasa.áan* (fig. 4.28) that was raised by Chief Skowl, funded by his daughter, around 1880, two years before Skowl's death (Garfield 1941: notebook 1, Hydaburg, Klawock, p. 83; Garfield and Forrest 1949: 67–70). This pole and the four interior house posts that went with it were taken to Ketchikan and displayed in the city park. The pole is now in the Totem Heritage Center in Ketchikan. The eagle at the top in figure 4.28 is Skowl's daughter's crest, and the figures below it represent a white man pointing to the sky, the heavens where the white man's god resides, an angel, and a Russian orthodox priest with his hands crossed over his chest in a gesture of piety standing on a Russian eagle. These four figures are said to be ridicule figures, representing the failure of Russian priests to convert Skowl and his family to the Russian Orthodox faith. The white man at the base of the pole represents Charles V. Baronovich, an Austrian trader married to Skowl's daughter, who was not a religious man. After his death, his widow funded the raising of this pole with the money she inherited from Baronovich (Garfield and Forrest 1949: 67–70).[37]

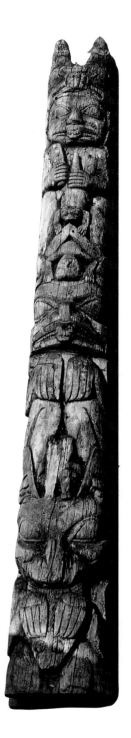

Fig. 4.26. Yeltadzie's pole (opposite at right) at *q'wí rándllass* (Koianglas), attributed to Dwight Wallace. Courtesy of the Smithsonian Institution, neg. no. 92-7098. Photograph by C. F. Newcombe, circa 1901.

Fig. 4.27. Sukkwan (*saxq'wa.áan*) pole attributed to Dwight Wallace. It belonged to Kusqwa'i, John Wallace's mother's brother. Denver Art Museum, cat. no. 1946.251. Photograph courtesy of the Special Collections Division, University of Washington Libraries, neg. no. 8592.

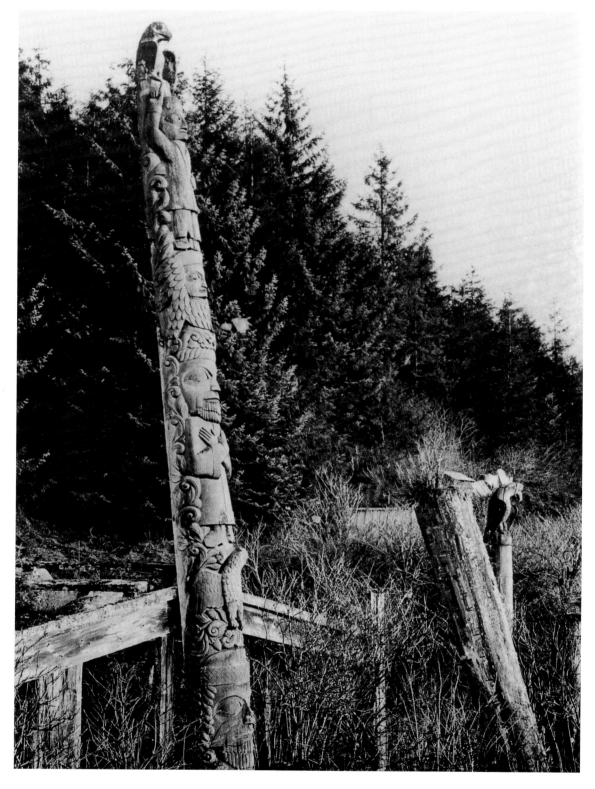

Fig. 4.28. Chief Skowl's pole at Old Kasaan, carved by Dwight Wallace around 1880. This pole was later taken to the totem park in Ketchikan and is now in the Totem Heritage Center. Photograph courtesy of the Canadian Museum of Civilization, neg. no. 71-4707.

Duncan *ginaawaan*'s Death

About the time this pole was being raised in defiance of the Russian presence, the Reverend S. Hall Young, the first Presbyterian minister to work with the northern Haida, arrived on the scene. Though he never managed to establish a mission church in old *gasa.áan*, he had more success in *hlanqwáan* and *ráwk'aan*. Hall and his wife even adopted one of Duncan *ginaawaan*'s daughters after his death. Duncan *ginaawaan* and his wife, *q'aawiidaa* (Albert Edward Edenshaw's niece), had at least three daughters, including Rose (*gad ʒaljaaw*), who married Alec Peel, and Martha (*dlagwaa t'aawaa*), who married Henry Edenshaw, Albert's son.[38] Another one of *ginaawaan*'s daughters, Susie, was taken in 1879, at age seven or eight, to Mrs. McFarland's school in Wrangell by the niece of the *gasa.áan* chief Sanheit.[39] Soon after this, she was adopted by the Youngs, who were based in Wrangell from 1878 to 1888. In 1883 they took Susie east and left her in a school for girls in Washington, Pennsylvania, where she died of tuberculosis at age seventeen (Young 1927: 233).

In 1880, Young took a trip to *gasa.áan*, *ráwk'aan*, and *hlanqwáan* in order to secure adoption papers for Susie from her mother. During this trip he visited old *gasa.áan*, and in his account of the trip he described the poles in that village: "The finest of these were the work of Kenowan [*ginaawaan*], Susie's talented father. That man was an artist. He could take a little hand adz and sit down before you with a post of yellow cedar before him and begin to chip with his adz. In the course of a day he would have an image of your form carved on that pole which could be recognized by any of your friends" (Young 1927: 234).

Young must have acquired this information from others, since by the time he came to Alaska in 1878, *ginaawaan* had already died. Unfortunately, Young did not indicate which poles in *gasa.áan* were carved by *ginaawaan*. We know that James Swan met Duncan *ginaawaan* in *hlanqwáan* in 1875, the year before *ginaawaan*'s death, during his trip to Alaska on the revenue cutter *Wolcott* to collect material for the Centennial Exposition in Philadelphia. His diary of that trip included the following account of their meeting:

> Arrived at Klemmakoan village [*hlanqwáan*] at 3 p.m. [July 2, 1875]
> Bought of Kin-ow-an Chief of village 2 silver rings @ $3–6.00
>
> | 1 horn dish ornament | $5 |
> | stone hammer & [c? 4 shirt?] — | $5 |
> | lot of masks — 2 bird head masks | $6 |
> | 2 spoons & small boxes | $1 |
> | | $23 |
>
> Kinówen, wife 4 children & a number of other Indians came on board the steamer. Mr. Broadbent took pictures — etc.[40] Indians want a missionary sent. Kinówen said if one came he would look after him and be his friend. Build school house and make children go to school. Lot of carved posts at this place.
> Saturday, July 3, 1775–left Klinnakoan village. (Swan 1875)

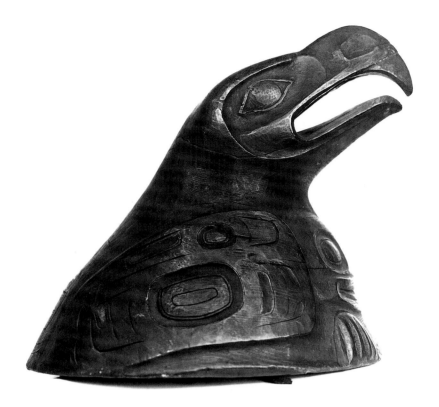

Fig. 4.29. Eagle war helmet collected by James G. Swan from Duncan *ginaawaan* at Klinkwan, 1875, 23 by 27 by 30.5 cm. Courtesy of the National Museum of Natural History, Smithsonian Institution, cat. no. 20883, neg. no. 43-229-E.

All of the objects Swan collected from *ginaawaan* were sent to the National Museum of Natural History in Washington, D.C., after being displayed at the Centennial Exposition in Philadelphia. Some have been exchanged or are now missing, but those that remain include an old stone maul (cat. no. 20893), a horn spoon (cat. no. 20841), a humanoid mask (Dall 1884: plate 17, figs. 31, 32), a matched set of war helmets (cat. no. 20882 and fig. 4.29), a dogfish headddress (fig. 4.31), a whale headdress (fig. 4.30) (Dall 1884: plate 19, figs. 43, 44), and a bear headdress with a trailer of wooden slats (cat. no. 20866). Two grease dishes were collected, one a Prince William Sound–style bird dish (cat. no. 20857) (Collins et al. 1977: 174, fig. 216) and one in the form of a human figure (fig. 4.32). A pair of spoons (cat. no. 20852) were said by Swan to represent skunk cabbage leaves. It may be that by "rings" Swan meant bracelets, since in his official report of this trip he reported buying "some beautiful bracelets and other jewelry of silver" from *ginaawaan* at *hlanqwáan* (Swan 1877: 148).

From *hlanqwáan*, Swan went to Karta Bay and the village of *gasa.áan*, where he met Charles Baronovich at his store and bought an embroidered shawl, four beaded bags, and some bracelets on July 6. He had hoped to buy a full-sized pole there, but none was for sale. On July 15, Swan wrote to Baronovich at Karta Bay asking him to arrange for a pole to be carved and sent to him. This pole was delivered, and Swan sent it, too, to the Philadelphia fair and from there to the Smithsonian (fig. 4.33).[41] It was illustrated in a drawing in Frank Leslie's *Historical Register of the United States Centennial Exhibition* (New York, 1877; see Cole 1985: cover; Trennert 1974: 119) and is now on exhibit at the National Museum of Natural History in Washington, D.C. There is no record of who carved this pole, though it must have been someone known to Charles

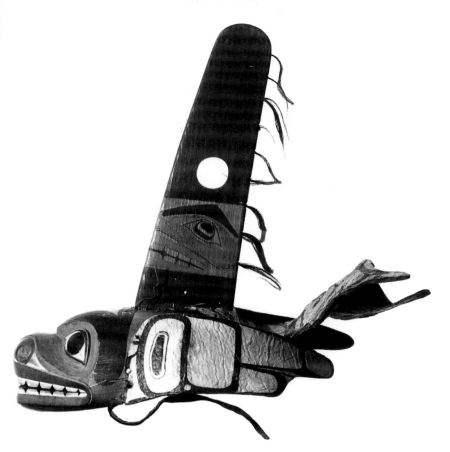

Fig. 4.30. Whale head-dress collected by James G. Swan from Duncan *ginaawaan* at Klinkwan, 1875; 58 by 18 by 13 cm (body), 42 by 13 cm (fin). Courtesy of the National Museum of Natural History, Smithsonian Institution, cat. no. 20890, neg. no. 89-21809.

Fig. 4.31. Dogfish headdress collected by James G. Swan from Duncan *ginaawaan* at Klinkwan, 1875, 35 by 20 by 13.5 cm. National Museum of Natural History, Smithsonian Institution, cat. no. 20891. Photograph by the author.

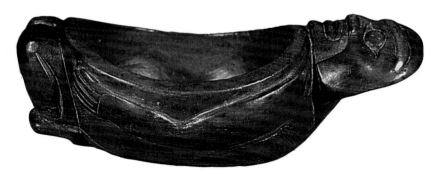

Fig. 4.32. Grease dish collected by James G. Swan from Duncan *ginaawaan* at Klinkwan, 1875, 13.5 by 7 by 5 cm. National Museum of Natural History, Smithsonian Institution, cat. no. 20855. Photograph by the author.

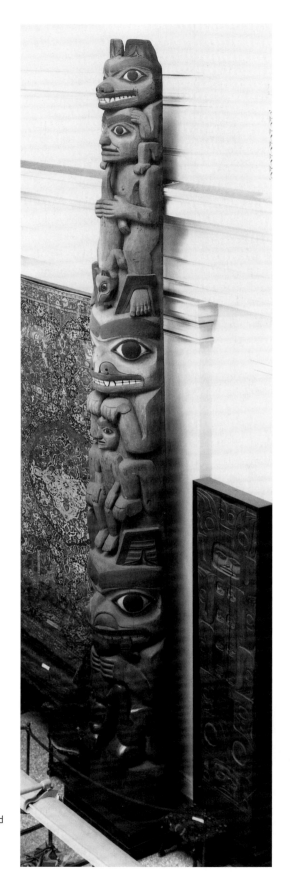

Fig. 4.33. Pole commissioned by James G. Swan through Charles Baronovich for the Centennial Exposition in Philadelphia, 1876. It is similar to the Sukkwan pole (fig. 4.27) and possibly was carved by Dwight Wallace. Smithsonian Institution, cat. no. 54298, neg. no. 38-109A.

Baronovich. Interestingly, the figures on the pole tell the same story of the man who defeated the land otters by wearing his dog's skin that was carved both by Dwight Wallace on a pole in *saxq'wa.áan* and by John Wallace in the twentieth century. We know that Dwight Wallace worked at old *gasa.áan* and in fact carved the pole that memorialized Charles Baronovich a few years later. The style of this pole may represent the youthful work of John Wallace, who would have been around fifteen at the time (Steve Brown, personal communication, September 1999), or perhaps the older Dwight and his son John worked together on this pole. Perhaps Duncan *ginaawaan* was even there at the time.

After leaving *gasa.áan*, Swan went to Wrangell, where he met a woman named Annie, who he said was a relative of "ken-ow-en the silversmith of Klmmakowan [one of Swan's spellings for *hlanqwáan*]." He bought a silver buckle from her (fig. 4.34) and a silver bracelet from the dealer Frohman in Wrangell (Swan 1875).[42] The silver belt buckle is inscribed on the back in Swan's handwriting with "made by Kinowen, a Haida at Klemmakoan village." Unfortunately, the silver that Swan had collected directly from *ginaanwaan* at *hlanqwáan* was mixed together with all the other silver from this collecting trip, and the four rings from the collection are missing. The buckle, then, is our only confirmed example of *ginaawaan*'s silver engraving style. Many other engraved floral bracelets were collected, though they are slightly different in style from the buckle.

Other evidence of Duncan *ginaawaan*'s work as a silversmith was given to Marius Barbeau by Alfred Adams of Massett in the 1940s. He said that Duncan *ginaawaan* made bracelets that were worn by *ginaawaan*'s daughter Martha, Mrs. Henry Edenshaw. They were "great big things no less than 3" or 3 1/2" wide. The gold of the yellowest shade. She wears one now. It is beautifully engraved, one of the wonders of that day. He must have died before 1890—around 1880. I think he was fairly old then" (Barbeau 1916–1954: B-F-249).

Fig. 4.34. Engraved silver belt buckle collected by James G. Swan from a woman named Annie, a relative of Duncan *ginaawaan*'s, at Wrangell, 1875; 6.6 by 3.9 cm. Inscribed in James G. Swan's handwriting on the back is "made by Kinowen [*ginaawaan*], a Haida at Klemmakoan [Klinkwan] village." National Museum of Natural History, Smithsonian Institution, cat. no. 19556. Photograph by Nancy Harris.

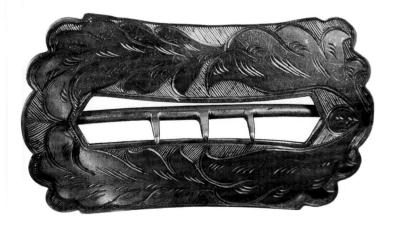

The "silver rings" acquired by Swan may have been among the last that *ginaawaan* made, since he died the year after they were collected. The circumstances surrounding his death were described to Reverend Young by *ginaawaan*'s daughter Susie:

Not very long before her arrival at Fort Wrangell she had gone through a terrible experience. There were three little girls in the family, Susie being the middle one. They had an old slave who was more a father to the little girls than their own parent. The old slave used to carry them on his back across the streams, make toys for them and give them little beads which looked like pearls. These were made from small pods of fucus or transparent seaweed; the old man filled them full of white venison tallow, and they made very beautiful, pearl-like beads.

Kenowan was taken very sick with consumption and was slowly dying. The medicine-men came and performed their incantations, but the chief was doomed. He enjoined upon his wife as his last request that she should send little Susie to the white people to be educated. When Kenowan died his relatives took the old slave, after their fashion, and at a great feast laid him on the ground; and while the natives were dancing around Kenowan's funeral pyre the medicine-man took a greenstone ax and in the presence of the little girls, who were compelled to look on at the ceremony and who prayed in vain for the life of the good old man, they dashed out his brains and sent him to wait upon his chief in the Happy Hunting Grounds.

The horror of this scene never left little Susie's mind. She tried to describe the scene to us in her broken language, but always broke down and wept so pitifully that we had to make her stop. She never forgot the cruelty and heathenism that surrounded her father's death. We used to have actually to compel her to go and see her mother and her aunt when they would come to visit her in Wrangell. When we went East on our first missionary lecture tour, in 1883, we took the child with us and left her in a school for girls in Washington, Pennsylvania. She endeared herself to teachers and pupils there and developed quite a talent for drawing and for making fancy work. But, alas, the germs of tuberculosis were in her blood, and she died at the age of seventeen. (Young 1927: 232–233)

It is possible that Reverend Young embellished this story beyond what young Susie told him. Sam Davis told Viola Garfield that *ginaawaan* was a great carver who died in Wrangell, but he mentioned nothing of this episode (Garfield 1941: 27). The name *ginaawaan* was also known by reputation in Skidegate, where a ridicule figure was carved to represent someone of that name. According to Newcombe's notes, Paul *nang jingwaas* (Nanadjingwas, d. 1888) of the *na s7agaas xàaydaraay* (Swanton's "Rotten House People" in Skidegate, E6b) left a copper shield in pledge for some flour with the Hudson's Bay Company factor in Port Simpson. The copper was not redeemed for some years, and a person named "Ginaoan," whom Newcombe described as "a son of one of the Edenshaws," is said to have "stolen" or otherwise "induced" the factor to let him take the copper away (or perhaps to sell it to him). To shame *ginaawaan*, *nang jingwaas* had a small figure of him carved and erected below the beak of the raven on

his house frontal pole (see fig. 5.32), such that the weight of the beak was supported by the head of the figure (MacDonald 1983: 50, plate 50; Newcombe 1900–1911: vol. 55, file 10). Because Newcombe clearly described this *ginaawaan* as a "son of one of the Edenshaws," the figure might have represented Charles Edenshaw's son, Robert, whose Haida name was *ginaawaan* — but he would have been a small boy, only ten years old, at the time *nang jingwaas* died. More likely it represented the older *ginaawaan*, and Newcombe incorrectly identified him as the son of an Edenshaw.[43]

A Christian-style gravestone for Duncan *ginaawaan* stands at *hlanqwáan* with a dogfish design on it (fig. 4.35). Margaret Blackman speculated that this stone, which bears the date April 10, 1876, was probably erected in the early 1880s, several years after *ginaawaan*'s death, because the custom of using European-style stone grave monuments was not introduced to the Haida until the first missionary arrived in Massett in late 1876, nor did such monuments appear in *ráwk'aan* and *hlanqwáan* until after the arrival of Reverend Young in 1880. The dogfish design on this stone (a crest of the *yahgu 'laanaas* clan) has been attributed to Charles Edenshaw, whose mother-in-law was *ginaawaan*'s niece (Blackman 1976: 400–401, 410).[44]

Fig. 4.35. The gravestone of Duncan *ginaawaan* (spelled Kinaon) dogfish design, attributed to Charles Edenshaw. Photograph by the author.

gwaaygu 7anhlan at *ya.aats'* and *daa.adans*

The village of *ya.aats'* (Yatz or Ya-tza) was an occasional residence of *gwaaygu 7anhlan*'s and *da.a xiigang*'s during the 1870s, and there was a *hlanqwáan* connection with this village as well. George Dawson, conducting a geological survey for the Canadian government, visited *ya.aats'* during his trip in 1878 and photographed *gwaaygu 7anhlan* standing with *7wii.aa* on the beach there (see fig. 3.9). He wrote:

> This village site is quite new, having been occupied only a few years. There are at present eight or ten roughly built houses, with few and poorly carved posts. The people who formerly lived at the entrance to Virago Sound [*qang*] are abandoning that place for this, because, as was explained to me by their chief, Edensaw, they can get more trade here, as many Indians come across from the north. The traverse from Cape Kygane or Muzon to Klas-kwun is about forty miles, and there is a rather prominent hill behind the point by which the canoe-men doubtless direct their course. At the time of our visit, in August 1878, a great part of the population of the northern portion of the Queen Charlotte Islands was collected here preparatory to the erection of carved posts and giving away of property, for which the arrival of the Kai-ga-ni Haidas was waited, these people being unable to cross owing to the prevalent fog and rough weather. (Cole and Lockner 1993: 155)

Douglas Cole and Bradley Lockner (1989: 504), who published Dawson's journals, suggested that Albert Edward Edenshaw had moved to *ya.aats'* from *qang* in 1875, three years before Dawson's visit. Barry Gough (1993: 290) wrote that *gwaaygu 7anhlan* founded the village of *ya.aats'* around 1870 and settled there before moving to Massett. It is more likely that this village was simply one of many seasonal residences used by his family in the 1870s. According to George MacDonald (1983: 184), John Swanton disagreed with Dawson's account that a move from *qang* to *ya.aats'* was intended and suggested that *ya.aats'* was never more than a temporary village or campground. Florence Davidson's memories of that village tend to confirm this. She recalled that Albert Edward Edenshaw's family continued to visit both *qang* and *ya.aats'* seasonally after his death:

> In February we used to go to Gwǝs, near Kung. We stayed there for a long time until we got lots of halibut and dried it. We used to barbecue the halibut, the bony neck part. The tail and the head were boiled, to eat with seaweed.
>
> April they call *t'aawkanut*, "gardening time." My grandparents [Amy and Phillip],[45] my parents, my sisters, and I would go on a little canoe to Yatz to plant gardens. Lots of people from Masset went there to garden. They cut the eyes out of the potatoes to plant and we ate the middle part; they called that part *scusid stłu7El*, "potato's bottom." I used to really enjoy eating it. (Blackman 1982: 84–85)

Though Dawson described a few poorly carved poles in *ya.aats'* in 1878, by 1913, when Newcombe photographed the village, only one pole was standing (fig. 4.36), probably the one that was raised in 1878. This pole is said to have

been raised by the father of Mark Alexander, and Newcombe photographed Mark standing next to it. Newcombe identified the owner of the pole in 1913 as a man named Harry of *hlanqwáan*. This pole was removed to Prince Rupert in the early twentieth century and was destroyed in 1969 (MacDonald 1983: 184). It most likely was the pole referred to by Alfred Adams as having been picked up at Seven-Mile, a spot between Massett and *ya.aats'*. If so, this would confirm an Albert Edward Edenshaw attribution for this *ya.aats'* pole (see chapter 3).

Sometime shortly before Dawson's 1878 visit, *gwaaygu 7anhlan* is known to have carved a pole that was the last one to stand in the village of *daa.adans* (fig. 4.37). James Swan recorded it in the journal of his trip to the Queen Charlotte Islands in 1883 (Swan 1883b).[46] The figures on this pole are a grizzly bear (on a carved wooden helmet) at the top, seven *sgil* (hat rings), a raven (with human head) with a broken beak and a small raven between its ears, a moon with the berry picker inside, a grizzly bear with two cubs, and a partially obscured figure at the bottom. MacDonald identified the bottom figure as a whale, though its two U-form ears suggest that it is more likely a bear. This bear identification was confirmed by Florence Edenshaw Davidson, who described a potlatch held by Henry Edenshaw when this pole blew down in 1901:

> The summer I was eleven [1901], my Uncle Henry Edenshaw had a big doing at Dadens on North Island. The big old totem pole in front of my grandmother's [Amy Edenshaw's] house blew down during the wintertime. The pole had a grizzly bear on it, at the bottom. Jitkanj'əs [a girl of the *C'aƚ'lanas* Eagle lineage] made fun of the bear, poking it in the bottom. They said so much about it that my uncle took lots of food to North Island and invited the whole town. They had a big feast with stew and lots of oranges and apples. They gave Jitkanj'əs a big bowl of oranges mixed with grease and sugar. Her mother told her to say "*Haadé*" ["people"] real loud as they gave it to her. They wiped her mouth with a kerchief and then she gave ten dollars to ten men of the opposite tribe, one dollar to each. The doing lasted for two days, the ˤənsəngáda. The second day my uncle had a picnic across at Kiusta. He made Emma Matthews and me make sandwiches, ham sandwiches with hot mustard on them. Even though we were little girls, we were real busy. They had soda pop there, too. The bottles used to come in barrels — real big barrels just full of soda pop and funny bottles with round bottoms. The whole town had a picnic with my uncle. My mother and grandmother helped my uncle with the food and they gave him money toward his ˤənsəngáda. After it was all over they cut the totem pole up for firewood. (Blackman 1982: 86)

Davidson's identification of this pole as being associated with a house owned by Amy Edenshaw is interesting.[47] Amy was a member of the *yahgu 'laanaas*, the same clan as that of *gu.uu 7aww* and her son, George Cowhoe, and Amy's son, Henry Edenshaw. The crests on the pole are *yahgu 'laanaas* crests, similar to those found on the house of their relative *ginaawaan* in *hlanqwáan*.[48] Dawson photographed the *daa.adans* pole in 1878 and described it as being "not very old" at that time. We know that George Cowhoe (*gu.uu*), Albert Edward Edenshaw's older son, had the title of town chief at *daa.adans*.[49] It is possible that *gu.uu* raised this pole when he acquired his title.[50] If this occurred when

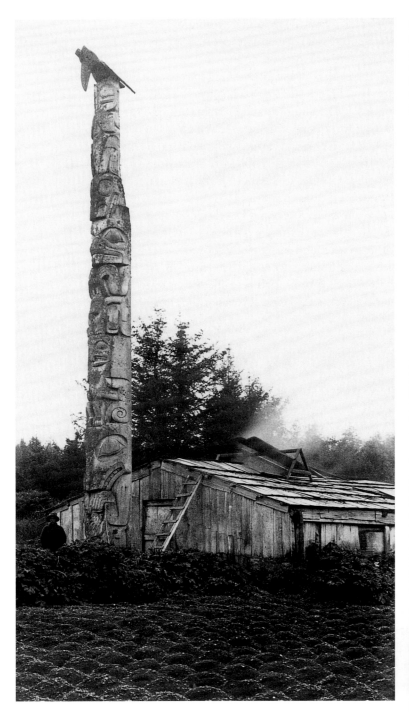

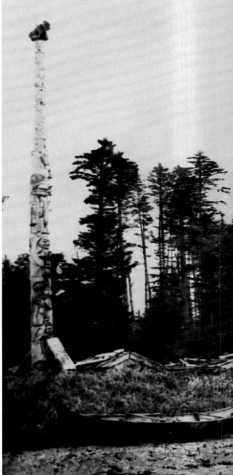

Fig. 4.36. Mark Alexander standing near the only pole in the village of *ya.aats'* in 1913. It possibly was carved by Albert Edward Edenshaw. Courtesy of the American Museum of Natural History, neg. no. 106694. Photograph by C. F. Newcombe.

Fig. 4.37. The last pole standing in the village of *daa.adans*. It is known to have been carved by Albert Edward Edenshaw (*gwaaygu 7anhlan*). Courtesy of the National Archives of Canada, neg. no. PA44326. Photograph by George M. Dawson, 1878.

gu.uu was in his early twenties (after 1871), then the pole would indeed have appeared nearly new in 1878 when Dawson photographed it, shortly after *gwaaygu 7anhlan* carved it. In Dawson's 1878 photo, the pole appears to be free standing and not a house frontal pole. Perhaps *gu.uu* commissioned his father to carve this pole as a memorial for *gu.uu*'s maternal uncle, from whom he would likely have inherited the chiefly position at *daa.adans*. It would have been appropriate for *gwaaygu 7anhlan* to carve the pole, because he was of the opposite Eagle moiety. We know that *gu.uu* had two maternal uncles, *kihl guulaans* and Duncan *ginaawaan*. *kihl guulaans*, presumably the older brother, was married to *q'aawiidaa*, who, after his death by drowning, married his brother, Duncan *ginaawaan*. This would place *kihl guulaans*'s death sometime in the early 1860s or earlier (judging from the late-1860s birthdates of *ginaawaan*'s children with *q'aawiidaa*). Therefore, it may be that the pole raised by *gu.uu* (George Cowhoe) at *daa.adans* was a memorial to his uncle, Duncan *ginaawaan*, after *ginaawaan*'s death in 1876, shortly before Dawson photographed it in 1878. It is also possible that the raven-finned whale memorial near the Edenshaw house in Massett (see fig. 4.47), which was said to be for *ginaawaan*, was also raised at about this time.

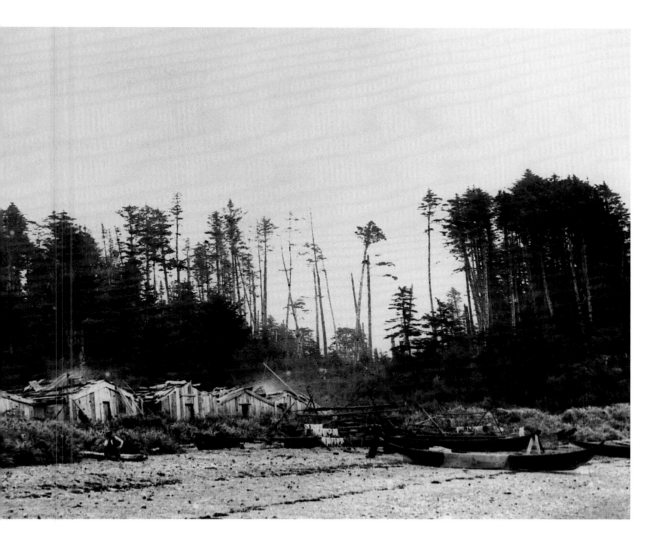

The *daa.adans* pole is known only from Dawson's photograph. It represents a period late in *gwaaygu 7anhlan*'s artistic career, when he was in his late fifties or early sixties. He is known to have carved a number of other poles in the 1870s. From the 1860s through the 1880s — the last great period of Haida pole carving in the nineteenth century — we know that both Albert Edward and Charles Edenshaw carved several full-sized poles. Five poles have previously been attributed to Charles Edenshaw, but it is probable that several of these, if not all of them, were carved either by Albert Edward Edenshaw alone or by both artists working together, Albert as the master carver and Charles as his apprentice, at least in the period of the 1860s.

The Edenshaws' Work at Skidegate

C. F. Newcombe attributed to Charles Edenshaw a frontal pole and an interior house post in Skidegate that belonged to Chief Skidegate (*sriida giids*). Newcombe described the two poles as coming from a house named *daa7agu qanhlln*, "house bellying up over the central pit." The frontal pole has not survived, though it was still standing in 1905 and is known from a photograph that shows part of the pole (fig. 4.38, third pole from left, partially obscured). Newcombe's description of the frontal pole explains that at the top was a raven wearing a hat with three *sgil*, and the figure obscured by the mortuary panel in the photograph is a whale. Below the whale is a female shaman holding circular puffin-beak rattles in each hand, and below her is the head of a young whale. Next comes the *7waasru* (Wasgo), or sea-wolf, and below it are frogs and a seated human figure with a grizzly bear at the bottom.

Newcombe wrote that the figure at the top of the interior house post represented a seated eagle with its beak turned down to make the head more visible when looked at in the gloom of a smoky house. A frog hangs from its mouth (fig. 4.39). The upturned tail of the eagle has a secondary figure with no special significance, and at the bottom of the post is a raven. This house post was acquired by Hugo Schauinsland, the founding director of the Übersee Museum in Bremen, Germany, during a trip to British Columbia in 1896–1897. At the conclusion of his description, Newcombe wrote: "The two poles were both made by Chief Edensaw so often mentioned by Drs. Boas & Swanton as an artist and narrator of Haida stories. He is still alive, getting high prices for his slate and silver work and is considered to be the most influential man of his tribe" (Newcombe 1900–1911: vol. 55, folders 1 and 10).

Quoting from Newcombe's information, von J. Weissenborn published an article in 1908 that described the maker of these poles, saying that "an elder chief named Edenshaw who had carved these poles in his youth still lives" (Weissenborn 1908). This certainly implies that Charles Edenshaw was the maker, because Albert Edward Edenshaw was no longer alive at the time Newcombe and Weissenborn were writing.

George MacDonald believes that the interior post and frontal pole described by Newcombe actually came from two houses that were situated next to each other. The house with the frontal pole (MacDonald's House 17), *cahl tayru*, "Shining House," was said to have been built by Chief Skidegate IV (ca. 1842–1850), whereas the interior post was from House 18, which had no frontal pole but was painted with whales on the front and sides. It belonged to Chief Skidegate

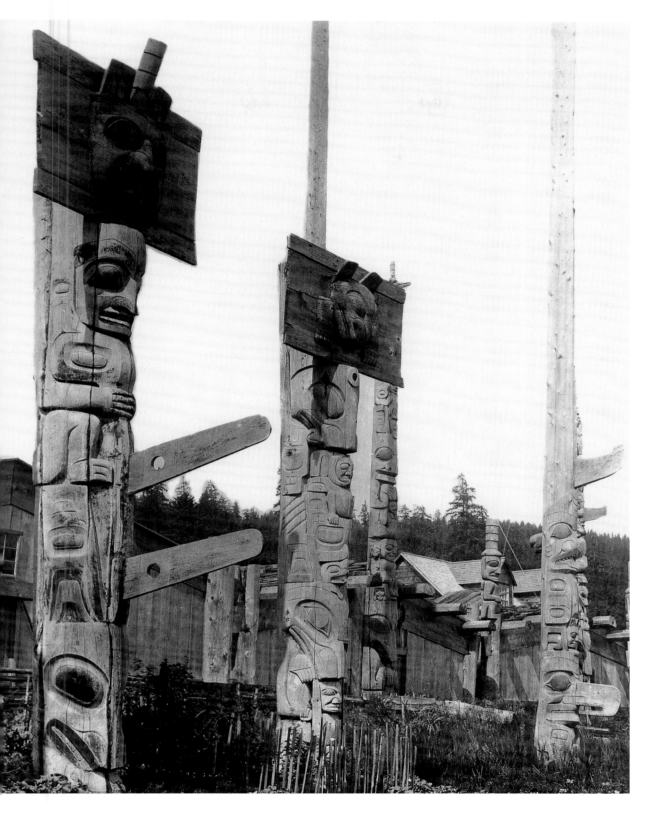

Fig. 4.38. Frontal pole of *daa7agu qanhlln,* "house bellying up over the central pit," owned by one of the Chief Skidegates (partially obscured behind the mortuary panel). Courtesy of the British Columbia Archives, neg. no. G-02207.

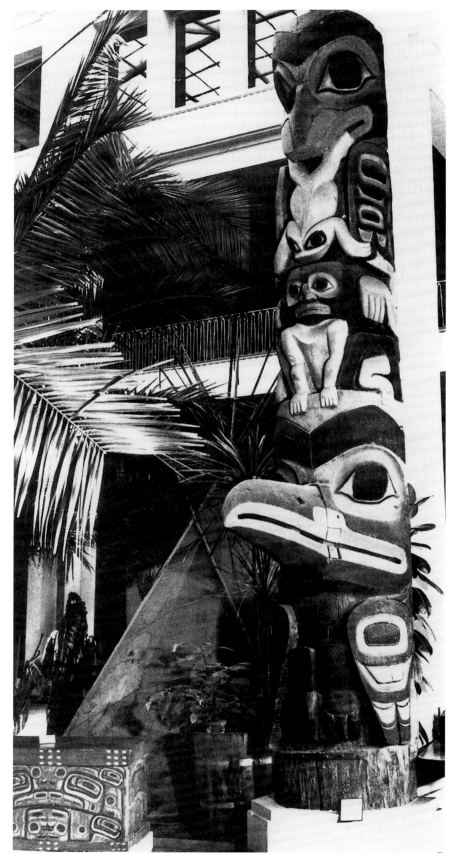

Fig. 4.39. Interior house
post from *daa7agu qanhlln*,
4.85 m high. Courtesy of
the Übersee Museum,
Bremen, Germany. Both
of the poles in figures 4.38
and 4.39 were attributed
to Charles Edenshaw by
C. F. Newcombe, but they
may have been carved by
Albert Edward Edenshaw
together with Charles.

V (ca. 1850–1860). If House 17 was built by Chief Skidegate IV, as MacDonald suggested, it must have been raised in the 1840s, when Charles Edenshaw was still a child but when Albert Edward Edenshaw would have been in his prime. House 18, then, would have been built in the 1850s, though MacDonald gave an estimated date of the 1860s for the interior post. Charles Edenshaw would have been about twenty-two in 1860 (MacDonald 1983: 48–49, plates 45–46). Depending on the actual dates when these poles were carved, it might be that Charles helped his uncle carve the frontal pole when he was very young, and he might have been the principal carver of the interior post. However, if both the post and the frontal pole were from the earlier house, as Newcombe suggested, then Albert Edward might have been the principal carver of both. The angular lower eyelid lines on the Bremen post seem unlike those of Albert Edward Edenshaw's on the *qang* and *daa.adans* poles, but the shapes of the ovoids and the handling of the secondary spaces suggest a strong link with the elder Edenshaw.

Two other interior house posts from Skidegate, purchased by James Deans in 1892 and now in the Royal British Columbia Museum (figs. 4.40, 4.41), were attributed to Charles Edenshaw by Wilson Duff (Duff, Holm, and Reid 1967: 341–342). Newcombe's original notes, however, in the 1898 catalog at the Royal British Columbia Museum, give this attribution only for Post 1 — "made by one of the Edenshaws of Massett" — and give no attribution for Post 2. A later attribution of "C. Edenshaw" for Post 2 in the Royal British Columbia Museum catalog was probably made by Wilson Duff (Alan Hoover, personal communication, 1996). Of these two poles, Newcombe wrote:

House No. 17 [MacDonald's House 22][51]

House Poles at the Provincial Museum, Victoria, B.C. (cat. no. 1)

This formerly stood at the back of "The house which chiefs peep at from concealment" (Feeling their inferiority), at Skidegate, Queen Charlotte Islands [*naagi 7iitl'lxagiid k'aydanggans*]. It belonged to the chief "Though younger brother must be obeyed" of the "Rotten House" division of the Eagles of Skidegate [Swanton's E6a], and shows some of his principal crests.

The upper figure is a Raven with two frogs hanging from its mouth and below it is the mythical Mountain Hawk.

The pole faced the door of the house in the front of which, outside, stood the high pole which showed not only the crests of the chief but also his wife's. At the top are three small male figures, wearing high-crowned hats, then comes the Raven with Dog-fish below it, both Eagle crests, and at the bottom is a Killer-whale which belonged to the wife, who was of the Raven division.

Purchased at Skidegate, QCI, by J. Deans, 1892.

House no. 20, cat. no. 2 [MacDonald's House 19]

Heraldic house pole which formerly stood at the back of "the house so large that people must shout to make themselves heard in it [*nara gudgi tl'l kyaagaans*]."

This belonged to Chief Nostakana, of the "Great House" division of the Eagles of Skidegate, QCI, and shows two of his crests.

The upper figure is the Raven with its beak broken and bent down as told

in one of the stories of its adventures and below is a whale. The smaller figures are used to fill up space ornamentally. . . .

Purchased at Skidegate, QCI, by J. Deans, 1892. (Newcombe 1900–1911: vol. 55, file 10)

Comparing these two house posts, it seems that Post 1 was carved by the more accomplished artist, and its style seems most similar to that of the Bremen post from House 18. The eyelid lines of Post 1 are angular on the bottom edge, whereas those on Post 2 are more curved, and the handling of the eyebrows and the area above the bridge of the nose is also more angular than the rounded edges in the same areas of Post 2. Also, the formline details in the pectoral fins of the whale on Post 2 are handled in an unusual way.[52] This pole has been painted with several primary color shifts, and although this paint may not reflect the original intentions of the carver, the formline constructions seem awkward. Post 2 also has very bulbous nostrils, both on the large whale and raven and on the smaller humanoid faces. These seem almost out of proportion to the rest of the face, compared with the compact and crisp nostrils on Post 1. Perhaps the carver of Post 2 was a beginner, experimenting with the formline details. In any case, two different carvers must have made these two posts. The owner of Post 1, Skidegate VI, held that position from about 1860 to 1870, the probable time period for this post. Newcombe tells us his name was Nangdjingwas (*nang jingwaas*), and his wife's name was Queskun unandas, "high up in the sky."

If Charles Edenshaw carved the Bremen post, as Newcombe suggested, then he probably also carved Post 1, but an attribution of Charles Edenshaw for Post 2 seems much less supportable. We know that Charles Edenshaw's carving style in the late nineteenth century was quite different from this angular style. His ovoids were rounded and never concave on their bottom edges as are the ovoids on these poles. His eyelid lines were open and centered, rather than constricted and lowered at their points as these eyelid lines are. Perhaps Post 1 represents Charles Edenshaw's early style of carving, a relatively conservative and conventional style, closer to that of his uncle, Albert Edward Edenshaw. There is also a possibility that Post 1, as well as the Bremen post, was actually carved by Albert Edward Edenshaw. Some of the stylistic details on this post are remarkably similar to the style of a pole that he carved as a memorial for Chief *sdi-ihldaa* in Massett (to be discussed in the next section), which is one of the two poles that can be firmly documented to have been carved by him.

Most amazing are the similarities between Post 1 and the small model that Charles Edenshaw carved of the interior post of Albert Edward Edenshaw's house at *qang*, which was said to be a copy of *skil.aa.u*'s interior house post at *hl7yaalang* (see fig. 4.3). The only differences are that the small grizzly bear at the top of the *qang* post is missing in Post 1, the figure wearing the hat is human on Post 1 rather than a small hawk, and the large hawk at the bottom is holding a whale (said to be the crest of Skidegate VI's wife) on Post 1 instead of the frog on the *qang* post. Though these are posts from two different Eagle clans, the artist's hand is evident. Perhaps the interior post from Albert Edward Edenshaw's *qang* house had recently been finished when the commission for the Skidegate post was received. Whether Albert Edward Edenshaw worked alone or together with Charles on these poles is unclear, but the design influence between the *qang* and Skidegate posts is unmistakable.

Fig. 4.40. House post in "house chiefs peeped at from a distance," *naagi 7iitl'lxagiid k'aydanggans*, owned by one of the Chiefs Skidegate. Collected by James Deans, 1892. Royal British Columbia Museum, cat. no. 1. Photograph courtesy of the American Museum of Natural History, neg. no. 42288. Photograph by Edward Dossetter, 1881.

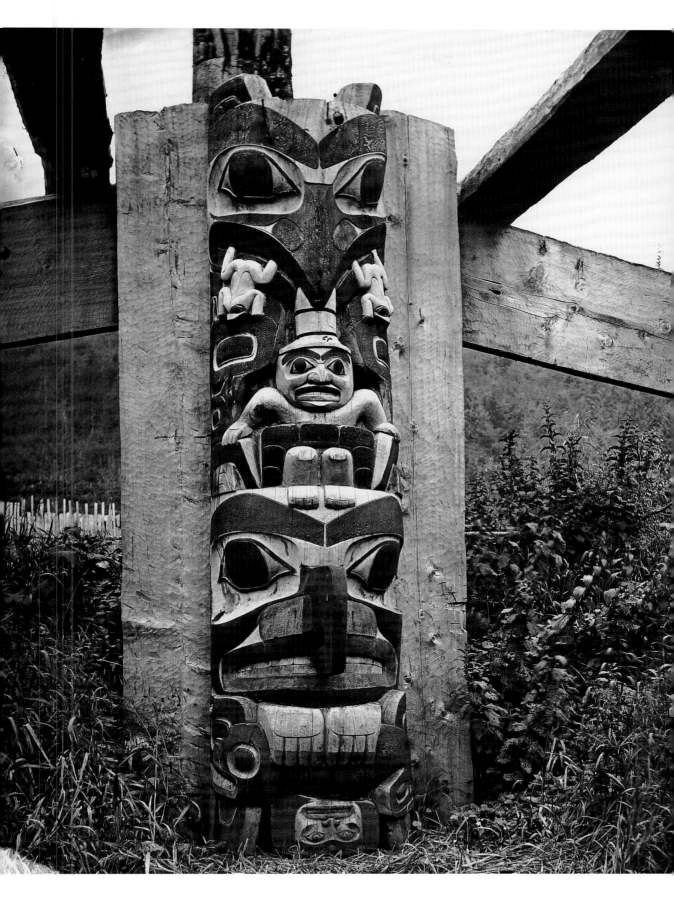

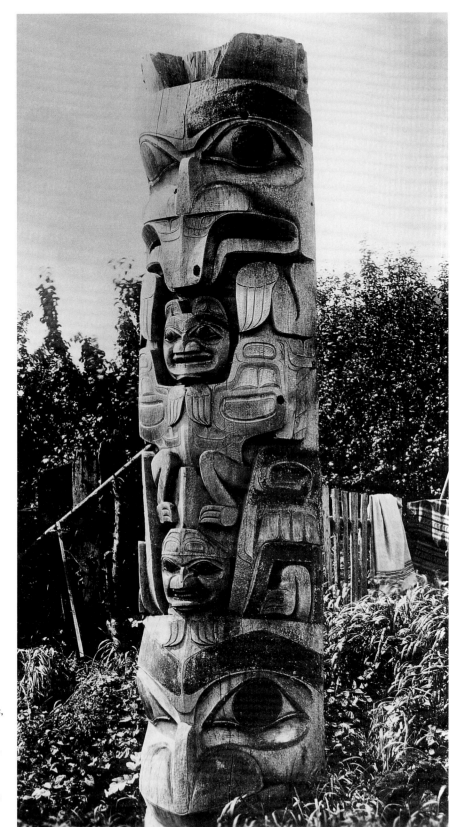

Fig. 4.41. House post from "house so large that people must shout to make themselves heard in it," *nara gudgi tl'l kyaagaans*, in Skidegate, owned by *niisda kana* or *yeesda kana* (Nostakana). Collected by James Deans, 1892. Royal British Columbia Museum, cat. no. 2. Courtesy of the Field Museum of Natural History, neg. no. 17452.

The Edenshaws' Work in Massett

George MacDonald (1983: 146) speculated that Charles Edenshaw might have made the memorial pole for Chief *sdiihldaa* that was erected in Massett by *sdiihldaa*'s brother, James Stanley (fig. 4.42). The pole appears in a panoramic view of Massett taken by George Dawson in 1878 and must have been new at that time, because *sdiihldaa* died in 1876 (see chapter 5). This pole was purchased by Adrien Jacobsen in 1881 and taken to Berlin. It was once thought that this pole, along with a number of other Jacobsen pieces, had been destroyed during World War II, but it was recently rediscovered in the former East Germany and returned to Berlin (Briesemeister et al. 1992: 157). In his journal, Jacobsen quoted Alexander MacKenzie, the Hudson's Bay Company factor who arranged for the purchase of the pole, stating that it had been carved by "Edenshaw, head chief of the northern part of the island, who is still in Masset" (Jacobsen 1977: 26). At that time, 1881, Albert Edward Edenshaw still retained the position of chief and must certainly have been the Edenshaw MacKenzie identified as the carver. This pole still retains much of its original paint. Surprisingly, in addition to the black, red, and blue-green typical of Haida painting, this pole has white painted at the whites of the eyes and the teeth, and green stripes of facial paint on the woman's face.

Chief *sdiihldaa*'s pole has an eagle at the top (the original beak is now missing), a whale with its tail curled up, and a human figure with a frog in its mouth and a small human figure between its knees. In the middle of the pole, a female shaman wearing a headdress and a labret holds circular puffin-beak rattles in her hands. She is the mother-in-law from the *suu sraa.n* story, like the one on Albert Edward Edenshaw's house in *k'yuust'aa*, and she sits on the head of a whale. The *suu sraa.n*, or Wasgo, at the base of the pole has another whale in its mouth. The angular treatment of the eyebrows and the area above the bridge of the nose on this pole is similar to that on the Bremen house post and the Royal British Columbia Museum Post 1.

Another pole partially attributed to "Edenshaw," now at the Pitt Rivers Museum at Oxford, once stood in front of *k'aayhlt'áa na.as*, "Star House," at Massett, which, according to Newcombe, belonged to Anetlas of the Sea Eggs, a subdivision of the *sdast'a.aas* Eagles (fig. 4.43). Newcombe's field notes at the British Columbia Archives say that "Edenshaw" carved the lower portion of this house frontal pole. Because these notes date to 1901, after Albert Edward had died and Charles had taken the name Edenshaw, it is possible that Newcombe was referring to Charles Edenshaw, but the style of this pole fits with what we know of Albert Edward's other poles. Dawson's 1878 photo of Massett shows Anetlas's house with only the interior house posts in place. Within four years of this photograph, Anetlas had raised the frontal pole when he and his wife, until then childless, adopted a young girl.

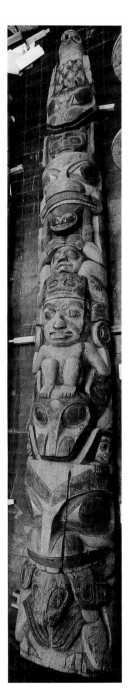

Fig. 4.42. Chief *sdiihldaa*'s memorial pole. Collected by Adrien Jacobsen at Massett, 1881. Attributed to Albert Edward Edenshaw by Alexander MacKenzie. Photograph courtesy of the Museum für Völkerkunde, Berlin, cat. no. IV A 2299.

About the same time, *gwaaygu 7anhlan* inherited a house in Massett from his cousin, according to Newcombe, who photographed the house in 1901 (figs. 4.44, 4.45). Swanton (1905a: 290) gave the cousin's Haida name as Skîl o'ndjas (*skil runts'aas*)[53] of the *k'aawaas sdast'a.aas* (E21f) from Low Tide River. This is probably the same house that Florence Edenshaw Davidson identified: "A lady named Kwoiyat gudang awu ["Kwoiyat's mother"] willed my dad a longhouse in Masset after her husband died. Her husband was my dad's tribe [lineage], one of his uncles. That was the time that my dad gave a big potlatch for his two children, Emily and Gináwən, my older sister and brother. By the time my parents had Agnes [1888], they moved to a white man's [style] house" (Blackman 1982: 72).

Albert Edward Edenshaw was said to have lived in this house after 1875 (MacDonald 1983: 139). By the time of the first census, however, which was taken in 1881 by the Reverend George Sneath, both Albert Edward Edenshaw and Charles Edenshaw, with their families, were living in *skil na.as*, Property House (House 21).[54] If Florence Davidson's time estimates are correct, then the potlatch Charles gave for his two children must have taken place between 1880 and 1882, after the birth of Emily but before the birth of his third child, George (who lived for only three years) in 1882. In 1878, *da.a xiigang* and *qwii.aang*'s first son, *ginaawaan* (Robert), was born, and two years later, in 1880, their first daughter, *7waahlal gidák* (Emily). It may have been at this potlatch that Charles Edenshaw raised the one pole he is said to have carved in Massett. According to Peter Hill, who was interviewed by Marius Barbeau:

> Just once in my time he carved a big totem pole, and there was not much carving on it. It was done at the order of the family wanting it. It was for Yakwalános; he had made it for his daughter. In those days they put up these poles for giving a title; it was done with a purpose. It took place right here in the village. This pole was destroyed about 1915 or 1917. The young people did not want them any more. Even during the missionary times the old potlach was still going on; it was hard to put it down. (Barbeau 1916–1954: B-F-251.12)

The identity of this pole is uncertain, but judging from Hill's description of it as a pole with little carving, and Florence Davidson's memory that it was associated with the house inherited from Kwoiyat gudang awu, it may be that this was the pole (MacDonald's 7M [1983: 139]) that stood in front of House 7, with a raven at the base and a beaver at the top (fig. 4.44, left). The raven is associated with the *yahgu 'laanaas* (though it is a crest of the *sdast'a.aas* as well), and the beaver is a crest of the *sdast'a.aas*. If the Edenshaw family ever lived in House 7, however, it must have been before 1881. At that time, the Reverend George Sneath, the Anglican missionary in Massett from 1879 to 1881, listed Albert Edward Edenshaw's entire family as living in Property House (House 21) in Massett (fig. 4.46).[55]

Fig. 4.43. Frontal pole of Anetlas's Star House at Massett. The lower figures were attributed to Albert Edward Edenshaw by C. F. Newcombe. Now at the Pitt Rivers Museum, Oxford, UK. Photograph courtesy of the Royal British Columbia Museum, neg. no. PN9101. Photograph by Keen or McDougal, 1893.

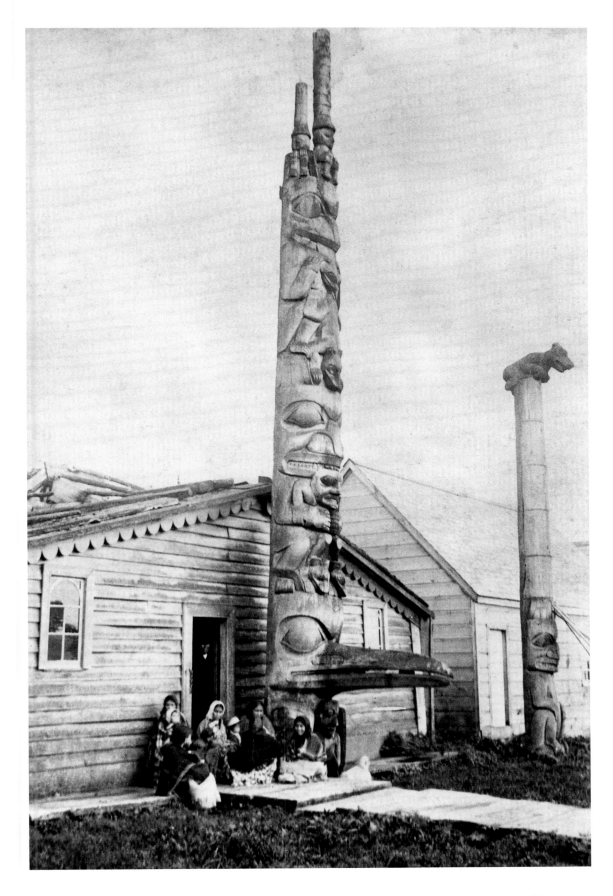

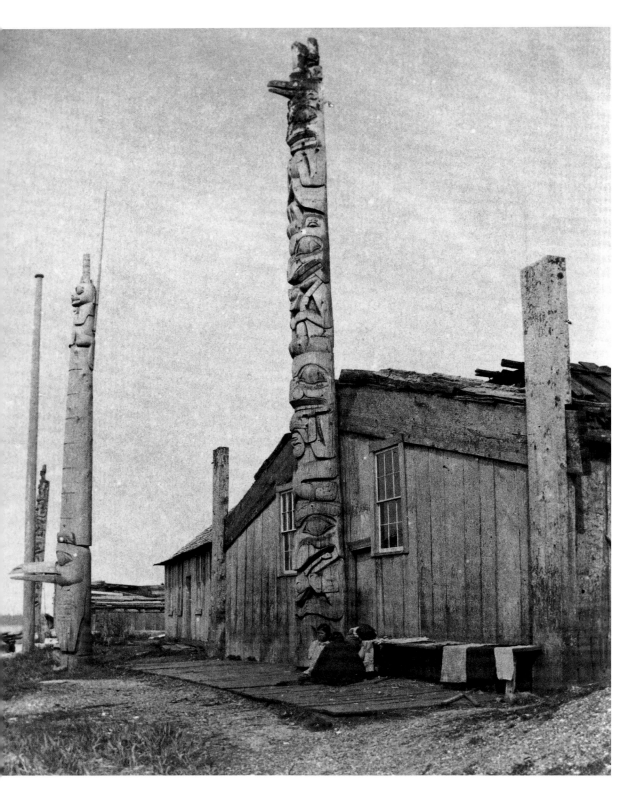

Fig. 4.44. *Skil runts'aas*'s Massett House, circa 1885, inherited by the Edenshaws in the late 1870s. Courtesy of the Canadian Museum of Civilization, neg. no. J-20962.

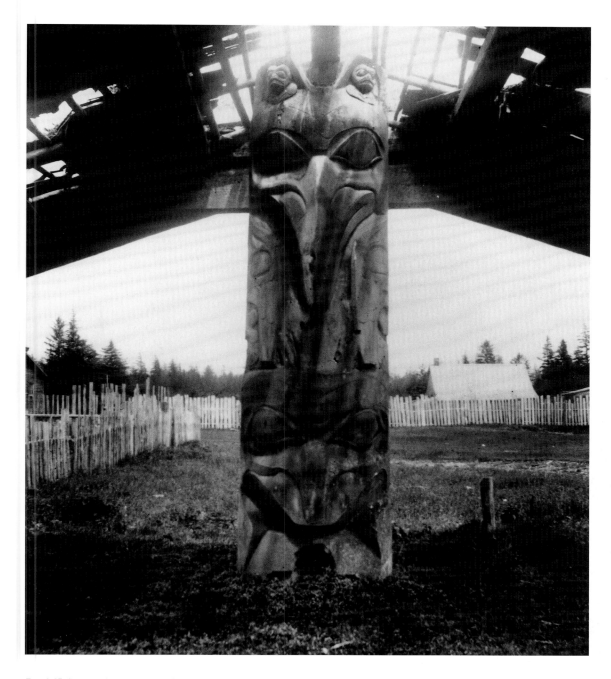

Fig. 4.45. Interior house post of *Skil runts'aas*'s
(the Edenshaws') house in Massett. Collected by
C. F. Newcombe, 1902. Field Museum of Natural
History, cat. no. 79720. Photograph courtesy
of the Royal British Columbia Museum, neg. no.
PN130. Photograph by C. F. Newcombe, 1901.

This house had the same name as old *7idansuu*'s house at *k'yuust'aa*, which stood on the spot later used by Albert Edward Edenshaw for his Myth House (MacDonald 1983: 189). The Massett Property House was a traditional-style house that was replaced by a European-style structure in about 1885 (fig. 4.47) (MacDonald 1983: 147). As at *gwaaygu 7anhlan*'s house at *qang*, the frontal pole had several bear figures.[56] A bear memorial pole also stood in front of this house. It closely resembled the bear pole raised for Enow's daughter at *k'yuust'aa*, which Captain Roberts helped to raise (see figs. 2.10, 2.11). Florence Edenshaw Davidson remembered that this memorial was in honor of Isabella Edenshaw's mother's mother's sister (Blackman 1982: 55). This would have been *gu.uu 7aww*, Albert Edward Edenshaw's first wife, the widow of old *7idansuu*, *ginaawaan*'s sister, and George Cowhoe's mother. The date of *gu.uu 7aww*'s death is unknown, but because her memorial pole is at Massett, she may have died after the family's move to this village in the 1870s. This memorial pole stood in Massett until at least 1930. By that time there were very few poles left standing in Massett, and most had disappeared completely by 1924.

Charles Harrison, the Anglican minister at Massett (1883–1890), reported that he baptized *gwaaygu 7anhlan* and his wife (Harrison 1911–1913: vol. 2, no. 8) and that *gwaaygu 7anhlan* took the name Albert Edward after the husband of Queen Victoria, the Prince of Wales (fig. 4.48). The actual baptismal records kept by Harrison were destroyed in a fire in Metlakatla in 1901, but the marriage records he kept have survived in the Church Diocese Archives in Prince Rupert. We can assume that baptism was followed immediately by a Christian marriage ceremony, and therefore we can glean information about the order of baptism from these marriage records.

The first to receive a Christian marriage in Massett, by the Reverend William Collison, were the Hudson's Bay Company factor, Martin Offutt, and his Tsimshian wife, Chuet, in 1877. Collison succeeded in marrying only two Haida couples before he departed in 1879.[57] His successor, Harrison, was much more successful. George Cowhoe, *gwaaygu 7anhlan*'s son, and his wife, Matilda, were married in September 1883, but it was not until December 27, 1885, that Albert Edward Edenshaw and Amy were married.[58] Their wedding was followed on the same day by the marriages of Charles Edenshaw and Isabella (who also took their Christian names from European nobility) and nine other couples. Clearly, the example set by Albert and Charles was influential in persuading other Haida couples to convert and be married in the Christian manner. Florence Edenshaw Davidson confirmed that it was immediately after their baptism that Charles and Isabella were married in the church:

> When Mr. Harrison came here, he married my parents in the church.
> Just before they got married, Mr. Harrison baptized them. My mother
> didn't read so Mr. Harrison mentioned lots of names to her. When he said
> "Isabella," she said "yes." He told her it was a queen's name; that's why she
> likes it, I guess. Albert Edward put my dad in his [Albert Edward's] place
> while he was still living. When my dad married my mother in the church
> that's when his uncle gave him the name Edenshaw. When the missionary
> called my mother Isabella Edenshaw, she wouldn't take the "Edenshaw"
> for a long time. She couldn't understand it; "How can I take Eagle's name?"
> she kept asking. Finally she gave up. (Blackman 1982: 72)

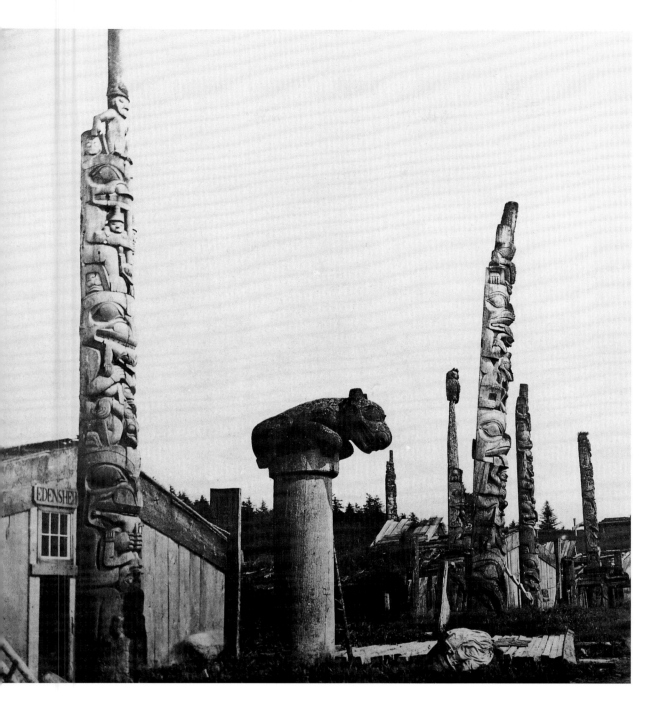

Fig. 4.46. Albert Edward Edenshaw's *skil na.as* (Wealth Spirit House or Property House at left) in Massett. Courtesy of the American Museum of Natural History, neg. no. 24421. Photograph attributed to Spencer, 1879, or Maynard, 1881.

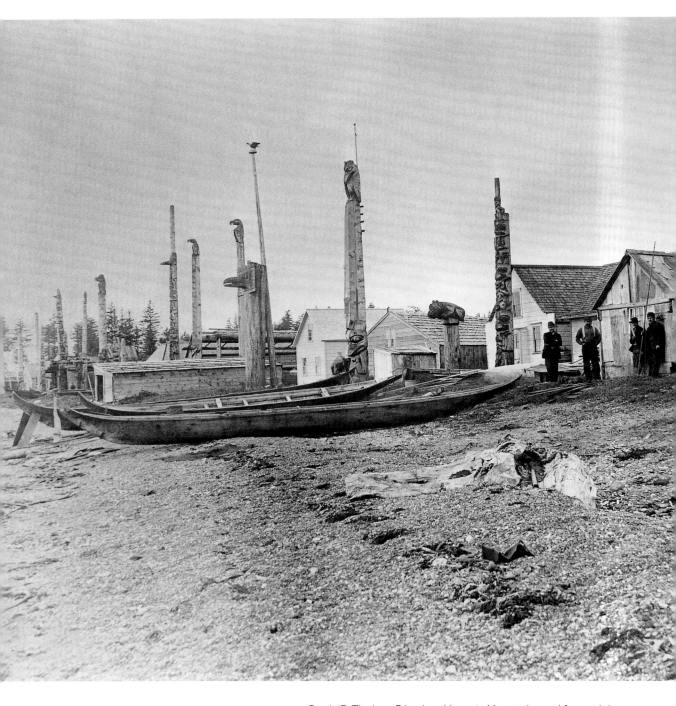

Fig. 4.47. The later Edenshaw House in Massett (second from right). In front of it stand (from right to left) the original frontal pole, the bear memorial for *gu.uu 7aww*, and the raven-finned whale memorial for *ginaawaan*. Courtesy of the Glenbow Archives, Calgary Alberta, neg. no. NA 879-12. Photograph by Robert Reford, 1890.

Fig. 4.48. Albert Edward Edenshaw (at far right) in Massett, 1890.
The other people in the photo are, from left to right, Alexander MacKenzie
(Hudson's Bay Company's agent), the Reverend William Collison, Mrs. Harrison
with a boy who may be Collison's son, the Reverend Charles Harrison, Dr. Kudé
(*k'udee*), and an unidentified man. This photo was taken when Collison returned
for a visit on the occasion of Harrison's retirement. Courtesy of the Public
Archives of Canada, neg. no. C60825. Photograph by Robert Reford.

When the name Edenshaw was given to Charles and Isabella, it was done by
the missionary, apparently with Albert Edward's consent. The name was not
potlatched in the way that chiefly names had been transferred in the past.

The following years must have been difficult, for Charles and Isabella's son
George died in 1885, and two infant daughters were born and died in 1885 and
1886, respectively. In 1888, their daughter Agnes was born.[59] According to
Florence Davidson (Blackman 1982: 72), by this time they were living in a cot-
tage-style house (see fig. 4.47). Albert Edward Edenshaw's son George Cowhoe
died in 1890, and William Collison recorded an account of his death (Collison
1915: 257–258). Four years later, in 1894, Albert Edward Edenshaw died.

Newton Henry Chittenden of the British Columbia exploratory expedition,
who met Albert Edward Edenshaw in 1884, reported: "He has succeeded one
after another of the chiefs of various parts of the group by virtue of the erec-
tion of carved poles to their memory, bountiful feasts and generous potlatches
to their people, until he is now recognized as their greatest chief" (quoted in
Gough 1993: 290). In his biography of Albert Edward Edenshaw, Gough
(1993: 290) concluded:

It is doubtful whether Eda'nsa was in fact the greatest of Haida chiefs; certainly he wanted to be, and he told credulous white men that he was. His life spanned the era of colonization and rampant disease among the Haidas, and he endeavoured, in the face of great structural and economic transformations among his people, to maintain and enhance his position. His achievements illustrate Haida adaptability to changing circumstances. Eda'nsa deserves to be seen as an energetic and powerful man, moved by inner forces, perhaps even by insecurities, to establish his own greatness within the framework of Haida social structure, ever mindful, it seems, of the white man's influence and commercial advantage.

Gough's assessment of Albert Edward Edenshaw's life does not mention his contributions as an artist, which are only now being recognized, though Chittenden had pointed out his raising of poles in 1884. It is hoped that as additional works are attributed to Edenshaw's hand in the twenty-first century, a more complete picture of his life and work can be realized.

The Late Nineteenth Century, the 1880s and 1890s

da.a xiigang, gyaawhllns, gwaay t'iihld,

skil kingaans, and skilee

The late nineteenth century, from the late 1870s through the end of the century, can be regarded as a new era in Haida art. It was after the arrival of the first resident missionaries — William H. Collison, who settled in Massett in 1876, George Sneath, who followed Collison from 1879 to 1881, and, in particular, Charles Harrison, who followed Sneath from 1883 through 1890 — that the old systems of naming and inheritance began to be disrupted by the baptism and renaming of families. The potlatch itself was outlawed by the Canadian government, and the production of ceremonial art used to celebrate the raising and potlatching of heraldic poles and cedar-plank houses ceased to be the primary activity of Haida artists. At the same time, voracious outside markets developed for these same poles and ceremonial arts. The old poles were lowered and sold to collectors. Family heirlooms and clan regalia were also sold for what were then considered to be high prices. By the early twentieth century, little of this material remained in Haida hands. Artists began to carve small-scale replicas of poles and houses in wood and argillite, and they made masks and headdress frontlets for sale as well. Several Haida artists were able to exploit this market, though records linking their identity to the pieces they made were rarely kept, and their identities have been confused by twentieth-century scholars. In this chapter I examine the record in an attempt to unravel some of the confusion that has developed.

Charles Edenshaw: The Productive Years

Charles Edenshaw is said to have earned his living entirely from his art throughout his life, not needing to supplement his income through fishing or hunting as many Haida artists did. By the time Albert Edward Edenshaw passed away in 1894, Charles was about fifty-five and in the prime of his artistic career. It appears from the many objects that have been attributed to him that he produced the majority of his work for sale to outsiders, but he must have made many other objects in his early years that have not yet been identified as his work.

In addition to the few poles that he is thought to have carved (perhaps with Albert Edward Edenshaw; see chapter 4), he designed the crest figures for three stone grave monuments that were raised by Haida families in *hlanqwáan* and Massett (Hoover 1995: 47–48). These monuments served the same function as

wooden memorial poles after missionaries introduced Christian burial practices in 1876. It appears that the same customs that held for the carving of memorial poles were followed for designs on gravestones — that is, an artist from the deceased's father's lineage was hired to design the memorial sculpture. The stones themselves were ordered from Euro-Canadian stonemasons, who were probably in Victoria, British Columbia, at this time, but crest designs were often supplied by Haida designers and could have been copied by the stonemasons or carved onto the stone after it was delivered.

The first gravestone designed by Charles Edenshaw was probably the dogfish on Duncan *ginaawaan*'s stone (see fig. 4.35) in the late 1870s or early 1880s (Blackman 1976: 399–400, 410–411 [n4], fig. 6). Next in date was the thunderbird designed for the gravestone of John Watts (d. August 16, 1904, age 12) in the Massett cemetery (fig. 5.1). This stone has a formline design above the name that is less well executed than the thunderbird below, and it may be that the design above was applied by the stonemason from a pattern book of designs, whereas the thunderbird by Edenshaw was designed specifically for this grave. Judging from the quality of the carving of the thunderbird and its difference from the design at the top, it may be that Charles Edenshaw carved the thunderbird design into the stone himself, after the stone was delivered with the other design in place at the top. This thunderbird design inspired one of Robert Davidson's early silkscreen print designs (see fig. 6.9; Holm 1981: 200, fig. 59). A third stone designed by Charles Edenshaw was for John *gwaay t'iihld*'s grave (fig. 5.2).[1] It took the form of a raven-finned killer whale. Though there is no date on this stone, John *gwaay t'iihld* is known to have died in 1912. Edenshaw probably designed the stone in 1913 or 1914, only six years before his own death.[2] Both John Watts and John *gwaay t'iihld* were of the *st'langng 'laanaas* Raven clan (Swanton's R15), the opposite side from the Edenshaws' *sdast'a.aas* Eagle clan.[3]

Also in the category of ceremonial art made for use within the Haida community are several headdress frontlets known to have been made by Charles Edenshaw. At least one of these (fig. 5.3) was probably made for sale. This beaver frontlet is unpainted and unrigged for use. Collected by Israel Powell between 1880 and 1885, it is the most firmly documented frontlet by Charles Edenshaw, since Franz Boas's catalog notes say, "made by Tahigan [*da.a xiigang*], a Haida, bought from a Tsimpshian." Another beaver frontlet that is rigged for use is very similar (fig. 5.4), with the same eagle faces in the beavers' tails. The beavers' hind feet rest on the eagles' wings on both frontlets. There is no stick in the beaver's mouth in figure 5.4, however, and the inlaid abalone teeth are less pronounced than the carved wooden ones in figure 5.3. The eye sockets in figure 5.4 are smoothly curved rather than sharply carved. An eagle frontlet (fig. 5.5) is also similar to the eagle faces in these two beavers' tails, suggesting that *da.a xiigang* carved all three (see also Holm 1981: fig. 30).

Several other frontlets that can be attributed to Charles Edenshaw have been rigged for use (plate 8, figs. 5.6, 5.7). The crests depicted on his frontlets are limited to those of the *sdast'a.aas* (beavers and eagles) and the *yahgu 'laanaas* (bears) and to portraitlike human faces, further indicating they were intended for family use. John Robson wore one such portrait frontlet, representing the woman in the moon, in a photograph taken in October 1901 by Harold and Edgar Flemming in Victoria (fig. 5.7). Robson, of the *na7i kun qiirawaay* Raven clan, as the nephew of Charles Edenshaw's father, was married to Charles Edenshaw's

Fig. 5.1. John Watts's gravestone in Massett, with a thunderbird design attributed to Charles Edenshaw. Photograph by the author, 1980.

Fig. 5.2. John *gwaay t'iihld*'s gravestone in Massett. Raven-finned killer whale design attributed to Charles Edenshaw. Photograph by the author, 1980.

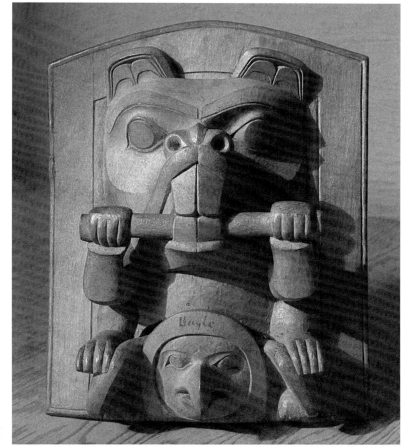

Fig. 5.3. Beaver headdress frontlet carved by Charles Edenshaw, 18.1 by 14.5 by 6.5 cm. Collected by Israel Powell for Heber Bishop, 1880–1885. American Museum of Natural History, cat. no. 16/241. Photograph by Bill Holm.

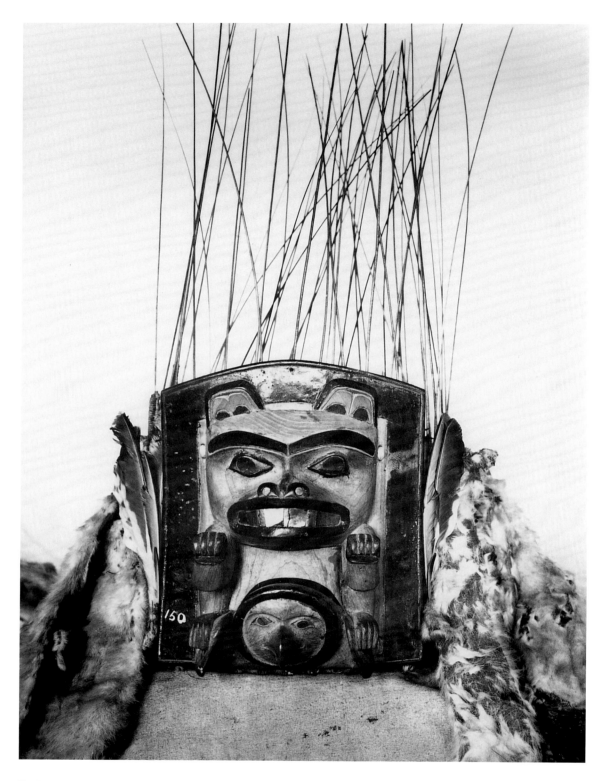

Fig. 5.4. Beaver headdress frontlet attributed
to Charles Edenshaw, 18 by 15.5 by 6 cm.
Acquired in 1891. Courtesy of the Royal
British Columbia Museum, cat. no. 95, neg.
no. PN 10969.

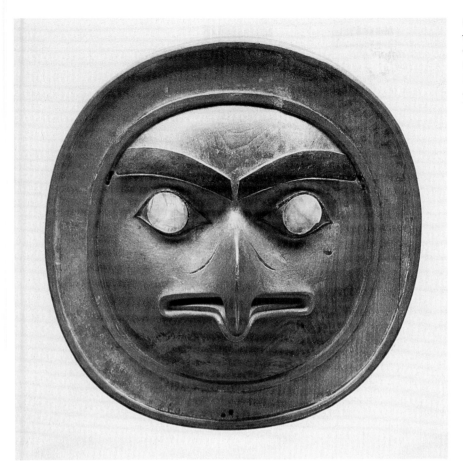

Fig. 5.5. Eagle headdress frontlet attributed to Charles Edenshaw. Private collection. Photograph courtesy of the Don Ellis Gallery.

mother after his father's death, according to the Haida practice. At the time this photograph was taken, the frontlet belonged to C. F. Newcombe, who probably supplied both Robson and Tom Price with the headdresses and robes they wore in the photo.[4] Newcombe had collected the frontlet in the summer of 1901 in *hlanqwáan,* where he said it belonged to a chief of the *sdast'a.aas* division (perhaps Charles Edenshaw himself or one of his clan relatives) — though the woman in the moon is a crest of the *yahgu 'laanaas* clan. There are two letters from Robson to Newcombe that refer to this photograph (Newcombe 1900–1911: vol. 5, file 124):

May 25, 1904

Dear Sir:

Last winter I sent you down to Chicago 1 book of pictures and you promised to pay me 1.00 a picture for them. I have been waiting for a long time for the money to come. Kindly sent it to Clacton Skeena River by first mail

I want you to send me two old fashioned photos that a man on Government Street took of myself a long time ago.

Yours truly

John Robson

Fig. 5.6. Beaver headdress frontlet attributed to Charles Edenshaw, 19 by 16 cm. Collected by Israel Powell for Heber Bishop, 1880–1885. American Museum of Natural History, cat. no. 16/247. Photograph by the author.

Fig. 5.7. John Robson (*right*) wearing the woman-in-the-moon headdress frontlet attributed to Charles Edenshaw (Field Museum, cat. no. 79548), standing next to Tom Price. This frontlet was purchased by C. F. Newcombe at Klinkwan, Alaska, in the summer of 1901 for $30 and is said to have belonged to a *sdast'a.aas* chief. Photograph courtesy of the Royal British Columbia Museum, neg. no. PN5444. Photograph by Fleming Photographers, Government Street, Victoria, October 1901.

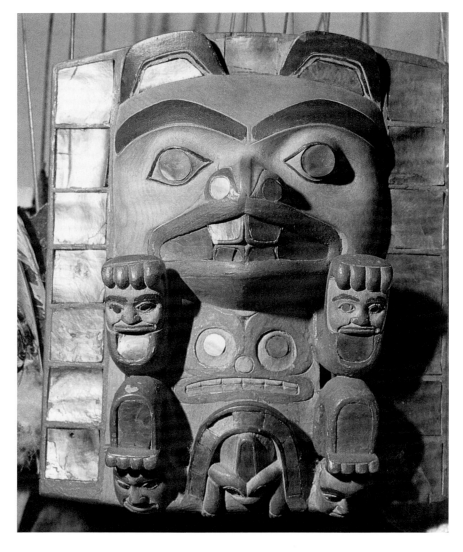

Claxton B.C.

Aug. 24th 1907

Dr. Newcomb

Dear Sir

I want to send you a letter to tell you about the Indian curios picture made for you I'll take you offer, that you offered me @ 50 c. a picture. Please send me two picture. That you taken of me with Thos. Price. Please send me the money as soon as you can to Skidegate because we will go home next two day more. That's all I can say in this letter, so good bye,

Yours truly, John Robson

A portrait frontlet in the Canadian Museum of Civilization is similar in style to the one worn by Robson (MacDonald 1996: 24, plate 13). These two portrait frontlets are similar in some ways to the work attributed to Albert Edward Edenshaw, in particular to the portrait faces in the ears of the Sosland bear front-

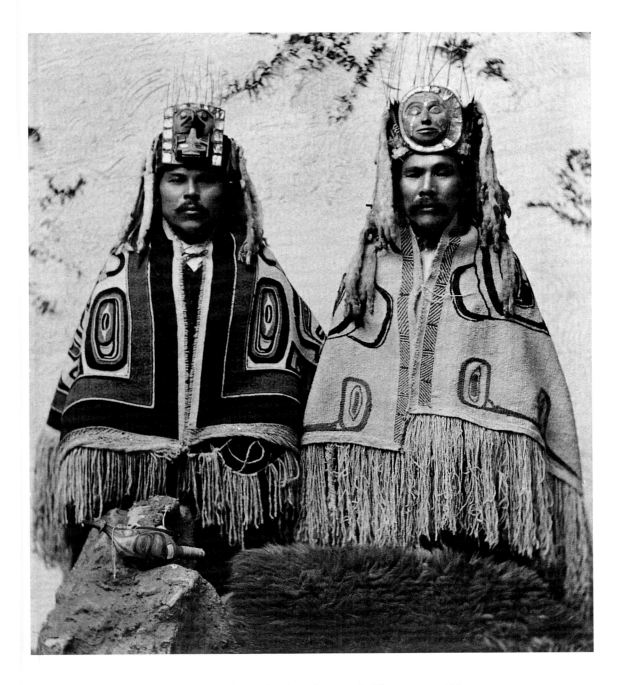

let (see fig. 3.16), as was pointed out by Holm (see chapter 3). The open eyelid lines used by both artists link their work, but differences in their carving styles can be discerned. A comparison of two bear frontlets, one of which I attribute to Albert Edward Edenshaw (fig. 3.16), and the other, to Charles Edenshaw (plate 8), shows their different treatments of the same subject. Bill Holm (1981: 188–189) pointed out how important the eye socket area is in determining individual style:

> It is in the eye and eyesocket area of the Northwest Coast sculpture that tribal and individual identities can be most quickly differentiated. Edensaw chose and consistently used a unique eye form which superficially resembles

that used by other artists but which has recognizable differences from them. The eye itself is on a well-rounded orb, and features a round iris enclosed in open, tapered lids with a well-refined rim. As in the flat designs the points of the lids are not dropped much below the centre of the eye. Above the upper lid the socket is fairly wide and shallowly recessed, retaining the feeling of the underlying orb. The most distinctive feature, however, is the treatment of the area under the eye. Here, the upper cheek plane intersects the eye orb immediately below the lower eyelid line. There is usually no hollowing of the socket below the eye, except the recessed definition of the eyelid line. In human faces and in more naturalistically rendered animal faces there is no defined ovoid eyesocket. This common feature of Haida sculpture is eliminated in favour of rounded cheek planes. Even where the more stylized eye socket is used, the orb–upper cheek plane intersection remains an identifying feature.

 This style matches exactly the eye socket on the frontlet in plate 8, which can be attributed to Charles Edenshaw on this basis. Comparing the eye socket of the Sosland frontlet, however, the orb of the eye is less pronounced in the area above the eyelid line, and the eye socket is hollowed below the lower eyelid line. The eyelid line is open and slightly lowered below the center of the eye, but there is a larger eye-white area exposed within the eyelid lines, which are less constricted than those on the Charles Edenshaw frontlet. This exposed eye-white area gives the effect of the orb of the eye projecting out within the eyelid lines. This effect can be seen in the other frontlets attributed to Albert Edward Edenshaw (see plate 7, figs. 3.12, 3.14–3.18). Charles Edenshaw's bear has rounded arms and legs as opposed to the more angular ones on the Sosland bear; along with the rounded cheeks, this gives an overall rounded effect. Charles's bear frontlet is similar to one of the beaver frontlets attributed to him (fig. 5.4) in the handling of the snout and eye socket area, as well as in the use of small por-traitlike faces in the paws.

 These two frontlets are stylistically linked, in turn, with a beaver chest that has been attributed to Charles Edenshaw (fig. 5.8). Because it is carved only on the front, in the manner of a burial chest, MacDonald (1996: 129) speculated that Edenshaw might have made it as his own coffin. This would have been con-trary, however, to the custom of having someone from the opposite moiety, the deceased's father's clan, carve the memorial poles and chests. This chest was collected from a Gitksan chief at Kitwanga, British Columbia, in 1918 and might initially have been intended for that chief. The two-dimensional formline design on the chest, particularly the treatment of the claws, seems directly related to the design on a frog settee (fig. 5.9) that may have been used by Charles Edenshaw's own family.

 Charles Edenshaw made two known "settees," or chief's seats (figs. 5.9, 5.10). The earlier of the two, with a frog design, consists of three carved panels in the old style of chief's seats, made to sit on the wooden platform of the cedar-plank house. This settee was the inspiration for the house-front design carved as a memorial to Charles Edenshaw by his great-grandson Robert Davidson in 1979 (see fig. 6.15). The second seat was constructed with legs in the manner of Euro-American furniture and was used in Edenshaw's own home, according to his daughter, Florence Edenshaw Davidson, who reported:

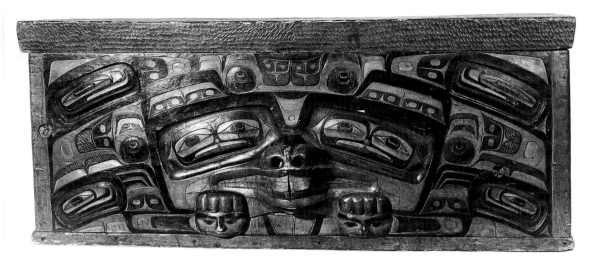

Fig. 5.8. Bentwood chest attributed to Charles
Edenshaw. Purchased from Charlie William by
C. V. Smith at Kitwanga, 1918. Remnants of a San
Francisco pictorial newspaper dated October 4,
1872, are inside. Courtesy of the Canadian Museum
of Civilization, cat. no. VII-C-1183, neg. no. 72-2975.

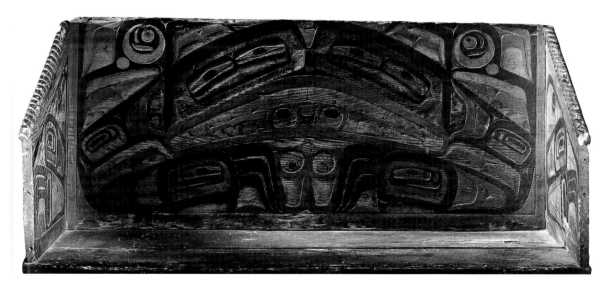

Fig. 5.9. Frog settee made by Charles Edenshaw,
136.5 by 64.3 by 61.3 cm. Acquired in 1901. Courtesy
of the Royal British Columbia Museum, cat. no. 1296,
neg. no. CPN-1296.

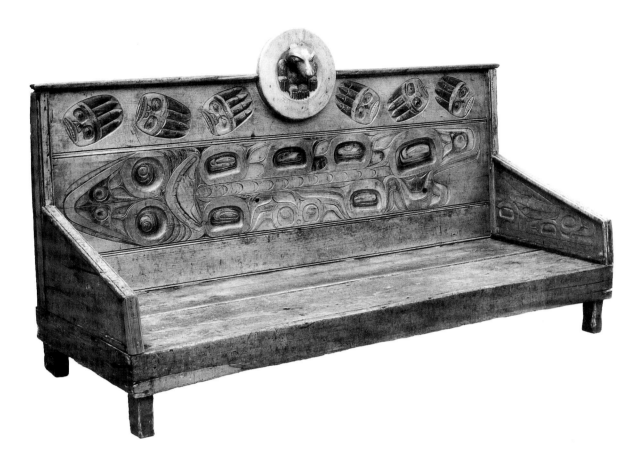

Fig. 5.10. Dogfish and bear settee made by Charles Edenshaw. Collected by George T. Emmons. Courtesy of the National Museum of the American Indian, cat. no. 8/2098, neg. no. N20564.

My parents didn't own much of my dad's work. What they had they sold. My mother even sold her bracelets when people wanted them. We had a chesterfield in our house that my dad carved for my mother. It was like a chief's seat, with a *q'ad* (dogfish) on it and a *xudj* (grizzly bear). It had *xudj* tracks on it — *st'asəl,* we call the tracks. My mother put a feather mattress on it and we used it for a chesterfield. It went to Alec (Yeltatzie) when he took my dad's place, and he and Agnes sold it for $150 to buy a casket for their son who died. (Blackman 1982: 79–80)

Two cradles have been attributed to Charles Edenshaw. One of these, with a dogfish design (fig. 5.11), was collected by C. F. Newcombe at Massett in 1900. It is known to have been used by the family and shows the wear of use. Nora Cogo, one of Edenshaw's daughters, who saw the cradle at the Royal British Columbia Museum in 1985, identified it as one of her sisters' cradles (Hoover 1993: 49, fig. 7). Because Nora was born in 1899, a year before the cradle was sold to Newcombe, it might have been used as her own cradle as well as for the older girls, Florence (born in 1890) and Eliza (1891–1892).

At New Kasaan in July 1902, Newcombe bought a new basketry cradle liner with a painted dogfish design, together with a new wooden cradle with a carved, unpainted raven design (figs. 5.12, 5.13). On July 21 of that year, Isabella Edenshaw had given birth to her youngest daughter, Alice (*skil jadee*), at New Kasaan while Newcombe was in town. The Field Museum catalog notes that the wooden cradle was a copy of one seen in use, so it may be that the

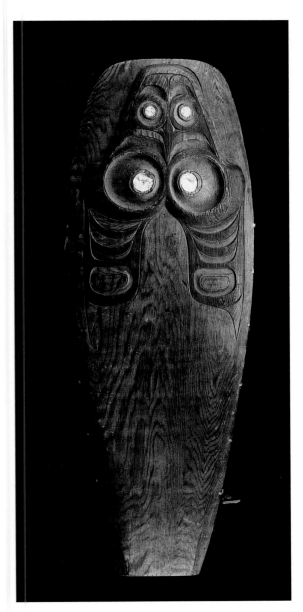

Fig. 5.11. Red cedar cradle with dogfish design made by Charles Edenshaw, 130.7 by 86 by 5.5 cm. Courtesy of the Royal British Columbia Museum, cat. no. 1294, neg. no. CPN-1294.

Edenshaws were using another cradle for Alice, and Newcombe admired it and commissioned a copy for the Field Museum. It is also possible that Charles and Isabella had made this cradle for their unborn child to replace the one sold to Newcombe in 1900, and when the opportunity arose again, they sold the new one as well, before it could be used by their last daughter. This wooden cradle has a raven rather than a dogfish carved on it, but the painting on the basketry cradle liner does appear to be a copy of the dogfish carved and painted on the earlier cradle. The cradle appears on Newcombe's list dated July 25, four days after Alice's birth. An account of the birth was recorded by Henry Joseph Muskett, who accompanied Newcombe on this trip: "July 21. . . . Mrs. Edensaw delivered of a daughter the success of the operation chiefly due to the medicine she took. viz: some water in which was mixed the ashes of four hairs

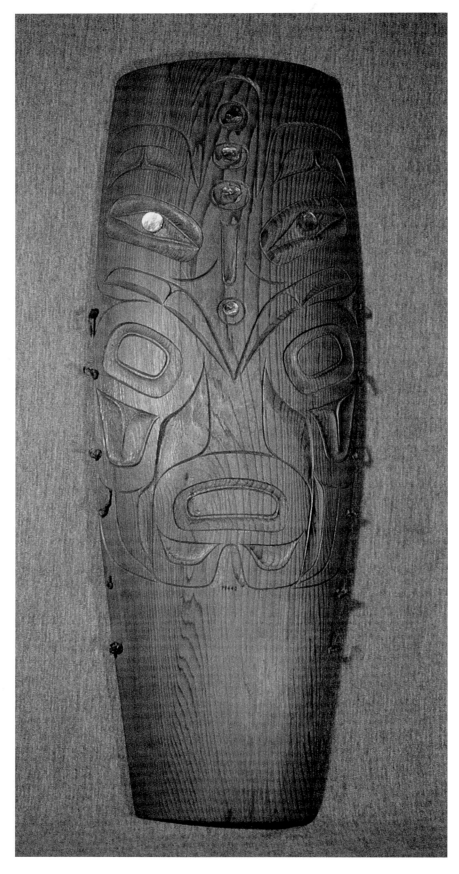

Fig. 5.12. Red cedar cradle with raven design inlaid with abalone, made by Charles Edenshaw, 71 by 25 by 6 cm. Collected by C. F. Newcombe, 1902. Field Museum of Natural History, cat. no. 79440, photograph by Bill Holm.

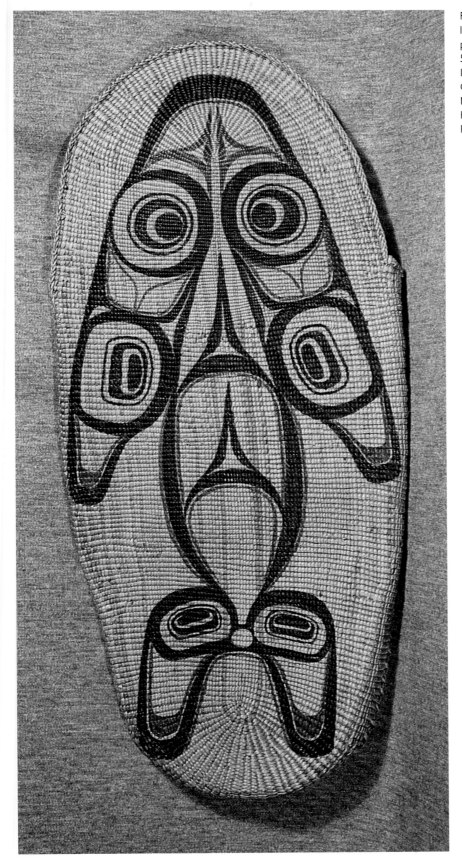

Fig. 5.13. Basketry cradle
liner of spruce root with
painted dogfish design,
56.5 by 25 cm. Made by
Isabella Edenshaw and
Charles Edenshaw. Field
Museum of Natural
History, cat. no. 79441.
Photograph by Bill Holm.

from the very tip of the marten's tail, & four hairs fr. the very tip of the sea-otter's tail, which had been burnt together four blades grass from medicine mans grave in North Island" (Muskett 1902: n.p.).

Another account of Alice's birth was written in the form of a letter on the back of a description of a raven rattle that Newcombe recorded from information supplied by Charles Edenshaw in New Kasaan at this time:

Kasaan Post Office, Alaska 27th July 1902

Dear Henry:

You will be glad to hear that Mrs. Edenshaw has got over her confinement all right. She has a little girl again. Both are quite well & strong. . . .

Dr. Newcombe is taking my inside totem pole for $30.00 and he wants it sent by this years's steamer.

This letter is unsigned and may have been dictated by Charles Edenshaw to Charles Newcombe and sent to Henry Edenshaw on different stationery. The inside pole he refers to is probably the interior post for House 7 in Massett (see fig. 4.45), which was sent to the Field Museum in Chicago in 1902 and was part of the same accession with other material purchased from the Edenshaws in New Kasaan.

Alan Hoover (1993) pointed out that Charles Edenshaw probably made many of his silver and gold bracelets, if not all of them, initially for native use. The earliest bracelets that can be attributed to him are two in the Canadian Museum of Civilization (figs. 5.14, 5.15), both collected in 1879 by Israel Powell. Bill Holm (1981: 182–183) suggested that Charles Edenshaw's two-dimensional design style, which is characterized by medium- to narrow-width formlines, very rounded Us and ovoids, a lack of nonconcentricity in the ovoid complexes, and stacked U complexes, among other things, was fully formed by 1879, when these two bracelets were collected. He explained that one of the two bracelets displays an earlier, less fluid style: "The older of the two 1879 bracelets exhibits features which suggest the form of Edensaw's earlier style. Less smoothly flowing formlines result from more angular ovoids and somewhat awkward junctures. Ground and tertiary forms (which result from the relationship of adjacent primary formlines) are less integrated with the whole composition than in later work" (Holm 1981: 187).

Holm went on to describe the settee at the Royal British Columbia Museum (fig. 5.9) as a transitional piece in Charles Edenshaw's career, representing a style dating several decades before its 1901 collection date, pre-1879. By the time he made the early settee, he had already incorporated the stacked Us and mouthless, circular "salmon-trout-heads" into his design system (Holm 1981: 187).

John Robson (*gyaawhllns*) and Charles Edenshaw

Florence Edenshaw Davidson reported that Charles Edenshaw's earliest carvings were done in argillite while he lived in Skidegate, before moving to the north of Graham Island in the 1850s. The carving of argillite for sale to outside visitors is a tradition that had started with an earlier generation of Haida carvers who produced black stone tobacco pipes for sale to Euro-American maritime

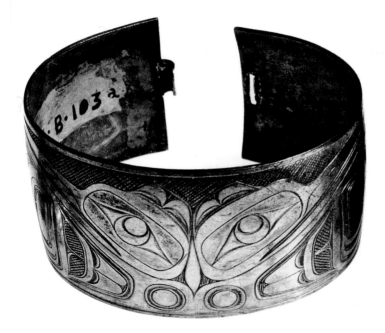

Fig. 5.14. Silver bracelet attributed to Charles Edenshaw, 6.5 by 5.5 by 3.5 cm. Collected by Israel Powell, 1879. Courtesy of the Canadian Museum of Civilization, cat. no. VII-B-103a, neg. no. 72-16721.

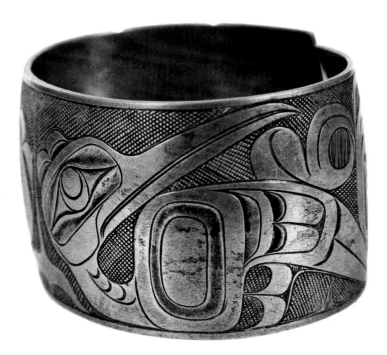

Fig. 5.15. Silver bracelet attributed to Charles Edenshaw, 6.5 by 5 by 3.5 cm. Collected by Israel Powell, 1879. Cat. no. VII-B-103b. Photograph courtesy of Nancy Harris.

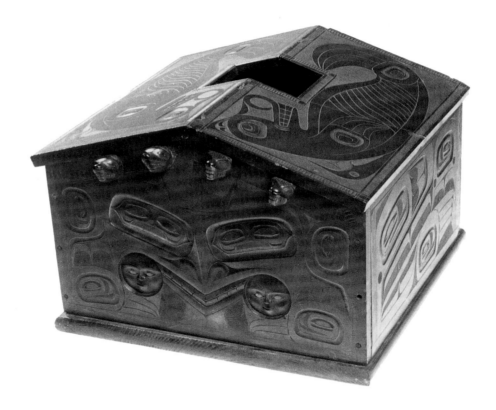

Fig. 5.16. Model of Grizzly
Bear's Mouth House,
argillite, attributed to
Charles Edenshaw; 32.1
by 31.4 by 24.4 cm.
Collected by Reuben
(Robert) Goldstein, a
Juneau merchant, from a
group of Haidas who had
come to Juneau to trade,
ca. 1885–1900. Donated
in 1962 by Belle Simpson,
owner of the Nugget
Shop and daughter of the
collector. Courtesy of the
Alaska State Museum, cat.
no. II-B-1304. Photograph
by Mark Daughhetee.

fur traders at least as early as 1820 and probably a decade or two earlier (Wright 1977, 1985). Unfortunately, no argillite carvings attributed to Charles Edenshaw have been dated to the very earliest years of his carving career.[5] Holm described two argillite house models (figs. 5.16, 5.17) as characteristic of his early style of carving:

> A number of argillite carvings — the [Grizzly] Bear's Mouth house models in the Vancouver Centennial Museum and the Alaska State Museum are examples — illustrate this earlier and somewhat less elegant structure while already incorporating Edensaw traits such as the double outlines of tertiary and ground spaces and rudimentary stacked Us. More massive and angular formlines with greater width variation, and more frequent use of the tertiary U–double secondary U complex characterize these early pieces. (Holm 1981: 187)

These two argillite house models both depict Grizzly Bear's Mouth House (*cu7aji xihl7ii*) in Skidegate (fig. 5.18), which belonged to *gyaawhllns* (Giatlins) of Those Born at Rose Spit (*na7i kun qiirawaay*, Swanton's R13). John Robson is said to have inherited this house after *gyaawhllns*'s death in the late 1860s (MacDonald 1996: 216).[6] Newcombe recorded Robson's Haida name in 1901 as Gwaiskunagiatlens, which reflects his assumption of the name *gyaawhllns* by that time.[7] Further documentation of this name appears on an argillite chest that has "CAOWTLINS" inscribed on the lid (fig. 5.19). Marius Barbeau had attributed this chest to Charles Edenshaw, explaining the name as "meaningless capitals" (Barbeau 1957: 58). Holm originally attributed the chest to Edenshaw as well, but he corrected his attribution to John Robson on the

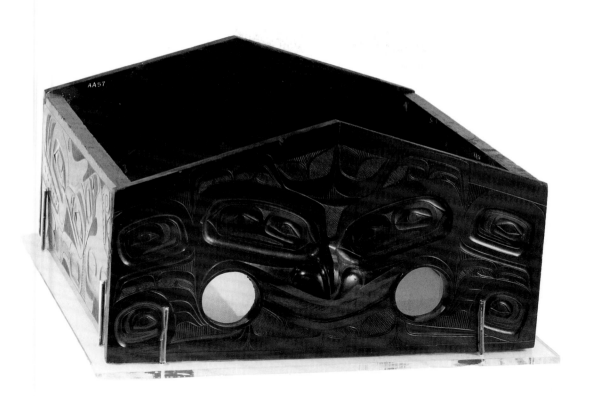

Fig. 5.17. Model of Grizzly
Bear's Mouth House,
argillite, attributed to
Charles Edenshaw, 31.7 by
31.1 by 24.1 cm. Courtesy
of the Vancouver Museum,
cat. nos. AA54, 55, 56, 57,
neg. no. 1-2560.

basis of stylistic differences, pointing out Newcombe's record of John
Robson's Haida name, Gwaiskunagiatlens (Holm 1981: 191). In the documen-
tation that James Deans provided to the Field Museum along with a wooden
model of Grizzly Bear's Mouth House carved by John Robson, he reported that
Robson had worked on it together with David Shakespeare (*skil duunaas*). He
also noted that the owner of Grizzly Bear's Mouth House at Skidegate was named
"Goatlins" and was the grandfather of the parties who had built the model
(Deans 1893[?]; Holm 1981: 191). Deans's identification of *gyaawhllns* as the
grandfather of Robson and Shakespeare is probably incorrect; he was more
likely their uncle or great-uncle. Deans's information, however, does suggest
that David Shakespeare and John Robson might have been brothers or cousins,
from the same *na7i kun qiirawaay* Raven clan.[8]

After the death of *da.a xiigang*'s father, his mother, *q'àaw quunaa*, is said to
have married John Robson, probably a nephew of *tl'aajaang quuna*'s, since it
was the custom for Haida widows to marry either their husband's brother or
his nephew. John Robson was younger than Charles Edenshaw by at least seven
years, though the exact date of his birth is uncertain. The 1881 census lists a thirty-
year-old man named "Gaotlans" (Robson) living in Grizzly Bear's Mouth House
with his fifty-five-year-old wife, "Tlgadsat." One of *q'àaw quunaa*'s Haida names
was *7itl'gajaad ga t'a.aas,* which means "a rich woman grabs heavy things with
her claws like an eagle" (Blackman 1982: 70). This might conceivably have been
spelled Tlgadsat by the census taker, George Sneath. An age of fifty-five for
q'àaw quunaa in 1881 would give her a birth date of 1826; thus she would
have been about thirteen when Charles was born. The 1891 census lists John
Robson as forty-eight and married to Clachoona (*q'àaw quunaa*), age fifty-
two (three years younger than she was ten years earlier!), with a son, John

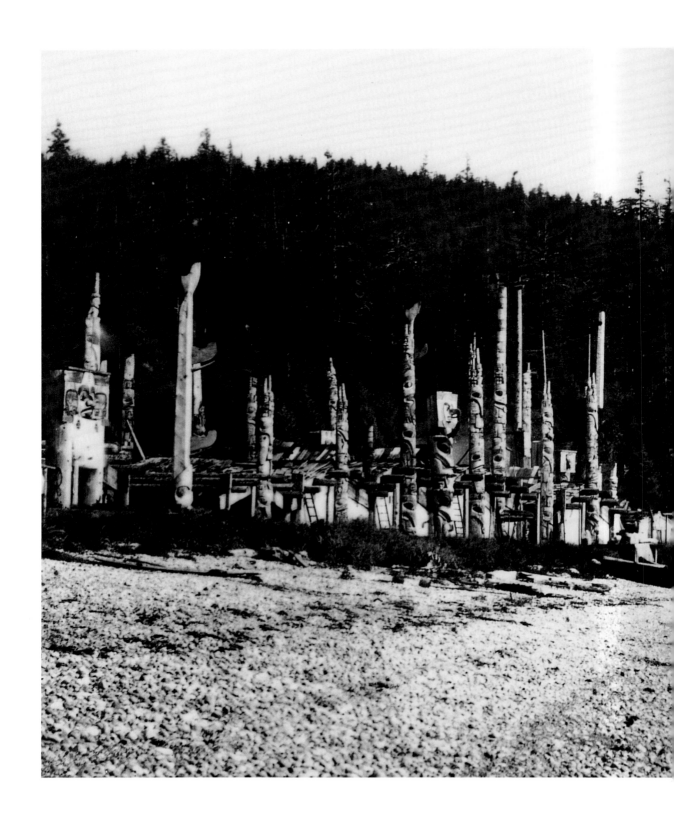

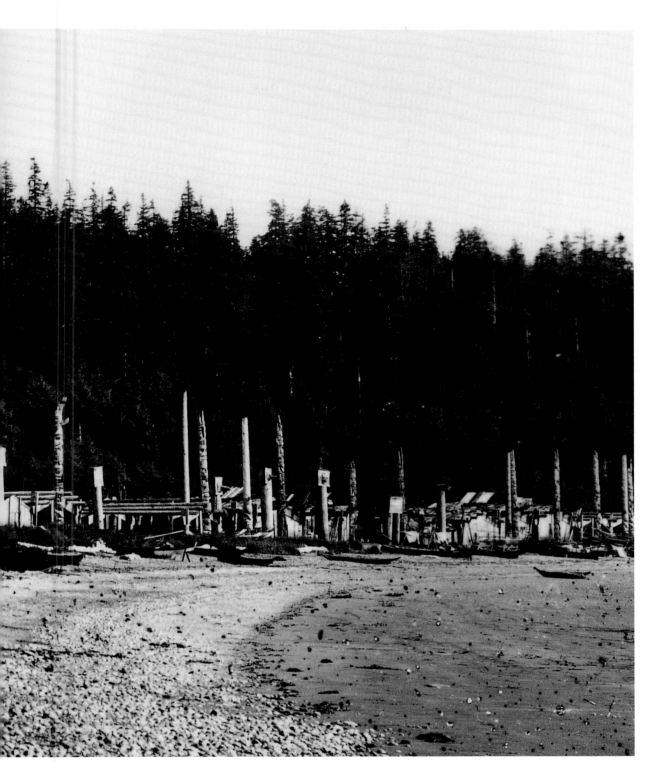

Fig. 5.18. Grizzly Bear's Mouth House (arrow, far right),
Skidegate. Courtesy of the Canadian Museum of Civilization,
neg. no. 253. Photograph by George Dawson, 1878.

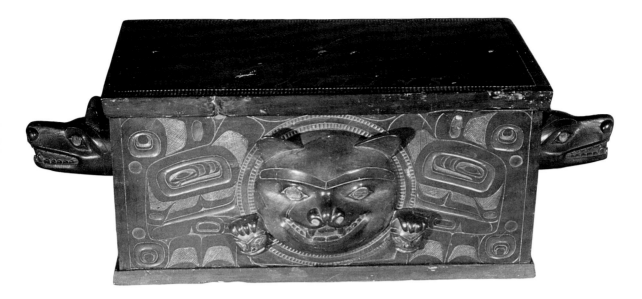

Fig. 5.19. Argillite chest attributed to John Robson. The name "CAOWTLINS" is inscribed on the lid. Barbeau recorded this name incorrectly as "COWTLINS" (Barbeau 1957:58). The lid is cracked across the letter "A." Collected by James G. Swan, 1884. National Museum of Natural History, Smithsonian Institution, cat. no. 88999. Photograph by the author.

Robson, age twenty.[9] Clearly, the ages on the census reports were grossly inaccurate estimates on the part of the census taker. The baptismal records indicate that John Robson and his wife, Martha (probably *q'àaw quunaa*'s Christian name), were baptized in 1893, and the death records for Skidegate give Robson's death date as 1924 (he was 78). Martha Robson died in 1896 (at 68). She may actually have been older than this at her death, judging from Charles's birthdate. In any case, it is clear that Robson was at least twenty years younger than *q'àaw quunaa*. Robson must have had to assume responsibility for his uncle's widow early in his life.

John Robson is said to have erected a pole in honor of *q'àaw quunaa* (fig. 5.20) that stood near Grizzly Bear's Mouth House, next to an older beaver pole.[10] Newcombe called this pole the "Amos Russ Monument" (perhaps because it

belonged to Amos Russ at the time) and explained that it was put up by John Robson for his wife (Newcombe 1900–1911: vol. 55, file 10). The pole had a beaver at the bottom and an eagle at the top, both crests of q'àaw quunaa's sdast'a.aas clan. There is a raven above the beaver, however, which suggests that rather than being a memorial to q'àaw quunaa, as MacDonald described it (1983: 45), this pole combined the crests of Robson and q'àaw quunaa. The pole does not appear in Dawson's 1878 photograph of Skidegate (fig. 5.18), but it does appear in one taken by Maynard in 1884 (fig. 5.20), which dates it between 1878 and 1884.[11] The Maynard photo shows the paint still visible, which confirms that the pole had been recently raised at this time. An 1897 photograph taken by Newcombe (fig. 5.21) shows little paint remaining thirteen years later.

Given q'àaw quunaa's death date of 1896, and the fact that both her crests and Robson's are on the pole, it seems clear that this pole was not a posthumous memorial to her. James Deans's notes (1893[?]: 93) confirm this: "This Hat [xaad] was erected many years ago as a mark of respect for his wife by one of the Cathlins Coon folks named John Robson. . . . As soon as she dies it is the intention of her people to cut it down, then she will have a costly marble monument in the graveyard." It is possible that Robson raised the pole in recognition of his marriage to q'àaw quunaa while she was still alive, perhaps at the time he took the place of gyaawhllns and acquired Grizzly Bear's Mouth House. The photographic evidence places the raising of the pole in the late 1870s or early 1880s, and it may be that Robson assumed the name gyaawhllns at that time rather than in the late 1860s, as MacDonald suggested (1996: 216). Robson carved at least two large models of this pole, one of which is now in the Royal British Columbia Museum (fig. 5.22). The other was made for James Deans's model exhibit of the village of Skidegate and was placed next to a model of Grizzly Bear's Mouth House, also made by Robson (Field Museum cat. no. 17838). The stylistic features of these accurate models match well what is known of John Robson's carving style, further supporting the supposition that he carved the full-sized pole as well.[12]

Two wooden models of Grizzly Bear's Mouth House have been attributed to John Robson. One was collected by James Deans for the model of the village of Skidegate that was exhibited at the World's Columbian Exposition in Chicago in 1893 (fig. 5.23); it is now in the Field Museum of Natural History. The other was acquired by Lord Bossom around 1900 (MacDonald 1996: 109, plate 83). Of the two, the Field Museum model is most similar to the original house, with the bear's ears extending onto the gable planks. Two Euro-American ridicule figures, said to represent Judge Pemberton and George Smith of Victoria, were also made for this model (MacDonald 1983: 45). Deans reported that Grizzly Bear's Mouth House, as well as the figures of Pemberton and Smith, was pulled down and used for fuel a few years before 1893. Interestingly, this model originally had a small figure of a girl inside, peeking out from behind a screen, which illustrated a girl's puberty ritual:

> Inside of the house is the model of a Lall, that is when a girl reaches
> a certain time in her life she is kept behind the curtains, as it were, for
> a month or six weeks or until the return of the event, when her friends
> make presents to their chief and the rest of the tribe, and she gets a name

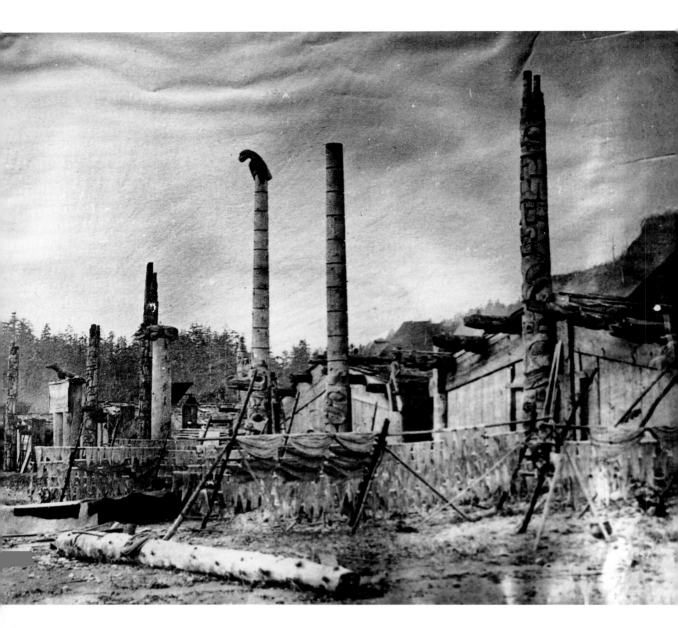

Fig. 5.20. John Robson's pole honoring *q'àaw quunaa* (center, with eagle on top), in front of Grizzly Bear's Mouth House. Grizzly Bear House is next door, at far right. Courtesy of the Royal British Columbia Museum, neg. no. PN331. Photograph by Richard Maynard, 1884.

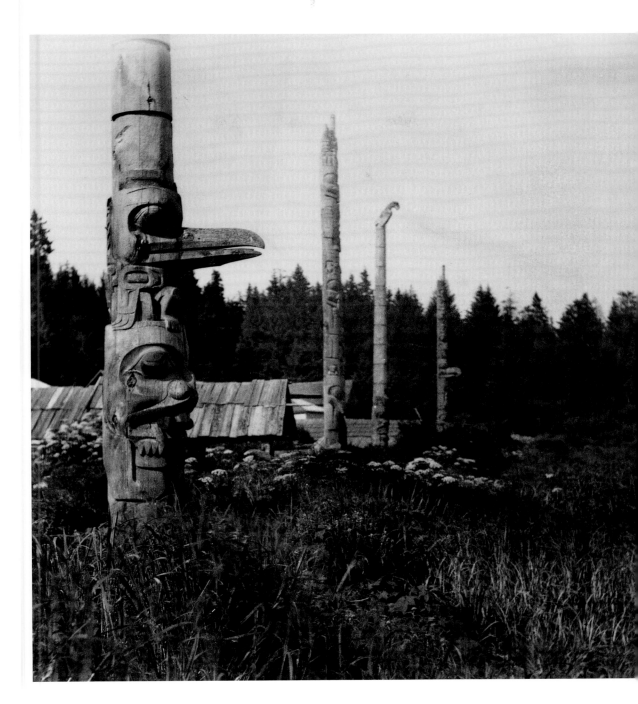

Fig. 5.21. John Robson's pole honoring *q'àaw quunaa*
(in foreground). Courtesy of the Royal British Columbia
Museum, neg. no. PN18. Photograph by C. F. Newcombe,
1897.

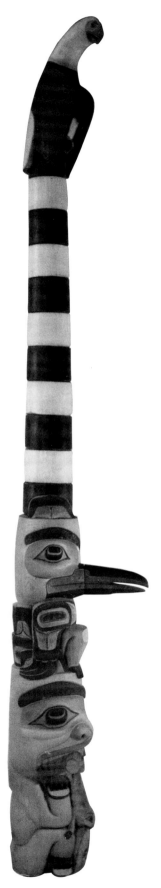

Fig. 5.22. Model of *q'àaw quunaa*'s pole carved by John Robson, 201.5 by 18 by 31 cm. Acquired in 1892. Courtesy of the Royal British Columbia Museum, cat. no. 231, neg. no. CPN-231.

and is at liberty to marry. The girl is shown as looking out behind a wall on which is painted a Cahie or sculpin, which is the name she is given. This used to be the great event in her life and was known and spoken of by young and old. The place of her confinement is generally made by hanging blankets over a rope in a corner of the house. None has had to undergo this ordeal for about three years I believe. (Deans 1893[?]: 57)[13]

A note at the bottom of Deans's manuscript explains that the screen for the pubescent girl is gone from the model, and only the house front was kept (Deans 1893[?]: 57).

Charles Edenshaw's argillite model of Grizzly Bear's Mouth House in the Vancouver Museum (fig. 5.17) has the ears extending onto the gables, whereas his model in the Alaska State Museum (fig. 5.16) lacks this feature but adds human faces in the two circular doors and bears' heads on the ends of the beams, as well as sea lions engraved on the roof. Holm has suggested, on the basis of their more awkward formline constructions, that Edenshaw's two argillite models are early examples of his work (pre-1879). The large number of argillite carvings that have been attributed to Charles Edenshaw suggests that this was a medium in which he worked over a long period of time, probably his entire carving career. In searching for Charles Edenshaw's earliest work, it is tempting to think that he carved his two argillite models of Grizzly Bear's Mouth House in the 1850s, while he was still living in Skidegate with his mother — but at that time he lived in a different house. Newcombe's notes indicate that Charles Edenshaw's mother (and presumably Charles when he was young) lived in *t'awts'i na7as* (Taodsᴀ naas), or Fort House, in Skidegate, which was two houses east of Grizzly Bear's Mouth House (Newcombe 1900–1911: vol. 55, file 10).

Holm (1981) has pointed out the close similarity between the carving styles of John Robson and Charles Edenshaw and has provided us with the tools to differentiate the subtle differences in their work. It may be that while living with *q'àaw quunaa* and her son *da.a xiigang* (Charles Edenshaw) in Skidegate, Robson learned about argillite carving from *da.a xiigang,* who, though his stepson, would have been the more senior carver at the time. That Charles's father is said to have died when Charles and Robson were still young boys suggests that the two might have lived together with *q'àaw quunaa* in Skidegate, though by the time Charles moved to the north at age eighteen or nineteen, around 1857, Robson would have been only about eleven. Given the age difference between Charles Edenshaw and John Robson, it is unlikely that Robson "taught his stepson many carving skills," as MacDonald suggested (1996: 216). It is more likely that Charles taught Robson, which would explain the similarity in their styles.[14]

Charles Edenshaw was probably the first of the two to carve models of Grizzly Bear's Mouth House, perhaps on the occasion of Robson's acquisition of the house. If this occurred in the late 1860s, as MacDonald suggested, then the two

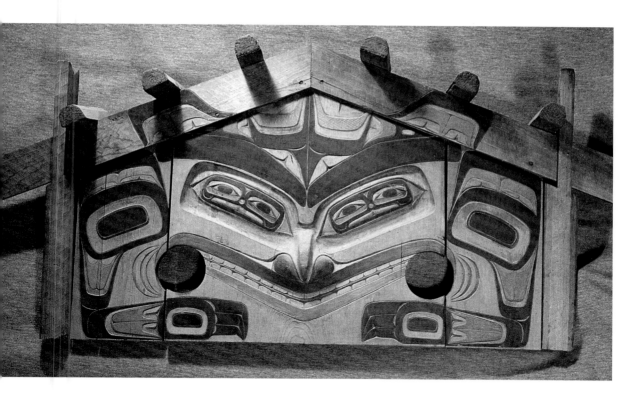

Fig. 5.23. Model of Grizzly Bear's Mouth House front made by
John Robson and David Shakespeare and exhibited at the World's
Columbia Exposition in 1893; 111 by 54 cm. Collected by James
Deans. Field Museum of Natural History, cat. no. 17990.
Photograph by Bill Holm.

argillite models made by Charles Edenshaw may have been carved after this event,
dating them to the decade from the late 1860s to the late 1870s. If Robson's inher-
itance of the house was also acknowledged by his raising of the pole in front of
it, with both his and *q'àaw quunaa*'s crests — documented to have occurred
after Dawson's 1878 photograph — then Charles Edenshaw may have carved
his argillite models of the house after 1878. Robson's first model of the house
might have been the one made for Deans in the early 1890s, more than a decade
later.

 Also at this time, John Robson and David Shakespeare (*skil duunaas*) carved
a model of the house that stood next door to Grizzly Bear's Mouth House (fig.
5.24), between it and Fort House. This was *cu7aji na7as* (Koot Nas or X̲u'adji
na'as), Grizzly Bear House, MacDonald's House 4 and Swanton's House 6
(MacDonald 1983: 45; Swanton 1905a: 286), also belonging to the *na7i kun
qiirawaay* Ravens.[15] The original house, as well as the model, had grizzly bears
carved on the six extended roof beams (see fig. 5.20 right). Inside this model
was a set of figures (fig. 5.25):

> Inside of this model. There is a number of men and women going through
> the dance the Haida call Skagga in presence of a chief. They are all repre-
> sented in full dancing dress with a full complement of feathers. The women
> in darker dresses are looking on while the drummer is beating time on the

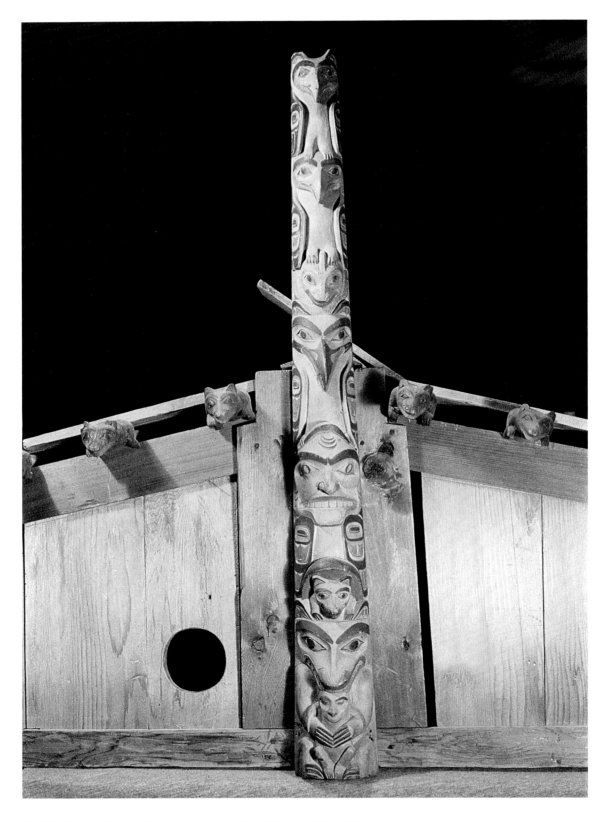

Fig. 5.24. Model of Grizzly Bear House made by John Robson and David Shakespeare and exhibited at the World's Columbian Exposition in 1893; 98 by 53 cm. Collected by James Deans. Field Museum of Natural History, cat. no. 17836. Photograph by Bill Holm.

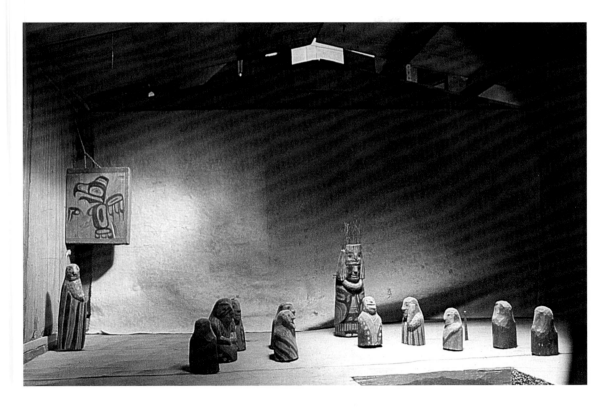

Fig. 5.25. Figures inside the model of Grizzly Bear House, made by John Robson and David Shakespeare. Field Museum of Natural History, cat. no. 17836. Photograph by Bill Holm.

Cowjow or box drum, of which I send a specimen. The painting on the one shown is the Ellanga or thunder bird. This is a very good picture of an old time dance. . . . This model was made by two Haidas named John Robson and David Skilldonass (Shakespeare). (Deans 1893[?]: 82)

Deans recorded two long stories that explain the figures on the house frontal pole, which are a bear holding a human figure at the bottom, a small bear (in a den), dogfish woman, Raven, a clam(?), and two eagles at the top. The bear story is said to come from Alaska and is the same story as that of Qats, who married the grizzly bear woman, recounted by Charles Edenshaw about the house frontal pole belonging to *skil.aa.u* in *hl7yaalang* (see chapter 3). The story of the eagles is called by Deans "the king of the eagles" and is said to come from Skedans (*q'una 'llnagaay*). In this story a young boy is turned out of his house by his uncle and, after wandering around, is found by a woman and taken to her town, the Eagles' town, high in the trees. She marries him, and he earns the respect of his father-in-law. One day the father-in-law says he would like some whale's flesh for dinner. The young man goes out dressed in a suit of the old man's feathers and returns with a piece of whale meat. He enjoys flying so much that he asks for a suit of feathers for himself. The old man goes to a box and gives him a full suit of eagle feathers, making him a full-fledged eagle. He flies farther and farther away, finding the place where many whales live. His father-

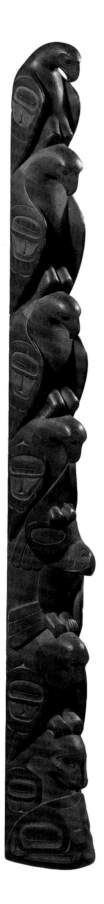

in-law warns him to beware of danger and to avoid the "Ah Seak" if he sees it floating about on the water, and not to touch it. The Ah Seak is described as a large clam.[16] One day he is flying around and sees something floating on the water. Wishing to see what it is, he touches it. It grabs hold of his hand, pulls him under the water, and holds him there. He manages to keep one arm above water, and seeing this arm, the other eagles come to his rescue. But as soon as an eagle grabs his arm, it, too, is pulled under. Each eagle in turn is grabbed and pulled under until the last eagle has only its arm above water. Finally, the mother eagle, sensing that something is wrong, comes looking for them and is able to pull all the eagles out and restore them to their former health (Deans 1893[?]: 58–60).

The figures on the frontal pole of Robson's model of Grizzly Bear House seem not to match those shown in the photograph of the frontal pole on the house immediately to the east (right) of Grizzly Bear's Mouth House in figure 5.20. That pole has a beaver at the top rather than an eagle. The figures on the frontal pole of Fort House, however — the house in which *q'àaw quunaa* is said to have lived and the house to the east of Grizzly Bear House — are more similar (see fig. 5.18, far right). Newcombe identified these figures as Eagle at the top (with a small beaver between two watchmen figures), and Sea Bear and *sraa.n* (Whale) at the bottom. Neither house frontal pole (that is, of Grizzly Bear House or Fort House) has a dogfish woman, as the Robson model does. Like other models, this one displays Robson's freedom not to copy the original pole exactly. Both of these houses were *na7i kun qiirawaay* houses, and it may be that Robson combined the pole from Fort House with the bear beams of the house next door. He certainly would have been familiar with all of these houses. Both Grizzly Bear's Mouth House and Grizzly Bear House had been dismantled by the end of the 1890s (see fig. 5.21),[17] but the frontal pole of Fort House stood in Skidegate until the 1940s (see MacDonald 1983: 44, plate 34). Robson carved another model pole that shows the story of the eagles and the clam even more clearly than does the Grizzly Bear House model (fig. 5.26). On this pole, six eagles struggle to free themselves above the clam, which has a seal-like head.[18]

Charles Edenshaw's relationship with John Robson must have continued throughout his lifetime; the model poles they carved for John Swanton in 1901 suggest that they might even have worked side by side at that time. It was during this turn-of-the-century period that Charles Edenshaw was consulted and commissioned by a series of collectors and anthropologists whom he met in Port Essington, *gasa.áan*, Victoria, and Massett. These few documented collections of his work provide the foundation upon which many later attributions of his work have been based. Nevertheless, many misattributions of his work have been made during the twentieth century.

In August 1897, at Port Essington (at the mouth of the Skeena River, directly east of Massett on the mainland), Franz Boas hired Charles Edenshaw as a consultant. Edenshaw identified artifacts from museum collections and provided

Fig. 5.26. Model pole showing the story of the eagles and the clam, attributed to John Robson. Courtesy of the Royal Ontario Museum, cat. no. HN838, neg. no. 87GTH62.

several drawings, sixteen of which were later published in Boas's *Primitive Art* and Swanton's ethnography of the Haida (Boas 1927: 71, fig. 67; 159, figs. 134, 135; Swanton 1905a: plate 20, fig. 8, plate 21, figs. 7, 8, plate 22, figs. 1–6, plate 23, figs. 2–4; 144, fig. 19). Boas explained to his wife how lucky he was to have caught Edenshaw there: "I spend the rest of the time with a Haida painter whom I got just in time. He was ready to leave for Fort Simpson the day before yesterday when I quickly engaged him. I am showing him all the photographs which I had made in New York and Washington, as well as in Ottawa, and I am able to identify many objects with his help. I am very happy about this because our collections from now on will be much more [complete?]" (Rohner 1969: 223).

One of these drawings is of the dogfish tattoo of Charles Edenshaw's wife, Isabella (plate 9). Swanton explained:

> It belongs to Edensaw's wife, who belonged to the Middle-Town-People (R19). Originally this tattooing belonged to Those-born-at-Skedans (E3). At one time the Gîti'ns began to use it without authority, and in return Those-born-at-Skedans used the raven, which up to that time had belonged to the Gîti'ns. This nearly led to war. This is the reason that both of these crests are used at the present time by both groups. The dog-fish represented in the tattooing is the sister of A-Slender-One-who-was-given-away. The woman is represented in the dog-fish in order to indicate that the dog-fish has human form and is a female at the same time. (Swanton 1905a: 142)

Another tattoo design that Edenshaw drew for Boas is the figure of a skate, a crest obtained by the *tsiij git'anee* Eagles (E17) from the Tsimshian of Port Simpson (Swanton 1905a: plate 20, fig. 8). A third tattoo design is that of a sea lion with a dorsal fin, a crest of the *sgwaahlaadaas* (Sqao'ładas, R10; Swanton 1905a: plate 21, fig. 8).

In addition, ten blanket border designs that Edenshaw drew for Boas were also illustrated by Swanton, apparently at Boas's urging (Jonaitis 1992: 36; Swanton 1905a: plate 22, figs. 1–6; plate 23, figs. 2–4; 144, fig. 19). These included one showing a profile of a whale with Raven inside his belly, from one of the Raven stories (plate 10), and another depicting a mosquito with a scrolled snout and pointed tongue (plate 11). A third border design shows a beaver with a frog below it (plate 12). The published version shows three frogs in a row, apparently duplicated from Edenshaw's original single frog (see Swanton 1905a: plate 23, fig. 4).

Most interesting is the tenth blanket border design, which shows the story of the eagle and the clam (plate 13). This is the same story John Robson carved on two model poles (figs. 5.24, 5.26). The clam is shown at the bottom, its foot rendered as a profile head with sharp teeth about to pull the eagle under. One eagle perches on the snout of the clam's foot, and another balances on the first eagle's upraised wing, suggesting the chain of eagles that was pulled under the water by the clam. Next to this drawing is a sketch that appears to depict a clam with a long extended foot; it was apparently abandoned unfinished in favor of the version to the right. All of these images were published in black and white in Boas's and Swanton's books, though the original drawings are rendered colorfully, with green and yellow used in tertiary areas.

Charles Edenshaw also drew a Wasgo (*ɂwaasru*) design (plate 14), again com-

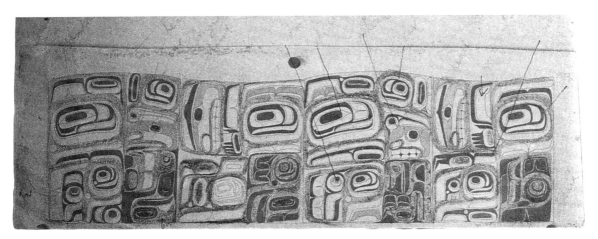

Fig. 5.27. Printed diagram of bentwood bowl (cat. no. 19/1233) with Boas's notes written while interviewing Charles Edenshaw in Port Essington in 1897; 20 by 8.8 cm. Boas Collection, American Museum of Natural History, Anthropology Department. Photograph by the author.

missioned by Boas. Unlike his other drawings, which are on plain, newsprint-like paper, this one was drawn on a piece of American Museum of Natural History stationery. First published in Boas's *Primitive Art* in 1927, the drawing was used on the cover of the 1955 reprint and is probably the most famous of Edenshaw's drawings. It was accompanied by a narrative scene, now missing from the museum, depicting the monster's capture (Boas 1927: 159, fig. 135). This latter drawing told the same story as that found on the model of Albert Edward Edenshaw's Myth House from *k'yuust'aa*, commissioned from Charles Edenshaw by Swanton in 1901 (see fig. 3.29). The split-tree trap was baited with a child, shown in Edenshaw's drawing with his head in the monster's mouth. The young man crouches near the trap, and the jealous mother-in-law, with her puffin-beak rattles, stands nearby. Interestingly, her feet, as well as the feet and hands of the child, are rendered as birdlike, three-toed claws.

A scene that Edenshaw drew of an eagle carrying away a woman (plate 15) interested Boas not only for its narrative quality but also because of its three-quarter view of the woman's head (Boas 1927: 71, fig. 67). Two additional unpublished drawings, both of thunderbirds, are included among Boas's notes in the American Museum of Natural History Anthropological Archives (plate 16). In both, Edenshaw used circles in the secondary red color to indicate the backbone of the birds.[19]

Also included among Boas's drawings is his diagram of the famous bentwood bowl in the American Museum of Natural History (cat. no. 19/1233; see chapter 3). Boas brought this diagram with him to Port Essington and later used it as an illustration in *Primitive Art* (1927: 276, fig. 287c). His penciled comments on the drawing indicate how Charles Edenshaw interpreted its abstract "ultra-primary" design (fig. 5.27). Wilson Duff, in the last paper he wrote before his death, attributed this bowl to Albert Edward Edenshaw, despite its having been collected by George Emmons from the Chilkat Tlingit (Anderson 1996: 142–143). Duff described this piece as the "final exam" in northern Northwest Coast art because he felt that if scholars could understand the meaning of its

design, they could understand the meaning of Northwest Coast art as a whole (Duff 1981: 212). Boas had struggled with this issue in Port Essington in 1897, but he did not believe Charles Edenshaw's explanation, as he indicated when he published it in 1927:

> An interpretation was given to me for the box shown in fig. 287b. Although obtained from Charles Edensaw, one of the best artists among the Haida, I consider it entirely fanciful. The first side to the left, corresponds to the third side, which is opposite to it on the box. The second side corresponds to the fourth side. Edensaw explained the design as showing four interpretations of the raven as culture-hero. The upper right hand rectangle of the first side he claimed to represent the head of the raven surmounted by the ear; the large eye to the left of it, in the left hand upper corner, the shoulder and under it the wing and tail. The design in the right hand lower corner he interpreted as the foot; the toes are clearly visible in the lowest right hand corner of this field. He claims that the head turned upside down in the left hand upper rectangle of the second side represents the head of the raven and under it the hand; the raven being conceived as a human being. The rectangle in the upper right hand corner contains the shoulder; the right hand lower corner under it, the tail; and the left hand lower corner, leg and foot. (Boas 1927: 275–276)

Considering that Albert Edward Edenshaw probably did not create this design, contrary to Duff's belief, and that Charles Edenshaw may have been seeing it for the first time in 1897, his interpretation seems an entirely reasonable attempt to explain the design (which would perhaps have been better left unexplained) to an avid Boas, who must have urged him to try. Bill Reid's essay on this bowl, which was a favorite of both his and Duff's, recounts how it was selected and displayed in the "Arts of the Raven" exhibit in 1967 and gives the descriptive name of the artist as the "Master of the Black Field" (Abbott 1981: 300–301). This bowl's importance to Reid is indicated by his having copied the design several times during his life; he even asked to be buried in a box that replicated it (see chapter 6; also see Shadbolt 1998: 195–205).[20] That Boas did not believe Edenshaw's explanation of this bowl does not undermine the value Boas placed on the information he received from him, much of which can only be inferred from Boas's publications and various catalog records at the American Museum of Natural History.

John Robson also drew a number of designs on paper for C. F. Newcombe between 1902 and 1911. They make an interesting comparison with those that Edenshaw drew for Boas in 1897.[21] Robson's dogfish (fig. 5.28) is the same crest figure as that drawn by Edenshaw (plate 9), yet the two are quite different in style. Robson's drawings appear to be more hastily done, with thinner formlines, yet they show his distinctive salmon-trout-head, which brings the jawline around the front of the snout to join at the upper corner, as described by Holm (1981: 190–192). His use of color is perhaps even more daring than Edenshaw's, with green and blue primary formlines. Though most of these drawings were simply done, in order to identify the main features that characterize the crests, some show real originality in the design, particularly Robson's rendering of a crab (fig. 5.29).

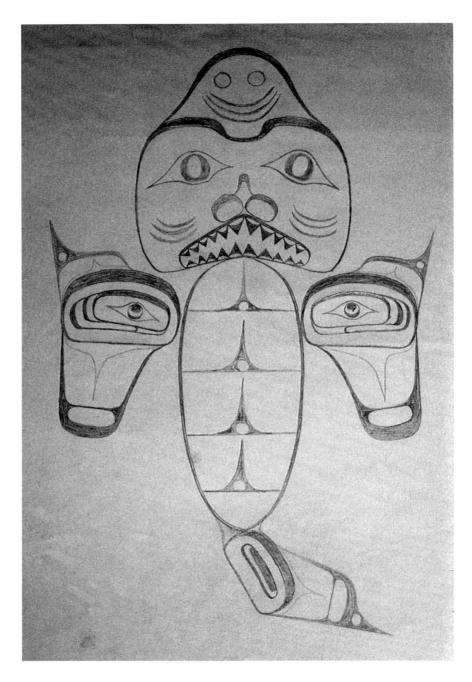

Fig. 5.28. Drawing of a dogfish by John Robson. Collected by C. F. Newcombe, 1911. Field Museum of Natural History, cat. no. 79790-7. Photograph by the author.

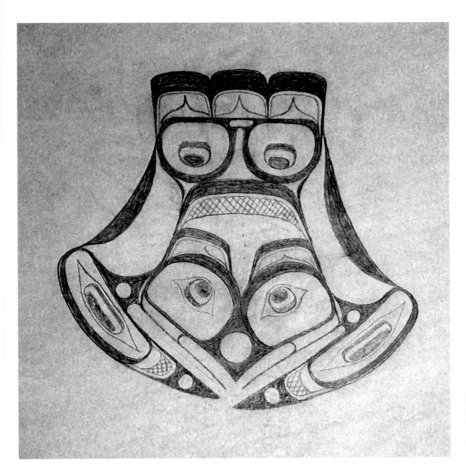

Fig. 5.29. Drawing of a crab by John Robson. Field Museum of Natural History, cat. no. 19986-8. Photograph by the author.

Swanton's letters from Haida Gwaii, sent to Boas at the American Museum of Natural History during 1900–1901, recount the commissioning of several model poles from Charles Edenshaw and John Robson. The letters give some sense of how Edenshaw moved around during this time. Florence Davidson told Margaret Blackman (1982: 72) that after her father got married, but before she was born, he used to go to Victoria and carve all winter long. In a letter dated March 31, 1901, Swanton wrote: "I am staying with Henry Edenshaw whose employment as a teacher keeps him always in the village. Your informant Charlie Edensaw is at Virago Sound just now, and I am going to send by him a commission to make me some totem poles, a house and perhaps one or two model canoes." On June 2, 1901, he reported:

By the first of August I hope to reach Inverness on the Skeena where Charlie Edenshaw, who is doing carving for me, will camp during the summer. . . . Charlie Edenshaw has made me a fine model of a house, copied from Chief Edenshaws at Kioosta, and I am going to have him put up a frame for me without the outside boards. In it he is going to put an outside house post. He is also going to make me several memorial posts and one or two story house posts.

Still later, on June 20, 1901, he told Boas: "I have just learned that small-pox has broken out in Alaska, and has been brought to the Skeena. Charlie Edenshaw

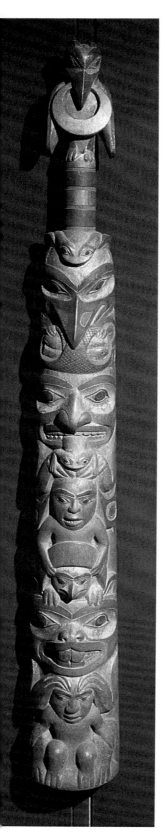

has been quarrantined. He went to Alaska just before going to the Skeena, and I may be able to come away without making my Alaska trip and without getting the models Charlie Edenshaw was making."

Eventually Edenshaw provided Swanton with eight model poles, two house models (each with associated poles), and one model canoe.[22] The two model houses represent Albert Edward Edenshaw's houses at *k'yuust'aa* (*q'iigangng na.as*, Myth House, cat. no. 16/8771) and at *qang* (Sk!ū'lha haiya't, cat. nos. 16/8772, 16/8770) (see figs. 3.29, 3.30, 4.3).

One of the Edenshaw models is of a pole owned by *yáahl daajée* (Yeł daji) (fig. 5.30). Though Swanton's published account of this model says only that *yáahl daajée* was a chief of the "Eagle-House People (R19e)," who lived in Alaska, his original list in the American Museum of Natural History archives indicates that *yáahl daajée* was of the Yeł nas xadai, part of the *yahgu 'laanaas* clan at *hlanqwáan*. This must certainly be the Yeltadzie who lived in *hlanqwáan* and later moved to *ráwk'aan* (see chapter 4). This pole illustrates several stories from the Raven series, including Raven with the moon and Raven stealing fish and freshwater from Beaver. Though the original is said to have been owned by *yáahl daajée*, no full-sized poles like this model are known from either *hlanqwáan* or *ráwk'aan*. Other model poles from this set represent either actual poles from Haida villages (though none is an exact copy of the original) or poles that may not have existed but to which the rights were owned by individuals (see Jonaitis 1992: 36–38; Swanton 1905a: 125).

Of the thirteen model poles John Robson made for Swanton, one (fig. 5.31) is a model of the house frontal pole from Skidegate that belonged to Paul *nang jingwaas*, the grandfather of Amos Russ (this was MacDonald's House 21 [1983: 51]). The full-sized pole had a small human figure at the base holding up the beak of the raven (fig. 5.32); this figure was said to have been erected to shame *ginaawaan* (see chapter 4).

Also among Robson's models is one of a frontal pole that belonged to *tl'aa-jaang quuna*, "great splashing of waves" (fig. 5.33). He was a member of Those Born at Rose Spit (*na7i kun qiirawaay*, R13) and was said to have married a *sdast'a.aas* woman — likely Albert Edward Edenshaw's sister.[23] Chief *tl'aajaang quuna* owned at least two houses in Skidegate. MacDonald identified two, House 12 (Field Museum cat. no. 17999) and House 8 (MacDonald 1983: 46–47), but neither of these housepoles appears to be the one copied by Robson. House 12 was based on an earlier house at Cape Ball.

In 1892, James Deans purchased House 12 from its owner at the time, Thomas Stevens, and sent it to Chicago for the World's Columbian Exhibition, where it was exhibited complete with its frontal pole.[24] The house was not retained, but the frontal pole still stands in the foyer of the Field Museum of Natural

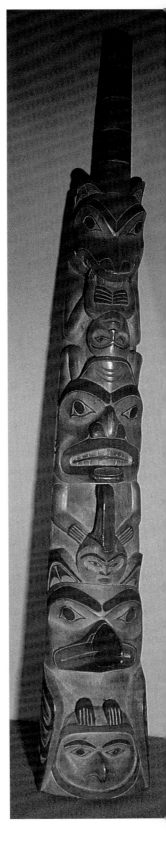

Fig. 5.31. Model of Paul *nang jingwaas*'s house frontal pole by John Robson, 96 by 14 by 19.5 cm. Commissioned by John Swanton, 1901. American Museum of Natural History, cat. no. 16/8748. Photograph by the author.

History in Chicago (fig. 5.34). The figures on it do not match those on Robson's model. Newcombe recorded the history of this pole in 1904, on the basis of information from Charles Jefferson of Skidegate:

The lowest figure is the sea grizzly bear, charun-huaji [eating a boy].

Next comes a mythical monstrous sea centipede, charun-staxɛmai, which lives under large stones & when uncovered, wriggles away like a worm or snake. It is represented with its head hanging downwards.

The third from the bottom is tsɛmos, a Skeena River monster, which is able to transform itself into a great number of different shapes. It is eating the staxɛmai. The headquarters of the tsɛmos tribe was near the mouth of the Skeena R. at a place called la-tsɛmos.

The topmost figure is a Killer whale, srana. The face shown in its mouth is that of a man. Drowned Haidas were supposed to be always eaten by killer whales, &, if chiefs, themselves turned into killer whales. The central straight projection at the top of the pole is the dorsal fin of the killer.

The crests shown all belonged to one person, probably to the man who erected the house & pole. All belonged to the *Raven* phratry, and could be used by Jefferson himself who has many of them tattooed on his body and hands.

The original pole with these crests stood at or near Gathlinskun, not far from Cape Ball, on the east side of Graham Island. (Newcombe 1900–1911: vol. 55, file 10)

Newcombe obtained more information about the pole from Thomas Stevens of Skidegate in 1903. Stevens was the man from whom Deans had purchased the pole:

Fig 1) Topmost figures = "Totem pole men"

between them is the dorsal fin of

Fig 2) The Killer whale

Fig 3) Tsamoas [*ts'am7oos*], the mythical erect drift log

Fig 4) The Grizzly Bear

All of these crests belong to the Raven Clan. The pole is a copy of one that was erected at a town long ago abandoned, but which stood near a point called Gathlinskun, the Cape Ball of the whites, and was mostly washed away before the year 1840. Here, a chief named Klajankuna, 70 or 80 years

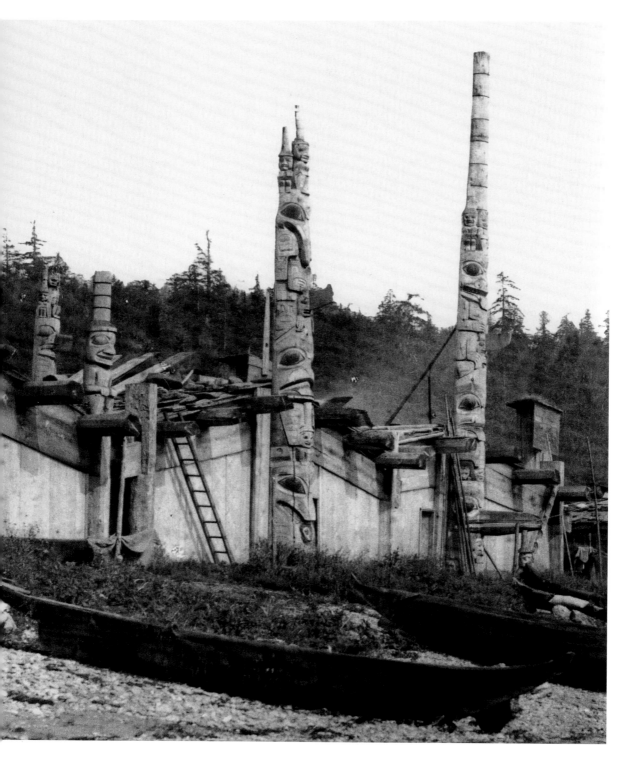

Fig. 5.32. Paul *nang jingwaas*'s house (far right) in Skidegate, showing the ridicule figure holding up the beak of the raven at the base of the frontal pole. Courtesy of the National Archives of Canada, neg. no. PA37756. Photograph by George Dawson, 1878.

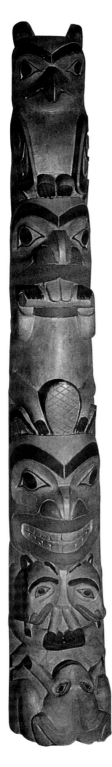

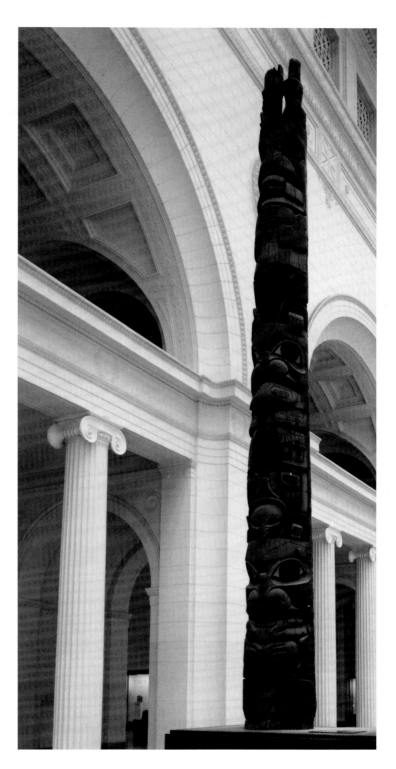

Fig. 5.33. Model of *tl'aajaang quuna*'s frontal pole by John Robson, 75 by 10 by 7.5 cm. Commissioned by John Swanton, 1901. American Museum of Natural History, cat. no. 16/8754. Photograph by the author.

Fig. 5.34. The frontal pole of one of *tl'aajaang quuna*'s houses (House 12) in Skidegate. Collected by James Deans in 1892 for the World's Columbian Exposition. Field Museum of Natural History, cat. no. 17999. Photograph courtesy of the Field Museum, neg. no. A108441.

ago, after a long time managed to get together all the materials required to build himself a new house. In addition to the large outside pole there were 6 other carved posts, namely the large horizontal roof beams of which there were three on each side. The front ends of these beams were carved to represent human heads and they were decorated with real human hair taken from slaves and from the heads of enemies killed in battle. The chief had had a dream in which he saw a number of men so placed by him.

When everything was ready for his friends to help him to raise the house and also for the feast which was to follow, a message was sent to all the neighbors. But just as they were getting to work a great storm came on from the southeast with a very heavy sea and all the timbers were washed away. Three times again Klajakuna got all the timbers ready for his house and three times again everything was carried away by storms from the southeast.

At the fifth attempt the house was properly erected, the accompanying potlatch was a success and the Chief thereupon took the name of Nagagaitlas Kilstlaigen-klaxada. In memory of the repeated washing away of the house timbers the house site was called na-gagitlas, that is the house of the stormy sea. Not very long after this, the Gathlinskun people were suddenly attacked by the Tongas people, living in the Tlingit country across Dixon's Entrance and not very far away. A great number of the men were killed and many women and children were made slaves so that the remainder thought it best to take refuge with their friends the Skidegate people. Not all went there however, as some were more closely related to the Massett people and preferred to go there. (Newcombe 1900–1911: vol. 55, file 10)

Models of both houses (12 and 8) were collected by James Deans and displayed at the Chicago fair in the diorama of Skidegate village.[25] Deans's description of the model frontal pole of Box House (House 8) is as follows:

> Model No. 20 [Field Museum cat. no. 17837]. This model was made by the present Clads-an-coona [tl'aajaang quuna], and is a model of a house the original of which stood near the large house and belonged to one of the Cathlins Coon people. The figures on this gayring are: First and lowest, a chooats or brown bear. 2nd a fisherman named Skulsit who also had an island for himself on which he used to go and shoot birds. 3rd is a whale eating the 4th one the raven. The wife's crest was the raven, the husband's a bear, of the eagle phratry.

Deans goes on to tell an edited story of the fisherman and his wife who was seduced by Raven, who was then killed by the fisherman and eaten by a whale (Deans 1893 [?]: 49–50). Deans was mistaken about the eagle identity of the husband, as the bear is a crest of the *na7i kun qiirawaay* Ravens.

A photograph of the frontal pole for this house (third pole from the left in fig. 5.20) shows two large figures that could be a bear and a whale, though not in the same positions as on Deans' model. Robson's model pole matches neither of these houses, said to have belonged to *tl'aajaang quuna*. It does,

however, fit with the description of Fort House (House 3), where *q'àaw quunaa* lived. Swanton described the Robson pole and its owner as follows:

> The original of plate III, fig. 1, belonged to Great-Breakers (Lā'djAñ qō'na), chief of Those-born-at-Rose-Spit (R13), who received his name from one of Cape Ball's names. His wife was one of the StA'stas, and one of her names was Chief-Woman-whose-Voice-is-Sharp, that is, has effect (I'Lga djat kîlk!î'gAs). At the top is an eagle sitting upon the head of a beaver. These are the wife's crests. At the bottom a grizzly bear holding her two cubs is rearing in terror at sight of a frog, of which creature the Haida supposed grizzly bears to be mortally afraid. The artist has thus introduced a crest and illustrated a story at the same time. Frogs are also said to have been placed upon house-poles sometimes, to keep them from falling over. (Swanton 1905a: 124)

This description matches Newcombe's account of Fort House:

> It belonged to an uncle of A. Russ named Taołgiakuna of the Naikun ravens. His wife belonged to the StAstas and was named Itkadjat-g.Akag.as. This means that she was like a great eagle looking down and swooping from time to time. The man's name means "he brings loads of food." The crests at the bottom are those of the man. They are sea-bear and killer. Above are eagle and a beaver between two hat men. (Newcombe 1900–1911: vol. 55, file 10)

Robson's model pole (fig. 5.33), then, is most likely based on the Fort House pole, where he may have lived with *q'àaw quunaa* and Charles Edenshaw before he acquired Grizzly Bear's Mouth House. The *sdast'a.aas* wife, mentioned in Newcombe's account, Itkadjat-g.Akag.as, is probably *ʒitl'gajaad ga t'a.aas*, one of *q'àaw quunaa*'s names.[26] Robson enlarged the small beaver that was between the two watchmen figures at the top, placing it in the middle of the pole, and leaving out the sea-bear and the killer whale. Certainly in this case, as with the other models made by Robson and Edenshaw, a great deal of license was taken with the figures on the pole.

After Swanton commissioned Charles Edenshaw and John Robson to carve model poles for the American Museum of Natural History, he published illustrations of them but attributed only some of Edenshaw's work to him (Swanton 1905a: 125, plates 1–8), though Swanton's notes on the collection in the museum archives list all the poles by artist. Marius Barbeau later published these illustrations, too, and attributed all of them, including Robson's, to Charles Edenshaw (Barbeau 1957: figs. 171–176, 181–182). On the basis Holm's analysis (1981: 188–192), the two different sculptural styles can be distinguished by their proportions, their eye socket configurations, and their two-dimensional designs. Robson's animal faces are longer in proportion to their width, with eye sockets hollowed under the eye, whereas Edenshaw's eye sockets have upper cheek planes that intersect the eye orb immediately below the lower eyelid line. Edenshaw's eyebrows have rounded ends, whereas Robson's eyebrows are squared. Robson's ovoids are more angular, with greater width variation, than Edenshaw's.

Swanton commissioned one model canoe from Charles Edenshaw and illustrated it in his ethnography (fig. 5.35). This was said to be a model of the canoe

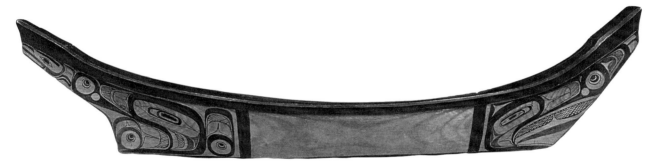

Fig. 5.35. Model canoe painted by Charles Edenshaw, representing the full-sized canoe destroyed by Albert Edward Edenshaw at his house-raising potlatch at *k'yuust'aa;* 72.5 by 18.5 by 18 cm. Commissioned by John Swanton, 1901. American Museum of Natural History, cat. no. 16/8773. Photograph by the author.

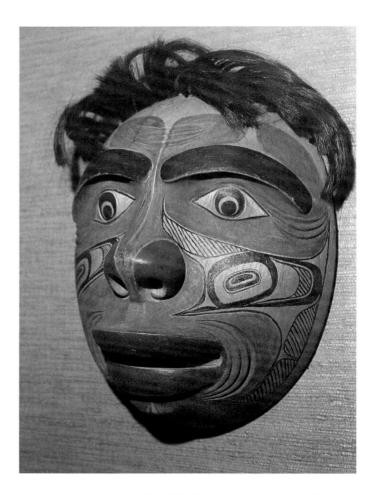

Fig. 5.36. Humanoid mask made by Charles Edenshaw. Commissioned by John Swanton through Henry Edenshaw, 1902; 30 by 21 cm. American Museum of Natural History, cat. no. 16.1/128. Photograph by Bill Holm.

destroyed by Albert Edward Edenshaw at the *7waahlal* potlatch held at the completion of his Myth House in *k'yuust'aa* (Swanton 1905a: 126, 135, fig. 16). The painted designs on several other model canoes have also been tentatively attributed to Charles Edenshaw (Royal Scottish Museum cat. no. 6.304.109; Burke Museum cat. no. 1–3004; Seattle Art Museum cat. no. L93.1) (see Brown 1998: 112; Holm 1987: 144–145). The model canoes themselves were probably made by others who specialized in canoe making.

Though Charles Edenshaw is not known to have carved any full-sized canoes, he did paint canoes that had been made by others. One of these full-sized canoes was made by Alfred Davidson and his brother Robert Davidson, Sr. The canoe had been ordered by a Seattle company in 1908, probably for display at the Alaska Yukon Pacific Exposition held in Seattle in 1909. According to records in the Canadian Museum of Civilization, the Davidsons, after working for eight months on the canoe, felt that the price of $200 offered by the Seattle company was too low. In 1910 they sold it instead to R. W. Brock for $500. It later went to the Canadian Museum of Civilization (cat. no. VII-B-1128) (see MacDonald 1996: 134, plate 99).

Only two masks are known to have been carved by Charles Edenshaw, and both of them were made for sale. John Swanton commissioned one of them after he returned to New York, and it was shipped to the American Museum of Natural History (fig. 5.36). The other was collected by the Reverend Charles Harrison, the Anglican missionary in Massett (fig. 5.37). Harrison described this transformation raven mask as representing Ni-kils-tlas, "with an Indian standing on top and a human face in miniature in the centre of the forehead. The

Fig. 5.37. Transforming raven mask made by Charles Edenshaw. Collected by the Reverend Charles Harrison. Pitt Rivers Museum, Oxford, cat. no. 1891.49.8. Photograph by Bill Holm.

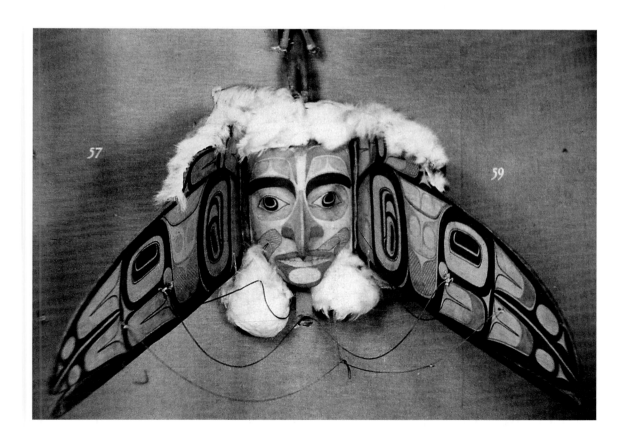

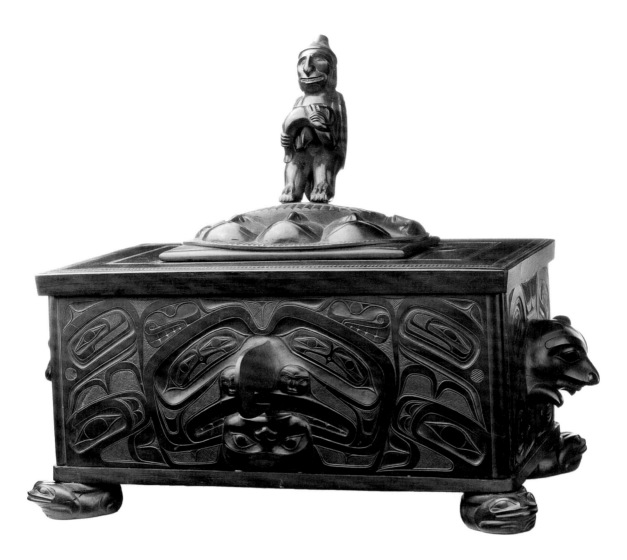

Fig. 5.38. Argillite chest by Charles Edenshaw, showing Raven transforming into human form while standing on the clam shell with the first humans emerging; 45.5 by 30 by 37 cm. Courtesy of the Royal British Columbia Museum, cat. no. 10622, neg. no. CPN-10622.

symbolism it was intended to convey being the raven as the creator or perhaps the original ancestor of man, and the raven's male slave" (Bedford 1998). The mask opens to reveal a female face within, and a small, puppetlike figure on the top folds down when the mask is closed.

Charles Edenshaw's carvings often represent narrative scenes drawn from Raven creation stories. An argillite chest in the Royal British Columbia Museum (fig. 5.38) has Raven discovering the first humans in the clamshell on the lid. He also depicted the first humans coming out of the clamshell on a walrus ivory cane handle (see *American Indian Art,* vol. 2, no. 2, 1977, p. 1). The sequel to this story, the sexing of human beings, is shown on three argillite platters, one of which is illustrated in figure 5.39.[27] John Robson, too, was fond of carving episodes from the Raven stories. An argillite chest made by Robson (and once attributed to Edenshaw) depicts the story of Raven eating the eyes of the sky people (fig. 5.40). Raven's adopted mother reclines on the lid, surrounded by small heads, each missing one eye. Raven in human form is shown holding a basketful of eyeballs (see chapter 1). No other depictions of this story are known from the nineteenth century.[28]

Canes with ivory handles and silver ferrules were a specialty of Charles Edenshaw's; he made them both for his own use and for sale (Hoover 1995).

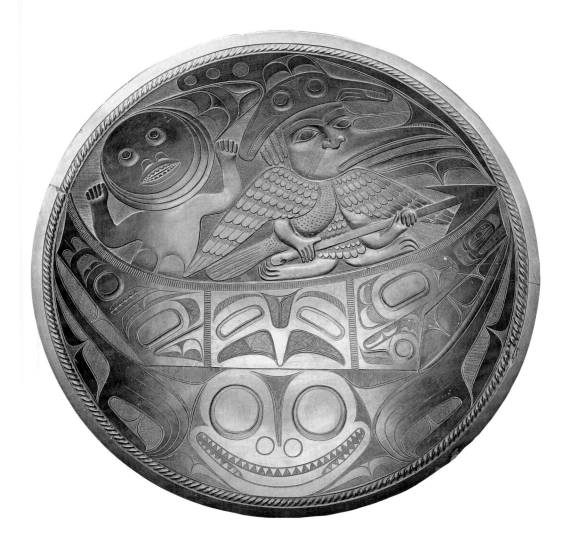

He sold two to James Swan in Massett in 1883. In his diary entry for July 19, 1883, Swan wrote: "Charley Edinso has two splendid canes. Serpents twined around a stick. One has a clenched hand of ivory and the other an eliphants head the design taken from a picture of Jumbo. he asked $10 each." In another version of this account, Swan elaborated on the sources of these motifs:

> He showed me two beautiful canes nearly finished, each representing a serpent twined around the stick which was a crab apple sapling, two inches in diameter with the serpent of life size around it, on the top of one was a clinched fist holding a stick and the other was an elephants head, both were carved in walrus tooth ivory. I found on questioning Charley that he got the idea from a London Pictorial newspaper which he showed me. The clinched fist was from Laoccoon grasping a serpent and the elephant, was from a picture of Barnums Jumbo, representing the hoisting on board a steamer when bound to New York. Underneath each ivory carving was a silver band around the cane, elaborately carved with Indian devices. (Swan 1883b: 23)

Swan purchased both of these canes. He retained the one with the fist in his own collection; it later went to the Jefferson County Historical Museum in Port

Fig. 5.39. Argillite platter representing the story of the sexing of human beings, attributed to Charles Edenshaw, 32.9 by 5.7 cm. Gift of John H. Hauberg. Courtesy of the Seattle Art Museum, cat. no. 91.1.127. Photograph by Paul Macapia.

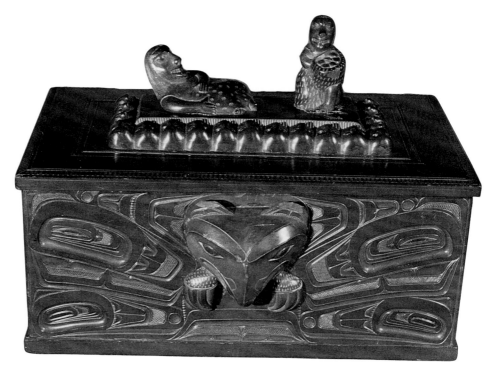

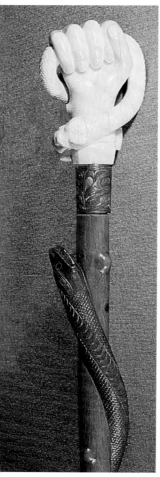

Townsend, Washington (fig. 5.41). He gave the elephant cane to his brother; it eventually went to the American Museum of Natural History (cat. no. 16/737), although the elephant-head handle is now in the Royal British Columbia Museum (fig. 5.42).[29]

The clenched hand motif is found on four other canes, two of which have serpents held in the hand and entwined around the shaft.[30] Laocoön in Greek mythology was Apollo's priest who was crushed to death by a serpent for trying to warn his fellow citizens about the Trojan horse. The Hellenistic marble sculpture of this event was a famous icon to nineteenth-century Europeans, and through the medium of newsprint it had made its way to Haida Gwaii by 1883. Images of current events from England were equally available in printed media brought around the world. The dramatic account of Jumbo's valiant struggle to avoid being shipped from the London Zoo to the United States after he was purchased by P. T. Barnum was recounted in the February 25 issue of the *Illustrated London News*. This article was accompanied by two full-page illustrations, one showing Jumbo being forced into a crate (fig. 5.43) and the other showing five different views of his life at the zoo. One view shows his tusk before it was broken off, much as it appears on Edenshaw's cane handle. A later issue showed Jumbo on the cover giving rides to children before his departure (*Illustrated London News*, March 18, 1882, p. 1).

In one of two known photographs showing Charles Edenshaw carving (fig. 5.44), two canes with entwined serpents on the shaft can be seen leaning against the wall. Beaver designs on cane handles were also favorites of his, and it was such a design that Edenshaw had on his own cane, the shaft of which is visible in fig. 5.63 (see Hoover 1995: 46, fig. 4).[31]

A fifth cane with an ivory handle in the form of a clenched fist was recently brought to my attention by Peggy Whitehead at the Denver Museum of Natural

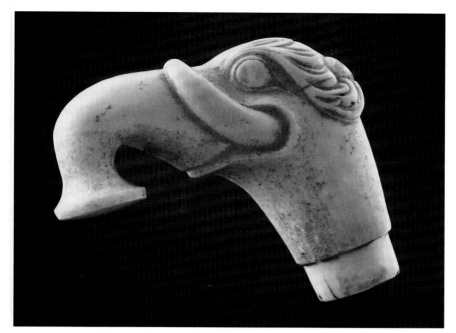

Fig. 5.42. Walrus ivory cane handle made by Charles Edenshaw in the form of the head of Jumbo the elephant, 6.8 by 5.7 by 2.7 cm. Sold to James G. Swan in 1883. Photograph courtesy of the Royal British Columbia Museum, cat. no. 16471, neg. no. CPN-16471.

Fig. 5.43. Jumbo the elephant being forced into a crate for shipment after P. T. Barnum purchased him from the London Zoo. This illustration was shown to James G. Swan by Charles Edenshaw as the source for his Jumbo cane handle. From the *Illustrated London News*, February 25, 1882, p. 200.

Fig. 5.44. Charles Edenshaw carving in his home, circa 1906. An argillite pole stands on the bench, and two canes with snakes lean against the wall. Courtesy of the Royal British Columbia Museum, neg. no. PN5168.

History (fig. 5.45). This cane was collected from David Peele, the great-grandson of Chief Son-I-Hat of Kasaan (b. 1832; d. 1912). David Peele reported that this cane had been carved for Chief Son-I-Hat by Albert Edward Edenshaw. The fist handle fits very closely with the other ivory fists carved by Charles Edenshaw on his cane handles. The raised wrist knob, the delicate fingernails, and the raised ridges running from the knuckles on the back of the hand all suggest that this is Charles's work. The unusual carving on the shaft of the cane, however, seems very different from either Charles Edenshaw's or Albert Edward Edenshaw's style of carving. This may again be a case in which the gift giver has been assumed to be the maker, when in fact the work was produced by other artists.[32]

In addition to direct commissions from ethnographers such as Boas and Swanton, Charles and Isabella Edenshaw (fig. 5.46) also had an outlet for their work through the trading post owned by Robert Cunningham at Port Essington. Both Charles's argillite carvings and his and Isabella's collaborative work, as well as basketry mats, cylindrical baskets, and hats woven by Isabella and perhaps other female members of his family and painted by Charles, were sold in large numbers through this outlet. Alan Hoover (1995: 50) pointed out that most of the basketry hats made by Isabella and painted by Charles, if not all of them, were probably made for sale. This is likely true of the painted basketry mats and baskets as well. The weaving of the hat or basket would have taken much longer than the painting, and it seems that Charles Edenshaw developed a hat painting style that was suited to rapid decoration. These hats usually have a single crest figure wrapped around the flaring brim and his signature four-pointed star on the crown, with the points painted black on one side and red on the

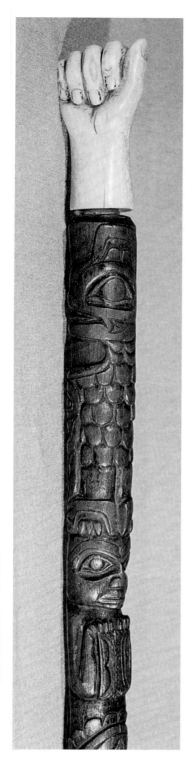

Fig. 5.45. Cane with ivory handle. The handle is attributed to Charles Edenshaw, 102 by 3.5 cm (shaft), 5 by 3.5 by 8.6 cm (fist handle). Purchased from David Peele, great-grandson of Chief Son-I-Hat of Kasaan. Denver Museum of Natural History, cat. no. AC.11510. Photograph by the author.

Fig. 5.46. Photograph of Isabella Edenshaw. Photograph courtesy of Violet Edgars, Old Massett, B.C.

Fig. 5.47. Painted spruce-root hat with whale design, made by Isabella and Charles Edenshaw, 43.2 by 14 cm. Gift of John H. Hauberg. Courtesy of the Seattle Art Museum, cat. no. 83.226. Photograph by Paul Macapia.

other (figs. 5.47, 5.48). Recent research into the weaving style of these hats has revealed techniques that are equally definitive signatures of Isabella Edenshaw:

> Isabella Edenshaw's style can be seen in the appearance of the *mamatsiki* [concentric diamonds] motif in conjunction with four-ply twining (especially S-twining) at the perimeter of the top, the absence of special demarcation at the lower perimeter of the crown, and the use of four-strand braid . . . as brim finish when, and this is essential, the construction of the top, crown, and brim of the hat is in accord with the standard Haida formula. (Laforet 1990: 295)

The figures represented on these collaborative pieces include many of the figures Charles used in other media. On the thirty-one known hats attributed to the Edenshaws, there are ten with frogs, nine with ravens, four with sharks, three with whales, one with a beaver, one with a hawk, one with a sculpin, one with a long-beaked bird, and one with a sea lion. Seven painted mats include three with sea lions, one with a halibut, one with a sculpin, one with a mosquito, and one with a bear. Of seven cylindrical baskets, there are two with Wasgo figures, one with a whale, one with a beaver on the outside and a salmon inside, one with a frog, one with a bird, and one with a frog and a whale.

Charles and Isabella Edenshaw's lifestyle during the 1880s, 1890s, and the first decade of the twentieth century — the period of his greatest artistic production — has been described by their daughter, Florence Davidson, who was born in 1896. As his uncle had before him, *da.a xiigang* and his family made frequent seasonal visits to places such as Juneau, Port Essington, Fort Simpson, *gasa.áan, hlanqwáan,* Ketchikan, and Victoria in the spring and summer. There

Fig. 5.48. Painted spruce-root hat with frog design, made by Isabella and Charles Edenshaw, 42 by 19 cm. Collected by C. F. Newcombe at New Kasaan, 1902. Field Museum of Natural History, cat. no. 79504. Photograph by Bill Holm.

Charles would carve and sell his work, and Isabella would sell her baskets and work in canneries. During the winter he carved in a shed behind the house in Massett while Isabella wove basketry. After the children were grown, he began carving in the house. According to Davidson, her father prayed every morning before he began to work, and he was a devout member of St. John's Anglican Church in Massett (Blackman 1982: 79).

In 1896, Charles Edenshaw and his family stopped at Rivers Inlet, where many Massett people were working in a cannery, including Amy Edenshaw and her new husband, Phillip White, whom she married after the death of Albert Edward. Charles and Isabella's son, Robert (*ginaawaan*), stayed there while his parents went on to Fort Simpson. He was later drowned in a swimming accident, and his parents were told as they waited for him in Fort Simpson. This was a terrible blow to the entire family. The loss to Charles must have been deeply felt, for *ginaawaan* was a promising carver when he died. One wonders whether any of his carvings survive, though none has been identified. Florence Edenshaw was born the next month, and according to her, they were disappointed that she was not a boy who could take *ginaawaan*'s place (Blackman 1982: 76). As it turned out, Florence became a treasured child to Charles, for she was considered the reincarnation of his mother, *q'àaw quunaa* — his mother's "second birth." Her first words were, "Dad, I'm your mother" (Blackman 1982: 78). When Florence was very small, Charles was out collecting driftwood when he filled his canoe too full and tipped over. He was rescued by Robert Williams's father and Tl'a?ˢuntz, a former slave. Because his rescuers were from the opposite moiety, Charles subsequently hosted a face-saving potlatch and gave out money to the opposite side to erase the memory of the embarrassing event (Blackman 1982: 84). This may have been the last potlatch hosted by Charles Edenshaw.

Edenshaw's eyesight and health are said to have declined after 1910, and his art production probably declined in quality and tapered off in quantity during the last ten years of his life, though he is said to have carved until his death (Barbeau 1957: 158, 182).[33] Charles Edenshaw's career remains remarkable for the quality and range of objects he produced over a sixty-seven-year period, as well as for its stylistic and narrative innovation, which expanded traditional Haida style beyond its previous boundaries.

Isaac Chapman

Robert Cunningham promoted not only Charles and Isabella Edenshaw's work but also the work of a man named Isaac Chapman. In the process, he or his sone, George, or both indulged in a bit of marketing strategy that confused the record about Chapman. Much misinformation has been published about a so-called rivalry between Chapman and Charles Edenshaw. This story began as a fanciful label written by George Cunningham to advertise the family's collection of argillite carvings (Barbeau 1957: 181). Barbeau recorded a portion of this label:

> The history of Chapman is as pathetic as it is entrancing. In one of the intertribal wars of the last century, his parents, who belonged to the Bella Bella tribe, were captured by the Haidas, that war-like nation known as the Vikings of the Pacific. Young Chapman was born while his parents were in captivity, and his family, after a prolonged association with their conquerors, preferred to remain on the island after they were freed rather than go back to the mainland. The boy, a cripple and an alien, grew up at Massett, and made friends around him. At a very early age he displayed a precocious ability as a carver, using rude tools of bone and shell manufactured by himself, but he died before reaching his thirtieth year. His skill was such, however, that in his numerous carvings he produced some of the choicest samples of the art as preserved in this collection. . . .
>
> Mr. Cunningham [Robert] first met Charlie Edensaw, then a comparatively young man, at the time when he [Cunningham] was travelling on a lumber schooner that called at Massett, an Indian village near the northeast end of the Queen Charlotte Islands. This meeting ripened into friendship, and during subsequent visits the white man had the opportunity to observe the work of the chief and of the crippled boy, the son of a slave.
>
> Competition seems to have existed between the chief and the cripple, the chief holding himself above any recognition of the poor alien lad, never addressing him directly, and unable to check his pride and jealousy. . . . When the chief, later, visited Cunningham and could not help noticing some of Chapman's carvings in the trader's possession, he proudly dismissed them with the remark, "This may be all very good, but I will show you something better," and he would proceed to carve, on the spot, a new and finer piece, illustrating his own family story.
>
> The most highly prized of the totems passed from the hands of Charlie Edensaw to Cunningham senior at such a moment of pique. It turned out to be a genealogical tree of the Edensaw family, and Edensaw was known to concentrate upon the history of his own clan. (Barbeau 1957: 180–181)

Barbeau explained the extreme inaccuracy of this story, pointing out that Isaac Chapman was not a slave but a member of a Haida Eagle clan. His information came from Peter Hill, Alfred Adams, and Edward Russ of Massett, though Barbeau somewhat confused their comments about Chapman's parents. He correctly reported that Isaac Chapman was adopted by Benjamin Bennett, that Isaac also went by the name Ben Bennett, and that his true father was James Sykes, a chief of the *kuna'laanaas* (Swanton's R14) at *hl7yaalang*. He later identified Chapman's true father as Kwaiwas, a leading chief of the *yahgu 'laanaas* Ravens (Barbeau 1957: 180), but perhaps he meant Chapman's adoptive father. Another account, which Barbeau received from Andrew Brown, identified Chapman's father as a white person. Recent research into Isaac Chapman's genealogy has revealed more about his family relationships (see chart 6).

We know from information given to Barbeau by Peter Hill that Isaac Chapman was not a slave, but he was crippled. His Haida name was *skilee* (also spelled Skelai, Skelay, and Skilé), and his father was James Sykes, a chief of the *kuna'laanaas* from *hl7yaalang* village who occupied a high place at the end of the village (Barbeau 1916–1954: B-F-258.4). Though Barbeau suggested that Chapman and Edenshaw might have been distant relatives, Hill denied this, saying they were of different tribes. We know from Edward Russ's account that *skilee*'s birth mother was *jast'aalans* (Nellie, b. 1871), of the *du.ugwaa tsiij git'a-nee* Eagles, and that he was her oldest boy. She gave her son to her sister, *jask-ilaas* (Eileen or Ellen?), who adopted him with her husband, Ben Bennett. Eileen and Ben Bennett also adopted Alice (Isaac Chapman's half-sister). Ben Bennett later changed his name to Chapman, and it was then that *skilee* took the name Isaac Chapman.

Russ gave a long account of the carving of one of the first totem poles at *yaan*, which he attributed to a man named Oti wans (*ruud 7iw7waans*), who was *jast'aalans*'s uncle. Oti wans built a house named *na k'udang qins* at *yaan* (fig. 5.49). Swanton listed House 14 (MacDonald's House 11) at *yaan* as Na k!ō'dañ qens, "house looking at its beak," saying that on this house, the carved block of wood that in old times took the place of the house pole bore the beak of a bird standing out in front. MacDonald (1983: 167, plate 227) suggested that this ancient-style house frontal pole was on the predecessor of this house in a different village. Swanton (1905a: 292) listed the owner of the house as *sdiihldaa* (Stī'łta, "returned"), of the *tuuhlk'aa git'anee* (E16). This suggests that *ruud 7iw7waans* was one of the names of this *sdiihldaa* (see below).

According to Russ, *skilee* started carving argillite poles when his uncle was still alive. Russ also told Barbeau that *skilee* was healthy when he was born but injured one leg as a child and used two canes to walk. He was born around 1880 and died in about 1907. He had a touch of tuberculosis, and after being capsized near North Island while fishing and being in the water for some twenty minutes, he never recovered. He was sick in bed for two years before he died (Barbeau 1916–1954: B-F-256.13).

Although Barbeau did clarify the fictitious nature of the Cunningham story about Isaac Chapman, he also misidentified several of Charles Edenshaw's argillite model poles as being by Chapman (Barbeau 1957: 179–199), thoroughly confusing the record on what Chapman's carving style really was. Of the thirty-seven argillite poles Barbeau attributed to Chapman, at least eighteen can now be attributed to Charles Edenshaw.[34] Several of these poles have gone to the

Chart 6. The family of *skilee* (Isaac Chapman).

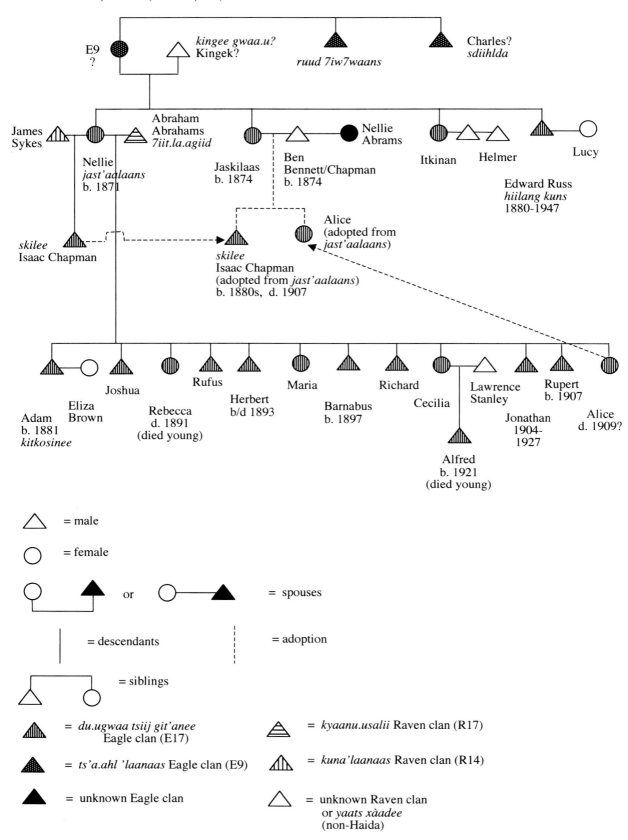

= male

= female

= spouses

= descendants

= adoption

= siblings

= *du.ugwaa tsiij git'anee* Eagle clan (E17)

= *ts'a.ahl 'laanaas* Eagle clan (E9)

= unknown Eagle clan

= *kyaanu.usalii* Raven clan (R17)

= *kuna'laanaas* Raven clan (R14)

= unknown Raven clan or *yaats xàadee* (non-Haida)

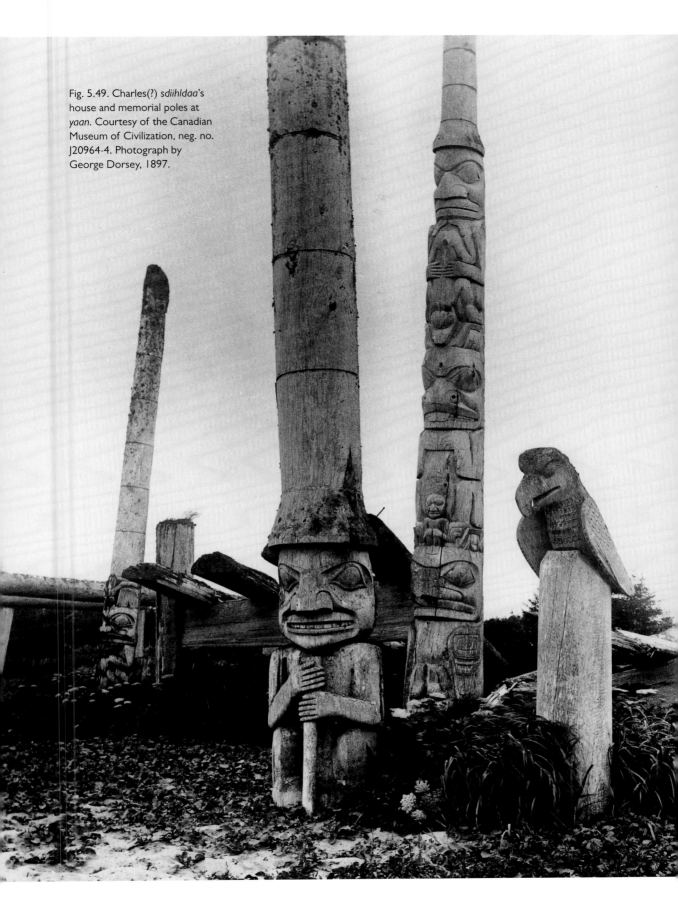

Fig. 5.49. Charles(?) *sdiihldaa*'s house and memorial poles at *yaan*. Courtesy of the Canadian Museum of Civilization, neg. no. J20964-4. Photograph by George Dorsey, 1897.

Art Gallery of Ontario (figs. 5.50, 5.51) and afford us the opportunity to compare the two artists' work closely. Chapman's work can easily be distinguished from Edenshaw's by his consistent use of a compass point in the center of each eye, his frequent use of dashing and stippling in place of formline designs on the wings, and his marked separation of the figures on the poles, unlike Edenshaw's interlocked compositions. Chapman, who was at least forty years younger than Edenshaw, was said to have hung around him and learned from him in Massett, copying some of his argillite poles. A comparison of their work, however, shows that Chapman was unquestionably the less accomplished carver. Any suggestion that his work was as skilled as Edenshaw's must surely arise from the misattributions made by Barbeau.

The first exhibit that featured Charles Edenshaw's work as "fine art" and named him as an artist alongside such Canadian artists as Emily Carr, Paul Kane, and A. Y. Jackson was the 1927 "Exhibition of Canadian West Coast Art" that was mounted at the National Gallery of Canada.[35] The small catalog of this exhibit lists no individual pieces by Haida artists but mentions only "No. 112, Slate Carvings."[36] The text reports: "Many of the best pieces of this kind are the work of the famous Haida chief, Edenshaw, and his faithful Tlingit slave" (National Gallery of Canada 1927). This reference must be to George Cunningham's myth about Isaac Chapman, though it confuses his tribal affiliation even further. This was the first of many repetitions of the "slave" story (Harrington 1949: 201).

sdiihldaa and gwaay t'iihld

Charles Edenshaw's work has been confused with that of a number of other Haida artists who were working in either Massett or Skidegate at the same time he was active, including an artist named gwaay t'iihld (Holm 1981). Further confusion has existed over the true identity and work of gwaay t'iihld and another artist named Simeon sdiihldaa (Wright 1998). The Eagle name sdiihldaa comes from the same Eagle family to which skilee (Isaac Chapman) belonged, the du.ugwaa tsiij git'anee Eagles of yaan. Marius Barbeau was the first to misattribute carvings that we now believe are by Simeon sdiihldaa to Charles Edenshaw in his Medicine-Men on the North Pacific Coast, which credited Edenshaw for the drawings of three of sdiihldaa's shaman figures (figs. 5.52–5.54) that are illustrated in Swanton's ethnography of the Haida (Barbeau 1958: 37, 58; Swanton 1905a: 41, 134). Although Edenshaw did do a number of drawings for Franz Boas, which were published and identified as such in Swanton's book, the drawings referred to by Barbeau were book illustrations no doubt done by a commercial artist in New York, where the sdiihldaa figures were housed at the American Museum of Natural History (Swanton 1905a: figs. 1–3; Wardwell 1996: 55, no. 34).

In 1967, the exhibit "Arts of the Raven," curated by Wilson Duff, Bill Holm, and Bill Reid at the Vancouver Art Gallery, featured an entire gallery (sixty-six objects) devoted to the work of Charles Edenshaw (Duff, Holm, and Reid 1967) — but two of those objects were probably made by Simeon sdiihldaa (Wright 1998: figs. 4, 5). The "Edenshaw Gallery" was primarily Wilson Duff's responsibility, though all three curators consulted on its content. While they did not always agree, their discussions honed their own views on the identity of Haida

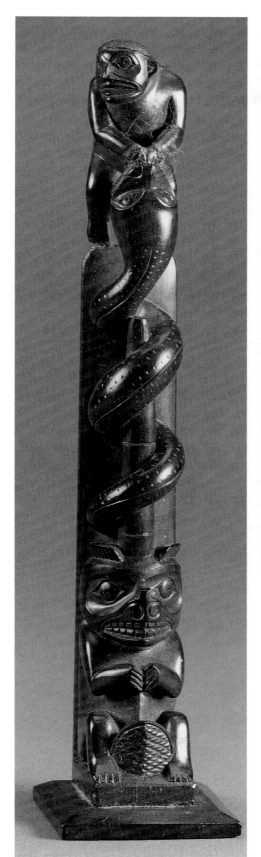

Fig. 5.50. Argillite model pole with snake and beaver, attributed to Isaac Chapman, 63.5 by 15.9 by 3.7 cm. Cunningham Collection, gift of Roy Cole, 1997. Courtesy of the Art Gallery of Ontario, acc. no. 97/175.2, neg. no. 8438#1. Photograph by Carlo Catenazzi.

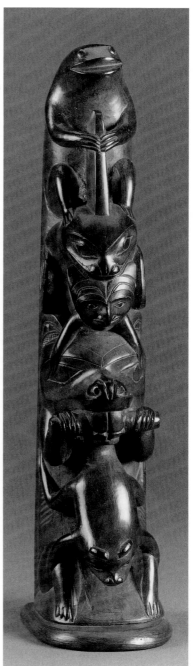

Fig. 5.51. Argillite model pole with beaver and frog, attributed to Charles Edenshaw, 21.0 by 4.7 by 5.8 cm. Cunningham Collection, gift of Roy Cole, 1997. Courtesy of the Art Gallery of Ontario, acc. no. 97/175.35, neg. no. 8464#1. Photograph by Carlo Cantenazzi.

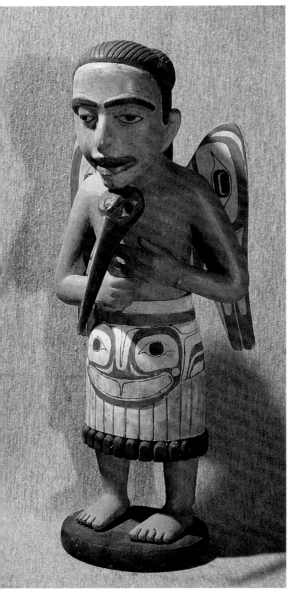

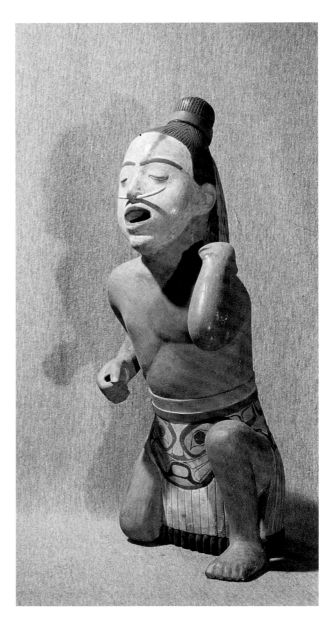

Fig. 5.52. Shaman figure attributed to Simeon *sdiihldaa* (*skil kingaans*), 60 by 25 by 20 cm. Collected by Israel Powell for Heber Bishop, 1880–1885. American Museum of Natural History, cat. no. 16/396. Photograph by Bill Holm.

Fig. 5.53. Shaman figure attributed to Simeon *sdiihldaa* (*skil kingaans*), 51 by 20 by 18 cm. Collected by Israel Powell for Heber Bishop, 1880–1885. American Museum of Natural History, cat. no. 16/397. Photograph by Bill Holm.

artists.[37] Of the sixty-six "Edenshaw" pieces in the exhibit, it now appears that at least twenty were probably not made by Charles Edenshaw. In the exhibit's "Faces Gallery," several unattributed masks that are similar in style were featured (Wright 1998: figs. 6, 7). At the time, Holm has pointed out, there was some speculation about an Edenshaw attribution for this group of masks, but they were eventually left as anonymous Haida masks in the exhibit (Holm 1981: 177).

Bill Holm has wisely said that the business of stylistic attribution is a risky one. Art historians continuously change their minds and reassess previous attri-

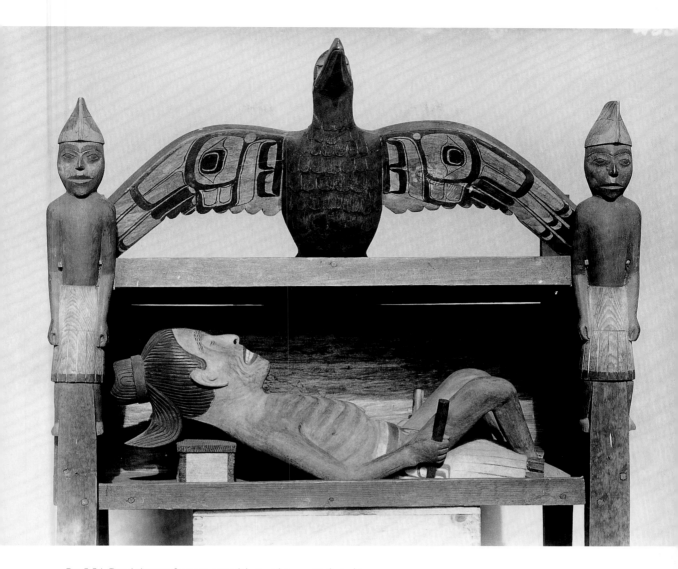

Fig. 5.54. Dead shaman figure in a model grave house, attributed to
Simeon *sdiihldaa (skil kingaans)*, 62 by 33 by 70 cm. Collected by Israel
Powell for Heber Bishop, 1880–1885. Courtesy of the American Museum
of Natural History, cat. no. 16/739, neg. no.445326.

butions when new information comes to light. Between "Arts of the Raven" in
1967 and the publication of Holm's 1981 article, "Will the Real Charles Edenshaw
Please Stand Up?" several pieces that had been thought to be by Charles
Edenshaw were reattributed to other artists. So for a while in the 1970s and 1980s,
the three shaman figures at the American Museum of Natural History, the two
shaman figures attributed to Edenshaw in "Arts of the Raven," and several other
shaman figures, as well as a large number of stylistically similar masks, frontlets,
and rattles, were thought to have been made by "Charles" *gwaay t'iihld.* They
were identified that way in Holm's 1981 article. But new information received
as his article went to press prompted Holm to add a footnote pointing out that
one of the pieces he had attributed to *gwaay t'iihld,* a wooden "sphinx" figure
in the British Museum (fig. 5.55), had documentation indicating that it was carved
by Simeon Stilthda (*sdiihldaa*). He therefore concluded that some of the pieces

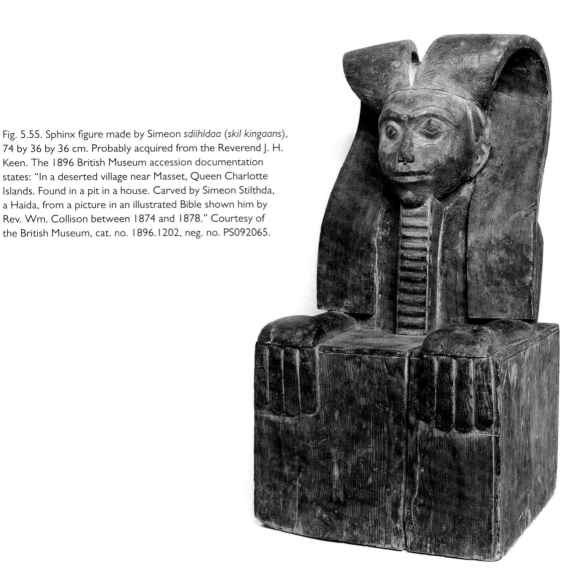

Fig. 5.55. Sphinx figure made by Simeon *sdiihldaa* (*skil kingaans*), 74 by 36 by 36 cm. Probably acquired from the Reverend J. H. Keen. The 1896 British Museum accession documentation states: "In a deserted village near Masset, Queen Charlotte Islands. Found in a pit in a house. Carved by Simeon Stilthda, a Haida, from a picture in an illustrated Bible shown him by Rev. Wm. Collison between 1874 and 1878." Courtesy of the British Museum, cat. no. 1896.1202, neg. no. PS092065.

attributed to *gwaay t'iihld* in his article might actually have been by *sdiihldaa* (Holm 1981: 176). It now appears that almost all of the pieces previously attributed to *gwaay t'iihld* were probably made by Simeon *sdiihldaa*.

The confusion between the artist "Charles" *gwaay t'iihld* (whom we now know was really named John *gwaay t'iihld*) and Simeon *sdiihldaa* can be traced back to the primary source used in the attribution of works to *gwaay t'iihld*, which is a group of Haida masks and the three shaman figures illustrated by Swanton and misidentified by Barbeau (figs. 5.52–54, 5.56, 5.57). These pieces are all part of the Bishop Collection of nearly eight hundred Northwest Coast objects acquired between 1880 and 1885 for Heber Bishop, a trustee of the American Museum of Natural History, by Israel W. Powell, the Indian Superintendent of British Columbia. A note in the catalog entry associated with mask 16/362 (fig. 5.56), the first in the series of twenty-three Haida masks, says: "This mask and the following ones are evidently made for sale only. They are entirely different [in] character from other masks as are really used in dances [which] have a mythological meaning" (Franz Boas's catalog of the Bishop Collection,

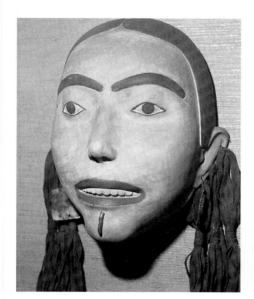

Fig. 5.56. Young woman mask attributed to Simeon *sdiihldaa (skil kingaans)*, 22 by 18 cm. Collected by Israel Powell for Heber Bishop, 1880–1885. American Museum of Natural History, cat. no. 16/362. Photograph by Bill Holm.

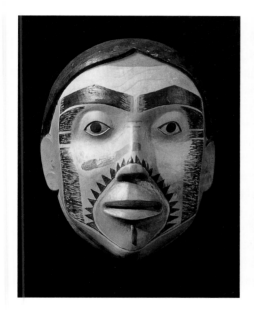

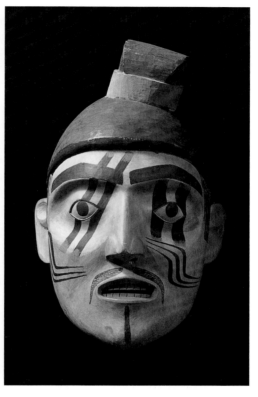

Fig. 5.57. Young woman mask made by John *gwaay t'iihld,* 24.4 by 18.5 by 9 cm. Collected by Israel Powell for Heber Bishop, 1882. An inscription on the back reads: "Carved by Quaa-telth Masset Qn. Char. Is. 1882." American Museum of Natural History cat. no. 16/364, neg. no. 318694. Photograph by Charles Coles, 1942.

Fig. 5.58. Shaman mask attributed to John *gwaay t'iihld,* 34 by 20 cm. Collected by Israel Powell for Heber Bishop, 1880–1885. Courtesy of the American Museum of Natural History, cat. no. 16/372, neg. no. 318694. Photograph by Charles Coles, 1942.

American Museum of Natural History). Only one of these twenty-three masks (fig. 5.57) is specifically documented as being by a named artist, "Quaa-telth," and an inscription is written on the back of the mask: "carved by Quaa-telth, Masset, Qn. Char. Is., 1882." This mask is similar in style to at least five of the other masks in this group, as well as to the three shaman figures, and for this reason it was assumed by various scholars that the six masks and three figures were all by the artist *gwaay t'iihld.*

Jonathan C. H. King, in his *Portrait Masks of the Northwest Coast of America*, illustrated four of the Powell masks on one page, attributing them all to Quaatehl (King 1979: 71, fig. 69). In fact, three different artists probably produced these four masks: John *gwaay t'iihld* (figs. 5.57, 5.58), Simeon *sdiihldaa* (fig. 5.56), and a third, as yet unidentified artist (AMNH 16/363) who worked in a clearly different style (Wright 1998). Of these four masks, only the portrait mask of a young woman wearing a small labret (fig. 5.56) displays the classic stylistic characteristics described by Holm for *gwaay t'iihld* (who we now know is not *gwaay t'iihld* but *sdiihldaa*). It has

small eyes, by Haida standards, on a moderate orb. The eyelids are open, with little or no constriction, and they have a narrow black rim. The inner ovoid is round. The space between the long, narrow and slightly arched brows and the eye is wide and shallowly recessed. The orbs continue well below the eyes before giving way to full round cheeks. These cheeks have a naturalistic relationship to the corners of the mouth, which are slightly recessed. The lips are narrow and rounded, tending to be less ribbon-like and more naturalistic than is usual for Haida sculpture. The nose is very narrow and rather long, with small unflared nostrils. Full cheeks merge smoothly with a prominent, rounded chin. . . . One of the most individualistic conventions of Gwaytihl's sculpture is the form of the ears. They are rendered naturalistically but invariably stand well out and taper at the bottom to a small lobe. This form is unique to Gwaytihl's work. . . . Gwaytihl regularly rendered the hair on his masks and carvings in a naturalistic manner, modelling well-defined parallel grooves. At least one mask has attached hair and many are fitted with fur moustaches and beards. A few have moveable eyebrows of furred skin. Gwaytihl also frequently added nose rings, ear pendants and small lip pins to his wooden faces and he sometimes mechanized his masks to move eyes, lower eyelids, raise brows and open lips. With all this he retained his conventionalized proportion and form of the facial features. Gwaytihl's portrait masks are small, barely large enough to fit on a face. Those with mechanized features, particularly eyes, are cluttered in the inside with strings and moving parts which makes them difficult or impractical to wear. This is consistent with the statements that the masks were made for sale to foreigners and not for Haida use. (Holm 1981: 180–181)

I would add to this description the distinctive positioning of the ears, which, when viewed from the front, can be seen to align at their top with the deepest part of the eye socket, below the lower eyelid, while the earlobes align at the bottom with the middle of the mouth or the lower lip. These characteristics can be seen to be consistent in five of the masks collected by Powell as well as in a large group of masks found in museums throughout the world.[38]

Four headdress frontlets depicting young women without labrets fit clearly within this style (figs. 5.59, 5.60, Oakland Museum cat. no. H79.5.97 [Wright 1998: fig. 10], and Canadian Museum of Civilization cat. no. VIIB25 [Wright 1986: 40]). The Oakland frontlet has inlaid abalone in patterns consistent with the traditional Haida use of facial paint. The other three have unembellished faces. Although most of the masks in this group were probably made for sale and never

worn, we know that at least one of the frontlets was worn (fig. 5.60), as seen in a group photo taken in Skidegate around 1890 (Wright 1998: fig. 11). This frontlet was collected by George T. Emmons shortly after the photo was taken; he recorded that it was commissioned as a portrait of a Haida chief's daughter who had died young (Emmons 1914: 66). By this time, the practice of piercing the lower lips of high-ranking women had been discontinued. Several of the women in the photograph, however, were proudly wearing facial paint in traditional patterns and eagle down in their hair — one of the few such ceremonial displays documented photographically in the nineteenth century.

Like potlatching and other traditional displays of inherited crests, the practice of shamanism had been actively discouraged by missionaries in the Queen Charlotte Islands starting in the late 1870s. Nevertheless, artists were able to create images of shamans for sale to outsiders, who had a fascination with such practices even while abhorring them. In addition to the three shaman figures in the American Museum of Natural History (figs. 5.52–5.54), there is a shaman figure by the same artist in the DeYoung Museum in San Francisco (cat. no. X7152), and three in the Horniman Museum in London (cat. nos. 2911a, b, c). A Janis-headed figure in the Alaska State Museum in Juneau (II-B-798) is unique, and there are two figural groups showing shamans torturing witches that are similar to each other (Phoebe Hearst Museum 2–15545; Alaska State Museum IIB801). In addition, there are four figures of dead shamans carved with remarkable naturalism, depicted as they would have been laid out in their graves with their tools in their hands, one complete with the surrounding grave house (fig. 5.54, Princeton University 5160, British Museum 1944.AM2.131, St. Louis Art Museum 132 [Wardwell 1996: 89, no. 63 and no. 64; 50, no. 31; and 55, no. 34]). Despite their sunken, corpselike faces, the shapes of the eyes, eyebrows, nose, chin, lips, and ears clearly link these dead shaman figures with the others.

This brings us back to the remarkable sphinx figure in the British Museum (fig. 5.55). The catalog entry for this piece says: "In a deserted village near Masset, Queen Charlotte Islands. Found in a pit in a house. Carved by Simeon *sdiihldaa*, a Haida, from a picture in an illustrated Bible shown him by Reverend Collison between 1874 and 1878."[39] The piece was purchased by British Museum Keeper A. W. Franks in 1896. The dates of probable manufacture could be adjusted to between 1876 and 1879, because Collison arrived in Fort Simpson in 1873 but did not move to Massett until 1876, and he stayed there until the spring of 1879. The information about Simeon *sdiihldaa* and the circumstances surrounding the carving must have come indirectly from Collison, who was in Metlakatla, through the Reverend J. H. Keen, the missionary in Massett at the time Franks purchased the sphinx. Keen may have been the one who found the sphinx in the house pit. The village referred to is probably *yaan*, across the inlet from Massett, since this was the home village of Simeon *sdiihldaa*. The residents of this village had all moved to Massett by the 1890s, and *sdiihldaa* was probably no longer alive at this time (see below).

Simeon *sdiihldaa*'s sphinx does not end in a lion's body but shows human shoulder blades on its truncated body. It may be that the view of the sphinx in Collison's Bible was a frontal one, not revealing the lion's body, which might account for *sdiihldaa*'s shortened view. Comparing the knobby chin, rounded orb with small eyes, open eyelids, pinched nose, and low naturalistic ears, we can see the work of the same artist who made the shaman figures and portrait

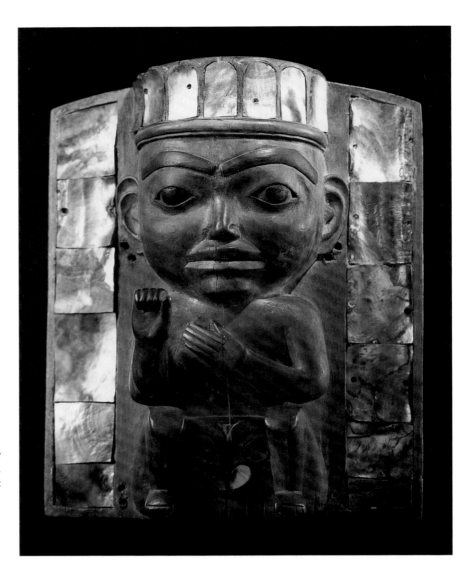

Fig. 5.59. Headdress frontlet attributed to Simeon *sdiihldaa* (*skil kingaans*), 18.4 by 14.6 by 6.2 cm. Acquired in 1990. Penciled inscription reads: "Bella Coola, B.C. Oct. 1943." Courtesy of the Royal British Columbia Museum, cat. no. 19008, neg. no. CPN 19008.

masks. Combined with the British Museum's documentation, the stylistic evidence suggests that the maker of all of these works is Simeon *sdiihldaa* and not *gwaay t'iihld*.

The portrait masks and figures, being naturalistic in style, do not utilize the stylized formline design features that characterize much of Haida sculpture. Several of the shaman figures, however, wear aprons that have been painted like shamans' leather garments, and they allow us a glimpse of *sdiihldaa*'s two-dimensional formline design style (figs. 5.52–5.54). These relatively thin, rounded formlines might seem similar to Charles Edenshaw's work, which is also characterized by rounded, narrow to medium-weight formlines. The lower eyelid lines on *sdiihldaa*'s formline paintings, however, are more angular on their bottom edge than are Edenshaw's. And *sdiihldaa* seems to have preferred a long tertiary split-U design within formline Us, whereas Edenshaw's favored pattern tends toward a combination of stacked secondary and tertiary split Us.

There are a number of sculptures that include both portraitlike faces and formline designs, giving us a better understanding of *sdiihldaa*'s formline style. These

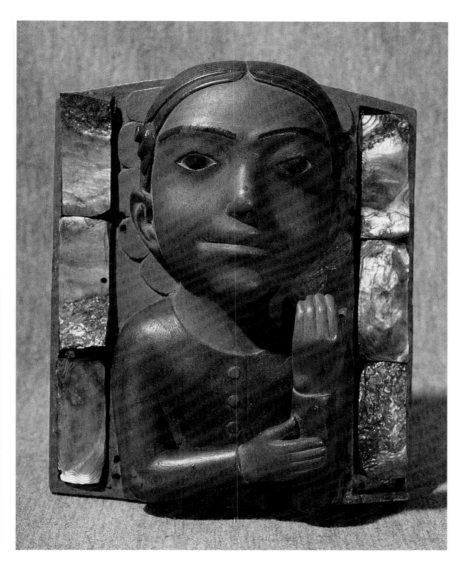

Fig. 5.60. Headdress frontlet attributed to Simeon *sdiihldaa* (*skil kingaans*), 18.5 by 15.5 by 7.5 cm. Collected by George T. Emmons. Courtesy of the National Museum of Natural History, Smithsonian Institution, cat. no. 221176. Photograph by Bill Holm.

include a number of headdress frontlets, rattles, and model poles. A whale front-let in the Brooklyn Museum (fig. 5.61) has a portraitlike face in the upturned tail of the whale. This face has the knobby chin, open centered eyelid lines, and eye-socket features of the *sdiihldaa* style. The main whale's head has ovoid-delin-eated eye sockets, yet, in much the same way as in the portrait faces, the orb of the eye extends both above and below the open eyelid line. Perhaps most dis-tinctive in *sdiihldaa*'s formline-style facial sculpture is the shape of the nose, with the bridge rounded and raised, ending in small round nostrils. A bear frontlet in the Hauberg Collection of the Seattle Art Museum (Seattle Art Museum 1995: 100–101) shows a similar eye-socket and nose arrangement. Two beaver frontlets (Jonaitis 1988: 32, plate 15; AMNH 16/245) are also similar in style, with the orb of the eye bulging above the eyelid line and the rounded, raised bridge of the nose ending in small round nostrils. Eyebrows in the formline style are broader and more peaked in the middle than those on the portrait faces, but they are still relatively thin and rounded in comparison with most Haida-style eyebrows.

These frontlets in turn link this artist to six bear rattles that are similar in

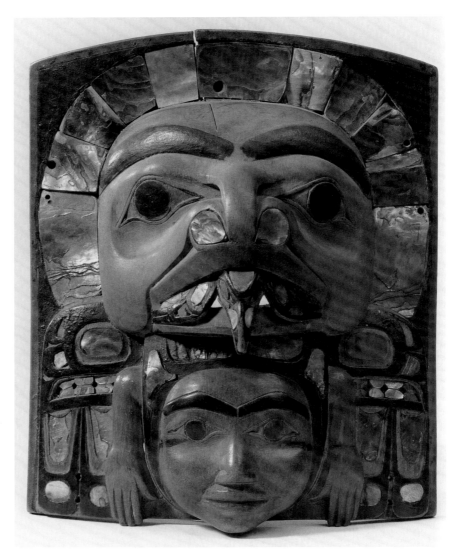

Fig. 5.61. Whale head-
dress frontlet attributed
to Simeon *sdiihldaa* (*skil
kingaans*), 17.9 by 14.8 cm.
This frontlet was photo-
graphed being worn by a
Kwakwaka'wakw man and
published by Franz Boas
(1897: plate 47).
Anonymous loan to the
Brooklyn Museum.
Courtesy of the Brooklyn
Museum, cat. no. L52.3.

style, one of which is shown in figure 5.62.[40] The bear's head forms the globe
of the rattle. A human figure is draped between the bear's ears, with its head
over the bear's nose and its feet behind the bear's head. On three of the six rat-
tles, the small human faces have formline-type facial structures, whereas the
others are of the portrait type. On the large bears' heads, the shape of the eyes
and the eyelids on the orbs of the eyes, as well as the thin rounded eyebrows,
remind us of the portrait masks, while the structure of the ovoid eye sockets
and their relationship with the snouts and nostrils link these rattles with the
animal frontlets discussed earlier.

Having established a large body of work for this artist, the question remains,
who was Simeon *sdiihldaa*? Several men with the name *sdiihldaa* lived in the
villages of Massett and *yaan* in the late nineteenth century.[41] When the first mis-
sionary, the Reverend William Collison, arrived in Massett in 1876, a famous
Eagle chief named "Stelta" lived in a house with his name above the door
(MacDonald 1983: 146, plate 194). According to Swanton (1905a: 290), this house
was named Eagle House, and it belonged to the *srajuuga.ahl 7laanaas* (E14).

Above the name Stelta over the door was an eagle, a Euro-American ship's carving, which, according to Charles Harrison (1925: 173), had been taken from the ship *Susan Sturgis* when it was plundered by Chief *7wii.aa*, perhaps in collaboration with both *sdiihldaa* and Albert Edward Edenshaw (see chapter 3).

Chief *sdiihldaa*'s death in 1877 was described by Collison, who quoted *sdiihldaa* as saying on his deathbed, "Had I lived, I should have been first in the way of the Great Chief above." According to Collison, immediately after *sdiihldaa*'s death, grief overcame his aged father, and he "rushed to the fire and threw himself on it. Assisted by another chief I rescued him but not before he had been badly burnt." Chief *sdiihldaa* was the first person in Massett to receive a Christian burial, as insisted on by Collison (Collison 1915: 188–191). He was succeeded by his brother (which suggests that he might not have had a nephew), who then took the name *sdiihldaa* (Collison 1915: 213).

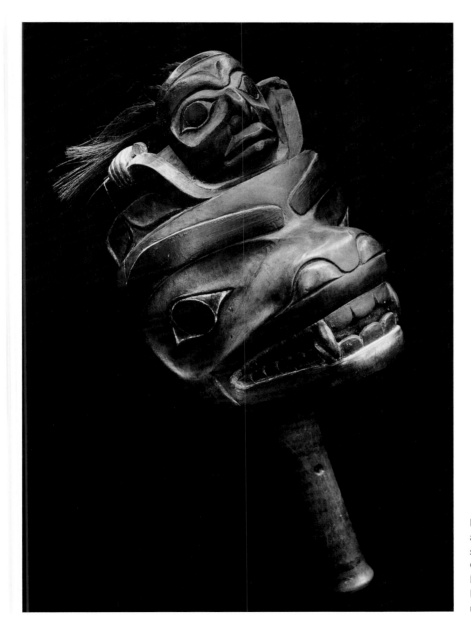

Fig. 5.62. Bear rattle attributed to Simeon *sdiihldaa* (*skil kingaans*). Courtesy of the Royal British Columbia Museum, cat. no. 9729, neg. no. CPN 9729.

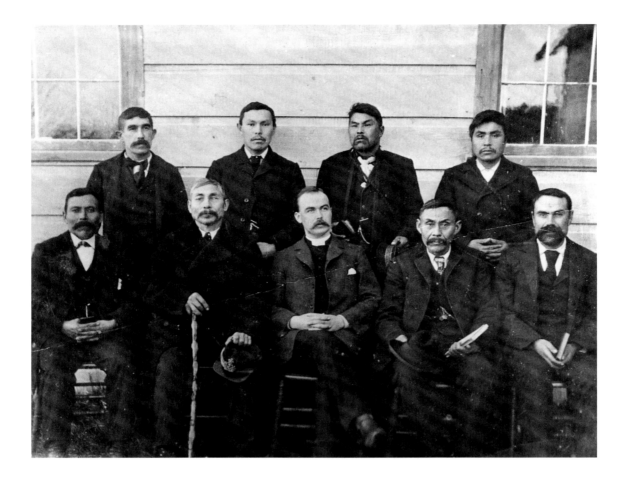

Fig. 5.63. Massett lay readers, circa 1910. Seated (left to right): Richard Russ, Charles Edenshaw, the Reverend William E. Collison (son of William H. Collison), James Stanley (*sdiihldaa*), Thomas Weir. Standing (left to right): Sam Gerard Davis, Henry Edenshaw, Robert Ridley (*gannyaa*), Frederick Young. Courtesy of the British Columbia Archives.

Four years after Chief *sdiihldaa*'s death, the 1881 census for Massett and *yaan* showed four Steltas: two nine-year-old boys and a thirty-one-year-old man, all living in different houses in Massett, and a sixty-four-year-old man living in *yaan* (Public Archives of Canada). The man in *yaan* was probably the uncle of *skilee* (Isaac Chapman). The thirty-one-year-old Stelta living in Massett in 1881 was probably James *sdiihldaa* (fig. 5.63), because ten years later, the 1891 census showed James Steelta (a widower, age fifty) living in the same location. This man later took the name Stanley as a surname, perhaps because it shared the first two letters of his Haida name. I believe that James *sdiihldaa* (Stanley) was the brother and successor of the Chief *sdiihldaa* who died in 1877. This belief is based on the fact that the brother of the deceased Chief *sdiihldaa* is known to have commissioned a memorial pole to be raised for him; it was purchased for the Berlin Museum by Adrian Jacobsen in 1881, and according to Jacobsen, this man was also known as Captain Jim. He described him as a young man at the time (Jacobsen 1977: 24–26) (see chapter 4). Both the age and the name fit the thirty-one-year-old Stelta who was living in Massett in 1881. Collison referred to this second *sdiihldaa* in a letter, saying that he would be willing to be baptized and "live only for god . . . but only one thing keeps me [*sdiihldaa*] back," referring to a potlatch for his deceased brother and the raising of a pole to his memory (Collison 1878).

We know that the father of James *sdiihldaa* was Simeon *sdiihldaa,* because the marriage record of James Stilthda (who married Edith Wait on January 22, 1894)

lists Simeon Stilthda as his father (Church Missionary Society records, Diocese of Caledonia, Prince Rupert, B.C.). James *sdiihldaa*'s age was given as forty in 1894, but this must be the same James Steelta listed in the 1891 census for Massett, who was listed as a widower, age fifty, at that time. The ages on the census reports must frequently have been guesses, given the number of ages that do not match with known biographical data. Because his father, Simeon, would have been from the opposite, or Raven, moiety, it might seem strange that Simeon, too, had the name *sdiihldaa,* which was an Eagle name (see chart 7).

In the late 1870s and 1880s, however, owing to the influence of Christian missionaries such as Collison and later Sneath and Harrison, the Haida people began to change the way they were named to a system imposed upon them as they were baptized by the missionaries. When they were married, wives took their husbands' Haida names as surnames, with a Christian first name. Most adult baptisms in the early years were done at the time couples were married in the Christian way. At the birth and baptism of children, sons and daughters took their father's names as surnames. Thus, when both wives and children began to name themselves after husbands and fathers, Eagle names came to the Raven side, and vice versa.[42] It is probable that Simeon *sdiihldaa* took the name Simeon when he was baptized and that he was given his son's name *sdiihldaa,* which is an Eagle name, at the same time.

That Simeon took the name *sdiihldaa* is further circumstantial evidence that, in addition to being James's father, he was the father of Chief *sdiihldaa* (James's brother) and therefore the man who threw himself on the fire at the moment of his son's death. We know from Marius Barbeau's notes at the Canadian Museum of Civilization that Simeon survived and lived on into the 1880s, and the notes also confirm that Simeon *sdiihldaa* was a Raven. Barbeau's consultant Alfred Adams told Barbeau that Daniel Stanley, a Massett Haida carver, was Simeon *sdiihldaa*'s grandson and had learned his craft from both Simeon *sdiihldaa* and Charles Edenshaw (Barbeau 1916–1954: B-F-251 p. 18). Because Daniel Stanley was born in 1881, Simeon must have lived at least until the late 1880s, when Daniel was old enough to learn to carve.

There are four gravestones in Massett with variations on the name *sdiihldaa* that help in the identification of Simeon: (1) Stilta, d. December 18, 1877, age fifty; (2) Charles Steltha, d. 1898; (3) Steelta, d. 1888, age fifty-six; and (4) Chief Steel-tah, died 1889, age ninety. The first name is that of the chief who died shortly after Collison's arrival. The second man, Charles Steltha, is known to have lived at *yaan* in 1881, in the house that, according to Swanton, was owned by Stĩ'ɬta. MacDonald (1983: 167) mentioned two memorial poles for this house, raised for *sdiihldaa* and his wife. Judging from genealogies currently being developed by families in Massett, the sixty-four-year-old *sdiihldaa* living in *yaan* in 1881 was probably the Charles *sdiihldaa* (Isaac Chapman's great uncle), an Eagle, who died in 1898.

The third stone, dated 1888, is carved in the form of a human figure holding a staff and wearing a hat with a frog on it. The human is a portraitlike figure that displays similarities with Simeon *sdiihldaa*'s style of carving. Obviously, Simeon would not have carved his own gravestone, and traditionally, someone from the opposite moiety carved the memorial for the deceased. The figure on this stone resembles one on a full-sized memorial pole in *yaan* (fig. 5.49) said to have been raised for a *sdiihldaa.* Probably, then, the 1888 stone is for an Eagle

Chart 7. The family of *skil kingaans* (Simeon *sdiihldaa*).

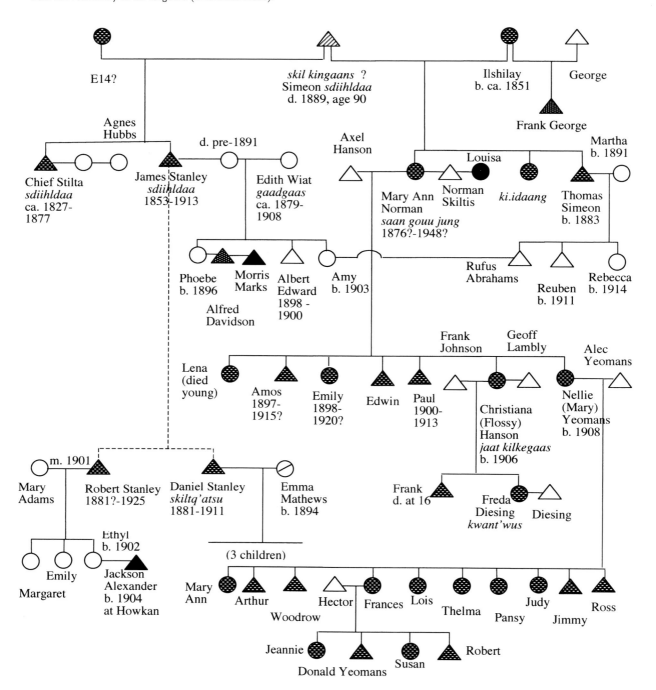

\triangle = male

\bigcirc = female

$\bigcirc\!\!-\!\!\blacktriangle$ or $\bigcirc\!\!-\!\!\blacktriangle$ = spouses

| = descendants

¦ = adoption

\triangle \bigcirc = siblings

\blacktriangle = *srajuuga.ahl 'laanaas* Eagle clan (E14)

\blacktriangle = *ts'aa7ahl 'laanaas* Eagle clan (E9)

\blacktriangle = unknown Eagle clan

\triangle = *st'langng 'laanaas* Raven clan (R15)

\triangle = *yahgu 'laanaas* Raven clan (R19)

\triangle = unknown Raven clan or *yaats xàadee* (non-Haida)

sdiihldaa, perhaps carved by Simeon. This means that the fourth stone — the one for Chief Steel-tah, who died in 1889 at the age of ninety — is probably Simeon *sdiihldaa*'s gravestone.

Alfred Adams, who was born in 1880, also remembered Simeon from his early childhood:

> When I was a small boy, he carved large totem poles, also masks. He was one of the best canoe makers of his time. He belonged to the family Slinghla'nos, of yaan. Slinghla.nos means "extreme inside of harbour." He was a Raven. Stilte was a canoe maker, a carver of masks and totems, also a painter. The tall totem pole of Jasper Park is his, also some in Ottawa and New York museums; short house posts in New York — I sent one or two to the American Museum of Natural History. Harlan I. Smith was getting things for them at the time. At Yan there is much of his work, perhaps most of it. He was one of the old Haidas, a good man with clean living. He was one of the old chiefs who had capacity for high respect. He lived on to old age. When Archdeacon Collison came here he accepted him right away. But he went on carving just the same. He carved masks. (Barbeau 1916–1954: B-F-251.16, p. 20)

A further clue to Simeon's identity comes from genealogy studies that are ongoing in Haida Gwaii. Simeon Stilthda is listed as the father of Mary Ann Norman, and marriage records for Mary Ann Skil-king-ants (age eighteen) show

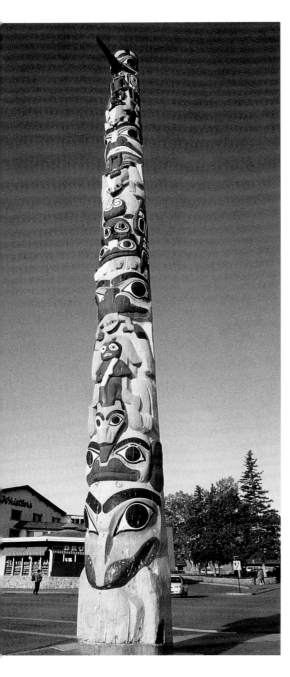

Fig. 5.64. Pole made by Simeon *sdiihldaa* (*skil kingaans*) and erected by the National Railroad of Canada in Jasper National Park, Alberta. Photograph by the author, 1997.

Fig. 5.65. The pole made by Simeon *sdiihldaa* (*skil kingaans*) in place at Massett, before being moved to Jasper National Park. Courtesy of the Royal British Columbia Museum, neg. no. 62240. Photograph by Richard Maynard, 1884.

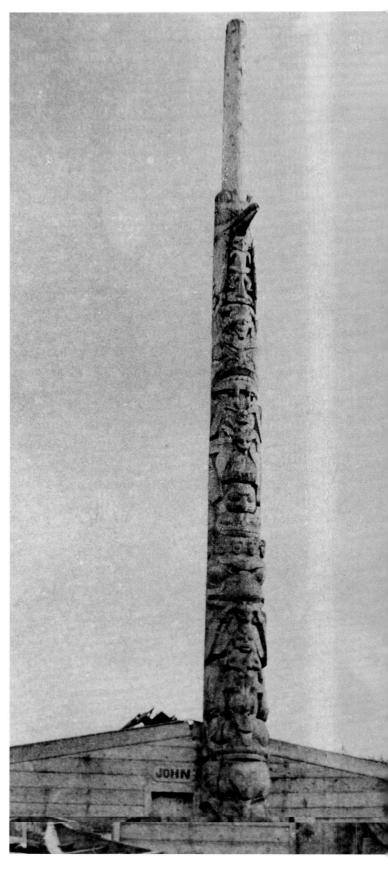

her marrying Norman Skiltis (age thirty) in 1891. Her father's name is listed as Skil-king-ants (Church Missionary Society records, Diocese of Caledonia, Prince Rupert, B.C.). Mary Ann Skil-king-ants became Mary Ann Norman when she married, and therefore we know now that Simeon *sdiihldaa*'s Haida name was really *skil kingaans* (Skil-king-ants). This name for Simeon is further suggested in the 1881 census, which listed a sixty-four-year-old man named Skiltkingas as living in the same house with Stelta (James *sdiihldaa* Stanley). The Haida name *skil kingaans* means "calling wealth spirit" and is a name of the *t'ii.is stl'anng 'lanngee,* a branch of the *st'langng 'laanaas* (R14a) (Swanton 1905a: 291).

The tall totem pole in Jasper National Park mentioned by Adams was erected there by the Canadian National Railroad in 1920 and still stands there today (fig. 5.64). It is attributed to "Chief Stiltae" in the label. According to MacDonald, it once stood in front of "Halibut House" in Massett and was carved around 1870. The house was photographed by Maynard and shows the name John above the door (fig. 5.65). Since its removal to Jasper, this pole has been repainted several times, and a plain top shaft seen in early photographs taken in the village has been removed (MacDonald 1983: 134–135). The style of this pole does fit with the style of other animal figures carved by Simeon *sdiihldaa,* especially those carved on a model totem pole in the Eugene Thaw Collection in the Fenimore House Museum (fig. 5.66). At the top of the Thaw pole, a shaman figure wearing a feathered headdress stands on the head of a sea lion. The knobby chin, eye sockets, nose, and lips all match those of the *sdiihldaa* figural sculpture. The raised and rounded bridge of the nose on the bear at the bottom also relates directly to *sdiihldaa*'s animal frontlets and bear rattles. This model pole seems to be based on figures used in two house posts referred to in Barbeau's notes from his interviews with Alfred Adams (fig. 5.67). These two posts, now on exhibit at the American Museum of Natural History in New York, show slight differences, particularly in the carving of the human faces, and there may have been more than one artist at work here, but their similarity to the Thaw model pole is interesting. These house posts came from "Sea Lion House" in *yaan,* which, according to Swanton (1905a: 292), belonged to T!ʌ'lgas of the *st'langng 'laanaas* Ravens (R15a).

Two other model poles no doubt carved by Simeon *sdiihldaa* are known. One is in the Fairbanks Museum and Planetarium in St. Johnsbury, Vermont (fig. 5.68), and the other is known only from a photograph located by Allen Wardwell (personal communication 1997). Both show a portraitlike shaman figure at the top, standing on the back of a killer whale, with a bear at the bottom. The pole in the photograph has an additional shaman figure between the whale and bear, and a small human head below the bear at the bottom. The bear at the bottom of the Fairbanks Museum pole sits on a chest. The human figures on these model poles are similar to those on the Thaw model and the full-sized house posts from Sea Lion House. The *st'langng 'laanaas* Ravens had the killer whale, hawk, grizzly bear, thunderbird, and cumulus clouds as crests (Swanton 1905a: 271), and both bears and whales are prominent in *sdiihldaa*'s work.

The range of objects that can be attributed to Simeon *sdiihldaa* continues to grow, whereas works of art that can be attributed to *gwaay t'iihld* are relatively few. Returning to the signature mask at the American Museum of Natural History

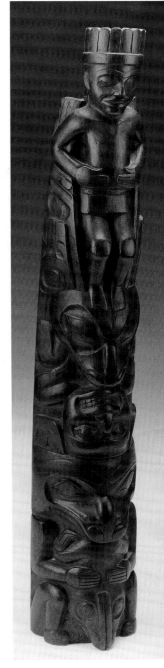

Fig. 5.66. Model pole attributed to Simeon *sdiihldaa* (*skil kingaans*), 64.1 by 11.2 by 8 cm. Eugene and Clare Thaw Collection, Fenimore House Museum, New York State Historical Association, cat. no. T189. Photograph by Richard Walker.

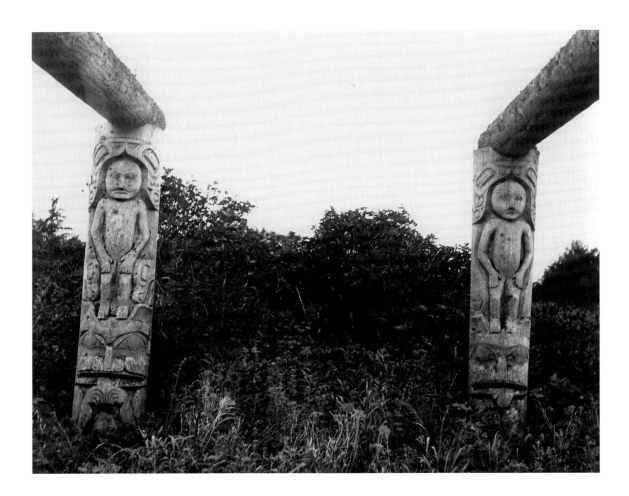

(fig. 5.57), let us compare it with the *sdiihldaa* masks. If the stylistic criteria that distinguish the *sdiihldaa* group are applied to the *gwaay t'iihld* signature mask, it can be seen to differ in many respects. The ears are less naturalistic — flat at the top, with a raised oval at the bottom — and they are positioned slightly higher on the head. The overall proportions of the head are more square than elongated. The eyebrows are broad and squared at the ends with a peak in the middle, and the nose, though long and narrow, is less rounded at the tip and nostrils, showing flattened nostrils and a sharply cut angle from the profile view. There are some similarities. The hair is raised, the orbs are pronounced, and the eyelids are open and nearly centered as on the other masks in this group. But *gwaay t'iihld*'s eyelids are more diamond-shaped and open than *sdiihldaa*'s, and the pupils are slightly raised within them. On *sdiihldaa*'s masks, the transition between the temple and the eye socket is a smooth one, whereas on *gwaay t'iihld*'s there is a sharper demarcation where the temple meets the orb of the eye at the outer corner of the eye socket. The chin has a smaller knob or point than do those on *sdiihldaa*'s masks. There are enough differences in the way the eye sockets, ears, and other features are handled that this mask with the name Quaatehl written inside stands apart from the large body of work now attributed to Simeon *sdiihldaa*. It is similar, however, to the mask that was pictured next to it in Jonathan King's illustration (fig. 5.58). The same open eyelid lines and raised pupils, flattened ears, sharply cut-back nose, flat nostrils, square face, and small

pointed chin are present. Both of these masks were probably made by John *gwaay t'iihld.*

Though we know relatively few works of art by him, we actually know more about the life of John *gwaay t'iihld* than we do about Simeon *sdiihldaa*'s. Barbeau obtained information from Captain Andrew Brown, who was the son of Walter Kingego, about a "John Gwétiɫt" who was the brother of Walter Kingego (Barbeau 1916–1954: B-F-256.9). Unfortunately, when Barbeau published his *Haida Carvers,* he confused the record by changing the name to "Charles" *gwaay t'iihld* (Barbeau 1957: 178). It was from this Barbeau reference that Holm took the name Charles *gwaay t'iihld* in his 1981 article. Alfred Adams's sisters, Eliza Alexander and Mary Stanley, told Barbeau that "Gwetitk" and Walter "Kingegwa'o" were Ravens who moved from *yaan* to Massett, and all the poles at *yaan* were the work of Nis.go and "Gwetith" (Barbeau 1916–1954: B-F-256.3, 256.4).

John *gwaay t'iihld*'s gravestone in the Massett cemetery (John Gwaitelth, d. 1912, age ninety) has on it a Charles Edenshaw design of a raven-finned killer whale (see fig. 5.2). Florence Edenshaw Davidson told Bill Holm that she remembered *gwaay t'iihld* as a very old man before his death sometime before 1920. Davidson translated his name as "wets the island" (Holm 1981: 176–77). Barbeau (1957: 178) erred in translating John *gwaay t'iihld*'s name. He assumed that the name *gwaay t'iihld* was the one Swanton listed as K!wai'eɫ, which means "he-became-the-eldest," overlooking the true Gwai t!eɫt, "watering the island," whom Swanton listed later as the *st'langng 'laanaas* Raven owner of "Gambling House" in *yaan* (Swanton 1905a: 271, 292). The 1881 census listed a Gwiteith, male, age thirty-nine, living in *yaan.* His true age in 1881 was more likely fifty-nine, if the death date and age on his grave monument are accurate.

The church marriage records indicate that John *gwaay t'iihld*'s father's name was Swonkitswas and that he was married to Tatlouat (Jane) in 1887 in a Christian marriage, having previously been married to her in the Indian way. He married Emma Young in 1897, after his first wife's death. He had two children, Tagwutsang (Jane), born around 1860, and Jistalance (Nellie), born around 1871. His daughter Jane married Samuel Keetshantlas in 1885 but passed away sometime before Samuel remarried in 1894. His daughter Nellie married Daniel Skilkaitlas (born circa 1867) in 1890 (Church Missionary Society records, Diocese of Caledonia, Prince Rupert, B.C.).[43]

Florence Davidson told Bill Holm that *gwaay t'iihld* carved masks and figures of wood but did not carve argillite (Holm 1981: 176–177). This agrees with Barbeau's information from Alfred Adams that John *gwaay t'iihld* was not an argillite carver. It is possible that Simeon *sdiihldaa,* however, was an argillite carver. A dead shaman figure (Canadian Museum of Civilization VIIB794) and an unusual pipe (fig. 5.69), both in argillite, exhibit some of the same stylistic features shown by the wooden figures carved by Simeon *sdiihldaa.* Barbeau tells us something of John *gwaay t'iihld*'s repertoire:

> Of the personal lives of Kingego and his brother Gwaytihl, sculptors and fellow craftsmen of Massett, we know little. But we do know that some of their statuettes and high reliefs rank with the best in Haida art. Kingego, like his contemporaries, was a sculptor of argillite statuettes representing medicine-men, chiefs in regalia, warriors, and odd types from among his people; he also is credited with a "lot of large poles." Gwaytihl carved only wood,

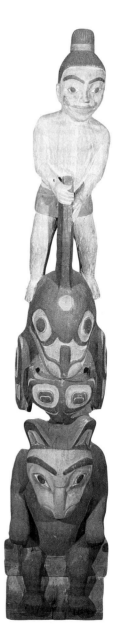

Fig. 5.68. Model pole attributed to Simeon *sdiihldaa (skil kingaans),* 78.7 by 12.7 by 7 cm. Collected by the Reverend Charles Shelton, Sitka, Alaska, 1889. Fairbanks Museum and Planetarium, St. Johnsbury, Vermont, cat. no. NA304. Photograph by the author.

Chart 8. The family of John *gwaay t'iihld*.

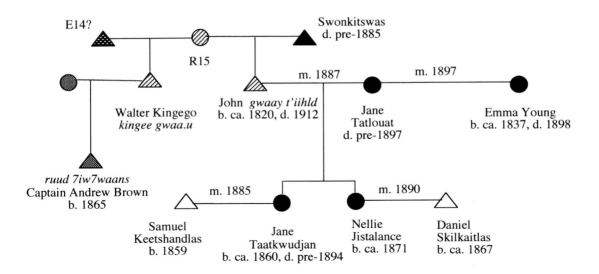

△ = male

○ = female

○─┐▲ or ○───▲ = spouses

│ = descendants ┊ = adoption

△─┐○ = siblings

▲ = *srajuuga.ahl 'laanaas*
Eagle clan (E14)

▲ = *git'ans*
Eagle clan (E13)

▲ = unknown Eagle clan

▲ = *st'langng 'laanaas*
Raven clan (R15)

△ = unknown Raven clan
or *yaats xàadee*
(non-Haida)

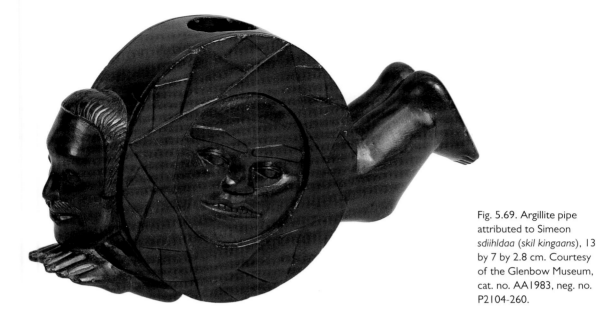

Fig. 5.69. Argillite pipe attributed to Simeon *sdiihldaa* (*skil kingaans*), 13 by 7 by 2.8 cm. Courtesy of the Glenbow Museum, cat. no. AA1983, neg. no. P2104-260.

never argillite, and his subjects were almost the same as his brother's, plus model houses, canoes, and small grave poles. (Barbeau 1957: 178)

At this point, at least three house models can be attributed to John *gwaay t'iihld*. One clue to these attributions was found in Charles F. Newcombe's field notes in the British Columbia Archives in Victoria: "John Gwaitilht — Has model of a house representing first totem poles erected at Skidegate by Wia of 4 generations ago when gwaititl was a boy" (Newcombe 1900–1911: vol. 36, file 13, p. 57).

I am not aware of any poles erected at Skidegate by Wia (*7wii.aa*), but perhaps Newcombe was referring to the house owned by Chief *7wii.aa* of Massett.[44] A model of Chief *7wii.aa*'s Massett house (fig. 5.70) is pictured in MacDonald's *Haida Monumental Art,* next to a photograph of Chief *7wii.aa*'s house itself. MacDonald attributed this model to Charles Edenshaw, but judging from the style of carving, it clearly is not his work. This model house may be the same one referred to in Newcombe's notes — at least it is a model of *7wii.aa*'s house in Massett, and it matches the carving style of John *gwaay t'iihld*. The open, centered eyelid lines on the poles are similar to those of both Charles Edenshaw and Simeon *sdiihldaa,* but the character of the small human faces at the top of the center pole and on the two side poles is closely linked to that of the signature "Quaa-tehl" mask. The nose is sharply cut with flattened nostrils, the ears are plain, and the eye socket has a rounded orb, similar to features on the mask.

Confirming this attribution to *gwaay t'iihld* is a house model in the Museum of Mankind, British Museum, that is documented to be by *gwaay t'iihld* and is nearly identical in style (fig. 5.71). This is a model of a house that once stood at *q'àayaang* (Kayang), near Massett; the full-sized pole from this house is also at the British Museum (MacDonald 1983: 159). The museum ordered the model on the basis of a photograph and purchased it from the missionary in residence in Massett, the Reverend J. H. Keen, on October 20, 1898. The British Museum catalog indicates that the original of this house was known as Bear House (Huj

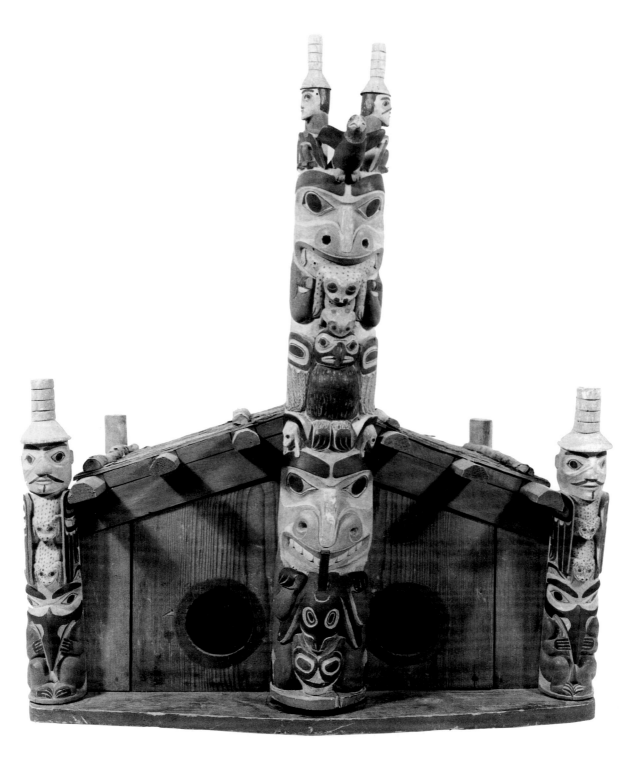

Fig. 5.70. Model of *7wii.aa*'s Monster House attributed to John
gwaay t'iihld, 72 by 60 by 56 cm. Acquired from the Deasy
Collection in 1914. Courtesy of the Canadian Museum of
Civilization, cat. no. VII-B-1166, neg. no. 75-12113.

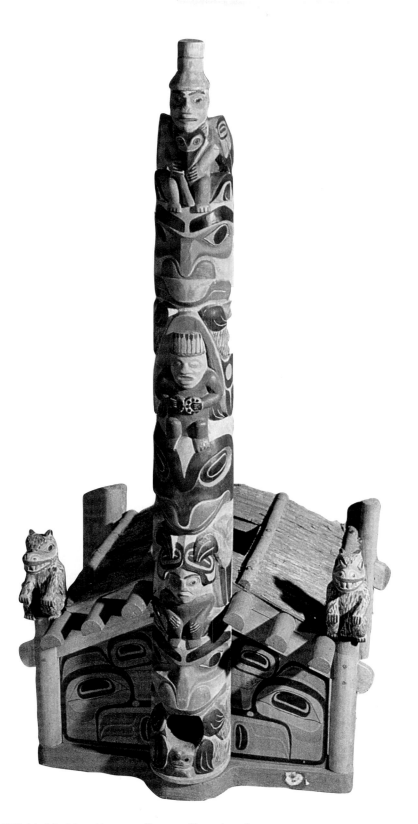

Fig. 5.71. Model of Bear House at *q'àayaang* (Kayang) made by John *gwaay t'iihld*, 50 by 38 by 88 cm. Collected by the Reverend J. H. Keen at Old Massett. British Museum, cat. no. 1898.10-20.1. Photograph by Bill Holm.

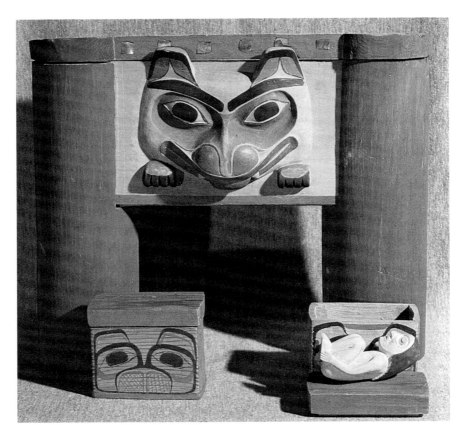

Fig. 5.72. Model mortuary (*xaad hlgisdang*) attributed to John *gwaay t'iihld*, 40 by 35 by 12 cm. Collected by the Reverend J. H. Keen at Old Massett. British Museum, cat. no. 1902.5-26.1. Photograph by Bill Holm.

Nas, or *cu7aji na7as*),[45] and the model was made for the British Museum to the order of Reverend Keen by a native of Massett. A model double mortuary (*xaad hlgisdang*) with a bear on the panel (fig. 5.72), complete with two small corpses crouched inside two mortuary chests, was purchased from Keen, then in Metlakatla, on May 26, 1902.[46] Correspondence and receipts for both the model house and the mortuary identify the artist as "Gwe-tilt/Kwaitiltht" (Jonathan J. H. King, personal communication). Jonathan King has recently located the photograph, which shows a third model house, also similar in style, next to a man who must be John *gwaay t'iihld* (fig. 5.73). If this is John *gwaay t'iihld*, then this is the only known photograph of him. The location of the model house in the photo is currently unknown. The two figures on the corner posts match nicely those on the Canadian Museum of Civilization and British Museum model houses, and they also link this house with the two masks in the American Museum of Natural History.

Not only is their art closely related, but John *gwaay t'iihld* and Simeon *sdi-ihldaa* were also related as members of the *st'langng 'laanaas* clan of *yaan*. They both lived in *yaan* before moving to Massett in the 1880s and must have worked together closely, even collaborating on some of their work. Both found a market for their masks and model poles among the outsiders who were visiting their homes, and both were certainly acquainted with Charles Edenshaw and his work. Edenshaw carved a model double mortuary (fig. 5.74) very similar to the one made by *gwaay t'iihld*, also with two coffin boxes with corpses inside. The extent to which these artists interacted with each other may never be known, but their work reflects a familiarity that must have existed in their lives.

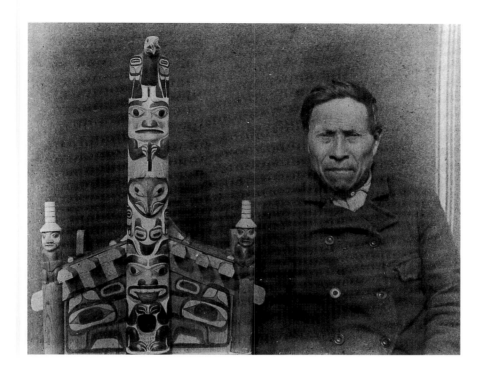

Fig. 5.73. John *gwaay t'iihld* posing with a house model (current location unknown). This photograph was sent to the British Museum by the Reverend J. H. Keen in 1898, and the Kayang house model (fig. 5.71) was purchased on the basis of it. Courtesy of the British Museum, neg. no. MM034497/3.

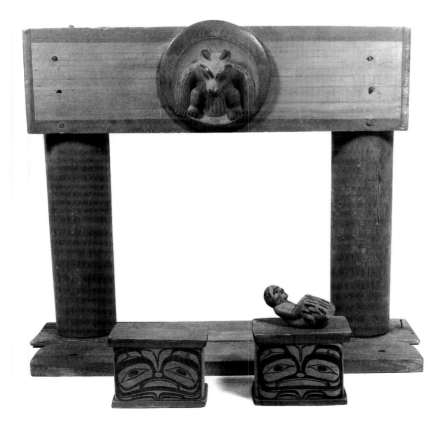

Fig. 5.74. Model mortuary attributed to Charles Edenshaw, 50 by 41 by 12 cm. Collected by C. F. Newcombe, 1895–1901. Courtesy of the Canadian Museum of Civilization, cat. no. VII-B-661, neg. no. 75-8884.

John Robson also made model mortuary poles, including one with a dogfish design for Swanton's American Museum of Natural History collection (fig. 5.75). This is a copy of one that was raised in Skidegate by a daughter for her mother, both of the *na s7agaas xàaydaraay* (Rotten House People, E6b; Swanton 1905a: 129–130).[47] This dogfish mortuary was one of the monuments that Bill Reid selected in 1957 when he was hired to carve replicas of several Skidegate poles and mortuary houses for the University of British Columbia's totem park. These were the first Haida poles to be raised in the twentieth century, though they were raised on Salish land in Vancouver, British Columbia. It took three and a half years to complete the Haida village on the University of British Columbia campus (Duffek 1993: 217). It would take another eight years before the next Haida pole was carved by Robert Davidson and raised this time on Haida Gwaii in Old Massett.

Fig. 5.75. Model mortuary made by John Robson, 56.5 by 46 by 12 cm. Commissioned by John Swanton, 1901. American Museum of Natural History, cat. no. 16/8760. Photograph by Bill Holm.

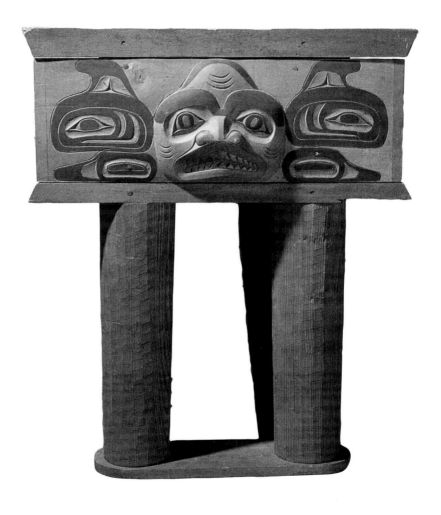

The Twentieth-Century Legacy

The first two decades of the twentieth century marked the end of an era of increased attention paid to Haida art by outsiders and the beginning of an era of inattention. Charles Edenshaw, his eyesight failing, carved little after 1910, in the last decade of his life. John Robson passed away in 1924, shortly after Edenshaw. The residents of *hlanqwáan, ráwk'aan,* and *saxq'wa.áan* all moved to Hydaburg, Alaska, to be nearer to schools and sources of income. Residents of old *gasa.áan* moved to New Kasaan to be near mining jobs. Children left their homes to be trained at residential schools, where they were discouraged from speaking their language and learned to reject their Haida culture in favor of blending in with the dominant society.

Pole Carving in the 1930s and 1940s

John Wallace's life reflects these changes. Born around 1861 (d. 1951), at the height of the pole carving era, he was given the name Giauda (or Gaowdaul), after his father's father, who was said to have been a great carver (see chart 5). The earlier Giauda would have been among the first generation of carvers in Kaigani, probably born in the early nineteenth century, and he is said to have been buried at Kaigani (Cape Muzon). Giauda's namesake, John Wallace (*rad.agang*), was trained as a young boy by his father, Dwight Wallace, to be a carver. John Wallace, however, longed to go to the residential school at Sitka:

> I was the only one among the boys that was anxious to learn about carving totems. While still young I learned all about the art of carving and made totems as good as my father. At that time they didn't make much money from totem poles, so I quit making them. When my father went to Wrangell I went with him, at the time we were there a Government boat came in the port. Dr. Young was a preacher at Wrangell at the time, so I went over to see him. The chief reason why I wanted to see him was because I wanted to ask him to help me so I could go to Sitka and go to school. Sitka was the first place that had a school. When I asked him, both he and the captain were willing to help me. So I borrowed a boat and took my new clothing aboard, while my parents were in town as I intended to go without telling my parents, but before I got back ashore they came home and Mr. William Paul's grandmother went over and told my parents that I was leaving for

Sitka. When I went in the house for a while they didn't want me to go to school. The boat left with all my clothing and blanket. (Garfield 1941: box 5, folder 4, "Life of John Wallace," p. 1)

This must have happened shortly after the Reverend S. Hall Young's arrival in Wrangell in 1878, when Wallace must have been around seventeen. Wallace later ran away to Massett and went to school there for a year. His father eventually came and got him, taking him back to be a carver. Though it has been said that John Wallace did not take up carving for a living until later in life (Museum of History and Industry n.d.), Viola Garfield's notes indicate that he did carve when he was a young man living at *ráwk'aan* with his mother's brother and sister. This would probably have been after his return from Massett. During that time he was hired to carve the "single fin" whale grave monument for Moses Kuł Kit at *ráwk'aan* (fig. 6.1) (Garfield 1941: notebook 1, Hydaburg, Klawock, p. 67).[1] This is the only confirmed carving from John Wallace's early career, though his daughter reported that he had also carved a "coffin," or bent-wood chest, and that his father was proud he had made it (Garfield 1941: box 5, folder 4, "Life of John Wallace," p. 1). It is possible that he worked with his father on other projects (see fig. 4.33).

John Wallace had six children with his first wife, Sicksonnie, who was his uncle's daughter. He remarried following her death, after twenty-two years of marriage; his second wife was *djat'cina* (Mae Skillie), with whom he had a second family. Their oldest daughter, Dorothy, married Douglas Edenshaw, Henry Edenshaw's son. In the early twentieth century, Wallace began work at Hunter's Bay, the fish saltery near *hlanqwáan*. After witnessing the problems of alcoholism in *hlanqwáan* and Hunter's Bay, he joined the Salvation Army at Klawock and dedicated himself to stopping the drinking in his community through the Christian mission, helping to build the church in *hlanqwáan* in 1907. Around this time, he visited Seattle and was impressed with the lifestyle of the townspeople. Rejecting the old way of life, he participated in the cutting down of poles in *hlanqwáan* to build the boardwalk that passed in front of the town and rested on the cut-up sections of poles (see fig. 4.8). A leader in his community, John Wallace encouraged the move to Hydaburg in 1911 and is considered to be one of the founding fathers of that community. He had long since given up carving, because he could make little money at it, and it was not until late in his life that he took it up again.[2]

Between 1920 and 1927, according to his son Bill, John Wallace carved a number of small-scale, fourteen-foot canoes for sale to collectors. Bill Wallace assisted him, and it must have been during this time that two small canoes, one in the Alaska State Museum and one in the Burke Museum (fig. 6.3), were carved (Abney 1993: 7).

Fig. 6.1. "Single-fin" whale grave monument carved by John Wallace, circa 1880. Commissioned by Moses Kuł Kit of Howkan as a memorial to his uncle, head of Brown Bear House (*kuts na.as*), a branch of the Mud Eaters (Quetas Ravens). Burke Museum cat. no. 1-1682 (fin only). Photograph courtesy of the Alaska State Library, neg. no. 87-058 6.2. Photograph by Winter and Pond, 1897.

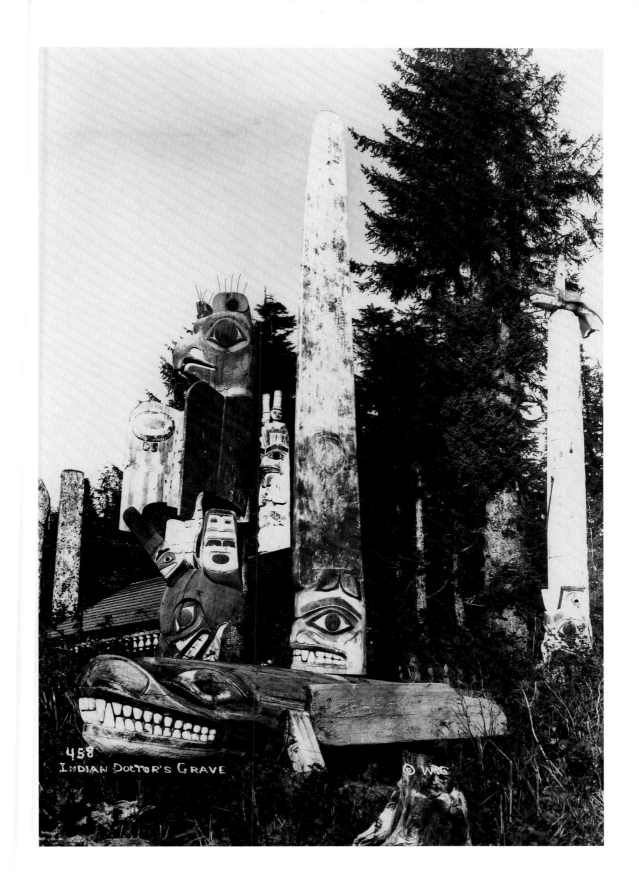

458
INDIAN DOCTOR'S GRAVE

© W.C.

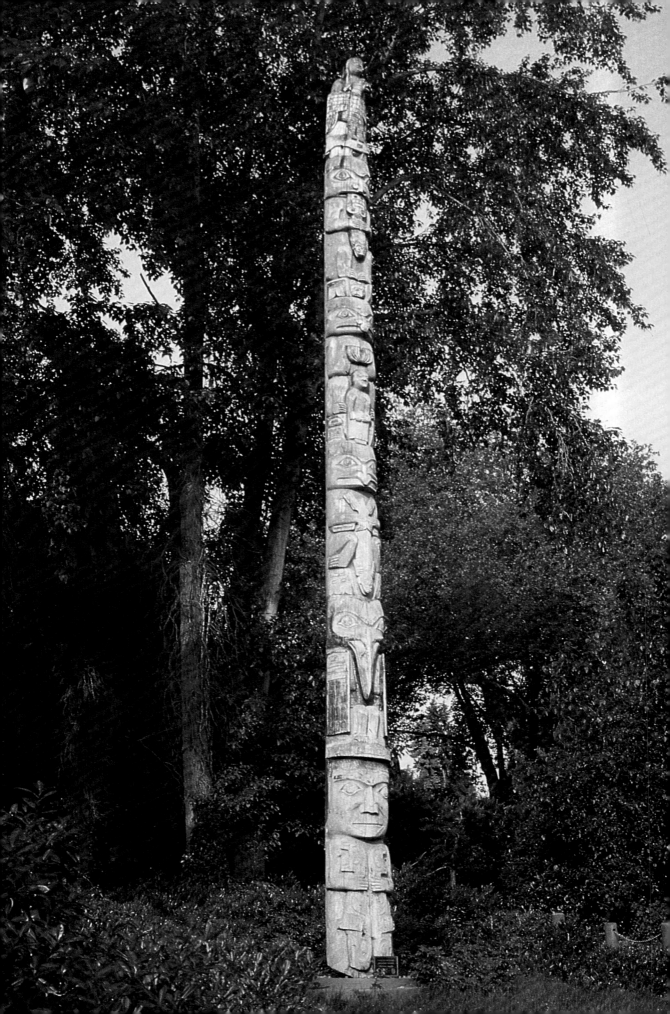

In 1931 John Wallace was commissioned by the U.S. secretary of the interior, Ray Lyman Wilbur, to carve two small poles that are now displayed on either side of the secretary of the interior's office doors in Washington, D.C. (letter from Ron Sheetz to Steve Henrikson, Nov. 16, 1990). In 1937, when he was about seventy-six, Wallace was hired to carve a large pole for the local cannery at Waterfall on Prince of Wales Island (fig. 6.2) (Museum of History and Industry n.d.). René d'Harnoncourt, director of the Indian Arts and Crafts Board at that time, is said to have seen and been impressed by the Waterfall pole, though he must have also known of the Department of Interior poles. He invited Wallace to demonstrate carving at an exhibit of Indian art he organized at the San Francisco Golden Gate International Exposition in 1939 (Jonaitis 1989: 241; Schrader 1983: 201). On this trip, Wallace brought with him two old poles that he owned from his mother's village of *saxq'wa.áan*. After being exhibited in San Francisco, both poles were sold to the University of Pennsylvania Museum in Philadelphia and then were transferred to the Denver Art Museum.[3] While in San Francisco, Wallace, with his son Fred, carved a thirty-foot pole commissioned by the Department of the Interior, which was later sent to New York and displayed outside the Museum of Modern Art during the exhibit "Indian Art of the United States" (Douglas and D'Harnoncourt 1941: 160). After this exhibit, the pole was moved from the front of the museum to the museum's garden, where it stood for almost thirty years. It was returned to the Department of the Interior in 1969, but its current location is unknown (Coe 1994: 72, 274). Wallace also carved a small pole in San Francisco that is now at the Denver Art Museum (cat. no. 1953.503); it was purchased from the Indian Arts and Crafts Board in 1953.

Between 1938 and 1941, when Hydaburg Totem Park was established as part of an Indian Civilian Conservation Corps project, all the poles remaining in *hlanqwáan* that were considered sound enough were taken to Hydaburg for restoration or copying. Two bear grave monuments and one totem pole from *hlanqwáan* were moved to Hydaburg without being restored, and five more were copied. The head carver for this project was John Wallace.[4] Altogether he copied

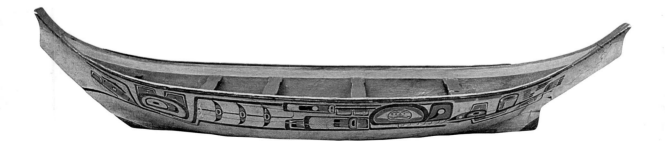

fifteen old poles at Hydaburg (figs. 6.4, 6.5), and he also carved two poles for Totem Bight near Ketchikan (Garfield and Forrest 1949: 90; Keithahn 1963: 128, 129). The Wallace legacy continues with Lee Wallace, John Wallace's grandson, who carves totem poles today, including one based on a pole his great-grandfather Dwight Wallace made for *yaahl dàajee* in Koianglas (fig. 6.6). That pole had been taken from Alaska to St. Louis by Governor Brady in 1903 and had spent the remainder of its life in a park in Indianapolis. Lee Wallace's replica has taken its place at the Eitlejorg Museum in Indianapolis (Feldman 1996).

Pole Carving in the 1950s

In Canada, totem pole restoration projects had been started in the 1920s. In 1924 a "totem pole preservation committee" that included the Canadian Superintendent of Indian Affairs, a member of the Canadian Parks Service, and Marius Barbeau, among others, was formed to oversee the restoration of poles with the goal of promoting tourism in British Columbia (Jonaitis 1999). The Canadian National Railroad helped to fund this project, along with the Canadian government. Ironically, this was during the time when it was illegal for the Haida people to potlatch new poles in Canada. During this period, many poles were removed from Haida Gwaii to the mainland. Simeon *sdiihldaa*'s pole at Massett, for example, was moved to the train station at Jasper National Park in Alberta (see fig. 5.64), and several other Haida poles, including *skil.aa.u*'s *hl7yaalang* pole (fig. 3.1) and a pole from *ya.aats'* (fig. 4.36), were moved to the city of Prince Rupert, the western terminus of the rail line. As these poles began to deteriorate in the 1950s and 1960s, many of them were copied, and the originals were sent to the British Columbia Provincial Museum in Victoria.[5]

In the 1950s, a totem pole restoration project was started at the University of British Columbia (UBC) in Vancouver, and the Kwakwaka'wakw artist Mungo Martin was hired to restore and replicate a number of Haida poles, including one that now stands at the British Columbia–United States border. Bill Reid (1920–1998) was invited to help carve this pole in 1957, during a two-week vacation from his job as a CBC radio announcer (Shadbolt 1998: 30). The next year Reid was hired and worked with Nimpkish artist Doug Cranmer to carve a replica of a Haida village, two houses, five poles, and two *manda* figures on the campus of UBC.[6] These were completed in 1962 (fig. 6.7). Reid's grandfather was Charles Edenshaw's nephew (his sister's son), but Reid was born in Victoria and raised away from Haida Gwaii. His training as an artist had been as a commercial jeweler, and he studied Haida objects in museum collections to learn about their style of carving. Reid was a member of the British Columbia Provincial Museum team, with Wilson Duff and Harry Hawthorne, that visited Haida Gwaii in 1955 and 1957 in order to remove several Haida poles from *t'anuu 'llnagaay, q'una 'llnagaay,* and *sran gwaay* to the British Columbia Provincial Museum in Victoria and the UBC Museum of Anthropology (Duff and Kew 1957). This experience was deeply moving to Reid, and he wrote eloquently about it (Reid and DeMenil 1971).

Since that time, attitudes about the appropriateness of removing old poles from their original locations in order to preserve them for future generations have been changing. During the eighteenth and nineteenth centuries, the most

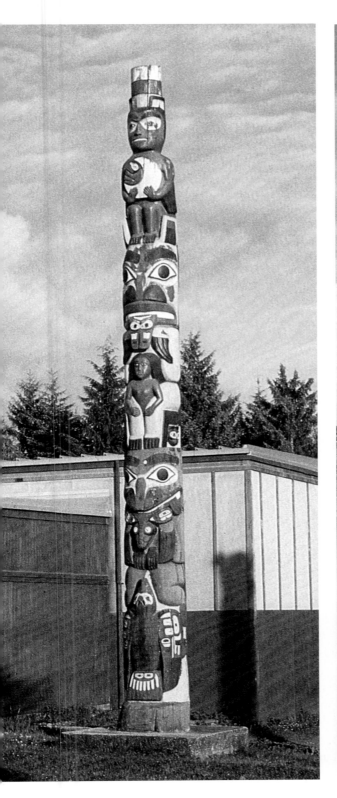

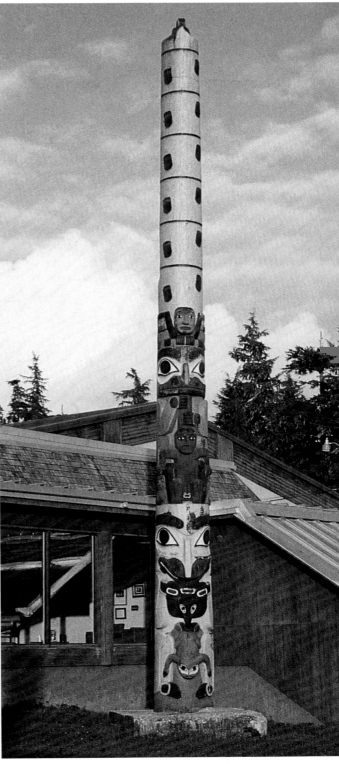

Fig. 6.4. Copy of the corner post of Duncan *ginaawaan*'s house at Klinkwan (*hlanqwáan*), Alaska (see fig. 4.8), carved by John Wallace for the Hydaburg Totem Park, circa 1940. Photograph by the author, 1997.

Fig. 6.5. Copy of the bear-tracks pole raised by Duncan *ginaawaan* in Klinkwan (see figs. 4.9 and 4.12), carved by John Wallace for the Hydaburg Totem Park, circa 1940. Photograph by the author, 1997.

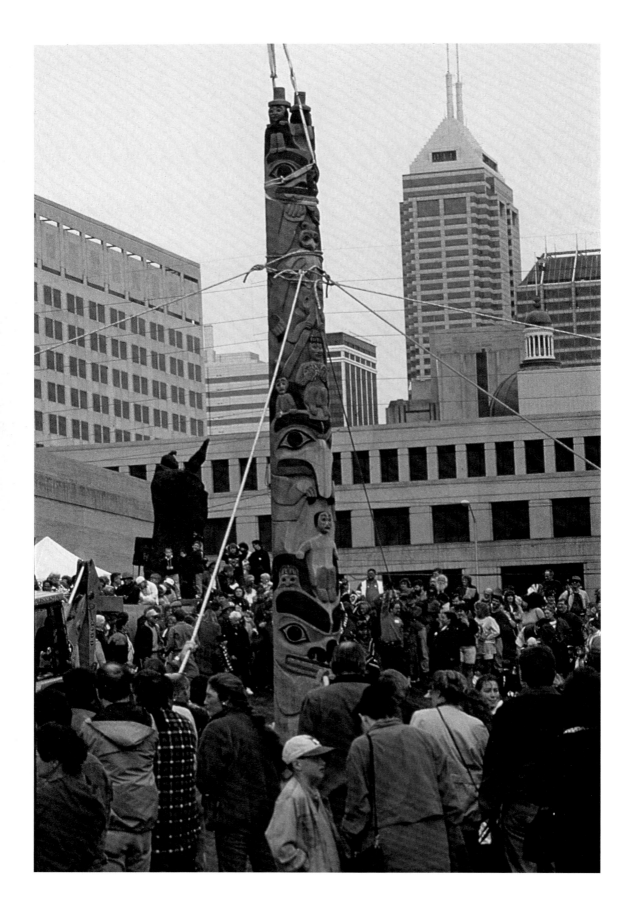

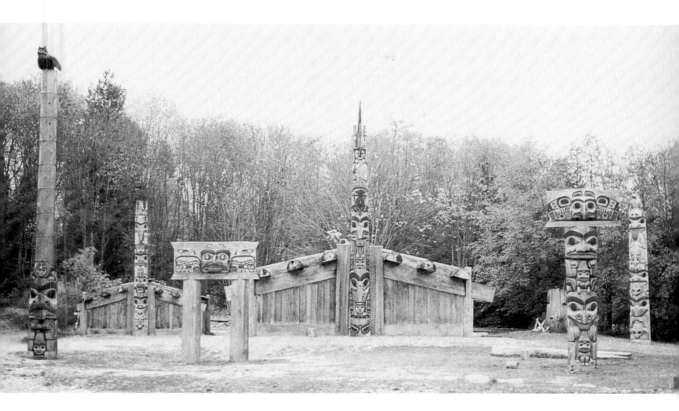

Fig. 6.7. Bill Reid's Haida village at the University of British Columbia Museum of Anthropology. Photograph by the author, 1982.

important moment in the life of a pole was the moment when it was raised and potlatched. It stood as a record of that event for as long as it was sound, and it was allowed to age, fall, and return to the earth in a natural course of decay. Poles that contained burials were also allowed to decay and fall where they stood. New poles were raised near the remains of the old ones. It was not until the late nineteenth century that museum personnel and other collectors, influenced by "salvage anthropologists" seeking to save what they considered to be remnants of dying cultures, sought to preserve poles in the controlled environments of museums. This process continued throughout the twentieth century until the 1970s, when the first of the Haida poles that had been removed were repatriated to Haida Gwaii from the Royal British Columbia Museum. These included the *hl7yaalang* pole that had stood in Prince Rupert from the 1920s until the 1950s, now back in Old Massett (*rad raci7waas*), and several poles from *t'anuu 'llnagaay* that are now housed at the Haida Gwaii Museum in Skidegate. *t'anuu* was Reid's mother's home village, and in 1998 he was buried there, as was his wish (Shadbolt 1998: 30–31, 193–205).

Fig. 6.8. The pole carved by Robert Davidson and raised in Old Massett in 1969. Photograph by the author, 1980.

Haida Art since the 1960s

Robert Davidson (b. 1946), Charles Edenshaw's great-grandson, had started carving argillite as a boy in Old Massett, learning from his grandfather Robert Davidson, Sr. (*gannyaa*). He apprenticed with Bill Reid in Vancouver in 1966–1967 and has the distinction of being the first Haida carver in the twentieth century to raise a pole in Haida Gwaii, which he did at Massett in 1969 (fig. 6.8). He intended this pole to be for the entire community, rather than for one family as poles had been in the past: "At that time I didn't have very much cultural knowledge, but I wanted this to be a neutral totem pole for the whole village. Now, I know that it's a Raven clan pole, since the Grizzly Bear, the main character of this pole, is a crest of the Raven clan. The only way it could have been neutral was to have crests from both Eagle and Raven clans on there" (Steltzer and Davidson 1994: 22).

By this time, Davidson had begun experimenting with the new medium of silk-screen printing, and the print given out to commemorate the pole raising represented the Eagle and Raven moieties combined, as a symbol of unity. His grandfather Robert Davidson, Sr., died shortly after the pole raising, and a print representing his beaver crest was used as a potlatch gift at his memorial (Stewart 1979: 43, 45). The next year, Davidson produced a print based on Charles Edenshaw's thunderbird design from John Watts's grave in Massett (fig. 6.9), which was his first commercially successful print (Stewart 1979: 49–50).

Printmaking was growing in popularity among Northwest Coast artists during the late 1960s and early 1970s, and artists began to sign and number their prints in limited editions in an effort to elevate both the appreciation for them and their price in the art market. The Gitanmaax School of Northwest Coast Indian Art at 'Ksan, near Hazelton, British Columbia, brought in a number of art teachers during those years, including Doug Cranmer, Tony Hunt, Bill Holm, Duane Pasco, and Robert Davidson. The artists at 'Ksan raised poles, carved masks, produced silk-screen prints, and recorded oral histories of the Gitksan (Tsimshian) people of the Skeena River area. One of the first students at the 'Ksan school was Freda Diesing (b. 1925), a Haida woman who is Simeon *sdi-ihldaa*'s great-granddaughter. Diesing's mother, Flossy, was the daughter of Mary Ann Norman, Simeon *sdiihldaa*'s daughter. Diesing had met Bill Reid and seen an exhibit called "People of the Potlatch" in Vancouver ten years earlier, which first exposed her to the art of her culture. She went on to teach carving and design in Prince Rupert, in Ketchikan, and in Terrace, British Columbia, where she lives, producing silk-screen prints (fig. 6.10) and carving masks (fig. 6.11), headdresses, and bowls (Blackman 1993: 238). Freda Diesing has the distinction of being the first Haida woman to become a pole carver. She carved a replica of a *t'anuu* pole with Josiah Tait in 1974 that stands in Moose Tot Park in Prince Rupert (fig. 6.12) (Stewart 1993: 155).

In 1976, Bill Reid's reconstructed Haida village at the University of British Columbia was moved to the west side of the new UBC Museum of Anthropology. In 1982, Jim Hart carved a pole based on the Old Massett pole that had stood in Beacon Hill Park, and it was raised at UBC to join Reid's poles (fig. 6.13, and see fig. 6.7, far right) (Stewart 1993: 58).

In addition to totem pole carving, the other great art of the old Haida master carvers — canoe carving — is again alive. Bill Reid carved a fifty-foot cedar

Fig. 6.9. "Thunderbird," silk-screen print by Robert Davidson, 1970, 45.7 by 36 cm. Based on Charles Edenshaw's thunderbird design on John Watts's gravestone, Old Massett cemetery. Blackman/Hall print collection, Burke Museum, cat. no. 1998-90/150.

canoe named *Luutaas* for Expo '86 in Vancouver and later gave it to the people of Skidegate. It was paddled from Vancouver to Skidegate with great ceremony in the summer of 1987. The occasion of the arrival of this canoe in Skidegate also marked the beginning of the Gwaii Haanas National Park Reserve on South Morseby Island.

The village of *sran gwaay* (Ninstints) was declared a World Heritage Cultural Site by UNESCO in 1981, leading many new visitors to this remote place on the southern tip of Haida Gwaii. The Haida people, caretakers of all the old Haida villages, have been concerned about the impact these visitors have had, as well as about the impact of logging. Efforts to stop clear-cutting in the South Moresby area eventually led to the establishment of Gwaii Haanas ("place of wonder") National Park Reserve, a park managed cooperatively by representatives of the Council of the Haida Nation and the Canadian government. This managed program enables visitors to see the old poles that have stayed in the villages as they age naturally in their own surroundings. As caretakers, the Haida Gwaii Watchmen occupy new houses built adjacent to the old village sites.

Fig. 6.10. "Haida Bear and Cubs," silk-screen print by Freda Diesing, 1977, 58.4 by 44.5 cm. Blackman/Hall print collection, Burke Museum, cat. no. 1998-90/272.

Fig. 6.11. Portrait mask of a man by Freda Diesing, 1980, 23.1 by 19.6 by 13.9 cm. An arm and hand holding a paintbrush are painted on the cheek and forehead. Royal British Columbia Museum, cat. no. 16606, neg. no. CPN-16606.

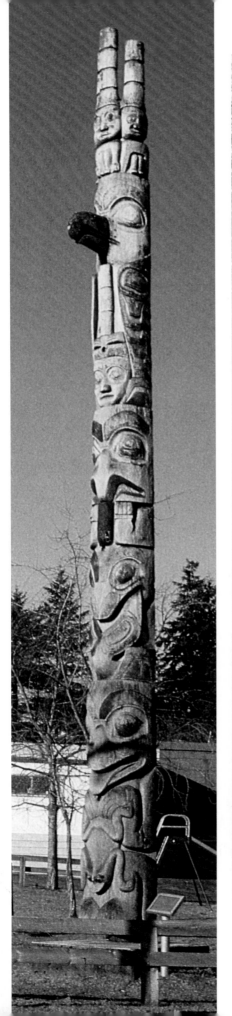

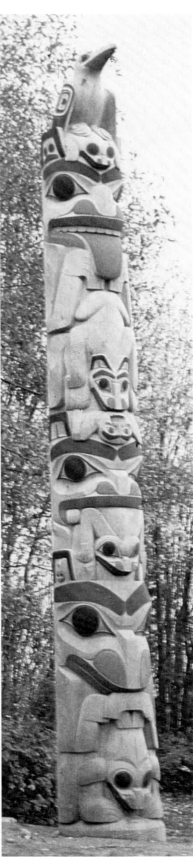

Fig. 6.12. Pole at Moose Tot Park, Prince Rupert, carved by Freda Diesing and Josiah Tait. Photograph by the author, 1997.

Fig. 6.13. Pole carved by Jim Hart at the University of British Columbia. Photograph by the author, 1982.

Outside the park, new poles are being raised again. In 1977–1978, Bill Reid designed a pole that was raised in front of the offices of the Skidegate Band Council (fig. 6.14). It combined crests from several poles that once stood in Skidegate. Several carvers, including Guujaaw (Gary Edenshaw) and Robert Davidson, assisted Reid with the carving of this pole. It was followed in 1978–1979 by Robert Davidson's memorial to Charles Edenshaw in Old Massett — a house with four carved interior posts and a painted design on the house front that was based on a carved settee made by Charles Edenshaw (figs. 6.15–6.17; see also fig. 5.10).[7] Several apprentices worked with Davidson on this house, including Jim Hart (b. 1952) and Donald Yeomans (b. 1958). Hart went on to assist Bill Reid in 1980 with the carving of "Raven and the First Men" — perhaps Reid's most famous sculpture — which is housed at the UBC Museum of Anthropology.

In 1984, Gerry Marks was the lead carver, with Richard Hunt and Tim Paul, on a pole raised in front of the carvers' shed at the Royal British Columbia Museum. This replica was based on a nineteenth-century *hlqin7ul* (Cumshewa) pole that had been destroyed by fire in 1980, when the carvers' shed burned down (Stewart 1993: 103).

Freda Diesing was the lead carver on two poles that now stand on Highway 16 west of Terrace, British Columbia. They were raised in 1987 in a ceremony called Su-sit-'aatk, which means "a new beginning." On this occasion, a high-ranking chief was installed. Both poles are Gitksan-style poles. One, commissioned by the Kitsumkalum Band (Gitksan), incorporates all the Gitksan crests of the families in the village, and the other is a replica of an old Kitsumkalum pole. Diesing was assisted by a team of mostly women carvers, including Dorothy Horner, Myrtle Laidlaw, Sandra Westley, and Lorraine McCarthy, as well as Vernon Horner and Norman Guno. Diesing and several other members of this team — Dorothy and Vernon Horner and Norman Guno — had carved a pole that was donated to the city of Terrace in July 1987 for the city's diamond jubilee (Stewart 1993: 155–158).

Donald Yeomans (b. 1958) is Freda Diesing's mother's sister's grandson, Simeon *sdiihldaa*'s great-great-grandson. He carved a pole in Vancouver while enrolled as a student in fine arts at Langara College (now Vancouver Community College); it stands at the entrance to that institution. Though the pole retains a traditional nineteenth-century Haida style, Yeomans's explanation of the meaning of the figures on it is attuned to his late-twentieth-century experience in the urban world (Stewart 1993: 73–74). Donald Yeomans has become one of the most innovative of all of the contemporary Haida artists (fig. 6.18).

The first modern pole to be raised in Massett on the occasion of the assumption of a chiefly name, as had been done in the past, was a pole carved by Reg Davidson and Glen Rabena and raised for Claude Davidson when he took the position of chief of *daa.adans* in 1987 (fig. 6.19). A pole was also raised in his honor after his death. Jim Hart raised a pole in the village of *yaan*, across Massett Inlet from Old Massett, in 1991 (fig. 6.20). This pole, which had been commissioned by the Vancouver Museum, went on tour to Yokohama, Japan, the sis-

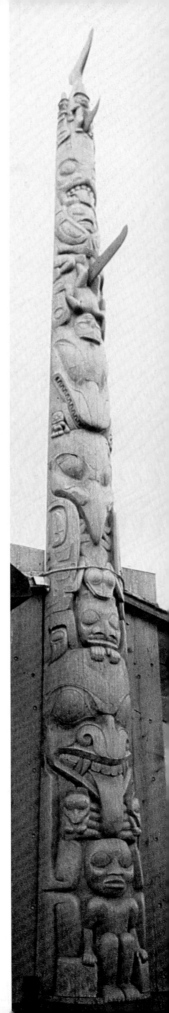

Fig. 6.14. Skidegate Band Council pole, designed by Bill Reid and raised in 1978. Photograph by the author.

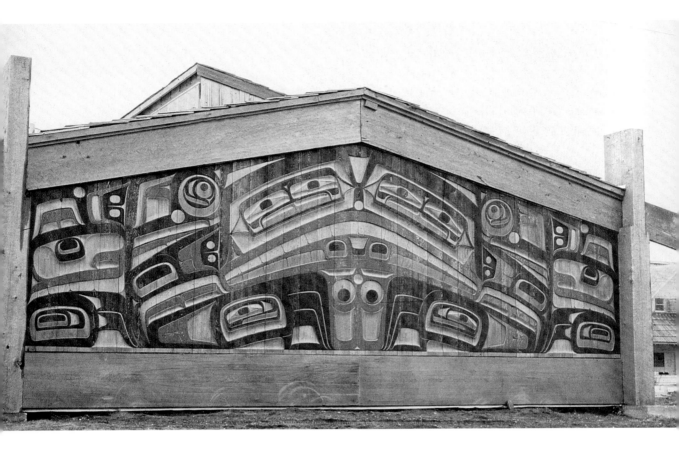

Fig. 6.15. Memorial house designed by Robert Davidson and dedicated to Charles Edenshaw, Old Massett, 1979. Photograph by the author.

ter city of Vancouver, and was then placed at *yaan* in memory of Dora Brooks, a *yaan* descendent who had accompanied the pole to Japan before her death (Time-Life Books 1993).

In October 1995, a pole carved by Christian White was raised for Morris White when he took the name *7idansuu* (fig. 6.21). Morris White was the first to hold the name *7idansuu* since Alec Yeltadzie (who also had the name *skil.aa.u*) had passed away in 1943. Alec Yeltadzie had taken Charles Edenshaw's place after his death (Blackman 1982: 79–80). Yeltadzie was married to Charles Edenshaw's daughter, Agnes, but his connection with the *7idansuu* name came through his mother, Hwanthren, who was the daughter of *gulsigut*, the sister of Albert Edward Edenshaw. Thus, he was Albert Edward Edenshaw's sister's daughter's son, a *sdast'a.aas* Eagle in the appropriate matrilineal line. His last name, Yeltadzie, which is actually a *yahgu 'laanaas* Raven name going back at least to the eighteenth century, was given to him as a surname in the Christian manner by his father, George Yeltadzie, who was a leader of the *yahgu 'laanaas* family in *ráwk'aan*.

Morris White was the son of Daisy Edenshaw, the daughter of Martha and Henry Edenshaw. Martha was the daughter of Duncan *ginaawaan* and *q'aawi-idaa* in *hlanqwáan*, and *q'aawiidaa* was another daughter of *gulsigut*, the sister of Albert Edward Edenshaw. Before Morris White passed away in 1997, he designated his sister's son, Jim Hart, as the next *7idansuu*. In August 1999, Jim Hart took the name *7idansuu* at a memorial potlatch for Morris White and raised a memorial pole near his house in Old Massett (plate 19). The pole has a bear

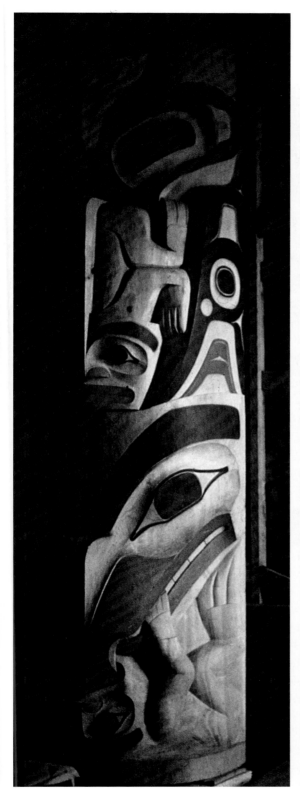

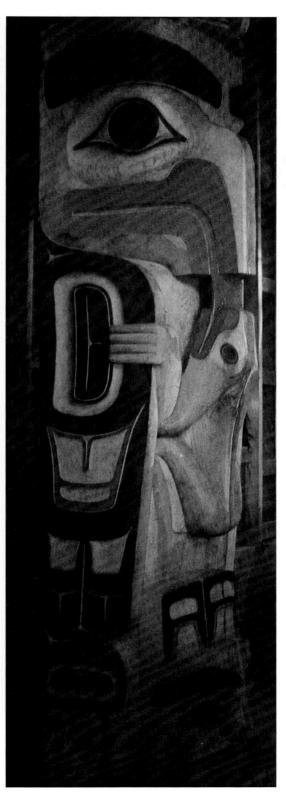

Fig. 6.17. Interior eagle post in the memorial house shown in figure 6.15. Photograph by the author.

Fig. 6.16. Interior whale post in the memorial house shown in figure 6.15. Photograph by the author.

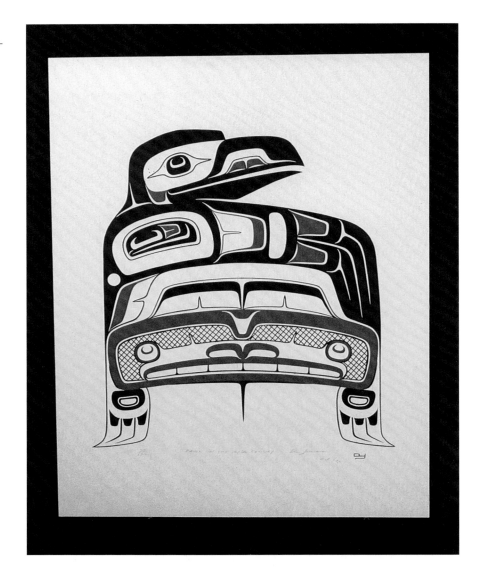

with extended tongue at the base, extending its arms to hold a small canoe. This
bear symbolizes the Raven women who have married into his family. A beaver
holds a sculpin in its paws. Both are crests of the *saangga.ahl 'laanaas sdast'a.aas*.
At the top is an eagle. Just after this pole had been raised and the Hart house
was about to be named, a triple rainbow came out and framed the house and
the pole. The house was named "Three Rainbows House" (*tuu.l sdahlun.ahl nee*).

All of these Haida artists have received commissions from museums, cor-
porations, and private collectors around the world to carve poles that now
reside in locations as remote as Japan and Sweden (Hart and Davidson 1990;
Holm 1990: 615, fig. 8; Shadbolt 1998; Steltzer and Davidson 1994). Many of
the Haida names that were first recorded in the journals of eighteenth-century
fur traders — *gannyaa, yaahl dàajee, gu.uu,* and *7idansuu* — have been handed
down and carried on by their descendants into the twentieth century. As the
twenty-first century begins, these names continue to live and will be linked to
great Haida carvers yet to come.

Fig. 6.19. The raising of a pole in Old Massett for Claude Davidson, 1986, on the occasion of his taking the name Chief *daa.dans.* Photograph by the author.

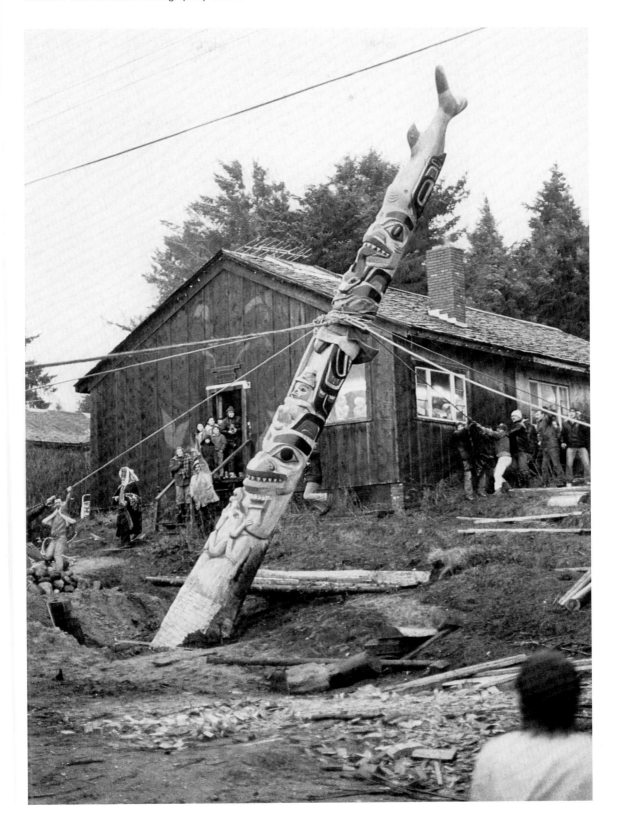

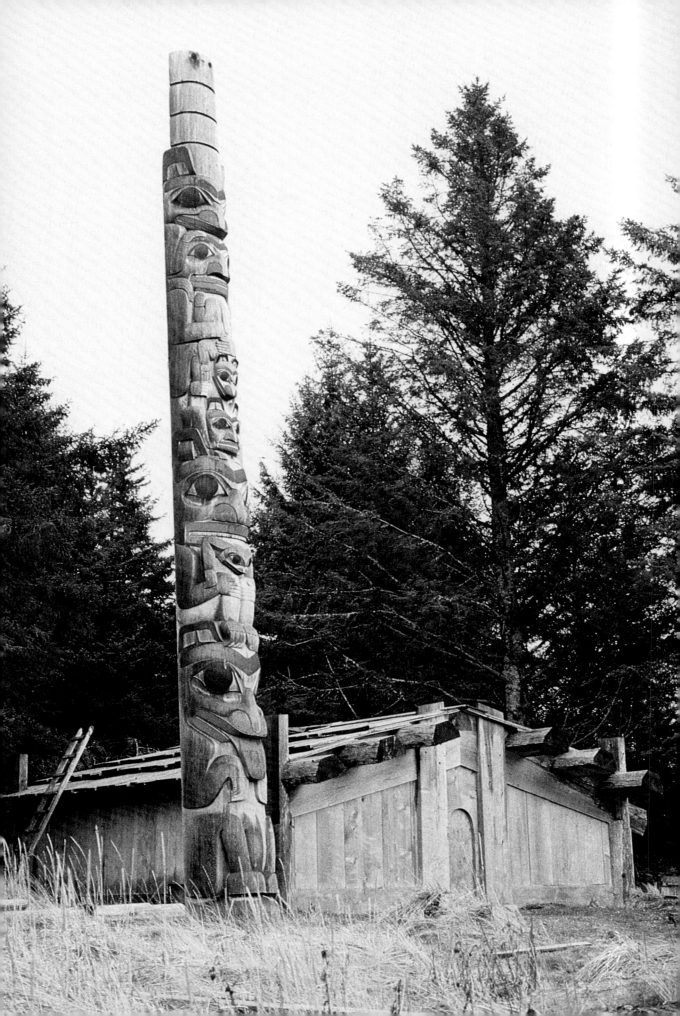

Fig. 6.20. Pole in *yaan* carved by Jim Hart.
Photograph by the author, 1997.

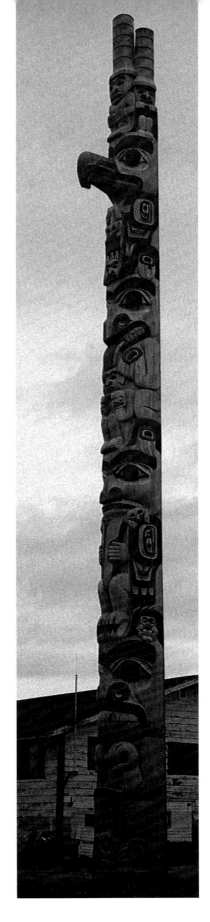

Fig. 6.21. Pole raised in Massett for Morris White on the
occasion of his taking the name *7idansuu.* Carved by Christian
White. Photograph by the author, 1996.

Appendix
Haida Language Orthography

Three dialects of the Haida language are spoken today in Hydaburg, Alaska, and in Old Massett and Skidegate, British Columbia. Skidegate (or southern) Haida is quite different from the Alaskan and Massett (or northern) Haida dialects, which are mutually intelligible (Enrico 1989). The method of spelling Haida words varies significantly among sources, and inconsistencies exist in this text according to the sources cited. In general, I have used northern Haida spellings for northern Haida names, Alaskan Haida for Alaskan names, and Skidegate Haida for Skidegate names, unless I am referring to specific quoted sources, in which case I use the original spelling.

John Swanton was the first linguist to transcribe and translate Haida texts and describe the language (Swanton 1905a, 1905b, 1908b, 1911; Swanton and Boas 1912). The only Haida dictionary available as I wrote this book was one compiled by Erma Lawrence (1977) for the Society for the Preservation of Haida Language and Literature and the Alaska Native Language Center, University of Alaska, Fairbanks. It is based on the Alaskan Haida dialect. John Enrico is currently working on a more comprehensive Haida dictionary. His orthography has been published in several sources (Enrico 1995: 205–207; Enrico and Stuart 1996: x–xii). The following lists are taken from Enrico's orthography and explain the spelling system currently in use in Haida Gwaii. Further explanations of linguistic terms provided by Enrico appear in square brackets.

Consonants

b partly voiced syllable-initially [at the beginning of a word], voiceless syllable-finally [at the end of a word, where it is pronounced as *p*]

p aspirated (borrowed) [Aspirated means a period of voicelessness before the vowel starts after the consonant is released; it sounds like a puff of air. Borrowed means the consonant appears in words of non-Haida origin.]

m

'm glottalized *m* (rare, exclamations only) [Glottalized means that air is interrupted by the closure of the glottis at the back of the throat.]

d partly voiced syllable-initially, voiceless syllable-finally

t aspirated

t' glottalized *t*

n

'n glottalized *n* (rare)

j	partly voiced (as in English *judge)* syllable-initially, voiceless (as in English *wits)* syllable-finally
ts	aspirated, as in English chew
ts'	glottalized *ts*
s	
dl	roughly as in English *waddle,* partly voiced syllable-initially, voiceless syllable-finally
tl	aspirated, roughly as in English *bottle*
tl'	glottalized *tl*
hl	voiceless *l,* similar to Welsh *ll,* Icelandic *hl* [there is no English equivalent]
l	
'l	glottalized *l*
g	partly voiced syllable-initially, voiceless syllable-finally
k	aspirated
k'	glottalized *k*
ng	
c	palatal-velar fricative, as in German *ich* [made by placing the tongue at the roof of the mouth behind the teeth]
r	Different values in Masset and Skidegate: partly voiced uvular stop in Skidegate [a uvular sound is produced with the back of the tongue up against the uvula]; pharyngealized glottal stop in Masset [a pharyngealized sound is produced with the back of the tongue up against the pharynx]. Masset has borrowed back the Skidegate value as a rare, distinct sound, represented in that dialect as G.
q	voiceless aspirated uvular stop
q'	glottalized uvular stop
x	Different values in Masset and Skidegate: uvular fricative in Skidegate [frictional passage of the expired breath through a narrowing in the vocal tract near the uvula]; pharyngeal fricative in Masset [produced with constriction or tensing of the pharynx]. Masset has borrowed back the Skidegate sound in a few words, represented as *X.*
7	glottal stop
h	
y	
w	
.	unlinked consonant slot (one can look at this as an abstract syllable boundary) [An abstract syllable boundary makes its presence known only by how it affects other sounds; in the case of Haida, it affects tone.]

Masset and Alaskan Vowels

a, aa	[as in English *fun, father*]
i, ii	[as in English *hit, heat*]
u, uu	[as in English *put, hoot*]
e, ee	[as in English *end, ate*]
oo	(very rare) [resembles the German short o in quality]

Syllabic resonants [resonants are the nasal stops *m, n,* and *ng* and the lateral *l*] are common in Masset and occasional in Alaskan Haida. Even in Masset they do not occur as such in underlying structure.

Skidegate Vowels

The southern Haida vowel system is rather different from the foregoing, having a contrast between ə and *a* rather than one between *e* and *a*. The vowell ə is realized and spelled as short *i* after *y, j, ts, ts'*, and *s;* and it is realized and spelled as *l* after *l, əl, dl, tl, tl'*, and *hl*. Elsewhere ə and *a* do not contrast, and ə is realized as a range of mid to low unrounded vowels, depending on the preceding consonant; because of the lack of contrast, ə is spelled there as *a*. The vowel *a* is spelled as @. Skidegate also has a long syllabic *l,* spelled *ll*. [An example of syllabic *l* is the second syllable in bottle or waddle; there is no equivalent of *ll* in English, but it is simply a longer syllabic *i* pronounced with a high tone.] Otherwise, Skidegate vowels are *i, ii, u, u,* and *aa* as in Massett.

a	= *a* after the two affricate series and after glides *y, w* [short *a* as in the English word *fun*]
	= ə elsewhere [as in English *fun*]
aa	[as in English *father*]
i	= ə after the nonlateral affricate series [as in English *hut*] [the lateral affricates are *dl, tl, tl', hl*. The schwa, ə, after one of these is pronounced as a syllablic *l*.]
	= i elsewhere [as in English *hit*]
ii	[as in English *eat*]
u, uu	[as in English *put, hoot*]
l	= ə after the lateral affricate series
ll	[like short *l* after a lateral affricate, long *ll* is a vowel]
oo	(rare) [resembles the German short *o* in quality]

Notes

Chapter 1. The First *gyaa.aang*

1. The name Haida comes from the word *xàadee*, which in the Massett Haida dialect means "the people."

2. Haida Gwaii is the Haida's name for their home, the Queen Charlotte Islands, British Columbia. It means "the islands (or the place) of the people."

3. Regarding the Master of the Chicago Settee, see note 30, chapter 2.

4. For a further discussion of words for "art" in Native American languages, see Holm 1999: 53–54, 59.

5. The term "totem pole," referring to the large carved poles that display family crests and histories, includes free-standing memorial poles, house frontal poles, interior house posts, and mortuary monuments that contained burials. The term has come into standard use by both native and non-native people, despite its technically inaccurate meaning. Whenever possible, I attempt to use the more accurate descriptors of specific types of poles.

6. John Enrico, personal communication, September 1999.

7. See Margaret Blackman's extensive work with historical photographs of Haida houses (Blackman 1973a, 1973b, 1974, 1975, 1976, 1981).

8. Duff cites Barbeau's knowledge of Bartlett's drawing of the house frontal pole at *daa.adans* in 1791 (Duff 1964: 85; see fig. 2.8, this volume).

9. MacDonald based much of his ethnographic data on Swanton's and Newcombe's records but rarely referenced those citations, making it difficult to determine the exact source of some of his information.

10. This is not a literal translation. Enrico (1995: 49) explained that *kilsdlaay* is an honorific term of address, roughly "sir," and that Raven was to have the title *kilsdlaay qun,* "powerful chief."

11. This pole apparently was not a copy of an existing or historical pole but one invented by Wallace to illustrate a variety of Haida crests and figures. For photographs of the pole, see Garfield and Forrest 1949: fig. 35, 90–91; Keithahn 1963: 129.

12. An edited version of this story appears in Garfield and Forrest's *The Wolf and the Raven* (1949: 91).

13. The name Oti wans (*ruud 7iw7waans*) was passed down in the family of chief *sdiihldaa* of *yaan.* It belonged to the brother of Charles *sdiihldaa* (see chapter 4) and later to Robert Ridley as well as Captain Andrew Brown (Barbeau 1916–1954: B-F-254.14, B-F-253.5, B-F-256.9, B-F-256.19).

14. John Swanton recorded the names of the various clans, or subgroups, of the two major divisions of the Haida, the Raven and Eagle moieties. He developed a numbering system for these, using the abbreviation *R* for Raven and *E* for Eagle. The names of the clans have been spelled variously in the literature, so I use Swanton's codes here to

identify them clearly. Thus the *tuuhlk'aa git'anee* Eagles are E16, the *yahgu 'laanaas* Ravens are R19, and the *sdast'a.aas* Eagles are E21 (Swanton 1905a: 268–276).

15. Burling's sketch of the houses at *k'yuust'aa* near North Island reveals large plank structures on the house fronts, which may be the carved planks that were the precursors of house frontal poles (see fig. 2.10).

Chapter 2. The Early Contact Period, 1774 to 1799

1. One Japanese junk was wrecked on the Queen Charlotte Islands in 1831. George Quimby (1985: 10, 13) speculated that given the six documented Japanese wrecks that reached the Northwest Coast between 1782 and 1833, fourteen or fifteen wrecked vessels might have reached there from Japan every one hundred years.

2. Herbert K. Beals (1989: 241) explained that this canoe would have been from thirty-four to forty-one feet long and nearly fourteen feet wide. Bill Holm (personal communication, 1999) pointed out that the width of ten codos (or fourteen feet) is very unlikely for a canoe of this length — it would have been nearly twice as wide as a typical Haida canoe of this length.

3. In his footnote 6 at this point in the text, Donald Cutter made the following comment: "Of course these Indians had no woolen stuffs. It is not probable that any of the natives seen during the voyage possessed any implements or weapons of iron or copper. The men were certainly not white; nor the women as fair and rosy as Spanish women" (Cutter and Griffin 1969: 160). In fact, the several accounts of finely woven woolen robes from this time fit precisely with what we know of the early "proto-Chilkat" or "Raven's Tail" robes made of twined mountain-goat wool that were both observed and collected on the northern Northwest Coast in the late eighteenth and early nineteenth centuries. In addition, we know that iron and copper were both in use on the Northwest Coast before the arrival of the Spaniards (Quimby 1985). Beals (1989: 238), in his commentary on the Pérez expedition diaries, considered various possible translations of the words "siendo su color blanco, pelo rubio, ojos azules y pardos" and concluded that *color blanco* did refer to a white complexion, *pelo rubio* could be translated as either "fair hair" or "blond hair," and *ojos azules* could only be "blue eyes." He pointed out that there was no reason to believe that Pérez and his two chaplains were mistaken in their description of the physical characteristics of the Haida people, and he cited Bacstrom's portrait of Gunya *(gannyaa)*, which depicts blue eyes (see plate 3).

4. Two inventories from December 1774 that list the articles obtained by the expedition in trade with Northwest Coast natives are in the Archivo General de la Nación, Mexico City. One, dated December 27, 1774, was cited and translated by Cutter from "A.G.N., Historia 61; Inventario de las Prendas combalachadas con los Yndios descubiertos a la altura de 55 grados y 49 minutos por los individuos de la Fragata Santiago destinada a explorar la costa septentrional de Californias que se remiten a S.M. por el virrey de Nueva España, Mexico, December 27, 1774." The other, dated December 3, 1774, was cited by Gormly and attributed to Francisco Hixosa, the commissary officer of San Blas (Beals 1989: 45, 237; Cutter and Griffin 1969: 278; Gormly 1977: 43).

5. See Holm 1965 for a full description of the two-dimensional "formline" style that characterizes the indigenous art of the northern Northwest Coast.

6. James Daniel Vaughan commented that it was impossible to know whether or not Cogo had been influenced by published accounts of the Spanish expedition; his story fits closely with the Spanish account. He pointed out, however, that published English accounts were only recently available (Vaughan 1985: 60). The additional detail of the placement of the gun in the grave does not appear in Bodega y Quadra's account, which suggests that this story is indeed one that has been passed down orally from the eighteenth-century Haida participants.

7. *He pa* is the Maori term for a fortified settlement (Starzecka 1996: 12, 162). For an illustration, see Kaeppler 1978.

8. Although many visitors conjectured about possible cannibalism on the Northwest Coast, this practice was limited to the ceremonial activities conducted by members of

certain secret societies, among the Haida known as ₇wiilaalaa (or Wᴀ'lala). For a discussion of the Haida ₇wiilaalaa ceremony, see Swanton 1905a: 162–170. For a general discussion of cannibalism on the Northwest Coast, see McDowell 1997.

9. Nancy Turner, Roy Taylor, and Alice Eastwood all assumed that Dixon and Menzies acquired their two samples of tobacco while together at the Queen Charlotte Islands. Dixon and Menzies (who was on the ship *Prince of Wales* with Captain Colnette) were together, however, only at Nootka Sound when Dixon had just returned from the north. Dixon gave Colnette copies of his charts and urged him to go to the Queen Charlottes, and then proceeded on to China. It is possible that Dixon's sample was collected from the Tlingit, since the use of the tobacco plant was described in Beresford's account at Port Mulgrave in Tlingit country: "The Indians are particularly fond of chewing a plant, which appears to be a species of tobacco; not content, however, with chewing it in its simple state, they generally mix lime along with it, and sometimes the inner rind of the pine-tree, together with a rosinous substance extracted from it." The tobacco sample collected by Dixon is now housed at the herbarium of the British Museum. The other leaf, collected by Archibald Menzies, is in the Royal Botanic Gardens at Kew. The Haida and other northern Northwest Coast peoples did not smoke tobacco before white contact, though the only plant they cultivated in precontact times was a now-extinct species of wild tobacco (most closely allied with *Nicotiana multivalvis,* a variety of *Nicotiana quadrivalvis).* They consumed this native tobacco by pulverizing it in stone mortars and forming it into balls that were sucked or chewed as a stimulant with lime obtained from burned clam shells. European seamen had learned the custom of smoking tobacco from Native Americans on the east coast of North America during the sixteenth century, and more than two hundred years later they in turn introduced the custom to the Northwest Coast (Beresford 1789: 175; Eastwood 1938: 92 ; King 1981: 61; Turner and Taylor 1972: 250).

The custom of smoking tobacco in pipes was introduced to the northern Northwest Coast by European sailors. When the first European sailing ships arrived, the sailors were smoking tobacco in white clay pipes. H. G. Barnett recorded an account of a Coast Salish reaction to this sight: "At Nanaimo I received a graphic account of the introduction of smoking with the arrival of the first ship there and the natives' amazement over men who had to keep their mouths open with tubes so as to breathe" (Barnett 1939). By the early nineteenth century, the smoking of tobacco in pipes had been incorporated by Tlingit, Haida, and Tsimshian peoples as a ceremonial part of their funeral feasts and house-raising celebrations. Elaborate wooden pipes with carved crest figures were used for these purposes along with the commercial clay pipes received in trade. Knut Fladmark's excavation of a house site near Tlell (just south of Cape Ball on the east coast of Graham Island) revealed "the presence of numerous tobacco pipes, suggestive of the debris from a tobacco feast." These included several clay trade-pipe fragments as well as three argillite pipes modeled after clay pipes, two Haida motif argillite pipes, and pipe fragments. The more elaborate of the two Haida motif pipes, in the form of a cockle with human faces in the shell, was found in association with a burial at the rear of the house. This led Fladmark to conclude that the house had been abandoned after the funeral feast and left as a mortuary monument sometime between 1810 and 1840 (Fladmark 1973: 59). This is the earliest archaeological evidence for the use of argillite on Haida Gwaii.

10. The various spellings for the name *gannyaa* include the following: Cuneah (in Haswell's first log of the *Columbia,* 1789; see Howay 1990: 96); Blakow-Coneehaw (Captain Douglas, 1789; see Meares 1967 [1790]: 365); Connehow and Connehaw (Bartlett, 1791; see Snow 1925: 299, 306); Cunneyah (Captain Ingraham, 1791; see Kaplanoff 1971: 103); Taglas Cania (Caamaño, 1792; see Wagner and Howay 1938: 215); Cunnea (Haswell's second log of the Columbia, 1792; see Howay 1990: 325); Cunniha and Cunnyha (Bacstrom 1793; see Cole 1980); Cunneah (Captain Roberts, 1794; see Howay 1930: 89); Cunniah (Hoskins, 1791, and Boit, 1795; see Hayes 1981: 45; Howay 1990: 236); Cunneaw (Burling 1799: 28); Coneyaw (Captain Cleveland, 1799; see MacNair

1938: 192); Gunya (Barbeau 1957: 4); Gəniyá (Blackman 1982: 5); and Gaanyaa (Harris 1992: 193)

11. Captain Douglas and all aboard the *Iphigenia* were seized by the Spaniards at Nootka Sound on May 14, 1789, and held for nearly two weeks, after which Douglas claimed that the Spaniards had taken nearly everything of value, including trade goods (Pethick 1976: 150–151).

12. MacDonald (1983: 195) speculated that the crops Meares observed at *daa.adans* were potatoes, suggesting that Douglas saw this as evidence that other Europeans had gone ashore before him. Many sources, however, indicate that tobacco had been the only cultivated crop grown by Haida people in precontact times (Deans 1890; Dixon 1933; Turner and Taylor 1972). Perhaps introduced by fur traders in the late eighteenth century, potatoes became an important cash crop for the Haida people during the early nineteenth century (Blackman 1982: 43; Dunn 1846: 41). Delores Churchill reported that members of the Haida Hummingbird clan (the *git'anee* Eagles, Swanton's E15–E19) believe that their ancestors acquired potatoes before white contact, after being blown off course while on a canoe voyage and lost somewhere to the south, where the local people taught them how to grow the plant. Hummingbird eventually led them home, and they were able to return to Haida Gwaii with this knowledge and a supply of potatoes and tobacco (Delores Churchill, personal communication, July 1998).

13. John Wallace told Viola Garfield that the name Ga.u' *(gu.uu)*, which belonged to Henry Edenshaw's older brother, was said to be a white name from a sea captain. One of the crew of a ship killed a man of the *yahgu 'laanaas* Ravens, and the family was paid with the captain's name (Garfield 1941: 27). No reference to such an incident or to a captain's name resembling Kow has been found in the journals. If this event took place, it must have happened before 1791, when the name first appeared in Ingraham's journal. The various spellings for the name Kow include the following: Cow (Burling 1799: 39–40; Kaplanoff 1971: 101–111); Kow (Howay 1990: 228–230); Gow (Kaplanoff 1971: 193–194); Cawe (Howay 1930: 89); Kowe (Green 1915: 69–71; Roe 1967: 80–84); Gao (Harris 1992: 193); Ga.u' (Garfield 1941: 27); Gə7wu (Blackman 1982: 66); and *gu.uu* (Harris 1992: 193).

14. *Pe-shak* means "bad" in Chinook jargon, a trade language in use on the Northwest Coast when the first Europeans arrived that was made up of words from several native languages as well as French and English (Thomas 1970: 92).

15. While trading with Skidegate at Cumshewa's village, Ingraham offered him some feathered caps and cloaks that he had acquired in Hawaii: "I showed everything which I thought would induce them to trade, among which were some feathered caps and cloaks I had received as presents at the Sandwich Islands. With these they seemed vastly enamored. I sold a cap and two cloaks for five excellent skins. Skatzi praised them highly, which induced Skutkiss to buy them, but after possessing them a little while he repented his bargain and asked for his skins again. But as sea otter skins were to me much better curiosities than caps and cloaks, I chose to adhere to the bargain. Although I always gave these people the fairest chance in trade, yet to return skins after once bought would be to commence a custom tending to lose time and which could have no end. Seeing I was determined not to return the skins, the old chief threw those he had on board into the canoe and followed himself, where he sat for a while looking sullen. However, a small present reconciled us again" (Kaplanoff 1971: 128–131).

16. On July 21, 1792, Ingraham obtained from Skatzi an account of the injuries inflicted by Captain Kendrick on Koyah's family and friends. He asked how many had died: "They answered forty, among which were several women and children. Koyah, they said, was wounded in the back and lost in the battle a wife and two children; two of his brothers were likewise badly wounded. Sculkinants was wounded in the left cheek, and the ball lodged under his ear, which they could not extract till lately" (Kaplanoff 1971: 204).

17. According to John Enrico (personal communication, September 1999), this is not a recognizable Haida word.

18. The name Massett was taken from Maast, an island in the inlet about three miles above the village, and was later applied to the village. The Haida name for Massett is

rad raci7waas (Uttewas), which means "white slope" (MacDonald 1983: 133; Walbran 1971: 323).

19. The village on this island has been called Ninstints *(nan sdins)* after a later chief's name. In 1791 Captain Kendrick's behavior toward *xuyaa* (Coyah) precipitated a series of violent attacks, as reported by Hoskins on the *Columbia:* "On Coyah the chief's being asked for, we were informed by several of the natives, particularly a woman, who was very intelligible: that Captain Kendrick was here sometime ago in a vessel with one mast, and lately in one with two; that he took Coyah, tied a rope round his neck, whipt him, painted his face, cut off his hair, took away from him a great many skins, and then turned him ashore: Coyah was now no longer a Chief, but an 'Ahliko,' or one of the lower class; they have now no head Chief, but many inferior Chiefs. How much credit is to be given to this story, when it is considered our knowledge of their language is so very superficial as scarcely to be understood but by signs: and from Captain Kendrick's well known disposition, who has hitherto treated these people more like children than an ignorant race of savages; it must therefore be supposed Captain Kendrick has been provoked by these peoples conduct to punish their Chief" (Howay 1990: 200).

After their return to Nootka Sound they encountered Captain Kendrick with his version: "Captain Kendrick arrived on the 13th of June in latitude 52° 58' north he went into Barrell's Sound where his vessel a few days after his arrival was attacked and actually in possession of the natives nearly an hour when he again recovered his vessel killed and wounded a great many among the rest a woman who was a proper amazon. This he attributes to the following cause soon after he sent the Columbia on to China he sailed from Clioquot for Washington's Islands and went into Barrell's sound having been there a short time the natives found means to steal his linnen etca. that had that day been washed this with some other things they had at times robbed him of induced him to take the two Chiefs Coyah and Schulkinanse he dismounted one of his cannon and put one leg of each into the carriage where the arms of the cannon rest and fastened down the clamps threatning at the same time if they did not restore the stolen goods to kill them nearly all the goods were soon returned what was not he made them pay for in skins as this was a means though contrary to his wishes of breaking friendship with them and well knowing if he let those Chiefs go they would sell him no more skins he therefore made them fetch him all their skins and paid them the same price he had done for those before purchased when they had no more the two Chiefs were set at liberty when he went into the Sound this time the natives appeared to be quite friendly and brought skins for sale as usual the day of the attack there was an extraordinary number of visitors several Chiefs being aboard the arm chests were on the quarter deck with the keys in them the gunners having been overhauling the arms the Chiefs got on these chests and took the keys out when Coyah tauntingly said to Captain Kendrick pointing to his legs at the same time now put me into your gun carriage the vessel was immediately thronged with natives a woman standing in the main chains urging them on the officers and people all retired below having no arms but what was in possession of the natives save the officers private ones Captain Kendrick tarried on deck endeavouring to pacify the natives and bring them to some terms at the same time edging towards the companion way to secure his retreat to the cabbin a fellow all the time holding a huge marling spike he had stolen fixed into a stick over his head ready to strike the deadly blow whenever orders should be given the other natives with their daggers grasped and only waiting for the word to be given to begin a most savage massacree just as Captain Kendrick had reached the companion way Coyah jumpt down and he immediately jumpt on top of him Coyah then made a pass at him with his dagger but it luckily only went through his jacket and scritched his belly the officers by this time had their arms in readiness and would have ventured on deck with them before but for fear of killing their Captain Captain Kendrick now fired a musket from the cabbin then took a pair of pistols and another musket and went on deck being followed by his officers with the remainder of the arms they had collected the natives on seeing this made a precipitate retreat all but the woman before

mentioned in the chains who there continued urging them to action with the greatest ardour until the last moment though her arm had been previously cut of by one of the people with a hanger and she was otherways much wounded when she quitted all the natives had left the vessel and she jumpt over board and attempted to swim of but was afterwards shot though the natives had taken the keys of the arm chests yet they did not happen to be lockt they were therefore immediately opened and a constant fire was kept up as long as they could reach the natives with cannon or small arms after which they chased them in their armed boats making the most dreadfull havock by killing all they came across this accounts for the story the natives told us when we were there" (Howay 1990: 240–241).

20. On April 27, 1792, Haswell recorded in the log of the sloop *Adventure*: "The natives frequently tell us that one Jones, a person belonging to Captain Crowel's brig stayed among the natives of Tadents, and was now at Legonee [Kaigani]. Whether this is a device of their own brain to amuse or the fact, I know not" (Howay 1990: 323).

21. Ingraham must have enjoyed eating pork; he earlier attempted to establish a wild population of pigs on an uninhabited island in Magee's Sound in the southern Queen Charlottes, as recorded in his journal for June 28, 1791: "As I had some pigs on board which remained of those I had purchased at the Sandwich Islands, I put three on shore — two sow and a boar. Perhaps whoever may visit Magee's Sound at some future period will find the benefit of them. Be this as it may, I left them when I could ill spare them with that view, and on the same point where I left them I left a letter in a bottle sealed and fastened to the bough of a tree with a small chain. The purport of this letter was to acquaint those who might find it of our arrival, etc., and the name we had given the sound. Likewise we advised them of the pigs we had left, desiring them not to molest or destroy them till they had time to increase and multiply in the land" (Kaplanoff 1971: 97).

22. "Samoguet" is from the Tsimshian word for chief, *sm'oogyit* (Dunn 1995: 91).

23. On the Northwest Coast, song leaders frequently use eagle feather fans to punctuate the beat, suggesting that this blind man might have been the song leader.

24. John Enrico, personal communication, September 1999. It has also been spelled Kuscwai (Walbran 1971: 362).

25. The name Jammisit, if pronounced according to the Spanish spelling, would not have the English *j* sound at the beginning but rather an *h* sound. The name Hamtsid, meaning "eating owner" or "owner of eating," is widely known and used among both the Heiltsuk and Kwakwaka'wakw people. It is probable that the name written in the Spanish journal as Jammisit is in fact the name Hamtsid. If so, this man would most likely have been Heiltsuk (Bill Holm, personal communication, August 1998; see also Wright n.d.).

26. Vaughan speculated that Tchua was from Norfolk Sound in Tlingit country, but Bacstrom's label (plate 6) clearly indicates that he was a chief of the Queen Charlotte Islands (52° 12' N), thus confirming, along with Pérez's account, that the use of this type of robe was not limited to the Tlingit people (Cole 1980; Vaughan and Holm 1982: 207).

27. Clamons are heavy elk hides acquired by fur traders primarily from the Columbia River area and traded to the northern Northwest Coast tribes for use as armor (Gibson 1992: 9, 230).

28. In 1794, two ships were attacked in Koyah's Sound and their crews killed. One was a large English ship (name unknown) that put in to Koyah's Sound in the winter to replace broken masts; the other was the American brig *Eleanora*, under Captain Simon Metcalfe (Duff 1976: 86; Roe 1967: 103–104).

29. Both Hayes and Duff suggested that Skotcheye was an alternate spelling for Koyah, but they were clearly in error, since Skotseye had been encountered living in Cumshewa's village by earlier traders (Duff 1976: 86; Hayes 1981: 123). Duff based his conclusion on Howay's account of Boit's journal, because at the time he was writing, this journal had not been published (Holm, personal communication, 1998).

30. This man owned three houses at *qays7un*. MacDonald (1983: 117) reported that

C. F. Newcombe collected two of his settees for the Field Museum of Natural History (cat. nos. 79595, 79597), but the Field Museum catalog records indicate that only one settee belonged to "Skotsgaai" (cat. no. 79597). The second settee (cat. no. 79595), probably made by the same artist, was collected from a chief at *caynaa 'llnagaay* (Haina or New Gold Harbour). Both of these settees can be attributed to the "Master of the Chicago Settee," and the Haina settee is the signature piece that has given its name to this as yet anonymous artist (see Holm 1981). If the maker of these settees was also the owner of one of them when Newcombe collected them, then the "Chicago Settee Guy" might really be named *nang naara rii skil cawgyaas* (Nañ na'gage skilxa'ogas or Skotsgai).

31. There has been considerable confusion in the past over exactly who the author of this journal was. S. W. Jackman published the journal as *The Journal of William Sturgis* in 1978, despite the fact that many entries in the journal reveal that Sturgis was not the author. William Sturgis was sixteen, "a green hand before the mast," when he shipped on the *Eliza* in 1798, and he acted as an assistant to Captain Rowan in managing the business side of the fur trade. When the *Eliza* encountered the *Ulysses* at Kaigani, the latter ship was under mutiny. To resolve the situation, Sturgis went aboard the *Ulysses* as second officer and sailed with the ship to Canton, where he rejoined the *Eliza* for the return trip to Boston. The journal describes this exchange of Mr. Sturgis in the third person, clearly indicating that Sturgis was not the author of the narrative, which continues to describe events on the *Eliza* after Sturgis's departure (Jackman 1978: 99). Jackman pointed out that the last entry in Sturgis's log (only part of which is extant in the Massachusetts Historical Society) is dated February 6, 1799, just as the ship was arriving on the Northwest Coast at Sitka. Two copies of a narrative that continues after this date exist at the Massachusetts Historical Society and in a private collection. The Massachusetts Historical Society copy is listed as being by a John Burling (Burling 1799). Research conducted by Margaret L. Waddington and discussed in her correspondence with John Fraser Henry has revealed a great deal about the true identity of the author of the journal, who was in fact one Samuel Burling, the clerk aboard the *Eliza* (John Fraser Henry's collection of research notes was recently donated to the Burke Museum's Ethnology Archives). Frederick Howay (1990: 235), Robert A. Stearns (1961), and Sister Magdalen Coughlin (1970) all identified the author of the *Eliza*'s journal as Burling. There has been further confusion about this Samuel Burling, since he later changed his name to Samuel Curzon. He was apparently the son of a Samuel Curzon, who was a secret agent for the United States government during the Revolutionary War and who fell in love with Elizabeth Burling of Baltimore. They eloped, but she later returned to give birth to their son (around 1782) and live with her brother William in Baltimore, giving the son their name, Burling. William Burling later killed Samuel Curzon in a duel, presumably as the result of a dispute about his relationship with Elizabeth Burling (Pleasants 1919: 42–45). After learning of his father's fate, sometime before 1808, Samuel Burling changed his name to Samuel Curzon (Briggs 1927: 468–469). While aboard the *Eliza*, however, he was known as Samuel Burling. He kept the journal of the *Eliza* and probably shared it with Sturgis after his return to the *Eliza*. Sturgis later used it in many lectures about his adventures. See also Malloy 2000.

32. Samuel Burling's brother had been the captain aboard Captain Roberts's tender, the *Resolution*, when it was attacked at Cumshewa in July 1794. All aboard were killed except one man, who was held captive for a year (Roe 1967: 82, 97).

33. Burling apparently made drawings of *daa.adans*, *k'yuust'aa*, and *k'áyk'aanii* villages, but only the *k'yuust'aa* drawing has been published. A second drawing was located by John F. Henry and Margaret Waddington in the photocopy of Burling's journal at the University of British Columbia Special Collections. It shows a sketchy view of a beach with three hills in the background and trees along the shoreline. This may be the *k'áyk'aanii* sketch, since no houses are apparent in it, and Burling specifically stated that he sketched the two houses at *daa.adans* (see J. F. Henry's letters to Margaret Waddington, Burke Museum Ethnology Archives).

34. This pole stands to the right of the largest house pit in the village, which

MacDonald (1983: 190) identified as Iłtini's (*7ihldii'nii's*) house (House 9). In Burling's drawing it is to the left of *gaanyaa's* house (presumably the largest house at that time). It is possible that after *gannyaa's* departure from *k'yuust'aa*, *7ihldii'nii's* house was built to the left of the pole. See figure 4.47 for a similar bear memorial pole in Massett, raised in honor of *gu.uu 7aww*, Albert Edward Edenshaw's wife (Blackman 1982: 55).

35. Ts'ibasaa is a Coast Tsimshian chief's name from the village of Kitkatla.

36. Charts 1, 2, and 3 are based entirely on references to family relationships found in explorers' journals, and therefore are likely to contain many errors due to their misunderstandings. All of the genealogy charts in this book are likely to contain some errors, which I hope to correct as new information is received.

Chapter 3. The Early Nineteenth Century, 1800 to 1853

1. The name *7idansuu* is pronounced ee-DAN-suu, with the accent on the second syllable and with no "sh" sound. It was spelled with the "sh" in the baptismal records of both Albert Edward and Charles Edeshaw in 1885 and has been spelled and pronounced many ways over the years. Alternate spellings include Itemtchou (Roquefeuil 1981); Eadinshu (Green 1915: 64–65); Eda'nsa (Swanton 1905a: 12), Edensa (Gough 1993), Edensaw (Appleton 1970; Barbeau 1957; Dockstader 1977; Gough 1993; Waldman 1990), Edenshaw (Blackman 1982; Gough 1993; Harris 1966), Edenshew (written over the door on his house at Massett), Edinsa (Gough 1993), Edinso (Gough 1993), Eedensuh (Barbeau 1957), Ee-din-suh (Appleton 1970), Idansu (Dockstader 1977; Waldman 1990), *7idansuu* (Harris 1992), Idinsaw (Gough 1993), Itinsa (Dockstader 1977), and Itnsaw (Blackman 1982: 53).

2. See note 9, chapter 2.

3. Sk!u'lxa hai'yet is not a Haida name but resembles Tsimshian (John Enrico, personal communication, September 1999).

4. The other two houses were named *yaanaang na.as* ("Cloudy House"), owned by *gyaawhlans*, chief of the *kuna 'laanaas* (R14) and town chief, and *t'uuts' na.as* ("Fort House"), owned by *skil qii.aas*, a chief of the *kuna 'laanaas* (Point Town People, R14) (Swanton 1905a: 289). Charles Edenshaw told C. F. Newcombe that seven houses originally stood at the village. The remains of five houses were located during a site survey by the Canadian National Museum in 1981 (MacDonald 1983: 173).

5. In 1947 this pole was removed to Prince Rupert, where it was repainted repeatedly and stood for many years (MacDonald 1983: 173). After the Tsimshian artist William Jeffrey carved a replica of the pole, which still stands in Prince Rupert, in 1965, the original pole was taken to the Royal British Columbia Museum in Victoria. In 1976 it was repatriated to Massett, where it remains today.

6. Newcombe listed this date as eighteenth century in one typed version of the story but corrected it to nineteenth century in another (Newcombe 1900–1911: vol. 38, folder 3; vol. 55, folder 7). A third account gives the date as "near beginning of last century." This later date is most likely the correct one (Newcombe 1900–1911: vol. 56, folder 1).

7. In her fictional account of Albert Edward Edenshaw's family, *Raven's Cry*, Christie Harris (1966) identified the uncle of *gwaaygu 7anhlan* as a man named Yatza (born 1761, died 1840), who became Chief Edinsa in 1794, after the death in 1793 of a previous Chief Edinsa.

8. The story of Qats and the grizzly bear represented on *skil.aa.u's* pole belongs to the Tekwedi Tlingit clan (Swanton 1909: 228–229). The Burke Museum has two interior house posts collected by the Harriman expedition at the Sanya village of Gash at Cape Fox (near Tongass) that also illustrate the bear story of Qats (Holm 1987: 212). Tongass and Cape Fox are among the southernmost Tlingit villages, directly northeast of *hl7aalang* on the mainland.

9. It is said by the family of Mary Ebbetts (*Abbits*) Hunt (*Anaslaga*), who was a high-ranking Tongass Tlingit woman married to Robert Hunt, the Hudson's Bay factor at Fort Rupert, that a sister of Mary Ebbetts's had married into the Edenshaw family and brought the name *7idansuu* with her. Perhaps this was the woman who had married

skil.aa.u, bringing with her the story of Qats and his grizzly bear wife. If this is true, then Mary Ebbetts's sister must have been considerably older than Mary Ebbetts (b. circa 1823; d. 1919), because *skil.aa.u* probably died in the early nineteenth century, and an old *7idan-suu* was well established in Massett by 1818, when de Roquefeuil arrived there. The name *7idansuu* was also passed down through Mary Ebbetts's family among the Kwagulth at Fort Rupert, going to Bob Wilson, the son of Emily Hunt Wilson, who was the grand-daughter of Anaslaga (Hoover 1995: 49; Bill Holm, personal communication 1999).

10. This rear pole had fallen shortly before my visit there in June 1998.

11. A double-post mortuary in Tian village, on the west coast of Graham Island, also has stylized faces in the eye ovoids (MacDonald 1983: 205, plate 270).

12. See Wright 1977, 1979, 1980, 1982, 1985, 1986, 1987, 1992.

13. Other pipes that are related in style include one in the British Museum (cat. no. 1953.AM13.1), one in the New Bedford Whaling Museum, and one in the Milwaukee Public Museum (cat. no. 1318).

14. Kathleen Dalzell (1973: 453) said his death occurred around 1850, but most other sources give the date as around 1840. If Newcombe's account, that Sqiltcange died before Albert Edward Edenshaw was born, is correct, then the *k'yuust'aa* triple mortuary must have been carved before 1812.

15. Harrison wrote that Albert Edward Edenshaw succeeded his uncle as the chief of the Shongalth Lennas, who had their headquarters at Dadans, near North Island (Harrison 1911–1913: vol. 1, no. 52, p. 3). In fact, *daa.adans* is located on North Island, and the Edenshaws lived at *k'yuust'aa. saangga.ahl 'laanaas* is an alternate name for the *saangga.ahl sdast'a.aas* Eagle clan (Swanton's STᴀ'stas, E21). According to Swanton, "STᴀ'stas is a name given to salmon-eggs after the young have begun to form. A woman was the only one left of her tribe, and from her all of the family sprang. Sañg is the name of a kind of sea-bird, flocks of which rush down together upon anything they find to eat, and make a great noise. This was likened to the noise of this people at a potlatch" (Swanton 1905a: 275).

16. In a biography of Albert Edward Edenshaw, Barry M. Gough (1993: 289) listed his parents as Duncan and Ninasịnlahelawas. These were in fact the parents of Albert Edward's first wife, *gu.uu 7aww.* Perhaps the source of the error is a misreading of the genealogy chart in Blackman's *During My Time: Florence Edenshaw Davidson, a Haida Woman* (Blackman 1982: 60–61).

17. According to the Anglican practice, the names of the fathers of both husband and wife were recorded in the marriage record, but not the mothers' names.

18. Names were sometimes passed to people in different clans, so this may not nec-essarily be the case.

19. Dalzell (1968: 63) gives his birth date as about 1822, based on the date on his mon-ument in Massett. This monument, which acknowledges his rescue of the *Susan Sturgis* passengers, stands in front of the location where his house in Massett once stood and reads: "In memory of Albert Ed. Edenshaw, Head Chief of North Island, Q.C.I., born 1822, died 1894, Member of St. John's Church." Albert Edward Edenshaw's gravestone in the Massett cemetery, however, reads "Albert Ed. Edenshaw, chief, Nov. 16, 1894, 80." This would place his birth date at 1814. Because birth dates in this era were not recorded, these birth dates were estimates based on his approximate age at death. Margaret Blackman (1982: 60) gave his birth date as 1812 in her genealogy chart, and in his biog-raphy, Gough (1993: 289) gave the date as circa 1810. Charles Harrison gave his birth date as around 1812, based on his judgment that Albert Edward Edenshaw was about seventy when Harrison first met him — but if he first met him when he arrived at Massett in 1890, that would place Edenshaw's birthdate at about 1810 (Harrison 1911–1913: vol. 1, no. 52, p. 3).

20. The name of this village is spelled Althins Kwun by Dalzell (1968: 63), Ǥǎłiˈnskun lnagā'-i, "town set up high on a point," by Swanton (1905a:280), and *rahlans kun* by Enrico (1995).

21. Also spelled Ładja'ñ qo'na or Kłˈajangkúna.

22. Some have indicated that it was to this Raven lineage (R13) that *gwaaygu 7anhlan's* father belonged (Captain Gold genealogy, Haida Gwaii Museum archives), but judging from the father's name of Cowhoe in Albert Edward Edenshaw's marriage record, this may not be true.

23. Newcombe's notes describing Skidegate poles are the source of this name (Newcombe 1900–1911: Add. Mss. 1077, v. 55, file 10, p. 1). The word "branches" is given in quotation marks after the name *ga agit* as a translation of the word. MacDonald (1983: 46) gave the name "branches" as the wife of Tlajinkuna in relation to a beaver pole associated with House 10 in Skidegate, but he did not include the name *ga agit* with it. John Enrico (personal communication) reports that *ga agit* is not a known woman's name. The word does not mean branches in the Haida language, and Newcombe's use of it in his notes remains a mystery. While similar to the Haida word *ga gi.iid,* meaning "landotter man," this is not a name that would have been used for a woman (Enrico, personal communication, April 2000).

24. Dalzell (1968: 63) tells us that *gwaaygu 7anhlan* was eighteen at the time his older brothers died, and he grieved bitterly over their loss. She further reports that after their deaths, *gwaaygu 7anhlan* was taken immediately to *k'yuust'aa* to be with old *7idansuu* (whom she identifies as his maternal uncle). The source of her information was Charles Harrison's series of articles in the *Queen Charlotte Islander* (1911–1913, vol. 1, no. 52, p. 3), though Harrison did not explain the details of the brothers' deaths or date them other than to say they happened a few years before *gwaaygu 7anhlan* was called to prepare for the chieftainship. Dalzell's estimation of his age may be based on her belief that he was born in 1822 and assumed the name *7idansuu* around 1840.

25. The spelling *gyaawhlans* is the Massett dialect spelling of the name, and *gyaawhllns* is the Skidegate dialect spelling (John Enrico, personal communication 1998).

26. MacDonald (1996: 214) gave the date of about 1832 for Albert Edward Edenshaw's inheritance of the name *7idansuu,* also saying that his uncle's home village had been *daa.adans,* probably on the basis of Harrison's account (Harrison 1911–1913: vol. 1, no. 52, p. 3).

27. Boelscher (1988: 206) acknowledges that this name belonged to the *juus xàadee* (Tsiits Git7ans), but she questions whether the eighteenth-century chief called *gannyaa* from *k'yuust'aa* was from this clan, since it was from Massett Inlet and owned no land or villages near *k'yuust'aa.* The name *gannyaa* has been held by a number of men since the death of the late-eighteenth-century *gannyaa.* They include Robert Ridley (1857–1937), George Young (1864–1924), and Robert Davidson, Sr. (1880–1969), who was called that after his grandfather (Blackman 1982: 108). Marius Barbeau wrote about George Young (George Gunya) in his *Haida Carvers,* describing him as the owner of the argillite quarry and erroneously attributing to him many argillite flutes (Barbeau 1957: 4–9; Wright 1977: 18–19).

28. It seems that the only Captain Duncan who was on the Northwest Coast long enough to have fathered several children during this time was Captain Alexander Duncan. The earliest Duncan on the Northwest Coast was Captain Charles Duncan, who commanded the British trading sloop *Princess Royal* there in 1788–1789 (Gough 1992: 94; Howay 1990: 97–98; Walbran 1971: 157–158). Charles Duncan's brief visit to the Northwest Coast, however, took place before *nan na.aa san 'laa xiilawaas* would have been born. It is more likely that the father of her children was Captain Alexander Duncan, who rose from the position of seaman to that of master in the marine department of the Hudson's Bay Company in the early nineteenth century. He first arrived at Fort Vancouver, the Hudson's Bay Company's post on the Columbia River, in 1826, having sailed from London as a seaman on the *William & Ann.* He returned to London in 1828 and came back to the Northwest Coast as first officer on the brig *Dryad* in 1830. It appears that his first visits to the northern Northwest Coast came only after his return in 1830. By 1832 he was in command of the *Dryad.* He was captain of the schooner *Vancouver* when she was wrecked on the Queen Charlotte Islands in 1834. Exonerated from all blame, he was placed in command of the *Cadboro.* After commanding other vessels for the

Hudson's Bay Company, including the *Beaver,* he retired in 1848 (Baker 1948: 305–306; Work 1945: 21).

29. Another chest panel of somewhat similar style was collected by C. F. Newcombe and sold to Culin. Though it was said to have been a coffin board from Knight Inlet, it is possible that it was actually part of a Haida chest that Culin bought from G. T. Emmons in 1915. It is certainly Haida in style; the shapes of the inner ovoids are rounded like those on the Thaw and Nisyoq chests, though the U forms are more angular (Fane, Jacknis, and Breen 1991: 249).

30. MacDonald mistakenly described the *ráwk'aan* pole as one that was later taken to Indianapolis. The Indianapolis pole, however, was a similar pole attributed to Dwight Wallace and also belonging to Yeltadzie, but from the village of *q'wíi rándllass*, near *ráwk'aan.* This pole was acquired by Governor Brady of Alaska, along with several others, to be taken to the St. Louis World's Fair in 1904. Because it was damaged, it ended up in the "Esquimaux Village" exhibit rather than outside the Alaska Building as had originally been intended. It was sold to a St. Louis firm that later sent it to David M. Parry in Indianapolis as a gift, instead of its being returned to Sitka with most of the other poles (Feldman 1996).

31. Haida villages were not corporate units with a single chief. Within each village there were several autonomous households, each led by a high-ranking "chief." The head of the lineage holding title to the town site was recognized as the "town chief" or "town master" (Sterns 1981: 31).

32. MacDonald identified this pole as possibly belonging to House 8, "pointing hands with outstretched fingers in anger," owned by "Devil's Club" of the Stastas Eagles. It measured 10.5 meters wide and 12.0 meters long, with an interior pit 7.5 meters across. This seems too small to be the house Swan sketched. House 8 was located next to Myth House, but it is not shown as having a frontal pole in MacDonald's map of the village (MacDonald 1983: 189–190, plate 256).

33. Kadashan's pole was itself copied by the Civilian Conservation Corps in the 1930s, and this replica still stands in Wrangell on Shakes Island today (see Wright 1992: fig. 10). A fragment of the original pole is preserved in the Wrangell Museum.

34. Before I had seen the photograph of the family together, I had incorrectly described the man in the other photograph as wearing one of the two Chief Shakes whale hats, since the hat appeared similar to the one being held by the boy at the left in the Winter and Pond photo (fig. 3.38). The hat (seen more clearly in the family view) has five basketry rings with no fin at the top and an ermine skin pendant. This hat does not appear to be the "green paint hat" with two tops side by side that Swanton described, but since the hat is tipped to obscure the full view, it has yet to be firmly identified (Wright 1992: 52). There was a connection between the Kadashan and Shakes families, in that Chief Shakes VI married Kadashan's daughter (Winter and Pond 1905).These photos are the last record of the staff in native hands, before it was acquired after 1899 by F. W. Carlyon, a Wrangell shopkeeper. Two objects from the Shakes family were also in that collection when it came to the Oakland Museum in 1959 — a frog crest hat (cat. no. 4153.1) and a beaver pipe (cat. no. 4153.4).

35. For a fictional account of this incident, see Harris 1966: 95–101.

36. Gough (1982: 133) quoted this passage from Dalzell (1968: 67), but Dalzell attributed the quote to "William Houston Stewart, captain of the *Tricomalee.* " Gough, however, attributed the quotation to Kuper. Since in fact the captain of the *Trincomalee* was Wallace Houstoun, not William Houston Stewart (who was the previous commander of the *Virago),* I believe Dalzell was wrong, and Gough was correct in crediting the quotation to Kuper.

Chapter 4. The Mid- to Late Nineteenth Century, 1853 to the 1880s

1. Dalzell (1968: 65) got this information from Wilson Duff.

2. John Work used Nigh-tasis as the name for Kung in his 1836–1841 population estimates for the Haida, which were published by Dawson in 1880 (Dawson 1880: 173B).

3. In his book *Haida Art* (1996: 175), George MacDonald misidentified his plate 128 as showing Albert Edward Edenshaw's *qang* house. The two houses in the Dawson photograph were correctly identified in MacDonald's *Haida Monumental Art* (1983: 182, plate 247) as Houses 12 and 13 at the opposite end of the village.

4. June Bedford pointed out that George MacDonald confused Harrison's book with one by the Reverend William H. Collison (Bedford 1998: 3; MacDonald 1983: 149). This was apparently also the case when MacDonald gave "Collison 1925: 176" as the source of this information about the pole honoring Governor Douglas (MacDonald 1983: 181). The publication date for Collison's *In the Wake of the War Canoe*, however, is 1915, and no such information appears on that page. Harrison's *Ancient Warriors of the North Pacific* (1925), on the other hand, does include this information on page 176.

5. MacDonald, on the basis of Swanton's lists, identified this house (House 6) as House Child (Na gi'di), owned by Xalas of the *sa'gua laa'naas* (E19) (MacDonald 1983: 181; Swanton 1905a: 293).

6. This incident is the reverse of the experience of the owner of Grizzly Bear's Mouth House, who had portraits of Judge Pemberton of the Victoria Police Court and George Smith, the Victoria town clerk, raised on his corner posts in order to ridicule them after his arrest in Victoria in the 1870s (see chapter 5; MacDonald 1983: 45).

7. The Reverend Charles Harrison was aware that it was *gaanyaa*, not Edenshaw, who had met Captain Douglas, and it may be that Collison incorrectly interpreted what Albert Edward Edenshaw told him (Collison 1981: 180; Harrison 1925: 70).

8. Frederick Dockstader (1977: 83) and Carl Waldman (1990: 110) each erroneously reported that Charles Edenshaw was born at Cape Ball on Graham Island, probably confusing Charles with his uncle, since in fact this was where Albert Edward Edenshaw was born (Gough 1993: 289).

9. Charles Edenshaw's Haida names included *da.a xiigang* (Da.axiigang), meaning "noise in the housepit" (Harris 1966; alternate spellings are Dahʔégin [Blackman 1982: 53], Tahayghen [Harris 1966], Tahayren [Appleton 1970; Barbeau 1957], Tahigan [Duff, Holm, and Reid 1967], and Takayren [Dockstader 1977]), *skil runts'aas* ("wealth spirit breaks like a wave into the house" [Blackman 1982: 53; Enrico, personal communication July 2000]), and *nang qwi.igee tlaa.ahls*, "they gave ten potlatches for him," conferred at his parents' final potlatch (Blackman 1982: 53).

10. Swanton to Boas, March 31, 1901, American Museum of Natural History Anthropology Archives.

11. *naʔi kun qiirawaay* is the current spelling for Nikwǝn qiwe or Na'ikun Qiiraway, Swanton's Those Born at Rose Spit (R13), the Kwawduwawas or Kwaduwas clan. The 1885 marriage record shows the names Charles Edenshaw and Isabella Kweyang and lists their fathers as Geatles *(gyaawhllns)* and Stlantonquat *(stlaang du.ungaad)*, respectively. *gyaawhllns* was the name of John Robson's uncle (see chapter 5), who died sometime in the 1860s or 1870s. This *gyaawhllns*, listed as Charles's father, must have been a different man, since he is said to have died when Charles was young.

12. Mary Nelly Tulip, Charles Edenshaw's niece, told Barbeau: "Edenshaw had very sore eyes when he was young, and they remained that way." And Peter Hill of Massett told Barbeau that Charles Edenshaw was cross-eyed (Barbeau 1916–1954: box 314, file 10).

13. The Haida words for Shellfish Town are *tsaa.u 'lan.gáay*.

14. On the basis of her study of Haida lineages, Margaret Blackman (1981: 75–76) suggested that perhaps the migration occurred in the early eighteenth century rather than in the late eighteenth century, as Swanton suggested.

15. This name has also been spelled Kinaon (on his gravestone) and Ginouan (Blackman 1976: 400), Kenowan (Young 1927: 232), Gina'wan (Swanton 1905a: 139), Ginnowan (Newcombe 1900–1911: vol. 2, file 44), Gyinawen (Harris 1966), and Gináwǝn (Blackman 1982: 64).

16. The *yahgu 'laanaas* chief, *yáahl daajée* (Yełtadzie), who held the same name as the late-eighteenth-century chief at *da.adans* and who was the father of John Wallace's

mother, also lived in *hlanqwáan* before moving to *q'wíi rándlass* and later *ráwk'aan* (Garfield 1941).

17. If Duncan *ginaawaan's* father was Captain Alexander Duncan (see chapter 3, note 28), then he could not have been born before 1830, when Duncan first visited the northern Northwest Coast. This would have made Duncan *ginaawaan* forty-six or younger when he died in 1876, which seems possible. If, however, as Florence Edenshaw Davidson reported, old *7idansuu's* wife, *gu.uu 7aww (ginaawaan's* sister), who married Albert Edward Edenshaw after old *7idansuu's* death, was also Alexander Duncan's daughter, then she could not have been born around 1810, as was suggested in Blackman's genealogy (1982: 60–61), but would have been only a girl when old *7idansuu* died around 1840 and still a young girl when Albert Edward Edenshaw married her.

18. According to information given to John Swanton by a man named Douglas, whose Haida name was Səkwa *(sahgwaa)* and who was a resident of *hlanqwáan* of the Stəst Eagle clan, there were thirteen houses in *hlanqwáan* during the mid-nineteenth century. At that time all the houses belonged to members of the *yahgu 'laanaas* Raven clan (Swanton's Middle Town People, R19). These included (quoting from Swanton 1905a: 294):

1. Na giā'as ("House Standing Up") (R19b) [na gyáa.aas]
2. Q!ā'ad na'as ("Dogfish House") (R19b) [q'a.ad na.as]
3. Hi'liñ na'as ("Thunder House") (R19c) [híilang na.as]
4. Naᵋa ᵋā'tʌga ("House Having a Light in it") (R19b) [naráa radgáa]
5. Sk!î'sʟai na-i ("House where the people are always filled") (R19c) [sk'isdliyáay náay]
6. Naᵋa gu'tga ʟ! kiä'gans ("House in which they shout to each other") (R19c) [naráa gudga tl' kyáaygaans]
7. ᵋo'łal na'as ("Blue [stone paint] house") (R19b) [ruhláal na.as]
8. Hīn qaid na'as ("House over the stream") (R19b) [na xawáas]
9. Na yū'ʌns ("Big House") (R19b) [na 7íw7waans]
10. Na gī'di ("House Child") (R19b) [na gíit'ii]
11. The frame of a house . . . never finished or named.
 On the opposite side of the point:
12. xū' ʌdji na'as ("Grizzly Bear House") (R19d) [cuu.uj na.as]
13. — — Owner: Gusù'udañ. (R19b)

In a letter sent to the collector Charles F. Newcombe dated March 5, 1906, Samuel G. Davies listed eight named houses in *hlanqwáan*. By this time, several of the old houses had been removed or replaced by modern frame houses with no names (Newcombe 1900–1911: vol. 2, file 44). Davies's list was as follows:

1. Kaad naas (Dogfish House), Edwin Scott. [Swanton's number 2, *q'a.ad na.as*]
2. Kailthath naas (Star House), John Adams [*k'aayhlt'áa na.as*]
3. Woadnaas (Seal House), Old Quance [*xúd na.as*]
4. Skesslice Naas (Belly Full House), Yelthnow. [Swanton's number 5, *sk'isdliyáay náay*]
5. Eagle Lthmiles Naas (Pig House), Dungan Ginnowan [*hlama'l na.as*, which means "elk hide house"]
6. Keet naas (Pet House), Old Wallace [*gi'id na.as (?)*, which means "offspring house"]
7. Wookjus lihilkas (Bear Nest), Guy Skillie [Swanton's number 12(?)]
8. Naah hawas (House Wet), Johnny Wallace [Swanton's number 8, *na xawáas*]

19. John Wallace identified the owner of the corner post from this house, which he copied for the Hydaburg Totem Park, as Adam Spuhn (Garfield 1941: notebook 1, Hydaburg, Klawock, p. 37).

20. MacDonald identified the human figure as the Tcʌ'maos, or Supernatural Snag.

The snag, however was not a crest of either the *sdast'a.aas* or the *yahgu 'laanaas* clans. It was a Raven crest belonging primarily to Ninstints (*sran gwaay*) and Skidegate and Rose Spit families (R1, 3, 5, 6, 7, 10, 13, 14 in Swanton 1905a: 114). It may be that this figure represents the hermit of *k'yuust'aa*, a *sdast'a.aas* crest. Likewise, the bird above the head of the human figure is more likely a raven than a crane (MacDonald 1996: 192).

21. MacDonald (1996: 197) identified this as a baby raven in the moon.

22. Also in Swanton's publication is a drawing of this crest figure made by John Wiha for Franz Boas (Swanton 1905a: 142, plate 21, fig. 5).

23. These may have first appeared on the ears of the Edenshaw memorial poles at *k'yuust'aa* carved by Sqiltcange in the early nineteenth century (see fig. 3.3).

24. Old Wallace does not appear on any of the known genealogy charts as a brother of *ginaawaan*'s (Blackman 1982: 61). It may be that Wallace was using the broader meaning of the word "brother" to indicate that *ginaawaan* was a clan brother of his father's, both of them belonging the the *yahgu 'laanaas* clan.

25. The *yahgu 'laanaas* and other Alaskan Haida clans adopted the Tlingit method of identifying themselves by house name.

26. Though George MacDonald (1996: 192) wrote that Henry Edenshaw lived in *hlanqwáan,* there is no evidence that he ever actually lived there. He was listed in the 1881 census for Massett, living in Property House with his father at age fourteen. In the 1891 census, he was living in Massett with his wife, Martha, and daughter Josephine (Newcombe 1900–1911; Sneath 1881).

27. MacDonald (1996: 195) speculated that the double retaining planks in this house were carved on all four sides. The photograph, however, shows carving only on the back panels, and Newcombe's record of his offer to buy the planks from Henry Edenshaw mentions only the two rear planks, suggesting that these may have been the only two carved planks of the set of eight (Newcombe 1900–1911: vol. 2, file 51).

28. Shortly after this photo was taken, several poles were cut down and sawed into supports for a boardwalk that was constructed in front of the houses (Duncan *ginaawaan*'s frontal pole met this fate; see the beaver head supporting the boardwalk in Thwaites's 1922 photo [fig. 4.8]). In 1969, when Wilson Duff, Jane Wallen, and Joe Clark conducted their survey of totem poles in southeastern Alaska, they reported that the only pole fragment that might still be salvaged from the village, though very fragile, was a small face on the side of a three-foot basal segment of a pole that had been segmented from a larger pole and used to support the boardwalk.

29. Perhaps this Duncan was Ben Duncan, who had the name *ginaawaan* (Gennowaon) and is pictured in the Winter and Pond photographs (figs. 4.15, 4.16).

30. One pole was sold to the Milwaukee Public Museum. One broken pole from *q'wíi rándllass,* carved by Dwight Wallace, was sold to a St. Louis firm and was later given to David M. Parry in Indianapolis as a gift. It was erected on the Parry property in 1905, where it stood until 1939. A replica of this pole was recently carved by Lee Wallace and erected at the Eitlejorg Museum in Indianapolis (Feldman 1996).

31. Newcombe collected a headdress from Edwin Scott at *hlanqwáan* in 1902 that is now in the Field Museum (cat. no. 79529). Its catalog information explains that *tsilialas* (*ts'ál yáalaas*) "represents back fin of tsilialas, chief of killer whales. It is always represented as having raven's head at end."

32. Margaret Blackman's 1971 survey of *hlanqwáan* revealed that there were only two houses with excavated interiors in the village, *na gíit'ii* and *na 7íw7waans* (Blackman 1971).

33. Between 1938 and 1941, when the Hydaburg Totem Park was established as part of a Civilian Conservation Corps project, all the poles remaining in *hlanqwáan* that were considered sound enough were taken to Hydaburg for restoration or copying. The head carver for this project was John Wallace (see chapter 6, note 4).

34. Dwight Wallace (b. circa 1822; d. 1913) is often referred to as "Old Wallace" (Newcombe 1900–1911: vol. 2, file 44). He is said to have received his English name when

he was called to the United States to do some carving for a rich man; when he left, the man gave him the name Dwight Wallace (Abney 1993: 6). Keet naas, Pet House may be *gi'id na.as*, meaning "offspring house," according to John Enrico.

35. This name has also been spelled Kitkoojawus (Abney 1993: 6). According to John Enrico (personal communication, September 1999), the current spelling of the name would be *gid k'wáajuss*, translated as "big fat chief's son."

36. This pole, which Edward Keithahn called the "Old Witch Pole," was purchased by Dr. Robert Simpson of Juneau, who presented it to the city of Juneau. It once stood in front of the Nugget Shop and the Juneau City Library (Keithahn 1963: 146). It is currently displayed in the atrium of the State Office Building in Juneau and is in the collection of the Alaska State Museum (cat. no. II-B-1652) (Steve Henrikson, personal communication, October 1999).

37. The earliest account of the meaning of this pole was recorded by A. P. Niblack (1888: 327) during his visit to *gasa.áan*. T. T. Waterman (1923: 125) recorded an account of it in the 1920s that reversed the meaning, saying that it signified Skowl's conversion to Christianity. Information recorded by Garfield and Forrest in the 1940s, however, confirms Niblack's earlier version of the story (Garfield and Forrest 1949: 67–70).

38. Swan (1875) mentioned *ganaawaan*'s bringing four children on board the *Wolcott*, but no further evidence of a fourth child has been found.

39. Sanheit (Son-i-hat, b. ca. 1832, d. 1912), was married to a *yahgu 'laanaas* woman, and their son, Alec Peele, married *ginaawaan*'s daughter Rose (see chart 4).

40. A. L. Broadbent was the second assistant on the *Wolcott* (Swan 1877). No surviving photographs from this trip are currently known.

41. Barbeau illustrated this pole, together with another Smithsonian pole and the Dwight Wallace pole from Sukkwan that went to the Denver Art Museum, but he reversed the identifications in the caption (Barbeau 1950: 569, plate 307).

42. The Annie to whom Swan referred may have been Annie Martin. Swan gave the Haida name of Annie Martin as Kwa-Klen. She may have been the wife of George Martin, whose Indian name was listed as Sangkart (Swan 1875).

43. Perhaps the copper in question was one of those attached to the raven-fin memorial pole put up for *ginaawaan* in Massett (see fig. 4.47). If so, it might have been the one called Mountain-Copper (Ldao t!aos), said to have very little value (Swanton 1905a: 130).

44. Interestingly, next to Duncan *ginaawaan*'s gravestone at *hlanqwáan* is the gravestone of a man named Frederick Douglas that has no date but does have a moon carved at the top. That this name also belonged to a freed African-American slave is surely a coincidence; the name Douglas was certainly well known in *hlanqwáan*, going back to *k'yuust'aa* and the exchange of names between Captain Douglas and *gannyaa*. There was a Frederick Douglas (Edansa) living in *hlanqwáan* whom Fred Grant, Sr., described to Margaret Blackman as owning a house with carved *dáaʔaay* (retaining planks) that sat where Alec Peele's house later stood — possibly Big House, which belonged to *gasáawaag* and later Henry Edenshaw (Blackman 1971).

45. By "grandparents," Florence Davidson was referring to her great-uncle Albert Edward Edenshaw's widow, Amy, and to his nephew, Phillip White, who married Amy after Edenshaw died. It was the tradition for a nephew to marry and take care of his uncle's widow, just as Albert Edward had married *gu.uu ʔaww* (Blackman 1982: 84–85).

46. MacDonald (1983: 198) said that the carver of this pole was Charles Edenshaw, giving the source of this information as James G. Swan. Swan's diary, however, says only "carved by Edenshaw." Since at the time he wrote this account, Albert Edward Edenshaw was accompanying Swan and serving as his guide, and Charles had not yet been given the name Edenshaw, Swan's Edenshaw must surely be Albert Edward, and the source of this information must have been Albert Edward himself (Swan 1883b). MacDonald later corrected the attribution to Albert Edward Edenshaw (1996: 214)

47. MacDonald (1996: 214) also indicated that this pole was raised next to a house

that Albert Edward Edenshaw had built for his second wife, Amy, at *daa.adans*.

48. Barbeau (1950: 824) described a model pole with similar figures carved by John Wallace around 1926 for Mrs. William Paul of Juneau.

49. Charles Harrison (1925: 176) reported that George "Cohow" (*gu.uu*, Ka-hu, Ga'wu) succeeded his uncle — his father's brother — to the chieftainship of a clan in Alaska. He was no doubt mistaken, however, in reporting that the uncle was Cowhoe's father's brother, which would have violated the principle of matrilineal succession.

50. See Sterns 1984: 207.

51. MacDonald says this house post was in Raven House (his House 22), next door to "The House which chiefs peep at from a distance" (his House 23), but Newcombe's notes contradict this. Newcombe's translation was probably incorrect (Enrico, personal communication, May 2000). Enrico translates the name of this house, *naagi 7iitl'lx-agiid k'aydanggans,* as "standing at a distance and making oneself known by throwing a rock."

52. The pectoral fins of the whale extend up, with ears overlapping them, from the head at the bottom. They consist of an upper fin U form with an ovoid at the end that is cut back at a deeper level from the raised ear U forms that it encloses. The legs of this outer U form are broken into a solid U attached to the ovoid, linked to an L form that is adjacent to another solid U, which effectively breaks up the leg of the U. Above the black ear U forms, enclosed within the upper U complex, is a black secondary U enclosing two split tertiary Us. One leg of the black secondary U fails to join the primary U at its point, floating unconnected.

53. This name was also one of Charles Edenshaw's names (see chapter 4 note 9). Swanton translated it "property woman broke into the house" (1905a: 290).

54. In 1881, House 7 (the house the Edenshaws inherited) was occupied by a 52-year-old man named Khite and his wife, Kayinwas (age 24). Also living in the house were Kwulsugat (male, 26) and two children, Keetkaigince (male, 6) and Howday (female, 4), along with Washgui (male, 50) and Swonchawas (female, 56), Stelta (male, 9), Ilislulay (female, 8), Yoggot (female, 10), Sguioothgaa (female, 26), Kuttlekildans (female, 24), and Dian (male, 22) (Sneath 1881).

55. This house, and the bear memorial in front of it, are visible in Dawson's 1878 photograph of Massett. The 1881 census for House 21 lists Edenshaw (male, 65 [*gwaaygu 7anhlan*, Albert Edward], Sitagisugat (female, 40 [Amy]), Gaotlans (male, 14 [Henry Edenshaw]), Tlkunday (male, 11 [Phillip White?]), Ta'agan (male, 30 [*da.a xiigang*, Charles Edenshaw]), Quoyang (female, 28 [Isabella Edenshaw]), Kinaoue (male, 4 [Robert Edenshaw]), and an older couple, Nungidas (male, 50) and Touillowat (female, 55) (Sneath 1881).

56. MacDonald (1983: 147) identified the top "bear" as a snag, but this was not one of Edenshaw's crests.

57. The two couples were Kawes and Wahtstlica, married in March 1878, and Skeetlang and Sarah Nandiwas, married in February 1879.

58. Gough (1993: 290) reported that Albert Edward Edenshaw was baptized in 1884, but this is probably an error.

59. Agnes's Haida name was Kwənt qayngás; her married name was Agnes Yaelhtetsi. She died in 1978.

Chapter 5. The Late Nineteenth Century, the 1880s and 1890s

1. The name *gwaay t'iihld* has been spelled Quaa-telth (on a mask), Gwai t!élt (Swanton 1905a: 292), Gwétilh (Barbeau 1916–1954: B-F-256.9), Gwiteith (1881 census), Gwetith, Gwetitk (Barbeau 1916–1954: B-F-256.4), Gwaitilht (Newcombe 1900–1911: vol. 36, file 13, p. 57), Kwitiet, Qwaitil, Kwaitilt (daughter's marriage record), Gwétilt (daughter's 1890 marriage record), Kwitilt (1887 marriage record); Kwaitiltht (1897 marriage record), and Gwaitelth (on his gravestone).

2. Both Margaret Blackman and Alan Hoover gave the date of 1906 for Watts's gravestone, though the stone itself has a 1904 death date for Watts. Since gravestones usu-

ally were not erected for one or two years after the death, when the family could afford the memorial feast, the date of this design may be 1905 or 1906. Blackman also suggested that this stone was the most recent of the three designed by Charles Edenshaw (Blackman 1976: 400), but research on the death date of John *gwaay t'iihld* indicates that his gravestone was made at least six years after Watts's.

3. That Charles Edenshaw designed his gravestone suggests that John *gwaay t'iihld's* father may have been of the *sdast'a.aas* clan. We know from his marriage record that *gwaay t'iihld's* father's name was Swonkitswas, but his clan was not documented in either the marriage or census records.

4. George MacDonald (1996: 138–139) identified this photo as having been taken by an unknown photographer in Victoria in about 1884. Trisha Gessler (1981: 8–9, fig. 6), however, identified it as having been taken in October 1901 by Harold and Edgar Flemming at studios on Government Street in Victoria.

5. Wilson Duff (1981: 218) believed that Charles Edenshaw carved panel pipes in the mid-nineteenth century, but no panel pipes can be attributed to him (Holm 1981: 189).

6. Referring to the man who owned Grizzly Bear's Mouth House, MacDonald (1983: 45) wrote, "Giatlins was the second son of Chief Edenshaw of Kiusta." The second son of Albert Edward Edenshaw was Henry Edenshaw, who did have the name Gaotlans when he was a child. The owner of Bear's Mouth House in Skidegate, however, was a different man, from a different Raven moiety. Henry Edenshaw's childhood name was documented in the 1881 census report for Massett as Gaotlans; he was a fourteen-year-old male living with Albert Edward Edenshaw. Barbeau's notes from his interviews with Alfred Adams (Barbeau 1916–1954: B-F-251.16) confirm this as Henry's childhood name: "Henry Edenshaw was a son of Albert Edward (Edenshaw). Ke'u was his Indian name, which is a Haida name; it sounds Tsimshian. His adolescent name was Gyehlens, 'builder.'"

7. Newcombe's record of John Robson's name as Gwaiskunagiatlens is somewhat problematical. John Enrico (personal communication, September 1999) has explained that *gwaaysgu nang* means "one who . . . on the island." Alfred Adams interpreted the name Gyehlens as "builder," according to Barbeau's notes, and Charles Harrison translated the name Giatlins as "Standing" (Lillard 1984: 132). Enrico explained that *gyaawhlans* does not mean "builder" or "standing" — if anything, it means "edge (of something) be up on (something)" — and that personal names were often shortened and simplified until they became indecipherable. Holm suggested that the first part of this name might refer simply to the village Gwaiskun. Newcombe (1900–1911: vol. 55, file 10) thought this was the name of the town located near Cape Ball, the birthplace of Albert Edward Edenshaw. Swanton (1905a: 126) mentioned it as a town belonging to the *sdast'a.aas* where the Wasgo or Su'san story originated. Enrico has pointed out that *gwaays kun* was on the northwest side of Langara Island, and there was no village of that name anywhere near Cape Ball. He speculated that there might have been an earlier, longer version of the name, perhaps *gwaaysgu nang gyaawhlans,* "he who has his edge up on the island."

8. David Shakespeare (*skil duunaas,* d. 1895) was married to Jane, the sister of *q'aawiidaa,* who was the daughter of *gulsigut,* the sister of Albert Edward Edenshaw.

9. No further information about Robson's son, John, has been located as of this date. In October 1911, however, Robson wrote to Newcombe that he had no children to help him during the time when his wife was dying of cancer, suggesting that his son, who by this time would have been forty, had either died or moved away. Robson had apparently married this woman (Kilad of New Metlakatla?) after *q'àaw quunaa* died in 1896 (Newcombe 1900–1911: vol. 5, file 124).

10. MacDonald (1996: 219) attributed this pole to Charles Edenshaw, though the carving style suggests that it was more likely carved by John Robson himself.

11. MacDonald published this photo with two different credits: O. C. Hastings, 1879 (MacDonald 1996: 169), and Maynard 1884, Skidegate, though he dated *q'àaw quunaa's* pole between 1878 and 1881 (MacDonald 1983: 46, plate 39). Apparently the Maynard 1884 identification is correct.

12. A staff attributed to John Robson in the Royal Scottish Museum in Edinburgh (cat. no. 1911.206) has the same beaver, raven, and eagle figures with the addition of a dogfish between the beaver and the raven. The same figures are found on a model house frontal pole attributed to John Robson in the collection of the Fairbanks Museum and Planetarium in St. Johnsbury, Vermont. On this pole, the dogfish is positioned above both the beaver and raven.

13. Blackman reported that the first menstruation seclusion was called *tɔgwɔná* in the Haida language and that Florence Edenshaw Davidson was one of the last Haida women to go through this ritual seclusion, in the first decade of the twentieth century — though Reverend Harrison had reported that the ritual ceased after the death of the last shaman (Blackman 1985: 27–28, 57, 91–92).

14. MacDonald (1996: 216) suggested that John Robson and Charles Edenshaw might have worked together on a memorial pole that stood in front of House 25 in Skidegate. He made this suggestion on the basis of a perceived similarity in style between the mountain goat on the top of this pole and the top figure of an eagle (both of which MacDonald called whales) that is on the interior house post of House 18, which had been attributed to Charles Edenshaw (see chapter 4). He also speculated that the two carvers collaborated on carving the mortuary post raised in honor of Chief Skedans by Chief Skidegate and his wife (23X). Neither of these attributions can be confirmed.

15. Swanton (1905a: 286) reported that another Skidegate source told him that the name of the house should be X̱u'adji Lxol, because X̱u'adji na'as was used by Skedans, and they would not adopt it for fear of offending him.

16. Enrico (personal communication, September 1999) reported that this word vaguely resembles *rasangng,* "blenny," which is a fish found on the beach, not a clam.

17. One plank from Grizzly Bear's Mouth House is in the Royal British Columbia Museum, cat. no. 1395.

18. Robson also carved an argillite version of this story, illustrated by Barbeau and attributed by him to Charles Edenshaw. This pole was at one time in the Heye Foundation collection (cat. no. 1610), but is now at the Denver Art Museum (cat. no. 1951.296) (Barbeau 1953: 375, 409, plate 293).

19. Seven of Edenshaw's published drawings — those showing, respectively, a sea lion, a *hagulâ'* (a Tsimshian monster), a hawk, a flicker, a woodpecker, a hummingbird, and a *7waasru* trap — are missing from the American Museum of Natural History collections (see Swanton 1905a: plate 21, fig. 8; plate 22, figs. 2–5; plate 23, fig. 2; Boas 1955b: 159, fig. 135).

20. Bill Reid asked Bill McLennan at the University of British Columbia Museum of Anthropology to commission a copy of the bowl, but passed away before an artist was selected. Richard Sumner, an apprentice to Doug Cranmer, was commissioned to create the burial container after Reid's death. This box with Reid's ashes was transported to *t'anuu* in a large chest made by Don Yeomans aboard the *Luutaas* for burial.

21. Two separate sets of these drawings are now at the Field Museum of Natural History in Chicago (FM 79790, fifteen drawings accessioned on October 10, 1902; FM 19986, eight drawings accessioned on October 6, 1905). Other drawings by Robson are located at the Royal British Columbia Museum in Victoria, B.C. A series of letters from Robson to Newcombe, dated between 1902 and 1911, recount his efforts to be paid by Newcombe, at a rate of $.50 to $1.00 per drawing (Newcombe 1900–1911: vol. 5, file 124).

22. American Museum of Natural History, cat. nos. 16/8761, 16/8762, 16/8763, 16/8764, 16/8766, 16/8767, 16/8768, 16/8769, 16/8770, 16/8771, 16/8772, and 16/8773.

23. See Chapter 3.

24. MacDonald, Swanton, and Deans all used different house and house model numbering systems. For purposes of this discussion, I use MacDonald's numbers. His House 12 is Deans's House 61, and his House 8 is Deans's House 7 and Dean's House Model 20. (Deans 1893[?]; MacDonald 1983: 46–47).

25. Field Museum cat. no. 17834 is a model of MacDonald's House 12, Nah-ra-kielt-Nas. Field Museum cat. no. 17837, Deans's House Model 20, is a model of MacDonald's

House 8, Box House, now in the Brooklyn Museum (cat. no. 05.589.7792).

26. Florence Edenshaw Davidson said that *q'àaw quuna* had lots of names. She remembered that one of them was Itłgujatgut'aas, which she translated "rich woman grabs heavy things with her claws like an eagle" (Blackman 1982: 70). Enrico translates this name, *7itl'gajaad ga t'a.aas* (northern spelling), as "rich woman whom something carried off in its talons." The name given by Swanton, I'ʟga djat kı̂lk!ı̄'gᴀs, *7iitl'gajaad kil k'igas* (southern spelling), is "rich woman whose voice is sharp" (Enrico, personal communication, September 2000).

27. The other two platters are in the National Museum of Ireland in Dublin (cat. no. 1894:704) and the Field Museum of Natural History in Chicago (cat. no. 17952). Both of these plates were received by the museums in 1894. In addition, a silver cane ferrule by Charles Edenshaw in the Pitt Rivers Museum in Oxford (cat. no. 1929.7.1) illustrates this myth (see Hoover 1983; Wright 1995).

28. Robson also carved an argillite chest that probably depicts the story of Foam Woman (Glenbow Museum, cat. no. AA2003). It is very similar to the eyeballs chest, though here the eyes in the small heads are intact. These people may represent the grandmothers of the Raven moiety together with Foam Woman (see Sheehan 1981: 32, fig. 4).

29. Edenshaw's elephant cane came to the American Museum of Natural History with the Bishop Collection, collected by Israel Powell between 1882 and 1885. According to Powell's invoice in the accession file for the Bishop Collection in the American Museum of Natural History's Anthropology Archives, Powell hired Swan to label the collection before it was sent to New York. This explains the paper tag in Swan's handwriting attached to the cane, which reads: "May 13/84 Presented by Dr. S. Swan from his brother Mr. J. G. Swan." At some point the elephant handle was separated from the shaft. After being in Marius Barbeau's collection, it was acquired by the Royal British Columbia Museum in 1975. Careful measurements of the opening at the top of the shaft and collar and the base of the elephant handle indicate that the two would probably fit together perfectly (personal communications with Alan Hoover and Laila Williamson, March 2000). The wooden shaft has a snake entwined around it that clearly identifies it as Charles Edenshaw's work. The floral design on the collar of this cane is one of the few purely floral engravings that can be attributed to him.

30. These other canes are the following: Royal British Columbia Museum cat. no. 10675 (Hoover 1995: 46), Canadian Museum of Civilization cat. no. VIIB1159, Royal Ontario Museum cat. no. HN621, and Seattle Art Museum cat. no. 93.5 (Brown 1998: 118).

31. A cane handle in the British Museum (cat. no. 1971.AM9.2) that is lacking the shaft is similar to Charles's own cane, with a baby beaver swinging from the mouth of the bigger animal. A similar pendant figure is found on another cane (Royal British Columbia Museum, cat. no. 10677; see Hoover 1995: 46). Two of Edenshaw's canes now in the University of British Columbia's Museum of Anthropology were wedding gifts presented to W. E. Collison, W. H. Collison's son. One has a frog handle (cat. no. A7090), and the other, an eagle handle (cat. no. A7091), both crests of the Edenshaw family.

32. Two photographs in the Canadian Museum of Civilization (#36108 and #36107) show Son-i-hat holding two different canes, one with a plain shaft and the ivory clenched fist, the other with a carved shaft, suggesting that Charles Edenshaw's ivory fist was added later to the carved shaft.

33. Appleton (1970), Barbeau (1957), Dockstader (1977), and Waldman (1990) all erroneously reported that Charles Edenshaw died in 1924. Barbeau's *Haida Carvers* is probably the source for this date, and the error is no doubt due to the fact that 1924 is the date that appears on Edenshaw's headstone in the Massett cemetery. This apparently was the year when the gravestone was raised, however, and not his actual death date, which was four years earlier.

34. These were illustrated by Barbeau (1957) as figures 184, 187, 188, 189, 191, 192, 194, 197, 198, 199, 203, 208 (right), 209, 210, 211, 213, 214, and 215.

35. The "Exposition d'art canadien" held earlier in the same year at the Musée du Jeu de Paume in Paris also featured some of Edenshaw's argillite carvings along with sev-

eral paintings by the Euro-Canadian "Group of Seven" (Barbeau 1957: 181; Leslie Dawn, personal communication, March 2000).

36. In this exhibit catalog, the so-called Canadian artists were listed separately at the back, with just the titles of their works. The works by native artists — including those of Fred Alexee, who was described as "an old Tsimshian half-breed from Port Simpson" and who was the only native artist associated with specific works ("primitive paintings") — were listed with explanatory descriptions (National Gallery of Canada 1927).

37. Holm wrote a three-page outline titled "What Makes an Edenshaw? (2-D Version)" (Holm 1967) at the time of the "Arts of the Raven" exhibit, which was expanded into his "Will the Real Charles Edenshaw Please Stand Up?" (Holm 1981). Duff published nothing further on Edenshaw's work during his lifetime, aside from the *Arts of the Raven* catalog, though a paper on meaning in Haida art that refers to Edenshaw was presented in 1976 and published posthumously (Duff 1981), and some of his unpublished thoughts have recently been published (Anderson 1996). One of Duff's undergraduate students at the University of British Columbia at the time of the exhibit, Susan Thomas (Davidson), wrote a senior thesis on Edenshaw, citing Holm's outline as well as two 1966 unpublished undergraduate term papers about Edenshaw by other Duff students. Since then, much more attention has been focused on the work of Charles Edenshaw by other authors, such as Peter MacNair, Alan Hoover, Carol Sheehan, Leslie Drew and Douglas Wilson, and George MacDonald; UBC students such as Kelly Ransom continue to study his work (Drew and Wilson 1980; Hoover 1983, 1995; MacDonald 1983, 1996; Macnair and Hoover 1984; Macnair, Hoover, and Neary 1980; Ransom 1994; Sheehan 1981; Thomas 1967).

38. Twenty-nine masks that can be attributed to Simeon *sdiihldaa* are at the following institutions: the American Museum of Natural History in New York (AMNH 16/362, 16/366, 16/368, 16/376, 16/377), the Canadian Museum of Civilization in Hull, Quebec (CMC VII-B-7, VII-B-8), the Fenimore House Museum in Cooperstown, New York (FHM T188/NW61), the Field Museum of Natural History in Chicago (FM 14262, 53011), the Phoebe Hearst Museum in Berkeley (LMA 2-15547, 2-15548, 2-15549, 2-15550), the Royal British Columbia Museum in Victoria (RBCM 10663, 10664, 10665, 10666, 10667, 10668, 10670, 10671), the Pitt Rivers Museum in Oxford (PR 1891.49.2, 1891.49.3, 1891.49.4, 1891.49.5, 1891.49.6), the McMichael Canadian Collection in Kleinburg, Ontario (McM 1981.103), and the University Museum in Philadelphia (UM L-84.2.52). The masks can be grouped into four basic types: young women masks with small labrets (AMNH 16/362, 16/377; LMA 2-15549 [King 1979: 50; Harner and Elsasser 1965: 106]; RBCM 10666, PR 1891.49.3, 1891.49.4), old women masks with wrinkles and/or large labrets (AMNH 16/366, 16/368; CMC VII-B-7, VII-B-8; RBCM 10668, 10671, McM 1981.103), young men masks, some with beards and moustaches (FHM T188/NW61; FM 53011 [Harner and Elsasser 1965: 38]; LMA 2-15547; RBCM 10063, 10064, 10065, 10067; PR 1891.49.5, 1891.49.6; UM L-84.252), and old men masks with beards, moustaches, and wrinkles (FM 14262; LMA 2-15550 [Harner and Elsasser 1965: 104; King 1979: 69]; RBCM 10670). There are also a few unusual masks, such as one with a swollen tongue (LMA 2-15548), a frog mask (PR 1891.49.2), and a split mask (AMNH 16/376). This split mask is shown in an open position with an inside mask in Swanton's *Ethnology of the Haida* (1905a: pl. 25, fig. 6), and it was reprinted by Goddard (1945: 152). Swanton identified this mask as a compound mask representing Raven, in the outer mask as a man and in the inner mask as a woman (Swanton 1905a: 145), which agrees with Boas's catalog entry for the piece, which says "double mask, representing hermaphrodite." The inner woman mask, with hair parted in the middle in the feminine fashion, is no longer in the AMNH collection. There is a split mask that is similar to AMNH 16/376 in the Canadian Museum of Civilization (CMC VII-B-1), which MacDonald (1996: 74, pl. 54) attributed to Simeon *sdiihldaa*. The facial paint patterns are nearly identical, but the proportions of the face are more rounded, the chin is less pointed than those of the other *sdiihldaa* masks, and the CMC mask lacks ears, so I have left it in a questionable category.

39. Simeon *sdiihldaa* could possibly have seen a sphinx image even earlier. He might well have visited Fort Simpson and Metlakatla during the time before Collison came to the Northwest Coast, and there he might have met the Reverend William Duncan, an Anglican minister. An illustration in Duncan's illustrated Bible, which he brought with him to Fort Simpson in 1857, shows a sphinx in the background of an Egyptian scene from the book of Genesis. Duncan was later excommunicated and moved his Tsimshian congregation from British Columbia to Alaska. The new community was named New Metlakatla after the old one. Duncan's Bible is housed in the Duncan Museum in New Metlakatla.

40. The other five bear rattles are the following: Canadian Museum of Civilization cat. nos. VII-C-339, VII-C-340; Metropolitan Museum of Art cat. no. 89.4.616; Eiteljorg Museum, Indianapolis, cat. no. 89.30.16; and Newark Museum cat. no. 55.245.

41. According to Swanton, the name *sdiihldaa* means "returned." It has been spelled Stī'łta (Swanton 1905a: 292); Stilte (Barbeau 1916–1954: B-F-251.16); Stelta (on the house door; MacDonald 1983: 146, plate 194); Stilta, Steltha, Steelta, Steel-tah (on graves); Steta and Stilthta (witnesses on 1885 marriage records); Steilta (Collison 1981: 130); Stiltae (Canadian National Railroad); Stilthda (son James's marriage record and British Museum catalog).

42. Although some Haida names were retained as surnames, as in the case of the Edenshaws and the Yeltatzies, often Haida names were replaced by Christian names assigned by the missionaries. Occasionally, the Christian first name of a father was given as the surname of his children, and the father's Haida name was dropped as the surname after one generation.

43. It appears from the name and birthdate of *gwaay t'iihld*'s daughter Nellie (Jistalance) that she might in fact have been the birth mother of Isaac Chapman (*skilee*), which would make Isaac Chapman John *gwaay t'iihld*'s grandson. A different genealogy, however, has this woman married to Abraham Abrahams (*7iit'la.agiid*), born 1861 (with eleven children born between 1881 and 1904) (see charts 6 and 8). Also confusing the record is conflicting information about the father of Nellie, who is listed both as "King-ek" (Walter or Herbert Kingego, John *gwaay t'iihld*'s brother) and John *gwaay t'iihld*.

44. *7wii.aa* received the right to use the story of the flood on his frontal pole from Kitkun (Chief Klue) of *t'anuu*, who in turn received it from his relative Chief Kaxius of Those Born at Skedans. Two poles (an older one and a newer one raised in 1878) stood in front of Kitkun's house at *t'anuu* (House 5), and one was in front of Chief Kaxius's house at Skedans (House 17). All of these poles tell the story of the flood. According to MacDonald (1983: 93): "One version of the story relates to Qingi, the supernatural father of White Raven, who in ancient times was raising a new totem pole before his house when a flood struck the world. As the flood waters began to rise around the guests and relatives, they scrambled up the pole to keep from being drowned. White Raven, the wonder worker, alighted on top of the pole and by his magic caused it to grow as the waters rose. The totem pole became a gigantic tree filled with survivors of the flood." The poles illustrate this story with the figure wearing a hat with many *sgil* (potlatch cylinders), symbolizing the supernatural pole with people stacked (or clinging) along the sides.

45. MacDonald (1983: 159) identified this house as "Goose House," which was next door to Grizzly Bear House (see Swanton 1905a: 291).

46. William H. Collison illustrated a similar double mortuary in his book that may also be by John *gwaay t'iihld* (Collison 1915: opposite p. 160). This model was in the Collison family's collection and is now in the University of British Columbia Museum (cat. no. A7093).

47. MacDonald (1983: 53) gave the mother's name as "wants more property" and identified her as the mother of Chief Skidegate V. Skidegate V, however, was a member of the *na 7yuu7aans xàaydaraay* (E6a), a different branch of the Skidegate Eagles, so this woman could not have been his mother.

1. Bill Holm carved a replica of this whale monument now located in front of the Burke Museum in Seattle. The original fin was collected by Walter Waters in the 1920s and is preserved in the Burke Museum, cat. no. 1-1682.

2. This information is taken from an undated biography written by John Wallace's daughter that is preserved in the Garfield Papers at the University of Washington's Special Collections (Garfield 1941: box 5, folder 4).

3. One of these poles was carved by his father, Dwight Wallace (see fig. 4.27). The other pole (DAM 1946.251) was set up by John Wallace's uncle at *saxq'wa.áan* as a grave marker for Wallace's mother. Wallace's wife's (Mae Skillie's) grandfather was hired to carve this pole (Garfield 1941: notebook 1, Hydaburg, Klawock, p. 61).

4. The *hlanqwáan* poles copied by John Wallace were, according to Duff's numbering system, Pole 6, the right corner post from Duncan *ginaawaan's* Pig House; Pole 9, the bear tracks pole to the right in front of House Child; Poles 18 and 21, the bear house posts from *hlanqwáan;* and Pole 12, a pole with a bearded man that originally belonged to Adam Spuhn's father. The original *hlanqwáan* poles raised in Hydaburg were numbers 2 and 3, both bear memorial figures, and 8, a pole with a bear at the base, a man holding a staff, *sgil,* a bear, and an eagle at the top (Duff, Wallen, and Clark 1969: 26, 52).

5. The *hl7yaalang* pole was copied by the Tsimshian artist William Jeffrey in the 1960s. The copy still stands near the Jim Ciccone Civic Center in Prince Rupert.

6. A *manda* is a single carved crest figure that a coffin chest was placed on when it was in a grave house. After a memorial potlatch, the coffin was placed in a mortuary pole, and the *manda* was moved to the front of the house near the mortuary pole.

7. This house burned to the ground in 1981.

References Cited

Abbott, Donald (ed.). 1981. *The World Is as Sharp as a Knife: An Anthology in Honour of Wilson Duff*. Victoria: British Columbia Provincial Museum.

Abney, Brenda. 1993. Interview: Haida Carvers. In *Carving: A Cultural Heritage*, pp. 6–9. Ketchikan, Alaska: Tongass Historical Museum.

Anderson, E. N. 1996. *Bird of Paradox: The Unpublished Writings of Wilson Duff*. Surrey, B.C.: Hancock House.

Appleton, F. M. 1970. Life and Art of Charlie Edenshaw. *Canadian Geographic Journal* 81 (July): 20–25.

Baker, Burt Brown. 1948. *Letters of Dr. John McLoughlin*. Portland: Oregon Historical Society and Binfords and Mort.

Barbeau, C. Marius. 1916–1954. Unpublished notebooks, notes, and correspondence. Ottawa: Canadian Centre for Folk Culture Studies, Canadian Museum of Civilization.

———. 1930. Totem Poles: A Recent Native Art of the Northwest Coast of America. *Geographical Review* 20 (2): 258–272.

———. 1939. How Totem Poles Originated. *Queen Quarterly* 46 (3): 304–311.

———. 1940. The Modern Growth of the Totem Pole on the Northwest Coast. *Smithsonian Institution Annual Report 1939*, pp. 491–498. Washington, D.C.: U.S. Government Printing Office.

———. 1942. Totem Poles: A By-product of the Fur Trade. *Scientific Monthly*, December, pp. 507–514.

———. 1944. Totemism: A Modern Growth on the North Pacific. *Journal of American Folklore* 57: 223.

———. 1950. *Totem Poles*. Bulletin no. 119, vols. 1 and 2, Anthropological Series no. 30. Ottawa: National Museum of Canada.

———. 1953. *Haida Myths Illustrated in Argillite Carvings*. Bulletin no. 127, Anthropological Series no. 32. Ottawa: Department of Resources and Development, National Parks Branch, National Museum of Canada.

———. 1957. *Haida Carvers in Argillite*. Bulletin no. 139, Anthropological Series no. 38. Ottawa: Department of Northern Affairs and Natural Resources, National Museum of Canada.

———. 1958. *Medicine-Men on the North Pacific Coast*. Ottawa: Department of Northern Affairs and Natural Resources, National Museum of Canada.

Barnett, H. G. 1939. *Culture Element Distributions, 9: Gulf of Georgia Salish*. Berkeley: University of California Anthropological Records 1 (5).

Barrington, Daines. 1781. *Miscellanies by the Honourable Daines Barrington*. London.

Beals, Herbert K. (trans. and ed.). 1989. *Juan Pérez on the Northwest Coast: Six Documents of His Expedition in 1774*. Portland: Oregon Historical Society Press.

Bedford, June. 1998. Haida Art in the Pitt Rivers Museum, Oxford, and the Reverend Charles Harrison. *European Review of Native American Studies* 12 (2): 1–10.

Beresford, William. 1789. *A Voyage around the World; but More Particularly to the North-West Coast of America Performed in 1785, 1786, 1787, and 1788 in the* King George *and* Queen Charlotte, *Captains Portlock and Dixon.* London: George Goulding.

Blackman, Margaret B. 1971. Field notes, Klinkwan, Alaska.

———. 1973a. The Northern and Kaigani Haida: A Study in Photographic Ethnohistory. Ph.D. diss., Ohio State University.

———. 1973b. Totems to Tombstones: Culture Change as Viewed through the Haida Mortuary Complex, 1877–1971. *Ethnology* 12: 47–56.

———. 1974. Hat Na: The Haida Longhouse. *The Charlottes* 3: 33–41.

———. 1975. Mortuary Art from the Northwest Coast. *The Beaver* 306 (3): 54–57.

———. 1976. Creativity in Acculturation: Art, Architecture, and Ceremony from the Northwest Coast. *Ethnohistory* 23 (4): 387–413.

———. 1977. Ethnohistoric Changes in the Haida Potlatch Complex. *Arctic Anthropology* 14: 39–53.

———. 1981. *Window on the Past : The Photographic Ethnohistory of the Northern and Kaigani Haida.* Ottawa: National Museums of Canada.

———. 1982. *During My Time: Florence Edenshaw Davidson, a Haida Woman.* Seattle: University of Washington Press.

———. 1993. Master Carpenters' Daughters: Women Artists of the Northwest Coast. In *Art in Small-Scale Societies: Contemporary Readings,* edited by Richard L. Anderson and Karen L. Field, pp. 233–246. Englewood Cliffs, N.J.: Prentice Hall.

Blackman, Margaret B., and Edwin S. Hall, Jr. 1982. "The Afterimage and Image After: Visual Documents and the Renaissance in Northwest Coast Art." *American Indian Art* 7 (2): 30–39.

Boas, Franz. 1897. *The Social Organization and the Secret Societies of the Kwakiutl Indians.* Report of the United States National Museum for 1895. Washington, D.C.: Smithsonian Institution Press.

———. 1927. *Primitive Art.* Cambridge, Mass.: Harvard University Press. Reprint, 1955. New York: Dover.

Boelscher, Marianne. 1988. *The Curtain Within: Haida Social and Mythical Discourse.* Vancouver: University of British Columbia Press.

Brady, Governor John. 1903. Letter, November 2, 1903, from Brady to his wife, Elizabeth, aboard the USS *Rush,* off Klawack. Beinecke Rare Book and Manuscript Library, Yale University Library.

Briesemeister, Dietrich, Heinz Joachim Dopmnick, Klaus Helfrich, Peter Bolz, and Elke Ruhnau. 1992. *Amerika 1492–1992. Neue Welten—Neue Wirklichkeiten: Eine Dokumentation.* Braunschweig: Westermann.

Briggs, Lloyd Vernon. 1927. *History and Genealogy of the Cabot Family, 1475–1927.* Boston: C. E. Goodspeed and Company.

Brown, Steven C. 1998. *Native Visions: Evolution in Northwest Coast Art from the Eighteenth through the Twentieth Century.* Seattle: Seattle Art Museum and University of Washington Press.

Burling, John [Samuel]. 1799. *Journal of the Eliza.* Massachusetts Historical Society. Microfilm.

Choris, Louis. 1822. *Voyage pittoresque autour du monde, 1815–1818.* Paris: Firmin Didot.

Coe, Ralph T. 1994. "Native American Craft." In *Revivals! Diverse Traditions 1920–1945,* edited by Janet Kardon, pp. 65–76. New York: Abrams.

Cole, Douglas. 1980. Sigismund Bacstrom's Northwest Coast Drawings and an Account of His Curious Career. *B.C. Studies* 46: 61–86.

———. 1985. *Captured Heritage: The Scramble for Northwest Coast Artifacts*. Seattle: University of Washington Press.

Cole, Douglas, and Bradley Lockner. 1989. *Journals of George M. Dawson: British Columbia, 1875–1878*. Vancouver: University of British Columbia Press.

———. 1993. *To the Charlottes: George Dawson's 1878 Survey of the Queen Charlotte Islands*. Vancouver: University of British Columbia Press.

Collins, Henry B., Frederica de Laguna, Edmund Carpenter, and Peter Stone. 1977. *The Far North: Two Thousand Years of American Eskimo and Indian Art*. Bloomington: Indiana University Press.

Collison, William H. 1878. Letter to the Church Missionary Society, October 26. Church Missionary Society Archives, Birmingham University Library, Birmingham, England.

———. 1915. *In the Wake of the War Canoe*. London: Seeley, Service and Company, Ltd.

———. 1981. *In the Wake of the War Canoe*. Edited and annotated by Charles Lillard. Victoria, B.C.: Sono Nis Press.

Coughlin, Sister Magdalen. 1970. Boston Merchants on the Coast, 1787–1821: An Insight into the American Acquisition of California. Ph.D. diss., Department of History, University of Southern California.

Curtis, Edward S. 1916. *The Haida*. The North American Indian, vol. 11. Norwood, N.J.: Plimpton Press.

Cutter, Donald C., and George Butler Griffin (eds. and trans.). 1969. *The California Coast: A Bilingual Edition of Documents from the Sutro Collection*. Norman: University of Oklahoma Press.

Dall, William H. 1884. *On Masks, Labrets, and Certain Aboriginal Customs, with an Inquiry into the Bearing of their Geographical Distribution*. Third Annual Report of the Bureau of American Ethnology, 1881–1882. Washington, D.C.: Government Printing Office.

Dalzell, Kathleen E. 1968. *The Queen Charlotte Islands, 1774–1966*, vol. 1. Madeira Park, B.C.: Harbour Publishing.

———. 1973. *The Queen Charlotte Islands, Places and Names*, vol. 2. Madeira Park, B.C.: Harbour Publishing.

Dawson, George M. 1880. *Report on the Queen Charlotte Islands, 1878*. Montreal: Dawson Brothers.

Deans, James. 1890. The Huida-Kwul-Ra, or Native Tobacco of the Queen Charlotte Haidas. *American Antiquarian* 12: 48–50.

———. 1893[?]. Notes on Haida Model Houses in Field Museum. Unpublished ms. Chicago: Field Museum of Natural History.

Dixon, R. B. 1933. Tobacco Chewing on the Northwest Coast. *American Anthropologist* n.s. 35: 146–150.

Dockstader, Frederick. 1977. Charles Edensaw (1839–1924). In *Great North American Indians: Profiles in Life and Leadership*, pp. 83–84. New York: Van Nostrand.

Douglas, Frederic H., and René d'Harnoncourt. 1941. *Indian Art of the United States*. New York: The Museum of Modern Art.

Drew, Leslie, and Douglas Wilson. 1980. *Argillite: Art of the Haida*. Vancouver: Hancock House.

Drucker, Philip. 1948. The Antiquity of the Northwest Coast Totem Pole. *Journal of the Washington Academy of Sciences* 39 (12): 389–397.

Duff, Wilson. 1964. Contributions of Marius Barbeau to West Coast Ethnology. *Anthropologica* n.s. 6 (6): 63–96.

———. 1976. Mute Relics of Haida Tribe's Ghost Villages. *Smithsonian* 7 (6): 84–89.

———. 1981. The World Is as Sharp as a Knife: Meaning in Northern Northwest Coast

Art. In *The World Is as Sharp as a Knife: An Anthology in Honour of Wilson Duff,* edited by Donald Abbott, pp. 209–224. Victoria: British Columbia Provincial Museum.

Duff, Wilson, Bill Holm, and Bill Reid. 1967. *Arts of the Raven.* Vancouver: Vancouver Art Gallery.

Duff, Wilson, and Michael Kew. 1957. *Anthony Island: A Home of the Haidas.* Victoria, B.C.: Provincial Museum of Natural History and Anthropology.

Duff, Wilson (ed.), with Jane Wallen and Joe Clark. 1969. *Totem Pole Survey of Southeastern Alaska: Report of Field Survey and Follow-up Activities, June–October 1969.* Juneau: Alaska State Museum.

Duffek, Karen. 1993. Northwest Coast Indian Art from 1950 to the Present. In *In the Shadow of the Sun: Perspectives on Contemporary Native Art,* edited by the Canadian Museum of Civilization, pp. 213–231. Hull, Quebec: Canadian Museum of Civilization.

Duncan, Kate C. 2000. *1001 Curious Things: Ye Olde Curiosity Shopp and Native American Art.* Seattle: University of Washington Press.

Dunn, John. 1846. *The History of Oregon Territory.* London.

Dunn, John Asher. 1995. *Sm'algyax: A Reference Dictionary and Grammar for the Coast Tsimshian Language.* Seattle and Juneau: University of Washington Press and Sealaska Heritage Foundation.

Eastwood, Alice. 1938. The Tobacco Collected by Archibald Menzies on the Northwest Coast of America. *Leaflets of Western Botany* 2 (6): 92–94.

Edelstein, Susan F. (ed). 1980. *Carved History: The Totem Poles and House Posts of Sitka National Historical Park.* Anchorage: Alaska Natural History Association and the National Park Service.

Emmons, George T. 1914. Portraiture among the North Pacific Coast Tribes. *American Anthropologist* 16 (1): 59–67.

Enrico, John. 1989. The Haida Language. In *The Outer Shores,* edited by Geoffrey G. E. Scudder and Nicholas Gessler, pp. 223–247. Second Beach, B.C.: Queen Charlotte Islands Museum.

———, (ed. and trans.). 1995. *Skidegate Haida Myths and Histories Collected by John R. Swanton.* Skidegate, B.C.: Queen Charlotte Islands Museum Press.

Enrico, John, and Wendy Bross Stuart. 1996. *Northern Haida Songs.* Lincoln: University of Nebraska Press.

Fane, Diana, Ira Jacknis, and Lise M. Breen. 1991. *Objects of Myth and Memory: American Indian Art at the Brooklyn Museum.* Seattle: Brooklyn Museum in association with University of Washington Press.

Feldman, Richard D. 1996. The Golden Hill Totem Poles of Indianapolis: The Missing Pole from the Brady Collection of Sitka National Historical Park. *American Indian Art* 21 (2): 58–71.

Fisher, Robin. 1977. *Contact and Conflict: Indian and European Relations in British Columbia, 1774–1890.* Vancouver: University of British Columbia Press.

Fladmark, Knut R. 1973. The Richardson Ranch Site: A Nineteenth-Century Haida House. In *Historical Archaeology in Northwestern North America,* edited by Knut R. Fladmark and Ronald M. Getty, pp. 53–96. Calgary: University of Calgary Publications.

Fleurieu, Charles Pierre Claret de. 1801. *A Voyage Round the World, Performed during the Years 1790, 1791 and 1792 by Étienne Marchand,* vol. 1. London: T. N. Longman and O. Reese. Reprint, 1970. New York: Da Capo Press.

Garfield, Viola. 1941. Viola Garfield Papers, accn. no. 2027–72–25, box 10. Seattle: University of Washington Libraries.

Garfield, Viola, and Linn Forrest. 1949. *The Wolf and the Raven.* Seattle: University of Washington Press.

Gessler, Nick, and Trisha Gessler. 1977. A Comparative Analysis of Argillite from Kiusta. *Syesis* 9: 13–18.

Gessler, Trisha (Glatthaar). 1981. *The Art of Nunstins.* Second Beach, B.C.: Queen Charlotte Islands Museum.

Gibson, James R. 1992. *Otter Skins, Boston Ships, and China Goods: The Maritime Fur Trade of the Northwest Coast, 1785–1841.* Seattle: University of Washington Press.

Goddard, Pliny E. 1945. *Indians of the Northwest Coast.* New York: American Museum of Natural History.

Gormly, Mary. 1977. Early Culture Contact on the Northwest Coast, 1774–1795: Analysis of Spanish Source Material. *Northwest Anthropological Research Notes* 11: 1–80.

Gough, Barry M. 1982. New Light on Haida Chiefship: The Case of Edenshaw, 1850–1853. *Ethnohistory* 29: 131–139.

———. 1992. *The Northwest Coast: British Navigation, Trade, and Discoveries to 1812.* Vancouver: University of British Columbia Press.

———. 1993. Eda'nsa. In *Dictionary of Canadian Biography,* pp. 289–291. Toronto: University of Toronto Press.

Green, Jonathan S. 1915. *Report of an Exploring Tour on the North-West Coast of North America in 1829.* New York: Charles Fred Heartman.

Halpin, Marjorie. 1981. *Totem Poles: An Illustrated Guide.* Vancouver: University of British Columbia.

Hanna, James. 1785. Journal of a Voyage from Macao towards King George's Sound in the *Sea Otter,* Captain James Hanna Commander. Unpublished manuscript. Victoria: British Columbia Archives.

Harner, Michael J., and Albert B. Elsasser. 1965. *Art of the Northwest Coast: An Exhibition at the Robert H. Lowie Museum of Anthropology.* Berkeley: University of California Press.

Harrington, Lyn. 1949. Last of the Haida Carvers. *Natural History* 58 (5): 200–205.

Harris, Christie. 1966. *Raven's Cry.* New York: Atheneum.

———. 1992. *Raven's Cry.* Rev. ed. Seattle and Vancouver: University of Washington Press and Douglas and McIntyre.

Harrison, Charles. 1911–1913. History of the Queen Charlotte Islands: The Haida and Their Legends. *Queen Charlotte Islander,* vol. 1, no. 11, through vol. 2, no. 14.

———. 1925. *Ancient Warriors of the North Pacific: The Haida, Their Laws, Customs and Legends, with Some Historical Account of the Queen Charlotte Islands.* London: H. F. and G. Witherby.

Hart, Jim, and Reg Davidson. 1990. *Haida Artifacts: An Exhibit with Commentaries by Jim Hart and Reg Davidson for the Lowie Museum of Anthropology, University of California at Berkeley.* Berkeley: Lowie Museum of Anthropology.

Hayes, Edmund (ed). 1981. *Log of the Union: John Boit's Remarkable Voyage to the Northwest Coast and around the World, 1794–1796.* Boston and Portland: Massachusetts Historical Society and Oregon Historical Society.

Henderson, John R. 1972. Haida Culture Change: A Geographical Analysis. Ph.D. diss., Michigan State University.

Henry, John Frazier. 1984. *Early Maritime Artists of the Pacific Northwest Coast, 1741–1841.* Seattle: University of Washington Press.

Hills, William Henry. 1853. Journal on Board HMS *Portland* and *Virago,* 1852–1858. Unpublished manuscript. Microfilm, University of British Columbia Library, Special Collections.

Holm, Bill. 1965. *Northwest Coast Indian Art: An Analysis of Form.* Seattle: University of Washington Press.

———. 1967. What Makes an Edenshaw? (2–D Version). Unpublished note.

———. 1972. *Crooked Beak of Heaven.* Seattle: University of Washington Press.

———. 1981. Will the Real Charles Edenshaw Please Stand Up? In *The World Is As Sharp As a Knife: An Anthology in Honour of Wilson Duff,* edited by D. Abbott, pp. 175–200. Victoria: British Columbia Provincial Museum.

———. 1982. A Wooling Mantle Neatly Wrought. *American Indian Art* 8 (1): 34–47.

———. 1987. *Spirit and Ancestor: A Century of Northwest Coast Indian Art at the Burke Museum.* Seattle: Burke Museum and University of Washington Press.

———. 1989. Cultural Exchange across the Gulf of Alaska: Eighteenth-Century Tlingit and Pacific Eskimo Art in Spain. In *Culturas de la Costa Noroeste de América,* edited by J. L. Peset, pp. 105–113. Madrid: Sociedad Estatal Quinto Centenario.

———. 1990. Art. In *Handbook of North American Indians, vol. 7: Northwest Coast,* edited by Wayne Suttles, pp. 602–632. Washington, D.C. Smithsonian Institution.

———. 1997. Variations on a Theme: Northern Northwest Coast Painted Boxes. *American Indian Art* 22 (2): 52–61.

———. 2000. Function of Art in Northwest Coast Indian Culture. In *Spirits of the Water: Native Art Collected on Expeditions to Alaska and British Columbia, 1774–1910,* pp. 46–51. Seattle: University of Washington Press.

Holm, Bill, and William Reid. 1975. *Form and Freedom: A Dialogue on Northwest Coast Indian Art.* Houston, Texas: Institute for the Arts, Rice University.

Hoover, Alan L. 1981. The Development of Narrative Structure in Nineteenth-Century Haida Tourist Art. Paper presented at the annual meeting of the Canadian Ethnology Society, University of British Columbia.

———. 1983. Charles Edensaw and the Creation of Human Beings. *American Indian Art* 8 (3): 62–67, 80.

———. 1993. The Arts of Charles Edenshaw: Haida, Tourist, Anthropologist. Paper presented at the biannual meeting of the Native American Art Studies Association, Santa Fe, N.M.

———. 1995. Charles Edenshaw: His Art and Audience. *American Indian Art* 20 (3): 44–53.

Howay, Frederick W. 1930. *A Yankee Trader on the Northwest Coast 1791–95.* Washington Historical Quarterly 21 (2).

———. 1934. *A List of Trading Vessels in Maritime Fur Trade, 1785–1825.* Royal Society of Canada, Proceedings and Transactions, Series 3, vols. 24–28.

———. 1990. *Voyages of the* Columbia *to the Northwest Coast, 1787–1790 and 1790–1793.* Portland: Oregon Historical Society in cooperation with the Massachusetts Historical Society.

Howay, Frederick W., and E. O. S. Scholefield. 1914. *British Columbia: From the Earliest Times to the Present.* Vancouver: S. J. Clarke.

Inskip, George Hastings. 1853. Journal of a Voyage from England to the Pacific, including the Northwest Coast of North America, master of HMS *Virago,* 1751–1855. 2 vols. Unpublished manuscript. Microfilm. Victoria: British Columbia Archives.

Jackman, S. W. (ed). 1978. *The Journal of William Sturgis.* Victoria, B.C.: Sono Nis Press.

Jacobsen, Johan Adrian. 1977. *Alaskan Voyage, 1881–1883.* Translated by Erna Gunther from the German text of Adrian Woldt. Chicago: University of Chicago Press.

Jonaitis, Aldona. 1988. *From the Land of the Totem Poles: The Northwest Coast Indian Art Collection at the American Museum of Natural History.* New York and Seattle: American Museum of Natural History and University of Washington Press.

———. 1989. Totem Poles and the Indian New Deal. *Canadian Journal of Native Studies* 9: 237–252.

———. 1992. Franz Boas, John Swanton, and the New Haida Sculpture at the American Museum of Natural History. In *The Early Years of Native American Art History,* edited by J. Berlo, pp. 22–61. Seattle and Vancouver: University of Washington Press and University of British Columbia Press.

————. 1999. Northwest Coast Totem Poles. In *Unpacking Culture: Art and Commodity in Colonial and Postcolonial Worlds*, edited by Ruth B. Phillips and Christopher B. Steiner, pp. 104–121. Berkeley: University of California Press.

Kaeppler, Adrienne. 1978. *Artificial Curiosities: An Exposition of Native Manufactures Collected on the Three Pacific Voyages of Captain James Cook, R.N.* Honolulu: Bernice Pauahi Bishop Museum.

Kaplanoff, Mark D. (ed). 1971. *Joseph Ingraham's Journal of the Brigantine* Hope, *1790–1792*. Barre, Mass.: Imprint Society.

Keithahn, Edward. 1963. *Monuments in Cedar*. Seattle: Superior Publishing Company.

King, Jonathan C. H. 1979. *Portrait Masks from the Northwest Coast of America*. London: British Museum.

————. 1981. *Artificial Curiosities from the Northwest Coast of American: Native American Artefacts in the British Museum Collected on the Third Voyage of Captain James Cook and Acquired through Sir Joseph Banks*. London: British Museum.

Laforet, Andrea. 1990. Regional and Personal Style in Northwest Coast Basketry. In *The Art of Native American Basketry*, edited by F. W. Porter, pp. 281–297. New York: Greenwood Press.

Lamb, W. K. 1942. Four Letters Relating to the Cruise of the *Thetis*, 1852–53. *British Columbia Historical Quarterly* 6: 189–206.

Lawrence, Erma. 1975. *Xaadas Gutilaa Gyaahlangaay: Haida Stories and History*. Ketchikan, Alaska: Society for the Preservation of Haida Language and Literature.

————, (ed). 1977. *Haida Dictionary*. Fairbanks: Society for the Preservation of Haida Language and Literature and Alaska Native Language Center, University of Alaska.

Lillard, Charles (ed). 1984. *Warriors of the North Pacific*. Victoria, B.C.: Sono Nis Press.

MacDonald, George F. 1973. *Haida Burial Practices: Three Archaeological Examples. The Gust Island Burial Shelter, the Skungo Cave, North Island, Mass Burials from Tanu*. Ottawa: National Museums of Canada.

————. 1983. *Haida Monumental Art: Villages of the Queen Charlotte Islands*. Vancouver: University of British Columbia.

————. 1996. *Haida Art*. Seattle: University of Washington Press.

Mackenzie, Alexander. 1891. Descriptive notes on certain implements, weapons, etc., from Graham Island, Queen Charlotte Islands, B.C. *Transactions of the Royal Society of Canada*, Proceedings, Series 1, vol. 9, pp. 45–59.

MacNair, H. F. (ed). 1938. The Log of the *Caroline* (1799). *Pacific Northwest Quarterly* 29: 61–84, 167–200.

Macnair, Peter, and Alan Hoover. 1984. *The Magic Leaves: A History of Haida Argillite Carving*. Victoria: British Columbia Provincial Museum.

Macnair, Peter, Alan Hoover, and Kevin Neary. 1980. *The Legacy: Continuing Traditions of Canadian Northwest Coast Indian Art*. Victoria: British Columbia Provincial Museum.

Magee, Bernard. 1794. *Log of the Jefferson*. Unpublished manuscript. Massachusetts Historical Society.

Malin, Edward. 1986. *Totem Poles of the Pacific Northwest Coast*. Portland: Timber Press.

Malloy, Mary, ed. 2000. *"A Most Remarkable Enterprise": Maritime Commerce and Culture of the Northwest Coast by Captain William Sturgis*. Marston Mills, Mass.: Parnassus Imprints.

McDonald, Lucile. 1972. *Swan among the Indians: Life of James G. Swan, 1818–1900*. Portland, Ore.: Binfords and Mort.

McDowell, Jim. 1997. *Hamatsa: The Enigma of Cannibalism on the Pacific Northwest Coast*. Vancouver: Ronsdale Press.

McLennan, Bill, and Karen Duffek. 2000. *The Transforming Image: Painted Arts of Northwest Coast First Nations*. Vancouver: University of British Columbia Press.

Meares, John. 1967 [1790]. *Voyages Made in the Years 1788 and 1789 from China to the*

North-West Coast of America. New York and Amsterdam: Da Capo Press and N. Israel.

Miller, Jay. 2000. Alaskan Tlingit and Tsimshian, in American Indians of the Pacific Northwest Digital Collection. Available at http://content.lib.washington.edu/aipnw/miller1/index.html. Seattle: University of Washington Libraries (accessed on November 25, 2000).

Museum of History and Industry. n.d. [1983?]. *Chief John Wallace's Totem Pole.* Seattle: Museum of History and Industry.

Muskett, Henry Joseph. 1902. Diary. Unpublished manuscript. Victoria: British Columbia Archives, Add. Mss. 2232.

National Gallery of Canada. 1927. *Exhibition of Canadian West Coast Art: Native and Modern.* Ottawa: National Gallery of Canada.

Newcombe, Charles F. 1900–1911. Newcombe Family Papers, unpublished notes. Victoria: British Columbia Archives, Add. Mss. 1077.

Newcombe, William A. 1931. Review of *Totem Poles of the Gitksan,* by Marius Barbeau. *American Anthropologist,* n.s. 33: 238–243.

Niblack, A. P. 1888. *The Coast Indians of Southern Alaska and Northern British Columbia.* Washington, D.C.

Olson, Ronald. 1967. *Social Structure and Social Life of the Tlingit in Alaska.* University of California Publications, Anthropological Records, vol. 26. Berkeley: University of California Press.

Pethick, Derek. 1976. *First Approaches to the Northwest Coast.* Vancouver: J. J. Douglas, Ltd.

Pleasants, J. Hall. 1919. *The Curzon Family of New York and Baltimore and Their English Descent.* Baltimore.

Prevost, James C. 1853. Report to Rear-Admiral Fairfax Moresby, 23 July 1853. Public Record Office, London.

Public Archives of Canada. Census Reports for 1881 and 1891. RG 31.

Quimby, George I. 1985. Japanese Wrecks, Iron Tools, and Prehistoric Indians of the Northwest Coast. *Arctic Anthropology* 22 (2): 7–15.

Ransom, Kelly Marie. 1994. Art as Negation: The Reciprocal Construction of Meanings in the Argillite Carvings of Charles Edenshaw. M.A. thesis, Department of Fine Art, University of British Columbia.

Reid, Bill, and A. DeMenil. 1971. *Out of the Silence.* New York: Harper and Row.

Roe, Michael (ed). 1967. *Journal and Letters of Captain Charles Bishop on the Northwest Coast of America, in the Pacific, and in New South Wales, 1794–1799.* Cambridge: Hakluyt Society.

Rohner, Ronald P. 1969. *The Ethnography of Franz Boas: Letters and Diaries of Franz Boas Written on the Northwest Coast from 1886 to 1931.* Chicago: University of Chicago Press.

Roquefeuil, Camille de. 1981. *Voyage around the World, 1816–1819, and Trading for Sea Otter Fur on the Northwest Coast of America.* Fairfield, Wash.: Ye Galleon Press.

Schrader, Robert Fay. 1983. *The Indian Arts and Crafts Board.* Albuquerque: University of New Mexico Press.

Seattle Art Museum. 1995. *The Spirit Within: Northwest Coast Native Art from the John H. Hauberg Collection.* Seattle and New York: Seattle Art Museum and Rizzoli.

Shadbolt, Doris. 1998. *Bill Reid.* Vancouver: Douglas and McIntyre.

Sheehan, Carol. 1981. *Pipes That Won't Smoke, Coal That Won't Burn.* Calgary: Glenbow Museum.

Snow, E. 1925. *The Sea, The Ship and The Sailor: Tales of Adventure from Log Books and Original Narratives.* Salem, Mass.: Marine Research Society.

Sotheby Parke Bernet, Inc. 1982. Fine American Indian, African, and Oceanic Art Auction Catalogue, October 23, 1982. New York: Sotheby Parke Bernet, Inc.

Starzecka, D. C. (ed). 1996. *Maori Art and Culture*. Chicago: Art Media Resources.

Stearns, Robert A. 1961. Sturgis's Journal: Its Value as an Historical Source. M.A. thesis, Department of History, University of California, Santa Barbara.

Steltzer, Ulli, and Robert Davidson. 1994. *Eagle Transforming: The Art of Robert Davidson*. Vancouver and Seattle: Douglas and McIntyre and University of Washington Press.

Sterns, Mary Lee. 1981. *Haida Culture in Custody: The Masset Band*. Seattle and Vancouver: University of Washington Press and Douglas and McIntyre.

————. 1984. Succession to Chiefship in Haida Society. In *The Tsimshian and Their Neighbors of the North Pacific Coast*, edited by Jay Miller and Carol M. Eastman, pp. 190–219. Seattle: University of Washington Press.

Stewart, Hilary. 1979. *Robert Davidson, Haida Printmaker*. Seattle: University of Washington Press.

————. 1993. *Looking at Totem Poles*. Seattle: University of Washington Press.

Swan, James G. 1875. Diary for 1875. Swan Papers, Box 2. Seattle: University of Washington Libraries.

————. 1877. Report on the Cruise of the U.S. Revenue Cutter *Wolcott*, in Alaska, during the Summer of 1875, to Procure Articles of Indian Manufacture for the Centennial Exposition. Washington, D.C.: Government Printing Office, Appendix to Senate Document n. 59, 45th Congress, 3rd Session.

————. 1883a. Diary for 1883. Swan Papers, Box 2. Seattle: University of Washington Libraries.

————. 1883b. Extract from Diary of Cruise to Queen Charlotte Islands, B.C. Unpublished typescript. Swan papers. Seattle: University of Washington Libraries.

————. 1884. The Carvings and Heraldic Paintings of the Haida Indians. *The West Shore*, August, pp. 250–255.

Swanton, John R. 1905a. *Contributions to the Ethnology of the Haida*. Leiden and New York: E. J. Brill and G. E. Stechert.

————. 1905b. *Haida Texts and Myths, Skidegate Dialect*. New York: Bureau of American Ethnology.

————. 1908a. *Social Condition, Beliefs, Linguistic Relationships of the Tlingit Indians*. Twenty-ninth Annual Report of the Bureau of American Ethnology, 1904–1905. Washington, D.C.: U.S. Government Printing Office.

————. 1908b. *Haida Texts: Masset Dialect*. Leiden: E. J. Brill.

————. 1909. *Tlingit Myths and Texts*. Bureau of American Ethnology, Bulletin 39. Washington, D.C.: U.S. Government Printing Office.

————. 1911. Haida. In *Handbook of American Indian Languages*, edited by Franz Boas. Bureau of American Ethnology, Bulletin 40. Washington, D.C.: Smithsonian Institution.

Swanton, John R., and Franz Boas (eds.). 1912. *Haida Songs and Tsimshian Texts*. Publications of the American Ethnological Society, vol. 3. Leyden: E. J. Brill.

Thomas, Edward Harper. 1970. *Chinook: A History and Dictionary*. Portland, Oreg.: Binfords and Mort.

Thomas, Susan Jane. 1967. The Life and Work of Charles Edenshaw: A Study of Innovation. Unpublished paper. Department of Anthropology and Sociology, University of British Columbia.

Time-Life Books. 1993. *Keepers of the Totem*. Alexandria, Va.: Time-Life Books.

Trennert, Robert A., Jr. 1974. A Grand Failure: The Centennial Indian Exhibition of 1876. *Prologue: The Journal of the National Archives* 6 (2): 118–129.

Treven, Henry. 1852–1854. The Diary of Surgeon Henry Treven, R.N., in HMS *Virago*. Unpublished manuscript. Ottawa: Public Archives of Canada.

Turner, Nancy J., and Roy L. Taylor. 1972. A Review of the Northwest Coast Tobacco Mystery. *Syesis* 5: 249–257.

Vaughan, James Daniel. 1985. Toward a New and Better Life: Two Hundred Years of Alaskan Haida Culture Change. Ph.D. diss., Department of Anthropology, University of Washington.

Vaughan, Thomas, and Bill Holm. 1982. *Soft Gold: The Fur Trade and Cultural Exchange on the Northwest Coast of America.* Portland: Oregon Historical Society.

Wagner, Henry R. 1937. *Cartography of Western North America to the Year 1800.* Berkeley: University of California Press.

Wagner, Henry R., and W. A. Newcombe. 1938. The Journal of Jacinto Camaaño. *British Columbia Historical Quarterly* 2 (3–4): 189–222, 265–310.

Walbran, Captain John T. 1971. *British Columbia Coast Names.* Vancouver: J. J. Douglas.

Waldman, Carl. 1990. *Edenshaw, Charles (Edensaw, Idansu).* New York: Facts on File.

Walker, Alexander 1982. *An Account of a Voyage to the North West Coast of America in 1785 and 1786.* Edited by Robin Fisher and J. M. Bumsted. Vancouver and Seattle: Douglas and McIntyre and University of Washington Press.

Wardwell, Allen. 1996. *Tangible Visions: Northwest Coast Indian Shamanism and Its Art.* New York: Monacelli Press with Corvus Press.

Waterman, T. T. 1923. *Observations among the Ancient Indian Monuments of Southeastern Alaska.* Washington, D.C.: Smithsonian Institution.

Weber, Ronald L. 1985. Photographs as Ethnographic Documents. *Arctic Anthropology* 22 (1): 67–78.

Weissenborn, von J. 1908. Der Totempfahl der Haida im Städtischen Museum für Natur., Volker. und handelskunde. *Jahrbuch der Bremischen Samnlungen* (Bremen, Germany), pp. 18–25.

Wherry, Joseph H. 1974. *The Totem Pole Indians.* New York: Thomas Y. Crowell.

Wilcox, R. Turner. 1948. *The Mode in Hats and Headdress.* New York: Charles Scribner's Sons.

Winter, Lloyd, and Percy Pond. 1905. *The Totems of Alaska.* New York: Albertype Company.

Work, John. 1945. *The Journal of John Work, January to October 1835.* With an introduction and notes by Henry Drummond Dee. Victoria, B.C.: Charles F. Banfield.

Wright, Robin K. 1977. Haida Argillite Pipes. M.A. thesis, School of Art, Division of Art History, University of Washington.

———. 1979. Haida Argillite Ship Pipes. *American Indian Art* 5 (1): 40–47.

———. 1980. Haida Argillite Pipes: The Influence of Clay Pipes. *American Indian Art* 5 (4): 42–47, 88.

———. 1982. Haida Argillite Carved for Sale. *American Indian Art* 8 (1): 48–55.

———. 1985. Nineteenth-Century Haida Argillite Pipe Carvers: Stylistic Attributions. Ph.D. diss., School of Art, Division of Art History, University of Washington.

———. 1986. The Depiction of Women in Nineteenth-Century Haida Argillite Carving. *American Indian Art* 11 (4): 36–45.

———. 1987. Haida Argillite Carvings in the Sheldon Jackson Museum. In *Faces, Voices, and Dreams: A Celebration of the Centennial of the Sheldon Jackson Museum,* edited by P. Corey, pp. 176–199. Juneau: Division of Alaska State Museums and Friends of the Alaska State Museum.

———. 1991. *A Time of Gathering: Native Heritage in Washington State.* Seattle: Burke Museum and University of Washington Press.

———. 1992. Kadashan's Staff: The Work of a Mid-Nineteenth-Century Haida Argillite Carver in Another Medium. *American Indian Art* 17 (4): 48–55.

———. 1995. Hlgas7agaa: Haida Argillite. In *The Spirit Within: Northwest Coast Native Art from the John H. Hauberg Collection,* edited by Seattle Art Museum, pp. 130–141. Seattle and New York: Seattle Art Museum and Rizzoli.

————. 1998. Two Haida Artists from Yan: Will John Gwaytihl and Simeon Stilthda Please Step Apart? *American Indian Art* 23 (3): 42–57, 106–107.

————. n.d. Northwest Coast Box Drums: The Earliest and the Latest. In *Proceedings of the Northwest Coast Art Symposium, Otsego Institute for Native American Art History,* edited by Aldona Jonaitis. Cooperstown: New York State Historical Association. In press.

Wyatt, Victoria. 1986. A Unique Attraction: The Alaskan Totem Poles at the St. Louis Exposition of 1904. *Alaska Journal* 16: 14–23.

————. 1989. *Images from the Inside Passage: An Alaskan Portrait by Winter and Pond.* Seattle: University of Washington Press.

Young, S. Hall. 1927. *Hall Young of Alaska: The Mushing Parson. The Autobiography of S. Hall Young.* New York: Fleming H. Revell.

Index

Boldface numbers refer to illustrations.

Davidson, Reg, 327
Davidson, Robert, 323; on Haida culture, 5–6; art of, 183, 240, 323, 327, **328**; silkscreen print by, 234, **324**; Old Massett pole by, 312, **322**; house post by, **329**
Davidson, Robert, Sr., 273, 323, 346n27
Davies, Samuel G. (Davis?), 349n18
Davis, Samuel Gerard, 203, 210, **298**
Dawson, George, 212–13, 223, 253
de Roquefeuil, Camill. *See* Roquefeuil, Camille de
Deans, James, 112, 147, 354n24; and Skidegate poles, 219, 266; and Field Museum, 249, 253; stories recorded by, 259–60
Deasy, Thomas, 134
Décany, Volunteer, 51
deer hooves, 80
DeMenil Collection, 127
dentalium shells, 70, 134
Denver Art Museum, 127, 199, 317
Department of the Interior. *See* U.S. Department of the Interior
devilfish, in art, 203
Devil's Club, 347n32
DeYoung Museum, 293
d'Harnoncourt, René, 317
Dian, 352n54
Dickerman, Alton, **140**
Diesing, Freda, 323, **325, 326**, 327
dishes, 38, **39**, 206, **207**
Dixon, Capt. George, 31–38, 51, 78, 339n9
Dixon Entrance, 31
djat'cina. See Skillie, Mae
Djus Island People. *See juus xàadee*
Djus xade'. See juus xàadee
dlagwaa t'aawaa. See Edenshaw, Martha
Dodge, Capt., 79
dogfish, in art, 127, 166, 206, 211, 242, 263, 280; in tattoo design, 175, 261; on poles and posts, 219, 259, 312
Dogfish House. *See q'a.ad na.as*
dogs, 80, 82, 103; in stories, 199
Douglas, Frederick, 351n44
Douglas, Gov. James, 167, **170, 172**
Douglas, Capt. William: voyage to Haida Gwaii, 40–43; name of, 41, 83, 96, 120, 172, 351n44; activities of, 42, 44, 46, 69, 102, 340n11
Douglas *gannyaa. See gannyaa*
Drake, Sir Francis, 16
drawings: by Charles Edenshaw,

261–63, **pls. 9–16**; by John Robson, 263–65, **264, 265**
dress, style of. *See* clothing
drink made of bark, 80
Drucker, Phillip, 8
drums, 24, 53, 64, 124, 257, 259
Dry Island, 148
Dryad (ship), 346n28
Duff, Wilson, 5, 8, 74, 118, 286, 318, 347n1; on old *7idansuu*, 100, 102; attribution of objects, 138, 219, 262
Duffin, Capt., 78, 81
Duncan, 193
Duncan, Capt. Alexander, 113, 346n28, 349n17
Duncan, Ben, **188**, 350n29
Duncan, Capt., 120, 346n28
Duncan, Capt. Charles, 40, 346n28
Duncan, Rev. William, 357n39
du.ugwaa tsiij git'anee (*git'ans* of the town of *tsiij*—E17), 114–16, 283, 284, 286

E

Eadinshu. *See 7idansuu*
eagle, in art, 127, 155, 173, 216, 234,; on poles, 104, 105, 223, 253, 259, 260, **260**, 271; in story, 259–60
eagle and the clam, 261
eagle feather fans, 342n23
Eagle moiety, 9
Eagle-House People, 266
ear ornaments, 41
Eastgut, 83
Ed ᴀ'nsa. *See* Edenshaw
Edensaw. *See* Edenshaw
Edenshaw, Agnes, 224, 231, 242, 328
Edenshaw, Albert Edward, 40, 118, 146, 162, 167, 172, 176, 273; family of, 4, 99, 100, 112, 118, 120, 266, 328, 345n16; descriptions of, 4, 102, 120, 352n55; and poles, 108, 145, 166; life of, 110, 111, 113, 118, 124, 138, 159, 163, 228, 231, 232, 345n19, 346n24, 352n58; photograph of, **111, 231**; marriage of, 111, 120, 159, 228; objects owned by, 121, **122, 123, 128, 134**, 155, **pl. 7**; and James G. Swan, 145, 147; and gold rush, 159–60; and *Susan Sturgis* incident, 160–61, 297; and pole for Gov. Douglas, 167, **170**; artworks attributed to, 4, 110–59, 135, **135**, 138, 262, 278; coppers, **122, 123**; headdress frontlets, **126, 129, 130, 131, 132**, 133, 238–40, **pl. 7**; poles,

141–55, **168**, 182–83, 213, **214**, 215, 219, 220, 223, **225**, 351n46; argillite pipes, 155–59
houses of, 141–45; in *k'yuust'aa*, 110, 145, 266; in *qang*, 156, **164, 165**; in Old Massett, 224, 228, **229**
Edenshaw, Alice, 242–46
Edenshaw, Amy, 159, 166, 176, 228, 352n55; marriage of, 111, 228, 351n45; travels of, 147, 175, 212, 281; house of, 183, 213, 352n47
Edenshaw, Charles, 120, 138, 246, 266, 281, 299; life of, 4, 172, 173, 175, 228, 281, 282, 313, 348n8, 355n33; accounts of, 12, 102, 282, 310, 352n55, 356n37; family of, 30, 112, 176, 318, 323, 329; on bentwood bowl design, 138, 263; name of, 173, 352n53; residence of, 174, 212, 224, 230; and John Robson, 256, 260; travels of, 265, 280; photograph of, **278, 298**; memorial to, 327, **328**
artwork of, 173, **198, 241, 272**, 274, 353n5; confused with others, 4, 286; exhibits, 5, 286, 355n35; model poles and houses, 100, 102, 104, 142, **143, 145**, 166, **166**, 177, 182, **182**, 266, **266**, 310, 311; headdress frontlets, 127, 234–40, **235, 236, 237, 238, 239, pl. 8**; canoes, 135, 273, 355n31; gravestones, 211, **211**, 233–34, **235**, 305; poles, 216, **217, 218**, 220, **221**, 223, 224, **226**; settees, 240–42, **241**; cradles, 242–46, **243, 244, 245**; argillite carvings, 242, 246–48, 256, **248, 249, 274, 275, 287**, 355n26; jewelry, 246, **247**; drawings, 260–63, 354n19, **pls. 9–16**; masks, **272, 273**, 273–74; canes, 274–78, **276, 277**, 355nn29-30; and other artists, 286, 323; carvings misattributed, 307, 351n46, 353n10, 354n18
Edenshaw, Chief. *See* Edenshaw, Albert Edward; *7idansuu*, old
Edenshaw, Daisy, 328
Edenshaw, Dorothy, 314
Edenshaw, Douglas, 314
Edenshaw, Eliza, 242
Edenshaw, Emily, 224
Edenshaw, Florence. *See* Davidson, Florence Edenshaw
Edenshaw, Gary. *See* Guujaaw
Edenshaw, George, 224, 231

148, **153**, **154**, 167; totem poles of, **151**, 347nn33–34
Kaigani. *See k'áyk'aanii*
Kaigani Strait, 68
Kaigani-style carving, 177
Kaisun. *See qays7un*
Kanskeeni, 50
Kane, Paul, 286
Karta Bay, 206
Kasaan. *See gasa.áan;* New Kasaan
Kasaan Bay, 102
Kask!le'k, 148
Kasq!a gue'di, 148
Katashan. *See* Kadashan, John, Chief
Katcadih, 148
Kawes, 352n57
Kaxius, 357n44
Kayang. *See q'àayaang*
Kayinwas, 352n54
k'áyk'aanii (Kaigany), 69, 81, 99, 199, 212, 343n33; visits of Europeans to, 40, 60, 61, 68, 75, 78, 86, 90, 95, 97, 98; *gu.uu* chief at, 46, 50, 60, 61; residents of, 61, 69, 74, 90, 93, 161, 313; conflicts at, 89, 94; carving at, 106, 177
Keen, Rev. J. H., 293, 307, 310
Keet naas. *See gi'id na.as*
Keetkaigince, 354n54
Keets Rist, 68
Keetshantlas, Samuel, 305
Kenai Peninsula, 30
Kendrick, Capt. John, 38, 80; attack on *xuyaa,* 60, 73, 340n16, 341n19
Kennedy, Dr., 117
Kenowan. *See ginaawaan,* Duncan
Ketchikan, Alaska, 203, 280, 318, 323
kettles, 31, 33, 34, 42, 57
Khite, 352n54
Kieunnee. *See k'áyk'aanii*
kihl guulaans, 215
Kiksadi, 148
k'il. See Flatrock Island
Kilad, 353n9
Kilchart, 89
Kilgarny. *See k'áyk'aanii*
Kilkinants, 51. *See also skil kingaans*
killer whales. *See* whales
kilsdlaa. *See* Kilshart
kilsdlaay, 337n10
Kilshart, 88
Kinaon. *See ginaawaan,* Duncan
King, Jonathan C. H., 292, 310
King George (ship), 31
Kingego, Walter, 305
Kingegwa'o. *See* Kingego, Walter

kingfishers, in art, 108
Kinninook, William, 190
Kin-ow-an. *See ginaawaan,* Duncan
Kinówen. *See ginaawaan,* Duncan
Kinsly, 117
Kit Elswa, Johnny, 147, **149**
Kit qwaədza'us. *See gid k'wáajuss*
Kitkatla, 88, 89, 344n35
Kitkoojawus. *See gid k'wáajuus*
Kitkun, 357n44
Kitsumkalum Band. *See* Gitksan people
Kitwanga, 240
Kiusta. *See k'yuust'aa*
Kl'ajangkúna. *See tl'aajaang quuna*
Klajankuna. *See tl'aajaang quuna*
Klakas Inlet, 176
Klawock, 314
Klemmakoan. *See hlanqwáan*
Kliew, Chief. *See* Kitkun; *xyuu*
Klinkwan. *See hlanqwáan*
Klinnakoa. *See hlanqwáan*
Klinquan. *See hlanqwáan*
Klue, Chief. *See* Kitkun; *xyuu*
Klukwan, Alaska, **140**
knives, 125; traded by Europeans, 19, 20, 21, 23–24, 34, 64, 99. *See also* daggers; weapons
Kodiak, 94
Koianglas, **202**, 318
Koihandlas. *See q'wíi rándllass*
Koot Nas. *See cu7aji na7as* and *cuu.uj na.as*
Koota-Hilslinga, 91, **pl. 4.** *See also gannyaa,* family of
Kotzebue expedition, 108
Kow. *See gu.uu*
Kowalt, 95
Koyah. *See xuyaa*
Kruzof Island, 29
'Ksan school. *See* Gitanmaax School of Northwest Coast Indian Art
k'udangqins, 15
Kudé, Dr. *See k'udee*
k'udee, 60, **231**
Kul Kit, Moses, 314
kuna 'laanaas (Town People of the Point—R14), 114–16, 283, 284, 344n4
Ku'na là'nas. *See kuna 'laanaas*
Kung. *See qang*
Kuper, Capt. Augustus Leopold, 161, 347n36
Kuscwai. *See q'iis gwaayee*
Kuttlekildans, 352n54
Kwənt qayngás. *See* Yaelhtetsi, Agnes Edenshaw
Kwaduwas. *See na7i kun qiirawaay*
K!wai'eł, 305

Kwaitiltht. *See gwaay t'iihld,* John
Kwaiwas, 283
Kwa-Klen. *See* Martin, Annie
Kwakwaka'wakw, 318, 342n25
Kwawduwawas. *See na7i kun qiirawaay*
Kwoiyat gudang awu, 224
Kwulsugat, 352n54
kyaanu.usalii (Cod People— R17), 114–16, 284
k'yuust'aa (Kiusta), 81, 86, 93, 100, 104, 158, 213; visits of Europeans to, 16, 36, 38, 61, 64, 68, 72, 78, 81, **146**, **147**; mortuary poles at, 40, 59, 85, **87**, **105**, 106, 108, 110, 345n14; Burling's drawing of, 84–85, **85**, 338n15, 343n33; *gannyaa* at, 69, 91; migration to and from, 69, 94, 99, 113, 163; Albert Edward Edenshaw at, 113, 118, 120; houses at, 119, 142, 228, 265– 66; pole at, 145, **149.** *See also sran.gu*

L

la.al, 6
labrets, 51, **51**, 72, 223, 293, **pl. 5;** described by Europeans, 19, 22, 25, 26, 33, 65, 67, 69, 76, 88; collected by Dixon, 33, 37, **37**, 38, **39**
Łà'dj Añ qò'na. *See tl'aajaang quuna*
ladles, 38, **39**
Lady Washington (ships), 38, 73
Laidlaw, Myrtle, 327
Lamb, Capt., 89
land otters, 199
landotter man. *See ga gi.iid*
Langara College. *See* Vancouver Community College
Langara Island, 17, 20, 31, 40, 68, 97, 176; totem pole story, 12–14; Pérez expedition at, 17–29
Laocoön, 276
Lawrence, Erma, 30, 334
ldao t!aos. See coppers Mountain-Copper
leather for armor, 62
Legaic, 121
Lenkwan. *See hlanqwáan*
Łi'el Añ. *See hl7yaalang*
Łi'el Añ qè'gawa-i. *See hl7yaalang sdast'aay,* 99
Lillard, Charles, 118–19, 120
Łinqoa'n. *See hlanqwáan*
lip ornaments. *See* labrets
liquor. *See* alcohol
liquorice, 83
Lisianski Strait. *See* Cross Sound

University of British Columbia Museum of Anthropology, 138, 318, 327, 357n46; Haida village at, 312, 323

University of Pennsylvania Museum, 199, 317

Up-Inlet-Town. *See sa'gua 'laa'-naas*

U.S. Department of the Interior, 317

Uttewas. *See* Old Massett

V

Vancouver (ship), 113–18, 346n28

Vancouver Art Gallery, 5, 286

Vancouver Community College, 327

Vancouver Museum, 248, 256, 329

venereal disease, 80

Vianna, Capt., 62, 72, 73

Victoria, B.C., 167, 173, 265, 280

Victoria, Queen, husband of, 228

Virago, HMS, 161, 347n36

Virago Sound, 50, 68, 124, 136, 163, 212, 265

Vizcaíno, Sebastián, 16

Volunteer (ship), 96

W

Waddington, Margaret L., 343n31

Wahtstlica, 352n57

Wait, Edith, 298

wa'jdiye, 198

Wakashan, 138

Wake, Capt. William, 73, 86

Wa'lala. *See 7wiilaalaa*

Wales, Prince of, 228

Walker, Alexander, 30

Wallace, Dorothy. *See* Edenshaw, Dorothy

Wallace, Dwight, **196**, 198, **198**, 313, 318, 350n24; pole attributed to, 141, **200**, **201**, **202**, **203**, **204**, 209, 347n30, 350n30, 358n3, 360; poles associated with, 193–204; name of, 198, 350n34

Wallace, Fred, 317

Wallace, John, 182, 199, 203, 340n13, 349n18; totem pole origin story of, 12–14; life and family of, 141, 313–18, 358nn2,3; house model, 193, **195**; Hydaburg Totem Park, 193, 317, 350n33; artworks by, **315**, **316**, **317**, **319**, 352n48

Wallace, Lee, 318, **320**, 350n30

Wallace, William, 314

Wardwell, Allen, 303

warfare, 35, 76

Wasgo. *See 7waasru; suu sraa.n*

Washgui, 352n54

Washington, Pa., 205

Washington's Isles. *See* Haida Gwaii

watchmen, in art, 142, 144, 183

Waterfall, Alaska, 317

Watson, Mary, 113

Watts, John, 352n2; gravestone of, 234, **235**, 323

weapons, 18, 49, 67; swords, 19, 20; muskets, 36, 41, 57, 59, 63; blunderbusses, 44, 118; bows and arrows, 44, 58, 67; pistols, 44, 174; spears, 44, 47, 48, 58, 67, 77. *See also* daggers; knives

weavings, 26

weddings, 175

Weir, Thomas, **298**

Weissenborn, von J., 216

welcoming ceremony, 18, 26

Westley, Sandra, 327

whales: in art, 108, 125, 192, 206, 261, 280, 295, 314; on poles, 106, 216, 220, 223, 270 killer whales (orcas) 303; Ocean people, 9, 11; crest, 15, 166, 303; on Skidegate pole, 219, 267, 271

whaler's hat, 27

White, Christian, 329

White, Henry, 147, 352n55

White, Morris, 328, **333**

White, Phillip, 212, 281, 351n45

White Raven. *See* Raven

Whitemore, George, 113

Wiha, John, 350n22

Wilbur, Ray Lyman, 317

Wilkes, Charles, 155, 156

William, Charlie, **241**

William & Ann (ship), 346n28

Williams, Robert, 281

Wilson, Bob, 345n9

Wilson, Emily Hunt, 345n9

Winter, Lloyd, 148, 183

Wolcott (ship), 205

Wolf phratry, 138

woman in the moon, 166, 175, 177, 213, 234, 237

women, Haida, **37**, 72. *See also* clothing, of Haida women

wool, 18

Work, John, 113–18, 160

World War II, Jacobsen collection after, 223

World's Columbian Exposition, 112, 253, 266

Wrangell, Alaska, 148, 205, 210, 313, 347n33

Wrangell Museum, 347n33

Wühtcïnnïna'h. *See* Kasq!a gue'di, 148

Wutensu'. *See* Edenshaw, Albert Edward

X

xaad, 6. *See also* totem poles, mortuary poles

xaad hlgisdang. See totem poles, mortuary poles

xàadee, 337n1

xaagyah, 11

Xa'd Asgot, 90

Xa'gi. *See xaagyah*

Xalas, 348n5

Xu'adji Lxol, 354n15

Xu'adji na'as, 354n15

xúd na.as (seal house), 349n18

xudj. See grizzly bears

xuyaa, 51, 61, 74, 341n19; as chief, 40, 50; encounter with Kendrick, 60, 73, 74, 340n16; wife of, 74. *See also* Raven

xyuu, 44, 50

Y

ya.aats', **111**, 175, 212–13, **214**

yaahl. See Raven

yáahl daajée (Alaskan dialect), 190, 193, 348n16; poles of, 141, 199, **201**, **202**, 266, 318, 347n30. *See also yaahl dàajee*

yaahl dàajee (Massett dialect), 78, 84, 85, 88; at *daa.adans*, 45, 69, 78, 79, 91; Caamaño on, 64, 65, 66; and *gu.uu*, 74, 75; at *k'áyk'aanii*, 75, 80, 94; and death of Capt. Newberry, 77, 78, 86; son of, 79 (*see also sriida giids*); mother of, 80; brother of, 82; wife of, 89

yaak'u 'lanngee, 36

yaan, 293, 299, 301, 303, 310; poles at, 15, 283, 305, 329; *Susan Sturgis* at, 160, 163

yaanaang na.as (Cloudy House), 344n4

yaats xàadee, 114-16, 197, 284, 300–301, 306

Yaehltetsi, Mary, 121

Yaelhtetsi, Agnes Edenshaw, 121, 352n59

Yaelhtetsi, Alex. *See* Yeltadzie, Alec

yah riid, 144, 145

yahEt. See yah riid

yahgu 'laanaas (Middle Town People—R19), 92–93, 114–16, 175, 176, 197, 224, 310, 340n13, 349n18; migration to Alaska, 90, 175; and Albert Edward